Desktop Publishing StyleGuide

Desktop Publishing StyleGuide

Sandra Lentz Devall
Esther Kibby (Chapter 13)

Delmar Publishers

an International Thomson Publishing company

Albany • Bonn • Boston • Cincinnati • Detroit • London • Madrid
Melbourne • Mexico City • New York • Pacific Grove • Paris • San Francisco
Singapore • Tokyo • Toronto • Washington

Cover design: Susan Mathews/Stillwater Studio

Delmar Staff
Publisher: Alar Elken
Developmental Editor: Michelle Ruelos Cannistraci

Production Manager: Larry Main
Art Director: Nicole Reamer
Editorial Assistant: John Fisher

COPYRIGHT © 1999
By Delmar Publishers
a division of International Thomson Publishing Inc.
The ITP logo is a trademark under license.
Printed in the United States of America
For more information, contact:

Delmar Publishers
3 Columbia Circle, Box 15015
Albany, New York 12212-5015

International Thomson Editores
Campos Eliseos 385, Piso 7
Col Polanco
11560 Mexico D F Mexico

International Thomson Publishing Europe
Berkshire House
168-173 High Holborn
London, WC1V 7AA
England

International Thomson Publishing GmbH
Königswinterer Strasse 418
53227 Bonn
Germany

Thomas Nelson Australia
102 Dodds Street
South Melbourne, 3205
Victoria, Australia

International Thomson Publishing Asia
60 Albert Street
#05-10 Albert Complex
Singapore 189969

Nelson Canada
1120 Birchmont Road
Scarborough, Ontario
Canada M1K 5G4

International Thomson Publishing—Japan
Hirakawacho Kyowa Building, 3F
2-2-1 Hirakawacho
Chiyoda-ku, Tokyo 102
Japan

2 3 4 5 6 7 8 9 10 XXX 02 01 00 99 98

Library of Congress Cataloging-in-Publication Data
Devall, Sandra Lentz.
 Desktop publishing style guide/Sandra Lentz Devall, Esther Kibby (chapter 13).
 p. cm.
 Includes bibliographical references (p.) and index.
 ISBN: 0-8273-7900-5
1. Desktop publishing. I. Kibby, Esther. II. Title.
Z253.53.D47 1998
686.2'2544536–dc21

98-27400
CIP

Dedication

In 1970, Charles Sullins first enrolled in one of my graphics classes. He had been setting type by hand for over a decade but then found himself nearing unemployment and obsolescence as traditional typesetting collapsed around him. Yet, instead of bitterness and anger, Charlie brought enthusiasm and excitement to the classroom.

The publishing industry changed dramatically over the next two decades, reinventing itself every four or five years. I struggled to grasp and to teach each new technology and with every new class, Charlie appeared. Sometimes he had a handful of colleagues in tow. Charlie, like the technology, constantly reinvented himself. He saw type and design as both an art and a science and he was motivated to continue learning by his love for words and the impact they could have on people's lives.

This book is dedicated to Charles Sullins who, before his premature death, taught me to love words and to recognize how designs can best bring them to readers. I taught him technology—he taught me lessons for living. I hope that, somewhere in the pages of this book, there will be a spark that ignites in you a sincere appreciation for design and a true fondness for words.

Contents

SECTION I
Steps to Professional Publications

Chapter 2

Living with the Software Production17

Chapter 3

Type Formatting Information35

Chapter 4

Typefaces and Their Uses73

Chapter 7
Quality Control Methods137

SECTION II
Types of Publications

Chapter 8
Business Communication Packages157

Chapter 11
News and Product Publications303

Preface

In the past, there were two kinds of publication designers: commercial artists who were part of the advertising market and production artists working for a typesetting company or in the secretarial, printing, and drafting departments of a corporation. Both kinds of designer had a lifetime of training available through on-the-job production and promotions. Today, the commercial artist is called a graphic artist and the production artist is called a desktop publishing specialist.

Desktop publishing is now available in word processing and page layout software. The responsibilities of desktop publishing extend to many people who are not trained designers and who do not have access to a support staff to offer on-the-job training. Most do-it-yourself desktop publishers have good design ideas but, because of the number of choices in type specification and quality control, they experience difficulty transferring the design idea to a finished product.

The author working "smarter, not harder" with *StyleGuide* information.

This book will become a companion for desktop publishing designers and students who are entering the market. Since changes in the marketplace have merged job responsibilities, the *StyleGuide* responds by merging resource information. Unlike other resources, the *StyleGuide* links design and typography techniques to the software language in a single source. It is an aid to visual design and will also guide the user through broad terms of production to specific projects such as letterheads, brochures, and newsletters. It details all the information needed to produce layouts exactly like the hundreds of samples included.

The standards and ideal guides for quick desktop success are not presented as rigid rules but rather as popular and dependable choices. They reflect today's trends and technology while still addressing fine typographic information used by traditional typesetters. As you master the standard layouts, you will be able to expand your choices to include complex layouts and custom level designs. Instant reference, instant instruction, instant quality.

Acknowledgements

This book reminds me of an old-time barn raising that involved the whole community, because this book involved my whole community.

Personally, I wish to thank my family and friends who said things such as, "Go for it!," "I'm tired of listening to you talk about it! Just do it!," "Can you bring a computer when I have the baby?," and "Take the sabbatical; we'll cover for your classes…" That group is led by my daughter editor, Kristine Holland, and also includes Patti Stettler, Lori Carraway, Pat Franks, Joan Mathew, Althea Choates, Freda O'Conner, Coleena Jackson, Jean Burkhardt, and my husband, Bill.

Professionally, I must thank the many "experts in their field" who became advisors for specific chapters: Jim Kannen, ABV Graphics; Ralph Vogel, retired hot type supervisor; Mary Ella Stoddard, UTMB; Tauna Partain Ready, Nationwide Paper Co.; Esther Kibby, Dallas Museum of Art; David Tietz, San Jacinto Junior College; Regina List-Grace, HL & P; Becky LaCrouix Wright, Signal Corporation; Debbie Kirby, *Galveston Daily News*; Suzanne Fattig, Printing Plus; Charlotte Nicks, St. Johns Hospital; Karen Hare, Bosworth Paper Co.; Lou Ledde, L&M Information; Toby Watashe, HL & P; and Jim Winstein, Texas Graphic Arts Education Foundation.

Collectively, I also must thank the College of the Mainland for allowing me sabbatical to produce this book; Delmar Publishers; Elena Mauceri; Susan Mathews, Stillwater Studio; for juggling the volumes of paper and helping verbally and physically to put them in order. And, most certainly, I thank God for this opportunity.

The author and the publisher thank the following reviewers who provided helpful suggestions for improving the manuscript:

Dr. Gary Hinkle
Graphic Arts Department
Illinois Central College
One College Drive
East Peoria, IL 61635

William A. Romano
Macomb Community College
14500 Twelve Mile Road
Warren, MI 48093-3896

Harvey R. Levenson, Ph.D.
California Polytechnic State University
Graphic Communications Department
San Luis Obispo, CA 93407

Linda J. Lee
Senior Editor
Desktop Publishers Journal
462 Boston Street
Topsfield, MA 01983-1232

Introduction

The *Desktop Publishing StyleGuide* helps new desktop publishers launch into publications with information and skills that lead to professional results. It also serves as a reusable foundation for more complex publications.

The *StyleGuide* is divided into two sections. Section I, including Chapters 1 through 7, provides background information and theory that helps expand design knowledge and creativity. This section, regarding *why* appropriate choices are made, is followed by *how* to make these choices, found in Section II, Chapters 8 through 13. The second section also guides the designer through twenty-five specific publications. Samples of each publication give more than a visual reference. All the specifications necessary for production, along with quality assurance techniques, are listed. By providing the specifications to plug into any software package, the confusion of software options is narrowed.

The specifications are presented in three ways, reflecting the needs of desktop publishers:

1. A range of specifications. Provided as appropriate choices for a publication but leaving room for creativity and design choices. For example, the popular sizes for a company name on a business card are 10–14-point type.

2. Specific specifications. The exact specifications for samples included at standard and custom design levels allow "instant success," saving research time and backtracking when deadlines are tight.

3. Visual samples. Standard and custom level samples correspond with the specific specifications listed, while premium level samples serve as examples of expanded techniques such as color ink, paper choices, and bindery.

The *StyleGuide* also provides "indicators," which allow *easy access* to the information:

- Charts. Approximately 400 charts and illustrations are located throughout the text to serve as visual representation. Easy access charts, including production specifications, provide instant information and design options.

- Cross references. Cross references are available to reinforce the information and provide additional choices. A designer beginning in the last half of the book because of production deadlines will have the benefit of the first half of the book, as needed, through cross references.

- Markers. All chapters contain markers such as bullets and numbers, which highlight important data or sequential steps.

- Check points. Check points follow a set of steps when all steps are not required for all publications. An example of a check point would be a completed job ticket, which assures the designer that all information has been completed at that point for the project.

Because the *StyleGuide* is presented in a unique, comprehensive manner, a section, chapter, page, illustration, or chart may be referenced at any time. This reference book can be used every time you begin a new graphic publication, want to expand your knowledge, or find initial research regarding a publication. You do not have to know everything in this book to be a good designer, but the *why* section and the *how* section are intended to work in any order to maximize design opportunities. Enjoy!

Steps to Professional Publications

Good habits are easy to expand; bad habits are hard to change.

Establishing a Process

Steps of the design process
Categories of publications
Design levels
Clarifying the process by job titles
For additional research

After reading this chapter and applying its principles, the designer should have success:

- Establishing patterns from the initial idea stage to the final product that are expandable and repeatable.

- Finding shared characteristics that help narrow specification choices by determining audience and effect and matching category.

- Identifying the four levels of design by complexity, deadline, and budget that affect the overall appearance of the final publication.

- Defining the role of a designer and major occupations in the graphic communications industry.

This chapter presents patterns, instruction, and easy steps to follow to help a "growing" designer. Read this chapter like it is a road map: by using this "map," some directions will be memorized for other trips. Without the map, detours will be costly, time consuming, and continuous.

Steps of the design process

The following five steps are the same whether the publication is simple or complex. Only complete the tasks within each step that are necessary for that specific project. The order in which the tasks are completed is not critical, but using them to gather as much information as possible prevents redesigning and backtracking. Designers know they are finished with a step when the "check" at the end of that step is accomplished. The five steps are:

1. Researching and analyzing the project.
2. Preparing the design.
3. Producing the design.
4. Organizing files.
5. Communicating with the service providers.

Step 1: Researching and analyzing the project

Research and analysis builds experience for the designer. Research time may vary from a few hours to several months. Gathering the correct information leads to knowledgeable decisions that carry over to other publication projects. Research allows the designer to give informed, professional recommendations while still giving the client the last word. Some common tasks in this step are:

- Fill out a work order, job ticket, or contract. A work order (figure 1-1) gives necessary technical and deadline information gathered from the client to move the project through each step. Other "orders" may be needed in other areas such as paper, service bureaus, and printing.

 ✘ Cross reference: Graphics forms are used for samples in Chapter 12.

- Evaluate the design level. Narrow the choices. Use information from the work order to establish limitations to tints, ink colors, output device, printing process, and bindery. Add this information to the work order.

 ✘ Cross reference: Limitations of each design level are given in Chapters 1 and 7.

Figure I-I A job ticket.
Credit: Gordon Green, President, Green Ink Works, Inc.

- Identify category and name the publication. A category and a name are essential for gathering related information from previous projects and samples. This step helps develop specific choices, adds to expanding design knowledge, and begins communication with the client and outside resources.

 ✗ Cross reference: A listing of all categories is in Chapter 1 and a detailed listing is in Chapters 8 through 12.

- Define the elements (parts of the copy). Label the copy by element names with a highlighter or typographic marks. Client input will establish the importance of different elements of copy, which will aid in determining the importance of the copy on the design. A name for each part of the copy helps establish type information and placement of the copy.

 ✗ Cross reference: Typographic marks are given in Chapter 3. Element names shown by definition and example are at the beginning of Chapters 8 through 13.

- Set a budget for each step in the process. Depend on a printing company representative or your company's service department to build a balanced total budget that matches components within the particular design level.

 ✗ Cross reference: Components are included in Chapters 8 through 13.

- Set a production schedule. Establish an intermittent date for each step of the process. This includes working with the outside vendors for the final due date.

 ✗ Cross reference: Suggestions for maintaining deadlines are included in Chapter 2.

- Locate samples and standards. Build resource information on professional choices from printed samples similar to the project.

 ✗ Cross reference: Types of reference notebooks are included in Chapter 2 and other reference materials are listed at the end of Chapters 8 through 13.

✔ *CHECK: A job ticket is completed.*

Step 2: Preparing the design

The designer determines how much time is available to spend on preparation of the design. An experienced designer draws on experience but uses design time to identify and experiment with new trends. Primary components for preparing the design usually include:

- Assemble the research information. Attach a work order to a large folder that will include everything needed to complete the process. Keep relevant design books handy.

 ✗ Cross reference: Additional research and suggested readings are included at the end of each chapter.

- Determine level of design. Establish the printing processes, output device to be used, and design elements such as the use of photos and tints, to match the level of design.

 ✗ Cross reference: Refer to Chapters 1 and 7 for levels of design and examples of the processes.

- Design at least three good thumbnails. Sketch miniature designs until all ideas from research and analysis are blended together onto paper (figure 1-2).

 ✗ Cross reference: Thumbnail sketch information is included in Chapter 3. Research information is part of Chapters 8 through 12.

- Determine a grid system. Establish a grid system that will bring the project together. Organize and group the elements with a grid. If it is helpful, include the grid on the thumbnail and rough sketches (figures 2-1 through 2-6).

 ✗ Cross reference: Layouts with grid information are explained in Chapter 2 and specific examples are included in Chapters 8 through 12.

- Draw a rough that includes type specifications. Redraw the best thumbnail sketch full size with exact measurements. Mark elements with their name and type specifications (figures 1-2, 3-9).

✗ Cross reference: Type information is found in Chapters 2 and 3 and specific type and paragraph information is located in Chapters 8 through 12.

- Select the paper and ink. Determine the number of pages, photos, and colors, as well as the type of printing and bindery to be used with the project so that all the components fit together. Finalize. Paper can be ordered by the printer or designer after this task.

 ✗ Cross reference: Paper information is found in Chapter 6. Suggestions for specific publications are included in Chapters 8 through 12.

✔ **CHECK: Three thumbnails and/or roughs are designed.**

Step 3: Producing the design

A clear picture of "what to do" and "how to do it" should now exist for the designer as the project moves onto the computer. The production of a design should follow this sequence:

- Prepare the artwork and photos. Determine a source for art and photo acquisition that coordinates with the project's software and file.

 ✗ Cross reference: Choices for line art and photos are found in Chapter 5.

- Produce the layout. Transfer the information from the roughs into the software. Place or type copy, place art, and check spelling.

 ✗ Cross reference: Type formatting is found in Chapter 3.

- Print one copy for corrections. Thoroughly proofread and then mark all corrections to be made, maintaining a balance between each type specification and the effect of other design elements.

 ✗ Cross reference: Proofreading marks are included in Chapter 3.

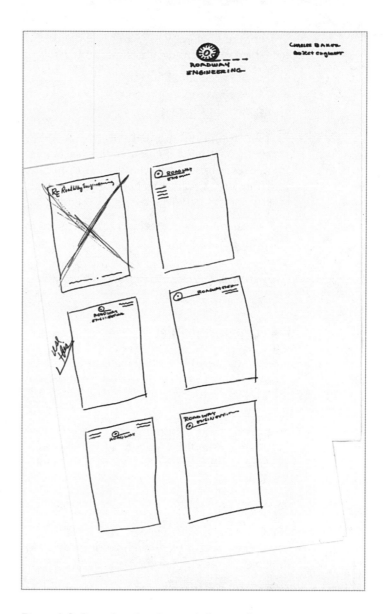

Figure 1-2 Best thumbnails equal the rough.

- Present the final copy to client. Use the best affordable proof of the publishing project to present to the client.

 ✗ Cross reference: Proofing choices are included in Chapter 7.

- Prepare for printing and bindery. Set up the project's computer files according to requirements for various services involving printing and bindery. Create the hard copy (from the laser printer) that will serve as an original.

 ✗ Cross reference: Production choices are included in Chapter 7.

✔ *CHECK: Ready to print the final proof.*

Step 4: Organizing files

Organize computer files to eliminate recreating lost files and to reuse on future related projects. This involves:

- Inspecting and renaming all files. To avoid confusion, establish a pattern for file names including publication name and numerical information.

 ✗ Cross reference: Follow files names similar to forms in Chapter 12.

- Updating backup files. Archive or back up the final set of project files.

 ✗ Cross reference: Read professional magazines for advice on current storage devices.

✔ *CHECK: Ready for future related projects.*

Step 5: Communicating with service providers

Every publishing service, including printing companies, the jobbers, paper companies, bindery companies, and service bureaus, has a representative who is responsible for communicating with the designer. Make an appointment with these representatives to discuss schedules and budgets. Avoid oral instructions. These discussions, where the outcome is written instructions, can help return the best product to the designer. Also:

- Take the project folder to the printing company. The project folder, containing all project information, should be available to the printing company representative and other publishing service representatives.

 ✗ Cross reference: Quality control is the focus of Chapter 7.

- Request additional copies for filing. Save samples for future projects and portfolios. They serve as excellent examples of special papers, varnishes, or die cuts.

 ✗ Cross reference: Reference notebooks are included at the end of Chapter 2.

- Evaluate press check or printed copies. Different printing processes allow the designer or director of the project to sign-off or check the final copies at some point of the production. Large presses require a press check during the press run to ensure image quality. Smaller presses and copiers are usually checked after bindery.

 ✗ Cross reference: A checklist is included in Chapter 7.

- Evaluate the finished publication. Complete the final examination of the finished product.

 ✗ Cross reference: A checklist is included in Chapter 7.

✔ *CHECK: The finished product is available.*

Categories of publications

Publications in one category will have similar names of elements (parts) and similar type information. Finding shared characteristics helps narrow the choices and establishing a category helps to narrow specification choices. When files are identified by groups and names, file information can be reused on similar projects

How categories are grouped

The intended audience and its initial effect are primary factors that identify a publishing project's category. Determine the audience needs with each publication by identifying *where* it is read and *what* might be done with the information. Recognize the variety of reading environments and choose a category that matches reader comprehension and outcome. Examples are reference books with easy-to-follow subjects, corporate reports with note-taking room, and unsolicited advertisements with brief topics set in large type. Different roles, different specification requirements.

The audience

The *audience* of a publication includes the readers or targeted readers. The design should be built around the reading audience and the intended outcome.

The effect

The *effect* on the audience creates a functional or visual response. Functional publications have a practical purpose: information is read for content and is usually "required" reading. Visually stimulating designs focus on the artistic image in order to draw a prospective audience. Information is presented by designs to draw a specific population to the publication.

Categories by name

Categories of publications are grouped by their purpose and similarities

Basic business package

The business package is essential to every company. It is a basic communication tool for an established or intended customer. Many of the projects included in this group will be the first publication a customer receives, such as letterhead, business cards, and envelopes.

AUDIENCE. Established or intended customers receive both formal and informal correspondences from a company on **shells** (files set up to insert specific information, such as employee names or departments) for both formal and informal correspondence.

EFFECT. Quiet, but creates an identity within formal communication publications. Choose small type sizes.

Text documents

The text document has one subject and the pages of text usually include technical visuals.

AUDIENCE. Employees or established customers needing research for subject interest.

EFFECT. Quiet, to prevent eye strain for long reading sessions; relays information. Choose readable type and easy-to-follow subheads. Allow room for notes, conclusions, and corrections.

Advertising packages

Advertising packages are used for new products or events by both profit and nonprofit organizations.

AUDIENCE. Everything is audience-driven in the advertising packages. Audience varies according to the market (such as business-to-business or business-to-community).

EFFECT. Strong visual designs draw attention and answer questions. Choose and maintain a design theme that matches the intended market.

News and product publications

News and product publications present information focused on a specific group of people by their special interest or leisure activity.

AUDIENCE. Specialized groups of people who are identified by criteria such as age, income, and family size.

EFFECT. Read selectively rather than continuously. The eye-catching effect should relate to the subject of the publication. Choose one or two words for the nameplate in type sizes up to 3″ tall and the same small-body text type for short line length articles.

Forms

Forms are functional publications that serve as a vehicle to gather data such as write-ins and computer fill-ins.

AUDIENCE. A universal audience who strives to spend minimal time and focuses only on the function.

EFFECT. A simple and uncomplicated effect. Choose clean, sparse designs that use only one typeface and size.

Web design packages

These packages are electronic publications allowing transfer of information that is constantly in flux. Web design packages draw from the printed publications in areas such as advertising, inter-company communication, and public relations.

AUDIENCE. A visit from the broad audience requires frequent changes of information at the web site and quick maneuvering through the site.

EFFECT. The effect is active participation of the audience by completion of programmed applications, direct ordering, and interaction with other browsers.

Design levels

Today's designer works in all publication categories but in specific **design levels**. Design levels are defined by common sense and controlling factors that relate to time and image quality. Budget and complex needs of the project establish the design level. Quality of design is created by using solid design principles with an awareness of the variables related to that design level.

Historically, the production work in design levels was priced into sixteen different levels. Today, most designers and printing companies communicate about four levels of design and production. This book defines these levels as standard, custom, premium, and showcase.

The following example illustrates three levels of design. Initially, a home-based start-up company has a limited budget and chooses a **standard** letterhead (a fifteen-minute to one-hour design printed in black or a standard color ink). As a growing company looking for bigger corporate clients, it upgrades to a **custom** letterhead (a four- to eight-hour design with a logo and one ink color). Later, after successful franchising, it includes a unique **premium** image (design time controlled only by budget and requiring marketing research resulting in a redesigned logo produced in multiple colors or with embossing).

Design levels help establish choice of components from each task that affects quality and overall appearance of the final publication. Using components that match a design level will also stabilize budget and deadlines while limiting problems.

The variables of budget and quantity dictate the design level. Plan for these six components in relationship to budget and quantity:

1. Time spent on each step.
2. Software options and number of software packages used.
3. Equipment or process complexity chosen for output, printing, and bindery.
4. Paper and ink choices.
5. Image and effect created with art, logo, or photos.
6. Critiquing by closing out each step with a firm agreement between client and designer.

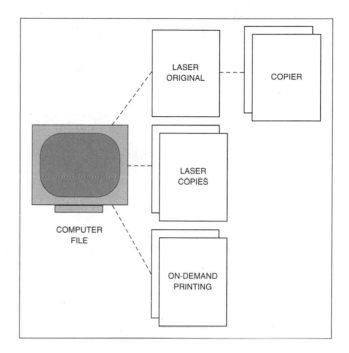

Figure 1-3 Standard level printing processes

Standard level

Typical uses include the business-to-employee audience, start-up companies, and small businesses.

Standard level designs are used for publications with small budgets and are produced by the most economic processes (figure 1-3). However, this never means lower quality design; rather, there are fewer choices in design techniques.

Time

Use research from existing standard level samples, reusing computer file data as templates. Layout production time is from *fifteen minutes to one hour per page* and total turn-around for the finished publication is "while-you-wait," or twenty-four hours.

Software

Work in *one* software package, using clip art and symbol fonts without alterations for graphics. Because of deadlines and output devices, avoid use of more than ten to fifteen type elements and one tint.

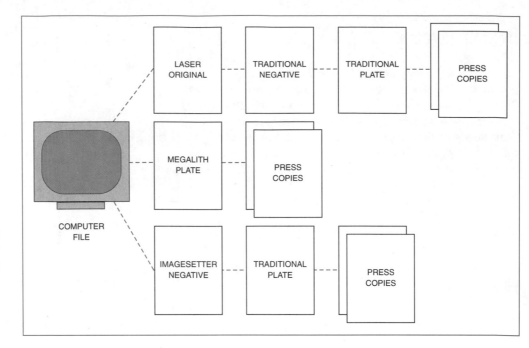

Figure 1-4
Custom level
printing processes

Equipment

Choose from copier, on-demand printing, or small offset for production. The image resolution for standard level is from 300-1000 dots per inch (dpi).

Paper and ink

Most standard level design printing is 8½″ x 11″ or 8½″ x 14″, 20#-24# bond in black ink. For heavy stock, use 65#-80# Bristol or covers without texture.

Image and effect

Bindery choices include spiral, punch, fold, pad, and staple. Thermography and perforating are included special effects because they can be done during the press run.

Critiquing

Watch for image quality, junk art, and clutter.

Custom level

Custom level designs involve a budget that has an established ceiling due to either profit or the need for the design to be functional but attractive. They are produced on most processes (figure 1-4). Projects include visuals such as charts, graphs, tables, and photos. Typical uses of custom level designs include business-to-public and business-to-business, and both small to medium-size companies.

Time

Research time includes locating and applying design solutions by using trends, esthetics, and tracking (such as mailing and numbering) techniques. Production time is four to ten hours per page. Use personalized templates that match the company identity or specific design package.

Software

Work in two software packages, usually a page layout package and a photo or drawing package. Avoid using two adjoining colors (also called tight register). Employ the use of complex specifications within each page element.

Equipment

Choose up to medium-size presses that print one or two colors at a time or color copier and duplicators. Range of image resolution is up to 2540 dpi on an imagesetter.

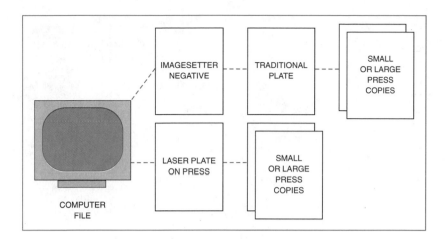

Figure 1-5 Premium level printing processes

Paper and ink

Complement designs with a variety of sizes and weights of paper and colors and shades of ink. Limitations include four-color process (except for color copiers) and enamel-coated paper.

Image and effect

Images and type are layered to create a two-dimensional professional look. This is accomplished with graduated shading and images that touch the edge of the page (see figure 5-9 for bleeds), through manipulation of stock photos, art, and use of tints.

Critiquing

Watch for typographic problems caused by complex type specifications. Pay special attention to combinations of ink and paper choices.

Premium level

The premium level of design provides a broader scope of choices. These designs reflect present trends or represent a single past era. They are produced on the high-end, high-quality processes (figure 1-5). Premium level designers' skills are strengthened by a broad background that may include writing, marketing, and fine arts. Typical uses include business to business for medium to large or expanding companies.

Time

Extensive research should include analysis of the market, audience, and client. Because of complexity and long range goals, deadlines are much more detailed and specific to each budget.

Software

Explore and gather knowledge of current software versions. Premium level designs are always produced in two or more packages. Often, a specialty package is required for the specific needs of the publication. A **specialty package** could be a type manipulation package chosen to create unique letters.

Equipment

Use medium presses for shorter runs (up to 5,000) and larger presses for longer runs and four-color process. 2540 dpi is required as a minimum. Complex finishing such as varnish, embossing, and die cuts are included on these projects.

Paper and ink

Ink choices include four-color process with an additional specialty process such as metallic inks and varnish. Designs are typically printed on enamel-coated stock or fine papers with textures and coatings as additional choices.

Image and effect

Presentation should stand out with elegance. Strive for a permanent identity for the company. Hire a professional photographer and use strong but personalized graphics.

Critiquing

After distribution, some publications are given a market analysis to evaluate their effectiveness.

Showcase level

Showcase publications are pacesetters and award winners and other designers learn from and emulate them (figure 1-6). They reflect trends built on typical design techniques but use experimental approaches and tools that often set new standards. Typical uses include all markets and all levels of design.

These experimental tools and approaches result from the process of solving design problems. Applying an appreciation of hand-crafted art, lost technology, and new technology not only solves the design problem but creates a trendsetting design.

Time

Broad, unlimited time is spent in non-traditional places. Research and time are approached in an artistic manner.

Software

Unlimited new version software options are necessary to recognize all design opportunities.

Equipment

This includes the mixing of unfamiliar and uncomplementary equipment and techniques for the de-

Figure 1-6 Showcase printed sample. *Courtesy of Delmar Publishers*

sired effect. An example is distorting an image with excess blur on a copier, then using it as a collage for photo manipulation.

Paper and ink

Paper and ink combined by experimenting apart from typical color combinations and typical color palettes create unique publications. This includes using papers from other markets, such as packaging and newsprint, to create impact.

Image and effect

Show stoppers! Exactness and detail make these unusual approaches "sit on the sheet."

Critiquing

Use these kinds of designs only when appropriate and put the design problem ahead of the technique.

Clarifying the process by job titles

Employment still requires different mixes of job titles, design level, and media. Some printed publications will be completed by one person assuming all these roles and others require a team management group. Usually, job titles fit one design level with some projects from one other level. Since there is not a strong licensing standard in the industry, people can call themselves anything they wish. Here are some definitions:

Designer

The general term **designer** is used to describe an entire group that includes anyone handling a printed publication through the prepress stage. Other titles might be communication specialist or graphic technician.

Attributes

Attributes require an unusual mix of creative and mechanical aptitudes. Additional strengths include organization, enthusiasm, precision, reliability, productivity, and service-oriented.

Desktop publishing specialist

This term is used to indicate a designer in an office environment who may have other responsibilities. Employment opportunities extend into copier service bureaus. Desktop publishing specialists have typographic and technical backgrounds related to the specific publications they produce. They also know papers and the printing process up to medium-size presses.

Attributes

A strong knowledge of standard level designs and an ability to produce custom level designs is required. The desktop publishing specialist has production skills in one page layout or a word processing package. This person also has production skills with drawing packages and can operate photo manipulation software.

Production artist

The production artist is the typesetter or assembler of the publication in a small to medium-size printing company or large copier service bureau. They have broad typographic backgrounds and strong command of the software.

Attributes

Production artists show a strong knowledge of custom level designs and the ability to produce standard or premium level designs. They have production skills in one or two page-layout packages and practice production skills in drawing and photo manipulation packages. They have a strong knowledge of custom design with attention to fine details and efficiency.

Graphic designer

The graphic designer designs and produces publishing projects. They produce publications that include professional artwork in traditional and computer-driven mediums.

Attributes

There is a use of strong artistic skills from both fine arts and computer art. The graphic designer applies skills to custom and premium level design and possesses color sense and awareness.

Art director

The main job of an art director is to meet the deadline and maintain the quality—keep the job on track. He/she contracts and supervises personnel.

Attributes

The art director uses a mix of organization and creative vision and has a wide range of skills and experiences for all steps of premium level publications.

Creative director

In larger ad agencies and design studios, the creative director controls and guides the art director.

Attributes

The creative director has an ability to manage creative people and can establish creative vision. Creative directors work in all media and coordinate long-term projects.

For additional research

Keep a well-balanced design approach by continuing research into some suggested sources:

Tour printing facilities

Read professional magazines

Contact the Printing Industries of America
 1730 North Lynn Street
 Arlington, VA 22209

Historical information

Bruno, Michael H., *Pocket Pal*, Memphis: International Paper Co., 1995.

U.S. Printing Office, *Book of Occupational Trades*, 1996.

Trends

Greenwald, Martin L., Ed.D., *Graphic Communications: Design Through Production,* Albany: Delmar Publishers, 1997.

Lem, Dean, *Graphic Master 6,* Maui: Dean Phillip Lem Associates, Inc., 1996.

Detours in the process can bring production to a halt.

2 Living with the Software Production

Developing software discipline
Designing with grids
Naming style formats
Building customized templates
The production critique
Building reference materials
For additional research

After reading this chapter and applying its principles, the designer should have success:

- Demonstrating good work habits when completing steps involving software.
- Identifying and using a grid system to give designs structure.
- Choosing style palette names.
- Critiquing and correcting new and existing designs.
- Establishing a personal library of reference information and samples.
- Organizing a file management system for opening, copying, saving, and deleting files.

This chapter presents general discipline attitudes along with the specific use of tools to increase production speed and aid in creating a system of growth. When any step of the process gets detoured, regrouping and rethinking is required and production must come to a halt. Following guidelines, using a checklist, and having a disciplined approach to software are preventive problem-solving tools.

Developing software discipline

Presented in this section are the "I told you so!" and "You should have…" as they apply to software. These ten strategies to approaching software save valuable time and prevent problems that can halt production. Establishing software discipline requires becoming familiar with the information in each approach and making it a habit. Read it! Learn it! Live it!

10 Strategies for software discipline

The first three strategies were first applied to desktop publishing by Kvern, Roth, and Fraser in *RealWorld PageMaker*. A lot of pain and suffering get credit for the rest.

1. Make it repeatable

The ability to keystroke data only once is a major attraction of computers. Save keystroking with the following production techniques:

- Templates. Create a few custom-made templates from typical finished publications with repeatable data. For similar projects, eliminate steps such as storing page size, margins, styles, and so on. Revise and improve templates as a final step.
- Styles. Match the style palette name with the element name to avoid confusion. Use the styles in new files in that category by copying them from the old file.
- Grids. Establish grids in the design stage and transfer them to the software. Use grids on design sketches that match software capabilities. Create sketch sheets by drawing half-point boxes on column grids. Print them as thumbnail sketches or full size for rough sketches.
- Master pages. Place repeatable running headers, footers, page numbers, grids, guidelines, and rules on master pages. Use multiple master pages for additional changes to page set-ups.

2. Make it simple

Words like *classic* and *elegant* help define "make it simple." Apply these words to prepare and produce a design that uses the following techniques:

- Less is more. Focus on simple but quality designs. Examples include using the least amount of text blocks, changing weight rather than adding a typeface, and finding the simplest grid that fits the number of pages. Since complex ideas often create problems, save these ideas for problem *solving*.

- Be practical. Know guidelines that make things simpler and understand that they do not always apply. For example, if a one-page project has a tight deadline and no repetitive information, skip the style palette.

- Use a 12-point leading. Use a 12-point leading or multiples of 12 (such as 24 or 72) whenever possible. Try 12 first, but do not sacrifice quality to use it. Aligning columns, copyfitting, working from a rough with 12-point grid lines, and dividing the leading in half or fourths before paragraph leading work smoother with 12. Also, the math for a 12-point leading is easier to memorize.

- Keep files clean and lean. Eliminate anything that will become a "gremlin," such as front and back page set-up for single-sided projects, textblocks left on the pasteboard, empty textblocks (select "all" with the pointer tool to find them), white boxes over copy, and additional style names in the style sheet or color names in the color palette.

3. Be consistent

From page to page and job to job, consistency eliminates guesswork. The end result of consistency has a positive effect on the reader, client, and designer.

- Establish a sequence to each step. Steps as small as saving to the hard drive first and to the back up second remove doubt about what was done and take guesswork out of even the smallest technique. Also, this consistency eliminates the question, "How did I do that?"

- Work proportionally. Keep page element specifications in a hierarchy order by their importance to the design. Throughout revisions, match the project needs to the effect on the reader. Maintain proportions with color and grids.

- Build page-to-page consistency. Check for consistency of page elements throughout the entire publication when proofing. Critical attention given to location, white space, location of copy on master pages, and specifications becomes a professional indicator to the reader.

4. Work smarter, not harder

Make efforts worthwhile. Exhaustion that is the result of poor planning or undeveloped work habits leaves little room for creative growth. Search for an easier way to accomplish each task.

- Add new tools. Explore software upgrades for tools that increase production speed.

- Learn one keyboard shortcut with each project. Learn as you work. Begin a new project using one new keyboard shortcut that is repetitive in the project.

- Try one new technique with each project. Practice new techniques during production and in small steps that can be abandoned if the deadline gets tight. Begin with important techniques such as setting tabs, using points, and using **em** and **en** spaces that professionals use.

- Work smoother. Use smooth movements at the computer to prevent the "whoops!" which means, "I didn't mean to click on that."

5. Garbage in, garbage out

Keep the quality transferring from concept to delivery. Once a garbage (poor quality) image is in the product, garbage comes out in the final publication—the quality decreases with each step. Corrections, if possible, increase printing company cost.

- All scans are not created equal. Beware of inexpensive scanners lacking detail and of unskilled scanner operators. Poor quality scanners create visible dots on images that can indicate poor quality to the audience. Use outside services for high quality scanning from slides or transparencies.

- All laser printers are not equal. Rather than depending on dpi (dots per inch), test the laser printer's quality by actually printing a standardized test original.

 ✘ Cross reference: A suggested test original is found in Chapter 7.

- All typefaces are not equal. Assess the printed quality of a typeface by comparing it to a sample with the same name but a different brand. Include both display type and a paragraph of text type in the sample.

- Eliminate poor quality line art. Discard poor photos or line art that create poor quality publications when enlarged. Designing with tints, textures, and reverses is an effective alternative to using poor images.

6. Work backwards

Everything comes together at the printing and finishing processes. Planning each step requires an awareness of the final design steps, printing and finishing. This knowledge furnishes the design requirements for the output or printing equipment up front. Backtracking causes loss of valuable time, repeated steps, and reruns.

- Design and equipment work together. The best way to eliminate mismatch is to find out about the equipment and its capabilities. Ensure an economical, quality image by discussing the features with the production personnel, attending equipment shows, and reading professional magazines.

- Establish deadlines for each step. Work with production personnel to establish deadlines. Work from the final deadline forward, placing deadline dates at each step. Leave some flexibility for unplanned emergencies.

7. Know when to go for help

Two kinds of people get in trouble: those that ask for help all the time and never learn to problem solve and those that stay with a problem past the point where they are capable of seeing new solutions. While struggling with a problem, it is difficult to stop and get help. Consider these checkpoints to stay on track and apply solution techniques.

- Be specific about the problem. Ask for help with concrete information instead of "It's broken!" State what is happening, such as, "This file will not print," and write down any error messages that appear on the computer.

- State the possible causes. Recognize what led up to the problem by knowing what was happening before the problem occurred. You may have done nothing wrong, but key information includes what you did, what you did differently, and what you have tried to do.

- Isolate the cause. Systematically eliminate the cause of the problem by making changes *one at a time*. Examine causes such as software operator, electrical, hardware, software, or the file. For example, move the file to another computer.

- Get away from it. Consider the deadline but use a technique to move away from the situation. For example, push the chair back, turn it in a circle, and take a deep breath—whatever works for you.

- Know when and where to go for help. Set a time limit, then go for help. When personal resources and manuals appear exhausted or time is limited, seek help from an established support person.

- Be prepared to start from scratch. Sometimes, starting over with the right focus can take less time than struggling with a contaminated file.

8. Designing on the screen is designing down

The screen image can hypnotize like a highway stripe. The longer the inexperienced designer works at the monitor, the more they become lost in the design. It is impossible for an inexperienced designer to visualize the differences between monitor images and quality publications without practice and experience.

- Screen images vs. output. What looks good on the monitor might look bad on the output device and the publication. Working without a sketch creates constant file revision at the monitor that will not look the same on the laser printer, imagesetter, or direct output to printing.

- Compare the first printout to the rough sketch. Lettering and layout measurements on a rough are a good reference for correcting design problems. Hold the rough next to the monitor at the actual size view. Closely examine display type for size, letter width, and letter spacing. Change the setting until both images look identical. Examine body type for leading and line length.

- Use italics. When designing on the screen, the monitor version of italics is poor, but italic on the laser and final copies is perfect (and a solution to many design problems).

- Watch for large type. New designers tend to use large type sizes that make designs look heavy. 12-point monitor type is clearest, which is too large for body type of most printed publications. To critique type sizes, print a copy at 80–90% and compare it to a full-size sample. If the reduction looks better, cut the sizes down for the next publication.

9. Match all components

Identify the design level of the project. Then, choose the components that match the design level. Mismatched equipment or different levels of technical and creative skills produce disappointing image quality on the publication.

- Refer to the schedule, budget, and design level. Continuously check the match between machines (laser printer, platemaking device, printing press, and bindery). If one component or process is changed during the project, the design may need to be adjusted.

- Watch out for fonts. Fonts print differently to laser printers and imagesetters. PostScript 1 and TrueType fonts will print well to most lasers and not print to imagesetters. Removing or avoiding these fonts can eliminate problems later. These fonts appear in the font folder with one icon rather than two—a printer and screen font. Adobe multiple master fonts provide the most accurate way of changing character shapes (width and thickness of letters) without destroying the integrity of the letters, avoiding a distorted look. They are ideal for custom and premium level designs and output devices.

- Design only what you can produce. Use samples to confirm the software's abilities. Use a personal evaluation to determine your level of computer skills. Stay with what you know for tight deadlines. Experiment with what the software can do for flexible deadlines.

10. Be organized

Organizational skills enable good habits and good attitudes to grow. Organized files are accessible for revisions and for reuse of grids, styles, and templates. The designer gains the confidence of others when samples and files are available if needed.

- Keep notebooks. Keep samples of fonts, printed samples, and templates accessible.

- Protect data. Treat data with care. Correct file name and back-up files as soon as possible after the first printout.

- Have cleanup time. Allow ten minutes at the end of each day to tie up loose ends. Check for unused styles and empty blocks before giving a file the final "save as..."

- Be a technician. Allow time for cleanup of design "tools" such as the project, software, and system files. Technicians with tools in excellent working order will perform systematically and with precision.

Designing with grids

The grid system is a skeleton invisibly supporting a design. A grid helps page elements form groups and these groups direct the reader through the design. Grids transfer from sketch to computer production almost intuitively; experienced designers use grids without any conscious effort. Other names for grids are columns, unit grids, or modulars.

Suitable grids are vertical and/or horizontal. Basic grids are vertical, like columns. Grids helpful in solving complex design problems include both horizontal and vertical divisions.

Vertical grids

Vertical grids work as column guides in page layout and word processing software. The number of columns available in a specific software package determines the variety of grid patterns available. Copy may be placed over one column or several columns (figure 2-1) depending on layout factors such as audience and typeface. Unless some portion of the copy is placed across several columns, the design looks rigid.

To transform cluttered or boring copy to readable copy, use the four most common grids: two, three, five, and seven. The number of grid columns increases with larger numbers of page elements, type, charts, and images. Use a **scholar's column** (a column without body text) for pull quotes, images, long titles, and introductions.

At first, it is hard to identify grids in resource samples since they appear hidden. To simplify this task, look for the smallest column width of copy. Then, find multiples of that column by appearance, not measurement (figures 2-1, 2-2, and 2-3 have the grids marked with boxes to help identification). Designs with complex page elements require more grids; for example, this book is a two-column grid.

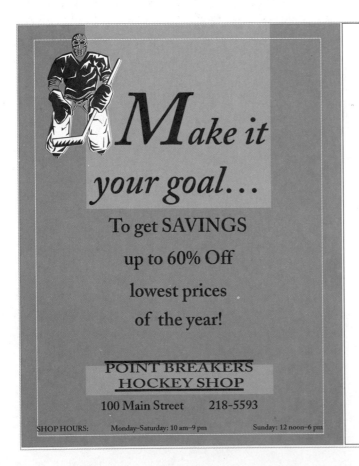

Figure 2-1 Centered for formal presentation. *Credit: Brian Campbell, graphic artist - art work*
(Opposite, top) Figure 2-2 Two-column for two to three page elements. *Credit: Brian Campbell, graphic artist - art work*
(Opposite, bottom) Figure 2-3 Three-column for five or more page elements. *Credit: Brian Campbell, graphic artist - art work*

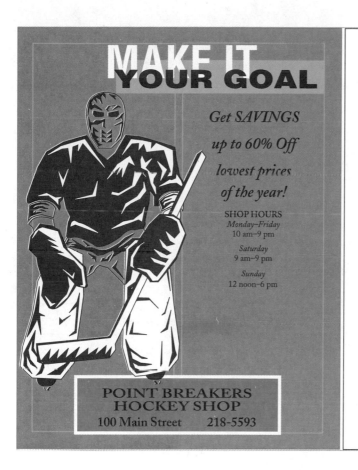

Design & Desktop

your path to professional communications…

PRINTED AND ELECTRONIC PIECES are all produced today on software that has the capability to add type design previously unavailable to anyone but experienced craftsman. These craftsmen spent years as an apprentice, learning how to solve the problems of printed piece by applying the standards that had been taught to them. As each advanced in technology began, the exclusiveness of the tools began to disappear. The research and preparation that cannot be done by someone standing by your shoulder can still be part of the design, you just have to look another place. Without the research and design step, you will find yourself designing pieces that don't look right and worse, not knowing what to do.

Desktop is your next step after the research and design are completed. Desktop work requires you to sit in front of CRT screen and tell the computer what is to be on your design. It should happen and part of a pattern. The desktop steps themselves should be a pattern. Not just the order they are completed, but choices should have a pattern as to how often and what first. The best way to learn production techniques that work is to find a specialist or professional organization of specialist that your can brainstorm. This will be valuable to you, not just when things go wrong, but it will also be someone or several someones whose opinion you respect and it will make the "Great job!"

Line art, pull quote, chart or photo

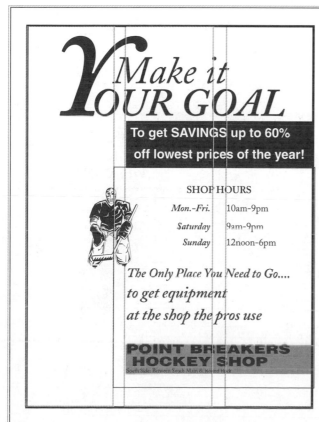

DESIGN & DESKTOP

…your path to professional communications

Printed and electronic pieces are all produced today on software that has the capability to add type design previously unavailable to anyone but experienced craftsman. These craftsmen spent years as an apprentice, learning how to solve the problems of printed piece by applying the standards that had been taught to them. As each advanced in technology began, the exclusiveness of the tools began to disappear. The research and preparation that cannot be done by someone standing by your shoulder can still be part of the design, you just have to look another place. Without the research and design step, you will find yourself designing pieces that don't look right and worse, not knowing what to do to fix it.

Desktop is your next step after the research and design are completed. Desktop work requires you to sit in front of CRT screen and tell the computer what is to be on your design. It should happen and part of a pattern. The desktop steps themselves should be a pattern. Not just the order they are completed, but choices should have a pattern as to how often and what first. The best way to learn production techniques that work is to find a specialist or professional organization of specialist that your can brainstorm. This will be valuable to you, not just when things go wrong, but it will also be someone or several someone's whose opinion you respect and it will make the "Great job!" means so much more.

One column of text

One column of text on a page is either **symmetrical** (in the center) or **asymmetrically** placed across several columns (figure 2-4). Asymmetrical columns are useful if the audience needs to write comments in the margins because the reader does not need to go up and down several columns. All software supports both symmetrical and asymmetrical designs for copy set in one column. Since one line has a mini-

mum of seven and a maximum of fifteen words, longer line length requires larger text sizes, more leading, and larger indents. The text will consume more pages because of the type requirements.

Watch for longer line lengths with more than fifteen words per line with the maximum of 11-point type (12 points for a few typefaces). The line length will have to be shortened or the text broken into two columns.

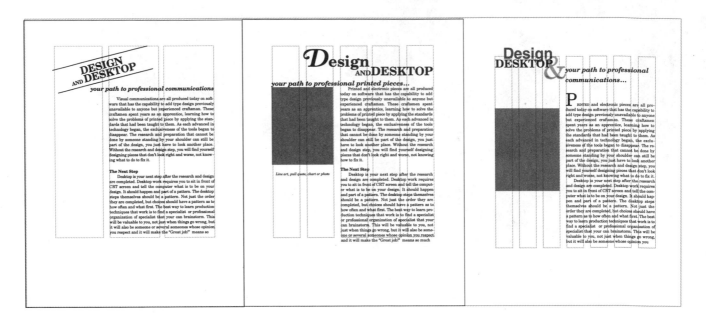

Figure 2-4 One column of type across a 3/5/7 grid

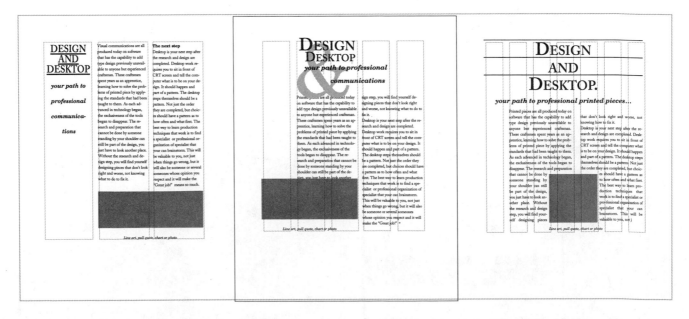

Figure 2-5 Two columns of type across a 3/5/7 grid

Multiple columns of text

Larger numbers of page elements create the need for a more complex use of grids. Several opportunities open up when text is placed in multiple columns.

Using multiple columns of text increases placement options for additional page elements (figure 2-5). These additional page elements can spread into the margins of other columns of text and the page margins, giving the page interest.

Placing columns of type across one grid column is an excellent solution for fitting more words on a page. Narrow line lengths require smaller type sizes to maintain the minimum of seven words per line. Narrow line lengths also require smaller leading and indents.

Horizontal grids

The most common horizontal grid divides a sheet into eight parts (figure 2-6). The most important area is the third block down from the top, called **optical center**. This is where the audience first looks when reading a page. For example, chapter titles for *StyleGuide* are optically centered. Also, advertising samples place important copy at optical center.

Saving time with grids and columns

When deadlines are critical, grids aid in placing the text in an orderly fashion. Every software package includes some tools that apply columns and grids to the following production designs and techniques:

- Relating copy to grids without columns. If the software works without columns, use a simple grid pattern for sketches. Within the software, move the copy with left indent to establish columns. The amount of indent will be the same for all designs.

- Establishing an eye pattern. Eye patterns guide the reader's eyes through the copy—left to right and top to bottom. Projects designed with grids create identifiable eye patterns.

- Two- and three-column grid limit. Some software limitations include three-column grids. Know the measurement for half columns and use indents to create more complex grids.

- Thumbnail grid sheet for sketching. Begin by drawing a half-point box around each grid box.

Figure 2-6 2 x 8, 3 x 8, 5 x 8, and 7 x 8 grids

If the software will not give thumbnail prints, print four copies at 25% and paste up, printing on one sketch sheet. If the software will print thumbnails, draw boxes on the master page, open four pages, and print a sheet as four thumbnails.

- Dividing equal portions. When the measurement across a page needs to be divided into equal increments, let the software do its job. Use the number of column guides to match the number of divisions needed with "0" spaces between. Place guidelines at the divisions and use this to set up columns or location of boxes.

- Autoflow to grid columns. Software with autoflow will place text automatically into all pages as long as all columns without body text have been removed. To eliminate those columns not used for body text, customize the columns by marking all columns with guidelines. Then, switch to the number of columns with body text and move these columns to the guidelines.

Naming style formats

Most software allows for style sheets for formatting the repeated use of each page elements. Style format recalls type and paragraph specifications and applies them to the copy. Styles apply to paragraph-level styles, but usually not character-level style changes within a paragraph. **Paragraph** not only refers to a paragraph of body text, but also to any set of copy that is completed with a return. **Character** refers to a section of a paragraph. For example, run-in subheads, symbols from another typeface, fractions, or large initial capitals are character-level styles. Placing either type of the specification information into style name will retrieve the information without additional keystroking and will give consistency. To be practical and save time, manually specify the type when an element appears only once on a page.

The name chosen for each style is critical, since reusing it requires that it be identified. Using the proper name for the element from its category is the most straightforward approach.

Naming large groups of styles

As the number of style formats increase, it becomes difficult to find a specific name because the software arranges these names alphabetically. Adding code information to style names will group them to be easily located.

Group by name

For a style name that will not be difficult to locate, keep the names together in the style palette by including similar beginnings in the name, such as "Body indent" and "Body tabs" rather than "Indent" and "Tabs." Another example includes changes in

Style Palette Order

NUMBER CODE	STYLE NAMES
0 = master pages	0 folio, 0 running head
1 = sidebar area	1 quote, 1 name
2 = text, inside pages	2 body, 2 subheadA
3 = charts	3 title, 3 body, 3 legends
4 = forms	4 title, 4 body, 4 lines
5 = ads	5 heads, 5 subA

Figure 2-7 A style window listing by number and name

specification, such as "Body 10" and "Body 8" or "Body Times" and "Head 2 pt Rule." Keyboard symbols shorten the name and provide ownership, such as "Body •" and "Body #."

Group by layout location

Numbers in front of the style name work to group publications with multiple sections. Figure 2-7 shows a style list that works well for newsletters, magazines, and books.

> ✗ Cross reference: Chapters 8 through 13 include suggestions for shortening names that work in the style sheet palette.

Additional grouping techniques

If a single style needs to be used frequently, place a space bar in front of the name or type it in all capitals.

Building customized templates

Templates are the file folders for grids and styles (figure 2-8). Opening a template is like opening a new file and allows the designer a head start in specific publication categories. Opening a customized template built from a designer's best files is more effective than a commercially produced template. Smart designers will be able to cut production time in half with a good template system while adding personalized style and technique.

Using templates

Templates are most effective for monthly production pieces like newsletters and for similar publication projects. For standard level designs, a single sketch with alignment and typeface changes creates a new publication for a product or event. For custom and premium publications, changing the grid, typeface, additional styles in the style palette, and paper size still saves production time.

Create templates from quality publication projects, not from scratch. Begin with one good template for each kind of publication to utilize size, guidelines, grids, type specs, paragraph specs, tabs, and indents. Too many templates cause confusion and take as long to locate as starting a new file so add additional templates cautiously, depending on what works for your market. Update templates during production use and as software techniques improve. No additional time is required to update templates; simply use one in a new project, improve it during production, and create a revision of the old template with the new techniques.

Making a personalized template

Examine the commercially produced templates that come with the software for suggested ways to save personalized templates. For the first project, open one of these and add the changes that fit your needs. Save this unique and improved template in a format typical to the software. Four steps to making a template from a complete publication are:

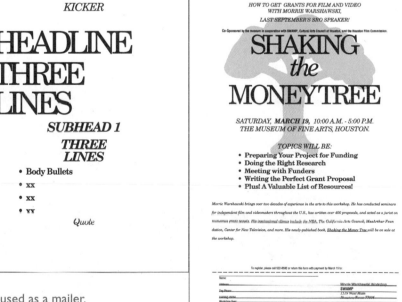

Figure 2-8 A flyer, saved as a template and reused as a mailer.
Courtesy of Chris Kovacevich, designer

1. Open the file.
2. Delete type and images or place markers in their place.
 - Photos and line art. Put a tint box in its place if the size is critical.
 - Text. Highlight each piece of copy and type the style name of the element in its place.
3. Clean up anything that will increase the size of the file, including turning off facing pages and removing items from the pasteboard area and additional pages.
4. Use "Save as..." Be sure to save it as a template rather than a document. Templates open like new documents "untitled," which eliminates accidentally filing a new project over the top of the original file.
5. Save a copy of the first publication in the research notebook with the name of the file. File names with a "T" in front of the name make templates easier to locate.

The production critique

Part of the discipline of professional designers includes evaluating new ideas and improving on design experiences. Living up to the name designer includes having a hunger to critique design. Take a detective-like approach to determining if a design gives a good first impression and how and why it was done.

- Critique someone else's work. Critique *everything* around. A twenty-four hour day may bring fifty opportunities to see designs and critique them. The newest trends can be understood technically by making an exact copy on the computer. Those slight nuances are what gives new trends a lasting effect.

- Critique your own work while you correct it. Find a method to critique your own work. Roy Dabney, an ad designer, says he works on new ads in the morning and turns the first print upside down. When he comes back from lunch, he is further away from the ad and can better critique and correct it.

- Critique designs from different eras for a broader perspective. A publication using design styles from the 1940s could serve as a special effect for a new product. Like fashion, some techniques recycle. For instance, today's letterheads follow type sizes for addresses from the 1920s.

How to separate strong and weak designs

First impressions often identify a publication as strong or weak. To understand why a particular publication has a strong or weak effect, answer the questions on the critique checklist presented in this chapter. To build understanding, evaluate the reasons for successful elements and identify solutions for the weak components.

The critique checklist

"Can you read it, see it, print it?" A weak design will probably include "too much" rather than not enough of at least five of the following elements:

Type

1. Type sizes follow a good hierarchy. For example, 36, 24, 8, and 6, or 144, 72, 18, 14, and so on.
2. Type cases blend. For example, all caps, upper and lower, lower case, and so on.
3. Type styles and weights blend. For example, bold, medium, italics, and so on.

Design and trends

4. Eye patterns are easy or difficult to follow.
5. Follow a grid, grouping the positioning of copy.
6. Has a focus point. Images or headline relate to subject matter, creating scale, pattern, or interest.
7. Blank space helps present the copy.
8. Are grouped, tightening copy toward the center of the page and keeping alignments similar.
9. Are formal or informal. What is the purpose?
10. Follow a specific new design trend, using new techniques for elements or design.
11. Format and logo distinguish this company from others.

Shades and color

12. Borders: What did they accomplish? Do they harmonize with type?
13. Reverse: Use no more than two unrelated shapes; add contrast; help eye patterns; use legible type.
14. Shades of gray: Type and other page techniques give the page an overall look of different density; contrast level.

Image quality

15. Quality of publication: Type, tints, and photo are not broken and do not show visible dots.

Revising weak production layouts

When starting with copy that is in a poor design form, the designer must identify the problem areas and repair them (figures 2-9, 2-10, 2-11). Follow three steps to correct a weak design.

1. See the copy, not the layout. Write out the copy or cut a sample to separate page elements. Then, assign standard names (figure 2-10).

2. Redesign the project. Step away from the old design and consider new possibilities by pulling out fresh quality samples in the swipe file.

3. Change the type sizes to match the standard level of design samples. To remove too much white space or clutter, experiment with different type sizes.

Revising another designer's file

Revising a file that someone else has produced can also create problems. To determine problem areas and "fix" the file, follow these five steps:

1. Select the pointer tool and hit "select all." Check for the number of text blocks. A problem file will be full of separate or empty text blocks. Start over—it will be faster than revising the file.

2. Determine whether the blocks of text are linked. If the elements are not defined in the style palette, use "new" in the style palette and define them. Most software allows specifications from existing type to be placed into the style palette without rekeying. Place guidelines to mark positioning for each text block.

3. Highlight each element. Determine its specification. In most software, the highlighted page element will automatically bring specifications into the style palette if they are given names. (This is helpful for a page element that needs to be used again in the new publication.)

4. Link the copy together. Turn it into a word processing file. Retag it.

5. Eliminate any automatic leadings. When changing a character's type size, avoid incorrectly leading alignment within a paragraph.

To learn something from any file, approach someone else's files with an open mind and try to understand why specific techniques were used.

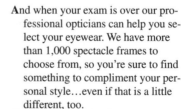

We Try To Be A Little Different.

Dr. Paul Garcia
Dr. Karen Hertz
Dr. H. Middleton
Optometrists

You'll probably notice a difference as soon as you walk in the door. No orange plastic chairs in the waiting room. No stiff white lab coats. No receptionist behind a glass window. Instead, you'll find a homey atmosphere, friendly, accessible staff members and waiting room chairs that are really comfortable.

Of course, you'll notice a big difference in your exam. We perform more than 20 different tests to evaluate your vision, eye health, eye muscle balance, and perceptual skills. Our exam may take a little longer than the other guys', but you can be sure you've had a thorough, quality exam.

And when your exam is over our professional opticians can help you select your eyewear. We have more than 1,000 spectacle frames to choose from, so you're sure to find something to compliment your personal style…even if that is a little different, too.

2345 Grove Avenue
Wassau, Washington
881-55670

Figure 2-9 A weak ad: too many faces, distorted art, indistinguishable type elements, text too close to the border

Headline:	We Try To be A Little Different.
Subhead A:	You'll probably notice a difference as soon as you walk in the door…
Body Bullet:	No orange plastic chairs in the waiting room.
	No stiff white lab coats.
	No receptionist behind a glass window.
Body:	Instead, you'll find a homey atmosphere, friendly, accessible staff members and waiting room chairs that are really comfortable.
	Of course, you'll notice a big difference in your exam. We perform more than 20 different test to evaluate your vision, eye health, eye muscle balance, and perceptual skills. Our exam may take a little longer than the other guy's, but you can be sure you've had a thorough and quality exam.
	And when your exam is over our professional opticians can help you select your eyewear. We have more than 1,000 spectacle frames to choose from, so you're sure to find something to compliment your personal style…even if that is a little different, too.
Signature:	Dr. Paul Garcia
	Dr. Karen Hertz
	Dr. H. Middleton
	Optometrists
	2345 Grove Avenue
	Wassau, Washington
	881-5567
Art/Photo:	Doctor with children

Figure 2-10 Write out page element names followed by information

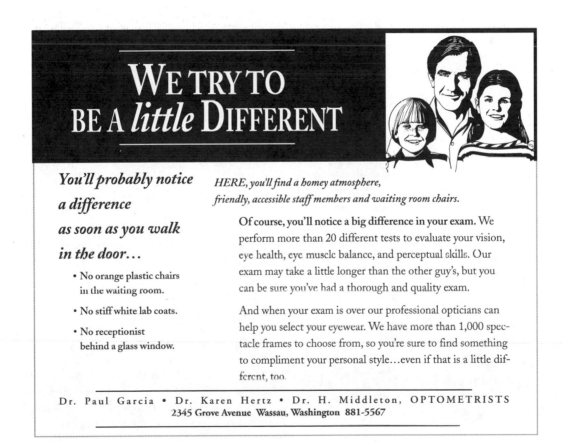

Figure 2-11 A strong ad: uses grid, distinguishable page elements, appropriate art, good use of rules.

Building reference materials

A work area should contain reference information since production or design often requires research. Some reference materials include books such as the *StyleGuide*, "how to" books for specific software, and samples books showing award-winning designs. Also, create custom reference materials: use loose-leaf notebooks for up-to-date versions of printed samples and spiral notebooks for technical steps and troubleshooting notes.

Saving printed samples

Printed samples from a variety of sources contribute to up-to-date research files.

Departmental and personal samples

Request a few extra copies of your projects and, if possible, larger amounts of the best ones. To make them available, file by category of publication for:

- Template samples. To help identify exactly what a particular template contains, keep a template notebook with printed samples of publications. Write the template name on the sample.

- Local and national design competitions. Local design groups, software manufacturers, and paper manufacturers often request printed samples for their competitions.

- Potential clients, employees, and supervisors. When making a business proposal or requesting new equipment, "a printed sample is worth a thousand words."

- Personal portfolio updates. A portfolio should consist of twenty of the designer's best samples, making sure that all levels of design are represented.

- References. Any publication has potential for revisions or updates. Samples from a previous version can provide a reference point.

The swipe file

The swipe file is an accumulation of other designers' samples on all levels of design. This file is more like sample "swatches" than "swiping" because it represents visual information about trends. Designs with new color combinations, typefaces, or any techniques that create design solutions should be included. Organize the samples by name of publication or by level of design.

- Paper samples from paper manufacturers. These samples are presented as successful printed publications from designers or pamphlets of important information related to type, paper, and finishes. The samples aid in demonstrating for clients the recommended papers and finishing techniques. Some samples will be kept indefinitely because they represent special techniques or uses of finishes or colors.

- Samples offered to the public. Travel bureaus, medical groups, and home repair centers are a few of the places that offer free quality design publications to the public.

- The mailbox. Unsolicited mail may demonstrate a design technique that is worth saving.

- Shared samples. Get involved with your professional organizations and swap copies of designs that are admired.

Creating an exact replica of a design can bring about the discovery of new typographic subtleties. Samples illustrate colors choices that mix well or applications for new typefaces that then can be mixed with personal interpretations. As Sammy Davis, Jr. said about tap dancing, "…you see a step, you shuffle it, and you bring it into your own routine."

Always practice discretion: swipe files can be misused if a total design is copied exactly or line art is scanned. This unethical behavior limits learning and growth. Use the swipe file to learn new ideas, *not* to copy publications.

Keeping technical notebooks

Keep technical information in two kinds of notebooks: loose-leaf for printed sheets, tech sheets, and changing information, and a spiral notebook for writing down information and notes.

The loose-leaf notebook

Here are some helpful divisions that work well in a loose-leaf notebook:

- All typefaces. Print out the best body size for each face and the best display size and case. Also, print out from a software package by creating font specimen sheets. Group the faces by categories (refer to Chapters 3 and 4).

- A test original. *One* standard test original used as a constant for all available printing processes demonstrates what will and will not print well.

 ✘ Cross reference: A sample test original is shown in Chapter 7.

- Samples of finishing techniques. Die cuts, varnishes, and embossing are some techniques included as samples from the paper manufacturers because they show the best paper for these finishing processes.

- Magazine articles. Informative articles discuss frequently asked questions and often contain charts of when to use what, similar to those at the end of many of these chapters.

The spiral notebook

Use notebook(s) for notes, operating steps, and troubleshooting related specifically to computers, software, fonts, and networks. A 9½″ x 6″ five-subject spiral notebook is suggested because the size makes it easy to find. Divide the notebook into sections labeled computer, software, and network.

So that steps can be written down quickly, develop a consistent shorthand. For example, when referring to a menu item use all capitals and ellipses such as, "1. FILE-Preferences…" rather than, "Go to the menu item, file, and pull down to preferences." This "shorthand" allows quick writing during verbal instructions. Practice from the written steps for exactness.

For additional research

Keep a well-balanced design approach by continuing research into the historical and trendy information found in:

Blatner, David, *The QuarkXpress Book,* Berkeley: Peachpit Press, 1994.

Kvern, Olav, Roth, Stephen, Fraser, Bruce, *Real-World PageMaker,* New York: Random House Electronic Publishing, 1995.

Landa, Robin, *Graphic Design Solutions,* New York: Delmar Publishers, 1995.

Swann, Alan, *How to Understand and Use Grids,* Cincinnati: North Light Books, 1989.

Additional research activities:

1. Find samples from the 1920s through 1970s and begin to date different styles.

2. Locate samples of this year's fashion palette from car colors or commercial art magazines and match them with the PANTONE Color Formula Guide.

3. Look through other designers' swipe files and discuss why they saved the publications.

4. Join professional organizations.

5. Find and file samples of newspaper and magazine ads for future reference.

6. Read current computer magazines.

7. Read and file hardware and software mailings.

*A fascination
for type and words
go hand in hand.*

3 Type Formatting Information

The type classification system
The measuring system
Using type formatting
Typographic techniques
Typographic corrections
For additional research

After reading this chapter and applying its principles, the designer should have success:

- Identifying type fundamentals.
- Using points and picas to measure type and other graphic elements.
- Distinguishing the different uses of type formatting.

In desktop publishing software, the choices in type formatting can be overwhelming. With a knowledge of type classifications and measurements, informed decisions can be made. Good type choices pay respect to the words.

The type classification system

Understanding the type classification system establishes information about similar typefaces. Organized groups of typefaces can be applied to a font management system for initial sorting. The designer must make five choices concerning type. These are labeled category, group, family name, weight, and/or style, and size. Type classified under these headings become the type formatting information that is keystroked into the software. To review similarities and differences, imagine the characteristics for each classification as characteristics in a family tree.

1. Category

Classifying type puts the unmanageable list of typefaces into two categories: display faces and text faces. When the creator of a typeface draws a new display and text face, the approach for each is different. The proportional letterspacing of display faces is different from that of text faces. The effect on the type is shown in the samples used in figure 3-1. Faces are presented on the computer in a list of names and categorizing is the responsibility of the designer.

As late as 1975, type choices were separated by typesetting machines for display faces (14–72 points) and for text faces (6–14 points). Today, most text faces are used for both display and text type, but display faces are used for display type *only*.

Images and symbols have a category of their own. They are not letters of type but images, symbols, and graphics. Some, such as "Caslon ornament," are considered a font in a typeface.

Characteristic review

Compare the type categories to the roles of family members: those who listen (body text), those who talk (display), and those who play or direct (symbols).

TEXT and DISPLAY FACES

-Roman-

Bookman
Caslon
Garamond
New Century
Schoolbook
Palatino
Times

-Sans Serif-

Avant Garde
Helvetica
Helvetica Condensed
Optima

IMAGE & SYMBOLS

-Symbols-
CARTA

-Pictures-
HOLIDAY

Ornaments
CASLON ORNAMENT

DISPLAY ONLY FACES

-Roman-

Aachen bold
Cooper Black
COPPERPLATE GOTHIC
TRAJAN BOLD
University Roman

-Square Serif-
Officina Serif

-Sans Serif-
Revue

-Script-
Snell Roundhand Script

-Old English-
Fette Fraktur

-Decorative-
Schmutz ICG Cleaned
MESQUITE

Figure 3-1 Categories, groups, and family names

2. Group

Typefaces fit into a group when the letter form carries mutual characteristics. Characteristics can include the thickness of lines, serifs, and the line of stress. The six groups in figure 3-1 are:

1. Serif or roman type. Thick and thin lines and serifs.
2. Sans Serif. Even-stroked lines and no serifs.
3. Square Serif. Even strokes and blocked serifs.
4. Script and cursive. The look of calligraphy or handwriting.
5. Old English. The look of lettering from the 1300s.
6. Decorative. A "catch all" that includes the typefaces with zany trends or seasonal-looks known as grunge, decorative, or picture fonts (also called pi, symbol, and Zapf Dingbats). Some are alphabet letters and others are key positions with symbols.

Text faces are from two of the groups: serif and sans serif. It is both easy and acceptable to use one text face for all page elements of a project. The popular trend in design is to use one serif text face that is light on the page. Using two text faces, one serif and one sans serif, adds contrast and helps with complex page elements.

Display faces fit all six groups with limited sizes of 14 points or larger. Because display faces are undesirable for smaller type, a body face is chosen for the second face.

Characteristic review

Think of a family reunion where everyone has different last names but all are still part of the same group.

3. Family name (typeface)

The family name of the typeface is chosen by the inventor of the typeface or is named after the inventor. It was probably easier to distinguish categories of typefaces when they were carved from wooden blocks or formed in hot metal because the number of faces and sizes were limited. Locating a specific typeface meant going to several type houses that had different brands of typesetting equipment. As the number of type houses increased, different versions of typefaces were invented. For example, there are at least four versions of "Caslon." Today, there are thousands of typefaces available.

To narrow the choices, it is important to see a sample of all display and text faces and to choose a good library for every day use. Put aside many of the faces, allowing access to a smaller list of premium faces that will be used for 80–90% of production.

> ✘ Cross reference: Twenty-two typefaces categorized in figure 3-1 are covered in detail in Chapter 4.

Characteristic review

The family name for a typeface is like the branch of your family tree that maintains the same last name.

4. Weight and style

One type family can have a variety of weights and styles. The unique structure and shape of the letter is maintained, but each set or font includes changes such as line thickness, width of letters, and slant. Weights are described as regular, medium, book, bold, semi-bold, demi-bold, light, extra bold, black, expanded, and condensed. The changes in structure (called styles and effects in software language) are italics, oblique, small caps, outline, and shadow. Some type software requires that family, weight, and style be chosen together from the font window to guarantee printing to high-end output devices.

Unfortunately, software uses two windows that allow choices for style and weight. If the font window includes choices showing the family name, style, and weight, it is the safest place to make these choices. If style and weight are not available in the font window, they are only a safe choice from the alternate "style" window when they are in the font set of the computer. Be aware of the disadvantages of using the alternate window:

- Some of these "styles" are weak. Typographic choices such as underline, strike-through, shadow, and outline are not the best choices for designs.

- Mixing weight at both windows. This creates distorted type such as an awkward 30° angle for italics rather than 15°.
- Projects proofing to a laser printer. This will not show type weight from the alternate window at the imagesetter.

Figure 3-2 shows weight and style samples in a sans serif and serif face. Weights and styles for serif faces follow the same changes as sans serif, with the exception of italics. Roman italics has serifs that curve up with flair.

Characteristic review

Several people in your family might be exactly the same height, but weigh different amounts or have different personalities.

5. Size

Size refers to the amount of vertical space an entire alphabet requires. The software packages give standard point sizes in pull down windows and this should be the designer's first choice. It is common to "go down a size" when problem solving. This refers to the next *common* size instead of going down in points. Use alternate sizes when there is a problem with fitting copy or legibility. Keep body and display type within the size range (figure 3-3).

Shortcuts for changing type sizes outside of the style sheet palette that are common to most software are:

- command/shift > for increases in one type size.
- command/shift < for decreases in one type size.

Characteristic review

Size can be used to describe people in terms of their height.

Caslon	Helvetica
regular	light
semi-bold	regular
bold	bold
	black
SAMPLES OF WEIGHTS	
italics	light italics
semi-bold italics	italics
bold italics	bold italics
	black italics
THESE STYLES CAN BE MIXED WITH THE FIRST GROUP	
REGULAR, SMALL CAPS	condensed medium
SEMI-BOLD, SMALL CAPS	condensed light
italics old style 12345	condensed bold
semibold italics old style 12345	condensed black
bold old style 12345	condensed italics
bold italics old style 12345	condensed light italics
REGULAR EXPERT½⅛⅜⅝	condensed bold italics
regular, alternate: ctkft w	condensed black italics
swash, italics: CKTFW	
THESE WEIGHTS AND STYLES COMBINE WITH BOTH GROUPS	

Figure 3-2 A variety of weights and styles of two typefaces

TEXT SIZES
6 POINT ALL CAPS
7 point
8 point
10 point
11 point
12 point (in smaller faces)

DISPLAY SIZES

14 point

18 point

24 point

30 point

36 point

48 point

60 point

72 point

Figure 3-3 Sample of standard sizes

Classifying the body text of the *StyleGuide*

Category: Body—chosen because this is a long text document.

Group: Serif—usually the first choice for long text documents.

Family name: Garamond—does not strain the eyes for long reading.

Weight and/or style: Medium—an absolute for body copy.

Size: 10 points.

The measuring system

Type is measured in points and formatting decisions are built proportionally around the type size in points and picas. Type size in points will not proportionally translate into related measurements in decimal inches.

After the first printout, rely on points and picas for fine adjustments. Using minute changes, adjust leading and type sizes vertically; adjust size, case, and spacing changes horizontally. With point and pica measuring experience, advanced type formatting decisions such as drop caps, hierarchy of leading, baseline copyfitting, and em paragraph indents are simple to learn.

Application of measurement

Do not throw away the inch ruler. It is needed for measurements such as page size and margins. Figure 3-4 shows how the measurements interact with each other and each type formatting item.

The pica ruler

For a beginning pica user, buy several inexpensive rulers (figure 3-5). A pica ruler can be purchased at

BASIC MEASUREMENTS

6P (picas) = 1 inch

72p (points) = 1 inch

12p (points) = 1 pica

1½ picas = 18 points (1p6)

USE THIS KIND OF MEASUREMENT TO MEASURE

Paper size - inches

Margins - inches/picas

Line length - picas

Indents - picas/points

Gutters - picas/points

Type size - points

USE SAMPLES OF CAPITALS TO MEASURE...

Leading - points

USE LEADING PART OF THE RULER TO MEASURE...

Before paragraph leading - points

Figure 3-4 Measurements and where to use them

Figure 3-5 Pica ruler. *Courtesy of C-Thru Ruler*

larger graphic arts supply stores and computer software supply companies and is an important resource tool. Rather than memorize "12 points in one pica and six picas in an inch," just use it to learn it!

Some software automatically defaults to points or picas for all leadings and column measurements. For software that shows these measurements in fractional inches, switch to point and pica measurements after the page size and margins are set.

Type identification

Researching quality samples and updating last year's graphic projects without the old file requires careful measuring of type sizes and leadings.

The structure of type

Recognizing the different parts of a letter form helps place the type into its correct group, which in turn identifies its intended use (figure 3-6). The inventors of each typeface give a shape and proportion to the face form to fit a specific design need.

> ✘ Cross reference: Chapter 4 examines twenty-four common and representative typefaces.

To further understand the parts of type, visualize letters of an alphabet standing up like soldiers. The parts include:

- Cap height. The distance from the bottom surface on which a capital stands to the top of that capital.

- Baseline. The bottom surface of all letters that can stand up by themselves.
- Serif. The brace at the end of a letter that increases the surface it can stand on.
- Ascenders. The part of letters with upward strokes that stand tall like capitals.
- Descenders. The downward stroke of letters that will not stand up.
- x-height. The height of the lower case letter "x" and all other letters that are short.

Measuring type

There are two fast and efficient ways to determine a type size: the capital section on the ruler identifies standard type sizes and the point section is used for larger sizes. Both methods work faster if an intelligent guess is included in the measuring process.

The reason both methods require a guess is because type measurement is not an exact science. Figure 3-7 shows two typefaces in the same size that are obviously not the same size because of minute changes in the structure and proportion of the faces. Also, type does not always fill up its measurement space vertically.

Try both measuring methods on figure 3-8: the capitals section on the ruler and the points section. When the point ruler is used, a descender and ascender is included. If there is not a descender in the type, sketch a descending letter on the line of type proportional to the size of type.

Figure 3-6 Structure of a letter form

TIMES (SHORTER DESCENDERS AND ASCENDERS)

CASLON (LONGER DESCENDERS)

Figure 3-7 Two different size typefaces in 24-point type

The baseline is located at the dotted lines on this page and the line length is the gray area behind this paragraph. Just remember when you learned to print in kindergarten; it is the same lines just closer together.

} 12-POINT LEADING BASELINE TO BASELINE

LEADING = BASELINE TO BASELINE IN POINTS

Figure 3-8 Leading

Type leading

Type leading is measured from baseline to baseline. The baseline is located at the dotted lines, as shown on figure 3-8. It is similar to the baselines used on elementary school writing paper.

Steps to measure type and leading

Both size and leading can be measured at the same time, but exact measurements often print differently than expected. To verify the measurement, print a sample of this exact copy and check it on a light table. The four steps for size and leading are:

1. Guess the size. Consider this paragraph of body text. What size does it appear to be? A small size (6 to 7), a medium size (8 to 9), or a large size (10 to 11)? For display type, glance at the ruler capitals and guess the size.

2. Measure the size. Use the capital section on the type ruler and measure a capital on each or use the point section of the ruler, measuring from the top of the ascender to the bottom of the descender. With practice, the guess in Step 1 will be accurate.

3. Guess the leading. For body text, add two points to the type size as a beginning point for leading. For display type, start with the same number as the type size and then measure with the point section of the ruler.

4. Measure the leading. Use the leading section of the ruler for body text and the point section of the ruler for display type.

Using type formatting

Type formatting is used throughout the design process. It is measured on research samples to determine the technique used for quality samples and trends.

Measuring research samples

One of the first steps of validating a quality sample or new trend is to measure the type sizes and leadings. To identify the standard ranges of type sizes for publications not included in this book, a large group of samples should be measured. Research is an ongoing process because trends will change, reflecting a variation in the size commonly used. Continue to measure type in research samples. The range of sizes eventually shifts over a longer period of time.

> ✘ Cross reference: The introduction of Web pages is another trend that causes change because the type is read from a monitor. Refer to Chapter 13.

Adding specifications to the rough sketch

There are typographic terms used to give formatting instruction after the first printout. Another way to say "adding formatting instructions" is "to spec the type." Formatting instructions or specing type gives written information (figure 3-9) for the type and paragraph software windows for each different type element.

To shorten the written specifications, the most common settings are assumed. The following information explains what is commonly eliminated out of each set of specifications.

> ✘ Cross reference: Producing a rough is relatively simple and is an excellent reference tool for all steps of the design process, but if the terms are unfamiliar, a detailed cross reference, "Applying font information to the rough," is presented in the next section of this chapter.

- Typeface. The name of the typeface family is always written on the rough; if it is used for all the copy, then it can be written at the top of the rough.

Figure 3-9 A rough with specs

✘ Cross reference: Chapter 4 shows a broad selection of typefaces with at least one from each category.

- Weight and style. "Medium" (regular) is not written because it is understood, but all others are indicated after the typeface name.

 ✘ Cross reference: Figure 3-2 shows a set of weights and styles.

- Size/leading. Size and leading are written together with a slash, such as 10/12, and spoken as "ten on twelve" (10-point type on a 12-point leading).

 ✘ Cross reference: Figure 3-3 shows standard sizes and Chapter 4 includes samples of different leading combinations for text and display type.

- Case. Upper and lower case letters ("U" and "lc") with sentence capitalization are understood. Other typical settings to be indicated are all caps, small caps, and lower case.

 ✘ Cross reference: Possibilities for case are included in the display samples in Chapter 4.

- Alignment. Alignment is indicated by a line on the edge where the type is to be straight. Use a dotted line to show where the line would be drawn on the rough for each type of alignment, figure 3-10.

- Letter width. Letter width is the width of the letters within one font set. If the designer has created a typeface narrower than the standard typefaces, it is called "narrower" or "condensed." Changes can be made in the character specification window to distort the typeface to a narrower or wider width than as it was drawn. Some display type works well at 70% and 120% of the original width. Body width changes are reserved for experts. If a project requires letter width changes in the body text, purchase an Adobe® Multiple Master font that allows width changes while maintaining the integrity of the typeface.

 ✘ Cross reference: See Chapter 4 for width changes for display faces.

The ability to set type formally
is accomplished by setting
the alignment centered.

CENTERED (C) - VERY FORMAL, GOOD MIX WITH JUSTIFIED BODY TEXT

The flush left alignment of body text is readable with minimum line lengths and is for a modern look. There have been comprehension tests to determine which alignment is more readable, but they have had opposite conclusions from their studies.

FLUSH LEFT (FL) - EASIEST TO READ WITH LASER OUTPUT OF TEXT

The justification of body text is readable with maximum line lengths or with copy that does not cause large white gaps in wordspacing. Be aware that there may be gaps in copy if you are using the justification mode. The best approach is evaluating alignment from the first printout.

JUSTIFICATION (JUSTI) - FOR BODY TEXT WITH MAXIMUM LINE LENGTHS

FINAL
Summer
Clearance

FLUSH RIGHT (FR) - MODERN AND WORKS FOR TITLES AND ADVERTISING

FORCE
JUSTIFICATION

FORCE JUSTIFICATION FOR DISPLAY TYPE
WITH SINGLE WORDS OR FIXED SPACES

Figure 3-10 Uses of alignments

- Indents. First line indents and paragraph indents should be built into the style and can be marked with typographer's marks.

 ✗ Cross reference: Typographic proofreading marks are found in figure 3-26. Indent choices are found in figure 4-10.

- Line length. Line length is established by measuring margins on a rough, indicated by grids of columns.

 ✗ Cross reference: Grids are covered in Chapter 2, and line length choices in Chapter 4.

Applying format information to design production

Formatting comes together smoothly in the software when the rough contains the basic specifications, the information is placed into the style palette, and fine-tuning techniques are applied to the first printout. (Files will freeze and become useless from too many copy changes at the monitor; this is usually the result of no planning or not enough critiquing or examination of the first printout.)

Simply follow the rough and add its information to the style palette. A clear relationship between all page elements is then established. When changes need to be made, the rough serves as a first reference to make sure the hierarchy of styles is maintained.

This is a good time to do some artistic fine-tuning—adding elements of contrast, color, and scaling images. The first printout can be compared to the monitor image of display type and be adjusted until the fine-tuning techniques give the rough and the monitor image a match. View the monitor image at 100% and hold the rough next to the monitor after each adjustment to check visual consistency. Changes like letter width, letterspacing, kerning, and small cap size can be quickly fixed. Leading for body copy can be adjusted by measuring the space allowed for type on the rough or measuring the space between the lines that were drawn to indicate the body text.

Allow artistic fine-tuning beyond the rough and flexibility to use this technology to expand the creative process. But if the design gets into an unending loop, return to the original specifications and work from there.

Fine-tuning formatting

The greatest advantage of computer production is how quickly corrections can be made. Roughs no longer require the exactness that they once did. They are, however, an important step for less experienced designers in order to avoid getting lost in the software. Experienced designers refer to roughs for client conversations or complex projects before production.

When the design process is in the production stage and the first printout has been made to match the rough, fine-tuning begins. Below are a few of the fine-tuning techniques found in most software packages:

Alignment

Figure 3-10 shows the available alignment choices and how to mark them. Display type uses all the settings, but body type is commonly set **justified** (both margins straight) or **flush left** (only the left margin is straight).

Leading

Leading is the line spacing from the baseline of one line to the baseline of the next line. An example of different leading is the line spacing on the paper used in elementary school compared to the paper used in college. Replace the automatic leading with a leading point size for all type formatting. "Auto" looks fine with some faces because it gives a standard leading of 120% of the type size, but does not allow enough room for some text faces and needs to be set differently for display type. Common settings like vertical alignment, secondary leading, and first line indents build on the leading. When "auto" is not replaced with a number, special first line effects using larger type on the first line will create a gap between the first and second line that is different from the leading for the rest of the paragraph (figure 3-11).

Copy *set* in ten points on automatic leading looks fine for most typefaces because 120% leading leaves enough white space in the copy.

But when large type is added to the beginning of the first line, the computer uses the 'auto' leading of the large type giving a noticeable difference in the leading between the first and second lines.

Copy set in 10/12 looks the same in 10-point type because it leaves the same leading as 120% automatic leading and keeps the copy from looking cramped.

But when large type is added to the beginning of the first line with a 12-point leading put in the leading window, the large type can be given the same leading and the first and second lines have the same leading.

LEADING SET AUTOMATICALLY LEADING SET IN POINTS

Figure 3-11 Autoleading and assigned leading with larger type on first line

Copy begins with an introduction and is followed by a subhead, which continues throughout the copy.

10/12 LEADING WITH
6 POINTS BEFORE
PARAGRAPH LEADING

Subheads

When a subhead is separated from the rest of the copy by size only, size gets unmanageable on the page.

10/12 LEADING A secondary leading above the copy gives the attention to the subhead that is required without burdening the reader with increased darkness to the page.

Figure 3-12 Paragraph spacing before subheads

Before paragraph spacing (secondary leading)

The primary leading is the leading number in the leading window. The secondary leading (SL) is above a paragraph to add contrast with white space. There is more control of space when using secondary leadings rather than double returns. Use below paragraph leading sparingly if the contrast required cannot be achieved with above paragraph leading alone. Otherwise, it is difficult during corrections to sort out which leading was used on the page elements. After looking at figure 3-12, find the above paragraph leadings used throughout the *StyleGuide*.

Changes in horizontal scaling

The width of the letter "m" in a typeface determines its natural width. Adobe multiple master fonts and some typefaces can be used when type is needed with a narrower (condensed) or wider (expanded) horizontal scaling without distortion and with opportunity to adjust the thickness of the letters. Additionally, the horizontal scaling of any typeface can be changed in some of the software but requires a close check for letter distortion. Some faces will handle up to 40% scaling changes while others cannot handle any (figure 3-13).

Watch out! Watch out!

CASLON ON THE LEFT LOOKS BETTER AT REGULAR WIDTHS

Watch out! Watch out!

120 PERCENT SET WIDTH CHANGES HOLD UP BETTER IN HELVETICA

Watch out! Watch out!

70 PERCENT SET WIDTH CHANGES HOLD UP BETTER IN HELVETICA ALSO

Figure 3-13 Two typefaces with horizontal scale changes

Letterspacing (tracking) and kerning

Although they are included together, letterspacing and kerning are not the same thing. What they do have in common is the addition of space between letters. **Letterspacing** (tracking) globally adds or subtracts space between sections of copy and **kerning** (expert kerning) selectively adds and subtracts space between two adjacent letters (figure 3-14). Some techniques to make letterspacing (global) changes include the following: The character windows in some software have a place for "tracking." It can be set under the paragraph window under "letterspacing" or it can be adjusted with the control panel by highlighting the word, line, or paragraph. Two settings that add kerning for different software are expert kerning, where the computer reads the combinations and adds preprogrammed changes,

and **ligatures**, which are keystrokes found in some keyboards that give two letters instead of one, such as an fi or ff. Kerning also can be adjusted visually with the control panel by highlighting two characters or with software keyboard shortcuts to add and remove spaces. Depend on the method that fits the situation. Changes made at the control panel level are practical when they apply to one specific piece of copy. If the changes are needed repeatedly, make the changes that place them permanently in the style sheet.

Display type benefits from kerning and letterspacing. Most typefaces that are used for both display and body are set for body letterspacing. Kerning is set for some letter combinations and in some software more combinations can be added, but usually a line of display can benefit from expert or manual kerning.

The official
TAFFY PULLING
WITHOUT LETTERSPACING GLOBALLY ON TITLE

The official
TAFFY PULLING
WITHOUT KERNING

The official
TAFFY PULLING
LETTERSPACING DECREASED

The official
TAFFY PULLING
EXPERT KERNING AT NORMAL

The official
TAFFY PULLING
TRACKING VERY LOOSE

The official
TAFFY PULLING
EXPERT KERNING WITH TIGHTER SETTING

The official
TAFFY PULLING
TRACKING VERY TIGHT

The official
TAFFY PULLING
CASLON EXPERT LIGATURE 'FF' IN 'OFFICIAL'

Figure 3-14
Comparison of the variety of letterspacing and kerning options

Word spacing

Word spacing involves increasing the space bar value. Changes are only necessary for display type that seem to run together or for body type using leading that appears out of proportion to the space bar value (figure 3-15).

Ruled lines

For many application programs, ruled lines or rules can be built into a format. Rules are not limited to lines, as with underline. They can be included as a second color, tinted, or designed wide enough to appear to be a box. The applications measure the location from the baseline of the type. When the default setting does not work, use the point size for the positioning of the above rule and use four points below for a starting point. When using rules for upper and lower case type, the line needs to break under the descending letters (figure 3-16). If the applications program cannot build in rules, use a drawing pen to create them.

Copy set in additional leading gives a quality look to the text. It may give a cramped look to some typefaces, especially in flush left alignment, which keeps even space bar values.

When extra value is added to the space bar, the leading and space bar values seem more compatible.

Copy set in additional leading gives a quality look to the text. It may give a cramped look to some typefaces, especially in flush left alignment, which keeps even space bar values.

When extra value is added to the space bar, the leading and space bar values seem more compatible.

DEFAULT SETTING FOR WORDSPACING

Copy set in additional leading gives a quality look to the text. It may give a cramped look to some typefaces, especially in flush left alignment, which keeps even space bar values.

When extra value is added to the space bar, the leading and space bar values seem more compatible.

Copy set in additional leading gives a quality look to the text. It may give a cramped look to some typefaces, especially in flush left alignment, which keeps even space bar values.

When extra value is added to the space bar, the leading and space bar values seem more compatible.

25 PERCENT INCREASE IN WORDSPACING

Figure 3-15 Word spacing changes the value of the space bar to be visually proportional with the 16-point leading.

Be consistent

Be consistent

•••••*Be consistent*
DISPLAY TYPE USES

A rule can be used to set off body text from another column.

When the listing in the copy needs to be separate such as in quotes, fillers, or want ads.

Other text copy that benefits from rules is copy that is set off with an indent left.
TEXT TYPE USES

Figure 3-16 Various uses of rules

Baseline shift

Baseline shift moves the location of the baseline of a single letter or an entire line. It is also used for bouncing letters for special effects (figure 3-17).

Measuring for publication production

Printing presses and paper measure in inches. Therefore, all information throughout the process should be given in inches and decimal inches. These choices include printing size, finished size, and image location.

Figure 3-17 Baseline shift for individual letters

Typographic techniques

Professional designers use precise measurements and apply them to typography. Typography gives subtle addition and subtraction of space that is not noticed by the casual reader and adds characters not available in regular typing. Its purpose is to make the copy easier to read. Used correctly, these techniques can be the difference between a good publication and an excellent publication.

Small cap sizes

Small cap sizes may need changing when used as display type (figure 3-18). This can be accomplished in three ways. Increase the size of the small cap to 80–90%. If the software does not allow for small caps, a typeface can be purchased for some body text faces that are small caps. Another solution is to choose a different size in the type so that the letters look like small caps. This may give the appearance of two different weights.

Manual letter kerning

Display type for custom and premium designs requires manual kerning. As explained in "fine-tune formatting," manual kerning moves a letter away or toward the next letter. It also visually adjusts the volume of space between sets of letters (figure 3-19).

Make it repeatable
COPY WITH A NORMAL UPPER AND LOWER CASE IN CASLON

MAKE IT REPEATABLE
COPY WITH THE SOFTWARE WINDOW FOR SMALL CAPS

MAKE IT REPEATABLE
COPY WITH FONT, CASLON SMALL CAPS

MAKE IT REPEATABLE
COPY WITH THE SMALL CAPS DIALOG WINDOW SET AT 85 %

Figure 3-18 Different methods of creating small caps

Figure 3-19 The second sample has white space between the letters adjusted to the slant of the letters and the left margin is moved two points for the last three lines to line up visually with the "W."

without kerning with manual kerning

Some software programs assist manual letter kerning with an expert kerning. This takes most of the common letter combination adjustments and applies kerning. The designer can also add additional space between letters by using the following shortcut key combination:

- Add space = option/shift + the key "delete" for Mac applications and contol/shift + backspace for Windows applications.
- Removing space = option + the key "delete" for Mac applications and control + backspace for Windows applications.

More white spacing surround the capitals Y, V, X, P, L, and F because of their shapes; lower case l, f, and q are changed proportionally in width from lower case to all caps.

Indents

Indents are described in two different ways: **first line indents** and **hanging indents**. First line indents are similar to typewriting indents because they shift text in the first line. Hanging indents do not move the first line of text, but instead shift over the remaining lines of text following the first line (figure 3-20).

Tabs

Tabs have the same use in desktop publishing as they have in typewritten copy. Tabs divide copy horizontally, but bring the reader from one element to the other. Practice on simple tabs and work up to complex tabular material.

Some additional uses for tabs include leader dots as found in tables of contents and for forms. They mix well with indents and hanging indents and occur with bullets, numbers, and column material in the *StyleGuide*.

Fixed spaces

The width of the lower case letters "t," "n," and "m" can be put to work for locked-in spacing called fixed spaces. Fixed spaces keep the computer from using

First line indents are the indents of standard. They have been used in handwriting, typing, and typesetting. Once the return key is used, the software uses the indent for any additional paragraphs without any additional keystrokes.
FIRST LINE INDENT

Left and right indents are also built into the style, shifting different lines of text in the same text block rather than putting the elements into separate textblocks.
LEFT AND RIGHT INDENT

Hanging indents are set under tabs and indents and reverse the indent to the second and third line of type and continue to indent until it's returned.
HANGING INDENT

Figure 3-20 Paragraph indents

Figure 3-21 The effects of various fixed spaces on forced justification

the varying space bar value given added with justification and forced justification. The "t," "n," or "m" space allows all spaces to expand proportionately. Use the space that matches proportionally with the letterspacing (figure 3-21).

Since the space bar value is not always the choice of spacing needed for professional-looking type, try the various fixed spaces. If it seems to be easier to use space bars instead of setting a tab, apply that instinct to fixed spaces of either en, em, or thin spaces. If the copy is ever changed to justified copy or if the type size changes, the space value will be proportional to the changes. Many of the figures in this book are typeset with the text and spaced with these fixed spaces.

Thin space (flex space)

The thin space or flex space gives more space than the space bar, but it is the smallest amount of the three choices. It is one of the choices for a forced justified line instead of space bars. It also is a good choice for bulleted material when the type is in display sizes.

En space

"N" space or en space is worth different amounts in different software packages. It is measured by the letter "n" or two figure "0" and can be used to align un-

Figure 3-22 En spacing after bullets

18439 20th Street North • University City, North Carolina 55312

Figure 3-23 Em spacing around bullets

even numbers. Additionally, rather than set a right tab at the colon or use a space bar, which can change value in justified lines, this space can be used to separate bullets, colons, and so on (figure 3-22).

Em space

"M" space or em space is the most frequently used spacing value. It naturally provides a proportional square space for any size type because it is not only the space of the letter "m," but it is also a square of the type size.

The em space is a term used to indicate the amount of first line indent for the paragraphs, such as "one em space" or "three em spaces." Using an em space manually indents paragraphs that appear only once in the copy.

Em also serves as a marker when setting tight-fitting columns of information and should be the minimum amount of space between columns (figure 3-23).

Dashes

When most long documents were produced on a typewriter, a single dash was used for all dash situations. One dash, two dashes, or three dashes were keyed to indicate a hyphen dash, en dash, or em dash respectively. Historically, typesetting always provided several kinds of dashes. Here is a general guideline to follow for determining which dash to use for effect: the longer the pause—the longer the dash. Dashes also can be used instead of colons when a large number of commas make the copy difficult to read.

Before production, the designer should know whether the use of dashes has been indicated by the author. If the author uses the traditional typewriter method of two regular dashes to indicate an en dash, this can be changed globally with "find and replace" in the software package. If the author or editor does not indicate the typographical dash, the typesetter should follow the information in the following section.

Dashes are set without a space bar on either side of the dash, but one space can be included on each side. Once a pattern is set, be consistent.

The copy in figure 3-24 uses a hyphen in paragraph one, an en dash (alt or option dash) in paragraph two, and an em dash (alt or option/shift dash) in paragraph three. The shortcut keystrokes for all four dashes are shown for both Mac and Windows in figures 3-25a and b.

Hyphen dash

This is the common dash used for a regular typewriter or word processing software.

- End of line hyphenation. To change line length, the designer can manually hyphenate a word by keystroking a lower case hyphen.
- Hyphenated words. Simply use a single stroke hyphen for compound words such as self-assurance and mid-semester.
- Separating groups of numbers. A single stroke hyphen can be used to separate phone numbers and social security numbers that have common divisions.

Underline dash

This dash is used seldomly unless the copy is set up with blanks to be filled in, such as those on a form without upper left-hand corner (ULC) arrangement. The weight of the line is controlled by the weight of the type.

 ✘ Cross reference: This is discussed in detail in Chapter 12.

En dash

An en dash is the length of a capital "N" and longer than a hyphen. It is located in the option position of the hyphen key. En dashes can be used in sequences to indicate a range of choices, with or without a space bar on either side. It is used frequently to indicate sequence with choices in between, especially numbers.

 ✘ Cross reference: See figures 10-5 through 10-10 for samples of en dashes.

Em dash

The long dash (em dash) is as long as the capital "M" or the square of the type size. Because it is used

SELF-ASSURANCE GROUP CREED

Hyphens: Self-assurance is the way we feel about ourselves and we project that without even trying. In both professional and daily situations, the amount of self-assurance shows as the confidence we feel is projected to others.

en dash: Begin with an experiment, from 8:00–12:00 noon do not show any self-assurance. Record how others treat you. Write down 5–10 situations in which you noticed how you were treated. From 12 noon–7:00 pm, change to an appearance of little confidence. Write down how you felt about yourself to gain confidence and what kind of message you gave to yourself.

em dash: When you do not have any confidence you treat yourself differently—different expectations and satisfaction. When you have high confidence you have more room to grow and you can do a better job of helping others, too.

Underline We appreciate your generous donation of $ _____, which will be used toward new computers.

Figure 3-24 Samples of various dashes

more frequently than the en dash, it is also called simply "dash." It is used for long pauses within a sentence, preceding an author's name instead of the word "by," and as a substitute for bullets. Em dash can be set with or without a space bar on either side, but the most popular method is without spacing. Again, once a pattern is chosen, be consistent.

The slash

The slash is used as an alternate to a dash when two opposite choices are presented within the text, such as: either/or, he/she, and yes/no. With either/or situations, the slash is a clearer choice. It also can be used as another alternative to separate an area code from the rest of a phone number.

LOWERCASE	SHIFT	OPTION	OPTION/SHIFT
a	A	ß	Å
b	B	∫	ı
c	C	ç	Ç
d	D	∂	Î
e	E	´	´
f	F	ƒ	Ï
g	H	·	Ó
h	G	©	˝
i	I	^	^
j	J	Δ	Ô
k	K	°	
l	L	¬	Ò
m	M	µ	Â
n	N	~	˜
o	O	ø	Ø
p	P	π	∏
q	Q	œ	Œ
r	R	®	‰
s	S	ß	Í
t	T	†	˚
u	U	¨	¨
v	V	√	◊
w	W	Σ	„
x	X	≈	˛
y	Y	¥	Á
z	Z	Ω	¸
1	!	¡	/
2	@	™	¤
3	#	£	‹
4	$	¢	›
5	%	∞	fi
6	^	§	fl
7	and	¶	‡
8	*	•	˚
9	(ª	·
0)	º	‚
-	–	–	—
=	+	≠	±
[{	"	"
]	}	'	'
;	:	…	Ú
'	"	æ	Æ

Figure 3-25a Mac keyboard typographic marks

CHARACTER	Windows CODE	MAC CODE
Cents ¢	alt/0188	option/4
Degree °	alt/0189	option/K
Copyright ©	alt/0169	option/H
Register Mark ®	alt/R	option/R
Trademark ™	alt/0153	option/2
¼	alt/0188	expert font: shift/G
½	alt/0189	expert font: shift/H
¾	alt/0190	expert font: shift/I
…	alt/0133	option/colon
	THESE ARE SYSTEM SPECIFIC	
Em dash	alt/shift/-	option/shift/-
En dash	alt/-option/-	
Em space	control/shift/M	cmd/shift/M
En space	control/shift/N	cmd/shift/N
Thin space	ctrl/shift/T	cmd/shift/T
	THESE ARE AN EXAMPLE OF POSSIBILITIES THAT ARE SOFTWARE SPECIFIC	

Figure 3-25b Windows and Mac system and software-specific typographic techniques

The ellipse

The ellipse is three dots spaced with fixed spaces. The ellipse has been given several new uses today: to draw reader into copy, as a substitute for bullets, and at the end of headlines. Additionally, the original use, when sections of a sentence were omitted in quotations, still applies. The set of ellipses is included as a key position in figure 3-25a and b.

Accessing typographic characters

There are other typographic characters found on the symbol font for Windows (figure 3-25b) and through coding. They are also found on keyboard positions for the Mac (figure 3-25a) under option and option/shift.

Typographic corrections

Typographic corrections are an essential part of the production process requiring background information and knowledge. So that it is approached in a professional manner, "etiquette" exists in the industry along with steps for a systematic approach.

Publisher alterations vs. author alterations

Proofreading produces two different kinds of changes to the copy. Publisher's alterations (PA) are typos that caused the copy to appear differently than the author had originally written. Author's Alterations (AA) are changes that the author requests that do not match the original copy.

An important question arises as to who pays for the time required to make changes. Minor changes that affect the overall time required for the job but do not negate the deadline are easy to waive. Changes that require large volumes of production time or that cancel the scheduled printing time are normally charged.

It is important to have these decisions involving alterations in the contract signed by the client and the designer. With a corporate production department, an agreement for deadline revision usually exists or the requesting department agrees to pay overtime charges in order to meet the deadline.

Proofreading techniques

Publications are proofread and marked for typing mistakes and typographic mistakes. One of many versions of proofreading marks is included in figure 3-26. Whichever marks are used, the typesetter should understand them and a red pen should be used for easy identification. Once the typesetting is finished and passed on as a proof, it implies that the typesetter is "signing-off" that all spelling and typographic inconsistencies are corrected. There are three ways to proofread copy:

1. The typesetter reads alone. This method takes less time and usually results in the greatest amount of typos.

2. A partner can read it to a typesetter who has the final copy. This doubles the proofreading expense because it requires two people, but it is the most effective.

3 A proofreader is responsible for the proofreading of all copy. Large companies with volumes of long documents often use a professional proofreader. Some proofreaders read the copy backwards to identify errors.

Weak design techniques for new designers

Some weak design techniques are overused by new designers when a stronger design alternative exists. A common example includes choosing more than two typefaces for a publication, resulting in clutter and distraction. A stronger design choice is to change weights and sizes. Strong design choices are indications of experience and knowledge. Learn the pitfalls first. Examine some pitfalls of weak design techniques and their alternatives (figure 3-27).

The pitfalls for the new designers are easy to step into and difficult to see after they are applied to the design. The following ten tips are not absolutes, but suggestions for eliminating problems that new designers encounter:

1. Use no more than two typefaces. The design will look cluttered with more than two typefaces.

2. Choose typefaces from different groups. For example, use one serif and one sans serif. The subtle difference between two serif faces can confuse both the hierarchy of sizes and the audience.

3. Avoid small caps, except in headlines. Since small caps make smaller capitals, the appearance on the page is toward the size of the small caps not the larger capitals; then the hierarchy is more difficult to maintain.

4. Use one typeface. Whenever possible, use one typeface or have a good reason for using two (such as more contrast is needed or because of the number of page elements). Try changing size or weight rather than adding another typeface. It changes printing time and makes it easier to keep up with page elements.

Description	in text	If necessary, Marks in Margin
Capitalize	now is the time	cap
Lower case	Now is the Time	lc
Small Caps	Now is the time	sc
Italics	Now is the time	ital
Bold	Now is the time	bf
Add paragraph indent	⌐ Now is the time	
Add EM space	⌐ Now is the time	☐
Add EN space	•Now is the time	⯊
Add tab	Now is the	
Add a space	Now‸is the time	#
Bring together	Now is the ͜ time	
Insert	Now is ‸ time	the
Spelling	Now is the tin	time
Transposed letters	Now is the them	
Delete	Now is the the time	
Move to here	←Now is the time	
Combine to one paragraph	Now is the time.⏋ For all good men	
Begin a new paragraph	Now is the time⌐ For all good men	
Specifications for elements not consistent	(Now is the time)	NC

Figure 3-26
Proofreaders' marks

𝕴𝕹𝕱𝕺𝕽𝕸 𝕴𝖓𝖋𝖔𝖗𝖒

WEAK: OLD ENGLISH IN ALL CAPS STRONG: UPPER AND LOWER

WEAK: STRONG:
VERTICAL 90ᵃ
LETTERS LETTERS

I
N
F
O
R
M
A
T
I
O
N

INFORMATION

NOW IS THE TIME FOR ALL GOOD MEN TO COME TO THE AID OF THEIR COUNTRY. NOW IS THE TIME FOR ALL GOOD MEN TO COME TO THE AID OF THEIR COUNTRY.

WEAK: PARAGRAPH IN ALL CAPS

Now is the time for all good men to come to the aid of their country. Now is the time for all good men to come to the aid of their country.

STRONG: CHANGE TO
SENTENCE CAPITALS, IN BOX, 1
PICA INDENT LEFT AND RIGHT.

SEMI-ANNUAL
CLEARANCE SALE
NEW SELECTION
OF THIS SEASON'S FASHIONS

WEAK: THREE TYPEFACES

SEMI-ANNUAL
Clearance Sale
New selection
of this season's fashions

STRONG: THREE WEIGHTS, ONE FACE

Now is the time for all good men to come to the aid of their country. Now is the time for all good men to come to the aid of their country. Now is the time for all good men to come to the aid of their country. Now is the time for all good men to come to the aid of their country.

WEAK: MORE THAN 15 WORDS ON A LONG LINE LENGTH

Now is the time for all good men to come to the aid of their country. Now is the time for all good men to come to the aid of their country. Now is the time for all good men to come to the aid of their country.

STRONG: SET IN TWO COLUMNS

Now is the time for all good men to come to the aid of their country. Now is the time for all good men to come to the aid of their country.

Figure 3-27 Weak and strong choices with typefaces

5. Change weight or structure instead of size. When a section of the copy needs some separation between its parts, try italics, bold, or all caps to add the contrast required. Then, less additional copyfitting is required.

6. Leave letterspacing and width changes "as is" for body text. Although typeface characteristics are easy to identify in large sizes, they are more subtle in smaller sizes.

7. Avoid 12-point body text. The monitor looks better with 12-point type and some software defaults to 12-point, but research shows that 12-point type is rarely the best choice for body text.

8. Add contrast. Add contrast by lightening the page rather than darkening it. Start with the body text and make it one size smaller with the same leading.

9. Keep to a few good trusted typefaces. The headline of advertising can carry the unusual typefaces, but concentrate on learning the basic typefaces well. Instead of knowing a little about a whole lot of typefaces, know a lot about a few.

10. Use one piece of good art or none at all. Let line art have a true purpose (subtle or explosive on the page, but not distracting). If there is not "good" art available, use the headline for the focus instead, or let all the type carry the design.

Summary

Recognizing typefaces is like recognizing cars: after buying a new car, you suddenly notice all the others like it on the road. Appreciation of one specific car or *type* produces meticulous examination and instant recognition.

The typeface charts on the following pages (figure 3-28) give detailed information as well as samples for comparison and study. The charts can serve as an immediate start-up set of typeface choices or as a step to establishing a personalized set. See also figure 4-30 for the list of typefaces and their uses.

For additional research

Keep a well-balanced design approach by continuing research into some suggested sources:

Historical information

Bain, Eric K., *The Theory and Practice of Typographic Design,* New York: Hastings House Publishers, 1970.

Rogondino, Michael, *Computer Type,* Vancouver: Raincoast Books, 1991.

White, Jan V., *Graphic Idea Notebook,* Rockport Publishing, 1990.

Trends

Cardamone, Tom, *How to Spec and Buy Type,* New York: Art Direction Book Company, 1993.

Moriaty, Sandra Ernst, *The ABC's of Typography,* New York: Art Direction Book Company, 1990.

Typography 15: *The Annual of Type Directors Club,* New York: Watson-Guptill, 1994.

Wheildon, Colin, *Type and Layout,* Berkeley: Strathmoor Press, 1995.

TEXT AND DISPLAY - Serif faces

BOOKMAN

- *Display — For large, extra wide display.*
- *Text — Sets large with a dark tone.*
 Try extra leading.

Strong, straightforward look; italics is happy and playful. Try one size smaller than other faces.

STRENGTH: For readers with vision difficulties and extends copy length to fill a space. Highly legible on laser output—no thin strokes. Prints well on a wide range of paper from newsprint to high gloss enamel. Gives high contrast between regular and **bold.** Holds up well when reversed.

LIMITS: Busy look on pages with a large number of different type specs. Because it sets so large, it requires careful use of sizes and sometimes requires half sizes in both type size and leadings.

WEIGHT/STYLE

Light *Light Italics*

Demi *Demi Italics*

abcdefghijklmnopqrstuvwxyz
ABCDEFGHIJKLMNOPQRSTUV
WXYZ1234567890=!@#$%^*()_+

6/8 SIX-POINT ALL CAPS IS USED ON BUSINESS CARDS.

7/9 SEVEN-POINT ALL CAPS or lower case is used on business cards and forms.

8/10 To the inexperienced person, all type faces may look the same. Blindly picking a type which looks good on the screen, may produce poor type after it is printed.

9/11 Every typeface looks different to each different output devices. Printing type samples to the production output device leads to accurate choices.

10/12 The lower the dpi of a laser printer, the larger the dots forming each letter. The stroke on a letter appears thicker with the larger dots of lower dpi.

11/13 Comparing samples from different type faces help determine: what is the ideal body copy size; the leading for each face; the set of the face; and the readability and legibility.

12/14 TWELVE slows the reader if the set is large and the line is short.

CASLON

- *Display — Distinctive capital "A". Wide capitals.*
- *Text — Sets small and light on the page. Try standard leading.*

A very dependable old style Roman. Classy and readable.

STRENGTH: Used for book text and makes an excellent "basic" serif face. Works well for designs requiring a lighter look on the page. Very dependable for annual reports and all dpi printing.

LIMITS: Will not hold a reverse without looking broken.

WEIGHT/STYLE

Regular *Italics*

Semibold *SemiBold Italics*

Bold *Bold Italics*

abcdefghijklmnopqrstuvwxyz
ABCDEFGHIJKLMNOPQRSTUV
WXYZ1234567890=!@#$%^*()_+

6/8 SIX-POINT ALL CAPS IS USED ON BUSINESS CARDS.

7/9 SEVEN-POINT ALL CAPS or lower case is used on business cards and forms.

8/10 To the inexperienced person, all type faces may look the same. Blindly picking a type which looks good on the screen, may produce poor type after it is printed.

9/11 Every typeface looks different to each different output devices. Printing type samples to the production output device leads to accurate choices.

10/12 The lower the dpi of a laser printer, the larger the dots forming each letter. The stroke on a letter appears thicker with the larger dots of lower dpi.

11/13 Comparing samples from different type faces help determine: what is the ideal body copy size; the leading for each face; the set of the face; and the readability and legibility.

12/14 TWELVE slows the reader if the set is large and the line is short.

Figure 3-28 Typeface specimen charts

TEXT AND DISPLAY - Serif faces

GARAMOND

- *Display — Not readable for posters or flyers.*
- *Text — Sets small with a light tone. Try standard leadings or one point above the type size.*

There are numerous versions of Garamond today. Originally designed for the arts: programs, prose and short verse. Elegant family to use for prestige work.

STRENGTH: Gives a light and even color on the page. Easy to read and elegant. Sets small and will work in 12-point as well as 6-point. Designed with Caslon.

LIMITS: As a light face, it requires the best environment (exhausted chemicals or film will cause broken letters) for imagesetter dpi. Not recommended for laser dpi in smaller sizes. Contrast between medium and **bold**. Watch for gray images on originals to be copied, the type will become broken.

WEIGHT/STYLE

Roman *Italics* Bold ***Bold Italics***

SemiBold *SemiBold Italics*

abcdefghijklmnopqrstuvwxyz

ABCDEFGHIJKLMNOPQRSTUV

WXYZ1234567890-=!@#$%^&*()_+

6/8 SIX-POINT ALL CAPS IS USED ON BUSINESS CARDS.

7/9 SEVEN-POINT ALL CAPS or lower case is used on business cards and forms.

8/10 To the inexperienced person, all type faces may look the same. Blindly picking a type which looks good on the screen, may produce poor type after it is printed.

9/11 Every typeface looks different to each different output devices. Printing type samples to the production output device leads to accurate choices.

10/12 The lower the dpi of a laser printer, the larger the dots forming each letter. The stroke on a letter appears thicker with the larger dots of lower dpi.

11/13 Comparing samples from different type faces help determine: what is the ideal body copy size; the leading for each face; the set of the face; and the readability and legibility.

12/14 TWELVE slows the reader if the set is large and the line is short.

NEW CENTURY SCHOOLBOOK

- *Display — Standard size.*
- *Text — Sets medium with a medium tone. Try standard leadings.*

A plain look and medium size face. A modern roman.

STRENGTH: Easy to reproduce, strokes are not too thin. Is both readable and legible. Will not suffer from overuse. Solves a lot of problems that Times will cause, but try one type size smaller than Times.

LIMITS: Will not give a unique look to the copy.

WEIGHT/STYLE

Roman Italics **Bold** ***Bold Italics***

abcdefghijklmnopqrstuvwxyz

ABCDEFGHIJKLMNOPQRSTUV

WXYZ1234567890-=!@#$%^*()_+

6/8 SIX-POINT ALL CAPS IS USED ON BUSINESS CARDS.

7/9 SEVEN-POINT ALL CAPS or lower case is used on business cards and forms.

8/10 To the inexperienced person, all type faces may look the same. Blindly picking a type which looks good on the screen, may produce poor type after it is printed.

9/11 Every typeface looks different to each different output devices. Printing type samples to the production output device leads to accurate choices.

10/12 The lower the dpi of a laser printer, the larger the dots forming each letter. The stroke on a letter appears thicker with the larger dots of lower dpi.

11/13 Comparing samples from different type faces help determine: what is the ideal body copy size; the leading for each face; the set of the face; and the readability and legibility.

12/14 TWELVE slows the reader if the set is large and the line is short.

TEXT AND DISPLAY - Serif faces

PALATINO

- *Display — Nice italics and works in larger sizes.*
- *Text — Sets normal with a medium tone. Longer descenders require extra leading.*

Designed by Hermann Zapf to use for display and body copy . Also works combines with Optima as heads and subheads. Gives a look of grace and prestige with a hand drawn look.

STRENGTHS: Highly legible. Good contrast in different size of display type in **bold**. A company may chose Palatino for all text documents for a prestigious look. A very useful face for almost all jobs.

LIMITS: Shapes of letters look blotchy in 6–7pt. type output to laser dpi. Palatino requires more file memory than most faces because of shape of letters. *Italics* appears smaller that regular in a text block.

WEIGHT/STYLE

Roman Italics **Bold** *Bold Italics*
abcdefghijklmnopqrstuvwxyz
ABCDEFGHIJKLMNOPQRSTUV
WXYZ1234567890-=!@#$%^*()_+

6/8 SIX-POINT ALL CAPS IS USED ON BUSINESS CARDS.

7/9 SEVEN-POINT ALL CAPS or lower case is used on business cards and forms.

8/10 To the inexperienced person, all type faces may look the same. Blindly picking a type which looks good on the screen, may produce poor type after it is printed.

9/11 Every typeface looks different to each different output devices. Printing type samples to the production output device leads to accurate choices.

10/12 The lower the dpi of a laser printer, the larger the dots forming each letter. The stroke on a letter appears thicker with the larger dots of lower dpi.

11/13 Comparing samples from different type faces help determine: what is the ideal body copy size; the leading for each face; the set of the face; and the readability and legibility.

12/14 TWELVE slows the reader if the set is large and the line is short.

TIMES

- *Display — Try 2 sizes larger than standards. Kern letterspacing.*
- *Text — Sets small with a medium tone. Try standard leadings.*

Used for all categories of printed material except forms and posters. Designed for newspaper body text. A contemporary Roman, with small serifs and thicker strokes.

STRENGTH: Times Roman has a larger x-height than most type faces (the relationship of its lower case letter to its ascending letters), but it appears smaller than most type. This face fits more word per line than most faces. Works at 12-point body text.

LIMITS: Times will not give a contrast for subheads if they are upper and lower case bold and one standard type size different. Because of its small size, it is not readable in 6-point type nor is it legible in 6-point type at laser dpi.

WEIGHT/STYLE

Roman *Italics* **Bold** *Bold Italics*
abcdefghijklmnopqrstuvwxyz
ABCDEFGHIJKLMNOPQRSTUV
WXYZ1234567890-=!@#$%^&*()_

6/8 SIX-POINT ALL CAPS IS USED ON BUSINESS CARDS.

7/9 SEVEN-POINT ALL CAPS or lower case is used on business cards and forms.

8/10 To the inexperienced person, all type faces may look the same. Blindly picking a type which looks good on the screen, may produce poor type after it is printed.

9/11 Every typeface looks different to each different output devices. Printing type samples to the production output device leads to accurate choices.

10/12 The lower the dpi of a laser printer, the larger the dots forming each letter. The stroke on a letter appears thicker with the larger dots of lower dpi.

11/13 Comparing samples from different type faces help determine: what is the ideal body copy size; the leading for each face; the set of the face; and the readability and legibility.

12/14 TWELVE slows the reader if the set is large and the line is short.

TEXT AND DISPLAY - Sans serif faces

AVANT GARDE

- *Display — Try 2 sizes larger than anticipated because it looks light.*
- *Text — Try a size smaller because it looks crowded. Add extra leading and usually limited to 3 lines of type (advertisements).*

Modern, unique letter "a". Round letters.

STRENGTHS: Very unique look. Great with additional leading and white space design. Works as body copy from a distance (posters).

LIMITS: Tracking and leading needs to be increased. Requires extra time and effort to get a professional look as text. Would become tiring to read as body in a text document.

WEIGHT/STYLE

Book *Book Oblique*

Demi *Demi Oblique*

abcdefghijklmnopqrstuvwxyz

ABCDEFGHIJKLMNOP

QRSTUVWXYZ

1234567890!@#$%^&*()_+

6/8	SIX-POINT ALL CAPS IS USED ON BUSINESS CARDS.
7/9	SEVEN-POINT ALL CAPS or lower case is used on business cards and forms.
8/10	To the inexperienced person, all type faces may look the same. Blindly picking a type which looks good on the screen, may produce poor type after it is printed.
9/11	Every typeface looks different to each different output devices. Printing type samples to the production output device leads to accurate choices.
10/12	The lower the dpi of a laser printer, the larger the dots forming each letter. The stroke on a letter appears thicker with the larger dots of lower dpi.
11/13	Comparing samples from different type faces help determine: what is the ideal body copy size; the leading for each face; the set of the face; and the readability and legibility.
12/14	TWELVE slows the reader if the set is large and the line is short.

HELVETICA

- *Display — Try one size smaller than standards. A heavy look with contrasting weights.*
- *Text — Looks large and heavy above 9-points. Requires extra leading. Regular is too dark for laser resolution, use light.*

A contemporary face.

STRENGTHS: Used for all categories of printed material. A clean, well organized look. Has even strokes and even color on the page. Handles severe width changes. One of the largest choices and weights and styles.

LIMITS: Not a distinguished face. Large x-height requires careful size leading choices.

WEIGHT/STYLE

Light *Light Oblique* Regular *Oblique*

Bold *Bold Oblique*

Black *Black Oblique*

abcdefghijklmnopqrstuvwxyz

ABCDEFGHIJKLMNOPQRSTUV

WXYZ1234567890-=!@#$%^*()_+

6/8	SIX-POINT ALL CAPS IS USED ON BUSINESS CARDS.
7/9	SEVEN-POINT ALL CAPS or lower case is used on business cards and forms.
8/10	To the inexperienced person, all type faces may look the same. Blindly picking a type which looks good on the screen, may produce poor type after it is printed.
9/11	Every typeface looks different to each different output devices. Printing type samples to the production output device leads to accurate choices.
10/12	The lower the dpi of a laser printer, the larger the dots forming each letter. The stroke on a letter appears thicker with the larger dots of lower dpi.
11/13	Comparing samples from different type faces help determine: what is the ideal body copy size; the leading for each face; the set of the face; and the readability and legibility.
12/14	TWELVE slows the reader if the set is large and the line is short.

TEXT AND DISPLAY - Sans serif faces

HELVETICA CONDENSED

- *Display — Try 2 sizes larger than standards.*
- *Text — Sets narrow with a dark tone. Try standard leadings or greater. Try body text is light rather than regular.*

Used for ads, flyers, posters. Gives you a face to mix with Helvetica when a variety of specs are required.

STRENGTH: Specifically for listings like price and parts list, directories, catalogs, newsletter when economy of space and maximum legibility are of prime importance. Great for short blocks of type.

LIMITS: Not as readable as normal width faces.

WEIGHT/STYLE

Light *Light Oblique* Regular *Oblique*

Bold *Bold Oblique* **Black** *Black Oblique*

abcdefghijklmnopqrstuvwxyz
ABCDEFGHIJKLMNOPQRSTUv
WXYZ1234567890-=!@#$%^*()_+

6/8 SIX-POINT ALL CAPS IS USED ON BUSINESS CARDS.

7/9 SEVEN-POINT ALL CAPS or lower case is used on business cards and forms.

8/10 To the inexperienced person, all type faces may look the same. Blindly picking a type which looks good on the screen, may produce poor type after it is printed.

9/11 Every typeface looks different to each different output devices. Printing type samples to the production output device leads to accurate choices.

10/12 The lower the dpi of a laser printer, the larger the dots forming each letter. The stroke on a letter appears thicker with the larger dots of lower dpi.

11/13 Comparing samples from different type faces help determine: what is the ideal body copy size; the leading for each face; the set of the face; and the readability and legibility.

12/14 TWELVE slows the reader if the set is large and the line is short.

OPTIMA

- *Display — Try 2 sizes larger than standards, especially designed to work with Palatino.*
- *Text — Sets medium with a light tone. Try standard leadings.*

Has an elegant stylish and distinct look, slightly contrasting thick and thin strokes.
Best choice for sans serif body copy if output to laser.

STRENGTHS: One of the few faces that will combined well with both serif and sans serif faces. Nice contrast between regular and **bold.**

LIMITS: Will create a larger file size because of the shape of the letters. May appear broken in 6 or 7-point type. Distinguishable look can suffer from overuse.

WEIGHT/STYLE

Regular *Oblique* **Bold** *Bold Oblique*

abcdefghijklmnopqrstuvwxyz
ABCDEFGHIJKLMNOPQRSTUV
WXYZ1234567890-=!@#$%^*()_+

6/8 SIX-POINT ALL CAPS IS USED ON BUSINESS CARDS.

7/9 SEVEN-POINT ALL CAPS or lower case is used on business cards and forms.

8/10 To the inexperienced person, all type faces may look the same. Blindly picking a type which looks good on the screen, may produce poor type after it is printed.

9/11 Every typeface looks different to each different output devices. Printing type samples to the production output device leads to accurate choices.

10/12 The lower the dpi of a laser printer, the larger the dots forming each letter. The stroke on a letter appears thicker with the larger dots of lower dpi.

11/13 Comparing samples from different type faces help determine: what is the ideal body copy size; the leading for each face; the set of the face; and the readability and legibility.

12/14 TWELVE slows the reader if the set is large and the line is short.

TEXT AND DISPLAY - Square serif face

OFFICINA SERIF

- *Display — Condensed width and clean.*
- *Text — Sets regular with a dark tone. Try standard leadings.*

Has a modern, clean, open look. Condensed shape.

There are a limited amount of square serif faces available today and most are used for display type. This face is usually set in lower case with at least .5 letterspacing.

STRENGTHS: One of the few faces that will combined well with both serif and sans serif faces. Nice contrast between regular and bold.

LIMITS: Book weight is heavy in color. Get burdensome to read for long documents. Very distinguishable look that may suffer if overused.

WEIGHT/STYLE

Book *Book Italics* **Bold** *Bold Italics*

abcdefghijklmnopqrstuvwxyz

ABCDEFGHIJKLMNOP

QRSTUVWXYZ

1234567890-=!@#$%^*()_+

COURIER (a typing face)

A true typewriter look, therefore shown in 10-point type.

STRENGTHS: Try as 10-12 point type for electronic forms to quickly identify fill-ins. Try as the body copy of a letter or memo to contrast between original printing.

Limits: Not readable in long documents. Poor letter and word spacing.

WEIGHT/STYLE

regular **bold**

oblique ***bold oblique***

abcdefghijklmnopqrstuvwxyz

ABCDEFGHIJKLMNOPQRSTUV

WXYZ1234567890=-!@#$%^and*()_+

6/8 SIX-POINT ALL CAPS IS USED ON BUSINESS CARDS.

7/9 SEVEN-POINT ALL CAPS or lower case is used on business cards and forms.

8/10 To the inexperienced person, all type faces may look the same. Blindly picking a type which looks good on the screen, may produce poor type after it is printed.

9/11 Every typeface looks different to each different output devices. Printing type samples to the production output device leads to accurate choices.

10/12 The lower the dpi of a laser printer, the larger the dots forming each letter. The stroke on a letter appears thicker with the larger dots of lower dpi.

11/13 Comparing samples from different type faces help determine: what is the ideal body copy size; the leading for each face; the set of the face; and the readability and legibility.

12/14 TWELVE slows the reader if the set is large and the line is short.

6/8 SIX-POINT ALL CAPS IS USED ON BUSINESS CARDS.

7/9 SEVEN-POINT ALL CAPS or lower case is used on business cards and forms.

8/10 To the inexperienced person, all type faces may look the same. Blindly picking a type which looks good on the screen, may produce poor type after it is printed.

9/11 Every typeface looks different to each different output devices. Printing type samples to the production output device leads to accurate choices.

10/12 The lower the dpi of a laser printer, the larger the dots forming each letter. The stroke on a letter appears thicker with the larger dots of lower dpi.

11/13 Comparing samples from different type faces help determine: what is the ideal body copy size; the leading for each face; the set of the face; and the readability and legibility.

12/14 TWELVE slows the reader if the set is large and the line is short.

DISPLAY ONLY - Serif faces

AACHEN

Strong, but not overpowering.

STRENGTHS: Works well on a portrait page because shape of the type matches the shape of the page.

LIMITS: No apostrophe. Unable to create contrast with lots of different specs, careful use beyond 3 - 4 lines, only mixes with a clean Sans Serif like Helvetica

WEIGHT/STYLE

Bold

ABCDEFGHIJKLMNOPQRSTUV WXYZ1234567890! $%

Work SMART
Work SMART
Work SMART
Work SMART

COOPER BLACK

Strong, masculine, friendly, informal

STRENGTHS: Works well for single words or initials. Can be read from long distances.

LIMITS: Will not be used as often as other faces because of distinct strong message it conveys. Too strong for more than one or two lines.

WEIGHT/STYLE

Bold

abcdefghijkmnopqrstuvwxyz ABCDEFGHIJKLMNOPQRS TUVWXYZ1234567890!@$%^

Work SMART
Work SMART
Work SMART
Work SMART

COPPERPLATE GOTHIC

Distinquishing look from a hot type face.

STRENGTHS: Legible face for laser and imagesetter. Mixes well with any face. Is still readable in 6-point type in all caps. The lower case capitals have a letter width drawn for small caps. Professional business like appearance. Was the original font used for forms.

LIMITS: No lower case letters

WEIGHT/STYLE

BOLD

ABCDEFGHIJKLMNOPQRSTUVWXYZ ABCDEFGHIJKLMNOPQRSTUV WXYZ1234567890-=!@#$%^

WORK SMART
WORK SMART
WORK SMART
WORK SMART

DISPLAY ONLY - Serif faces

Revue

A forceful, strong and festive look

STRENGTH: Works well in color. Excellent for outside, display type but one or two words only.

WEAKNESS: The face is unrelenting, inflexible. If it does not work well, leading or tracking changes do not seem to help.

WEIGHT/STYLE

Bold

abcdefghijklmnopqrstuvwxyz

ABCDEFGHIJKLMNOP

QRSTUVWXYZ

1234567890- !@#$%^and*()_+

Work SMART
Work SMART
Work SMART
WorkSMART

TRAJAN

- ROMAN FACE, OLD WORLD LOOK OF CHISELLED IN STONE
- USED FOR INVITATIONS AND AWARDS

LIMITS: NO LOWER CASE

WEIGHT/STYLE

MEDIUM

ABCDEFGHIJKLMNOP

QRSTUVWXYZ

1234567890- !$% AND*()_

WORK SMART
WORK SMART
WORK SMART
WORKSMART

University Roman

Feminine, informal

STRENGTHS: Works in 72-point without overpowering the page, even in reports. Works as body text for invitations

LIMITS: Do not use in sizes smaller than 14-point type. No apostrophe, use Times apostrophe. Difficult for long readings.

WEIGHT/STYLE

Light

abcdefghijklmnopqrstuvwxyz

ABCDEFGHIJKLMNOPQRSTUV

WXYZ1234567890- ! $% and*()_

Work Smart
Work Smart
Work Smart
WorkSmart

DISPLAY ONLY - Script faces

COCHIN

A classical hot type face

STRENGTHS: Excellent for invitations and programs because the face has a script like italics and a regular serif. Excellent in italics for subheads with the text in regular.

LIMITS: The elaborate italics is not readable in all caps. Use as upper and lower case italics in 14-point or larger.

WEIGHT/STYLE

Regular *Italics*

abcdefghijklmnopqrstuvwxyz

ABCDEFGHIJKLMNOP

QRSTUVWXYZ

1234567890=!@#$%^*()_+

abcdefghijklmnopqrstuvwxyz

ABCDEFGHIJKLMNOP

QRSTUVWXYZ

1234567890-=!@#$%^()_+*

Work SMART
Work SMART
Work SMART
WorkSMART

Work SMART
Work SMART
Work SMART
WorkSMART

Snell Roundhand

Clear script, easy to read and reproduce.

LIMITS: Do not use in all caps
Use 14-point or larger.

WEIGHTS

Light

abcdefghijklmnopqrstuvwxyz

ABCDEFGHIJKLMNOP

QRSTUVWXYZ

1234567890- =!@#$%^()_+*

Work Smart
Work Smart
Work Smart
WorkSmart

DISPLAY ONLY - Old English face

Schmutz Cleaned

A redraw of 1940s version of fabric ribbon typewriter.

STRENGTHS: Readable, comes in a family of faces. Follows current trends. May be used for body text in advertising.

LIMITS: Display type as headlines, titles and pull quotes. Can be used smaller than 14-point type, but losing its personality at smaller sizes. Like other decorative faces, it should be used sparingly, but in fun!

WEIGHT/STYLE

Regular

abcdefghijklmnopqrstuvwxyz

ABCDEFGHIJKLMNOPQRSTUV WXYZ1234567890=!@#$%^and*()_+

Work SMART
Work SMART
Work SMART
WorkSMART

MESQUITE

A face with a western or 1900s fun look.

STRENGTHS: One of the narrowest faces to use for display type. Can be used on 8H x 11 page in sizes of three inch type or greater.

LIMITS: Display type only. Difficult to read without additional letterspacing of at least .5-point. Do not use smaller than 14-point type.

WEIGHT/STYLE IN 14-POINT (LETTERSPACING ADDED FOR LEGIBILITY)

ABCDEFGHIJKLMNOP
QRSTUVWXYZ
1234567890-[];',./

WORK SMART
WORK SMART
WORK SMART
WORKSMART

DISPLAY ONLY - Decorative

Fette Fraktur

An Old English face, for initials and titles on legal documents.

ADVANTAGES: Lower case letters are extremely readable for an Old English face.

LIMITS: The capitals are extremely illegible for an Old English face. All letters do not stay on baseline.

WEIGHTS

Bold

abcdefghijklmnopqrstuvwxyz

ABCDEFGHIJKLMNOP

QRSTUVWXYZ
1234567890=!@#$%^and*()_+

Work Smart
Work Smart
Work Smart
WorkSmart

ADDITIONAL FACES

This is a listing of additional commonly used faces that are dependable. Your faces may differ slightly in names. If you choose to use any of these faces, set up a sample similar to this book.

DISPLAY AND TEXT	DISPLAY ONLY	
SERIF	**SERIF**	**OLD ENGLISH**
Beguiat	Americana	Engravers Old English
Bodoni	Engravers	Cloister BlackAridi
Century	Souvenir	
Galliard	Tiffany	
Goudy Old Style		
Korinna		
Mediaeval		
SANS SERIF	**SANS SERIF**	**SCRIPT AND CURSIVE**
Gill Sans	Franklin Gothic	Ashley
Futura (Spartan)	Gothic	Brush
Univers	Olive	Dorchester
SQUARE SERIF	**SQUARE SERIF**	**DECORATIVE**
Rockwell	City	Caslon Open Face
Stymie	Lubalin	Charlemagne
Lubalin		**ORNAMENTS**
		Poetica Ornaments
		Adobe Wood Type

DISPLAY ONLY - Decorative-picture faces with key positions

CARTA
• A SYMBOL FACE, GREAT FOR MAPS

LOWER CASE

a b c d e f g h i j k l m n o p q r s t u v w x y z

1 2 3 4 5 6 7 8 9 0 - = [] ; ' , . /

SHIFT

A B C D E F G H I J K L M N O P Q R S T U V W X Y Z

1 2 3 4 5 6 7 8 9 0 - = [] ; ' , . /

OPTION

a b c d e f g h i j k l m n o p q r s t u v w x y z

1 2 3 4 5 6 7 8 9 0 - = [] ; ' , . /

OPTION/SHIFT

a b c d e f g h i j k l m n o p q r s t u v w x y z

1 2 3 4 5 6 7 8 9 0 - = [] ; ' , . /

ZAPF DINGBAT
• A SYMBOL FACE, GOOD REVERSE NUMBERS, BASIC SYMBOLS

LOWER CASE

a b c d e f g h i j k l m n o p q r s t u v w x y z

1 2 3 4 5 6 7 8 9 0 - = [] ; ' , . /

SHIFT

A B C D E F G H I J K L M N O P Q R S T U V W X Y Z

1 2 3 4 5 6 7 8 9 0 - = [] ; ' , . /

OPTION

a b c d e f g h i j k l m n o p q r s t u v w x y z

1 2 3 4 5 6 7 8 9 0 - = [] ; ' , . /

OPTION/SHIFT

a b c d e f g h i j k l m n o p q r s t u v w x y z

1 2 3 4 5 6 7 8 9 0 - = [] ; ' , . /

*Have a romance
with a typeface.*

4 Typefaces and Their Uses

Setting up a type library
Selecting formatting for body text
Choosing display type
For additional research

*After reading this chapter and applying its principles, the
designer should have success:*

- Assembling a starter group of typefaces.
- Identifying typefaces by name and characteristics.
- Determining character and paragraph formatting
 to match line lengths.
- Blending character and paragraph formatting for
 display type, body type, and subheads to match
 each other.

Chapter 3 dealt with type formatting—what the software does with type and how the computer accomplishes formatting. This chapter focuses on type and its relationship to categories, families, groups, and weights, or, simply, how to select the formatting. Each selection step in this chapter builds answers to important questions related to type formatting…

Is it appropriate? Does the personality of the face match the project?

Is it readable? Can the reader comprehend the words?

Is it legible? Can the words be "seen" by the reader?

Will it print well? Will the image quality match the output device?

Setting up a type library

The listing of typefaces that appear in the window of a software package can be endless and pointless without seeing the face and knowing its uses. If the list contains over thirty typefaces, separating typefaces will make the list more manageable and allow more opportunity to study the faces.

Step 1: Inventory the typefaces

Sample sheets of typefaces are called **type specimen sheets** and serve as a reference for production and inventory. The initial sorting requires specimen sheets to show each typeface without styles and weights. Make a customized type specimen sheet with each face in both a 10-point body text size with a 12-point leading and a display size of 24-point type with one of the words in all caps (figure 4-1).

Using the printout, separate the typefaces by categories and groups. Some type houses list the typefaces in their catalogs by group. If information is not available for categories and groups, visually evaluate the body text line to determine those faces that are heavy or unreadable as display faces.

✖ Cross reference: Use figure 3-1 to determine groups.

Remove typefaces that are limiting. Some faces print to one printer only. TrueType and other faces that are packaged with a specific laser printer will only print to that particular output device. These are examples of typefaces that should be eliminated or separated. Also, remove most monospaced typefaces. Some are easy to detect because their names are cities and countries. This group of faces can be described as typewriter faces. The safest procedure to follow is to remove all fonts from the basic group that do not have a printer and screen version.

TEXT AND DISPLAY

Avant Garde — The best way to choose a face is to treat it with romance not rules.

Caslon — The best way to choose a face is to treat it with romance not rules.

Garamond — The best way to choose a face is to treat it with romance not rules.

Helvetica — The best way to choose a face is to treat it with romance not rules.

Helvetica Condensed — The best way to choose a face is to treat it with romance not rules.

N.C.Schoolbook — The best way to choose a face is to treat it with romance not rules.

Palatino — The best way to choose a face is to treat it with romance not rules.

Times — The best way to choose a face is to treat it with romance not rules.

DISPLAY ONLY

Aachen — The best way to choose a face is to treat it with romance

COPPERPLATE GOTHIC — THE BEST WAY TO CHOOSE A FACE IS TO TREAT IT W

TRAJAN — THE BEST WAY TO CHOOSE A FACE IS TO TREAT IT WITH

Nuptial Script — The best way to choose a face is to treat it with romance.

SYMBOLS

Carta

Wood ornament

Figure 4-1 Sorting type by printing out all available faces by groups

Caslon

REGULAR				BOLD				SEMIBOLD				ITALICS			
a	A	å	Å	**a**	**A**	**å**	**Å**	a	A	å	Å	*a*	*A*	*å*	*Å*
b	B	∫	ı	**b**	**B**	**∫**	**ı**	b	B	∫	ı	*b*	*B*	*∫*	*ı*
c	C	ç	Ç	**c**	**C**	**ç**	**Ç**	c	C	ç	Ç	*c*	*C*	*ç*	*Ç*
d	D	∂	Î	**d**	**D**	**∂**	**Î**	d	D	∂	Î	*d*	*D*	*∂*	*Î*
e	E	´	″	**e**	**E**	**´**	**″**	e	E	´	″	*e*	*E*	*´*	*″*
f	F	ƒ	Ï	**f**	**F**	**ƒ**	**Ï**	f	F	ƒ	Ï	*f*	*F*	*ƒ*	*Ï*
g	G	©	″	**g**	**G**	**©**	**″**	g	G	©	″	*g*	*G*	*©*	*″*
h	H	·	Ó	**h**	**H**	**·**	**Ó**	h	H	·	Ó	*h*	*H*	*·*	*Ó*
i	I	^	^	**i**	**I**	**^**	**^**	i	I	^	^	*i*	*I*	*^*	*^*
j	J	Δ	Ô	**j**	**J**	**Δ**	**Ô**	j	J	Δ	Ô	*j*	*J*	*Δ*	*Ô*
k	K	°		**k**	**K**	**°**		k	K	°		*k*	*K*	*°*	
l	L	¬	Ò	**l**	**L**	**¬**	**Ò**	l	L	¬	Ò	*l*	*L*	*¬*	*Ò*
m	M	µ	Â	**m**	**M**	**µ**	**Â**	m	M	µ	Â	*m*	*M*	*µ*	*Â*
n	N	˜	~	**n**	**N**	**˜**	**~**	n	N	˜	~	*n*	*N*	*˜*	*~*
o	O	ø	Ø	**o**	**O**	**ø**	**Ø**	o	O	ø	Ø	*o*	*O*	*ø*	*Ø*
p	P	π	Π	**p**	**P**	**π**	**Π**	p	P	π	Π	*p*	*P*	*π*	*Π*
q	Q	œ	Œ	**q**	**Q**	**œ**	**Œ**	q	Q	œ	Œ	*q*	*Q*	*œ*	*Œ*
r	R	®	‰	**r**	**R**	**®**	**‰**	r	R	®	‰	*r*	*R*	*®*	*‰*
s	S	ß	Í	**s**	**S**	**ß**	**Í**	s	S	ß	Í	*s*	*S*	*ß*	*Í*
t	T	†	ˇ	**t**	**T**	**†**	**ˇ**	t	T	†	ˇ	*t*	*T*	*†*	*ˇ*
u	U	¨	¨	**u**	**U**	**¨**	**¨**	u	U	¨	¨	*u*	*U*	*¨*	*¨*
v	V	√	◊	**v**	**V**	**√**	**◊**	v	V	√	◊	*v*	*V*	*√*	*◊*
w	W	Σ	„	**w**	**W**	**Σ**	**„**	w	W	Σ	„	*w*	*W*	*Σ*	*„*
x	X	≈	ˋ	**x**	**X**	**≈**	**ˋ**	x	X	≈	ˋ	*x*	*X*	*≈*	*ˋ*
y	Y	Á	Á	**y**	**Y**	**Á**	**Á**	y	Y	Á	Á	*y*	*Y*	*Á*	*Á*
z	Z	Ω	˛	**z**	**Z**	**Ω**	**˛**	z	Z	Ω	˛	*z*	*Z*	*Ω*	*˛*
1	!	¡	⁄	**1**	**!**	**¡**	**⁄**	1	!	¡	⁄	*1*	*!*	*¡*	*⁄*
2	@	™	¤	**2**	**@**	**™**	**¤**	2	@	™	¤	*2*	*@*	*™*	*¤*
3	#	£	‹	**3**	**#**	**£**	**‹**	3	#	£	‹	*3*	*#*	*£*	*‹*
4	$	¢	›	**4**	**$**	**¢**	**›**	4	$	¢	›	*4*	*$*	*¢*	*›*
5	%	∞	fi	**5**	**%**	**∞**	**fi**	5	%	∞	fi	*5*	*%*	*∞*	*fi*
6	^	§	fl	**6**	**^**	**§**	**fl**	6	^	§	fl	*6*	*^*	*§*	*fl*
7	&	¶	‡	**7**	**&**	**¶**	**‡**	7	&	¶	‡	*7*	*&*	*¶*	*‡*
8	*	•	°	**8**	***	**•**	**°**	8	*	•	°	*8*	***	*•*	*°*
9	(ª	·	**9**	**(**	**ª**	**·**	9	(ª	·	*9*	*(*	*ª*	*·*
0)	º	‚	**0**	**)**	**º**	**‚**	0)	º	‚	*0*	*)*	*º*	*‚*
-	–	—	—	**-**	**–**	**—**	**—**	-	–	—	—	*-*	*–*	*—*	*—*
=	+	≠	±	**=**	**+**	**≠**	**±**	=	+	≠	±	*=*	*+*	*≠*	*±*
[{	"	"	**[**	**{**	**"**	**"**	[{	"	"	*[*	*{*	*"*	*"*
]	}	'	'	**]**	**}**	**'**	**'**]	}	'	'	*]*	*}*	*'*	*'*
;	:	…	Ú	**;**	**:**	**…**	**Ú**	;	:	…	Ú	*;*	*:*	*…*	*Ú*
'	"	æ	Æ	**'**	**"**	**æ**	**Æ**	'	"	æ	Æ	*'*	*"*	*æ*	*Æ*
,	<	≤	¯	**,**	**<**	**≤**	**¯**	,	<	≤	¯	*,*	*<*	*≤*	*¯*
.	>	≥	˘	**.**	**>**	**≥**	**˘**	.	>	≥	˘	*.*	*>*	*≥*	*˘*
/	?	÷	¿	**/**	**?**	**÷**	**¿**	/	?	÷	¿	*/*	*?*	*÷*	*¿*

Figure 4-2 Sample of four key positions on a Mac

Step 2: Set up customized sets of typefaces

Divide typefaces into an essential start-up group and alternatives. The essential start-up group should hold twenty to thirty typefaces and give a representation of each category and group of typefaces. Use the typeface samples at the end of this chapter for an example of a broad range of face sizes and audience for the essential group. The essential group should also be flexible and updated because of changing trends and project requirements.

Notice that text faces are found in two groups: serif and sans serif, with a large variety of weights within each typeface. Display faces are in six groups and are more numerous, but come in less variety of weight and style. The characteristics of display faces are more unique. The extremes of letter widths and line weights would make the body type difficult to read, but would create that attention-getting look required of some advertising projects. Include at least one expert font series that contains fractions, ornaments, swashes, and true small caps, as well as a serif and sans serif multiple master font that can be used when special line width, type width, and sizes are needed.

Step 3: Fit the type library into all steps of the process

Grouping for essential and alternative typefaces should be maintained in the reference notebook so that they are easy to locate and identify. A single page printout of each typeface created from key caps software packages (figure 4-2) or personally produced helps accomplish this goal. Also, a personalized sheet of each face could be made (similar to the type charts at the end of this chapter).

Because typeface samples are accurate to the output device, faces can be chosen confidently at the beginning of the design process. If the file is output to a different device or at a different location, screen and printer versions of the typeface need to be transported with the file to ensure image quality.

Selecting formatting for body text

For comprehension, body text needs to be the reader's friend. Good type choices should not distract the reader's focus. After a project has been designed, look at the typeface samples from the output device and find a face that suits the needs of the reader.

Step 1: Choose an appropriate typeface for the body text

Begin choosing an appropriate typeface by referring to the type specimen sheet at the back of this chapter. Presented are the characteristics of the typical set of essential faces in relationship to the limitations of the output device or needs of the audience.

A careful examination of typefaces is an essential research step. One good body text face provides a foundation that can be transferred to other projects.

When designing for one company, choose one body text face for each category of publications in order to maintain a company identity. When designing for a number of companies, the designer will need to refer to the entire group of typefaces.

✔ **CHECK: Personality and print quality of typeface are acceptable.**

Step 2: Determine readable size by line length

Type is read just as words are spoken. When type is set correctly, there will be seven to fifteen words on

8/10 9-17 PICA LINE LENGTH

Part of learning any software program is getting an eye for the kinds of things that the program can do. In the first part of research, you will begin to recognize what looks good, but in the second part of research you will begin to understand how it was done and which software package it can be completed in easily.

9/11 10–19 PICA LINE LENGTH

Part of learning any software program is getting an eye for the kinds of things that the program can do. In the first part of research, you will begin to recognize what looks good, but in the second part of research you will begin to understand how it was done and which software package it can be completed in easily.

10/12 11–21 PICA LINE LENGTH

Part of learning any software program is getting an eye for the kinds of things that the program can do. In the first part of research, you will begin to recognize what looks good, but in the second part of research you will begin to understand how it was done and which software package it can be completed in easily.

11/13 12–23 PICA LINE LENGTH

Part of learning any software program is getting an eye for the kinds of things that the program can do. In the first part of research, you will begin to recognize what looks good, but in the second part of research you will begin to understand how it was done and which software package it can be completed in easily.

Figure 4-3 Sample of a face with four common sizes and seven to fifteen words marked

8/10 The ability to set type quickly and clearly is accomplished by setting several sample lines to choose the best size and leading.

8/11 The ability to set type quickly and clearly is accomplished by setting several sample lines to choose the best size and leading.

8/12 The ability to set type quickly and clearly is accomplished by setting several sample lines to choose the best size and leading.

8/13 The ability to set type quickly and clearly is accomplished by setting several sample lines to choose the best size and leading.

8/14 The ability to set type quickly and clearly is accomplished by setting several sample lines to choose the best size and leading.

8/16 The ability to set type quickly and clearly is accomplished by setting several sample lines to choose the best size and leading.

8/18 The ability to set type quickly and clearly is accomplished by setting several sample lines to choose the best size and leading.

Figure 4-4 Test the typeface and line length with a variety of leadings

a line and line length will not be wider than the outside measurement across the eyes (24 picas). If the line length is longer than 24 picas, the reader will be uncomfortable from moving back and forth across the line, and comprehension will be more difficult.

When copyfitting is a factor, remember that typefaces with small x-height and oval "o"s fit more words per line. Since the face, size, and line length are dependent on each other, make these choices together.

- Make a chart similar to figure 4-3.
- Count and mark seven words and fifteen words.
- Use the look of the size and the line length of the page design to find a size that falls within the minimum and maximum word length of each line.

✔ *CHECK: Face and size are equal to the ideal line length.*

Step 3: Find a matching leading

Each typeface handles the spacing between letters and spacing between words differently. Use the typeface and size chosen from the previous steps to set up another sample that only changes leading. Examine the white space between words for this typeface and include other variables like line length, indexes, and amount of white space in the overall design. Weigh all factors to determine four leading choices to examine with this typeface (figure 4-4).

✔ *CHECK: Face, size, and line length are equal to the necessary leading.*

Step 4: Subhead techniques

The best subhead size is up to two points greater than the body text. This choice allows for easy adjustment to secondary leading and other hierarchy problems.

Depending on the number of page elements and the amount of contrast, subheads are presented with the same face as the body text or in a second face (figures 4-5, 4-6, 4-7).

Upper and Lower Subheads

This copy has no first indent and is used for the first paragraph in a section followed by one or two pica indent.

The second paragraph begins with a normal first line indent, in this case it is set at an em space.

SUBHEAD COMBINED WITH NO INDENT
FOR THE PARAGRAPH INTRODUCTION

ALL CAPS SUBHEADS

This is a first line one pica indent and is the most common indent used for a line length of this amount. If the line was longer, the indent could be two or three picas.

This is a first line indent of 10 points which is the type size and therefore an em space, a finer measurement than one pica. Both can be used with or without above paragraph.

FIRST LINE INDENT OF ONE PICA OR ONE EM SPACE

Italics with Subheads

This copy has a left indent and no first line indent. It is used for all paragraphs.

A before paragraph leading of half the leading or 6-7 points is used to separate the paragraphs.

COPY WITH AN INDENT LEFT

Mixing with Subheads. This is used for bibliographies, verse and some leader dots. After the first line, it automatically indents till the end of a paragraph.

A 'before paragraph' leading of half the leading or 6-7 points is used to separate the paragraphs.

HANGING INDENT

Figure 4-5 Traditional subhead combinations

SUBHEAD ONE

The subhead has a two-point rule above built in and the rule has an indent right on the body text. Helpful for large documents requiring more than four levels of subheads and one type face.

SUBHEAD ABOVE PARAGRAPH 2 PT RULE

SUBHEAD ONE

The subhead has one-point rule above and below, built in. Useful for copy that is placed in the center of the page, set in a traditional design. If the line were black, a hairline might also be chosen.

SUBHEAD ABOVE AND BELOW PARAGRAPH 1 PT RULE

SUBHEAD

This rule can be set in a tint or color and it will not give the piece a blotchy look when the page is full of subheads. It can be longer or larger if the tint or color is lighter. The sample is 30% blue.

SUBHEAD 2 PT ABOVE PARAGRAPH RULE

SUBHEAD

This reverse is built into the style for subhead. It has an above and below rule the width of the type with an en space (cmd/shift n) before and after the type and the type is paper. This could be a color or a tint of 40% or greater. Be sure that the type face does not look broken when it is used.

SUBHEAD 2 PT ABOVE AND BELOW PARAGRAPH RULE

Figure 4-6 Subheads with rules

Run-In Subheads. A favorite among typographic people because it adds a recognizable amount of contrast, is easy to see and makes the copy fit together nicely. Works for a third level subhead and requires no additional above paragraph leading.

AFTER THE SUBHEAD, THE PERIOD IS
FOLLOWED BY AN EN SPACE.

Run-In Subheads. Another approach

that continues with the idea in the first sample but adds more contrast. Works for text that must carry the design because of the absence of illustrations or photos and also in advertisements. The period is followed by an en space.

RUN-IN SUBHEADS WITH AN EN SPACE AFTER THE PERIOD

Run-in Subhead This copy requires a hanging indent at the left side of the text and two tabs: a right tab next to the 'D' in subhead and a left tab at the exact location of the hanging indent. The copy appears rather straight forward, but without the tabs, it would be unlinked text blocks and cause multiple corrections for copy revision.

The second paragraph is given another style name in the style palette with an above leading of 7 points, a left indent of 9 points.

RUN-IN SUBHEAD WITH TAB AND HANGING INDENT

Figure 4-7 Run-in subheads

✘ Cross reference: For publication-specific subheads, see Section Two of the *StyleGuide.*

Projects frequently require multiple subheads or multiple levels of subheads. If one bold face does not provide enough contrast, try increasing letterspacing and width before increasing type size. Most design solutions for multiple subheads can be found in the wide variety of choices in figures 4-8 and 4-9.

✔ *CHECK: Body text size and face are equal to subhead, size, and face with bold.*

Step 5: Break up text with indents

One project can require different body text indents. Indents are used to break up the text and identify its purpose to the reader. These techniques provide the reader clues as to where new information begins and to what type of paragraph is being presented. Within a single publication, indents change for basic body text, the introduction paragraph after a subhead, quotes from another person, and numbered or bulleted information.

✔ *CHECK: The longer the line length, the greater the indent.*

You can begin the first step at any time to help you produce the best possible piece.

THE FINAL PROJECT

Research the variety of printed pieces that are part of the desktop publishing industries that interact with your industry or choose a specific market of desktop.

Combine the operations of software learned during this class as they apply to that work group.

Research

Your research to how your market uses desktop publishing can consist of interviewing other teachers, people in industry, reading articles in our library. Once you feel comfortable with the basic information you have found you need to discuss it with your instructor. The instructor will set a deadline.

Identify the kind of market. The instructor will approve your project, help you determine if that project fits into your time frame and ability, and handout information on standards for that printed piece.

8/12 WITH ONE TYPEFACE

You can begin the first step at any time to help you produce the best possible piece.

THE FINAL PROJECT

Research the variety of printed pieces that are part of the desktop publishing industries that interact with your industry or choose a specific market of desktop.

Combine the operations of software learned during this class as they apply to that work group.

Research

Your research to how your market uses desktop publishing can consist of interviewing other teachers, people in industry, reading articles in our library. Once you feel comfortable with the basic information you have found you need to discuss it with your instructor. The instructor will set a deadline.

Identify the kind of market. The instructor will approve your project, help you determine if that project fits into your time frame and ability, and handout information on standards for that printed piece.

8/12 WITH TWO TYPEFACES

Figure 4-8 Two samples of multiple level subheads; changes include case, weight, size, and before paragraph leadings.

THIS drop cap is set for two lines because the body of text was too short to handle a three-line drop. Spacing can be removed between the "T" and the "h" in the first word, if it is a letter that is narrow at the top like an "A." Using all caps helps tie the cap to its word.

The size of the drop cap shown was highlighted and changed to a size that placed it even with the top of the first line and the bottom of the second line.

DROP CAP ADJUSTED TO TWO LINES FOLLOWED BY CAPITALS

Not used as often as drop caps because it has to be done manually. Type sizes used are 8 and 16, be sure the leading is not on automatic but use the same number for both type sizes or the first two lines of this paragraph would have a different leading than the rest of it. The spacing in the larger type has been done using expert kerning.

PARAGRAPH OPENING IN 16-POINT TYPE

NOT USED AS OFTEN AS DROP CAPS BECAUSE IT HAS TO BE DONE manually. Type size used is 8, be sure the leading is not on automatic but use the same number for both type sizes or the first two lines of this paragraph would have a different leading than the rest of it. The spacing in the larger type has been done with expert kerning.

PARAGRAPH OPENING IN SMALL CAPS

Figure 4-9 Type changes in paragraph opening

Basic indents

The first line indent shown is an em indent. Professional production artists use em indents because they are proportional to the type size. For instance, if it is 8-point type, use an 8-point indent; or, for larger indents with longer line lengths, use multiples of the type size. First line indents can be up to half the width of the paragraph. Usually, the wider the paragraph the greater the indent (figure 4-10).

Introduction paragraph after subheads

The first paragraph after each subhead is usually written as an introduction to the reader about the rest of the copy. It is set off from the rest of the copy with no first line indent (figure 4-11) and should be given a separate name in the style palette, such as "body intro."

Paragraph markers

Rather than using a paragraph indent, try a symbol or special effect as a paragraph marker for body text in introductions or copy requiring the text to carry the design. Other paragraph markers make drastic changes to the first line or first letter of type (figure 4-12).

Step 6: Break up text with secondary leadings

Once all other type formatting has been chosen, locate a page that includes all required formatting and determine additional contrast requirements that can be accomplished with white space. Rather than use an additional return that cannot be adjusted, use a secondary leading and follow the hierarchy of type to decide where to add it and how much to add. For special circumstances that exclude a first line indent in all paragraphs, before leading is needed to separate paragraphs (figure 4-13).

✔ **CHECK: *The more important the page element, the greater the amount of white space is needed.***

This is a first line with a one pica indent and is the most common indent used for short line lengths. If the line were longer, the indent could be one or two picas.

This is a first line with a two pica indent and is the most common indent used for short line lengths. If the line were longer, the indent could be two or three picas.

This is a first line indent of three pica indent and works for this line because it has a maximum number of words in the line. Both can be used with or without above paragraph leading depending on the lightness of the page.

Figure 4-10 Three indents that increase proportionally to the line length

The Title

THE purpose of this project is to understand how desktop publishing is an integral part of many jobs. You may already know which job market you intend to pursue.

We hope you will choose a project that fits into that market so your fellow students will learn a variety of related applications for the use of this kind of software as well as typographic information.

THE FINAL PROJECT

Research the variety of printed pieces that are part of the desktop publishing industries that interact with your industry or choose a specific market of desktop: Secretarial, writer, artist, print shop, drafter, commercial artist, T-shirt printing, newspaper publishing.

Research

Your research to how your market uses desktop publishing can consist of interviewing other teachers, people in industry, reading articles in our library. Once you feel comfortable with the basic information you have found you need to discuss it with your instructor. The instructor will set a deadline.

Identify the kind of market. The instructor will approve your project, help you determine if that project fits into your time frame and ability, and handout information on standards.

Figure 4-11 Multiple subheads with baseline leadings remaining constant

■ Some magazines are beginning and ending their articles or shorts with a symbol font. It gives a marker for the end of the article or brief and the reader does not have any trouble recognizing it.■

Others are using the symbol at the end. ▲

Figure 4-12 Popular paragraph markers from the font Zapf Dingbats, used to separate the groups of paragraphs or articles

This copy has no first line indent and is used for the first paragraph in a section followed by one or two pica indents for the rest of the paragraphs or with an above paragraph leading.

The paragraphs that follow need the before leading to help the reader separate the copy. This works well on brochures with the body text given a left indent from the subhead.

Figure 4-13 Body text without first line indents need 6-point before-paragraph leading

Choosing display type

The problem with display type is how to make choices when there are no limits. Display type heralds the rest of the copy. Display type sizes are a minimum of 14 points up to billboard sizes, depending on the limitations of page size and software package. Display type sizes and techniques are used for headlines and subheads in advertising pieces, title sheets in text documents, nameplates and headlines in news publications, and company names for business communications.

Some production techniques for display type generally include no hyphenation and deliberate extreme leadings. Tighter leadings include techniques such as the same leading as the typefaces (set solid) or leading one type size smaller than the type size (negative leading). Loose and varying leadings for upper and lower case display lines also provide options (figure 4-14). Some software allows leading method changes to top of caps or baseline—a more logical effect on headlines in several different type sizes. Try changing the leading to baseline; the space above each line can be adjusted.

Although multiple lines of display type need to grab the reader's attention, they also should be easy to read. Samples in figures 4-15 through 4-17 show one or all of these characteristics.

- A title has a "bowl shape" from line to line, regardless of the alignment used.
- To focus or contrast, use weight, case, or size changes.
- The line division must be logical (by prepositions).

A Guide to Type
CHARACTER SCALE 70%

A guide to type
SENTENCE CAPITAL

a guide to type
LOWER CASE

A Guide to Type
CAPITALIZING IMPORTANT WORDS

A Guide To Type
CAPITALIZING ALL WORDS

A GUIDE TO TYPE
ADDITIONAL LETTERSPACING

A GUIDE TO TYPE
UPPERCASE (ALL CAPS)

A GUIDE TO TYPE
SMALL CAPS, LOWER CASE ONLY

A GUIDE TO TYPE
ADDITIONAL LETTERSPACING

A GUIDE TO TYPE
CHARACTER SCALE 120% WITH THIN SPACES

A GUIDE TO TYPE
SMALL CAPS, 85% SMALL CAPS

A Guide to Type
BOLD

A GUIDE TO TYPE
BOLD ALL CAPS

A Guide to Type
BOLD ITALICS

A GUIDE TO TYPE
BOLD ITALICS, ALL CAPS WITH THIN SPACE INSTEAD OF SPACE BARS

Figure 4-14 (Right) Single lines for titles or headlines

Column 1

A Guide
to Type

18 ON 14, NEGATIVE LEADING

A Guide
to Type

18 ON 18, SET SOLID

A Guide

to Type

18 ON 24, NEGATIVE LEADING

A GUIDE
TO TYPE

18 ON 14, NEGATIVE LEADING - ALL CAPS

A GUIDE
TO TYPE

18 ON 18, SET SOLID - ALL CAPS

A guide

to Type

18 ON 24

Figure 4-15 Multiple line titles and
headlines with various leadings

Figure 4-16 (Center) Display type
with character scale changes

Figure 4-17 (Far Right) Display
type with typeface and letterspacing
changes

Column 2

A GUIDE TO
TYPE

CASLON SEMIBOLD, 18/18 WITH BASELINE
LEADING

A GUIDE TO
TYPE

SIZE CHANGE FOR SECOND LINE: 30/24
CHARACTER SCALE OF 70%

A GUIDE
TO
TYPE

SIZE CHANGE
CHARACTER SCALE OF 120%

A GUIDE TO
TYPE

NEGATIVE LEADING: 18/14, SMALL CAPS
CHARACTER SCALE OF 70%

a guide to
Type

NEGATIVE LEADING, 18/14, LOWER CASE
CHARACTER SCALE OF 120%

A GUIDE TO
TYPE

CHARACTER SCALE OF BOTH:
70% AND 120%

A TYPE
GUIDE

.5 RULE AT THE TOP
AND HAIRLINE RULE AT THE BOTTOM
CHARACTER SCALE OF 120%

A GUIDE TO
TYPE

LOWER CASE SMALL CAPS
CHARACTER SCALE OF 70%

A GUIDE TO
T Y P E

LOWER CASE SMALL CAPS
WITH FORCE JUSTIFIED
CHARACTER SCALE OF 120%

Column 3

a guide to
type

18/18 WITH BASELINE LEADING
AND DECREASED LETTERSPACING

the guide
to type

SIZE CHANGE FOR SECOND LINE: 30/24
WITH DECREASED LETTERSPACING

the
guide
to
type

SIZE CHANGE
WITH INCREASED LETTERSPACING

• the •
guide to type

BULLET WITH DECREASED LETTERSPACING

—the—
guide to type

'M' DASH
WITH INCREASED LETTERSPACING

the guide
and
type

SNELL ROUNDHAND 'AND'
WITH INCREASED LETTERSPACING

THE
Type
GUIDE

30-POINT COCHIN ITALICS
WITH DECREASED LETTERSPACING

THE
T Y P E
GUIDE

30-POINT SMUTZ CLEANED WITH BASELINE
SHIFTS AND INCREASED LETTERSPACING

Medium-weight italics is a resurgent trend from the 1920s. For a highly visible headline, additional contrast can be added using the current trends in negative leading, multiple sizes, and every imaginable typeface (figure 4-18).

Tabular section of display or text

Special spacing and tabs might seem hard to understand and difficult to learn to set, but they are essential to design. (Refer to the instruction manual or additional reference guides to practice tabular techniques in the software package as they apply.)

Use the same leading and before paragraph leading as in the body text for single lines of bullets and numbers. For multiple lines of bullets and numbers, add a small before paragraphs leading (one-fourth the type size) to separate each one.

If there is a small amount of before paragraph leading between each number, it is helpful to separate multiple lines of bulleted text from each other. As in leaderworks, the type specifications leading can be cut back and 3-point before paragraph leading is usually enough to separate these for the reader.

Leader dots need at least 4 to 6 points of leading more than the type size to help the reader stay on the same line (figure 4-19). Use the largest amounts of leading whenever possible for readability. This can be accomplished by using a standard leading for the leader dot specifications and an above leading. These samples show the effects of leading on leader dots.

Single lines—bullets

The purpose of a bullet is to direct the eyes to a group of similar information (figure 4-20). If there is more horizontal spacing between the bullet and the copy than between the lines of copy, the reader might drop down a line. Then, the bullet is both ineffective and distracting. Spacing from the bullets or numbers to the text should be one en or less of space, depending on the size of the type. An attempt to use bullets with a default tab defeats the purpose of a bullet.

Figure 4-19 (Right) Weak and strong sample of leading that helps the reader move across the leader dots

a guide to
type
NEGATIVE LEADING WITH HAIRLINE RULE AT BASELINE

An important Guide
to using TYPE
MIXED SIZES AND STYLES

a guide to
TYPE
NEGATIVE LEADING 18/14, ALL CAPS

a guide to
Type
WIDTH CHANGE: 70% WITH TYPE SIZE CHANGE

A GUIDE TO
TYPE
SHADOW CREATED WITH LAYER OF TYPE SET AT 20% BLACK

Figure 4-18 Display type with current trends

ORDER OF CEREMONY

Invocation . Michael R. Button
Introduction . Donna Frieling
Guest Speaker James Barnett
Closing . Michael Drew
WEAK: 8-POINT TYPE WITH A 10-POINT LEADING

ORDER OF CEREMONY

Invocation . Michael R. Button

Introduction . Donna Frieling

Guest Speaker James Barnett

Closing . Michael Drew
STRONG: 8-POINT TYPE WITH A 14-POINT LEADING

Figure 4-20 Single line bullets draw the reader to the copy when placed closer to the type.

Figure 4-21 Single line numbers

Single lines—numbers

Single digit numbering with a single line of text is straightforward and can be set up similar to bullets (figure 4-21). If numbering goes up to 10, the alignment of the numbers will be inappropriate, because of the double digit.

Follow the steps listed under bullets and numbers with multiple lines of text.

Multiple lines—bullets and numbers

Multiple lines of text will require a marker for the first line and an additional marker for the rest of the copy in the block. Figure 4-22 shows alignment of bullets and numbers in a 10/12 type with a 3-point before leading. The fastest way to draw attention to information is by rewriting a sentence or paragraph and arranging it in bullets or numbers. Copy is easier to follow with the help of bullets and numbers. Paragraphs can be rewritten as bulleted lists and numbered lists in résumés, advertising, and text documents. Using bullets or numbers presents two choices:

1. If the information must be done in a specific order, or a specific number of items has been referenced (as in this numbered list), use numbers.

2. If it is information that can be used in any order, use bullets.

✔ **CHECK: Number tab set-up in the style sheets is available to all files.**

Figure 4-22 Numbers and bullet tabs

Set-up for number tabs

Follow these steps in exact order. If Step 4 is done before Step 3, it erases the tab. Most software will open the tab marker to match the location on the copy when the full page is seen on the screen.

1. Type one line of copy and pull two guidelines. This marks the right side of the bullet and numbers and the left side of the text.

2. Set a hanging indent. Use this technique for all lines following the first line of each bullet or number.

3. Set a left tab at the exact setting of the hanging indent. This matches the first line of the paragraph of copy with the lines that follow the hanging indent.

4. Set a right tab for the bullet or number. This matches the alignment for single, double, and so on, digit numbers for alignment. Be sure to add the tab keystroke to the copy.

5. Save this in the style palette as "body •." Save this in a file with all other styles removed but "Body •." In most software programs, a new document can use this setup by copying the style to the new file. If display type is usually in the same size, create a file for that.

Tab columns

When information is presented in columns, leader dots and 4 to 6 points of extra leading help the reader move from one side of the copy to the other, as in a table of contents. The longer the column, the more important the leader dots.

Some publications that may require leader dots include a table of contents, programs, menus, charts, price list, and telephone books. Because the reader may move down a line without realizing it, leaders and extra leading assist in accurately following the copy. Lists with two or three columns can be difficult to read without leader dots. Those without additional leading are also difficult to read.

New kinds of leader dots (figure 4-23) have emerged as typesetting methods have changed, but all styles are acceptable. The best style is space bar/period because it gives copy with multiple lines of leader dots a light look, avoiding overwhelming the copy (any of the samples can be produced in the page layout software by adding a custom setting when the tab is selected) .

1. Solid dash _____Hot metal
2. Space bar/periodStrike-on
3. Solid periods.Phototypesetting
4. Your choice • • • • • • • •Desktop Publishing

Figure 4-23 Types of leader dots

LEFT TAB	RIGHT TAB WITH LEADERS
	DECIMAL TAB
Electricity	$225.99
Water	9.59
Telephone	60.76

Figure 4-24 Using three kinds of tab markers

Setting custom leaders

To set custom leaders, complete the following three steps:

1. Select the tab.
2. Choose a custom setting.
3. Type space bar + period for the custom setting.

When leading to numbers, the leader dots stop in a straight line. Set the right tab with the leader dot stored in it where the leader dots should end and then a right tab or decimal tab for the numbers (figure 4-24).

Chart titles and headings

Titles and headings are important with complex charts. The title is the name of the chart and the **headings** are the names of the columns.

Chart headings are secondary to the copy itself, so they are set "quietly." (They are not like subheads, which need to be read first.) Type size on headings is smaller than the type used for the leader dots. It is either italics upper and lower for traditional documents, or 6-point type in all caps for others. The heading is centered above the full area for the data below it (figure 4-25).

Sublevels on leader dots

When there are several lines of copy that are part of the left side, forming a sentence, the second line should have an indent of one em space—the point size of the type. If there are paragraphs on the right side of the design, they should also have a second line indent of one em space.

When subcategorizing exists, it should be indented two em spaces and the category should use a semicolon to separate its copy. Leader dots with multiple line copy need standard leading between the lines in the same copy block, and added leading between the next block of copy. For the above paragraph leading, use one-half the type size to lead the reader to lines that belong together.

When the right and the left copy take up two lines, the second line should have an em indent established with a hanging indent that is as many points as the type size (figure 4-26).

CATCH OF THE DAY

FISH	INCHES	COST PER M
Perch . 6		$ 20.00
Catfish 8		15.00
Bass 4		25.00

WITH EXTRA TAB

DESTINATION	MILEAGE
Houston 1.437	
Raleigh . 953½	

WITH FRACTIONS

WIDTH	PICAS
One column ad 11	
Two column ad 23.5	

WITH DECIMALS

Figure 4-25 Special situations with numbers

CLEANING MATERIALS

Alcohol:
 Rubbing alcohol .pharmacy
Ammonia .grocery
Baking soda:
 Baking supply .grocery
Borax .grocery

WEDDING CEREMONY

Prelude
 Jesu, Joy of Man's DesiringJ.S. Bach

The guests are asked to join
 the mother of the bride in standing
 during the entrance of the bride and her father
 Trumpet VoluntaryH. Purcell

Figure 4-26 Second line subcategory

Tint blocks

The more complex the table, the greater the need may be for distinguishing tints or color. A tint block adds contrast to charts for all categories of publications using imagesetter resolutions (figure 4-27).

Tabs only

Leader dots guide the reader from one set of text to another, but there are a few other techniques that also accomplish this. Tabs, for example, work well with programs and tables of contents (figure 4-28).

Leader dots within charts

A complex table may need leader dots and horizontal and vertical hairlines (narrower than a .5-point line) to help split up the table for the reader (figure 4-29). Add horizontal rules to separate groups of information, column titles, or the chart itself. Add vertical lines when the reader needs to get information frequently from one category. (Most software programs will build basic charts.)

> ✗ Cross reference: Assigned specifications are presented at the beginning of Chapter 4, page 86 and figure 4-19.

Summary

The summary for this chapter is presented in a chart (figure 4-30) to create an accessible reference for choosing faces and matching them to the publication. The type samples are the set of good, trusted typefaces shown in the chart. They will help when locating a basic set for setting up a library of typefaces. This chart will make a quick reference for launching into learning typefaces. Use the chart to understand the points to look for in using typefaces for specific publications.

–Weather–

DATE		HIGH	LOW	RAIN
Mon.	4	84	46	
Tues.	5	90	55	
Wed.	6	83	65	
Thurs.	7	84	69	
Fri.	8	72	57	.31
Sat.	9	90	58	
Sun.	10	88	47	.05

.036 for the week
.031 for the month

2.15 for year
Average rainfall in county
for a year: 44 inches

Figure 4-27 Using color tints instead of leader dots

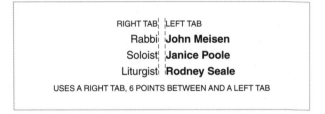

RIGHT TAB | LEFT TAB
Rabbi | **John Meisen**
Soloist | **Janice Poole**
Liturgist | **Rodney Seale**
USES A RIGHT TAB, 6 POINTS BETWEEN AND A LEFT TAB

Figure 4-28 Tab only alignment

CONDENSED FINANCIAL INFORMATION
(for a Share Outstanding Throughout Each Year)

The following information has been audited by Henderson-Carraway, independent accountants, whose report covering the most recent five years is incorporated by reference in Part B, the statement of Additional Information. This information should be read in conjunction with the Company's latest financial statements and notes thereto, which are also incorporated by reference in Part B, the Statement of Additional Information.

	Year Ended December 31				
	1999	1998	1997	1996	1995
Investment income	$.57	$.52	$.50	$.50	$.46
Expenses	.06	.06	.05	.05	.05
Net investment income	.51	.46	.45	.45	.41
Dividends declared from net investments	1.14	.23	2.21	2.99	.28
Distributions declared from net realized gain on investments	(.76)	(.75)	(2.45)	(.49)	(.51)
New increase (decrease in net asset value)	33	(.58)	(.32)	2.51	(.26)
Net asset value:					
Beginning of year	$12.61	$12.61	$13.19	$13.51	$11.00
End of year	$12.94	$12.61	$13.19	$13.51	$11.00
Ratio of expenses to average net assets	.48%	.42%	.41%	.43%	.47%
Ratio of net investment income to average net assets	3.78%	3.14%	3.47%	3.80%	3.98%
Portfolio turnover	16.4%	11.5%	10.8%	17.5%	19.8%
Number of shares outstanding at end of year (in thousands)	318,134	308,834	282,897	227,214	218,774

Note: figures representing per share amounts have been adjusted to reflect the 100% stock dividend effective March 15.

Figure 4-29 A complex chart with dots and hairlines common to annual reports

	Fette Fraktur	Snell Roundhand	Schmutz ICG cleaned	University Roman	Revue	Helvetica Black	Copperplate Gothic	Cooper Black	Aachen	Optima	Helvetica Light	Helvetica Condensed	Helvetica	Times	Officina Serif	Palatino	NC Schoolbook	Caslon	Bookman	Avant Garde
BUSINESS PKG.																				
BODY COPY							■			■	■	■	■	■	■	■	■	■	■	■
COMPANY NAME	■	■	■	■	■	■	■	■	■	■	■	■	■	■	■	■	■	■	■	■
TEXT DOCUMENTS																				
BODY COPY										■			■	■		■	■	■	■	
ANNUAL REPORTS										■	■	■	■	■	■	■	■	■	■	■
BOOK										■			■	■		■	■	■	■	
ADVERTISING PKG.																				
DIRECT MAIL PIECES	■	■	■	■	■	■	■	■	■	■	■	■	■		■	■	■		■	
BUSINESS TO BUSINESS	■	■				■	■			■	■	■	■	■	■	■	■	■	■	■
COMPANY PUBLICATIONS	■	■	■	■	■	■	■		■	■	■	■	■	■	■	■	■	■	■	■
FLYERS /POSTERS-ALL COPY	■	■		■																■
NEWS PUBLICATIONS																				
NEWSLETTERS										■	■	■	■	■		■	■	■		
JOURNALS										■	■	■	■	■		■	■	■	■	
CATALOGS				■		■	■			■	■	■	■		■	■	■		■	
FORMS AND LISTINGS																				
FORMS										■	■	■	■							
DIRECTORIES AND LISTING							■			■	■	■	■			■	■	■		
CHARTS			■	■	■	■	■	■		■	■		■	■		■	■	■	■	■
MEDIA																				
READABLE ON A MONITOR	■	■	■	■	■	■	■	■	■	■	■	■	■	■	■	■	■	■		■
UNIQUE CAPITAL	𝕭	𝒢	A	𝒮	A	G	A	R	Ag	R	G	M	G	Q	F	R	A	Q	Q	G
UNIQUE LOWERCASE	m	y	b	r	a	a	A	f	Ag	f	a	o	a	j	l	t	g	n	r	a
SIZE LOOKS SMALLER THAN NORMAL	■	■		■						■	■				■		■		■	
SIZE LOOKS LARGER THAN NORMAL				■		■	■	■	■				■						■	■

Figure 4-30 Typefaces and their uses in specific documents

For additional research

Keep a well-balanced design approach by continuing research into some suggested sources:

Historical information

The Chicago Manual of Style, Chicago: The University of Chicago Press, 1993.

U.S. Government, *Style Manual,* Washington: United States Government Printing Office, 1986.

Adding accessories will complement, polish, and add dimension.

5 Adding Shades and Colors

Adding shades
Printed color
For additional research

After reading this chapter and applying its principles, the designer should have success:

- Choosing techniques for adding shades that solve design problems.
- Matching the design level to the technique while maintaining image quality.
- Understanding the purposes of color and the budget restraints of each technique.

Ruled lines, boxes, textures, tints, images, and colors are "design accessories" to a page, like accessories are to a room. They are techniques that add shades and color to the design foundation and solve design problems. When available in desktop publishing software, these techniques provide a convenience that may be distracting to the purpose of the design. This chapter clarifies why to use the techniques and what design level maintains image quality for a specific level of design.

✘ Cross reference: These techniques are included in quality reference charts, figures 7-2 through 7-10.

Shades and colors solve design problems that cannot be solved with changes in type specifications or by adding white space. The purpose of *any* of these techniques is to group and separate, add contrast, focus, and dimension, reinforce the grid pattern, help create an eye pattern, and indicate quality.

Often, a poor choice of technique is not identified until *after* the job is finished. Without the foresight to ensure image quality, a professional job can take an amateur look. So, be cautious before trying too many techniques on one page. The result of too many techniques is often overcrowding and clutter (refer to figure 2-9).

The research stage of shades and colors begins with a visual evaluation to identify their purposes. Because the choices are overwhelming, examine research samples separately by the uses of shades and colors. First, visualize the design without the shading. Then, in order to critique the design, ask these questions:

1. What is the **basic color** in the design?
 …Are there shades of that color?
 …What is their purpose?

2. Are there **additional colors?**
 …Why were they added?
 …Are there shades?

3. Did the **paper color** help the page?

4. What kinds of **color techniques** were used?
 …Were they cost effective?
 …Could a different color technique have been as effective but less expensive?

5. How well did the **shading or images** reproduce?
 …What is the quality level of the dot size?
 …Did the techniques match the printing process?

Adding shades

Software tools exist for creating shades for all levels of design, even with one color of ink. If those available do not solve a design problem, a second ink color may be needed to add contrast or dimension.

Some techniques are commonly used for specific categories of publications and can become a first choice when designing:

- Ruled lines in business communication, text documents, and forms
- Reverses and boxes in classified advertising
- Boxes in news publication

Boxes, tints, or textures can help organize a design. A single box, tint, or texture helps to add contrast and focus, or to separate text. Grouping is effective in matching any of these measurements: copy placement, length, height, or alignment. Multiple boxes, tints, or textures help group unequal page elements. Tints and texture work best when they are not boxed in with a line.

Many of the figures in this chapter appear with the same copy as in figure 5-1. Only two sets of fonts, weight, and size are used. By limiting options, a stronger reference point to the impact of these techniques is presented. Even with the same type specifications, the type appears different depending on its color and the color surrounding it. Consider figures 5-1 and 5-2 as research when applying the techniques to any design. Additionally, do not limit

Wanted
New Designers
You may fit into this new and exciting field with abilities such as...

- Creative Thinking
- Mechanical Curiosity
- Work Well with People
- Open to New Ideas
- Command of English
- Handle Tight Deadlines

HANNAH AND HARRISON
Phone: 700/337-1260
Fax: 700/337-5961
e-mail: hannah@adv.com

Figure 5-1 Basic design. The correct type specification but a flat-looking page without shades of gray.

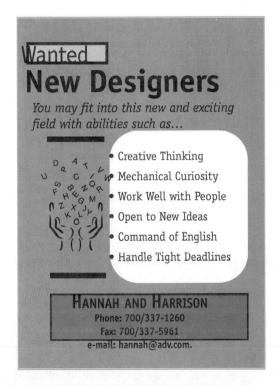

Figure 5-2 Cluttered design. A page with too much shading and color has a cluttered, confusing effect and added expense to run the tight register. *Credit: Brian Campbell, graphic artist—artwork*

their application to projects requiring two colors of ink. Good designs carry as well in one or two colors (especially with tints) as they do in a four-color process.

Each of the designs (figures 5-3 and 5-4) will work within all levels by using a simple technique. Information included with each design refers to design levels and visually shows what prints with each process. Match the output device to the level of design. Both are usable copy, but the techniques change. Limitations to the level of design are included in each technique.

Ruled lines

Adding ruled lines is a fast way to add contrast. Ruled lines work for all output devices and printing techniques. Ruled lines can be repositioned and the thickness and width of lines varied to accommodate the typeface and the design. (Be aware that ruled lines are not the same as the underline.)

Use as many of one rule as needed, unless the pages appears "patchy." Too many *different* kinds and thickness of ruled lines will always clutter a page. As a guideline, use no more than three kinds or thicknesses of ruled lines in one publication. Be cautious when designing with hairlines and printing to an imagesetter. True hairlines may present a thinner line than expected.

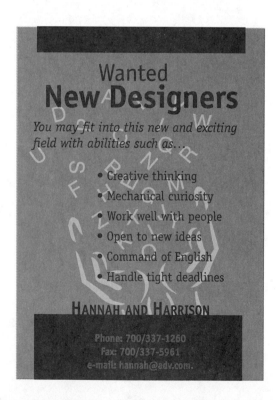

Figure 5-3 Standard level design. Correct type specifications complemented by original line art, plus reverses. *Credit: Brian Campbell, graphic artist—artwork*

Figure 5-4 Custom level design. This requires a medium-size press to guarantee quality of tints. Bleed requires printing on larger paper than final cut size. Shows one color ink with tints. *Credit: Brian Campbell, graphic artist—artwork*

Positioning ruled lines

A few desktop programs build ruled lines into style names. Without a built-in line, positioning is not repeatable and the line must be repositioned with each use.

The position of the ruled line is measured using the baseline as a starting point for both above and below lines (figure 5-5). Also, changes can be made to the thickness of the ruled lines. Whether building ruled lines into a style name or manually adding ruled lines, use the following measurements to help position them.

FOR BODY TEXT. Set the bottom rule at 2 to 4 points below it. Set the top rule the same size as the body text.

FOR DISPLAY TYPE. Use 20% of the type size for the bottom rule and the type size for the top rule.

Line thickness

A traditional approach to changing line thickness is to match the line thickness to the line thickness of the type or use a one-half- or 1-point rule. Double lines work well with serif faces because they have thick and thin lines. Dashes and dots work well with sans serif display faces or a face with a bold, playful look. Hairlines will accurately print as very fine line on high resolution imagesetters, but will print an inconsistent thickness to different laser resolutions.

INTERACTION, INC

*The most important job you have
is the one you do today.*

Figure 5-5 Ruled lines placed: above the baseline at 24 and 8 pts respectively (the type size), and below the baseline at 5 and 2 pts respectively (20% of the type size).

Designing with ruled lines

Ruled lines print well to all output devices and printing processes (figure 5-6). Ruled lines can be both traditional or trendy (figure 5-7). Here are some problems and solutions using lines:

- Group and separate. Use 1″ longcentered hairlines.
- Add contrast. Use a line below, with the line breaking around lower case descenders (draw manually in page design or drawing packages).
- Add focus. Use lines on each side of a title.
- Add dimension. Use above and below the second line of display type or a signature.

- Reinforce the grid pattern. Use lines the length of one or more grids, symmetrically and asymmetrically placed.
- Help an eye pattern. Use a line from the left margin to indented body text.
- Indicate quality. Use a dotted line or tinted block above a subhead.

Boxes

Boxes enclose and define a space. One box can add contrast to a headline (when, because of the space available, this cannot be accomplished by making it any larger or bolder). Boxes can also be used to

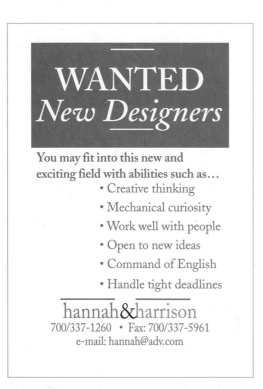

Figure 5-6 Ruled lines, presented in one color work well for all output and printing processes.

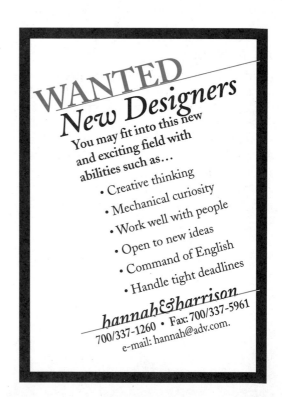

Figure 5-7 A non-traditional design and a traditional typeface. Lines help draw attention to the headline and the company name. Copy and lines set at a 14° angle and tint is 40%. Two colors without tight register, but difficult vertical bleed for small press.

help the shape of a block of type match the shape of the page.

Boxes that match the page help organize the copy. When adding a box to display type, leave an en space between the type and box; when adding a box to text type, indent the copy one pica both left and right. A page full of boxed copy, such as an organization chart, may be easier to produce in a drawing package if the desktop publishing package does not group and center the type in the boxes.

Designing with boxes

Boxes output to any device and printing process. To strengthen a design with boxes (figures 5-8 and 5-9), consider the following solutions:

- Group and separate. Use a hairline box to separate different sets of body text.
- Add contrast. Use a wide line on a box to contrast a page element.
- Add focus. Use a placed box and type at a 15° or 45° angle.
- Add dimension. Use an additional box without a fill and with a white line one pica inside a tinted box or photo.
- Reinforce the grid pattern. Use a box around the body text or drawing on the grid.
- Help an eye pattern. Use an additional box around the type element at the bottom line of the page.
- Indicate quality. Use a double line box at the page margin to complement formal centered copy.

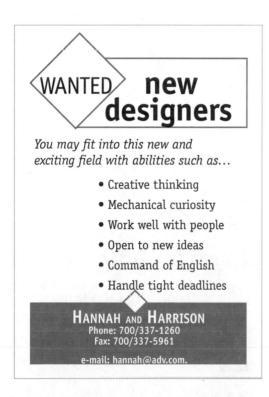

Figure 5-8 A box used for a reverse and another turned at 90° to form the diamond to thread the headline and signature. This can print as spot color with laser original to a small press.

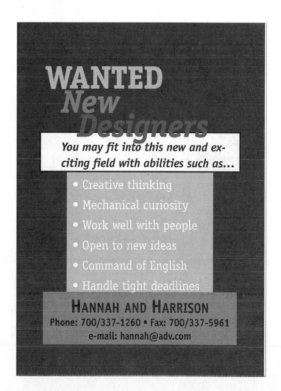

Figure 5-9 Box for headline and signature are linked by body text box. Tints are 40% and 60%, although this design would work without the tints. Large black background requires medium-size press.

Textures

Textures are the most overlooked technique for adding a shade to a one-color standard level design. Textures give dimension to basic designs just as tints give dimension to custom and premium designs. Textures can be used as a layer under line art, as display type, and as a border on a page as shown in the illustrations for this chapter. To keep type readable when layered over a texture, use an extra-bold weight of type or place a white box between the texture and the type.

When working with textures, recognize that they are built *behind* the page. The technique is similar to cutting a hole in the page and letting the texture in that particular spot show through. If alignment of a texture is critical, the texture should be manually drawn in the drawing package.

Designing with textures

Textures substitute for tints where a laser original is used to print additional copies creating shades and layers (figures 5-10 and 11). Texture can be added under text as a solution to the following:

- Group and separate. Use a drawn rectangle filled with a texture 1-2 picas wide or use like a border.
- Add contrast. Use several texture fills to add contrast to a cover.
- Add focus. Use as a box over extra-bold type.
- Add dimension. Use with a white circle or square to create a one-time logo look.

Figure 5-10 Line art with text. A texture under line art that fits a column of the grid adds contrast to the art and reinforces the grid pattern. Works for on-demand copiers and from a laser original to copier and small presses.

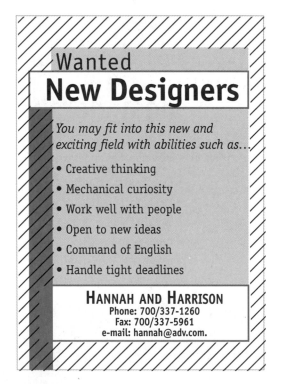

Figure 5-11 The texture groups the mix of solid blocks and tints. This is an imagesetter-to-small press or greater job. No tight register because the body text is overprinted.

- Reinforce the grid pattern. Use a filled box behind part of the art to help direct the eyes toward the text.

- Help an eye pattern. Use a texture with a white box over it to fill a large space with a small amount of body copy when the type size should not be increased.

- Indicate quality. Use a personalized texture made from a pattern of art, type, or a company logo tinted on a tint in the background.

Reverses

Reverses are used to create a heavier look for type without changing the type itself. Reverses are similar to boxes because of the effect of containing an area, but a reverse adds more intensity than a box does.

Many classified ads and flyers use reverses because they print well on both newsprint and bright colored paper. Reverses are also helpful on the custom design level when using one color of ink on a colored paper, giving the effect of an additional ink color.

When using reverses, be aware of factors that affect image quality. To make the type legible, use a clean sans serif typeface in bold or serif bold (avoid those with thin stroke lines) in sizes above 7 points. A reversed is called a "knockout" when the color of the type is set reversed or white and is placed on a box set from 40% (60% for imagesetters) to black. Use lines "none" to keep the size of the box true to measurement.

> ✘ Cross reference: Check the quality information in Chapter 7 for sizes of color blocks that will print to each process.

Designing with reverses

Check the maximum size of the reverse with a test to output devices and printing processes (figures 5-12 and 5-13). Here are the problems and solutions that can be solved with a reverse:

- Group and separate. Use a reverse at the bottom or top of a page to set off a headline or signature.

Wanted
New Designers

You may fit into this new and exciting field with abilities such as...

- Creative thinking
- Mechanical curiosity
- Work well with people
- Open to new ideas
- Command of English
- Handle tight deadlines

HANNAH AND HARRISON
Phone: 700/337-1260
· Fax: 700/337-5961
e-mail: hannah@adv.com.

Figure 5-12 Reverse and boxes. Shows the use of boxes and reverse box that prints well to small presses and on-demand color copiers as a standard level design. Overprinting could be done from two laser originals because there is no tight register.

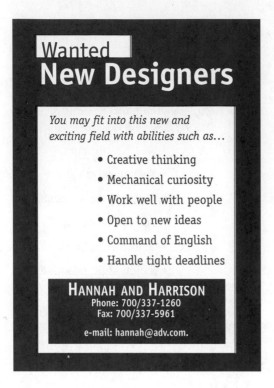

Figure 5-13 Reverse. Using both reverse and white boxes in alternate layers gives this one-color design the look of multiple colors. Without an outside box, it could be used on all processes.

- Add contrast. Use a reverse with display type to add the maximum contrast to a block of type.

- Add focus. Use white type above a black box for important body text information.

- Add dimension. Use white lines, rules, and boxes over display or body text.

- Reinforce the grid pattern. Use boxes shaped to match the grid pattern or multiples of it.

- Help an eye pattern. Use a black box under a series of ruled boxes to bring them together.

- Indicate quality. Use reverses with a double line to give a formal look to the copy.

Tints

Tints add a smooth tone to a design. A tint is made up of dots and gives a page a layered or two-dimensional look. Tinting gives the appearance of a second color by allowing the color of the paper to mix with the color of ink, which appears as another color. Type, textures, lines, and boxes produced in a page layout program can be tinted. Additionally, line art can be tinted in the drawing package and the page layout software will recognize the tint.

When using multiple tints, keep a 20% difference for contrast (20% and 40% or 30% and 50%, for example). Using tints in one color of ink is often as effective as adding an additional ink color.

When adding tints, be aware of the cost factors. Black ink on muted and fiber-looking paper also gives the look of a second color without additional cost.

Tints cannot be reproduced accurately from a laser original (hard copy). Files with tints sent directly to a copier, plate, or film negative maintain the image quality on the tints. Tints will print in coarser, low quality dots with laser copiers. Tints will change in appearance if created in a drawing package and given a size change in page layout.

> ✘ Cross reference: Determine the quality of the specific output by following the test original in Chapter 7.

Tinting boxes, lines, and textures

Although boxes are the most common object to tint, lines and textures can also be tinted to create a lighter dimension to the page. When type is over-

printed or reversed on a tint, it must be legible and fit within the cost of the document. Samples of type on a tint appear on Colorplates C-1 through C-9.

- White letters (reverse or knockout). Use on a tint 40% (60% for imagesetters) or greater.
- Black type (overprinting). Use on a tint 40% or less of the second color.
- Solid letter of the second color. Use on a tint 40% or less of the second color.

Tinting letter characters

Changing lines or words of type to a percent of an ink color complements solid lines or words of type. This provides more flexibility in type size when a portion of the type is tinted; since tinted type lowers the contrast of the type, the type size can be increased. Solid letters can be overprinted or reversed

on the tinted type or on a tinted box (figures 5-14 and 5-15).

- Tinted type by itself must be 40% or darker in black ink. With other colors of ink, the lighter the color of an ink, the darker the percent needs to be for the image to be readable.
- Tinted letters 40% or less. Use on a tint 60% or greater (be sure there is a 20% difference between both).
- Type in a color of ink (overprinting). Use on a tint 40% or less of the black or any other color.
- Solid letter of a color. Use on a tint 40% or less of another color.
- Tinted letters of a color. Use on a tint 40% or less; on a tint of another color, use a tint 40% or greater (be sure there is a 20% difference between both).

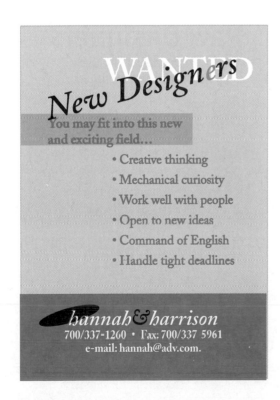

Figure 5-14 Boxes and reverse box that prints well to small presses and copiers as a standard level design

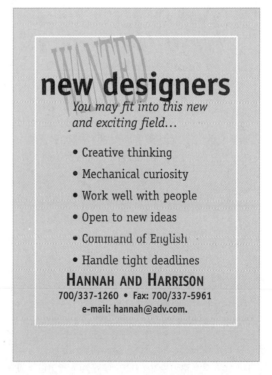

Figure 5-15 Tints. This combination of type distortion, with a 14° slant quieted down some with a 40% tint of "Wanted." This requires a medium-size press because of background ink coverage, but it is just overprinting of black so it does not need traps.

Tinting line art

Tinting works best with line art that is a silhouette or has few details.

Designing with tints

Check the quality and appearance of the tint with a test to specific output devices and printing processes. For example, a 20% tint will appear much lighter and smoother to imagesetter in comparison to laser printer. Box, ruled lines, art, type, and photos can be tinted and layered (figures 5-16 and 5-17). Here are problems and solutions associated with tints:

- Group and separate. Use line boxes or tint boxes to separate display type or special body text.

- Add contrast. Use tint to tone down artwork that takes over a page or is a bad piece of artwork.

- Add focus. Use tint of display type up to 40% when using 72-point or larger type.

- Add dimension. Use layers of tint boxes, textures, or line art below the layer of type.

- Reinforce the grid pattern. Use tint boxes that follow multiple columns of grid patterns with type, photos, or line art.

- Help an eye pattern. Use tint boxes in areas that reinforce the eye pattern.

- Indicate quality. Use a combination of any of the above techniques to create tint boxes under tinted lines, art, type, and so on, in order to give the appearance of a second color of ink without the expense.

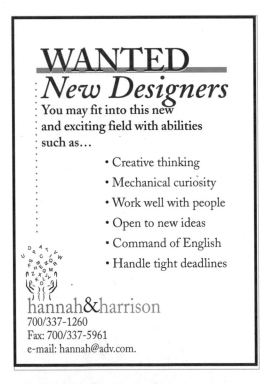

Figure 5-16 Tinted line and type. The line at the headline and the company name would require tight register with printing to small press and up. *Credit: Brian Campbell, graphic artist—artwork*

Figure 5-17 Tinting line box with art. Shows the use of boxes around the art to help it group with the other boxes. Prints well to small presses and copiers as a standard level design.

Line art

In the last fifty years, line art has changed both its look and its process. Look at a dollar bill to see the line art of yesterday. Before photography, line drawings were used for pictures, art, and logos. Today, the misuse of line art can damage an expensive publication rather than help it. For example, jagged edged drawings and cute cartoon art are inappropriate for professional publications. Too many pieces of art placed all over the page contribute to the bad reputation of line art. There are, however, two professional situations requiring line art:

1. When a general piece of art can help relay the message.

2. When the client wants a specific drawing, such as a Siamese cat eating their brand of cat food, on the specification sheet.

For advertising, line art is an effective focal point because it draws attention to a particular subject (figure 5-18). For business communications packages, line art can serve as a logo for a small start-up company (figure 5-19) or as standard level designs. For text and news publications, line art breaks up the text or sets a theme throughout the piece.

Purchasing line art

Some line art is free while some can cost up to $100 per disk. When establishing a library of line art, sort subjects according to market, avoid dated materials, and be sure that the file format allows for modification. The best buy is line art that can be colorized, converted to color, or modified. This allows layers that do not fit the subject to be revised or removed.

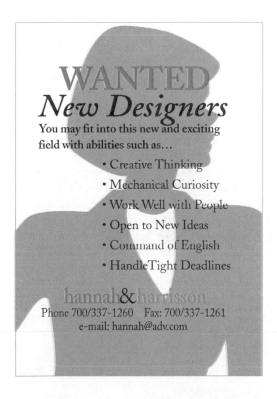

Figure 5-18 Art design with scale. The art was opened in the drawing package, turned into an outline, and tinted.

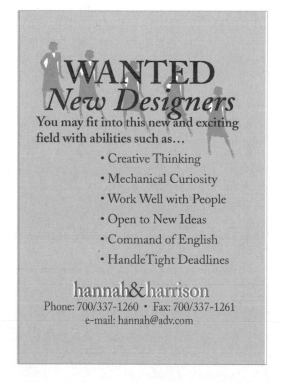

Figure 5-19 Line art as a pattern. Shows line art and tints support the eye pattern and give depth . *Credit: Brian Campbell, graphic artist—artwork*

Additions to the drawing or fills create an opaque layer to color or to tint. Quality art which can be revised is the most useful. Also, once revised, it can be used in various projects without being recognized.

Scanning and redrawing line art

Line art requiring placement in a computer package must be scanned or drawn if it does not exist as a computer file.

Line art can be successfully scanned if it is placed as the same size and if the size of the file is not an issue. A scanned image, or a **raster file**, is covered in black and white dots similar to the dots on a photograph. When scanned art is enlarged, the dots give a coarse effect (jagged edges). Because the scan records the image and the white spaces, scanned images occupy a large file.

Redrawing in a vector-based package like Adobe® Streamline, CorelDraw, Adobe® Illustrator, or Macromedia® FreeHand produces an image with information about each point and curve. If the drawing will be reused, is part of a line art library, or will be revised, the time spent on automatic redrawing or manual redrawing is beneficial.

Placing line art

Line art is either linked to the page or all the information about the image is stored in the page.

> ✗ Cross reference: Many important quality maintenance issues for placing and managing line art are covered in Chapter 7.

Designing with line art

Line art outputs to any device and printing process. Following are uses of line art for various design problems:

- Group and separate. Use with white boxes printed on top of it for type or images.
- Add contrast. Use tinted line art to lighten.
- Add focus. Use at a large scale, covering at least one-quarter of the page.
- Add dimension. Try overprinting on line art for advertising and business packages.

- Reinforce the grid pattern. Layer art above a texture, box, or solid that fits the grid.
- Help an eye pattern. Use a series of the same line art scaled to 1″ or less and place them in a line as a border, as a texture behind the whole page, or as a pattern moving with the eye pattern.
- Indicate quality. Bleed images off the edge of the sheet.

Photographs

Photographs can be placed into two groups: **Continuous shade or tone** (traditional photographs from traditional cameras, having hundreds of shades of gray or color), and **halftone or process** (photographs that have been converted to a monitor or printable image). To print a photograph, it must be converted by scanner from a continuous tone photo to a halftone.

To scan a photo, scale and set the number of dots per line inch to match the printing process. Once it is scanned, the number of dots per inch is fixed. If the photo or line art is enlarged, the detail will be lost. However, if the photo is scanned for the maximum dots per inch (dpi) screen that can be used, it will print well to a lesser screen, but the size of the file will be unmanageable. A better solution is to include the photo size to page percentage in the scanning. Photos that are scanned as black and white photographs are used for one color of ink (Colorplate C-7) or four-color process (Colorplate C-13). Color can be corrected and additional effects can be added to these scans with photo manipulation software.

Opening the page layout software and placing a scanned photo or art in it may not produce the same quality image as on the screen. To handle photographs professionally, seek additional training with the photo manipulation software and kinds of input and output systems used.

Sources of photos

Purchase quality photographs individually from stock photo services, stock CDs by subject matter, or royalty-free stock photos. Additionally, customized

photos can be created from photo scans, prints, or slides sent to a service bureau that specializes in scanning and producing. CDs and digital cameras record images ready for the computer. Photo color can be corrected and edited in photo manipulation software. For high-end photos, use the professional scans to a CD. Except for monitor viewing and nesting of photos, avoid low-end scans.

✘ Cross reference: See Chapter 7 for quality issue with photographs.

Designing with photos

Check with the printing company to match the correct line screen with the printing process. Photos are included in publications to show detail (Colorplate C-13 through C-15) or to create an effect (Colorplate C-16 through C-24). This is accomplished by using the following techniques:

- Group and separate. Use sections of a tinted photo like a tint block under page headings to tie a booklet together (Colorplate C-13).

- Add contrast. Use as a background layer with type overprinting (Colorplate C-24).

- Add focus. Use a heavy border around a photo (Colorplate C-10).

- Add dimension. Use a ghost of a photo in the background as a layer with the detailed photo (Colorplate C-21).

- Reinforce the grid pattern. Use a photo size that matches the grid(s) (Colorplate C-11).

- Help an eye pattern. Use photos placed in line with the eye pattern (Colorplate C-13).

- Indicate quality. Use mixed photo techniques and combine photos (Colorplate C-10).

Cropping

If only part of an original photo is used, it is cropped. Cropping, while scanning, will eliminate a large file size containing unused file information and keep the page layout file "clean and lean."

To identify the best area of a photo, make two L-shaped tools about the width of a ruler out of poster board. View the possible image areas with

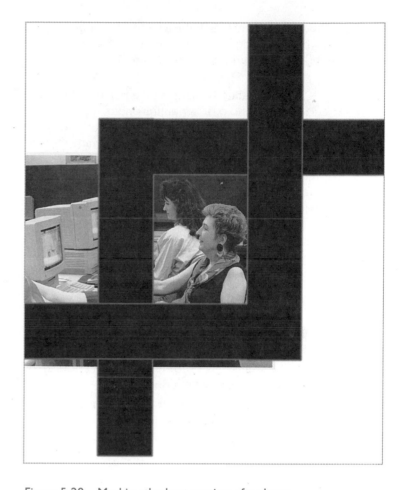

Figure 5-20 Marking the best section of a photo with cropping tools

the tools. Lightly mark the area to be cropped on the white border of the photo or mount the photo on a board and mark the board (figure 5-20).

SCALING. Scaling is changing the percent of original size of the photo. If an entire photo or a cropped section requires a larger or smaller image, scale it by a percentage of the original size. Determine the size and cropping for an accurate reduction size for scanning. The desired area can only be reduced or enlarged proportionally (a rectangular shape cannot become a square). Follow these steps:

1. Draw the *shape* of the area of the photo to be used.

2. Draw a *diagonal line* from the bottom left corner to the upper right corner and then measure it. X = the *length* of the diagonal of the original and Y = the *diagonal size* of the space available on the rough.

3. Use the calculator to divide the original size of the diagonal by the printed size.

4. Use this percentage in the scanning software when the photo is scanned.

5. Include the *dpi* setting to match the line screen required by the printing process. When scanning, be sure to set the scanner for an output resolution that is double the line screen size, not the dpi.

 1254 dpi = 85 line screen

 2400 dpi = 133 line screen

Working with a photographer

If the designer is responsible for a photo shoot, he/she must hire the photographer and attend the shoot. For a successful shoot, refer to the following suggestions:

- Carefully interview the photographer. Examine portfolios, models, charges, ownership of originals, rights to reprint, cost of additional prints, and photo CDs.

- Keep a file of names of employees or friends who could be used as models.

- Storyboard the shots in a practical order. Save time by sketching each shot to identify small details. Gather home props.

- Borrow from local stores, both antique or traditional. Build their trust by returning everything promptly and in top condition.

- Keep an emergency kit handy. Some items are straight pins, duct and adhesive tape, lint brushes, hair pins, brushes, and hair spray.

- Use a professional photographer. Quality saves money. Also, use the best equipment and brand name film whenever possible.

- Convert to CD files. Photos stored on a CD save photo shoots for future uses.

A Closeness
And Trust
Children Need
To Feel

.

.

PEARSALL PEDIATRIC
Gurney F. Pearsall, M.D., P.A.
Peggy P.H. Kan, M.D.

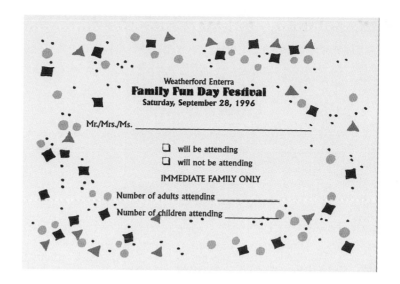

Weatherford Enterra
Family Fun Day Festival
Saturday, September 28, 1996

Mr./Mrs./Ms. _____

❏ will be attending
❏ will not be attending

IMMEDIATE FAMILY ONLY

Number of adults attending _____

Number of children attending _____

C-1 (Above) One color of ink with tints.
Credit: Vosburg de Seretti, inc., designers

C-2 (Left) Two spot colors with tight register.
Credit: Vosburg de Seretti, inc., designers

C-3 (Below left) Color on
color. *Credit: Vosburg de Seretti,
inc., designers*

C-4 (Right) Two colors of ink
with tints and traps. *Credit:
Vosburg de Seretti, inc., designers*

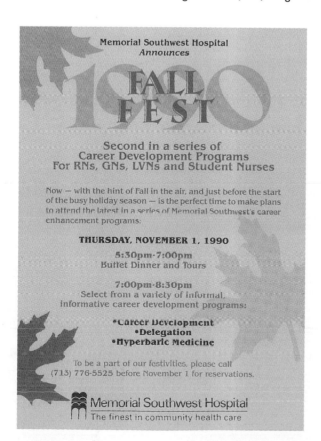

Memorial Southwest Hospital
Announces

1990

FALL
FEST

Second in a series of
Career Development Programs
For RNs, GNs, LVNs and Student Nurses

Now — with the hint of Fall in the air, and just before the start
of the busy holiday season — is the perfect time to make plans
to attend the latest in a series of Memorial Southwest's career
enhancement programs:

THURSDAY, NOVEMBER 1, 1990

5:30pm-7:00pm
Buffet Dinner and Tours

7:00pm-8:30pm
Select from a variety of informal,
informative career development programs:

•Career Development
•Delegation
•Hyperbaric Medicine

To be a part of our festivities, please call
(713) 776-5525 before November 1 for reservations.

Memorial Southwest Hospital
The finest in community health care

THIRD ANNUAL GULF COAST

FLY-IN
FESTIVAL
NOVEMBER 18, 1995
ADMISSION FREE • PARKING $3.00 PER CAR

C-5 (Left) Two spot colors overprinted on white paper. *Credit: Vosburg de Seretti, inc., designers*

C-6 (Below left) Two spot colors overprinted on yellow paper. *Credit: Vosburg de Seretti, inc., designers*

C-7 (Below) Two colors of ink with blue and gray duotones. *Credit: Vosburg de Seretti, inc., designers*

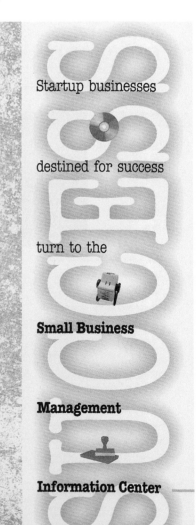

PLACEMENT SERVICES

With an extensive candidate base, we can provide personnel in a number of disciplines including accounting, financial services, information processing, legal, marketing, mortgage banking, office support, plus engineering and technical services. Our experienced staff is dedicated and committed to providing only the best available candidates for your staffing requirements.

In depth interviews of candidates, background and performance evaluations, plus skills testing, when applicable, are just a few of the methods used to assure you of an ideal match to job specifications.

OUTPLACEMENT

When businesses downsize, we provide a valuable service that helps you maintain a good reputation for being a conscientious and caring employer. Our Outplacement workshops assist employees in understanding and adapting to changes in the job market. We prepare them for career and job search planning, and also offer a resume service to showcase their skills, experience, and education.

We serve companies of all sizes, including small emerging growth companies to Fortune 500 firms, with a commitment to provide client satisfaction. Our team provides our clients with the personalized attention they need in order to make the right choices in hiring for all positions.

CLIENT SATISFACTION

BRADY PERSONNEL SERVICES, INC.

LET'S RODEO!

SADDLE UP FOR METHODIST'S STUDENT NURSE ROUNDUP!

Pull on your boots and dust off your hat for the biggest event this side of the Rodeo. Gather 'round the chuckwagon for great food, somethin' cool to wet your whistle, special prizes, a riproarin' video and gifts for all. Our guest speaker, Melodie Chenevert, MN, RN, will entertain and enlighten you about the profession of nursing. And our experienced Nurse Managers will talk to you about the all-star career you can have by joinin' up with Methodist, the top medical outfit in the Southwest. Join the Big Roundup! We only sign on the very best hands, so put your name in the hat now!

STUDENT NURSE ROUNDUP
Thursday, February 18, 1993
Marriott Medical Center Hotel
Grand Ballroom
Registration 4:00 p.m.-4:30 p.m.
Dinner, Program & Prizes 4:30 p.m.-7:30 p.m.
RSVP (713) 790-2186
Western Attire

Methodist

The Methodist Hospital System
Houston, Texas

C-8 (Above) Three colors of ink, blending colors.
Credit: Vosburg de Seretti, inc., designers

C-9 (Left) Three colors of ink, opaque white plus two. *Credit: Vosburg de Seretti, inc., designers*

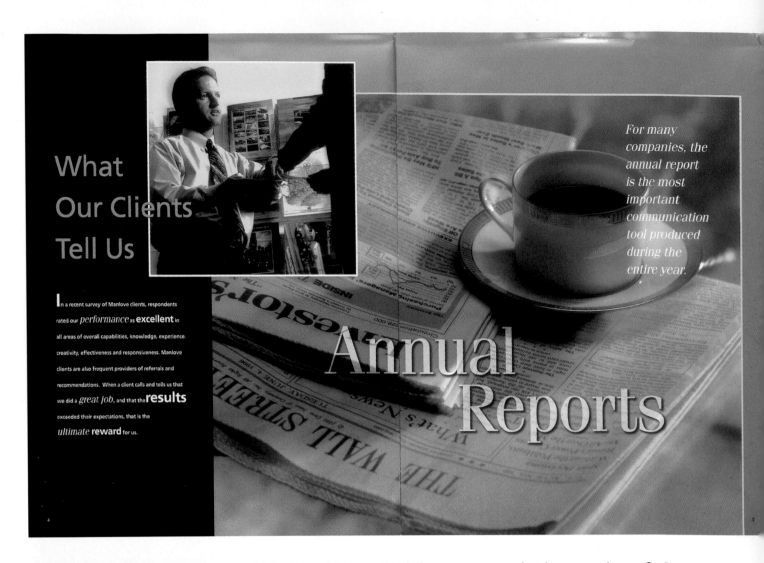

What Our Clients Tell Us

In a recent survey of Manlove clients, respondents rated our *performance* as **excellent** in all areas of overall capabilities, knowledge, experience, creativity, effectiveness and responsiveness. Manlove clients are also frequent providers of referrals and recommendations. When a client calls and tells us that we did a *great job*, and that the **results** exceeded their expectations, that is the *ultimate* **reward** for us.

For many companies, the annual report is the most important communication tool produced during the entire year.

Annual Reports

C-10 (Above) Blue and black duotone contrasted with process photos. *Credit: Manlove Advertising, Pasadena, TX, design and production*

C-11 (Opposite, top) Black and black duotone with one spot color. *Credit: Creative Art Director: Jennifer Woeste, University of Houston Small Business Development Center, Graphic Designer: David Leiper, Leiper Design, Photographer: Fred Carr, Photograper, Houston, TX, Printer: Jimmy Seiford, the Beasley Company*

C-12 (Left) Blue-green and black duotone from photo. *Credit: Credit: Manlove Advertising, Pasadena, TX, design and production*

C-13 (Opposite, bottom left) Four-color process plus one spot color. *Credit: Western National Life Insurance Co. Randi Stephens and Jennifer Junemann, designers/production*

C-14 (Oppostite, bottom right) Four-color process with multiple photo manipulations. *Credit: Manlove Advertising, Pasadena, TX, design and production*

Dear Friends,

It is a pleasure to send my best wishes and to congratulate you on 10 years of outstanding service.

The success of small business fuels our economy. Small businesses create many of the jobs in Texas, introduce new products and services, and fill niches in local and international markets. This strong entrepreneurial spirit also has made Texas a leader in developing new technologies. Small businesses have played an important role in putting Texas at the forefront of technological developments in aerospace, energy, medicine, and computing.

Through its philosophy of partnership, the University of Houston Small Business Development Center has united universities, community colleges, cities, chambers of commerce, civic groups, and large corporations in a single mission: To help small businesses grow and prosper. Thanks to this collaboration, valuable business consulting and training has reached more than 82,000 small business owners and employees since 1984.

The University of Houston Small Business Development Center provides practical knowledge and expertise to help entrepreneurs meet the challenges of running a small business, while allowing them to concentrate on growth and success.

Congratulations to the people of the University of Houston Small Business Development Center who create a positive impact on our state. I wish you the best of luck for success in the future.

George W. Bush
Governor
State of Texas

The University of Houston Small Business Development Center delivers technical and management assistance to help business start, grow, and prosper. UH SBDC supports all businesses with consulting and training and specialized services in the areas of government contracting, international trade, product development, technology transfer, and manufacturing assistance. Through these efforts, UH SBDC continues to make a significant and positive impact on the economy. Highlights of 1993-1994 include the following:

•) Created the Institute for Enterprise Excellence as the umbrella organization managing the University of Houston Small Business Development Center, International Trade Center, Texas Information Procurement Service, Texas Manufacturing Assistance Center-Gulf Coast, Training Center, and Texas Product Development Center.

•) A 1994 independent study found that UH SBDC clients generated more than $128 million in new sales and more than 1,700 new jobs after receiving SBDC assistance from 1992 to 1993.

•) Consulted with more than 6,700 small business owners and provided training for 11,000 seminar participants.

•) Provided more than 42,000 hours of consulting and nearly 49,000 hours of training.

•) Selected as a team member of the Texas Manufacturing Assistance Center network, a partnership dedicated to improving the competitive position of Texas' 20,000 small manufacturers.

•) Assisted eight Texas Product Development Center clients in receiving a total of $640,000 in Small Business Innovative Research awards. These awards help small businesses fund innovative research and development of leading technologies.

•) Enhanced existing and added new bilingual and minority programs through community sponsorships. The Hispanic Entrepreneur Training Series, underwritten by Southwestern Bell Telephone, conducts business seminars in Spanish. Minorities in Northeast Houston turn to the new Training Seminars for Entrepreneurs, a program in partnership with Texas Commerce Bank. Historically underserved Third Ward residents now seek business consulting at UH SBDC's satellite locations at Texas Commerce Bank's Riverside Branch.

•) Co-sponsored international trade missions to Columbia and Peru resulting in significant sales and ongoing negotiations for Houston-based companies.

UNIVERSITY OF HOUSTON
SMALL BUSINESS DEVELOPMENT CENTER
client history

85 86 87 88 89 90 91 92 93 94 *Fiscal Year*

•) Added a 13-unit computer training laboratory to teach business applications for managing a business more effectively and operating more efficiently.

•) Completed 445 TAP/*Texas* computer on-line information search projects. More than 400 entrepreneurs received database information in areas such as patents, market research, and specific technologies. High client satisfaction has generated an increasing demand for TAP/*Texas* services.

•) Upgraded the Computer Learning Centers at nine SBDC offices with new IBM hardware (Value Point 486 computers) and Lotus software (SmartSuite for Windows) to provide basic training through tutorials and one-on-one assistance. These computer work stations resulted from a long-standing partnership of the Association of Small Business Development Centers with IBM Corp. and Lotus Development Corp.

•) Assisted clients throughout the region to

(highlights continued)

EXCARGO SERVICES

client profile

Even before boxes were unpacked and furniture had been delivered for UH SBDC's first office, Marcia Faschingbauer arrived at the door looking for help.

"The consultant stopped unpacking office supplies and sat down on the floor with me for three hours to talk about my business. My transportation company was rapidly growing, but cash flow problems were straining the company's overall success. The consultant's expertise and assistance helped me determine good solutions for my business," Marcia Faschingbauer, Excargo Services president, said.

Excargo Services provides intermodal trucking and warehouse services for international shippers, manufacturers, and distributors. The company transports ocean containers between ports and warehouses and also transports cargo via piggyback trailers between Houston-area rail terminals and industries.

Entrepreneurship runs in Faschingbauer's family. While working at her family's food packaging business, she discovered a need for quality intermodal trucking services for small to mid-size companies.

Faschingbauer focuses her business goals around offering the services she found lacking as a customer. She seeks to provide excellent customer service and on-time deliveries, with courteous, professional drivers. Her strategy has taken the company from two employees in 1979 to 30 employees today and annual gross sales of $2 million.

From 1984 to 1989, Faschingbauer relied on UH SBDC for assistance when working out concerns for obtaining loans, installing computers, and managing financial issues. "Great coaching from UH SBDC consultants helped me tackle the various phases of building a growing and successful business," Faschingbauer said.

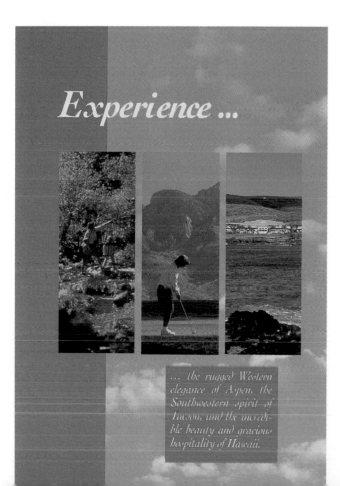

Experience ...

... the rugged Western elegance of Aspen, the Southwestern spirit of Tucson, and the incredible beauty and gracious hospitality of Hawaii.

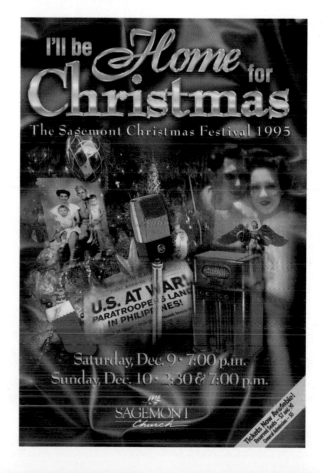

I'll be *Home* for Christmas

The Sagemont Christmas Festival 1995

U.S. AT WAR!
PARATROOPERS LAND
IN PHILIPPINES!

Saturday, Dec. 9 • 7:00 p.m.
Sunday, Dec. 10 • 2:30 & 7:00 p.m.

SAGEMONT
Church

Tickets Now Available!
Reserved Seats — $7 and $6
General Admission — $5

C-15 Traditional four-color process.
Credit: C.C. Nicks, photographer

C-16 Tritone.
Credit: C.C. Nicks, photographer

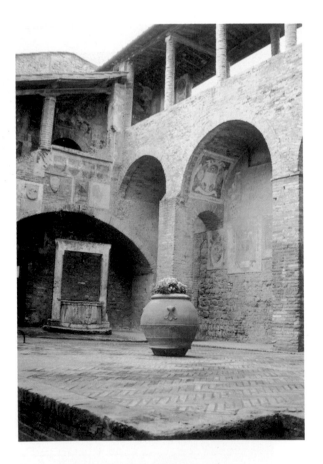

C-17 Duotone, cyan and black.
Credit: C.C. Nicks, photographer

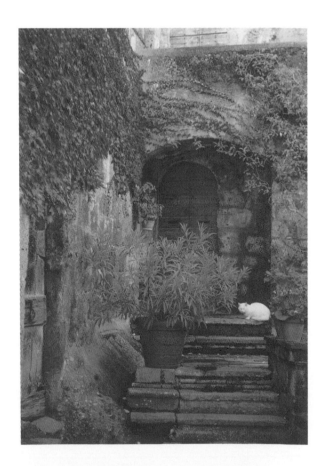

C-18 Duotone, twin color, magenta and cyan.
Credit: C.C. Nicks, photographer

C-19 Posterization.
Credit: C.C. Nicks, photographer

C-20 Special edging.
Credit: C.C. Nicks, photographer

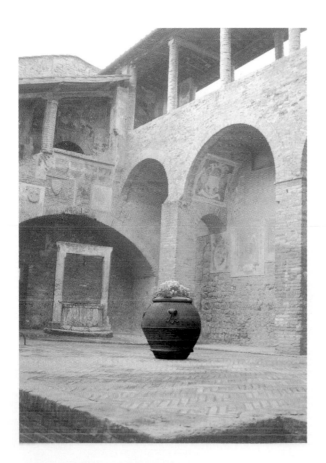

C-21 Ghosted background.
Credit: C.C. Nicks, photographer

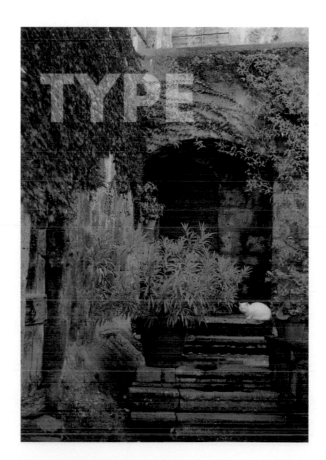

C-22 With transparent type.
Credit: C.C. Nicks, photographer

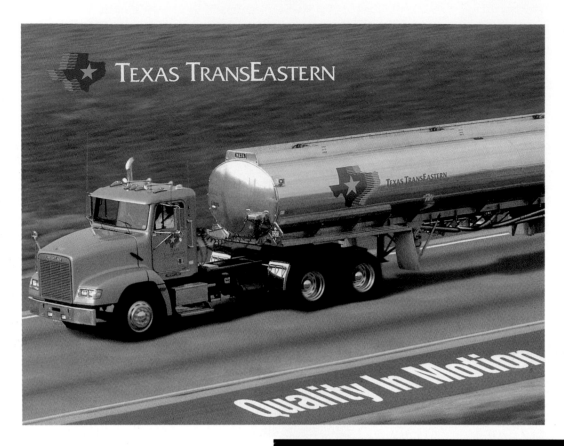

TEXAS TransEastern

Quality In Motion

C-23 Four-color process with action effect by blurring background.
Credit: Manlove Advertising, Pasadena, TX, design and production

C-24 Four-color process with multiple photo ghosting. *Credit: Manlove Advertising, Pasadena, TX, design and production*

INTER-CITY PERSONNEL ASSOCIATES, INC.

WE ARE PEOPLE HELPING PEOPLE!

WE ASSIST THE EMPLOYER IN RECRUITING QUALITY CANDIDATES AND WE ASSIST THE
CANDIDATE IN LOCATING THE RIGHT CAREER OPPORTUNITIES! YES, WE'RE PEOPLE
HELPING PEOPLE AND WE PROVIDE THESE SERVICES NATIONWIDE.

WHY JOIN IPA?

As the employment industry continues to change, independent staffing firms are finding it increasingly difficult to remain competitive in the marketplace. Job candidates recognize the opportunities associated with gaining greater exposure for their resumes, and are looking for staffing firms which can offer them this advantage. Likewise, employers are drawn to those that offer the most diverse and comprehensive candidate pools. Many of these employers, particularly larger ones, have trimmed their recruiting staffs and are looking more often to personnel recruiting firms to meet their hiring needs. As these companies become increasingly reliant on staffing organizations, they are also setting higher standards for quality and service and demanding

The experienced professionals in IPA can provide the advantage you need in today's competitive staffing industry.

better applicants. Most recruiters find that expanding their service area proves to be cost-prohibitive, and are instead meeting the changing needs of job applicants and prospective employers by networking through cost-effective organizations like Inter-City Personnel Associates, Inc.

Inter-City Personnel Associates, Inc., or IPA, offers a variety of services to our affiliate members. Established in 1972, we now cover the U.S. with a network that includes some of the best independent personnel firms in the business. Our average member has more than 10 years of experience in the personnel industry, and several have spent upwards of 40 years finding the best applicants to fill professional and other positions. Experience like this means that when you join IPA, you'll be establishing relationships with firms that have built a solid base of operations and strong connections with a variety of client companies. Our affiliates share confidential information on the basis of trust, honesty, professionalism and integrity while establishing connections with business and industry leaders at the local, state and national level. Such relationships mean a healthy business – last year, our top producer generated more than half a million dollars in fees.

IPA STAFFING SERVICES

When you join IPA you also gain access to the opportunity to utilize our IPA Staffing Services division.

Staffing firms who provide contract professional employees for their clients are experiencing record growth. Information technology, electronics, telecommunications, technical

and financial services are among the areas experiencing high demand.

IPA Staffing Services (IPASS) will provide everything you need to make contract placements. IPASS is registered to do business in all states and becomes the employer of record for all contract employees. IPA Staffing Services also will:

• Handle all paperwork between your client and the contract employee, fund your payrolls and handle all billing matters and collections.

• Provide insurance coverage for contract employees including comprehensive general liability insurance, fidelity bonding and non-owned and hired automobile liability coverage. IPASS also provides all worker's compensation and unemployment insurance coverage.

• IPASS provides all reports concerning affiliate members' contract operations and sends profit checks on a weekly basis.

Consider contract staffing as you evaluate future opportunities.

Printed color

Adding color to publications requires a knowledge of the *categories* of printed color. Working with the correct color system matches printing techniques and printing processes and is controlled by the project. Design techniques can easily use the wrong color system, which may not be noticed until press or plate preparation. Complex file repair can require redesigning or costly professional file intervention.

Color is grouped into four categories depending on how the color is created. Color groups have different sets of colors that exist within their color palette. Swatches serve as a guide (similar to those at the paint store) to ensure the accuracy and availability of a color in the printed color palettes. The four color groups are:

1. Visual color. Color produced by light beams that is visible. *Color palette: Unlimited colors*

2. Monitor color. Color on the monitor that is transmitted with lines of red, green, and blue and is used by designers as "view only" color. *Color palette: Thousands of colors*

3. Spot color. Printed color from "mixed" inks. Ink on a printed sheet from an ink mixed to match that specified color. These are similar to colors of house paint picked from swatches and mixed by a formula to produce the color (Colorplates C-1 through C-9). *Color palette: Approximately one thousand colors*

4. Four-color process. Printed color from four ink colors: cyan, magenta, yellow, and black (CMYK). A color photograph printed in four-color process looks like the original unless it is viewed with a 9x to 15x magnifying glass, (then the dots of the four colors can be seen) (Colorplates C-13 through C-15). *Color palette: Most of the spot colors, but not the brilliant ones*

Designing backwards is even more important when using color since the color on the monitor can take several paths to be printed. The goal is to know the printing path of the project, identify the color category (spot or process) and pick the color from the proper color guide.

Color guide software or color guide samples give true printed color and eliminate colors that are outside of a color palette. A set of color guide swatches are the exact replica of the printing ink colors and are, therefore, the most dependable tool for choosing colors. Unreliable, uncalibrated monitor color can be troublesome since the color is often untrue. A variety of color guides translate color from one source to another. Just as several language dictionaries are needed to convert English to Spanish and Spanish to French, several different guides are needed to translate screen color to different output devices. There are several excellent color guide systems that link to desktop publishing software: TRU-MATCH®, PANTONE MATCHING SYSTEM® and FOCALTONE®. (PANTONE is a registered trademark of Pantone, Inc.) Examples refer to the most popular color system, the PANTONE MATCHING SYSTEM. The uses for each kind of guide are:

- Converting computer color to spot color—PANTONE Color Formula Guide
- Converting computer color to process color PANTONE Process Color System Guide
- Converting PANTONE spot color to be printed as four-color process—PANTONE Process Color Imaging Guide
- Document file to color laser output—Calibration files and software packages built specifically for each laser device

Designs with color add another dimension to rules, boxes, textures, tints, type, and images with additional effects invoked by specific colors (green = alive, growing, Irish, and so on.)

Spot color

Spot color is printing with inks that are premixed before they go on the printing press. All design levels and printing devices can produce some type of spot color, but the alignment and techniques used with the spot colors may not print to all output and printing processes. For example, accidental tight register requirements may not print to a small press, causing additional expenses by requiring the professional use of trapping software and printing to

large presses (figure 5-21). Spot color requires the use of the following tools:

Swatches: Use PANTONE Color Formula Guide.

Output: Copier original (hard copy) up to imagesetter to small press and larger.

No tints. Spot color also may be chosen for a clean, formal design matching either standard to premium level printing processes. Using spot color for a standard level design with two or more colors of ink allows production from a lower cost platemaker, or laser copy original.

Tints. Tints create the effect of an additional color (figure 5-22). One color of ink with a tint (Colorplate C-1) may be as effective and more economical as the same design with two colors of ink without a tint.

Multiples of spot color

When using multiple PANTONE color inks, one color should be darker and referred to as the primary color (Colorplate C-2). For readable body text, print the text in the primary color. If any body type is in the lighter color (Colorplate C-3), it will appear lighter and smaller than it would if it were black ink. Give the type more contrast by adding bold or reverse to the type. Two or more spot colors can become even more effective with tints and paper colors (Colorplates C-5 and C-8). For multiple colors of equal value, keep the use of the color simple to avoid clutter and crowding.

Swatches: Use the PANTONE Two-Color Selector with two colors of ink with tints and use direct to copier, plate, or negative.

Output: Transfer the file directly to plate or film negative (service bureau) for all presses.

Tints. Since adding tints gives the same effect as adding color, several different tints let different amounts of color on the sheets. A range of colors is produced this way. Several examples of two colors of ink appear as duotone samples, Colorplate C-9 through C-11 and C-18, as twin color in Colorplate C-17, and as a posterization in C-19.

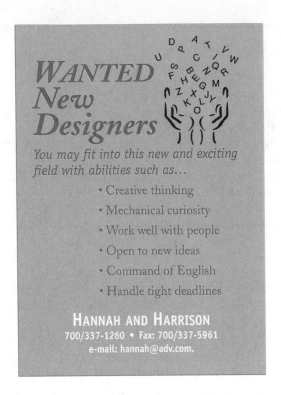

Figure 5-21 Accidental tight register. This figure has a 20% gray tint over the page that causes all blue to need traps requiring tight register. *Credit: Brian Campbell, graphic artist—artwork*

Number of Customers (End of Period)

CUSTOMER	TO DATE	LAST YEAR
Residential	1,301,074	1,258,556
Commercial	170,959	162,965
Industrial	2,143	1,876
Federal	71	72
State	6	7
Municipal	1	1
Total	1,473,876	1,443,243

Number of Customers (End of Period)

CUSTOMER	TO DATE	LAST YEAR
Residential	1,301,074	1,258,556
Commercial	170,959	162,965
Industrial	2,143	1,876
Federal	71	72
State	6	7
Municipal	1	1
Total	1,473,876	1,443,243

Number of Customers (End of Period)

CUSTOMER	TO DATE	LAST YEAR
Residential	1,301,074	1,258,556
Commercial	170,959	162,965
Industrial	2,143	1,876
Federal	71	72
State	6	7
Municipal	1	1
Total	1,473,876	1,443,243

Number of Customers (End of Period)

CUSTOMER	TO DATE	LAST YEAR
Residential	1,301,074	1,258,556
Commercial	170,959	162,965
Industrial	2,143	1,876
Federal	71	72
State	6	7
Municipal	1	1
Total	1,473,876	1,443,243

Figure 5-22 Tints add additional color possibilities and are useful for charts and tables of contents.

Overlapping tints. Overlapping tints of two different ink colors or a graduate of the two colors (figure 5-23b) can blend together to form a third color because, unlike monitor color, spot color inks are translucent. Set tints to overprint in the software package. Overlapping tints use the same printing processes as above, but may need larger presses when colors require tight register.

Three or more spot colors. When more than three spot colors are used and the chosen colors are all available to process color, the file may be converted to CMYK. Four-color process conversion from spot color to process requires a PANTONE Process Color Imaging Guide and shows both the spot and CMYK conversion samples. Be cautious: all spot colors do not convert to process colors, especially brilliant shades (Colorplates C-7 and C-8).

Tight register

Tight register means that the press will print all colors in exactly the same place on every sheet within a "pin head" tolerance (Colorplate C-4). Loose register allows for colors to be independent of each other. Some small presses can handle a small amount of tight register work. If the design is all tight register, include the cost of a large press run.

The *StyleGuide* uses loose register in custom level samples and tight register in premium level samples.

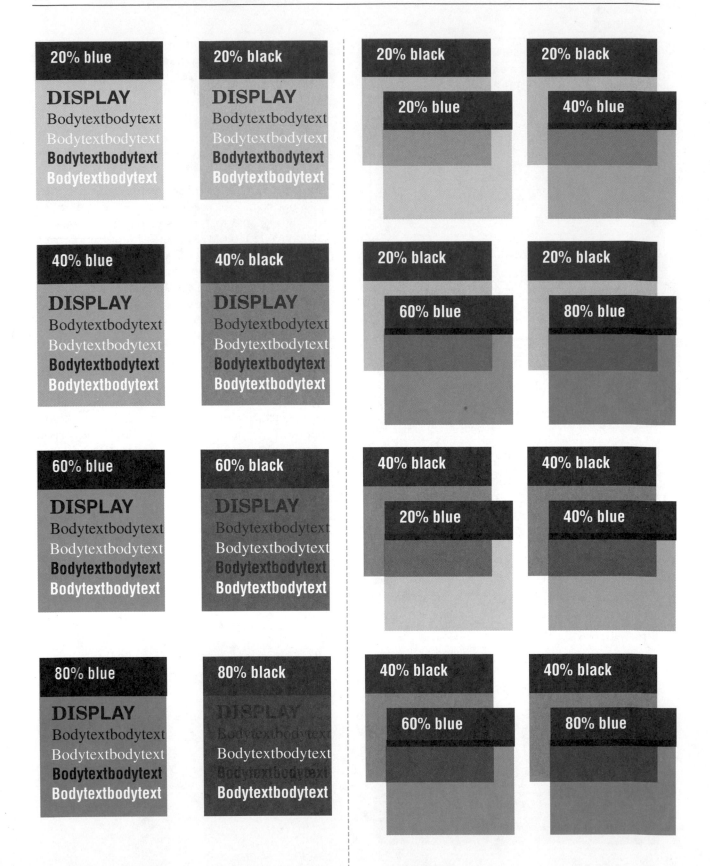

Figure 5-23a Comparison of type on color: serif and sans serif, solid and reverse, caps and lowercase on various background tints

Figure 5-23b Two colors of ink set to overprint and create additional colors

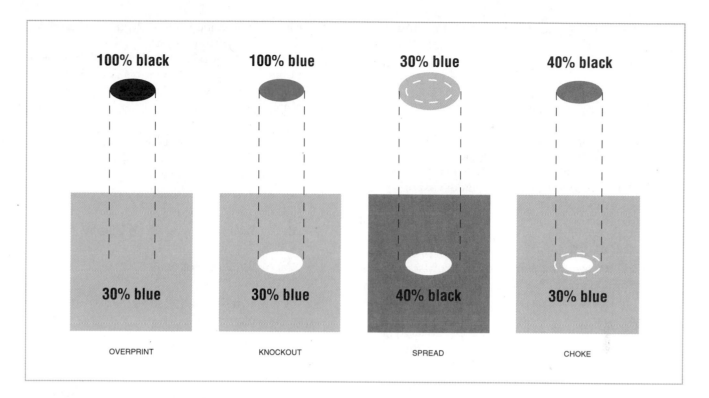

Figure 5-24 Traps for color register

Color with traps

When tight register is required, colors must overlap. The lightest color needs to be wider on the edges where the colors touch in order to overlap and be invisible (figure 5-24). If the lighter color is in the middle, it is a spread. A spread works like the bathtub plug; it is slightly larger than its knockout hole when two colors are not set to overprint. A **choke** is when the colors switch places and the lightest color is on the outside. The trap covers the edges of the hole so that the color of the paper does not seep through between the two colors. Trapping is done by building spreads and chokes.

Trapping is used for all printing processes when two colors of ink touch, overlap, or must be printed with tight register (Colorplates C-2 and C-4). The exception is color laser or direct-to-color copier. Tight register is required with some two-color jobs and all process jobs, but most require trapping. On-demand color copiers do not require trapping. Some inks can overprint (C 5 and C 7), not requiring tight register or traps.

Page layout programs build traps, but most service bureaus prefer to use their trapping software program on files. Trapping software sets general traps, but cannot reason special effects. Less experienced designers should consider the following if their designs have traps:

- The company may have its own imagesetter. Check with the expert before guessing how large of a trap to use. If there is not an expert, build a few simple traps, but keep a copy of the file without traps. If they are built incorrectly, the whole job may need to be scrapped.

- Printing firms and service bureaus prefer to build the traps. The cost to build traps is much lower than a file intervention fee to fix a mess the less experienced designer can make. The cost to straighten up a file incorrectly trapped could equal the entire budget for the project.

Two colors of ink with photos are shown in Colorplates C-9 through C-12. Although they require tight register, the emphasis on quality publications is

evident. Colorplate C-10 goes a step further and mixes both duotones and process photos to add more interest to the page.

Four-color process

Photo manipulation software is required to adjust the detail or make other additions or revisions to the photo. Calibrating color between the computer and the processor uses proper **addressability** (output dpi meets lines per inch needs) to match the line screen of the press and the reproduction size of the photo. This is a high-level skill area and one person is often trained to perform the photo process work. Ideally, photos are professionally scanned to a CD and high and low resolution scans are included for reuse.

Four-color process has been used for premium publications such as annual reports, on large presses with enamel text, or on cover for long runs (Colorplates C-13 through C-15). Color files need calibration to the color on its output device:

Swatches: PANTONE Process Color Imaging Guide

Output: Output the file directly to plate or film negative (service bureau) for all presses.

Four-color process plus one spot of color

Some designs printed in the four-color process require a spot color because that color is needed and will not convert to CMYK. Additionally, the spot color can be added as a high-fidelity color to intensify specific colors of the photo. The spot color that is added is usually a bright color. For example, it may be a royal blue company logo color (Colorplate 13). To determine which colors cannot be produced with CMYK, use the PANTONE Process Color Imaging Guide or software that gives the closest tint color and the percentage amount of each process color that makes up that color. When it is not a color match, it is said "not to be a tint match," and a five-color press is required to add the PANTONE color ink as the fifth ink color. A **fifth channel color** or high-fidelity color, is added to an area of the photo,

focusing on a specific subject. It punches the color and gives the image emphasis.

There are large presses that can print five colors with one run rather than four; this is the most economical approach. Other situations requiring additional printing heads are:

- For a varnish that prints like a clear ink in specific areas to add a shine or matte finish to that part of the printed sheet.
- For fluorescent inks that cannot be created with CMYK.
- For metallic inks that cannot be created with CMYK.
- For high-fidelity color.

The file must build a separate color for each additional color or finish.

$Saver

If the printing company running the project has six-color presses, negotiate a price cut for adding the sixth color for a varnish.

Paper color

The color of the paper must be treated as an additional color since it affects ink color and tints. A two-color ink effect can sometimes be accomplished with one color of ink with tints and a color paper (Colorplates C-5 and C-6). Tints and colored paper blend together forming an additional color because inks are transparent and their colors blend with the paper color. For example, yellow paper is used with red ink, the ink color would look orange not red, and ink tints would appear more orange than red. Gather samples from the paper houses that show colors of ink on colored paper or purchase color markers in the ink color chosen for a reference-point of the color combinations. To confirm your choice, have the printing make a **draw down** of the color of ink on the colored paper by scrapping a thin layer of the ink across a sample of the sheet.

Use contrasting colors of ink and paper for a high-contrast effect. Use shades of white for a modern effect and ivory white for classical projects.

Output: Printed on all processes, but unavailable for equipment requiring specially coated paper and rarely used for large presses.

Color guide: Match color guide to kind of printed color.

Two colors of ink with combined tones

An ink color and a paper color in the same family can result in a color-on-color effect that adds to the quality look of a project (Colorplate C-3). It creates a color combination that works even if the ink and paper color are lavender blue and lavender pink (use dark color ink to keep the type legible). This choice allows for creativity with colors. Inks are translucent and the color of paper blends with the ink whether it is a 100% solid or a tint.

Do not guess on the combination of ink and paper colors. Excellent research samples are free from quality paper companies that print samples of colored inks on their premium colored stock. These samples not only show the colors together, but also show what shade of a color works with a particular sheet. Because premium papers come in the fashion palette colors that are in cycle, use fashion color inks that match papers in fashion palette colors.

Photographs show less detail in colors of ink, but create moods. If the colored paper is medium to dark and the ink is lighter than the sheet, opaque inks or underprinting of a yellow or white will be added to the printing cost. When specifying a color sheet with a PANTONE color ink, the translucency of the sheet changes the color. Find a sample of similar color combinations with ink and paper color to see the effect of the colors together.

Color-on-color

Color-on-color is the name given to paper and ink in the same color group. Color-on-color can be used for one or two inks of the same color (Colorplate C-3).

For additional research

Keep a well-balanced design approach by continuing research into some suggested sources:

Contact the Color Marketing Group (www.colormarketing.org)
5904 Richmond Highway, Suite 408
Alexandria, VA 22303

Contact The International Prepress Association
720 France Avenue #327
Edna, MN 55435

Historical information

Chijiiwa, Hideaki, *Color Harmony: A Guide to Creative Color Combinations,* Cincinnati: North Light Books, 1987.

Trends

AGFA, *Digital Color Prepress,* Belgium: Agfa Prepress Education Resources, 1997.

Miller, Marc D., *The Color Mac, Production Techniques,* Annapolis: Hayden Books, 1995.

Schildgen, Thomas E., *Pocket Guide to Color with Digital Applications,* New York: Delmar Publishers, 1998.

There is nothing more costly than a poor paper choice.

6 Finding the Right Paper

Resources
Specifications
Categories of paper
Recycle & rethink
For additional research

After reading this chapter and applying its principles, the designer should have success:

- Identifying resource professionals and tools to analyze paper needs of a project.
- Completing specifications to order paper.
- Knowing characteristic of the four major paper categories.

The designer's ability to gather pertinent information about a project and link it to paper characteristics can result in a less expensive paper choice, but always results in a better choice. Understanding the categories of paper and their primary uses will help to process the project characteristics and find the right paper.

A weak design will not "fix" with an expensive paper. For example, a weak designer may have a laser original with type that looks too heavy on the page and choose an expensive sheet, such as 100% rag bond or a high gloss enamel, to brighten the design. Unfortunately, the bond with rag loses image quality on solids or photographs and the enamel defines the coarse dots from the laser printer and makes the words look bumpy and darker. The choice is wrong for two reasons: the cost of the paper does not match the cost of the other elements and the image quality is sacrificed. This chapter gives information about paper to provide consistent image quality and match paper with design levels and types of publications. Consistent image quality means not only understanding the categories of paper but also communicating through the correct terminology to define the elements of the project.

Resources

Paper resource professionals and paper samples are available from paper houses, paper manufacturers, and printing companies. Locate a paper professional who is knowledgeable about papers, willing to help match the paper to the performance needs of the project, and able to explain the pros and cons of each particular sheet. The final decision is then made by the designer.

Paper houses

Paper houses (merchants, suppliers) are the local paper companies. They are similar to grocery stores carrying different brands of each type of product. Paper houses offer assistance through specifications representatives, paper sales representatives, and inside sales personnel trained to match specifications and budgets. The specification representatives work specifically with the design industry as an additional service. They are not part of the sales force, but assist designers through all stages and sessions with ordering, printing, and bindery of the publication.

Paper houses furnish swatch books for each kind of paper they supply. Visual identity of a specific sheet is invaluable when discussing matching ink color, folding, or opacity of the sheet. Paper swatch books are wonderful because feeling and seeing a sample gives most of the information needed to choose the right sheet. Include paper swatch books in the reference notebook area for client conference and research.

Paper manufacturers

Paper is produced all over the United States at paper mills that make one specific brand and type of paper. These paper mills are called paper manufacturers. One manufacturer may produce a quality text and cover and another bond and index.

Paper manufacturers create sample publications using their papers, showcasing the vast number of possible uses of the sheet as well as comparison of ink color, finishing, and bindery techniques. Order these samples for product information cards in professional magazines or inquire about them from a paper house. Save samples for the reference notebook area. They serve as examples of photographic techniques, large solids, letterhead, business cards, thick books, thin books, ink colors, varnishes, and so on.

Printing companies

Working directly with the printing company personnel simplifies the number of outside contacts for less complex projects. An experienced printing company sales person is knowledgeable as to which sheets run best on their equipment. The printing company has a portfolio of their work, which will indicate the ability of the presses and personnel.

Paper inventory

Once the printing company is chosen, make a phone call or visit to check their available stock papers. The printing company can recommend additional sheets that run well on the press. A sheet that does not run well will cost more in wasted paper and time, and lower the quality of the publication.

Keep paper samples that represent this printing company's paper inventory or tag the paper house swatch books with this information. Make sure that the paper swatches match the paper manufacturer. Each sheet may be a different shade of white or a finish may be embossed deeper in the sheet. There are several 60# text, linen finish, off-white sheets with different brand names for each paper manufacturer.

If the printing company is located within a one-hour drive of the paper house, they will deliver a special paper order in 24 hours. When quantities of a publication are less than 5,000, the choice is a sheet that is normally stocked. There is an addition-al cost added to buy less than a case of a specific sheet and another additional cost to buy less than a package. A sheet that is not available from the printing company inventory or the local paper house's warehouse will require additional shipping time, which may delay the project beyond the deadline.

For finer papers and premium design projects, paper manufacturers furnish samples of the specified sheet to use for a mock-up (dummy) of the project. This is very critical for thickness, folding, and mailing. It is also critical on a single page, die cuts, embossing, and folding.

Paper manufacturers print pamphlets on their papers to advertise the potential uses of a specific sheet in a variety of inks or applications. These are available through professional magazine reply cards and the local paper houses.

Deadlines dictate the necessity for accessible paper. Discuss in-house paper stock with the printing companies in preparation for the rush projects that need immediate turn-around.

Small to medium printing company. A quick print or printing company with small and medium-size presses will have bond paper available in several sizes for any "as you wait" printing or standard level publication. They stock several colors and sizes of 20# bond or 50# book for copiers or on-demand presses, and 24# bond or 60# book for offset presses. They also stock a variety of heavy weights for covers and business cards.

Medium to large printing company. Each large printing company and some medium-size companies have a standard house sheet that matches their primary market. This "house sheet" may be coated text for advertising runs with process color or uncoated opaque for book publishing. Because press runs use cases of paper, other paper is ordered on an "as need" basis. The most commonly used sizes for press sheets are 24″ x 36″ and 28″ x 40″ for flat sheet presses and 19″ x 25″ for medium-size presses. A common large-web press uses a 35″ roll.

Specifications

Certain publication variables such as budget or finishing technique determine paper specifications. Understanding paper specifications is essential because correct terminology provides accurate communications when ordering paper or in discussions with paper resource professionals. Use the design level of the publications to match the following information to the paper choice:

- Budget. Each paper house carries several brands of similar paper in each weight and paper category. The brand name is a clue to the quality level of the sheet and the price book groups the choices of sheets from economical to premium.

- Weight and type of paper. Each particular printing process has recommended paper weight specifications. Some expert press operators surpass recommended weights, but the beginner should not depend on paper weights outside of the specifications to print or for another printing company to use the paper.

- Durability. Paper plays an important roll in register because a sheet may change sizes when squeezed between two cylinders and heat or water is applied. If a project has multiple colors, tight register, traps, or four-color process, the finer papers will be necessary for stability.

- Finishing and bindery. The quality of folding, die cuts, varnishing, and embossing are affected by the finish and weight of the sheet. Varnishes are usually applied to enamel stock during the press run.

- Bulk of the publication (like the difference between one pound of marshmallows and one pound of steel). Postal regulations and the look of the publication are affected by the bulk of a sheet. High bulk sheets help a one-page advertisement meet minimum postal regulations for weight and thickness. High bulk text sheets make small booklets look thicker and converse-

ly, a tightly woven sheet helps booklets with a greater number of pages become small enough to bind.

- Coatings. Request paper manufacturer printed samples that show the advantage of coated sheets for solids and halftones. The dots of photos will change sizes and appearance on different finishes, colors, and coatings.

- Textures. Textures are usually created after the sheet is made, but some writing papers are textured as the paper is being made.

- Opacity. When an image on the front and back of a publication must not show through, this is achieved with heavier papers or a sheet with greater opacity.

Paper terms

The following terms will help when communicating and examining the resources for paper choices.

Color

The color name of a sheet is specific to that brand and type of paper. Finer papers use poetic names for their sheets and they vary from paper manufacturer. White papers also include a description of the white, such as brilliant white, off-white, antique white, and ivory.

Cut size

The sheet size is listed in inches with the grain direction noted with an underline. Cut size is used for business papers run on copiers, small presses, and laser printers. Common sizes are 8½″ x 11″, 8½″ x 14″ and 11″ x 17″.

Finish

Paper surfaces have different tactile appeal. Feel the surface of papers from the paper samples. Different paper manufacturers use different names for the same finish. Finishes can be smooth, such as vel-

lum, or rough, such as linen. They also include polished finishes with names such as lustre, antique, smooth, cockle, and felt and those specific to a printing process, such as copier.

Grain

Grain is the direction of most of the fibers as it rolls out on the paper manufacturing machines. Printing company personnel need grain direction information for book weights to match the grain with the direction the sheet feeds through the press. Designers use grain direction information for folding cover weights because some sheets will crack when folded against the grain. Folding paper stock weighing over 70# book requires that the fold go *with* the grain (short grain) or it will crack on the fold, adding cost to the project for **scoring** (an embossed dent in the sheet). The grain direction of the sheets is called "grain long" and "grain short," which coordinate with the bigger or smaller measurement on the sheet size. Grain short or long refers to the direction of the fibers in paper manufacturing and is important to proper feeding and alignment of images on presses. It is indicated by an underline, as in 8½" x 11" (grain long).

Ink absorption

The printing ink absorbs differently on different sheets and with different levels of the printing process. For example, a sheet with a 25% rag or with laid finish will print photos, tints, and solid as a flat dark gray. To test a sheet for ink absorption, ask the printing company to scrape a little ink across the sheet and see how dull it dries. Since ink dries better on larger presses, it will also dry with more shine. Discuss the number and sizes of photos, tints, and solids with a paper professional for assurance that the sheet matches the page elements of the project.

Parent sizes

Larger presses order paper in their "parent size" or match the size of paper to these presses. Medium-size presses may use parent sizes or use parent-size stock to make their own pre-press cuts. Common parent sizes are 17" x 22", 23" x 35", and 19" x 25".

Textures

Just as images can be embossed into paper, textures come from the manufacturer embossed into the paper. "Laid" is a popular finish or texture, which means that some finishes are also textures if they are lightly embossed into the sheet during manufacturing or added as a deeper texture after manufacturing. Use caution with the deeper textures when adding type or image embossing, when printing on laser copiers, and with photos with detail. Popular textures include pebble, waffle, or leather. Be cautious of embossing on all weights of covers with textures without consulting the paper samples or a paper professional.

The colors of color sheets

Papers rely on five color palettes for their set of color. Some papers can be purchased in several of these palettes. A color from basic, white, or fluorescent will be available for reruns. Designers cause themselves grief when they pick colors from the fashion or fiber palette colors for a letterhead or publication requiring reruns, since those colors change every three to five years. The five color groups include:

1. Basic. Pink, canary, blue, green, gray, cherry, salmon, gray, buff, golden, tan, and orchid.

2. White. White, ivory, off-white, cream, and natural white.

3. Fluorescent. Electric blue, red, orange, lime green, and so on.

4. The fashion palette. Changing colors. Colors in this palette are determined by a group of colorists who are representatives from the paper, appliance, automotive, and fashion industries. They determine emerging color palettes that will be followed by all industries. The newest

fashion palette is available for three to five years and becomes obsolete when a new set of colors begin. When the ink colors and sheet colors from this new fashion palette combine, they give the publication excitement and interest. They are excellent choices for custom level design with brochures, programs, and announcements.

5. The fiber look. One of the newest looks in paper is not a color but a fiber look. Fibers are added to bonds, texts, and covers, usually in white and dusty colors. This gives the publication an additional color without adding another color of ink. Be careful when using color inks and photos because the fibers tend to tone down both.

Remember that paper colors mix with ink colors to give the publication the appearance of additional shades and colors (see Chapter 5).

$Saver

Preprinted sheets with abstract shapes and images in colored inks designed to overprint can be purchased economically for runs up to 100. They come in book and cover weights.

Understanding and comparing weights

The weight of the sheet is controlled during papermaking. Papermaking machines make rolls of paper, which are then slit and cut into frequently used sizes or the parent size. The weight of paper, if weighed in the parent size of its category, is the weight name given to the sheet. Each category of paper uses a different parent size; therefore, two sheets of the same weight can have different weight names. Refer to figure 6-1 for a comparison of the most common weights of paper in order to understand the relationship of the weight names to each category.

Equivalent weight scale

Bond		20#	24#	28#									
Index								90#		110#		140#	
Bristol						57#		67#	80#				
Book, Text	40#	50#	60#	70#	80#	90#	100#		120#				
Cover								60#	65#		80#	90#	

Figure 6-1 Comparison of weights

50# book vs. 20# bond

Why are two sheets that have the same feel used interchangeably and one is called 50# offset and the other 20# bond? It has to do with the parent size of each sheet. Books were originally manufactured for back and front publications run on large presses with a coating for photos. Its parent size became 23″ x 35″ because most of this paper was shipped to the printing company and run on the 23″ x 35″ (large presses). After the printing, a finishing cut of 8½″ x 11″ would produce an identical size to the bond sheet and if it was an uncoated sheet, the final product would look and feel similar to 20# bond.

Bond paper has a parent size of 17″ x 22″ because the paper is usually cut to 8½″ x 11″ before it is printed. Book paper has a parent size of 23″ x 35″ and usually runs on larger presses in that size and is then given a finishing cut to 8½″ x 11″. The weights of paper are calculated from 500 sheets (one ream) of those parent sizes (figure 6-2).

It is acceptable to use either book or bond for most publications. The differences are so slight that it is acceptable for a printing company to substitute one for the other. Is it different in weight? Slightly. Is it significant? If a publication is back and front and opacity of the sheet is important, the best offset sheet should be chosen.

500 SHEETS BOOK = 50#
25 X 38
8 OUT 8 1/2 X 11,
THEREFORE 50# ÷ 8 = 5# PER PACKAGE OF 8 1/2 X 11

500 SHEETS BOND = 20#
17 X 22
4 OUT 8 1/2 X 11,
THEREFORE 20# ÷ 4 = 5# PER PACKAGE OF 8 1/2 X 11

Figure 6-2 Paper weights with stacks of 500 sheets of paper

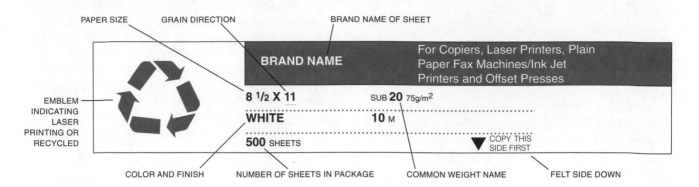

Figure 6-3 Paper label

Ordering paper

During discussions with the paper professional, follow these steps:

1. Pick the paper categories. Match how the sheet needs to perform.

2. Look and feel. Samples that can be held and touched give concrete information.

3. Find two samples in different price ranges. Present a first choice to the client as part of the project cost by total cost or cost per copy. If the cost becomes a factor, or if the sheet is not acceptable, go to the second choice.

4. Write down the variables that affect the sheet choice.

5. Order the paper, with deadlines included.

After choosing paper, use the specifications from the paper swatches or the price book to complete the work order. Include number of sheets, weight, brand, finish, color, and size. For example: 5,000 sheets, 80# Trusheet Book, 19″ x 25″, vellum finish, ivory. The same information appears on the package label or paper carton, but not in this order. The paper label in figure 6-3 represents a cut size package label for checking the specifications.

Categories of paper

Paper is grouped by specific manufacturing techniques and uses of the paper. They form four major groups of papers for offset printing: bond, book (text, offset, opaque), cover, and index. Other groups have similar uses with these four groups, such as tag and bristol, but have a different hardness or finish. Other papers are manufactured for other processes, such as form manufacturing companies, newspapers, flexography, and packaging printing.

Bond and index are companion sheets with common colors, uses, finishes, and an economical price range, generally used for standard level designs. Book (text/offset) papers have matching covers and, generally, are used for custom and premium designs.

Bond papers

Bond papers are the traditional business papers. They are chosen because there are inexpensive, practical sheets. Bond paper comes in 20# and 24# and is not manufactured with coatings or textures, but with rag (cotton fiber added). It is also manufactured with a few textures that can be embossed in the sheet during the manufacturing process. One of the most popular textures in bond is laid, for laser and copier.

Plain bond

Plain bond has a smooth texture and is a light weight sheet. It has a primary color palette that has not changed for fifty years: pink, blue, canary, salmon, buff, goldenrod, cherry, gray, ivory, orchid, tan, and green, plus the white and fluorescent palette. Plain bond fits budgets for standard level designs when using:

- Black inks or spot color
- Reader identification by color code
- Runs through copiers
- Back and front work, type only

There are several grades of bond. The highest quality sheet is #1 grade (a blue-white) and the least expensive #5 grade (a yellow-white). General purpose printing uses #3 or #4 bond.

Writing papers

Writing paper comes in 20# and 24# bond with 25-100% rag. Writing paper is designed for durability and for rollerball or fountain pens. When bond papers are manufactured with rag, cotton fibers are substituted for wood fibers for durability. Rag sheets are usually manufactured with a watermark that can be seen by holding the sheet up to the light. Check printed copies for watermark positioning. It should be turned so that the copy reads in the same direction as the watermark. Some of their uses are for legal documents, letterheads, and money. Be cautious if using large solids or photos with writing papers because rag does not hold ink as well as other papers.

Carbonless bond

Carbonless bond comes in 20# and 24# with a coating on the back that is abrasive and a coating on the front that has the micro particles of dye. When applying pressure with a pen, the abrasive layer breaks the encapsulated dye.

Carbonless papers are 2-part, 3-part, 4-part, 5-part, and 6-part. Colors available include white, canary, pink, blue, green, and golden, and can be purchased to run on offset presses, copiers, or laser printers. They can also be purchased in index or perforated 8½″ x 11½″ (perforated side) or 11″ x 9″ (perforated side).

Book papers

Book, text, offset, and offset opaque papers group together because they have the same weight names and common uses. Originally, offset paper was made for the publishing market and text paper for the advertising market.

Book

Book paper has a full range of colors, textures, and coatings that bond does not have. Book paper contains colors in the fashion color palette as well as other color palettes. Some paper manufacturers add coating and texture to book paper for effect. Many text sheets belonging to this group have a matching cover stock.

Uncoated offset

This is a high quality offset in smooth or vellum finish, which gives a publication an excellent presentation without coating or texture. Whites are a brilliant blue-white and the surface is polished smooth so that a dot can print more accurately than on any other uncoated stock. The smooth finish of a #1 uncoated offset will produce quality halftones, tints, and solids. The vellum finish is a smooth dependable sheet with some opacity for photos. Uncoated offset paper is an alternative to coated text for long text documents or for small presses.

Uncoated opaque

This is an offset sheet, which has been specifically produced for front and back publications. The opaque appearance prevents the image on the back side of a sheet from showing through on the front side. Lighter weight sheets require more opacity for front and back printing.

Coated text

Coated paper has a layer of clay added to one or both sides of the sheet, giving an even surface for black and white halftones, large tints, and four-color process images. Coated sheets were originally intended for large presses to make images sharp and exact in size. Drying the ink on a coated stock is difficult on smaller press. Some medium-size and most large offset presses use mostly coated paper and dry the ink with UV infrared or heat set, or are waterless.

When collecting samples of ink on different sheets, understand the variables. Not all presses can print a particular quality. Also, different coatings create different effects. Refer to paper manufacturing printed samples for the following enamel coatings:

- Premium Gloss. These glossier sheets are coated with an expensive clay to give a finish for publications. By giving the printing ink a shiny finish, the emphasis is on photographs.
- Gloss. This sheet has less gloss and is more economical for emphasis on photographs.
- Dull. These sheets are semi-smooth for publications with the emphasis on text or long documents. The softer look of the page causes less eye strain.
- Matte. These sheets have a velvet look for emphasis on text or long documents.

Textures (text)

Textures are an embossing of a uncoated sheet during the manufacturing process. The most common textures are linen and laid finishes. **Laid** is a reproduction of a handmade sheet and gives the sheet a classic look. Linen texture is also a traditional texture. The limitations of texture papers are as follows: The rougher the texture, the more difficult it is for ink to lay smooth for photographs and large solids. The harder or crisper the sheet, the more difficult it will be for the sheet to fold, although a sheet can have a score added to eliminate the cracking.

$Saver

Some mills create their own finishes during the papermaking process. These finishes are not as dramatic as those produced after the paper is made, but they give an additional choice.

$Saver

Sheet cost increases with the addition of textures and colors because it requires additional manufacturing techniques. White or off-white sheets with texture are usually less expensive than a color sheet without texture. Texture and color inks show up best on a white or off-white sheet.

Covers

Cover and text sheets share the same brand names, such as Grandee text and Grandee cover. They are called matching text and cover in different weights. One paper swatch booklet holds the matching text and color. Cover stock comes in 65# and 80#.

> ✘ Cross reference: Refer to figure 6-2 for comparable weights with text sheets.

Using cover stock as the cover for matching text sheets is only one of the many uses of cover stock. Cover stock can also be used for custom and premium business cards, mailers, invitations, menus, posters, and table tents.

Bristol

Bristol is a heavier sheet with a soft finish, but less durability. It works well for business cards, mailers, and tickets. Bristol weights are 57#, 67#, and 80#.

Index

Index is used for special long runs where durability and low cost are a factor. The hard surface means that index will hold up to handling. Index is a good choice for internal use. Index comes in the primary color palette that matches bond colors. Its uses include filing cards, filing folders, covers, tags, and tickets. Schools use index for report cards, flash cards, and student records. Index is referred to by weight, but also by ply: 1 ply, 90#, 2 ply, 110#, and 3 ply, 140#.

Tag

Tag uses the same weight numbers as index and shares the characteristic with index as to its durability and cost. It comes in whites and the basic color palette only, but the weights are slightly heavier, which is important for tags: 100#, 120#, 150#, 175#, and 200#.

$Saver

Some 67# bristol cover, 7-point return cards, and 80# cover will meet the weight and thickness postal regulations for mail. Ask the paper merchant to caliper the other cover weight stock, since two sheets of the same weight can be different thicknesses. 67# bristol cover runs on most copiers and on-demand printers and is a weight that laminates. Ink dries well on it because of its vellum finish.

Gum and pressure-sensitive papers

Gum and pressure-sensitive sheets are a combination of a sheet and a backing or coating. They can be any sheet, acetate, or fabric and the backing can be a specific gum or pressure-sensitive adhesive.

Contact the paper house specification representative to specify matching adhesive and sheets. It is important to know whether the publication needs to be permanent or removable, as some cases require special adhesives. These papers also come in different backing thickness. A heavy backing is required for tight register on the press.

Preprinted papers

Preprinted papers are available at office supply and paper companies for specific kinds of projects such as business cards, envelopes, tickets, folders, and corporate identity packages. The images on them are in both black ink and colors and some include finishing and bindery techniques such as numbering, perforation, hole punching, and die cuts. These papers are useful for standard design level projects and most can be fed through the laser printer for short runs.

Envelopes

Include the choice of the envelope paper and size early in the design process to eliminate the additional cost of custom die-cut envelopes. Figure 6-4 lists thirty-seven common envelopes and envelope groups with relationship to size of publication. For additional envelope sizes and styles, contact the paper professional.

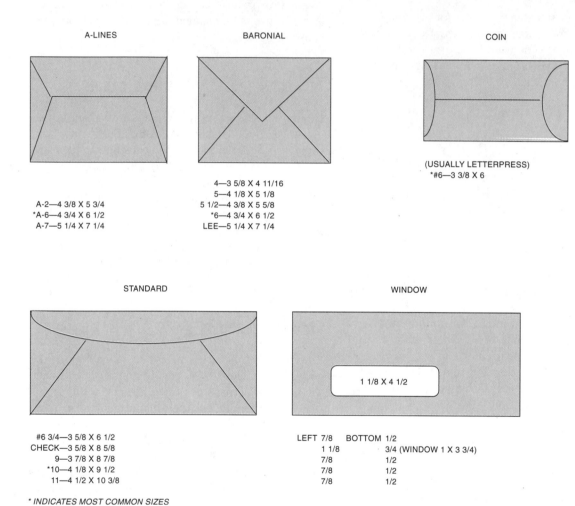

A-LINES

A-2—4 3/8 X 5 3/4
*A-6—4 3/4 X 6 1/2
A-7—5 1/4 X 7 1/4

BARONIAL

4—3 5/8 X 4 11/16
5—4 1/8 X 5 1/8
5 1/2—4 3/8 X 5 5/8
*6—4 3/4 X 6 1/2
LEE—5 1/4 X 7 1/4

COIN

(USUALLY LETTERPRESS)
*#6—3 3/8 X 6

STANDARD

#6 3/4—3 5/8 X 6 1/2
CHECK—3 5/8 X 8 5/8
9—3 7/8 X 8 7/8
*10—4 1/8 X 9 1/2
11—4 1/2 X 10 3/8

WINDOW

1 1/8 X 4 1/2

LEFT 7/8	BOTTOM 1/2
1 1/8	3/4 (WINDOW 1 X 3 3/4)
7/8	1/2
7/8	1/2
7/8	1/2

* INDICATES MOST COMMON SIZES

Figure 6-4 Envelope samples and sizes

BOOKLET

#6—5 3/4 X 8 7/8
6 3/4—6 1/2 X 9 1/2
 9—8 3/4 X 11 1/2
*9 1/2—9 X 12

CATALOG

#6—7 1/2 X 10 1/2
9 3/4—8 3/4 X 11 1/4
*13 1/2—10 X 13

FIRST CLASS

FIRST CLASS MAIL

*#10—4 1/8 X 9 1/2
 *#9—8 3/4 X 11 1/2
9 3/4—8 3/4 X 11 1/2

* INDICATES MOST COMMON SIZES

Figure 6-4 Envelope samples and sizes (continued)

Recycle & rethink

The commitment to the environment can be seen in all phases of printing and publishing. Paper companies are committed to environmental concerns by replanting when trees have been harvested. Paper manufacturers recycle the paper waste in the manufacturing process and companies sort their sheets for recycling. The group with the most power over environmental concerns is the designer. Designers determine how many pages a publication will include and how much paper waste will be involved because of cut size and paper choice. Consider using recycled paper on projects, but also think about type size and other factors that determine the length of a publication.

Rethink designs that cause paper waste

A designer does not see the amount of paper that is wasted when a design is not within a standard size. For instance, if a small brochure with bleeds has a finished size of 8½" x 11", the paper required to print it must be 11" x 17", doubling the paper waste and cost. If a brochure is designed for 8" x 10", 8" x 13", or 10" x 16", it can be run on standard paper sizes 8½" x 11", 8½" x 14", and 11" x 17" respectively. There are many creative sizes that fit within those three page sizes, especially when the sheet is folded differently.

✘ Cross reference: Refer to figure 10-56.

PLACE % OF RECYCLED
PRE- OR POST-CONSUMER FIBER

40%

DETAIL KIND OF WASTE PAPER

TOTAL RECYCLED FIBER
40% POST-CONSUMER

Figure 6-5 Recycle symbol

Recycled papers

All categories of paper can be purchased in some type of recycled paper. There are three classifications:

1. Recycled paper. This paper contains post-consumer paper.
2. Post consumer. This is made from recycled paper, or a percentage of it is made from recycled paper.
3. To be recycled. This type of paper can be recycled after use.

The recycle symbol (figure 6-5) is acceptable to use for all classifications of recycled paper. It is appropriate to include a statement below the symbol or a percent of recycled products in the middle of it in 6-point type.

This part of cutting down paper waste is frequently overlooked but is as important as choosing recycled papers:

- Pass the information. Pass on the information electronically to peers whenever possible.
- Print back and front. This will cut the amount of paper used in half.

- Use standard size sheets. Choose a paper that comes in a prepress size that can cut the final size without a lot of paper waste.
- When the press sheet is larger than the finished size. Add a useful project such as scratch pads, bookmarks, or any small items, to an unused area.
- Choose the lightest weight paper. Choose one that will do a job effectively and creatively. Paper cost is calculated by the weight, not by number of sheets.
- Choose a type size that is readable. But, use the smallest possible size rather than the largest possible size. A ten-page manual becomes 25% longer when type size is 12-point rather than 8-point, but it is not more readable (unless the audience is seniors or children).

Summary

The summary for this chapter is present in a chart (figure 6-6) to create an accessible reference for choosing paper to match with the publication. It details the most popular paper types and weights and is a quick reference when making paper choices.

Papers and their uses

Papers and their uses	LETTERHEAD	BUSINESS CARD	INVITATION	8½ X 11" DOCUMENTS	LONG SADDLE STITCHED	ANNUAL REPORTS	FLYERS	STUFFERS	PROGRAMS	BROCHURES	NEWSLETTERS	CATALOGS	MAGAZINES	FORMS
Plain Bond, 17#												■	■	■
Plain Bond, 20#	■			■	■		■					■	■	■
Plain Bond, 24#	■		■	■	■		■	■	■		■	■	■	■
Bond, 20–24# 25% rag	■		■			■								
Bond, 24# 100% rag	■		■			■								
Bond, carbonless														■
Book, 50#	■			■	■		■					■	■	■
Book, 60#	■		■	■	■	■	■				■	■	■	■
Book, 70–80#			■	■		■	■	■	■	■		■	■	
Opaque, 24#				■	■	■		■	■	■				
Text textured, 50–80#		■		■	■		■	■	■			■	■	
Text enamel coated, 40#					■	■			■			■	■	
Text enamel coated, 50-60#		■		■	■		■	■	■		■	■	■	
Text enamel coated, 70-80#		■		■	■		■	■	■		■	■	■	
Cover, 65# uncoated			■						■			■	■	■
Cover, 80# uncoated			■						■				■	■
Cover, 65–80# textured	■	■											■	
Cover, 85# smooth		■											■	
Cover, 85# coated		■												■
Index or Tag		■												■

Figure 6-6 Papers and their uses

For additional research

Keep a well-balanced design approach by continuing research into the historical and trendy information found in:

- Samples from paper houses
- Paper sample swatch books are full of information and sample about that particular sheet.

Adams, J. Michael, *Printing Technology,* New York: Delmar Publishers, 1996.

Beach, Mark, *Papers for Printing,* Manzanita: Elk Ridge Publishing, 1991.

Dynamic Graphics magazines

Why don't these printed copies look as good as they do on my monitor?

7 Quality Control Methods

About the files
About the equipment and their processes
Quality control devices
For additional research

After reading this chapter and applying its principles, the designer should have success:

- Understanding the principles of each process.
- Identifying the classifications for image quality.
- Recognizing and using control guides and calibration devices.

Quality publications begin with building proper files consisting of type and images. In addition to the files, quality can be ensured by performing checks at each piece of equipment used throughout production.

✘ *Cross reference:*
Refer to the different production paths for each design level in figures 1-2 through 1-4.

This chapter deals with the files, the fundamental processes of the equipment, and the expectations of control systems which ensure quality.

✘ *Cross reference:*
Since many different paths can be chosen during the production of a project, the quality control methods for web page distribution are covered in Chapter 13.

About the files

After the preliminary work on a file, including the proofing for copy corrections, is completed, design production ends. Communication with the graphic professionals begins at this point.

Final file examination (preflighting)

Building a proper file is the first and most important step. The page layout file and its set of linked files must be prepared specifically for the printing or final output equipment. If such preparation is not made, even the best production staff will be unable to adjust their equipment sufficiently to correct the problems. The files must be reconstructed by the designer, which wastes time. Otherwise, file intervention must be performed by the prepress professional who handles the file (and who charges an hourly rate to do so).

Follow a checklist provided by the service bureaus or a job ticket provided by the printing department. Fill out the checklist or job ticket correctly and completely. The checklist shown in figure 7-1 is for imagesetters or high-end, direct-to-plate devices. The job ticket (see figure 1-1) is used for low-end production.

The second step will prepare the files, including information about dpi of images, handling of colors, file formats, photos and images linked to the file, and fonts that have been used in the preparation of the file. Occasionally, the file also includes Post-Script® or Adobe Portable Document Format (PDF) files. To avoid confusion and to maintain the links with image or art files placed in the page layout, create one folder with the final copy of all files related to the project.

The folder should include files formatted for images and correct **resolution** (dpi) and addressability to match the output device and printing process. Resolution and addressability are very technical; the combination of these two describe the amount of detailed information required for each specific piece of equipment to perform at its anticipated level of quality, whether it is a laser printer, imagesetter, or printing press.

Client: _____ Promised: _____

Client Job _____ Operator: _____

Job Number One	Application	# pgs.	size	Media	Emulsion	lpi	Resolution	Separations	Proof
	Macintosh ☐Quark ☐Illustrator ☐Freehand ☐Photoshop ☐PageMaker ☐Other		☐8.5x11 ☐11x17 ☐	☐Paper ☐Film	☐RR/ED ☐RR/EU ☐Neg ☐Pos	☐133 ☐150 ☐175 ☐200+	☐1200 ☐2400 ☐3600	☐CYMK ☐PMS ☐Other	
Job Number Two	**Macintosh** ☐Quark ☐Illustrator ☐Freehand ☐Photoshop ☐PageMaker ☐Other		☐8.5x11 ☐11x17 ☐	☐Paper ☐Film	☐RR/ED ☐RR/EU ☐Neg ☐Pos	☐133 ☐150 ☐175 ☐200+	☐1200 ☐2400 ☐3600	☐CYMK ☐PMS ☐Other	
Job Number Three	**Macintosh** ☐Quark ☐Illustrator ☐Freehand ☐Photoshop ☐PageMaker ☐Other		☐8.5x11 ☐11x17 ☐	☐Paper ☐Film	☐RR/ED ☐RR/EU ☐Neg ☐Pos	☐133 ☐150 ☐175 ☐200+	☐1200 ☐2400 ☐3600	☐CYMK ☐PMS ☐Other	☐Agfa ☐Color Key ☐Pos Chrome ☐Velox

Fonts used in the above documents:

Disk Format
☐ Floppy
☐ SyQuest
44 or 88

Special Instructions:

Trapping specifications:
☐ Trapping has been done
☐ Trapping needs to be done
☐ Trap amount _____
☐ pts.
☐ inches

Trapping can be done on your files at your request. Some programs (like Pagemaker) don't allow any trapping to be done, so be sure to ask for details. **We recommend Quark Xpress** for page layout because of its trapping capabilities.

Figure 7-1 Imagesetter checklist

Without proper resolution and addressability, the stored information may be insufficient to build the shades of gray or the shades of each four-color process color and the detail of the image will suffer.

A general rule is to build files that meet the resolution (addressability) needs for the final output device—no more, no less. Unnecessarily large photo and drawing files saved at a higher resolution or addressability than needed, are not diminished in quality, but they do cause storage and transporting problems and will increase final output time. Be aware that service bureaus charge by the minute for file processing. If the file is excessively large, it will take longer than estimated and will cost more.

Most service bureaus and designers are using preflighting software packages to examine every file detail and spot potential production bottlenecks. This software can be beneficial because it alerts the designer to the file problems *before* the project leaves the originating production area. Preflighting software will note incorrectly prepared colors, font errors, and the format of each of the placed images. Preflighting software will also perform a "gather for output" function, placing linked files, page layout files, and fonts in a folder for the service bureau or printer. A report that details all the information for handling is also created.

Preparing a page layout file for output can follow one of three different paths: it can be collected as is, converted to a PostScript® file, or converted for electronic distribution. The file requirements for preparing, viewing, and distributing are as follows:

Fonts

Use and display of fonts should be the same throughout the viewing, editing, proofing, and output phases. Consistency will ensure the use of proper typefaces, weights, and letterspacing on output from the service bureau or printing company.

The most popular types are PostScript® Type 1 fonts and TrueType fonts. PostScript is a registered trademark of Adobe. Computers need both a printer font and a screen font. PostScript Type 1 fonts appear as several files that represent a separate file for the screen fonts and one or more files for the Post-Script printer font. TrueType uses one file for both printer and screen fonts. Test TrueType fonts with service bureaus since they may not print to all output devices, especially the more advanced high-end devices. Just because the document will print to the laser printer, there is no guarantee that it will output correctly on an imagesetter.

Be cautious of files that open requesting a font substitution. Even if the same font names are chosen, end-of-line decisions and letterspacing may change, completely reformatting the document.

Avoid using the style names from the lower part of the character window to modify the font style or weight. Many of these choices will be ignored by high-end output devices and text will be outputted completely in Roman or regular. To specify fonts, use the weight names that combine with the typeface name at the top of the menu, such as Caslon bold rather than Caslon at the top window and bold at the bottom window. By always using these font names together, imagesetter output will match laser printer proofs.

The safest technique is to identify all typefaces, including their weights and styles, in all files that are part of the publication. Check font licensing agreements. Most prohibit giving both the screen and printer fonts to another person, even a service bureau or a printer who is outputting a job. Some licensing agreements, however, allow printer fonts to be shared. Therefore, check with the service bureau and verify whether the fonts you intend to use are available. If at all possible, keep the font choices compatible with the service bureau's font library. If font licensing agreements are met, put copies of screen and printer fonts in a fonts folder that will be included with the job files, for transporting.

Photos

Photo images can be purchased, scanned, obtained from digital cameras, or created from another software package. These files must be saved in a file format that the page layout package understands and can import. To resolve detail, they should also be prepared and saved with sufficient, but not excessive, file information. Link (nest) photos and illustrations, but do not save them within the publication. Saving within the publication expands the page layout file, increases the file size of each image, creates a second copy, and devours space on the computer's hard drive.

Line drawings

Line drawings can be:

- Purchased line art or clip art
- Custom drawings created from a professional drawing package
- Scanned images

Purchased line art in Encapsulated PostScript format (EPS) can be opened as a file or placed in professional drawing package page. It can be modified in several ways, from simply adding a color selected from a color matching system to customizing the drawing. EPS line art that has been set and saved in layers will allow revisions. If you plan to purchase line or clip art, consider the package's ability to add, change, and convert color for compatibility with a color matching system. Also, consider functions that tint, revise, or add layers and detail. Custom-created drawings allow designs to be more project specific. Save them in the same EPS format.

Scanned images are raster (bitmap) images and must be sized according to the line screen to be used for final output. Otherwise, they must be automatically or manually redrawn in a drawing package to convert them to a vector file. They can also be opened in a photo manipulation program to adjust their file size and resolution. Adjust size and resolution to match the line screen to the requirements of the final output device for the product. They are, then, saved as a raster file, either in Tagged Image File Format (TIFF) or EPS file format.

EPS file format is the most popular raster art among graphics professionals. Although EPS files are slightly larger than TIFF files, they allow more special features to follow the file. Clipping paths from photo manipulation software (to isolate a desired foreground image from the background) will move with a file that is saved in the EPS format. This is not true of most other formats. Also, EPS format allows the creation of a Desktop Color Separation (DCS) file format and creates five separate files for each raster image. One of these files is a low resolution color composite file used for placement in the page assembly file. The other four files are high resolution CMYK (cyan, magenta, yellow, black) files that have already been separated by the image manipulation software, therefore, eliminating the need for page assembly software to perform this task.

TIFF files will allow colorization within a page assembly package, but most professionals will handle all image colorization with an image manipulation package that is specifically designed to deal with images and color. Avoid PICT (vector pictures) or PCX files for publication, as they will return very low resolution images unsuitable for professional projects. GIF or CompuServe GIF files should be avoided for the same reasons as the PICT and PCX files. GIF files should be used only when the project is targeted for Internet publication.

Word processing files

Text is placed in the page layout software document in a variety of ways. Copy can be imported from an original word processing file with the text editing done in the word processing package, or it can be typed directly into the page layout file. Unlike photos, text imported from a word processing file becomes part of the page layout file. Text takes up very little space in a file or on a hard drive.

> ✗ Cross reference: For more information about preparing word processing files, see Chapter 8.

Page layout files

The size of extensive documents can become unmanageable very quickly. To remedy this problem, break the long document into separate files, by chapters. If you are doing page imposition, break up the file by imposition page layouts. Create a book list in correct sequence in one of the page layout files, outlining the structure of the complete project. Copy this list to all the separate files that emerge when the large file is broken down into smaller files. This book list also builds a table of contents and an index.

Linking must be maintained and updated in all files. Changing names of linked files or page layout files can break links and make the service bureau's job very difficult. If you have an illustration named

"Caplin Street," for example, placed and linked to the page layout document, it has created a pointer, or tag, that gives the page layout software a path to the file "Caplin Street." If you change the name of "Caplin Street," the page layout software will not be able to locate the file unless you update the link to that illustration and make a new tag pointing to the file with the new name. Links can also be broken if you change the name of the page layout document while breaking it down to smaller files. If the document was named "My Project" and you broke it down into files named "My Project 1," "My Project 2," and so forth, many of the links to the original file can be broken. Before sending the file for output, be sure to check all the links for validity.

Attempting to print or output a file whose links have been broken will usually produce a very low resolution, bitmapped image on the printed page. The page layout package, while showing an image on the screen, cannot actually locate the original art or photo to send to the printer or output device. Consequently, the page assembly software is forced to send a 72 dpi, low resolution, screen image. The resulting output is less than satisfactory.

PostScript files

PostScript is a conversion of a software package's language to PostScript language when the print command is sent. These conversions can be saved directly to disk or sent to a printer. PostScript is a language invented by Adobe specifically for communicating complex file information to printers. A PostScript file conversion is required for nearly all on-demand copiers, direct-to-plate imagesetters, and film imagesetters with a hardware or software raster image processor (RIP). If the RIP is a PostScript RIP, it will demand a proper PostScript file.

About the equipment and their processes

The number of paths that a project can follow grows daily. As stated in Chapter 1, the designer must design backwards, preparing the file for each piece of equipment to be used. Sometimes, several final versions of the file need to exist. Functions that require another version of the file include proofing, preparation for imagesetter, preparation for on-demand color, and direct-to-digital plate. Preparing a file properly for all the equipment along the production path can increase the final quality of a project if the versions of the intermediate files have been properly formatted. Establish a clean file format for each of the following processes:

Proofing

Proofing checks the quality of type, color, and photographs, as well as registration and ink coverage. It is best to check proofs with a 9x to 15x magnifying glass or loupe. Different proofing systems are used for different kinds of checks. The high-end printer examines the proof for exactness of color, a process that requires proofs created from the same film that will be used to create the printing plates.

Proofing for image quality should be done at several points in the production process: at the laser printer before film is run, before the press run begins, and at the beginning of and during the press run. Premium high-end designs are proofed at each of these intervals, while a standard level design is usually proofed via the laser printer if the design is strictly black and white, or via a dye sublimation printer if there is color involved.

At the end of each proofing session, a copy of the proof is signed by the designer or the art director. When a proof is signed off, it indicates agreement that the work is satisfactory and has been accepted to that point. It is usually considered a "go ahead" for the next step in the production process.

High-end (analog)

Matchprints and blueline proofs are high-end analog proofing systems that produce proofs from the negative for the printing plate. Since they are created from the negatives, the dot structure of the halftones, orientation, trap and overprint, and image positioning will be exact. Bluelines produce only a blue image on paper, indicating positions of text and images so that the customer can see the layout of the final page.

Matchprint is used for color proofing and is very exact in color representation and all other page details. Matchprints, like plates, are exposed in an exposure frame with a high intensity exposure lamp. The strata used is a thin plastic. Four sheets of this thin, photosensitive material are used, each consisting of the four primary separation colors (cyan, magenta, yellow, and black). They can be attached to virtually any paper surface. The primary difference between Matchprints and the final printed piece is that Matchprints often have an extremely glossy surface. Some color sheets are available for proofing spot colors, but the color selection is extremely limited. Most of the time, a high-end project has all of the colors converted to CMYK and eliminates spot colors entirely. This saves production costs at every step of the project.

Mid-range (digital proofs)

Mid-range proofing uses processes such as inkjet and dye sublimation to create the image. The color is better than output to laser printers or color copiers but the photographs or any tone work done in photo manipulation software are still printed as a continuous tone image. To recognize a continuous tone image, look at a photo from a conventional photographic camera, like the one you use to take snapshots. Notice that, under magnification, color appears to be continuous and without pattern. Now view a printed color photo from a high-quality publication or a picture from a laser printer under the same magnification. The second image is made up of dots called halftone dots. Since high-resolution inkjet printers and dye sublimation printers do not produce a screened image, the color and image appearance differs slightly from a Matchprint and the final printed piece.

The most popular use of inkjet printers is large format printing (26″–50″ width range) where large dots of ink are placed on the sheet. Viewed from close range, the prints look coarse because of very low resolution. But when viewed from the distance for which they were designed (at least 10 feet), the images look sharp and the color is usually very vi-

brant. Inkjet prints are usually used for point-of-purchase (POP) advertising. Color photographs are often included in the composition and can be laminated or stretched over a frame for display. Most of the food ads in local grocery stores or convenience stores are inkjet prints. The process is a very attractive alternative to hand-painted signs or posters printed by the conventional lithographic method. The price is also attractive.

Laser-end (direct-to-laser)

Proofing of text for image location is usually the first of many steps for custom and premium designs, but it may be the only proofing method used for standard-level products. The typesetter proofs directly to color and/or black and white laser printers. These proofs are used to catch typographic errors, examine the typography specifications, and for editing. When photos or line art are not needed for the proofing, print with the proof option selected in the page setup or print dialog box. The images are replaced by a box on the printed page and the image files are not sent to the printer at all.

Prepress

Prepress consists of the negative and plate imaging process. Recently, this term has also been used to encompass the electronic prepress area (including computer operations) needed to output film to an imagesetter, digital proof, direct-to-plate, or laser printer. The quality of the process is determined by the length of run for laser printers and by the kinds of images and the use of correct imaging techniques in all cases. The list of processes are growing but, fortunately, most fit into three general categories:

1. Direct-to-plate. Direct-to-plate quality is dependent on the kind of plate the image is transferred to. These plates can be made of paper, plastic, or in the case of high-end equipment, aluminum. The aluminum plates yield the best register of images because the material is more stable than plastic or paper. The quality of an aluminum plate combined with a high-end, medium-sized press yields high quality within a specific moderate price range for press runs under 1,000 copies.

2. Imagesetter output. Imagesetters' negatives are the best quality output for projects with four-color process, tight register, photographs, large solids, or type in sizes under 7 points. The added cost of the negative is justified for longer runs. Often, the cost for negatives is negligible when calculated on a cost-per-copy basis. Imagesetters can be set up to output paper positives, film negatives, or higher level direct-to-plate.

3. Laser processes. The laser printing process uses electronic processes following specific steps, which include exposure, development, and fusing. Exposure imparts an electrical charge in the image area and creates a magnetic field in the area where the image should be placed. A toner mixed with iron filings attaches to the charged image area but not to the non-image area. The sheet is then run through a unit called a fuser, which fixes the toner to the paper or plate using very high heat and pressure. This is what makes the toner a permanent part of the paper or plate.

Printing

The term printing is used to signify the final production of copies. Other names for the printing process are offset, copying/duplicating, and large format. Each has become popular because of its ability to satisfy demands at a certain level of design considering three variables: budget, deadline, and quality. Usually, the client chooses the process based on one of those three variables. Keep in mind that each of the processes can yield acceptable or unacceptable quality for its technology. Learn to distinguish each process.

Offset printing

Some presses operate in different sequences, but the process consists basically of three steps:

1. **Ink** sticks to the image area on the plate and a combination of water and temperature keeps the non-image area clear of ink.

2. The **image** is transferred to a blanket (which is made of a rubber-like compound).

3. The **blanket cylinder** presses against the impression cylinder. The impression cylinder has a sheet of paper firmly held in a set of grippers and the image transfers off the blanket to the paper.

There are three levels of presses and each has limitations and advantages. Those levels are:

1. **Large presses.** Large presses print on sheet sizes that hold from eight to sixteen pages on an 8½″ x 11″ document per sheet. They can print 175 lines per inch (lpi) and higher. Some advanced presses are even capable of printing up to 400 lpi. These screens have resolutions of 2540 to 4000 dots per inch (dpi) on an image setter. The halftone dots are difficult to see without a magnifier and give the photos and tints a smoothness and exactness that cannot be achieved at a lower line screen. Large presses are capable of printing four, five, or six colors on a sheet with a single pass through the press, maintaining tight register between the colors. Some of these presses, called perfectors, can also print both sides of the sheet simultaneously. The large presses use a separate printing unit for each color laid on the paper. They utilize a system of transfer grippers to maintain register and advanced, high speed ink and water units. The additional printing units allow four-color process, so premium-level projects can be enhanced with additional colors beyond the standard CMYK. They can include other process colors for depth, PANTONE color inks for spot color, and varnishes for glossy or matte finish appearance. The matrix of acceptable and unacceptable job characteristics for each large press output system is detailed in figures 7-2 and 7-3.

2. **Medium-size presses.** Medium-size presses print up to two 8½″ x 11″ pages as a spread or a full bleed 11″ x 17″ page. The quality of tints and photos is high, as these presses are capable of printing 150 lpi and higher. The negatives output for these presses should be created at 2540 dpi or higher. These presses are designed to handle larger, solid ink coverage up to a full 11″ x 17″. Pressures on rollers and cylinders are set by micrometer-type adjusters and the press is capable of producing a higher level of sharpness and exactness in the printed image than small presses. The accurate pressure settings and larger ink coverage allow any publication to have excellent image quality. The matrix of acceptable and unacceptable characteristics of jobs for medium-size press output systems is detailed in figure 7-4

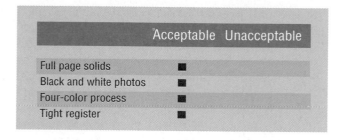

Figure 7-2 Large press from direct digital plate (2540 dpi or higher)

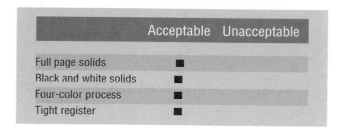

Figure 7-3 Large press from imagesetter film to plate (2540 dpi or higher)

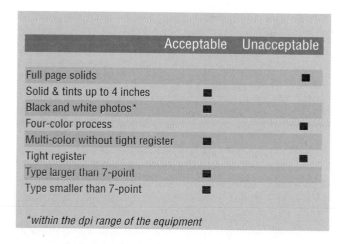

Figure 7-4 Medium-size press from imagesetter film to plate (2540 dpi or higher)

3. **Small presses.** Small presses are also called duplicators. Most of these presses will feed 11″ x 17″ paper. Quality control is in the hands of the operator. A skilled press operator will be able to run solids that are as long as the diameter of the ink form rollers (typically 4″ long with two colors of ink in tight register). Small presses are limited to 133 lpi for photos and tints. Some presses have two sets of ink and water rollers for printing two colors simultaneously. Since pressure settings between the image transfer system must be set by "feel," image accuracy is unsatisfactory for premium level projects. Using images and image sizes that fit within the specifications of these machines will give medium to good quality photos and tints. This is sometimes referred to as "pleasing color." The matrix of acceptable and unacceptable characteristics of jobs for each small press output system is detailed in figures 7-5, 7-6, and 7-7.

	Acceptable	Unacceptable
Full page solids		■
Solids up to 4 inches	■	
Black & white photos and tints*	■	
Four-color process		■
Multi-color without tight register	■	
Tight register	■	
Type larger than 7-point	■	
Type smaller than 7-point**		■
Textures	■	

*Printed result will be dependent on the quality of dots from laser printer.
**Higher resolution laser printers are capable of producing quality text smaller than 7-point. Evaluation on a case-by-case basis.

Figure 7-5 Small-size press from laser print original to negative (300-1800 dpi, depending on original)

Copying

A general division of printing devices places the 300-1000 dpi printers and duplicators in a class called laser processes. In general, when dealing with equipment in this group, the lower the number of dpi that the printer can use to create type and halftone dots, the coarser and thicker the image and type appears. On examination under magnification, the visible stair step effect called bitmapping can be seen at the edges of text that is printed on a diagonal line or around a curve. The equipment is listed in ascending order of quality:

- **Traditional copiers.** The lowest quality is produced by taking laser printer output from the file and making conventional copies. There will be a 20–25% loss of image quality because of the intermediate copy step. This loss of quality, called a generation loss, will occur every time an original is re-copied. If the laser print is copied and then the copy is copied, there is a second generation loss. For best results, prepare the laser printer for the best possible quality before printing. For a temporary solution,

	Acceptable	Unacceptable
Full page solids		■
Solids & tints up to 4 inches	■	
Black & white photos*		■
Four-color process		■
Multi-color without tight register		■
Tight register	■	
Type larger than 7-point	■	
Type smaller than 7-point	■	

* within dpi range of equipment

Figure 7-6 Small-size press direct to photo then direct to plate from laser printer (1200 dpi minimum)

	Acceptable	Unacceptable
Full page		■
Solids and tints up to 4 inches	■	
Black & white photos and tints*		■
Four-color process		■
Multi-color without tight register		■
Multi-color without overprinting	■	
Tight register		■
Type larger than 7-point	■	
Type smaller than-7 point		■

*within dpi range of equipment

Figure 7-7 Small-size press direct to imagesetter and then aluminum plate

	Acceptable	Unacceptable
Full page solids		■
Solids up to 4 inches	■	
Black & white photos and tints*		■
Type larger than 7-point	■	
Type smaller than 7-point*		■
COLOR COPIERS ONLY		
Full page color	■	
Tints and halftones*	■	
Tight register	■	

*within dpi range of equipment; if laser looks acceptable, output will look acceptable.

Figure 7-8 Traditional copier from laser original

gently rock the toner cartridge before printing the copies, or install a fresh toner cartridge. Always keep a package of the highest quality, whitest laser paper on hand for printing project originals and avoid adding tints or photos to pages without running a sample test (figure 7-8).

- **On-demand printing.** On-demand printing is direct output from the file to a laser copier. On-demand color must translate through a RIP. The quality can be acceptable for intercompany correspondence and presentations, but is rarely used for client output, especially with business-to-business clients. Tints and photographs are low quality because of the dpi of the device. Many of the copier manufacturers have attempted to compensate for low dpi by introducing a "dithered" screening method, which eliminates the traditional dot pattern and substitutes a more random one that gives the image the appearance of higher resolution. These output devices are very versatile in that they can feed overhead transparency material and the lighter cover weight stocks for short runs (figure 7-9).

	Acceptable	Unacceptable
Full-page tints or solids		■
Black & white photos*	■	
Four-color process*	■	
Tight register	■	
Type larger than 7-point	■	
Type smaller than 7-point*	■	

*within dpi range of equipment

Figure 7-9 On-demand printing direct from file to black and white or color copier

Large formats from dye sublimation

Dye sublimation printing uses a three- or four-color process, placing the image on the paper through a heat transfer system. A gel-based ribbon is rolled across the paper and a thermal head transfers the image to the paper, adding one color at a time. For color accuracy, a CMYK dye sublimation, not an RGB (red, green, blue) printer is recommended because the final output on press will be created with CMYK inks. An RGB representation of those colors may cause a noticeable color shift. CMYK dye sublimation printers more closely match accurate proofing color than any other color printing method. Many times, except for the feel of the paper and the lack of halftone dots, the color of a dye sublimation print is indistinguishable from that of an actual Matchprint proof (figure 7-10).

	Acceptable	Unacceptable
Full page	■	
Solids& tints up to 4 inches	■	
Black & white photos	■	
Four-color process*	■	
Tints	■	
Tight register	■	
Multi-color without tight register*	■	
Multi-color without overprinting*	■	
Type larger than 7-point	■	
Type smaller than 7-point		■

within dpi range of equipment

Figure 7-10 Dye sublimation direct from file to large format printing

Quality control devices

Use of a quality control device can isolate steps in the reproduction process that are responsible for quality problems and can give a visual picture of the quality range for each process being used in the output of the file. Various testing methods measure the exposure, latitude, and image quality of the various processes.

Equipment in the designer's area should be tested at established intervals. A calibration strip should be run with the first negative of the day on an imagesetter to verify the accuracy of the hardware and its calibration settings. Copiers are tested less frequently, but a calibration check should be run on them at least monthly. As with any valid scientific experiment, eliminate as many variables as possible before performing the tests. Use quality paper or film, making sure you have adequate quantities of toner for copier calibration and properly mixed chemistry for imagesetter calibrations. Also, ensure that you are using the appropriate calibration strip, target, or file for testing each piece of equipment.

Speak to the service technician about the proper file or target to use when testing the calibration of these devices and ask questions to clarify any confusion you may have. Also, remember that the calibration procedures used with any device are normally outlined in the documentation for that device.

Control strips, targets, and calibration files

Whether the calibration is performed at this location or by an outside professional, all processes use some sort of standard for calibration. Standards might include gray scale step wedges, color targets, and/or files within the software of each device that generates a calibration target on the output device. All of these will reference some known benchmark. Benchmarks may be industry standards (such as the Stouffer scales) or specific only to the device being testing (such as color copiers).

Quality and calibration can be tested at each step of the output process: laser prints, imagesetter film, color proofs, plates, and press sheets. (Figure 7-11 shows a Stouffer scale available in both negative and positive versions that is used to test calibration on scanners and platemakers.) Imagesetters normally have a calibration test target within their software to allow testing for proper calibration (figure 7-12).

Figure 7-11
A Stouffer control device is used for all levels of prepress and offset printing. *Courtesy of Delmar Publishers*

Figure 7-12a and b Sample calibration strips. *Courtesy of Delmar Publishers*

(As in figure 7-11b, targets may change depending on the type of page elements.)

Most importantly, if the printing company is having difficulty producing the quality or reproduction you require, ask to see their calibration results for the output device. If the printer cannot produce those results or, worse yet, does not know what you are talking about, use another printer.

Create a test original

A test original (figure 7-13), can serve as a control whenever test targets are unavailable. If a test original can be printed when the equipment is new, it can serve as a benchmark for quality control. When the same original is printed on all the output devices that will be used in the output of the file, it will serve as a visual aid and will help to explain quality differences in each output process. This test original should include solids, flesh tones, a gray scale step wedge, and a color tablet with cyan, magenta, yellow, black, red, green, and blue in various tints from 10–100%. If included, focus or resolution targets help to determine the equipment's ability to reproduce very fine or very small images.

Set up a schedule to run the test original. A problem will be easy to identify by comparing the original sample printout with a print made immediately after a service call. A comparison of the two will tell if the equipment is performing to specifications or not. The test original can be set up in a file and used to test a new laser printer, a copier reproducing original laser prints, and an on-demand laser printing device.

Color controls

Color control devices are very sophisticated systems that generate and control color quality. These systems use specific software and often include high quality measuring instruments to achieve quality and consistent color calibration. Each of these color control systems increases the accuracy of color at every step of the reproduction process. This is important because color perception changes with the medium—color on a monitor looks different than it does on a color proof or on the press sheet.

RGB is a computer monitor's native color mode. RGB colors are transmitted like television screen lines that appear to be continuous shades and colors. As a monitor uses a different numerical value system to generate color, it can only represent an approximation of CMYK on the screen. Even when great care has been taken to calibrate a monitor, what shows on the screen is "view only" color, not accurate color representation. There are CMYK monitors on the market but they are very expensive and few companies have invested in them. Even with these, the calibration is difficult to verify and so their colors should never be accepted as entirely accurate.

Spot and process colors are the designer's production colors. Their color names and composition data are included in the file containing the color names. This color is interpreted by software and hardware at each step of the production process. The calibration and accuracy of color at each of these steps helps ensure that the color will be as anticipated on the printed sheet.

Spot color (color and tints selected from the PANTONE MATCHING SYSTEM) requires that the printing company put a specific color of ink in their printing press' ink system. These colors are nearly always a custom ink mix and must be ordered specifically to print the file. In addition to having a custom ink mix, the printer must run each spot color as a separate color run. Each spot color requires another pass through the press, normally up to a maximum of four passes.

CMYK color is usually referred to as four-color process. Use a magnifying glass and examine several printed publications created with four-color process. Pay special attention to flesh tones. Notice that the dots appear to form flower patterns called rosettes, and yet those patterns give a smooth effect to the naked eye. Just as watercolor and oil paints will not produce the same colors, a monitor and a printing press will not create the same colors because they are created by different color systems. Since the monitor can produce more visible colors than a printing press can, adjust the color on the monitor to achieve the most accurate color match to

Figure 7-13 (Opposite) Sample of test original

TEST ORIGINAL

LINE WIDTHS HAIRLINE

 .5 LINE

 1-POINT LINE

 12-POINT LINE

SOLIDS

HELVETICA TIMES TINTED TYPE IN A REVERSE BOX,

BLACK REGULAR ROMAN FACE
REVERSED REVERSE **AND SANS SERIF FACE**

PHOTOS: ADD A BILLFOLD PHOTO, AN 85 LINE SCREEN PHOTO AND A 200 LINE SCREEN PHOTO

BILLFOLD PHOTO 85 LINE SCREEN 200 LINE SCREEN

SIX-POINT TYPE 72-POINT HEAVY TYPE

Six-point Aachen bold

Six-point Times

Six-point Helvetica

Six-point Snell Roundhand

Gill Sans

SCREEN TINTS WITH OVERPRINTING AND REVERSE TYPE

| 20% black | 40% Black | 60% Black | 80% Black |
| 20% black | 40% Black | 60% Black | 80% Black |

| 20% black | 40% Black | 60% Black | 80% Black |
| **20% black** | **40% Black** | **60% Black** | **80% Black** |

the printed piece. The color can be controlled on the monitor through software.

Files containing spot or process color require matching color palette choices for each file. In other words, when logos are created in drawing packages, the final page layout file contains both color systems. It will image all six colors: four CMYK and two spot colors.

Other common problems arise when line art containing spot colors or color in a drawing package are used. Revising a color choice in a page layout software package without revising the color of an included drawing can create difficulties. Any of these errors will produce an extra negative and require an extra color run through the press.

Color choices require quality control at each step of the production process. Monitor color, proofing color, and printed color require calibration and control strips or calibration files. Colors picked from the PANTONE MATCHING SYSTEM—regardless of what the monitor color appears to be—are consistent with press colors and are the most dependable method of determining color, shade, and hue. Monitors that have not been color calibrated may display color completely different from that produced on the printed piece.

Troubleshooting

When taking a car for service, the best results are produced when the customer and the service technician know each other's language and when the customer can use specific terminology. Below are some troubleshooting tips that may be helpful when discussing unacceptable quality with the printing company. If the printed copies do not look right, but the cause is not clear, use a magnifying glass to examine the image and compare it to a quality control sample from the same process and equipment.

What to look for on laser copier originals

The laser image varies depending on the number of copies and the time between service calls. Be sure to give the laser printer a cleanup when changing the toner cartridge. Follow the instruction manual for safety procedures and instructions for cleaning up toner dust inside the machine. Quality can deteriorate quickly when laser copies are used as originals.

Imagine the look of the final publication when, instead of a 25% generation loss of quality and detail from the intermediate laser copy, you observe a 50% loss.

If final copies are produced using laser printer output as an original, quality problems are likely. The following terms may be helpful when working with the operator to eliminate specific equipment problems.

- **Light or broken copy.** Through a magnifying glass, the type will look gray instead of black or the text may be thinner than expected. Both are caused by a light or gray image on the original or a need to lower the contrast on the copier.

- **Trash on the page.** There may be a flaw in the image area or black spots appearing at random on the sheet. Both can be caused by dirty glass on the copier or a dirty original.

- **Wrong color.** Since color varies from copier to copier, have the color copier run a test sheet of various colors. They will be a close match to PANTONE Color ink. If the calibration on the copier is off, choose the color you would like to have used from the sample that was just printed.

- **Image** and **sheet size.** An image longer than the image size of the laser device can be printed on 8½″ x 14″ paper and then trimmed to 8½″ x 11″, but an image that is wider than the printing area usually needs to be reduced. A 97% reduction is a good starting point and can usually give enough margins to print properly without changing the look of the publication.

- **Correct dpi on all images.** Check the test original for tint and photos. Not all tints print well on copiers and if photos are stored at a lower resolution than the copier's resolution, the dots will be visible without magnifying glass. When line art is enlarged from a computer and printed on a laser output device, the edges will remain smooth if the drawing has been saved as vector art. If the drawing was converted to another non-vector format, the edges will become jagged and bitmapped. Some of the file formats that can commonly cause bitmapping during enlargement are PICT, TIFF, BMP, and CompuServe GIF.

Printing press troubleshooting

The final printed copies are checked after the project is finished at the printing company. Each level of printing press has its own set of parameters for quality but all share sets of common problems. Look for the following on printed sheets from an offset press:

- **Set-off.** When one side of the printed publication is finished and the ink has not dried completely on that side of the sheet, transfer of ink can occur from the printed side of the sheet to the blank side while the job is sitting in stacks waiting for the next step. This is called set-off.

- **Scumming** or **toning.** A light tint or tone of the ink color appears, usually at the top of the sheet. This problem is easy to spot because there will usually be a definite line at the top of the paper where the ink did not go above the gripper margin. This can be corrected by adjustment of the ink and water systems on the press by the operator.

- **Slow-drying inks.** When a publication is finished, the ink should not come off on the customer's hands. If this occurs, the ink used in the publication is not drying quickly enough. This also can contribute to set-off and can be corrected by mixing a chemical drying agent with the ink.

- **Light** or **broken copy.** If parts of letters or images are missing or are lighter on the sheet than the surrounding images or text, the pressure adjustments on the printing press are probably off or the ink and water balance is off. Correction of this problem can be made by most skilled operators while you wait.

- **Trash on the page.** Paper may leave small pieces of lint or paper dust that can transfer back to the ink rollers and will then be distributed to the imaging blanket. They will appear as speckles in a non-image area or odd little circles that will not take ink and will print white on a solid or halftone. The printing companies often refer to these as **hickeys**. A thorough cleaning of the ink system, water system, and blankets is the only solution for this problem.

- **Wrong color.** When a color matching system is used to specify a color, the color reference for that color is usually printed on white paper in the selection guide book. If the printing company prints this color on white paper as well, the color should match exactly. One exception is if the page is to be printed on colored paper with transparent or semi-transparent inks. The color of the paper lends its tone to the color of the ink and a third, different color is produced. More advanced methods of color proofing allow the proof to be made on the actual paper to be used in production, thereby allowing the designer to more accurately anticipate any color shift due to paper color tone.

- **Wrong image** and **sheet size.** If images are traditionally added or stripped into the publication by the print company, errors can occur. Images can be turned around, cropped incorrectly, dislocated, or even omitted completely. An altered sheet size can cause **clipping** of the file, which means the image or text appears cut off at the edges. Check the sheet size to be sure it is what was agreed upon and double-check all images to verify that they are placed properly.

- **Correct dpi in all images.** Coarse dot patterns in files that are sent directly to the plate are difficult to identify without preflight software. This usually will occur in a file placed into a page layout software document from a drawing package that will not allow the setup of output dpi and lpi independently for that art file. Another source for this error is if the designer specified the dpi and lpi incorrectly before the job was sent to the RIP.

Summary

Determining the correct technique to use and understanding the resulting quality is the most effective approach for preventing errors in quality.

For additional research

Keep a well-balanced design approach by continuing research into some suggested sources:

Read software reference books.

Attend printing and computer shows.

Visit a service bureau and attend a software seminar.

Take adult education classes at local community colleges.

Join professional organizations.

Contact the service professionals:
 Graphic Arts Technical Society
 4615 Forbes Avenue
 Pittsburgh, PA 15213

Adams, J. Michael, *Printing Technology,* New York: Delmar Publishers, 1996.

Cost, Frank, *Pocket Guide to Digital Printing,* New York: Delmar Publishers, 1997.

The Lithographer's Manual, 10th ed., Pittsburgh: Graphic Arts Technical Foundation, 1995.

II Types of Publications

What we need to start this company is... and business cards

Chapter

8 Business Communication Packages

Production packages
Logos
Letterhead
Business cards
Envelopes
Composite
Invitations and announcement cards
Other business comunication projects
For additional research

*After reading this chapter and applying its principles,
the designer should have success producing:*

- Logos
- Business cards
- Invitations
- Appointment cards
- Diplomas

- Letterheads
- Envelopes
- Tickets
- Name tags
- Awards

Every company and organization needs publications that "formally" present themselves to present and potential customers. The publications allow the customer to access the company in a short amount of time. The process unfolds in the following manner. Formal publications are delivered personally or mailed. The customer identifies the company or begins to identify the company from the logo or name. The information may be read and then thrown away or filed for future reference. Through this communication, the beginning of a relationship between business and customer is established. These basic publications, along with the other complementing business communication projects, are covered in this chapter.

Publication packages

The company name and address information appear in most of these publications as an important communication link. Publications in this package are usually designed in a specific order beginning with the logo and then followed by either the business card or letterhead.

Page elements

Each piece of the basic business package (figure 8-1) repeats the page elements using the same type specifications in different sizes. The following definitions include information about the use of the page element in all publications.

Logo

A logo is an identity symbol composed of a drawing, shape, or unique typographic letters used in combination with the company location information. Used in the business packages, the logo commonly appears in sizes between ½ –1½".

> ✗ Cross reference: All samples in this chapter contain logos.

Company name

This is the legal name for a company or its acronym. Special attention is paid to the typeface and letterspacing. When there is not a symbol logo, the typesetting of the company name is considered the identity symbol.

> ✗ Cross reference: Follow techniques found in Chapter 4 under "Display Type."

Addresses

The mailing address is used if only one address exists. Some business publications include the physical street address along with other company addresses. Postal services request that the P.O. for box numbers be typed without a spacebar and that zip codes include zip code plus four, such as "77939-0307."

> ✗ Cross reference: Abbreviations for state names are found in the *Appendix*.

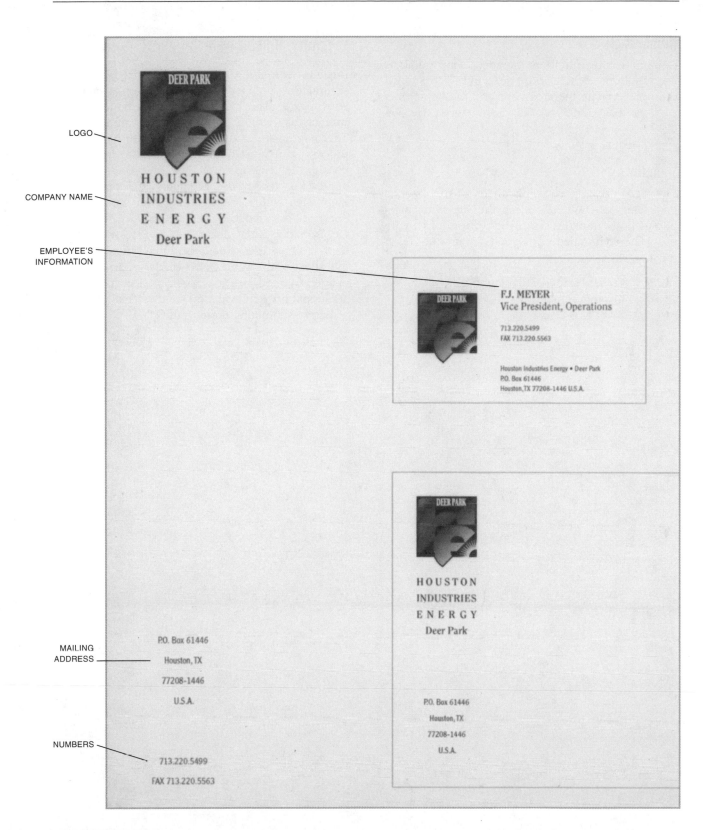

Figure 8-1 Essential page elements for business communication package. *Credit: HL&P Corporate Graphics, Regina List Grace, designer.*

Numbers

Communication numbers include phone numbers, fax numbers, e-mail addresses, and Web site addresses. Separate the area code and phone number, such as: 212-554-0909, (212) 554-0909, or 212/554-0909.

Signature

The signature is a combination of all the essential page elements. When placing the signature into a publication, transfer the specification exactly by using the style palette or copy from another document.

> ✘ Cross reference: Signatures appear
> throughout Chapter 10.

Specialty finishing techniques

Business communication packages frequently use several finishing techniques, even on a standard level design. The most popular technique is **thermography**, which is raised letters on the sheet. Thermography is done as part of the printing process so it must be specified before the project goes to the printing company. Other finishing techniques for custom and premium level projects are embossing with foil, embossing over ink colors, or blind embossing of the sheet without any ink or foil. Occasionally, a die cut will be used for premium level designs. These die cuts punch out a section of the sheet with razor sharp blades shaped as the image mounted into a wooden board. Include the additional price information for these extra processes before submitting them to the client.

Logos

The logo is the company symbol appearing on business publications as well as on advertising publications and outdoor advertising. The logo is the most effective tool of the basic business package and its design sets precedence for the complementing publications. Because of the importance of the logo, additional time should be spent with the client discussing the intended purpose and effect of the logo. After a logo is established, changes to the logo are completed gradually in order to retain the company's identity.

The logo's design must be carefully executed but completed on time, simple but unique, and a quality publication. Remember that a poorly designed logo seems magnified since it is seen repetitively. Present logo designs reflect clean style, classic type, and graphics with simple lines.

Logos are used in many sizes in both business and advertising publications. A logo may be enlarged to 40 feet or reduced to ¼″. Therefore, all flaws and complex details must be considered in all the possible environments. Smaller or new companies create a single logo that changes only in size. But larger companies require the designer to include variations of a specific logo to match requirements for four-color process, black and white, reversed, and spot color. They include various positioning, a multiple color use, and a black ink only use. (See figure 8-7, a logo tinted in the background requiring a redraw without a tint for fax and copiers.)

Research

The first essential step to building a logo is quality research. All levels of logo design require research:

1. Identify the message of the company with the typeface and design. Create an effect that matches words like traditional, conservative, innovative, sophisticated, fun, feminine, masculine, product-oriented, and service-oriented.

2. Request samples of other company publications. Then, consider the following:

- Typing format. Use the typing format as an indicator of where the logo should be placed (what are the margins?).

- Computer-generation or fax transfer. Use it to match the spacing to equipment and test readability.

- Business communication publications that already exist. Use them to match the design or include redesigning or redrawing in the estimate.

3. Request information on possible additional uses:

- A two-color logo for letterhead

- One color of the same logo for use on a copier or fax

- Marquees or billboards

- Embroidered on shirts and hats

Design

Logo design requires information about the company along with the categories of design, approaches to design, and production process.

Choose the type of logo

Begin by choosing from four different kinds of logos (figure 8-2):

1. Wordmark. Usually, the company name or the first word in the company name is set in type without any additional drawings. For unique identity, some companies have a special type designed for their logo or modify an existing typeface. Shape and contrast may added to the company name with a reverse box, circle, or shape. The major oil companies and fast food chains add a shape to their name to make it recognizable. Shapes most frequently used are square, round, oval, and diamond; but they are not longer than double the height.

2. Initialmarks. Initialmarks are similar to wordmarks but an initialmark may appear as an initial or initials in a shape. It is treated like an art logo and can be used with different placement

arrangements in the signature and different sizes in proportion to the address.

3. Graphics plus type. This type of logo includes the company name with a graphic either interwoven or layered together (figure 8-2b).

4. Graphic only. This logo is a drawing or symbol that has meaning and can be interpreted. The graphic conveys the message or purpose of a company and might consist of a very stylized drawing reflecting the product or service. It is usually used by large companies with national recognition.

Complete several sketches

Logos require a large quantity of sketches until the "look" that relays the message or effect is accomplished. The higher the design level, the more sketches are required. Divide sketching into series of ideas. The first set should pursue a variety of ideas and the second set should show variations of the ideas.

Carefully choose the typeface

Although each company wants to look unique, most national companies stick to standard typefaces. When experimenting with unusual typefaces, stay away from typefaces that are decorative or have extremely thin lines—they may not reproduce well.

Include type alignment and contrast

Try a variety of weights, width changes, or letterspacing. Also, contrast one word of the logo with another type face or size. When adding rules under the name, position them 2 to 6 points below the baseline.

Use proportional graphic shapes

If a shape is added, try a shape no longer than twice the height or twice as long as it is tall. If the logo is longer or wider than this, it is difficult to fit it into a page design when used in other publications.

Limit details in graphics

Maintain quality by using line widths that reproduce well. Choose graphics with a small amount of detail. The less detailed the line art the better it will reproduce as a logo in all the size requirements.

Production hints

These production hints help provide the flexibility needed for the various uses of a logo and ensure dependable line widths when enlarged or reduced:

- Set up a logo template file for all logos. By setting up a logo template, frequently used techniques such as guidelines, layers, default settings, and opened windows can be added. Use a page size 3″ x 3″ or a similar size to ensure the proportional shape of the logo. At this size, 4-point line widths and 4-point white spaces do not bleed together when reduced.

- Scan the sketch into the drawing package. Enlarge the sketch to the template size or slightly modify the page size to be proportional to the logo; then gray it to the background. This will help place guidelines, determine the type size, and build on past experiences.

- Test the logo at several sizes to all output devices. Place the logo into the page layout software at full size, 50%, and 25%. Include this as the proof sheet for final approval to the client.

- Scan existing logo to redraw. When given a copy of a logo, do not scan and place; rather, redraw it with a drawing package or with the pen tool.

Logo samples

Although the samples in figures 8-2 and 8-3 do not indicate the hours spent in research and conferences, they do show the contrast between stock images and custom production images throughout the levels of design.

KEN'S
TREE FARM

Figure 8-2 Wordmark and initialmark logos created in a drawing package.
Credit: No Bad Graphics, Regi Stewart and John Helms, owners/designers

Figure 8-3 Custom level design logos created
with a picture font. *Credit: No Bad Graphics,
Regi Stewart and John Helms, owners/designers*

Figure 8-4 Premium logos
created in a drawing package.
*Credit: Manlove Advertising,
Pasadena, TX, design and
production*

STANDARD

CUSTOM

PREMIUM

Standard level logos

Standard level logos are for start-up companies with a minimum of capital available for advertising (usually home-based or single employee companies). Figure 8-3 includes samples of some economical but effective logos that can be produced with the following tools:

- Ornament, symbol, or picture fonts. Type fonts with symbols, pictures, or sets of ornaments will produce high quality reproductions because they are imaged similar to typefaces. Adding a black square or oval to an ornament gives it a logo design look.
- Line art. Stock line art can be used as logos if the line width and shape match the requirements for logo sizes, or if it is encapsulated PostScript (EPS). EPS files allow modification in a drawing package such as converting to an outline shape or eliminating detail. Additionally, try a shape around the art to give it a logo look.

Custom level logos

Most company logos are custom level. Budgets are more generous and the number of uses of the logo encompass the overall cost of the logo. Wordmark and initialmark logos are custom level. When de-

signing a custom logo, picture fonts can be used in the drawing package. Since the symbol is part of a typeface, it can be modified in a drawing package by converting it from typeface letter to outline.

Premium level logos

Business-to-business communication and national corporations must project high quality. The size of the company is less of a determinate for this level of design than are the customers. Several kinds of logos fit into this group (figure 8-4):

- Symbol logo. A symbol that is unique to itself and stylized to reproduce at ½˝ or 40 feet tall is complex to design. Plan to sketch hundreds of designs and to attend a series of conferences to produce this design. Some intialmarks are so unique that they could be called art symbol logos.
- Type only. All type should be well kerned for a company name. The subtle twist, such as changing the dot on the letter "i," makes all the differences between a standard signature and a premium signature. Look at national and international companies for clean and simple logos, usually in one of the typefaces listed in Chapter 4.

Letterhead

After the logo is designed, the letterhead design is built around it. The letterhead serves as stationery for all business communications outside the company. It is a shell that frames a letter and further identifies the company to the customer or potential customer.

Margins

Before beginning a letterhead design, it is important to recognize the limitations of the design that are controlled by the printing. There are two limitations that must be considered with all design:

1. The letter format. There are several typist formats acceptable for typing a letter. Margins consist of 2½″ from the top, 1¼–1½″ from the sides, and 1″ from the bottom.

2. The printing company. Printing presses need the image no closer that ⅜–⅝″ from the top, depending on the presses gripper margin, and ¼″ from the side. Additional cost will be added for images outside these margins. The results of the requirements are a printable area shown in the third sample of figure 8-5.

Grids

Page design involves considerations such as creating a focus for the information and using a grid. The grid design and alignment choices of the letterhead should complement the typist's format. Otherwise, look for a grid that places copy like a frame around the letter and follow the letter format used to type the body of a letter. Although some copy is centered, most type is placed into grid sections.

For copy placed at the *bottom* of the sheet, allow ¼″ from the bottom to separate it from the body of the letter. Make sure to allow the printing company room for production variables.

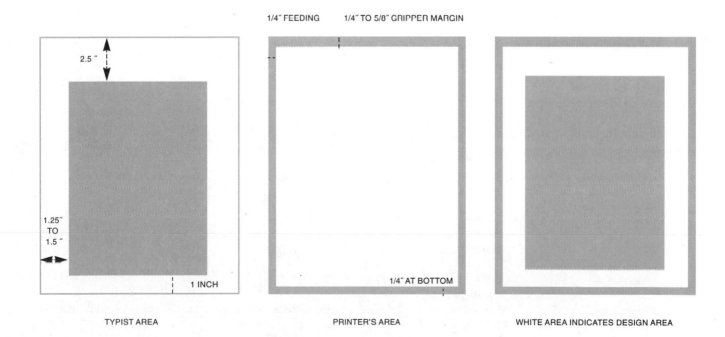

Figure 8-5 Limitations for design areas

A formal letterhead may have a hairline box around the outside, but it should be no closer to the edge of the paper than ⅝″. When using small presses, avoid heavy rules around the outside of the letterhead because the vertical part of the box is difficult to keep evenly inked.

Production hints

To help keep the type specifications exact for all business communication publications, determine which software package is the best to use for final production. The choices include:

- Typeset all elements in the page layout package. Then, bring the type into the next publication and scale down the type size as needed. This is most practical with standard level designs.

- Typeset the company name and signature in the drawing package. Save one as "Company name" and the other as "Signature." Be sure to keep all the publications with the file from one computer operating system to another.

- Typeset all elements in the drawing package. Use styles and names exactly as the type elements are named. Save the logo and signature as separate files and the final letterhead as a file.

Letterhead samples

Range for type specifications

Element	Type Sizes	Comments
Company name	14–18 pt	Choose from type specimen sheets (see figure 4-2)
Initials	24–48 pt	
Addresses	6 (caps), 7–11 pt	All caps or U & lc; width regular or condensed
City, state, zip		Same as the address
Communication numbers		Same as address; may be italics
Quote		Same size, use italics
Officers' names & titles		Names or titles are one size larger than body type or all caps

If the company's name uses a text typeface, the letterhead may use the same face. If the company's name uses a display typeface, the letterhead must use a text face. For the text, use a clean sans serif such as Helvetica (Arial) or a basic serif such as Garamond or Caslon.

Standard level letterheads

Small quantities and urgent deadlines are well met with standard level letterheads. Writing papers without deep textures will print easily in the laser printer. Ask the paper representative for specific paper choices.

If the body of the letter is added to a letterhead paper by feeding the paper through a laser printer or conventional copier for a second time, the letterhead cannot be run on a laser printer or conventional copier. The image will ghost on the page.

Try the specifications from figures 8-6 through 8-8 or change fonts and modify slightly.

Element	Type Specifications
Logo	72/60 Carta
Company name A	14/18 Caslon bold, all caps
Company name B	9/10 Caslon bold, all caps
Address	7/12 Caslon regular, all caps
Communication numbers	7/12 Caslon regular, all caps
Quote	8/18 Caslon italics, U & lc

PAPER AND INK. Black ink only on 20–24# bond, 8½″ x 11″, without rag, white, ivory, beige, or gray (check for matching envelopes); 60# book, 8½″ x 11″, without rag; or 20–24# bond or 8½″ x 11″, 25% rag.

FINISHING. Thermography

OUTPUT DEVICE.

1st Choice—Laser original (1000 dpi or greater) to copier.

2nd Choice—Laser original (1000 dpi or greater) to conventional printing company.

3rd Choice—Direct-to-plate at conventional printing company.

Figure 8-6, 8-7, 8-8 Standard level letterhead

Figure 8-9
Custom level letterhead with color
and tint on graphic

Figure 8-10 Custom level
letterhead with color and tint on
graphic and custom design
initialmark

Figure 8-11
Custom level letterhead
with wordmark logo

PREMIUM

Figure 8-12 Premium level
letterhead. *Credit: College of the
Mainland Foundation, Glenda Brents
Rebstock, designer*

Lawrence Emmett Markey

1303 Woodmere Lane

Richmond, Texas 77469

713-232-0531

LeM

DOCUMENT

Strategies inc.

9950 CYPRESSWOOD DRIVE

SUITE 201

HOUSTON TEXAS 77070

(713) 469-6992

FAX (713) 469-8114

First Annual
SILVER DOLLAR BALL
1 9 9 5

Bay Area Unit
American Cancer Society
Marina Bay Drive, Suite 130 – 199
League City, Texas 77573
713.335.1411
Fax 409.380.0007

Figure 8-13 Premium level
letterhead. *Credit: Emily Bush and
Freda O'Connor, designers*

Figure 8-14
Premium level letterhead. *Credit:
Vosburg de Seretti, inc., designers*

Custom level letterhead

Additional page elements, contrast techniques, and use of additional software packages add production time and increase printing requirements (figures 8-9 through 8-11).

Element	Type Specifications
Logo	Wordmark or initialmark produced in a drawing package
Company name A	9/18 Caslon bold, all caps
Company name B	9/10 Caslon bold
Address	7/12 Caslon regular, all caps
Communications numbers	7/10 Caslon regular, all caps
Quote	8/12 Caslon italics, all caps, increased letterspacing
Officers' names	8/12 Caslon semi-bold, U & lc
Officers' positions	8/12 Caslon italics, U & lc
Officers' departments	8/12 Caslon regular, all caps

Use an em space instead of a space bar before and after the bullet.

PAPER AND INK. Use one or two colors of ink. The most common colors for letterhead are very dark blue, very dark green, or wine. Check with the printing company for stocked popular premixed colors—it may save money and time. Use 20–24# bond, 8½″ x 11″, 25–100% rag; or 20–24# bond or 70# text, 8½″ x 11″, with laid or linen finish. Most text sheets have a matching envelope and cover weight stock for business cards. Business card stock that match rag sheets are bristol, vellum finish, and cover stock.

FINISHING. Thermography

OUTPUT DEVICE.

1st Choice—Laser original (1000 dpi or greater) to conventional small press.

2nd Choice—Direct-to-plate at conventional small press.

3rd Choice—Direct-to-film negative (service bureau) for conventional small press.

Premium level letterhead

Premium level designs focus on additional sketches, multiple presentation samples, and additional conferences with the client. Art boards should be used for all presentations.

The paper manufacturer will add a true watermark for a small additional charge on orders over 50,000 copies. Because the paper is wrapped commercially, it stores well and is a good investment. Thermography, embossing, blind embossing, special die cuts, and personalized watermarks can reinforce the quality of a premium letterhead.

Figure 8-12 is an example of a letterhead prepared for a professional executive. The sheet is a 20# writing paper. Type specifications are 48-point for initials and 8/20 for the address. Colors: PANTONE 4515, a gold; PANTONE 506, a burgundy; and black.

Figure 8-13 is for a new company doing business-to-business contracts. The light gray fiber sheet is a 75# text. The company address was 6/13. Although this design does not require trapping, it does require tight register. Colors: PANTONE 243, a purple; PANTONE 314, a turquoise; PANTONE 193, a paprika; PANTONE 477, a bronze; and black.

Figure 8-14 presents a letterhead for an event. The design required traps, and therefore, a medium to large-size press. Colors: PANTONE 185, a warm red; PANTONE 102, a yellow; PANTONE 475, a brown; PANTONE 312, a turquoise; and black.

Business cards

The purpose of a business card is to relay pertinent company information in a small space. Business cards are usually handed out during meetings, put in pockets or purses, and later saved in a card file. They are included with letters, brochures, and mailers. The business card should complement the other publications and match the letterhead type specifications. Understanding information about limitations, placement, and alignment, or following the samples, will ensure successful business card design.

Type

Because there are numerous elements on the business card, group as many as possible on a grid similar to the one used on the letterhead. Even though the type is small, the business card should relay an effective message to the reader even before they read the specific information.

Use the smallest readable sizes for the body text on business cards. Because there is so much type and so little space, using small type sizes is the only way to have room to group the type. Too many different sizes will confuse the reader. Compare a business card with body text larger than the standards next to one within standards. The card with large type will appear cluttered.

The serif or sans serif type used for the company name will usually hold up in 14-point type for the company name. If the address typeface from the letterhead does not work for the business card, an alternative is to use Helvetica and continue its use to all communication publications.

Fold-overs

Fold-over business cards add a flap with a single fold. Fold-overs can solve problems with too much copy. The cost of a fold-over makes it difficult to fit into a standard or custom level budget, but the design possibilities are excellent (figure 8-15). They require back and front printing with exact positioning on both sides and they may not fit into the customer's card filing system.

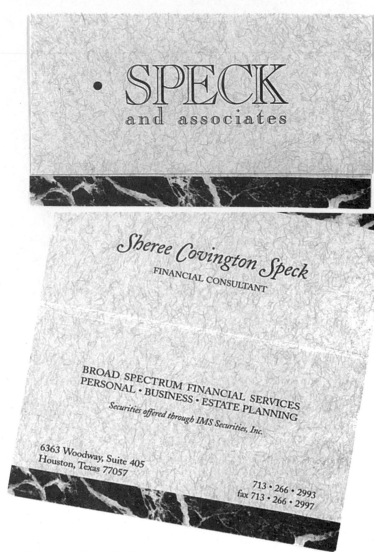

Figure 8-15 A fold-over business card in two colors of ink with bleeds.

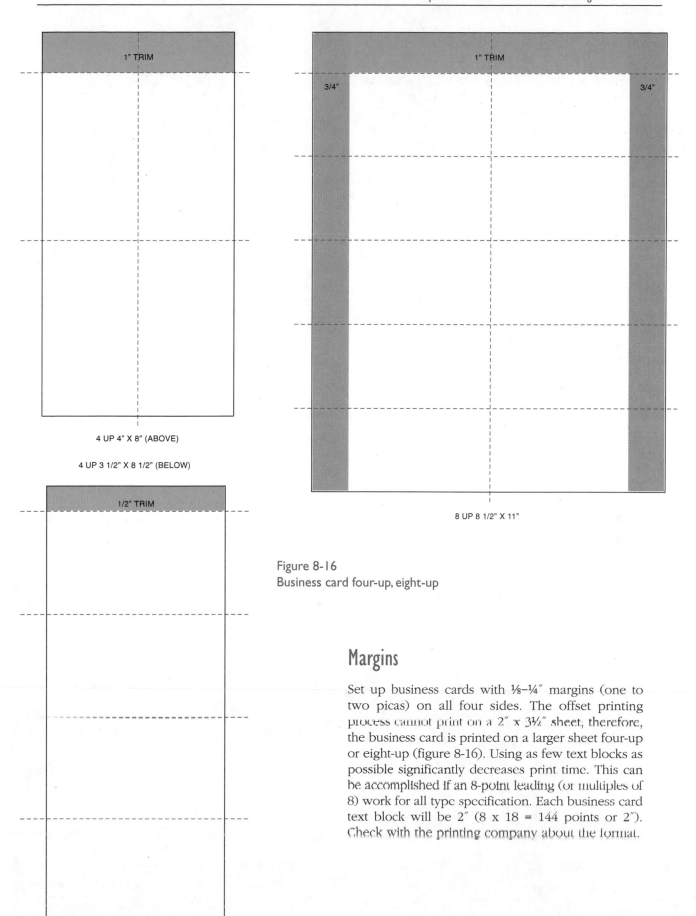

4 UP 4" X 8" (ABOVE)

4 UP 3 1/2" X 8 1/2" (BELOW)

8 UP 8 1/2" X 11"

Figure 8-16
Business card four-up, eight-up

Margins

Set up business cards with ⅛–¼″ margins (one to two picas) on all four sides. The offset printing process cannot print on a 2″ x 3½″ sheet; therefore, the business card is printed on a larger sheet four-up or eight-up (figure 8-16). Using as few text blocks as possible significantly decreases print time. This can be accomplished if an 8-point leading (or multiples of 8) work for all type specification. Each business card text block will be 2″ (8 x 18 = 144 points or 2″). Check with the printing company about the format.

Grids

The benefit of using a grid or repeating designs is that it works again and again. Follow the grid from the letterhead or create a new grid to help aid in the positioning and grouping of the copy. Following the letterhead designs may lead to a portrait business card (figures 8-18 and 8-21).

A business card with a small amount of copy and no logo may need a hairline around the ¼″ margin for contrast (figures 8-17 and 8-22). Copy must be one pica away from boxes to avoid a crowded look. A business card with what may seem like too much copy can be separated into several groups of elements with a horizontal short hairline or a vertical line on the left one-third of the card.

If the business card has multiple phone and communication numbers, logos, or art, separate them into groups.

Specialty printing companies

Specialty printing companies for business cards offer a guaranteed short turn-around time. Their basic prices are low, quality is consistent, and they offer thermography as an option. Basic paper choices are white and off-white. Additional cost is added for other colors and paper choices from the premium list. Also, expect an additional cost for reverse type, tints, logos, and other inks.

Business card samples

If the printing company needs a single copy original of the business card, output at 200% so that the dots on the finished publication will not be noticeable. At 100%, it is not a good idea to print from a 600 dpi or less because of the small type. As with the letterhead, avoid tints, extra large solids, or extra thin type that will get thick or broken using output to the laser.

Range for type specifications

Element	Type Sizes	Comments
Company name	10–14 pt	If initials, it can be 18 pt
Mailing address	6 (caps), 7–8 pt	
Communication numbers		Same as the address
Employee's name		Can be 1 pt larger than address
Employee's title		Can be italics
Kind of business	10 pt	Can be italics if it appears under the company name
Street address		Part of address
Listing of services/products		Italics
Product logos		½–1″
Margins sides		⅛″ to ¼″ (or 1 pica) on all four
Leading		8 pt or multiples of 8, if possible
Logo		½″ If the logo does not hold up well at this size reduction, place it in the background and give it a 5% to 15% tint and overprint the type.

Standard level business card

Small quantities and urgent deadlines are well met with standard level business cards. Rather than matching the writing papers, a 67# bristol will run through laser printers for short runs. Ask the paper representative for specific paper choices.

Try the specifications from figures 8-17 through 8-19 for style palette information or change fonts and modify slightly:

Element	Type Specifications
Logo	72/72 Carta
Company name A	14/10 Caslon bold
Company name B	10/10 Caslon bold
Address	6/8 Caslon regular, all caps
Communication numbers	6/8 Caslon regular, mixed case
Employee's name	7/8 Caslon semi-bold, all caps
Employee's title	6/8 Caslon italics, mixed case

W.E. WAISER, ADMINSTRATOR
Public Relations Department

SECURE INVESTMENTS
FINANCIAL GROUP
5114 CENTRAL EXPRESSWAY
BUFFALO, WA 50012-0412

PHONE 214-387-6632
FAX 214-387-6634
E-MAIL secure@ins.com

Figure 8-17, 8-18, 8-19
Standard level business cards

ARTHUR HERTZBERG
Plant Manager

SECURE INVESTMENTS
FINANCIAL GROUP
5114 CENTRAL EXPRESSWAY
BUFFALO, WA 50012-0412

PHONE (214) 387-6632
FAX (214) 367-3345
E-MAIL secure@ins.com

SECURE INVESTMENTS
FINANCIAL GROUP

COLEENA JACKSON
Senior Vice-President

5114 CENTRAL EXPRESSWAY • BUFFALO, WA 50012-0412
phone: (214)387-6632 • e-mail: secure@ins.com. • fax: (214)-387-6634

**SECURE
INVESTMENTS
FINANCIAL GROUP**

J.C. KOOI
Sales Manager

5114 CENTRAL EXPRESSWAY
BUFFALO, WA 50012-0412

PHONE 214-387-6632
FAX 214-387-6634
E-MAIL secure@ins.com

Figure 8-20, 8-21, 8-22
Custom level business cards

SECURE
INVESTMENTS
FINANCIAL GROUP
5114 CENTRAL EXPRESSWAY
BUFFALO, WA 50012-0412

JANICE POOLE
Employment Supervisor

PHONE 214- 387-6632
FAX 214 387 6634
E-MAIL secure@ins.com

SECURE INVESTMENT
FINANCIAL GROUP
5114 CENTRAL EXPRESSWAY
BUFFALO, WA 50012-0412

DONNA FRIELING (214) 387-6632
Training Coordinator Fax (214) 317-6632

Figure 8-23 Premium level business card. *Credit: Manlove Advertising, Pasadena, TX, design and production*

Figure 8-24 Premium level business card. *Credit: Vosburg de Seretti, inc., designers*

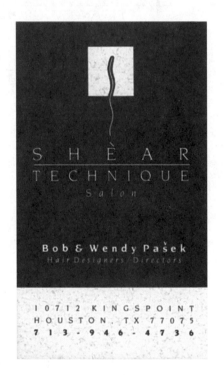

Figure 8-25 Premium level business card. *Credit: Air View Graphics and Printing*

PAPER AND INK. Black only with 67# bristol cover, vellum finish, ivory, white, cream, and colors feeds in laser printers. It has the "feel" of a 65# cover, is slightly lighter in weight, and is therefore less expensive. A second paper choice is 65# cover, uncoated, vellum finish, in warm white (off-white).

FINISHING. Thermography.

OUTPUT DEVICE. Be cautious of the small type at 600 dpi because it becomes dark and unreadable. Avoid tints, extra large solids, or extra thin type that will get thick or broken using output to the laser. An alternative choice is to output from the disk to the 1000 dpi or greater laser printer. 67# bristol will feed through most laser printers or copiers. The design will be eight-up.

1st Choice—Laser original (1000 dpi or greater) to copier.

2nd Choice—Laser original (1000 dpi or greater) to conventional small press.

3rd Choice—Direct-to-plate at conventional small press.

Custom level business card

Additional page elements, linking the design to the business package, and finer paper add production time and increase printing requirements (figures 8-20 through 8-22).

Element	Type Specifications
Logo	14/10 Wordmark or initialmark produced in a drawing package
Company name A	14/10 Caslon bold
Company name B	10/10 Caslon bold
Address	6/8 Caslon regular, all caps
Communication numbers	6/8 Caslon regular, mixed case
Employee's name	7/8 Caslon regular to semi-bold, all caps
Employee's title	6/8 Caslon italics, mixed case

PAPER AND INK. One or two colors of ink with 67# bristol cover, vellum finish will run through many laser printers and have the feel of a 65# cover with slightly less weight. It comes in ivory, white, cream, and colors. An additional choice is 65# cover, uncoated, vellum finish, in warm white (off-white).

OUTPUT DEVICE.

1st Choice—Laser original (1000 dpi or greater) to conventional small press.

2nd Choice—Direct-to-plate at conventional small press.

3rd Choice—Direct-to-film negative (service bureau) for conventional small press.

FINISHING. Thermography.

Premium level business cards

Premium level designs focus on additional sketches, multiple color samples, and additional conferences with the client. Art boards should be used for all presentations. The following are examples of typical premium level publications:

Figure 8-23 has spot colors converted to four-color process. The type and graphic logo is layered over a background tint which bleeds at the left. The type is in three sizes: 10, 7, and 6; the body copy has a 12-point leading.

Figure 8-24 is for a small business requesting a business card "with a difference." The cover stock is a light gray lavender fiber sheet using PANTONE 275, a purple, and PANTONE 185, a warm red. The type information is overprinted on a ghost photo.

Figure 8-25 is a black and white business card also on a fiber cover stock with a texture. The printing was difficult because thin type inside a reverse is difficult to print and sometimes results in broken type. This was printed on a medium-size press to control the reverse.

Envelopes

Envelopes offer few design options. The copy positioning and the sizes of envelopes are limited by the printing press and the postal service (figure 8-26).

- The printing company. Include a ⅜″ gripper margin on the left and allow at least ⅜″ on the top. Solids or lines may not print on the flap where variable thicknesses of paper exist. Envelopes require offset printing. There are only a few copiers or lasers that will feed envelopes. The glue sizing on an envelope deposits in the ink while it is being printed and makes it difficult to print a solid or a tint.

- The postal service. Keep an up-to-date copy of the U.S. Postal Regulations for any changes in requirements for the return address on envelopes. Presently, postal requirements for letters include thickness, size, and location of copy and bar code.

Thickness	Between .007″ and .25″
Size	No smaller than 3½″ x 5″; no larger than 6⅛″ x 11½″
Location of copy	One-third the length, one-half the height
Bar code	No image on the bottom 1″
Margins	⅜″ from left side of envelope for gripper margin on press
Leading	8 pt or multiples of 8 on all copy if possible

Type

For a return envelope, the mailing address should be simple and should complement the letterhead design. Postal regulations request that designs avoid typefaces with flat top numbers. They also request an em space for word spacing, especially between the state and zip. Use the type sizes on the lower end of the chart or the same size as the letterhead if the letterhead body text is 7-point. Leading needs to be 2 to 8 points for OCR scanning in the mailing address. Requirements for the return address are a leading proportional to the letterhead leading.

Figure 8-26 Limitations for envelope copy

Printed publications that must fit in an envelope should be ½″ narrower than the envelope and ¼″ shorter when folded. For bulky mailings, allow more space. Make a dummy from the paper choice and place it inside an envelope to be sure it fits. If a machine is used to insert the publications, it will require an open side envelope.

$Saver

Orders of 25,000 or more can be printed by the company that makes the envelopes. This costs the same as blank envelopes, or less than buying the envelopes and then paying printing costs. Also, blank "bargain" envelopes are a poor investment if they will not feed through the printing press flat. If any of the corners turn down, the press cannot feed them without waste. That waste can be offset by buying better quality envelopes. Check carefully with the paper salesman or the printing company.

Business reply envelopes

The postal service has specific guidelines for business reply envelopes (figure 8-27). The pamphlet "The Best Addressed Get the Best Response" advises the following specifications:

- Uniform left margin
- City and state (2 letter state abbreviation), all caps (see *Appendix*)
- 10 to 12-point type
- One space between city and state
- Two spaces between state and ZIP + 4 code
- Letter spacing: 1-point character spacing is recommended
- Word spacing: the width of 1 full size character
- 2- to 3-point line spacing

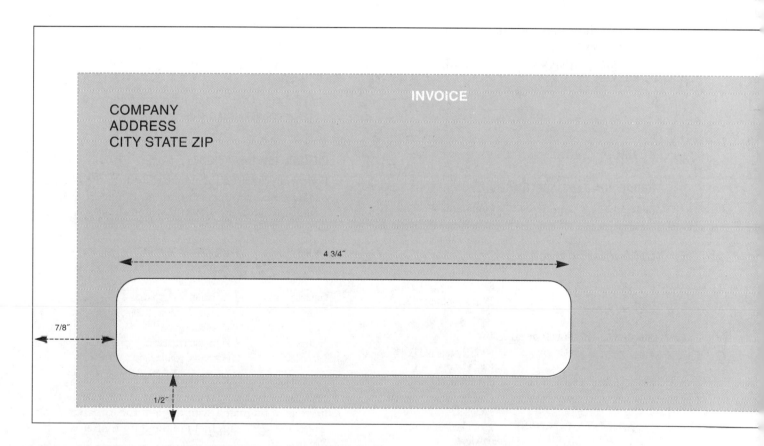

Figure 8-27 Window dimension on most envelopes allow invoice to slip sideways

- Clean sans serif typeface with uniform stroke thickness
- Appropriate ZIP + 4 code to identify the publication
- No punctuation (except hyphen in ZIP+4 code)

The bar code at the bottom of the envelope contains the 5 digits for the address plus ZIP + 4. A camera-ready copy may be obtained from the local Postal Business Office. The postal service holds classes on changes and uses of the guidelines free of charge and all of the materials are free also.

Window envelopes can be purchased in all standard sizes. With the exception of check window envelopes, the windows are all ½″ from the bottom. For #6¾, #7, #7¾, #9, #10, and #11 envelopes, all windows are ⅞″ from the left.

Postal regulations for the placement of return addresses and mailing addresses, as well as two additional rules that apply to window envelopes, include:

- Only the name and address may appear in the window.
- Name and address should be on white or light colored paper.

Envelope samples

Range for type specifications

Element	Type Sizes	Comments
Company name	10–14 pt	If company name is initials, it can be 18-pt
Mailing address	6 (caps), 7–8 pt	
Street address		Part of the address, must be on the line above PO Box
Logo		25% to minimum ½″

Number	Envelope size	Use
#10	4⅛″ x 9½″	Fits a sheet of 8½″ x 11″ folded twice
#9	3⅞″ x 8⅞″	Fits inside a #10
#6¾	3⅝″ x 6½″	Used for billing, personal stationery
Monarch	3⅞″ x 7½″	A standard announcement envelope
#10½	9″ x 12″	8½″ x 11″ sheet unfolded

Standard level envelopes

Small quantities and urgent deadlines are well met with standard level envelopes. Even small quantities of envelopes on matching writing papers without deep textures will print easily in the laser printer.

Try the specifications from figures 8-28 through 8-30 for style palette information or change fonts and modify slightly:

Element	Type Specifications
Logo	36/24 Carta
Company name A	14/18 Caslon bold
Company name B	9/10 Caslon bold, all caps
Address	7/12 Caslon regular, all caps, mixed letterspacing
Bar code	Check postal regulations

PAPER AND INK. Make choices to match the letterhead. If there is not a match for the paper, use 24# bond, white envelopes.

OUTPUT DEVICE.

1st Choice—Laser original (1000 dpi or greater) to conventional small press.

2nd Choice—Direct-to-plate at conventional small press.

3rd Choice—Direct-to-film negative (service bureau) for conventional small press.

Custom level envelopes

Following the additional techniques for the business package add production time and increase printing requirements (figures 8-31 through 8-33).

Element	Type Specifications
Logo	Wordmark or initialmark produced in a drawing package
Company name A	9/18 Caslon bold, all caps
Quote	8/12 Caslon italics, all caps, increased letterspacing
Address	7/12 Caslon regular, all caps
Bar code	Check postal regulations

PAPER AND INK. Choice to match the letterhead. If there is not a match with the letterhead paper, use a 24# bond, 25% rag. Include the ink number with the document.

OUTPUT DEVICE.

1st Choice—Direct-to-plate at conventional small press.

2nd Choice—Direct-to-film negative (service bureau) for conventional small press.

Premium level envelopes

Premium level designs focus on additional sketches, special printing techniques such as embossing, and additional conferences with the client. Art boards should be used for all presentations. The following are examples of typical premium level publications:

Figure 8-34 is a design for a national company using 24# off-white writing paper with a laid finish and matching letterhead. Type specifications are 14- and 8-point type for the company name and 7-point type on the address. Colors: PANTONE 301, a blue, with a gold stamp of the logo.

Figure 8-35 follows the business card and letterhead with type sizes and design and the vertical type block fits without going into the postal regulation area. 24# gray fiber matching bond/cover paper is used. Type size is 18-point with 8-point type for the company name and 7-point type for the address. Colors: PANTONE 313, a turquoise, and black.

Figure 8-36 is a two-color envelope with a tint of black for the shadow. It was printed on 24# white writing sheets with a light laid finish. The company name is 60-point type with letterspacing; the second line is 8-point type and the address is 7/10. Colors: PANTONE 186, a red, and black.

SECURE INVESTMENTS
FINANCIAL GROUP
5114 CENTRAL EXPRESSWAY
BUFFALO, WA 50012-0412

SECURE INVESTMENTS
FINANCIAL GROUP
5114 CENTRAL EXPRESSWAY • BUFFALO, WA 50012-0412

SECURE INVESTMENTS
FINANCIAL GROUP
5114 CENTRAL EXPRESSWAY
BUFFALO, WA 50012-0412

Figure 8-28, -29, -30 Standard level envelopes

SECURE
INVESTMENTS
FINANCIAL GROUP

5114 CENTRAL EXPRESSWAY
BUFFALO, WA 50012-0412

SECURE INVESTMENTS
FINANCIAL GROUP
5114 CENTRAL EXPRESSWAY
BUFFALO, WA 50012-0412

SECURE
INVESTMENTS
FINANCIAL GROUP
5114 CENTRAL EXPRESSWAY
BUFFALO, WA 50012-0412

SAFETY FILMS AND VIDEOS

SAFETY SUPPLIES

SAFETY SIGNAGE

Figure 8-31, -32, -33
Custom level envelopes

WESTERN ▮▮▮ NATIONAL
Life Insurance Company
P.O. Box 871
Amarillo, Texas 79105-0871

Figure 8-34
Premium level envelope.
*Credit: Western National Life Insurance
Co., Randi Stephens and Jennifer
Junemann, designers/production*

Figure 8-35 (Right) Premium level envelope.
Credit: Vosburg de Seretti, inc., designers

ABOVE
&
BEYOND™
PUBLISHING
1002 Todville
Seabrook, Texas 77586
713.474.2333

Figure 8-36 (Below) Premium level envelope.
Credit: Vosburg de Seretti, inc., designers

G💃NA
Special Events Management & Production

2951 Marina Bay Drive
Suite 130-332
League City
TX 77573

Composite

The three common publications for a basic business package create a composite (see figure 8-1). The layout of the composite is helpful for sketching, production, output for imagesetter, and as a customer presentation.

Sketch the package to create a design that maintains an effective resemblance later, even when only one of the publications is requested.

A composite is also called a **comprehensive** when it is used to show ink and paper colors to the customer before the job is printed. A comprehensive requires a proofing method that comes as close as possible to resembling the printed sheet. Since business packages are usually spot color, there are alternatives that fit their wide range of budgets. Try using available color copiers. Use color swatches to adjust the color on the file until it matches. Or, use Iris, Rainbow, Matchprint, or another high-end color proofing system. Check the register and color on the chosen paper. Trim each publication to its correct size, then mount them together on a black or dark gray board. A change is required in the file set-up to go directly to plate or film.

A composite for production can be done in a drawing package or a page design package. Some drawing packages will set corner marks for all three sizes by drawing a box the size of the publication and select print marks. The advantage of using the composite layout, if it is used to make the imagesetter negative, is that the cost is for one negative instead of three. Since a composite may not be practical for some printing, such as four-color process, check first with the printing company.

Invitations and announcement cards

The format and typography of invitations and announcements can be used for a large variety of formal printed publications. The format can be used to announce a business opening, a demonstration of new product, a sale, a seminar, a reception, an open house, or a performance. Announcements give information about a new company, new employee, death of an officer, mergers, and so on. The smaller cards are thank you cards, acknowledgments of donations and gifts, and response cards for nonprofit organizations.

Type

The body type is 14/20, and is in one face: script, Old English, serif, or sans serif. Hyphenation should be turned off and end of line decisions (manual returns) should be added at prepositional phrases or where they complement the shape of the sheet. Limit the copy to fourteen lines set tall **(portrait)** and eleven lines set wide **(landscape)**.

Use the type specimen sheets to locate available script and Old English typefaces. One excellent typeface in script is often all that is needed for formal invitation projects. Another option is to use a basic typeface with italics and/or outline italics. Be sure that the width of the outline letters will hold up for the printing process.

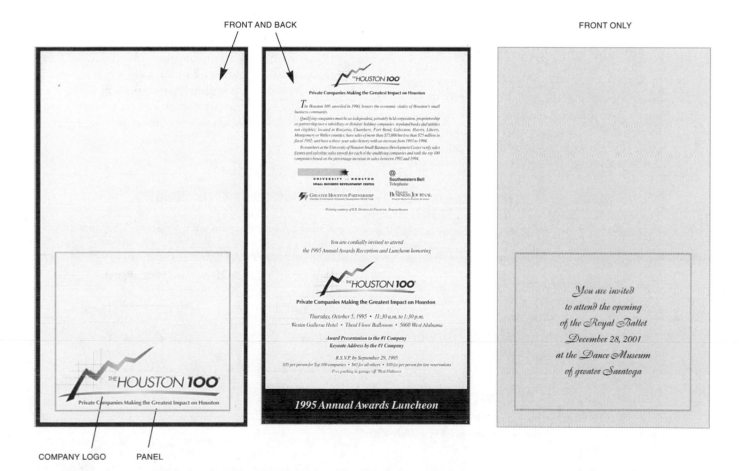

Figure 8-37 Placement of copy for two-sided announcements
Credit: Creative Art Director: Jennifer Woeste, University of Houston Small Business Development Center, Graphic Designer: Marsha Pehrson, Greater Houston Partnership, Printer: Dan Billington, R.R. Donnelley Financial Houston Division

Two of the serif typefaces commonly used in the 1920s are still included in sample books of invitations today: Copperplate Gothic and Charlemagne. Copperplate Gothic is a bold face that works in all caps and small caps and holds up well even as small as 6-point type. Charlemagne is an all caps, thin face that works in all caps but not 6-point type. These two typefaces are excellent choices for a company name.

Acceptable wording for all types of invitations and announcements can be found in Amy Vanderbilt's *Book of Etiquette*. Some invitation and announcement sample books also include a section on wording. Write out all numbers on formal invitations or printed publications, including the date, year, time, and so on. The line length of the copy should be one to two picas from the embossed border. On non-embossed invitations, draw one or two hairline boxes where the embossed edge would have been to give the invitation polish.

Paper and envelopes

Papers for announcements and invitations must complement the design and function. Choose the paper and envelopes together to be certain that there is an envelope matching color, weight, and size. Paper and envelopes can be purchased in different manners:

- The flat sheets of paper. Inside envelopes and outside envelopes can be purchased in sets called a "paper cabinet." The paper and card come with either an embossed panel or smooth.
- 70# vellum fold-over sheet. Use an 88# bristol vellum card in ivory or off-white with vellum envelopes ordered separately.
- Text or cover sheets. Matching envelopes can be purchased for larger quantities.

Positioning copy on fold-overs

It is acceptable to print one side or both sides of a folded invitation, but the set-up is different than with other printed publications (figure 8-37):

- Fold-over invitations with front only copy are placed on the outside of the fold-over.
- A two-sided invitation has copy on the outside and the inside. Be sure to make a folded dummy to determine where the copy should be placed. Use the unfolded size for the page design size; the copy for both pages should go in the bottom half.
- A self-mailer invitation printed on 70# text or heavier can be folded to form its own mailer cut to a baronial size. Purchase 1″ round adhesive tabs from an office supply store to close the flaps.

Specialty printing companies

Most printing companies will have catalogs available for ordering invitations, which will be more economical to purchase. Listings of mail order invitations for direct ordering appear in bridal magazines as well as the local Printing Industries of America (PIA). If the invitation requires personalized handling or has a tight deadline, this choice is not practical. Whether purchasing from a specialty catalog or printing locally, the price increases on invitations for additional items such as tints, ink colors, and logos.

Invitation and announcement card samples

PAPER. Use paper cabinets with 70–100# text or 65# cover.

Type	Plain Folders	Card Size	Panel
#5 baronial	5¼″ x 8″	4″ x 5¼″	½″
#5½ baronial	5½″ x 8½″	4¼″ x 5½″	½″ (3 picas) from edge
#4 baronial	4⅞″ x 7″	3½″ x 4⅞″	½″ (3 picas) from edge
#6 baronial	6½″ x 9¼″	4⅝″ x 6¼″	½″ (3 picas) from edge

Range for type specifications

Element	Type Sizes/Comments
Body text	14–20 pt Commercial Engraving or script, serif, or sans serif outline italics, centered, and no hyphenation
Company name	Same as body copy, or 18-pt type with extra leading above. For a fold-over, the company name and logo can be outside copy and the body text inside copy
Address	Smaller than body text if the type font will hold up at smaller sizes
Phone	Same as the address
RSVP	One size smaller than body text, 2 picas from the left embossed border
Logo	Used with body text at letterhead size, or no limit to size when used on the outside
Address/ Phone number	Same as RSVP, but if there are two, one is placed on the left
Direction	At the bottom of the text, same as the text with extra above paragraph leading

Standard level invitations and announcements cards

Small quantities and urgent deadlines are well met with standard level invitations and announcement cards. A vellum finish sheet prints easily in the laser printer. Ask the paper representative for specific paper choices.

Try the specifications from figures 8-38 through 8-40 for style palette information or change fonts and modify slightly:

Element	Type Specifications
Company name A	14/18 Caslon bold, all caps
Company name B	9/10 Caslon bold, all caps
Honoree	18/21 Caslon italics, U & lc
Body text	14/20 Cochin italics, centered, hyphenation turned off

PAPER AND INK. See "Paper and Envelopes" section for standard invitation choices. Use black ink.

OUTPUT DEVICE.

1st Choice—Laser printer for limited number of copies (under twenty-five), run through the laser printer, for longer runs.

2nd Choice—Laser original (1000 dpi or greater) to copier.

3rd Choice—Laser original (1000 dpi or greater) to conventional small press.

Custom level invitations and announcements cards

If the deadline or design does not allow ordering from a specialty printing company, the local printing company can order the paper cabinets for custom level invitations. Additional page elements such as maps and logos, two-sided printing, and use of additional software packages add production time and increase printing requirements (figures 8-41 through 8-43).

Element	Type Specifications
Body text	14/20 Snell Roundhand Script, mixed alignment, hyphenation turned off
Feature product	21/20 Snell Roundhand Script

PAPER AND INK. Choose from paper cabinets listed at the beginning of the invitations section. Use color as needed.

OUTPUT DEVICE.

1st Choice—Direct-to-film negative (service bureau) for conventional press.

Premium level invitations and announcements cards

Premium level designs for invitations focus on embossing, folding, and handwork with ribbons.

Figure 8-44 is part of an event package. The outside cover is folded shorter than the back side to allow the red ink on the inside to show from the outside. Type specifications are 9/18. Colors: PANTONE 185, a warm red, and black.

Figure 8-45 is an example of a traditional formal invitation where a number of additional techniques have blended well. The logo was embossed over the white ink on the cover and repeated on the outside of the text sheet as a 30% tint. The deckle was red, which gives it the appearance of being printed in two colors of ink. The ribbon was attached by a drilled punch through the loose inside sheet. The 65# cover and 70# text are a matching ivory waffle texture with matching envelope. Colors: PANTONE 185, a warm red, and pearl opaque white.

Figure 8-46 is a wonderful approach to a non-traditional invitation. This was shipped in a black tube. Also included were a wand and white cotton gloves. The invitation is printed on 80# enamel. Colors: PANTONE 185, a warm red, and black.

STANDARD

SECURE INVESTMENTS
FINANCIAL GROUP

proudly announces
a new member of our legal team,

Dana Henderson
You are cordially invited
to an open house in her honor
February 17, from 5:00–7:00 PM
at 4200 France Avenue
Buffalo, Washington

The Officers and Directors of
Secure Investment Clubs of America
invite you to attend their
annual awards banquet
Sunday, the ninth of July
Nineteen hundred and ninety-nine
at eight o'clock in the evening
The Grand Hotel
Crystal Ballroom
Buffalo, Washington

Figure 8-38, -39, -40
Standard level announcements

Secure Investments cordially invite you
to stop by for an open house
at our new location
5114 Central Expressway
Buffalo, Washington
starting at
twelve noon till nine in the evening

Secure Investments Financial Services
1025 Central Expressway

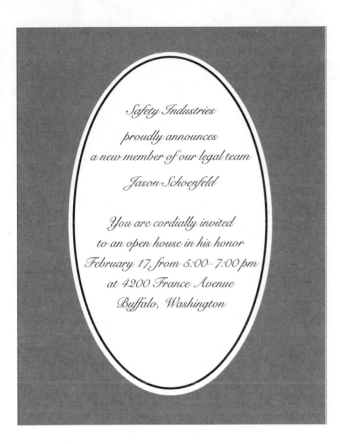

Safety Industries
proudly announces
a new member of our legal team
Jason Schoenfeld

You are cordially invited
to an open house in his honor
February 17, from 5:00–7:00 pm
at 4200 France Avenue
Buffalo, Washington

SECURE
INVESTMENTS
FINANCIAL GROUP

Safety Industries
announces the introduction of the revolutionary

Computer-controlled Water Filter System
at our demonstration floor
5114 Central Expressway
Buffalo, Washington
presentations at 7:30 am, 12 noon and 6 pm

R.S.V.P.
Buffet will be served

The Officers and Directors of
Safety Industries Club of America
invite you to attend their
annual safety awards banquet
Sunday, the ninth of July
Nineteen humdred and ninety-nine
at eight o'clock in the evening
The Grand Hotel
Crystal Ballroom
Buffalo, Washington

Figure 8-41, -42, -43
Custom level announcements

You are cordially invited to attend
the 1995 Annual Awards Reception and Luncheon honoring

THE HOUSTON 100®

Private Companies Making the Greatest Impact on Houston

Thursday, October 5, 1995 • 11:30 a.m. to 1:30 p.m.
Westin Galleria Hotel • Third Floor Ballroom • 5060 West Alabama

Award Presentation to the #1 Company
Keynote Address by the #1 Company

R.S.V.P. by September 29, 1995
$35 per person for Top 100 companies • $45 for all others • $10 fee per person for late reservations
Free parking in garage off West Alabama

1995 Annual Awards Luncheon

Figure 8-44
Premium level announcement.
Credit: Creative Art Director: Jennifer Woeste, University of Houston Small Business Development Center, Graphic Designer: Marsha Pehrson, Greater Houston Partnership, Printer: Dan Billington, R.R. Donnelley Financial Houston Division

Figure 8-45
Premium level announcement.
Credit: Vosburg de Seretti, inc., designers

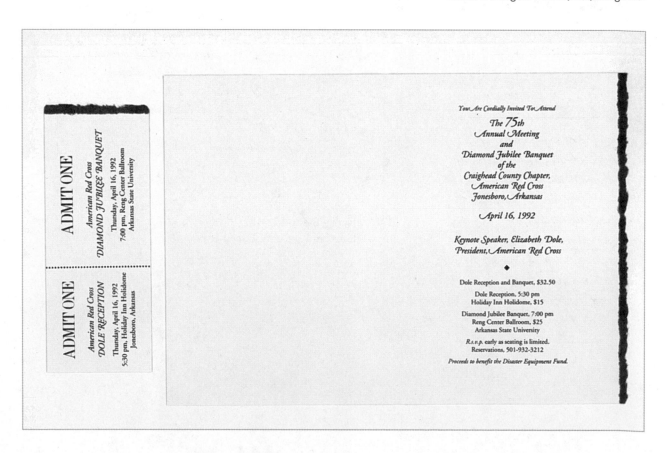

Figure 8-46
Premium level
announcement.
*Credit: Kathryn
Vosburg-Seretti,
designer*

Other business communication projects

Several other publications are grouped in this section either because the designs are usually similar to each other or the publication has similar specifications to another publication that was presented in great detail.

Name tags

Type	Specifications
Business badges	2¼″ x 3½″
Convention badges	2½″ x 4″
Paper	65# cover, 80# text with or without pressure-sensitive backing
Positioning	If names are computer generated onto name tags, check positioning as it is automatically fed

Because reading distance is about two feet, use 14-point type or larger. Usually include the company logo. Allow at least 1″ for the name and title or company. Tags can be purchased in sets to run through the laser printer from the paper company (figure 8-47).

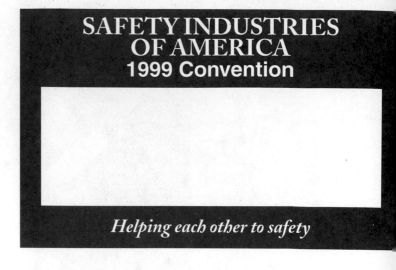

Figure 8-47 Name tag

Figure 8-48
Two-up ticket for standard blanks

Nº A 351	SAFETY INDUSTRIES OF AMERICA Convention Banquet and Dance July 9, 1999	SAFETY INDUSTRIES OF AMERICA Convention Banquet and Dance July 9, 1999 The Grand Hotel • Crystal Ballroom Helping each other to safety	Nº A 351
Nº A 351	SAFETY INDUSTRIES OF AMERICA Convention Banquet and Dance July 9, 1999	SAFETY INDUSTRIES OF AMERICA Convention Banquet and Dance July 9, 1999 The Grand Hotel • Crystal Ballroom	Nº A 351

Tickets

Type	Specifications
Sheet	Two-up, 4³⁄₁₆″ x 6½″
Tear-off ticket	2⅛″ x 4⅜″
Image limitations	⁵⁄₁₆″ at the top (includes numbering area) + stub information = 1⅜″ stub; ⅜″ at bottom for numbering

The specifications are determined by the amount of information and are set as small as business cards and as big as headlines in 24-point type.

For standard level (figure 8-48), use 67# vellum bristol cover, or 65# cover, perforated. Numbered tickets can be purchased in packs of 500, called blanks. A template is furnished showing the exact location of the copy. These tickets can be run on some lasers, copiers, and small offset printers.

If the design needs to be a custom or premium design, be sure to know the limitations of the location of the perforation and the numbering machine.

Appointment cards

Appointment cards are similar to business cards, but there is more copy and a need for room for fill-in information. They should be 2″ x 3½″. Use a 16-point leading for fill-in lines (since it will be handwritten copy) and an 8-point leading for other copy (figure 8-49).

Element	Type Specifications
Company name	Serif /sans serif, 10 to 11-pt type, to match other publications of package
Dr. name	Same as company name
Body text:	Helvetica regular, 6 to 8-pt type, all caps, or small caps 80%, centered.
Leading	8-pt

SERETTI COMPREHENSIVE DENTISTRY
16902 El Camino Real Suite 4A Houston, Texas 77058
Telephone: (713) 486-9440

Has an appointment on

☐ Monday ☐ Wednesday ☐ Friday
☐ Tuesday ☐ Thursday ☐ Saturday

Date _____ Time _____

A broken appointment is a loss to everyone. Please inform us one day in advance if you are unable to keep your appointment.

Figure 8-49 Standard appointment card.
Credit: Kathryn Vosburg-Seretti, designer

Diploma/award

Diplomas and awards use type specifications similar to formal invitations but with larger type sizes. Leave approximately 1″ for each line of personalized information (figure 8-50). Use ornament fonts for borders. These should be 8″ x 10″, suitable for framing, and the paper should be 24# 100% rag or parchment finish.

Element	Type specifications
Company name	Script or cursive, 24-pt type
Body	14/20 centered
Signature	7-pt type in serif or sans serif

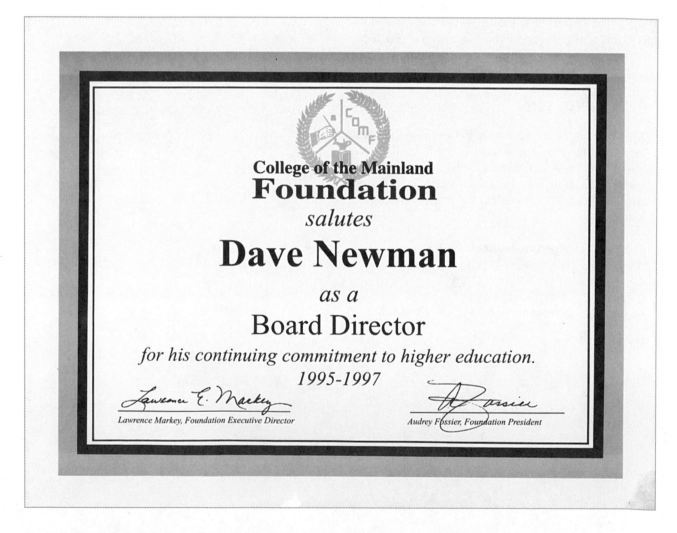

Figure 8-50 Standard diploma. *Credit: College of the Mainland Foundation, Glenda Brents Rebstock, designer*

For additional research

Keep a well-balanced design approach by continuing research into some suggested sources:

Review invitation sample books
Contact Art Director Clubs
 10 E. 39th Street
 New York, NY 10016

Historical information

Cabarza, Leslie, *Letters: 100 Years of Great Designs,* Cincinnati: Rockport Publishers.

Carter, David E., *Designing Corporate Symbols,* New York: Art Direction Book Company, Inc., 1978.

Letterhead and Logo Design 3: Creating the Corporate Image, Cincinnati: Rockport Publishing, 1994.

Trends

Carter, David E., *Letterheads/8,* New York: Art Direction Book Company,Inc., 1996.

Place, Jennifer, *Creating Logos and Letterheads,* Cincinnati: North Light Books, 1995.

Chapter

9 Text Documents

Designing documents
8½" x 11" short documents
Long documents
Résumés
Annual reports
Other text projects
For additional research

After reading this chapter and applying its principles, the designer should have success producing:

- Bulletins
- Booklets
- Planning materials
- Handbooks
- Press releases
- Instruction manuals
- Curriculums
- Résumés

- Reports
- Books
- Research papers
- Proposals
- Prospectus
- Specification sheets
- Textbooks

Companies and organizations of every size create volumes of text documents. Documents are used internally to inform and communicate and externally to educate.

Designing documents

Text documents are functional. Therefore, readability is imperative and should be the first consideration in design. Paragraph specifications for body text are as critical as the logo is for the business communications package. A good set of type specifications should be reused to create an identity in all documents since one good document builds on another. Good formats that are shared within the company help increase quality. Some companies publish their own style manual built on proven type specifications and designs.

Spend time locating the most readable body type and use it without stretching, tracking, or any other modification.

> ✗ Cross reference: Because type is critical to the words and the readability of these publications, Chapters 3 and 4 regarding type serve as excellent references.

Page elements

Several page elements are required in order to keep copy organized for the reader. Write down the element names and the type specifications in the order they are chosen as a checklist. Sample pages with all elements used in their logical order help visualize the relationships between page elements (figure 9-1). While revising, refer to the list to keep on track.

Bibliography subhead

A bibliography subhead appears before the bibliography and is not considered a regular subhead. It is set in the same specifications as the subhead but bibliography subheads are centered.

Figure 9-1 Essential page elements for text documents

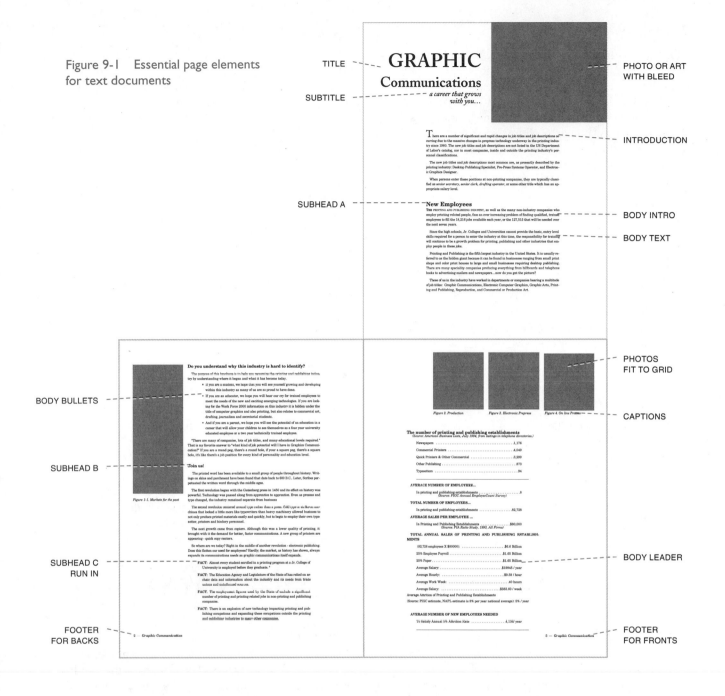

Labels surrounding the figure:

TITLE

SUBTITLE

SUBHEAD A

PHOTO OR ART WITH BLEED

INTRODUCTION

BODY INTRO

BODY TEXT

PHOTOS FIT TO GRID

CAPTIONS

BODY LEADER

BODY BULLETS

SUBHEAD B

SUBHEAD C RUN IN

FOOTER FOR BACKS

FOOTER FOR FRONTS

Bibliography text

Bibliography text refers to the actual text information in the bibliography section of the publication. Bibliography text is set with a 2-pica hanging indent or a standard first line indent. Use body text type specifications or one size smaller and the standard secondary leading. The name of any book or article is in italics rather than underlined. There are many styles for bibliographies but consistency in style, order of the particulars, and use of italics are the most important.

Body indent

Body indents occur when paragraphs are included in the text that are directly part of the text. Body indent is used for long quotes separated from the rest of the body text or for extracts or a paragraph that might be a side thought. The type specifications are the same as for the body text or one size smaller with tighter leading.

Body introduction

The first paragraph at the beginning of a section or after each subhead is a body introduction. Setting up a style for this paragraph separates it and eliminates secondary leading while bringing the paragraph closer to its subhead. The simplest method is removing the first line indent.

> ✘ Cross reference: See figures 4-11 and 4-12 for other paragraph markers.

Body lists, bullets, and numbers

The purpose of body lists, bullets, and numbers is to direct the reader to a listing for a group of choices or a sequence of steps. When paragraphs are broken into lists, bullets, and numbers, they can be scanned by the reader. This is valuable in publications where the reader is searching for specific information.

Body text

Body text includes the words of the document itself. Body text is usually set in 8- to 11-point type in serif typefaces or, occasionally, sans serif. Choose a face with the customized type specimen for leading, type size, and first line indent matching the line length of the design.

By-line information

A by-line gives reference to the author of the publication or article. A by-line can be placed at the beginning or end of the document. If it appears at the end, the word "by" is deleted. Either the caption or the by-line uses italics. If the document uses italics in another page element, try other choices (figure 9-2).

Captions and call outs

Captions appear at the bottom of illustrations and photographs as identification. Call outs add notes to specific areas of information. Usually, the type is smaller than the body text and is a different weight. Place them consistently on all illustrations. Allow one leading of space before and after other body text.

Charts

Charts are informative listings, such as financial information. Set chart type one size smaller than the body text and add lines and tints to help the reader.

> ✘ Cross reference: Samples of charts appear in figures 4-25 through 4-29.

Headers and footers

The running title information and page numbers are called headers and footers. The length of the publication dictates the need for headers and/or footers. Headers and footers include the title, page number (folio), and sometimes date and total number of

pages. Place them at least 2 picas outside of the body text block. For back and front designs, give the name of the publication (and sometimes the chapter name) on the left side page and the name of the book or subject on the right side page, placed as mirror images (figure 9-3).

Introduction to the publication

The introduction is a short opening following the title. The introduction sets the mood, similar to a kicker or subhead in an ad. Type specifications fall between the body type size and title type size similar to a subhead in advertising or a pull quote in news publications. Introductions are used frequently for publications without drawings or photos that need snap or contrast.

Pull quotes

Pull quotes fit a column of the grid or are used to create run-around text. Pull quotes should not cut a line in half or give the reader too many lines of one and two words. If a box is added to the pull quote, the quotes should be indented 1 pica from the box. If the same typeface is used for pull quotes and body text, use a leading noticeably different than the body text to separate the copy. For informal publications that need more contrast, place the pull quote and its box at a 14° angle. Additional contrast can be added with reverse type in bold.

Subheads

Subheads are the subject for a section of text. One-subject reports, without technical details, may have one level of subheads. Complex documents will have five or six levels of subheads. Subheads are recognized by contrast. Using weight, case, and surrounding white space (before paragraph leading) instead of drastic size changes keeps subheads simple and allows more room for multiple levels and a large number of page elements.

By Kim Any Nguyen
ITALICS BOLD, ONE SIZE SMALLER THAN BODY TYPE

By Kim Any Nguyen
ITALICS REGULAR, SAME SIZE AS BODY TYPE

By Kim Any Nguyen
ITALICS BOLD, ONE SIZE SMALLER THAN TYPE

—Kim Any Nguyen
ITALICS , ONE SIZE SMALLER THAN TYPE WITH AN EM DASH

Figure 9-2 By-line samples

GETTING ON THE INTERNET
ITALICS BOLD, SMALL CAPS WITH WORD CAPITALS

GETTING ON THE INTERNET
REGULAR, SMALL CAPS, NO SHIFT POSITION LETTERS

GETTING ON THE INTERNET
REGULAR, SMALL CAPS, NO SHIFT POSITION LETTERS
INCREASED LETTERSPACING

Getting on the Internet
ITALICS BOLD, ONE SIZE SMALLER THAN TYPE,
INCREASED LETTERSPACING

GETTING ON THE INTERNET
ITALICS , ONE SIZE SMALLER THAN TYPE, ALL CAPS

Figure 9-3 Header and footer samples

Table of contents

A listing of the chapters or sections and subheads is included in the table of contents. The table of contents may appear on a separate page after the title when the length of the publication requires reference points. Use the body text sizes with a narrower column for the type and additional leading between listings.

Title or title of chapter

The title presents the subject or the publication naming the chapter of a document. If a cover page does not exist, the title on the first page can be several type sizes larger than the body text. Although many choices are appropriate, the title typeface should blend with the body text. Turn off hyphenation in the style palette.

✘ Cross reference: Use display samples in Chapter 4 for title ideas.

Research

While researching the best type and paragraph specifications, give consideration to the reader. Scanning the title or the first paragraph of the text material often gives clues regarding the reader's special needs. Also, be aware of the length of the publication and determine how long the reader will be engaged. All of these considerations fit together to help with choices for type specification and page design: typeface, size, leading, indents, before leadings, and case. Some variables that help determine these decisions are questions such as:

- Reading distance and lighting. How far away will the page be from the reader? What kind of lighting will the reader be using? Keep type sizes within the average range of 8- to 10-point, but choose 10-point if the distance or lighting is a problem.
- Handling and notetaking. Does the document need wide margins for hand holds, highlighting, or notes? Keep 1½″ margins on documents requiring holding or notetaking.
- Complex subheads. Will subheads blend smoothly into the type but still be easy for the reader to browse? How many subheads will there be per page? How many levels of subheads will there be? Keep sizes down and before paragraph leadings as generous as possible.
- Poor vision or reading problems. Will the document need larger body type (11- or 12-point) for readers who are dyslexic or have poor vision? Try longer line lengths with larger first line indents, more leading, and more before paragraph leading along with extra large type. Note: Avoid 12-point type for normal readers because it places too few words on a line and darkens the copy.

Bindery effects on margins

Establish bindery requirements for the page margins and columns choices. Notice that the margin spacing for long and short documents take opposite directions because of the different bindery techniques (figure 9-4).

- Short documents (8½″ x 11″). Margins are fairly equal and additional space is added to the bound side for various bindery techniques. Spiral or plastic binding, three-hole punch, and top stapling allow each page of the report to be separate.
- Long documents (5½″ x 8½″, 7″ x 8½″, and 6″ x 9″). An open book that is saddle stitched or book bound shows the two pages that face each other seamlessly, which is best for long documents. To accomplish this, the margins are set uneven with the inside (or gutter) margin the smallest.

Determine the page size for the document by checking the printing method. Small presses and copiers can run documents from page sizes of 8½″ x 11″, 5½″ x 8½″, and 7″ x 8½″.

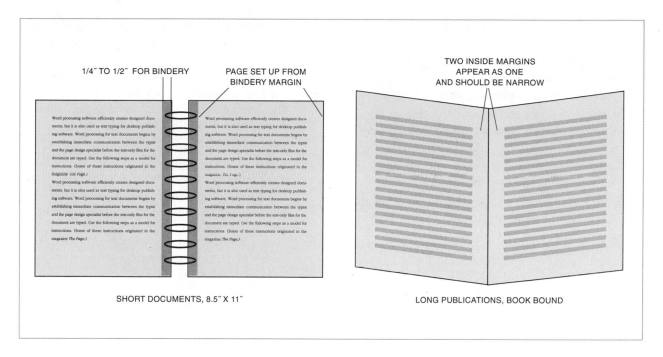

1/4″ TO 1/2″ FOR BINDERY

PAGE SET UP FROM BINDERY MARGIN

TWO INSIDE MARGINS APPEAR AS ONE AND SHOULD BE NARROW

SHORT DOCUMENTS, 8.5″ X 11″

LONG PUBLICATIONS, BOOK BOUND

Figure 9-4 Inside margins for facing pages—different bindery styles

Large presses do not change their sheet size for each job. Each press is set up for its maximum sheet size and the job is trimmed after printing. Large presses come in several different sizes. When designing a 6″ x 9″ document, realize that it will run on a large press that feeds 25″ x 38″ paper with sixteen pages printed on one sheet. 8½″ x 11″ with four-color process is run on medium and large presses, printing four to eight pages at a time.

Typing a text document

Word processing software efficiently creates designed documents, but it is also used as text typing for desktop publishing software. Word processing for text documents begins by establishing immediate communication between the typist and the page design specialist before the text-only files for the document are typed. Use the following steps as a model for instructions. (Some of these instructions originated in the magazine *The Page.*)

Word processing files can be used across platforms (varieties of computers). Check software instructions for file formats that are unacceptable. Presented are the standard typing techniques that eliminate any additional manipulation of the word processing file to place it into page layout software:

- Space once after periods. Do not hit multiple space bars!

- Leave tab information unformatted. Do not set tabs. Use the default tab setting and tab once to indicate a tab column, bullet, or numbered material.

- Use single returns. Add a single return at the end of a paragraph or title, but do not hit the return key until the end of a paragraph or section. Do not use any double returns after a paragraph.

- Indent with first line indent. Indent without hitting the tab or space bar keys, or do not indent

at all. All tabs will be manually stripped out by the page layout person.

- Use upper and lower case. Even if the final copy needs to be all caps, use typographers marks or tags to indicate copy to be set all caps.
- Complete proofreading. Before placing text in the page design software, proofread the text.
- Save each chapter as a separate file. Use a two-digit (01) number prefix on the file name so that it will appear in correct order.
- Add style names or tags. The page design specialist can translate the same name in both the style palette or a code tag such as <1> or <body> into the page layout style palette. The page design program will automatically strip out the "< >" and give it the specifications built into that name.

 Tags can also be included in the text without bracket, such as "figure 1″ or "Add art 1." The specialist can quickly search and replace those words with the required art in the in-line story editor.

- Avoid typographic bullets. Bullets in the word processing program are too large. The typist can substitute a bullet with the letter "o" followed by a tab, which can be replaced later in the page design software.

8½" x 11" Short documents

The reader of short documents must evaluate the facts presented in the document, reach a conclusion, and in some cases write a recommendation. Most of the body text is read at a distance of 12″ to 18″ and the readers are usually sitting at a desk. It is a one-subject document that often requires room in the leading and margins to write comments.

Margins and bindery decisions

One column of type of an 8½″ x 11″ page allows a generous margin of 1″ on all sides. Use ½″ or less with two or three columns of type to allow for wider columns and longer documents. The page will look visually proportional if the bottom margin is slightly wider than the other three. Additional left margin space is added for the binder. Spiral or comb binding is chosen as permanent binding. This requires an additional ¼″ (figure 9-5). Spiral and comb binders are metal and plastic. Spiral binders can be used with hard covers (book covers) that wrap around the document, exposing approximately half of the outside of the binder. Comb binders use flat sheets of cover weight stock that are punched just as the sheets are punched.

Publications needing page revisions usually are bound with the sheets drilled with three holes requiring an additional ½″ of the outside margin. Three holes drilled on the outside of the pages can be placed into three-ring notebooks, Duo Tang 2 piece covers, covers with screw post, or fasteners. Three-ring notebooks can be purchased at an office supply company with plastic sleeves to slip in the cover or can be printed in four-color process by specialty book binding companies.

Choice of bindery is usually related to how the publication will be handled when it is read. Since the extra binding margins are not seen by the reader as part of the page, they are added to the measurement.

Grid and column format

Grid and column format play an essential role in the presentation of a short document. One or two columns of type are the most common for an 8½″ x 11″ sheet. Use two or more columns if the line length exceeds 24 picas or the number of words in a line exceeds fifteen.

Figure 9-5 Margins plus bindery margins

Longer line lengths with one column of type

For one column of type with a 20-24 pica line length, use 10- or 11-point type with generous leading and before paragraph leadings and (2- to 4-pica first line indents. (For more information on mastering type to different line lengths, see figures 9-6 and 9-9.)

A one column grid can be built to match the design on a bulletin or press release and still look good for proposals, research papers, and reports. The additional space on the page can be used for pull quotes, line drawings, photographs, and definitions.

Shorter line lengths with multiple columns of type

For two or three columns of type in line lengths of 6-11 picas, use 8- or 9-point type that allows a minimum of seven words per line.

To save paper and space, multiple columns are useful for longer 8½″ x 11″ documents or documents that are in their final presentation stage. Two columns of type (see figure 9-10) have the most versatility built on a five column grid (see figure 9-7). Outside margins do not need to be as wide as with single columns. Multiple columns allow flexibility with the location of pull quotes, line drawings, and photographs.

Selecting type specifications

Because type specifications must fit together, select the type for the body text first, then build around it. Follow these steps:

1. Determine the look of the company. The most common choices are traditional or modern.
2. Set up body text specifications.
3. Choose italics or bold. Use for emphasis within text. Italics is acceptable for references to other publications, quotes, and word emphasis. Bold is used if words need impact. The company name may be set in italics or bold as its signature within the copy.
4. Choose subhead typeface. Traditional designs use only one typeface, which gives minimal contrast between elements.
5. Choose specifications for all other elements.
6. Write a style list. Include all the specifications in order of strength. When revisions are necessary, balance can be easily maintained by looking at the list.
7. Add contrast. Use before paragraph leading, lines, or reverses.
8. Prepare a sample page of text. Use all type specifications in their natural order. Most software packages include sample text that can be placed on the page for a sample copy.

Secondary leading

Secondary leading refers to space added before a paragraph of body text and subheads that help separate them from the other copy. Typewriters once used double returns for secondary leading. This creates more space than is needed for documents. Three or four different page elements often need different amounts of space before their copy. In traditional typesetting, this space is called secondary leading (secondary to the leading of the type). A single use of a secondary leading is set at one-half of the body text leading, replacing double returns. Use figures in the before paragraph leading window, half the size of the body text leading, and they will be added automatically with a return. Some software looks for a decimal inch measurement until the preferences are changed.

In figures 9-6 and 9-9, the secondary leading is set in the paragraph specifications as before paragraph leading for the subheads. Use a before paragraph leading of 6 points and visually check the subheads for proximity to their paragraph and the preceding paragraph.

Figures 9-7 and 9-10 show a more complex "leading-based" design. Leading-based designs apply to designs requiring all text to match on the front and back side of a page or column to column. The samples place a total of 12 points around the subhead (8 points before, 4 points after). For leading-based designs, the leading plus before and after leading of the subheads must total two or more baseline leadings.

Leading hierarchy

Leading should be arranged in a hierarchy for maximum readability. Set up the subhead order, adding increasing amounts of before paragraph leading to each level of subhead. If body text, bullets, or numbers need before paragraph leadings, use less than the bottom level subhead—as little as 3 or 4 points will be noticeable. Figures 9-8 and 9-11 show a suggested leading hierarchy. When uncertain, use the numbers for 12 point leading.

Adding contrast

When more contrast is needed between elements or when designing with ruled lines, reverses and color can be built into a style palette for subheads.

✘ Cross reference: See Chapter 5 for samples of adding contrast.

8½″ x 11″ Short document samples

Range for type specifications

Element	Type Sizes	Comments
Title	24-72 pt	All display type options, but compatible with text style
Introduction	8-18 pt	Body size or larger, leading 6-8 pt greater
Subheads	8-12 pt	Bold, body size or one size greater, see long documents section for Subhead B,C, and so on
Body text	8-11 pt	Leading 2-4 pt greater
Body introduction	8-11 pt	Leading 2-4 pt greater
By-line	8-11 pt	Italics, body text size
Header or footer	6-9 pt	Italics
Pull quote	14-18 pt	Leading 4-6 pt greater
Chart or graph	7-10 pt	Usually one type size smaller than body text
Chart title	8-12 pt	Same as subheads
Caption/call out	7-11 pt	Body size or smaller in regular or italics
Bibliography	8-12 pt	Matches type specifications of subhead, subhead centered
Bibliography text	8-11 pt	Matches type specifications of body, 2-pica hanging

Standard level short documents

Small quantities and urgent deadlines are well met with standard level short documents. Writing papers without deep textures will print easily in the laser printer. Ask the paper representative for specific paper choices. Try the specifications from figures 9-6 through 9-8 for style palette information or change fonts and modify slightly:

Element	Type specifications
Title	26/28 Caslon bold, flush left (FL), mixed case
Introduction	11/28 Caslon italics, U & lc, FL
By-line	7/14 Caslon bold italics, all caps, flush right (FR)
Subhead	11/14 Caslon bold, all caps, FL, mixed tracking, mixed letterspacing
Body introduction	9/14 Caslon Regular U & lc, FL
Body copy	9/14 Caslon Regular, FL first line indent 9 pt (same number of points as the type size)

PAPER AND INK. Use 20-24# bond white paper for the front only or 50-70# opaque or white, 8½″ x 11″, for back and front. Use black ink.

BINDERY.

Three-hole punch with an additional ½″ margin on the left side.

Spiral binding with an additional ¼″ margin on the left side.

Staple and tape with an additional ½″ margin on the left side.

OUTPUT DEVICE.

1st Choice—Laser original (600 dpi or greater) to copier.

2nd Choice—Laser original (1000 dpi or greater) to conventional small press.

3rd Choice—Direct-to-plate at conventional small press.

Custom level short documents

Additional page elements, contrast techniques, and use of additional software packages add production time and increase printing requirements (figures 9-9 through 9-11).

STANDARD

The Wonderful World of Universal Language

Vast numbers of people from all over the world have met to see the beginning of this revolutionary international language.

BY J.J. WREN

NOT long ago, our languages and dialect were averaging between 15 and 20 per country. Today, dialects have decreased but new expression are added at between 25 and 30 a year and one finishes the day asking if there are any more expressions to be added! The table on the next page indicates what will happen to our ability to communicate without control of use of universal expression for new technology and expression in our graphic communication pieces. The printed word can be the monitor to help those working with multiple languages by allowing only universally accepted words added.

Year to Date

Most countries have chosen to limit their slang expression. None will be used for publications unless the word has been given a universal meaning. Switching to universal expression has had an astounding effect on both our productivity and our ability to communicate with other countries in our area.

Not long ago, the language interpreters were finishing the day exhausted. Today, with the daily up-date on new term, translators and interrupters are averaging between five and ten words or expressions a day and finish the day asking if there are any more to be added! The table on the next page illustrates the impact universal wording have had on our business.

The idea of universal terms was first thought of by listening to teenagers around the world speak to each other about their music. They began to share terms that were acceptable to all and eagerly communicated to each other satisfactorily without the time lapse.

Not long ago, web publishing and networking of computers shrunk the size of the globe by bringing access to anyone in any country. It seems a natural phenomenon to use terms and phrases that had a language of their own.

Figure 9-6 (Left) Standard level short document. One column of type on a three column grid

Figure 9-7 (Below) Standard level short document. Two columns of type on a five column grid

the WONDERFUL WORLD of Universal Language

Vast numbers of people from all over the world have met to see the beginning of the new international language. It is a new approach to a problem that has found no solution for the last 3,000 years.

Not long ago, our languages and dialect were averaging between 15 and 20 per country. Today, dialects have decreased but new expression are added at between 25 and 30 a year and one finishes the day asking if there are any more expressions to be added! The table on the next page indicates what will happen to our ability to communicate without control of use of universal expression for new technology and expression in our graphic communication pieces. The printed word can be the monitor to help those working with multiple languages by allowing only universally accepted words to be added.

■ Year to Date

Most countries have chosen to limit their slang expression. None will be used for publications unless the word has been given a universal meaning. Switching to universal expression has had an astounding effect on both our productivity and our ability to communicate with other countries.

Not long ago, the language interpreters were finishing the day exhausted. Today, with the daily up date on new term, translators and interrupters are averaging between 5 and 10 words or expressions a day and finish the day asking if there are any more to be added! The table on the next page illustrates the impact universal wording have had on our business.

The idea of universal terms was first thought of by listening to teenagers around the world speak to each other about their music. They began to share terms that were acceptable to all and eagerly communicated to each other satisfactorily without the time lapse of translation

Not long ago, web publishing and networking of computers shrunk the size of the globe by bringing access to anyone in any country. It seem to be a natural phenomenon to use terms and phrases that had a language of their own.

■ This Month

After one year of experimenting with the universal language, those responsible for language dictionaries and usage in publications are beginning to experience relief because the change from the old way of multiple translation requirement to a single translation requirement are saving time. Nothing could add to the success of a new experiment in language than the support of the business community.

Managers are participating in training that supports the new language. When a new part or technique is referred to by its universal name in the beginning, the word itself has no learning curve because it is its only name. Managers are encourage to use only the correct name as reference and not adopt slang expressions that will confuse the worker. This will also have an advantage when workers move from one company.

—J.J. WREN

The Wonderful World of Universal Language

Vast numbers of people from all over the world have met to see the beginning of the new international language. It is a new approach to a problem that has found no solution for the last 3,000 years.

NOT LONG AGO, our languages and dialect were averaging between 15 and 20 per country. Today, dialects have decreased but new expression are added at between 25 and 30 a year and one finishes the day asking if there are any more expressions to be added! The table on the next page indicates what will happen to our ability to communicate without control of use of universal expression for new technology and expression in our graphic communication pieces. The printed word can be the monitor to help those working with multiple languages by allowing only universally accepted words to be added to all .

YEAR TO DATE

Most countries have chosen to limit their slang expression. None will be used for publications unless the word has been given a universal meaning. Switching to universal expression has had an astounding effect on both our productivity and our ability to communicate with others.

Not long ago, the language interpreters were finishing the day exhausted. Today, with the daily up date on new term, translators and interrupters are averaging between 5 and 10 words or expressions a day and finish the day asking if there are any

more to be added! The table on the next page illustrates the impact universal .

The idea of universal terms was first thought of by listening to teenagers around the world speak to each other about their music. They began to share terms that were acceptable to all and eagerly communicated to each other satisfactorily without the time lapse.

Not long ago, web publishing and networking of computers shrunk the size of the globe by bringing access to anyone in any country. It seem to be a natural phenomenon to use terms and phrases that had a language of their own.

This Month

After one year of experimenting with the universal language, those responsible for language dictionaries and usage in publications are beginning to experience relief because the change from the old way of multiple translation requirement to a single translation requirement are saving time. Nothing could add to the success of a new experiment in language than the support of the business community.

Managers are participating in training that supports the new language. When a new part or technique is referred to by its universal name in the beginning, the word

itself has no learning curve because it is its only name. Managers are encourage to use only the correct name as reference and not adopt slang expressions that will confuse the worker. This will also have an advantage when workers move from one company to another.

Software and hardware developers have eagerly adopted the use of universal language. Representative of large companies have formed a board called the Universal Language Board. During the last year, this board met once a month to agree on definitions translated into the twenty major language. Which means that if a user spoke English, they would receive the same definition in every software and hardware instruction package rather than as many definitions as there are packages.

Last Year

So far this year, small business have been able to go on-line and download new terms and expressions. It is free because the larger companies now see the importance of being able to communicate with all people and companies in the fast changing world!

—J.J. WREN

Figure 9-8 (Left) Standard level short document. 10/14 type with an 18-point first line indent. Three columns of type on a three column grid with baseline leadings.

Figure 9-9 (Left) Custom level short document

NOT LONG AGO, our languages and dialect were averaging between 15 and 20 per country. Today, dialects have decreased but new expression are added at between 25 and 30 a year and one finishes the day asking if there are any more expressions to be added! The table on the next page indicates what will happen to our ability to communicate without control of use of universal expression for new technology and expression in graphic communication pieces. The printed word on the monitor helps those working with multiple languages allowing only universally accepted words added to all languages.

Vast numbers of people from all over the world have met to see the beginning of the new international language. It is a new approach to a problem that has found no solution for the last 3,000 years.

YEAR TO DATE

Most countries have chosen to limit their slang expression None will be used for publications unless the word has been given a universal meaning. Switching to universal expression has had an astounding effect on both our productivity and our ability to communicate with other countries in our area.

Not long ago, the language interpreters were finishing the day exhausted. Today, with the daily up date on new term, translators and interrupters are averaging between 5 and 10 words or expressions a day and finish the day asking if there are any more to be added! The table on the next page illustrates the impact universal wording had on businesses.

The idea of universal terms was first thought of by listening to teenagers around the world speak to each other about their music. They began to share terms that were acceptable to all and eagerly communicated to each other satisfactorily without the time lapse of translation

Not long ago, web publishing and networking of computers shrunk the size of the globe by bringing access to anyone in any country. It seem to be a natural phenomenon to use terms and phrases that had a language.

The
Wonderful World of
Universal Language
By J.J Wren

Figure 9-9 (Left) Custom level short document. One column of type on a seven column grid

Figure 9-10 (Below) custom level short document. Uses Officina Sans Book typeface. Two columns of type on a two column grid with baseline leadings

Figure 9-10

the
wonderful
world of
Universal Language
By J.J. Wren

Vast numbers of people from all over the world have met to see the beginning of the new international language. It is a new approach to a problem that has found no solution for the last 3,000 years.

Not long ago, our languages and dialect were averaging between 15 and 20 per country. Today, dialects have decreased but new expression are added at between 25 and 30 a year and one finishes the day asking if there are any more expressions to be added! The table on the next page indicates what will happen to our ability to communicate without control of use of universal expression for new technology and expression in our graphic communication pieces. The printed word can be the monitor to help those working with multiple languages by allowing only universally accepted words added to languages.

Year to Date

Most countries have chosen to limit their slang expression None will be used for publications unless the word has been given a universal meaning. Switching to universal expression has had an astounding effect on both our productivity and our ability to communicate with other countries in our area.

Not long ago, the language interpreters were finishing the day exhausted. Today, with the daily up date on new term, translators and interrupters are averaging between 5 and 10 words or expressions a day and finish the day asking if there are any more to be added! The table on the next page illustrates the impact universal wording have had on our business.

The idea of universal terms was first thought of by listening to teenagers around the world speak to each other about their music. They began to share terms that were acceptable to all and eagerly communicated to each other satisfactorily without the time lapse of translation

Not long ago, web publishing and networking of computers shrunk the size of the globe by bringing access to anyone in any country. It seem to be a natural phenomenon to use terms and phrases that had a language of their own.

This Month

After one year of experimenting with the universal language, those responsible for language dictionaries and usage in publications are beginning to experience relief because the change from the old way of multiple translation requirement to a single translation requirement are saving time. Nothing could add to the success of a new experiment in language than the support of the business community.

Figure 9-11

the wonderful **world** of
Universal Language
By J.J. Wren

Not long ago, our languages and dialect were averaging between 15 and 20 per country. Today, dialects have decreased but new expression are added at between 25 and 30 a year and one finishes the day asking if there are any more expressions to be added! The table on the next page indicates what will happen to our ability to communicate without control of use of universal expression for new technology and expression in our graphic communication pieces. The printed word can be the monitor to help those working with multiple languages by allowing only universally accepted words to be added to all .

Year to Date

Most countries have chosen to limit their slang expression None will be used for publications unless the word has been given a universal meaning. Switching to universal expression has had an astounding effect on both our productivity and our ability to communicate with others

Not long ago, the language interpreters were finishing the day exhausted. Today, with the daily up date on new term, translators and interrupters are averaging between 5 and 10 words or expressions a day and finish the day asking if there are any more to be added! The table on the next page illustrates the impact

The idea of universal terms was first thought of by listening to teenagers around the world speak to each other about their music. They began to share terms that were acceptable to all and eagerly communicated to each other satisfactorily without the time lapse of translation

Not long ago, web publishing and networking of computers shrunk the size of the globe by bringing access to anyone in any country. It seem to be a natural phenomenon to use terms and phrases that had a language of their own.

This Month

After one year of experimenting with the universal language, those responsible for language dictionaries and usage in publications are beginning to experience relief because the change from the old way of multiple translation requirement to a single translation requirement are saving time. Nothing could add to the success of a new experiment in language than the support of the business community.

Managers are participating in training that supports the new language. When a new part or technique is referred to by its universal name in the beginning, the word itself has no learning curve because it is its only name. Managers are encourage to use only the correct name as reference and not adopt slang expressions that will confuse the worker. This will also have an advantage when workers move from one company.

Software and hardware developers have eagerly adopted the use of universal language. Representative of large companies have formed a board called the Universal Language Board. During the last year, this board met once a month to agree on definitions translated into the twenty major languages. Whiah means that if a user spoke English, they would receive the same definition in every software and hardware instruction package rather than as many definitions as there are packages.

Last Year

So far this year, small business have been able to go on line and download new terms and expressions. It is free because the larger companies now see the importance.

Figure 9-11 (Left) Custom level short document. Three columns of type on a three column grid with baseline leadings

Element	Type Specifications
Title A	60/40 Caslon regular, U & lc, FL
Title B	36/30 Caslon regular
Title C	14/15 Caslon regular
Introduction	10/18 Helvetica light oblique, U & lc
By-line	12/18 Caslon bold, FR, added letterspacing
Subhead 1	9/18 Caslon bold, all caps, FL, Tracking, very loose, before paragraph leading 30 pt, 6-pt after leading (gives leading baseline design)
Subhead 2	9/18 Caslon bold, U & lc, before paragraph leading 12 pt, 6-pt after leading
Body introduction	9/18 Caslon regular, U & lc, FL
Body copy	9/18 Caslon regular, first line indent 9 pt (same as the type size)

PAPER AND INK. Use 24# bond, white, 8½″ x 11″, 60-70# book, white or off-white, matte finish enamel; or 60-70# book, white or off-white, laid or linen finish with matching cover weight. Use black or one spot color ink.

BINDERY.

Three-hole punch with an additional ½″ margin on the left side.

Spiral binding with an additional ½″ margin on the left side.

Staple and tape with an additional ½″ margin on the left side.

OUTPUT DEVICE.

1st Choice—Laser original (1000 dpi or greater) to conventional small press.

2nd Choice—Direct-to-plate at conventional small press.

Long documents

Elements in long documents have some of the same names as in short documents to provide consistency. Because of the large number of elements, it is difficult to produce long publications without using two typefaces. If the publication requires only one face, choose one with a strong contrast between regular and bold. Some typefaces also have a swash or extra bold in their family.

Long documents usually include numbers, bullets, and leader dots as separate page elements in the body text.

Sections of a publication

Generally, publications requiring a table of contents will divide into three sections: preliminary, text, and references. Although all pages listed in each section may not appear in all documents, they usually maintain the following order:

Preliminary section

The preliminary section appears before the text, but it is usually typeset after the text. Page elements are consistent for titles and body text. Body text is the typeface of the text and similar specifications. Few pages are numbered but all are counted. Numbering uses lower case roman numerals. Check the comments after for related information including which pages are numbered and which are **backs** (even-numbered pages).

Long documents require additional page elements beyond those mentioned at the front of this chapter in order to solve the greater number of sections and purposes.

TITLES. The titles at the top of the preliminary section match each other in typeface and weight and have some identity with the other titles and subheads in the publication.

TABLES OF CONTENTS. Tables of contents are commonly set with leader dots and wide page margins. Bring in the column width until the shape of the text block matches the shape of the page. Building a table of contents automatically by using the styles in text is rarely appropriate. Treat the table of contents like a new page design and sketch it before production. Use a 1 to 2 pica indent to separate the chapter name and each level of subhead. Use before paragraph leading to separate chapters.

BODY TEXT. Body text should have identity with the chapter's body text, but may have additional leading or be set a size smaller and fit proportionally to the page.

Element	Comments
Book half title	Set like title page without author or publisher's name
Publisher's agencies	Back side of half title, set smaller than body text
Title page	Includes title, subtitle, edition number, author, and publisher's signature
Copyright	Back side of title page, set smaller than body text
Dedication	Title and body text, numbered
Table of contents	Chapters and subheads with page numbers, front and back if more than one page, numbered
List of illustrations	Title with leader dots listing, front and back if more than one page, numbered
List of tables	Title with leader dot listing, front and back if more than one page, numbered
Foreword	Title and body text, front and back if more than one page, numbered
Preface	Title and body text, front and back if more than one page, numbered
Acknowledgments	Title and body text, front and back if more than one page, numbered
Introduction	Title and body text, front and back if more than one page, numbered

Text (the chapters)

Sections inside the text carry all text material with running heads and page numbers on the master pages. With multiple master pages, set two inside

pages and one chapter title page. The numbering begins at chapter one and continues through the reference section.

CHAPTER TITLE. Because chapter titles vary in length, choose the longest title for designing. Type specifications are versatile, like advertising headlines. The chapter opening should begin as a front (an odd-numbered page).

CHAPTER NUMBER. If there are more than nineteen chapters, allow space for the wider "2." Type specifications are even more versatile than for titles, using the full range of type sizes and applying tints, color, and overprinting techniques.

Element	Comments
Chapter title page	A right hand page where the chapter begins, not numbered
Left inside page	Master page with name of book as running head
Right inside page	Mirror image of left side with name of chapter as running head

Reference section

The reference section contains columns of information usually set in more than one column of type and in smaller type sizes than the text. It is not unusual for the outside margins to be decreased to allow room for the columns. The reference section follows the text. The reference sections may contain:

TITLES. Set the same specifications as titles are in the preliminary section but use smaller type sizes and set tighter to the copy.

INDEX. Automatic indexing will give hanging indents and smaller type sizes, which allow for tighter copyfitting.

Element	Comments
Appendix	Used for technical books
Glossary (definitions)	Set in one to three columns, hanging indent, or running heads
Bibliography	Set in one column, 2-pica hanging indent, before leading
Index	Listing of page numbers for key words
References	Follow the text pages
Notes	Used on any blank pages at the end

Sheet sizes

Work with the printing company to determine the printing sheet size for matching the document size to the press and bindery. Production in the page layout software is completed on page sizes in numerical order. Then, the pages are changed to an order fitting in the page layout for the press. This imposition is built by the page layout software or a prepress software package that also builds color traps. The designer can insert blank pages at the end of a chapter to cause the title page to be a front. The blank pages have been added by the software so the number of pages are multiples of 4, 8, or 16 depending on which imposition is required for the press.

Small presses or copiers use a layout of four page impositions. Larger presses can use 4, 8, or 16 page impositions. When publications have multiple impositions, those are "married" together and sketched out as a dummy. They are married together, stacked for perfect binding, and inserted for saddle stitching, which automatically changes the page layout on the imposition (figure 9-12).

Copy placement

The text block is set up on the computer to match the **live area** on a page (the area controlled by where the chapter text automatically flows onto the page). It does not include running head and folio area. Set the measurement system to picas and follow the formula. Page margins are from smallest to largest in this order: inside (gutter), top, outside, bottom. Photos and drawings also can extend to the edges of the sheet (as a bleed). The text block should be proportional to the page size. Follow these steps to determine the location of text block for the facing pages:

1. Draw diagonals. Draw two diagonals from the top inside edges of the facing pages to the outside bottom edge of the pages.

2. Determine type size. Establish a line length up to 24 picas. The larger the type size, the longer the line length.

3. Set up inside and outside margins. Measure the width of the sheet in picas by eight to set the inside margin. The outside margin will be 2 picas wider than the inside (gutter) margin using a

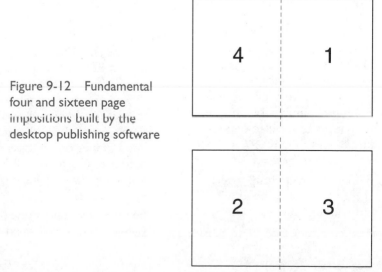

Figure 9-12 Fundamental four and sixteen page impositions built by the desktop publishing software

typeface and type size that produces seven to fifteen words or thirty-two to seventy-five characters per line.

4. Match the shape of the page. Use top and bottom margins. Work with the right hand side and draw a diagonal from its top left to its bottom right corners. The text will be proportional when its left and right corners match the diagonal (figure 9-13). Start with a top margin identical to the inside margin or 1 pica larger. Set the bottom margin at 1 to 2 picas larger than the outside margin.

Producing sketch sheets

After the margins are determined, print the sheets for sketching the chapter page designs (figure 9-14). To make sketch sheets, follow these steps:

1. Set up a file. Turn on facing pages and set margins.

2. Get the box tool. Draw a box on both master pages to fit the margins.

3. Open three pages. The first right hand page will be set up as a master for the chapter opening and the left and right page will be set up as a second master for facing inside pages.

4. Print at the scale of thumbnails, four to a page.

5. Remove these boxes. Use this file as the first chapter.

An organized style palette

Long publications use the same page elements as short documents adding additional specifications for complex text. When adding the type specifications to the style palette, divide the elements into four parts: master page, preliminary section, text pages, and reference section. By adding a number before the style name, the related style names will group together in the style palette. Refer to figure 2-7.

The master page area names that will group together are 0 header, 0 footer, 0 folio (page number), guidelines, and column guides.

The side bar areas on each page that are not part of the text are 1 pull quotes, 1 hints, 1 side bars, and, occasionally 1 subhead.

Inside pages need to flow into the page without breaking it into separate text blocks: 2 body, 2 sub A, 2 sub B, and 2 quote.

Turn on necessary options in the style palette. A less experienced designer will want to add these carefully since some can cause the wrong copy to move to another page. Some important options include:

- An **orphan**. The first line of a paragraph that is alone on a page or in a column.

- A **widow**. The last line sits alone on the next page or column or a single word is on a line by itself at the end of a paragraph.

- The paragraph setting. "Keep with next line" will keep titles and subheads with their copy.

Production hints

After placing type specifications in the style palette, some paragraph specifications need fine tuning. Fine-tune one typical chapter before proceeding to production. Work systematically through a completed chapter, checking paragraph indents and secondary leading to coordinate with the look of the page, number of times it is used on a page, and number of drawings and photos (they may conflict with each other). This document can be used two ways:

- Use it as a template. If the chapters are going to be built in separate files, create a template as shown in figure 2-8. Copy updates to the template as they are discovered in the production of the other chapters. The template may change the page numbering and master page chapter name, highlight and strike over chapter name and number on the opening chapter page, and autoflow the text. Other text documents can also begin from this template.

- Use it for this publication. If the entire publication is being built in one file, it will serve for this publication as well as additional publications.

Figure 9-13 Matching the text block to the shape of the page

Chapter 1

Printing Processes Today

Printing processes refers to the process used to output the final printed pieces. To produce the best possible copy for the lowest possible price, all the process need to be considered.

A test original that shows all possible ranges of problem output to all these process is an excellent quality control tool to help in choosing the process as well as evaluating new equipment.

LASER OUTPUT

If your quantity is 10-20 copies and your paper choice will run through your laser printer, your quality right off the laser printer will be excellent and the cost will be comparitive to taking one copy to a high volume copier. The reason the quality will be higher than when you take one copy to a copier is that you are one step or one generation away from the original. Any time you make a copy of a copy, any weak or gray type gets weaker and any fat or type gets fatter.

COPIER OUTPUT

No two copiers will produce the same quality, in fact a copier's quality will vary depending on the care that is given to it. Run a sample original of your type printed on that copier to be sure how big a solid it will hold and how thin a line or small a type it will print well. There are copiers that can output straight from the computer file and their copies will be the best because you are back to first generation copies. Talk to your copier operator before you begin a job to be sure of the kind of paper and quality of original that is needed.

SMALL PRESSES

Small presses are defined as up to 11 x 17 paper size and can run different sizes and weights of paper and colors of ink. They can print from several kinds of plates, which gives several price ranges, and will need an original or a negative from your output device. The quality will vary depending on the plate process used and quality can vary from press operator to press operator more that any of the other process. Finding a quality small press operator is a find because it can cut the cost of a quality job and give you a dependable source for future pieces.

LARGE PRESS OUTPUT

Presses that run 23 x 35, 35 x 38 are considered to be large presses. They usually run fine papers or enamel stock. There are sheet fed and webb fed presses. Newspapers and all quantities of forms are printed on webb presses as well as quanlity jobs. Sheet feed process usually only run one size sheet and the final size is cut out of that sheet.

ON DEMAND PRINTING

A new and very profitable method of printing has emerged recently that will remain part of the printing market, it is called on demand printing. The advantage of this process is that the printed copies are as good as the first copy from the file to the laser printer because that is exactly what it is.

FIGURE NUMBER • CAPTION

The electrostatic process of charge, expose, develop, fuse the same process that was used in the first copy machine and is still incorporated today to give a clean and exact replica of the original image. There are several things to watch for that may be unacceptable for the document. Those would include:
- A slight reduction in image size
- A course dot to produce photos and tints
- Color that requires adjustment and daily calibration

The advantages far outweigh these limitations. The on demand printing will probably not affect the high end color work, but will create its own market for short run, black and white printing with photos or color printing — each of these has never had a good process to fill the needs of these customers.

Figure 9-14 Sketch sheets for determining margins

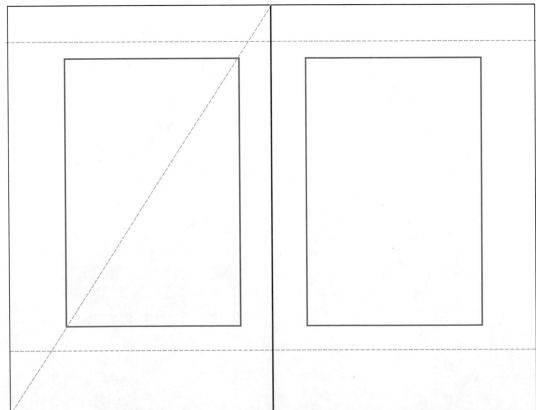

Booklet signatures are placed next to or inside each other depending on the finishing method. Some stitchers can handle up to 100 sheets of paper. If this causes too large a trim for the **creep**, convert to perfect bind or spiral bind. Creep is when the edge of the folded sheet does not align flush; instead, each sheet shifts further away from the edge of the outside folded sheets. Perfect binding is similar to binding on paperback books. It is used to create a more professional look and with booklets containing over 100 sheets of paper.

A final trim is given to the three edges of a booklet because of the uneven edges of the sheets after it is folded. The trim size of a long run on a large press is the booklet size specified in the job. Since small presses run on 8½″ x 11″ and 8½″ x 14″, the final size of that publication is trimmed to ¼″ less at the top and bottom and ½-¾″ less on the side edge. This is dependent on the thickness of the document because of creep when the sheets are folded. Try folding a dozen sheets in half to recognize the creep shown in figure 9-15. The margin for a copier or small press will need to be wide enough so that part of the image will not get trimmed. Check with the printing company for a safe minimum margin.

Figure 9-15 Trim required for creep

Long document samples

Range for type specifications

Element	Type Sizes	Comments
Running head	7-10 pt	Serif or sans serif, lower case small caps, loose tracking or condensed type, tight tracking
Folio	7-10 pt	Same as running head or larger, either face
Caption	7-9 pt	Smaller than body, lower case
Body text	8-10 pt	Serif, regular, first line indent, before paragraph leading, one-half body leading
Body introduction	8-11 pt	Match to body, no indent, no before leading
Body list	8-10 pt	Same as body text or one size smaller
Body bullets	8-10 pt	Same as body text
Subheads	8-14 pt	Body font or sans serif, same size or one size larger, bold, all caps or U & lc if the face has good contrast
Chapter number	All sizes	
Chapter title	12-72 pt	Body font or sans serif, contrast with weight
Footnotes	7-10 pt	Same size as body or up to two sizes smaller
REFERENCES (follow the text pages)		
Body text	7-9 pt	Smaller than text, 1-2 pica hanging indent, 6 pt before paragraph leading, set in columns if short lines of information
Titles	8-12 pt	Same as chapter titles, centered, smaller type size

Preliminary sections (established after the inside pages are completed)

Element	Type Sizes	Comments
Titles	12-72 pt	Same as chapter titles, centered, smaller type size
Table of Contents		Subhead or body text size with 1-3 pica indent for each subhead
Text	8-10 pt	Same as body text but with extra leading

Page Size*	Reader's spread
8½″ x 11″	11″ x 17″
8½″ x 7″	8½″ x 14″
8½″ x 5½″	8½″ x 11″
6″ x 9″	9″ x 12″

*All will receive a ⅛″ trim after printing.

PAPER. 24# bond, white, for front and back printing; 60-80# offset, uncoated, for small quantity publications; 60-80# book, coated, for photographs and four-process color; or 60-80# text, textured, neutral colors, for specialty publications.

Standard level long documents

Small quantities and urgent deadlines are well met with standard level long documents. Writing papers without deep textures will print easily in the laser printer. Ask the paper representative for specific paper choices. Try the specifications from figures 9-16 through 9-18 for style palette information or change fonts and modify slightly:

Type specifications for figure 9-16

Element	Type Specifications
Running head/folio	9/12 New Century Schoolbook bold, lower case small caps, increased letterspacing
Chapter title	24/30 New Century Schoolbook bold, all caps
Chapter number A	72/72 New Century Schoolbook bold
Chapter number B	72/72 New Century Schoolbook bold
Body text	9/12 New Century Schoolbook, 9 pt first indent, justified
Body introduction	9/12 New Century Schoolbook
Body number	9/12 New Century Schoolbook, 3-pt before paragraph leading
Subhead A	14/12 New Century Schoolbook bold, all caps, FL, 18-pt before paragraph leading
Subhead B	9/12 New Century Schoolbook bold, U & lc, FL, 12-pt before paragraph leading
Captions	10/12 New Century Schoolbook italics, centered
Hints	10/12 New Century Schoolbook italics, FL

Type specifications for figure 9-17

Element	Type Specifications
Running head/folio	9/12 New Century Schoolbook italics
Chapter title	22/26 New Century Schoolbook italics
Chapter number A	54/60 New Century Schoolbook
Chapter number B	10/10 New Century Schoolbook bold italics, all caps
Body text	9/12 New Century Schoolbook, 20-pt first indent, justified
Body introduction	9/12 New Century Schoolbook
Body number	9/12 New Century Schoolbook, 3-pt before paragraph leading
Subhead A	11/12 New Century Schoolbook italics, 12-pt before paragraph leading
Subhead B	11/12 Helvetica Black, all caps, 18-pt before paragraph leading
Captions	7/9 New Century Schoolbook, all caps
Hints	10/12, New Century Schoolbook italics, FL

Type specifications for figure 9-18

Element	Type Specifications
Running head/folio	10/12 Helvetica, small caps only, increase letterspacing
Chapter title	22/30 Helvetica condensed
Chapter number A	54/60 Helvetica bold
Body text	9/12 Helvetica light, 30-pt first line indent, 5-pica left indent, justified
Body introduction	9/12 Helvetica light
Body number	9/12 Helvetica light, 3-pt before paragraph leading
Subhead A	10/12 Helvetica bold, 6-pt left indent, 18-pt before paragraph leading, 1 pt rule before at 12 pt from baseline
Subhead B	14/18 Helvetica condensed bold, 36-pt before paragraph leading, 1 pt rule before, 16 pt from baseline
Captions	10/12 Helvetica oblique
Hints	10/12 Helvetica italics, FL

PAPER AND INK. 24# bond or 60# book, vellum finish, white with black ink.

OUTPUT DEVICE.

1st choice—Laser or copier printing, especially on-demand printers so that copies are straight from the file.

2nd Choice—Any dpi laser printer.

BINDERY. Saddle stitch.

Figure 9-16 Standard level design long documents, 5½″ x 8½″

CHAPTER
4
The Right Paper for the Right Job

MOST PEOPLE are sure that one of the most expensive papers will always give you the best paper for a job. Ironically, the opposite is true if you are in the wrong paper group. We will begin by studying the four most commonly used groups of paper and the variables for the use of each. You will be choosing papers for the final products and they will be printed on copiers, small presses and commercial presses.

BOND
Bond paper is a good general purpose sheet that has been the workhorse sheet in the office for a very long time.

Finish/Textures
Smooth sheet without texture or coating but has a cotton (rag) content — 25% rag, 50% rag, and 100% rag as a writing paper or for a lighter weight legal document .

Colors
Standard colors that are used in offices: pink, blue, canary (yel-

ANATOMY OF A BOOK

low), green, goldenrod, buff, cherry, and gray. The basic colors are always available. Occasionally, more expensive bond paper will have an additional palette of colors that include bright or more dramatic colors, but those change every five years.

Grades
Bond paper can be purchased in five grades, with #1 being the best. The color and smoothness of the sheets vary with the different grades. The less expensive grade is a yellow-white and will continue to yellow with age; #1 grade is a blue-white and usually holds it color longer. The blue-white gives a crisper look to the image and a brighter look to the sheet.

Uses
The lists of jobs that are printed on bond is extensive. General interoffice paperwork is produced on #4 grade bond. Copiers use bond paper and may include forms, memos, bulletins, parts lists, coupons, mailers, programs, manuals, newsletters, and inserts.

Make sure back and front printing is on a sheet that you cannot see through (opacity). Screen tints print well on bond paper; however, photos (halftones) do not. Bond folds easily which makes it excellent for mailing.

As mentioned previously, bond with rag is a letterhead or legal instrument sheet and carbonless forms are run on a special bond.

Sizes
Most jobs run on bond stock are 8 1/2 x 11, but it also comes in 8 1/2 x 14 and 11 x 17. Its basic size is 17 x 22 and that size determines the numbers used in the weight. The most Common Bond Sheet is 20# Bond, #4 grade, 8 1/2 x 11.

Carbonless Bond
Carbonless forms are printed on a bond sheet with special coating on each side that will automatically give you filled-in information on several sheets. The weight of this sheet varies depending on the position the sheet is in a set. The color sequence used is stan-

56

THE RIGHT PAPER FOR THE RIGHT JOB

dard: white, yellow, pink, goldenrod, and blue (*white is the first sheet and the other colors follow as needed by the number of copies per set*).

BOOK /TEXT
Book, offset, and text papers are both coated and uncoated and come with textures. You can find the basic color range in them, but some have unique palettes of colors that match both the newest colors and soft color palettes. They are a finer quality sheet than book because of these additional looks. They are used for jobs requiring a special look.

Figure 4-2. Chart of various paper choices

For laser printing, a paper should be hard and texture cannot be deep into the sheet. For offset printing, your best results will be on an absorbent but lint-free sheet. Most high-volume commercial presses run white, coated stock and add color by printing the color on the sheet. Since the jobs are all different, choosing the paper can only be done correctly.

The newest process of on line printing feed the paper the same as a copier, with friction or vacuum feed and there requires the same sheet of paper. The #2 grade of book or bond give these printed piece the quality that matches the printed image. Some on demand printers can run a variety of sheets included coated stock and a lighter weight cover stock that works well for business cards, invitations and covers.

57

Figure 9-17 Standard level design long documents, 6″ x 9″

The Right Paper for the Right Job

■ Most people are sure that the most expensive paper will always give you the best paper for a job. Ironically, the opposite is true if you are in the wrong paper group. We will begin by studying the four most commonly used groups of paper and the variables for the use of each.

You will be choosing papers for the final products and they will be printed on copiers, small presses and commercial presses.

BOND

Bond paper is a good general purpose sheet that has been the workhorse sheet in the office for a very long time.

Finish / Textures

Smooth sheet without texture or coating but has a cotton (rag) content — 25% rag, 50% rag, and 100% rag as a writing paper or for a lighter weight legal document found in business.

Colors

Standard colors that are used in offices: pink, blue, canary (yellow), green, goldenrod, buff, cherry, and gray. The basic colors are always available. Occasion-

ally, more expensive bond paper will have an additional palette of colors that include bright or more dramatic colors, but those change every five years.

FIGURE 4-1. CHART OF SI ZES AND WEIGHTS

Grades

Bond paper can be purchased in five grades, with #1 being the best. The color and smoothness of the sheets vary with the different grades. The less expensive grade is a yellow-white and will continue to yellow with age; #1 grade is a blue-white and usually holds it color longer. The blue-white gives a crisper look to the image and a brighter look to the sheet.

Uses

The lists of jobs that are printed on bond is extensive. General interoffice paperwork is produced on #4 grade bond. Copiers use bond paper and may include forms, memos, bulletins, parts lists, coupons, mailers, programs, manuals, newsletters, and inserts.

Make sure back and front printing is on a sheet that you cannot see through (opacity). Screen tints print well on bond paper; however, photos (halftones) do not. Bond folds easily which makes it excellent for mailing.

As mentioned previously, bond with rag is a letterhead or legal instrument sheet and carbonless forms are run on a special bond stock.

Sizes

Most jobs run on bond stock are 8 1/2 x 11, but it also comes in 8 1/2 x 14 and 11 x 17. Its basic size is 17 x 22 and that size determines the numbers used in the weight; i.e., 500 sheets 17 x 22 = 20#. The most common bond sheet is 20# Bond, #4 grade, 8 1/2 x 11.

Carbonless Bond

Carbonless forms are printed on a bond sheet with special coating on each side that will automatically give you filled-in information on several sheets. The weight of this sheet varies depending on the position the sheet is in a set. The color sequence used is standard: white, yellow, pink, goldenrod, and blue (white is the first sheet and the other colors follow as needed by the number of copies per set).

BOOK /TEXT

Book, offset, and text papers are both coated and uncoated and come with textures. You can find the basic color range in them, but some have unique palettes of colors that match both the newest colors and soft color palettes. They are a finer quality sheet than book because of these additional looks. They are used for jobs requiring a special look.

For laser printing, a paper should be hard and texture cannot be deep into the sheet. For offset printing, your best results will be on an absorbent but lint-free sheet. Most high-volume commercial presses run white, coated stock and add color by printing the color on the sheet. Since the jobs are all different, choosing the paper can only be done correctly if it is known how it is to be printed.

Key Words

Bond Paper	Carbonless forms	Opacity
Halftone	Commercial Printing	Offset

Figure 9-18 Standard level design long documents, 7″ x 8½″

4

The Right Paper for the Right Job

MOST PEOPLE are sure that the most expensive paper will always give you the best paper for a job. Ironically, the opposite is true if you are in the wrong paper group. We will begin by studying the four most commonly used groups of paper and the variables for the use of each.

You will be choosing papers for the final products and they will be printed on copiers, small presses and commercial presses.

Bond

Bond paper is a good general purpose sheet that has been the workhorse sheet in the office for a very long time.

Finish/Textures

Smooth sheet without texture or coating but has a cotton (rag) content - 25% Rag, 50% Rag, and 100% Rag as a writing paper or for a lighter weight legal document found in business.

Colors

Standard colors that are used in offices: pink, blue, canary (yellow), green, goldenrod, buff, cherry, and gray. The basic colors are always available. Occasion-

56 ANATOMY OF A BOOK

ally, more expensive bond paper will have an additional palette of colors that include bright or more dramatic colors, but those change every five years.

Figure 4-1. Chart of Paper Grades

Grades

Bond paper can be purchased in five grades, with #1 being the best. The color and smoothness of the sheets vary with the different grades. The less expensive grade is a yellow-white and will continue to yellow with age; #1 grade is a blue-white and usually holds it color longer. The blue-white gives a crisper look to the image and a brighter look to the sheet.

Uses

The lists of jobs that are printed on bond is extensive. General interoffice paperwork is produced on #4 grade bond. Copiers use bond paper and may include forms, memos, bulletins, parts lists, coupons, mailers, programs, manuals, newsletters, and inserts.

Make sure back and front printing is on a sheet that you cannot see through (opacity). Screen tints print well on bond paper; however, photos (halftones) do not. Bond folds easily which makes it excellent for mailing.

THE RIGHT PAPER FOR THE RIGHT JOB 57

As mentioned previously, bond with rag is a letterhead or legal instrument sheet and carbonless forms are run on a special bond stock.

Sizes

Most jobs run on bond stock are 8 1/2 x 11, but it also comes in 8 1/2 x 14 and 11 x 17. Its basic size is 17 x 22 and that size determines the numbers used in the weight; i.e., 500 sheets 17 x 22 = 20#. The most common bond sheet **is** 20# Bond, #4 grade, 8 1/2 x 11.

Carbonless Bond

Carbonless forms are printed on a bond sheet with special coating on each side that will automatically give you filled-in information on several sheets. The weight of this sheet varies depending on the position the sheet is in a set. The color sequence used is standard: white, yellow, pink, goldenrod, and blue (white is the first sheet and the other colors follow by the number of copies).

Book /Text

Book, offset, and text papers are both coated and uncoated and come with textures. You can find the basic color range in them, but some have unique palettes of colors that match both the newest colors and soft color palettes. They are a finer quality sheet than book because of these additional looks. They are used for jobs requiring a special look.

For laser printing, a paper should be hard and texture cannot be deep into the sheet. For offset printing, your best results will be on an absorbent but lint-free sheet. Most high-volume commercial presses run white, coated stock and add color by printing the color on the sheet. Since the jobs are all different, choosing the paper can only be done correctly if it is known how it is to be printed.

Key Words

Bond paper	Carbonless forms	Opacity	Halftone
Laser printing	Commercial printing	Offset	

Custom level long documents

Additional page elements, contrast techniques, and use of additional software packages add production time and increases printing requirements (figures 9-19 through 9-21).

Type specifications for figure 9-19

Element	Type Specifications
Running head	10/12 New Century Schoolbook, 1-pt rule after at 4 pt from baseline
Folio	12/14 New Century Schoolbook bold, 1-pt rule after at 4 pt from baseline
Chapter title	21/26 New Century Schoolbook bold, 80% horizontal scale, 2-pt rule before at 18 pt before baseline, .5 rule after at 18 pt from baseline
Chapter #	62/42 New Century Schoolbook bold
Introduction	10/15 New Century Schoolbook
Body text	10/15 New Century Schoolbook
Body intro para	10/15 New Century Schoolbook, 20-pt first line indent
Body number	10/15 New Century Schoolbook, 3-pt before paragraph leading
Subhead A	11/12 New Century Schoolbook bold, all caps, 80% horizontal scale
Subhead B	11/12 New Century Schoolbook bold, 80% horizontal scale, small caps at 85% cap size
Caption	10/12 New Century Schoolbook italics
Bibliography	10/12 New Century Schoolbook, 2-pica hanging indent, 6-pt before paragraph leading

Type specifications for figure 9-20

Element	Type Specifications
Running head/folio	11/12 Helvetica condensed light
Chapter title	24/28 Helvetica condensed bold, all caps
Chapter number	54/60 Helvetica bold
Introduction	9/12 New Century Schoolbook, justified
Body text	10/12 New Century Schoolbook, 9-pt first line indent, 6-pt before paragraph leading
Body introduction paragraph	9/12 New Century Schoolbook
Body number	9/12 New Century Schoolbook, 3-pt before paragraph leading
Subhead A	10/12 Helvetica bold, U & lc
Subhead B	10/12 Helvetica bold, all caps, 12-pt before paragraph leading
Caption	8/9.5 New Century Schoolbook italics, figure number in bold, italics

Type specifications for figure 9-21

Element	Type Specifications
Running head/folio	10/12 New Century Schoolbook, small caps only
Chapter title	22/27 Helvetica condensed bold
Chapter number	72/84 Helvetica bold
Introduction	9/13 Helvetica light
Body text	9/13 Helvetica light
Body introduction paragraph	9/13 Helvetica light
Body number	9/13 Helvetica light, 3-pt before paragraph leading
Subhead A	9/13 Helvetica bold, all caps, increased letterspacing, 23-pt before paragraph leading, 3-pt after leading
Subhead B	9/13 Helvetica bold, U & lc, 10-pt before paragraph leading, 3-pt after leading
Caption	8/13 Helvetica light oblique

PAPER AND INK. 24# bond or 60# book, vellum finish, white with black ink.

OUTPUT DEVICE.

1st Choice—Laser or copier printing, especially on-demand printers so that copies are straight from the file.

2nd Choice—Any dpi laser printer.

BINDERY. Saddle stitch or perfect binding.

Figure 9-19 Custom level design long documents, 5½″ x 8½″

4 The Right Paper for the Right Job

COMPENTENCIES
- Choose the correct paper to match the needs of the job.
- Learn variables in bindery to match the paper needs.

MOST PEOPLE are sure that the most expensive paper will always give you the best paper for a job. Ironically, the opposite is true if you are in the wrong paper group. We will begin by studying the four most commonly used groups of paper and the variables for the use of each.

You will be choosing papers for the final products and they will be printed on copiers, small presses and commercial presses.

BOND
Bond paper is a good general purpose sheet that has been the workhorse sheet in the office for a very long time. Smooth sheet without texture or coating but has a cotton (rag) content - 25% Rag, 50% Rag, and 100% Rag as a writing paper or for a lighter weight legal document .

ANATOMY OF A BOOK

56

Figure 4-1. The standard kinds of paper and sizes of paper

COLORS
Standard colors that are used in offices: pink, blue, canary (yellow), green, goldenrod, buff, cherry, and gray. The basic colors are always available. Occasionally, more expensive bond paper will have an additional palette of colors that include bright or more dramatic colors, but those change every five years. This sheet is available in 20# and 24#.

GRADES
Bond paper can be purchased in five grades, with #1 being the best. The color and smoothness of the sheets vary with the different grades. The less expensive grade is a yellow-white and will continue to yellow with age; #1 grade is a blue-white and usually holds it color longer. The blue-white gives a crisper look to the image and a brighter look to the sheet.

USES
The lists of jobs that are printed on bond is extensive. General interoffice paperwork is produced on #4 grade bond. Copiers use bond paper and may include forms, memos, bulletins, parts lists, coupons, mailers, programs, manuals, newsletters, and inserts.

Make sure back and front printing is on a sheet that you cannot see through (opacity). Screen tints print well on bond paper;

THE RIGHT PAPER FOR THE RIGHT JOB

however, photos (halftones) do not. Bond folds easily which makes it excellent for mailing.

As mentioned previously, bond with rag is a letterhead or legal instrument sheet and carbonless forms are run on a special bond stock and is excellent for quality work.

SIZES
Most jobs run on bond stock are 8 1/2 x 11, but it also comes in 8 1/2 x 14 and 11 x 17. Its basic size is 17 x 22 and that size determines the numbers used in the weight; i.e., 500 sheets 17 x 22 = 20#. The common bond sheet is 20# Bond, #4 grade, 8 1/2 x 11.

CARBONLESS BOND
Carbonless forms are printed on a bond sheet with special coating on each side that will automatically give you filled-in information on several sheets. The weight of this sheet varies depending on the position the sheet is in a set. The color sequence used is standard: white, yellow, pink, goldenrod, and blue (white is the first sheet and the other colors follow as needed by the number of copies per set).

STEPS TO THE RIGHT PAPER
1. Pick the paper categories that match the job.
2. Look and feel those samples.
3. Find two samples in different price ranges. Present your first choice to the client as part of the job cost
4. Write down the variables listed above that affect the sheet choice.
5. Use this information to talk with your paper merchant sales person or your print shop contact. Be sure to mention the deadline.
6. Once you have found a sheet you can rely on, put a sample in the notebook.

57

Figure 9-20 Custom level design long documents, 6″ x 9″

4
THE RIGHT PAPER FOR THE RIGHT JOB

COMPETENCIES
- *Choose the correct paper to match the job.*
- *Learn variables in bindery to match the paper.*

MOST PEOPLE ARE SURE THAT THE MOST EXPENSIVE PAPER WILL ALWAYS give you the best paper for a job. Ironically, the opposite is true if you are in the wrong paper group. We will begin by studying the four most commonly used groups of paper and the variables for the use of each.

You will be choosing papers for the final products and they will be printed on copiers, small presses and commercial presses.

BOND
Bond paper is a good general purpose sheet that has been the workhorse sheet in the office for a very long time.

Finish/Textures
Smooth sheet without texture or coating but has a cotton (rag) content — 25% rag, 50% rag, and 100% rag as a writing paper or for a lighter weight legal document .

Colors
Standard colors that are used in offices: pink, blue, canary (yellow), green, goldenrod, buff, cherry, and gray. The basic colors are always available. Occasionally, more expensive bond paper will have an additional palette of colors that include bright or more dramatic colors, but those change every five years.

Anatomy of a Book

Grades
Bond paper can be purchased in five grades, with #1 being the best. The color and smoothness of the sheets vary with the different grades. The less expensive grade is a yellow-white and will continue to yellow with age; #1 grade is a blue-white and usually holds it color longer. The blue-white gives a crisper look to the image and a brighter look to the sheet for quality jobs.

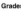

Figure 2
After several year, printing is alive and vital.

Steps to the right paper
1. Pick the paper categories that match the job.
2. Look and feel those samples.
3. Find two samples in different price ranges. Present your first choice to the client as part of the job cost by total cost or cost per copy. If the cost becomes a factor or if the sheet is not acceptable, go to sample B.
4. Write down the variables listed above that affect the sheet.
5. When specifying a colored sheet with a Pantone ink, the translucency of the sheet changes the color. Buy a PMS color marker and mark on a sample sheet.

Sizes
Most jobs run on bond stock are 8 1/2 x 11, but it also comes in 8 1/2 x 14 and 11 x 17. Its basic size is 17 x 22 and that size determines the numbers used in the weight; i.e., 500 sheets 17 x 22 = 20#. The most common bond sheet is 20# Bond, #4 grade, 8 1/2 x 11.

Carbonless Bond
Carbonless forms are printed on a bond sheet with special coating on each side that will automatically give you filled-in information on several sheets. The weight of this sheet varies depending on the position the sheet is in a set.

BOOK /TEXT
Book, offset, and text papers are both coated and uncoated and come with textures. You can find the basic color range in them, but

The Right Paper for the Right Job

Figure 4-1. Paper in the making

some have unique palettes of colors that match both the newest colors and soft color palettes. They are a finer quality sheet than book because of these additional looks. They are used for jobs requiring a special look.

For laser printing, a paper should be hard and texture cannot be deep into the sheet. For offset printing, your best results will be on an absorbent but lint-free sheet. Most high-volume commercial presses run white, coated stock and add color by printing the color on the sheet. Since the jobs are all different, choosing the paper can only be done correctly if it is known how it is to be printed.

Key Words
Bond paper	Carbonless forms
Opacity	Halftone
Laser printing	Offset
Commercial printing	

CUSTOM

Figure 9-21 Custom level design long documents, 7″ x 8½″

4

The Right Paper for the Right Job

COMPENTENCIES

- Choose the correct paper to match the needs of the job.
- Learn variables in bindery to match the paper needs.

MOST PEOPLE are sure that the most expensive paper will always give you the best paper for a job. Ironically, the opposite is true if you are in the wrong paper group. We will begin by studying the four most commonly used groups of paper and the variables for the use of each.

BOND

Bond paper is a good general purpose sheet that has been the workhorse sheet in the office for a very long time.

Finish/Textures

Smooth sheet without texture or coating but has a cotton (rag) content - 25% Rag, 50% Rag, and 100% Rag as a writing paper or for a lighter weight legal document .

Colors

Standard colors that are used in offices: pink, blue, canary (yellow), green, goldenrod, buff, cherry, and gray. The basic colors are always available. Occasionally, more expensive bond

THE RIGHT PAPER FOR THE RIGHT JOB 55

Figure 4-1. New processing techniques in papermaking

paper will have an additional palette of colors that include bright or more dramatic colors, but those change every five years.

Grades

Bond paper can be purchased in five grades, with #1 being the best. The color and smoothness of the sheets vary with the different grades. The less expensive grade is a yellow-white and will continue to yellow with age; #1 grade is a blue-white and usually holds it color longer. The blue-white gives a crisper look to the image and a brighter look to the sheet.

Uses

The lists of jobs that are printed on plain bond is extensive. General interoffice paperwork is produced on #4 grade bond. Copiers run bond paper for forms, memos, bulletins, coupons, flyers, stuffers, mailers, programs, manuals, newsletters, and inserts.

Make sure back and front printing is on a sheet that you cannot see through (opacity).

Screen tints print well on bond paper; however, photos (halftones) do not. Bond folds easily which makes it excellent for mailing.

As mentioned previously, bond with rag is a letterhead or legal instrument sheet and carbonless forms are run on special bond stock.

Sizes

Most jobs run on bond stock are 8 1/2 x 11, but it also comes in 8 1/2 x 14 and 11 x 17. Its basic size is 17 x 22 and that size determines the numbers used in the weight. The most common bond sheet is 20# Bond, #4 grade, 8 1/2 x 11.

Carbonless Bond

Carbonless forms are printed on a bond sheet with special coating on each side that will automatically give you filled-in information on several sheets. The weight of this sheet varies depending on the position the sheet is in a set. The color sequence used is standard: white, yellow, pink, goldenrod, and blue (white is the first sheet and the other colors follow as needed .

56 ANATOMY OF A BOOK

Book and Text

Book, offset, and text papers are both coated and uncoated and come with textures. You can find the basic color range in them, but some have unique palettes of colors that match both the newest colors and soft color palettes. They are a finer quality sheet than book because of these additional looks. They are used for jobs requiring a special look.

For laser printing, a paper should be hard and texture cannot be deep into the sheet. For offset printing, your best results will be on an absorbent but lint-free sheet. Most high-volume commercial presses run white, coated stock and add color by printing the color on the sheet. Since the jobs are all different, choosing the paper can only be done correctly if it is known how it is to be printed.

Key Words

Bond paper
Carbonless forms
Opacity
Halftone
Laser printing
Offset
Commercial printing

THE RIGHT PAPER FOR THE RIGHT JOB 57

Résumés

A résumé contains information that highlights the unique qualifications of a prospective employee's skill, training, and work experience.

Use all elements of fine typography and make every effort to fit the résumé on one page. Otherwise, the second page should be at least one-quarter full. Copyfitting should be controlled type and leadings (figures 9-22 through 9-27). Bookman or Helvetica (Arial) are examples of wide typefaces that can make a short résumé look longer; Times or Helvetica (Arial) condensed are examples of faces that will tighten lengthy résumés. Margins can be adjusted 1 or 2 picas to help fill the page. A heavy use of secondary leadings also helps the résumé to fit on one sheet.

Since a résumé is sent to prospective employers by fax or hard copy, test the quality of this document by making a sample output to both devices. The résumé design can use bullets, short sentences, or narratives for descriptions of previous jobs and responsibilities. The standard and custom samples in this section show each format. (Premium samples are not included, although this level would include web page design, which is covered in Chapter 13.)

Résumé samples

Résumés should be printed on white 20-24# bond with or without rag (such as writing papers) or textured 50-60# text in neutral colors.

Range for type specifications

Element	Type Sizes	Comments
Applicant name	9-12 pt	Bold, one size larger than body
Address	8-12 pt	Same as name or body
Titles	8-11 pt	Italics
Subheads	8-11 pt	All caps, bold, before paragraph leading
Body 1	8-11 pt	Medium, with or without 2-pica indent
Body 2	8-11 pt	Medium, with additional 2-pica indent
Body tabs	8-11 pt	Same as body

Standard level résumés

Small quantities and urgent deadlines are well met with standard level résumés. Writing papers without deep textures will print easily in the laser printer. Ask the paper representative for specific paper choices. Try the specifications from figures 9-22 through 9-24 for a style palette information or change fonts and modify slightly:

Element	Type Specifications
Applicant name	9.5/12 New Century Schoolbook bold, all caps, FL
Address	9.5/12 New Century Schoolbook, U & lc, FL
Objective	9.5/12 New Century Schoolbook bold, all caps, 120% horizontal scale, 6-pt before paragraph leading
Subhead	9.5/12 New Century Schoolbook bold, all caps, 120% horizontal scale, 6-pt before paragraph leading
School name	9.5/12 New Century Schoolbook bold, 3-pt before paragraph leading
Job titles	9.5/12 New Century Schoolbook italics, 3-pt before paragraph leading
Company name	9.5/12 New Century Schoolbook bold, 6-pt before paragraph leading
Body copy	9/12 New Century Schoolbook, 3-pt before paragraph leading

PAPER AND INK. 20# bond or 50# book, 8½″ x 11″, white or off-white, smooth or textured, with black ink.

OUTPUT DEVICE.

1st Choice—Laser original (600 dpi or greater) to copier.

2nd Choice—Laser original (1000 dpi or greater) to conventional small press.

For figures 9-22 through 9-24, applicant name is 12/12. Body copy is indented 4 picas and second line hanging indent of 9 points (same as the type size) and 6-point before paragraph leading (half of body text leading).

Figure 9-22 (Left) Standard level résumé

Karen Louise Parker
1614 Hutchings St. (409) 744-5534
Topeka, Kansas 33551

EMPLOYMENT OBJECTIVE Seeking employment involving the field
 of medical illustration

WORK EXPERIENCE
August 1993 **King Grocery Store**
 Floral Department Manager
 • Inventory Control
 • Ordered Flowers and greens
 • Instructional Leadership Council
 Reason for leaving: Husband was transferred from the
 Denver area to Topeka, KS

January 1991 to June 1991 **Kansas Independent School District**
 Substitute Teaching

September 1990 to December 1990 **Westwind Elementary**
 Denver, CO
 Student Teaching
 • Employed while in college as adult ed. lab instructor,
 day care caregiver, and tutor.

EDUCATION
1993 **College of the Westwind**
 Denver, Colorado
 Desktop Publishing Certificate
 Expected date of graduation, Summer 1994

1980 **Greenville College**
 Greenville, Texas
 A.A. Degree in Elective Studies

1974 **New Milway High School**
 New Milway, California
 Graduated

RELATED EXPERIENCE
 American Cancer Association, newsletter editor
 Milway Library, designed business package
 Girl Scouts Troup #181, Cookie Chairperson

Figure 9-23 (Below) Standard level résumé

KAREN LOUISE PARKER
1614 Hutchings St. (409) 744-5534
Topeka, Kansas 33551

EMPLOYMENT OBJECTIVE
Seeking employment involving the field of medical illustration

EDUCATION
1993 **College of the Westwind**
 Denver, Colorado
 Desktop Publishing Certificate
 Expected date of graduation, Summer 1994
1980 **Greenville College**
 Greenville, Texas
 A.A. Degree in Elective Studies
1974 **New Milway High School**
 New Milway, California
 Graduated

WORK EXPERIENCE
August 1993 **King Grocery Store**
 Floral Department Manager
 • Inventory Control
 • Ordered Flowers and greens
 • Instructional Leadership Council
 Reason for leaving: Husband was transfered from the
 Denver area to Topeka, KS

January 1991 to June 1991 **Kansas Independent School District**
 Substitute Teaching

September 1990 to December 1990 **Westwind Elementary**
 Denver, CO
 Student Teaching
 • Employed while in college as adult ed. lab instructor,
 day care caregiver, and tutor.

RELATED EXPERIENCE
 American Cancer Association, newsletter editor
 Milway Library, designed business package
 Girl Scouts Troup #181, Cookie Chairperson

Karen Louise Parker
1614 Hutchings St.
Topeka, Kansas 33551
(409) 744-5534

EMPLOYMENT OBJECTIVE

Seeking entry level employment involving Computer Aided Drafting

RELATED SKILLS

AutoCAD 1,2,3 Intro to AutoCAD Engineering Drafting

Pipe Drafting Electrical Drafting Structural Drafting

EDUCATION
'95-'96 **Coastland College**
 Billow Beach, CA
 Drafting and Design Certificate - Spring '96
 AA Degree - Anticipated December '96
'91-'93 **Coastland College**
 Billow Beach, CA
 General Education Classes
May '91 **West Side High School Diploma**
 Murrow, CA

WORK EXPERIENCE
Sept. '95 - Present **Coastland College**
 Student Assistant Career Counseling
 • Use MicroSoft Works & Word Perfect
 • Operated a network to generate student worksheet

May '94 - Sept. '95 **SportsWorks Inc.**
 Lead Salesperson for Sports Shoes / In-line skates
 • Advised customers
 • Inventoried shoes and supplies
 • Developed advertising strategy
 Reason for leaving: Company went bankrupt

May '93 - May '94 **Computers, Etc.**
 Sales Associate
 Reason for leaving: Better position

May '92 - Feb. '93 **Fast Delivery Service**
 Front Desk Sales Associate
 Reason for leaving: Better position

Figure 9-24 (Left) Standard level résumé

Custom level résumés

Additional page elements with subtle but complicated levels of before paragraph leadings give the quality to custom level résumés (figures 9-25 through 9-27).

Element	Type Specifications
Applicant name	9.5/12 Caslon bold, all caps
Address	9.5/12 Caslon, U & lc
Objective body copy	9.5/10 Caslon bold, lower case small caps
Summary	9.5/12 Caslon semi-bold
Subhead	9.5/10 Caslon bold, 120% horizontal scale
School/company name	9.5/12 Caslon italics
Job titles	9.5/12 Caslon bold, 12-point before paragraph leading
Body copy	9/12 Caslon, 1-pica hanging indent

PAPER AND INK.
20# bond or 50# book, 8½″ x 11″, white or off-white, smooth or textured, with black ink.

OUTPUT DEVICE.

1st Choice—Laser original (1000 dpi or greater) to conventional small press.

2nd Choice—Direct-to-plate at conventional small press.

ERIK A. SHARP
5114 Sea Side Circle, #321 (213) 317-1464
Billow Beach, CA 53009

OBJECTIVE
ADMINISTRATION OF OCCUPATIONAL EDUCATION PROGRAMS FOR MAJOR UNIVERSITY

EDUCATION
Doctoral Candidate, Occupational Education, Utah University,
 Anticipated Graduation, Spring 1996 (GPA 4.0)

M.A. CAD Drafting, Syracuse University

A.A., Westwind Jr. College, Billow Beach, CA

PROFESSIONAL HIGHLIGHTS
Built community college Drafting Program from scratch to 300 student enrollment.

Designed and taught college or university level CAD Drafting courses for twelve years.

Created CAD Drafting Continuing Education programs at two community colleges.

With team members, designed and established early NCDA-approved, cutting-edge computer laboratory.

Hired, supervised and mentored colleagues in college and community program settings.

Wrote successful research and program continuation proposals, negotiated contracts, developed and managed
 annual budgets.

Assumed leadership of multi-site "at risk" High school program, increasing revenues by over 50% in 18
 months. Conducted staff reorganization, contained costs, expanded service area, tightened compliance. Im-
 proved program quality and community involvement.

PROFESSIONAL POSITIONS

Director, Continuing Education Programs. **1990 to present**
Franks Jr. College, Mt. Vernon, WA

Lead Instructor, CAD Drafting Programs. **1987 to 1990**
Windmere Jr. College, Westminster, AK

Instructor, CAD Drafting. **1981 to 1987**
Mainland High School, Mainland, AL

Adjunct Faculty Member.
Utah University **1993**
University of Alaska, Mainland, AL **1983**

PROFESSIONAL AFFILIATIONS
National Council on Continuing Education (NCCE and WaNCCE)

American Association for Occupational Education (AAOE)

PRESENTATION (RECENT)

The Merging and Emerging Technology of Computers for Higher Education. Presented at the HCCE Conference
 2000, Honolulu, Hawaii September 1994

Figure 9-25 Custom level résumé

ERIK A. SHARP
5114 Sea Side Circle, #321 (213) 317-1464
Billow Beach, CA 55309

OBJECTIVE
ACADEMIC APPOINTMENT IN A CAD DRAFTING DEPARTMENT

EDUCATION

Doctoral Candidate, Occupational Education, Utah University
 Anticipated graduation, Summer 1996 (GPA 4.0)

M.A. CAD Drafting, Syracuse University

A.A., Westwind Jr. College, Billow Beach, CA

PROFESSIONAL EXPERIENCE

Director, Continuing Education Programs. **1990 to present**
 Franks Jr. College, Mt. Vernon, WA

Assumed leadership of multi-site continuing education program, creating turnaround situation and increasing reve-
 nues by over 50% in 18 months. Reorganized and revitalized program, contained costs, tightened compliance and
 increased program quality, dramatically. Wrote grant proposals and created positive linkages with community, par-
 ents and funding agencies.

Lead Instructor, CAD Drafting Programs. **1987 to 1990**
 Windmere Jr. College, Westminster, AK

Started new CAD Drafting degree program from scratch, enrolling 300 students within three years. Designed cur-
 riculum, taught courses, hired and supervised adjunct faculty, worked extensively with community, students, advi-
 sory groups and Board of Trustees.

Instructor, CAD Drafting. **1981 to 1987**
 Mainland High School, Mainland, AL

Taught CAD Drafting and Continuing Education classes, worked with advisory boards, counseled students, super-
 vised practicum placements. With team, designed and established NACD-approved, state-of-the-art computer
 laboratory .

Adjunct Teacher. **1970 to 1974**
Taught occupational teach training classes at four year schools in Missouri and New York.

PROFESSIONAL AFFILIATIONS

National Council on Occuatpional Education (NCOE)

American Association for CAD Drafing Instructors (AADI)

CERTIFICATIONS

Secondary Occupational Education, New York and Texas

Secondary Occupation Teacher Trainer, Washington

PRESENTATIONS (RECENT)

*Merging and Emerging Technology for the Four Year Teacher Colleges H*CCE Conference 2000,
 September 1994

Figure 9-26 Custom level résumé

ERIK A. SHARP

HOME ADDRESS
5114 Sea Side Circle
Billow Beach, CA 55309
(213) 317-1464

CURRENT ADDRESS
803 Central, # 4C
Bryan, UT 44821
(213) 920-7535

SUMMARY

An upcoming graduate of Utah University

Diverse classroom experience, including an international internship

High academic standing

A conscientious, energetic team player

Attention to detail

EDUCATION

Utah University
Doctor of Occupational Education., 5/9
GPA 3.72, Class Rank 13/121, 5/95

Westwind Jr. College
Associate of Arts, A.A., major: Biology, 5/92
GPA 3.84

University of Alaska
Bachelor of Science, B.S., major: CAD Drafting, 12/93
GPA 4.0

WORK EXPERIENCE

International trainer. *Summer 95*
Updating safety into refineries with CAD Drafting., Columbia
Under supervision of Dr. Jorge Calatayud
• Responsible for establishing curriculumn
• Assisted in producing and interpreting safety for refineries
• Monitored instruction
• Worked with International at Utrecht Veterinary School

CAD Trainer. *1991–92*
IUS Technical School. Westmeinster, AK
Under supervision of Dr. Ron Williams
Responsibilities included all aspects of instruction:
• Prepartion of insturctional materials
• Recruitment of students
• Job placement
• Budget managements
• Set up total quality managemnt for campus

VOLUNTEER WORK

AACD - Association of CAD Drafting President, 1993-1995
Redistrcting Proposal Chairperson, 1996

HONORS

Phi Theta Kappa - International Honor Society

Figure 9-27 Custom level résumé

Annual reports

Annual reports are produced once a year by companies or organizations. They began after the stock market crash of 1929 and primarily serve to inform stockholders of the financial state and accomplishments of the company. They also exist in simple format for annual meetings of nonprofit organizations. Usually, the stockholder looks at the report briefly when it is first opened and, although the information may be well written, it is not often well read. To encourage reading, give a classic look with a team approach to the research, design, and production of annual reports.

Invaluable to annual report research are booklets produced by the fine paper manufacturers, printed on a wide assortment of fine papers. They give helpful information such as statistics and trends in annual reports. Recent information provided by Hooper and Potlatch paper companies includes:

- Annual reports given to important associates include stockholder annual meeting announcements, job application packages, bank loan requests, marketing packages, and press releases.

- A theme is established at the beginning of the project which identifies with easy-to-read charts and quality photos.

- $2.00-6.00 per copy is the typical range of annual report production costs.

- Annual reports are produced by teams: financial, artistic, CEO, writers, and editors. All must agree on a deadline for each production phase.

- Allow three to four months for research and production time.

- Eliminate last minute corrections when deadlines are tight that can destroy cost control.

Research

Since an annual report takes months to produce and has a strict deadline, preliminary research is essential. Invest in a PostScript typeface specifically designed for the annual report. Use the type manufacturers' type catalogs with samples of body text to make a choice. Look for sharpness in typefaces with thin letters that justify well. This gives smoothness on the page and is like the difference between a coarse or fine screen tint. Fonts like Adobe Expert Caslon or Garamond, or traditional fonts like Baskersville, Bodoni, Cochin, and Palatino are frequently used. The title is commonly in the same face or classical faces like Caslon Openface, Charlemagne, Copperplate Gothic, or Cochin.

Because of the amount of time dedicated to compilation and production and executive involvement, annual reports are usually a premium or showcase publication. They are the single publication type that drives the changes in the market of design. They not only establish new design, but also contain the newest techniques. Annual reports can be used as research samples for the newest type and paragraph specifications, colors of ink, paper choices, and designs. Although they are pacesetters, most still fit into the medium range of choices.

Design

1. Schedule the phases of this project. There will be someone responsible for the team. The team will be developing their areas simultaneously. Be sure to review data on previous annual reports for deadline schedules.

2. Sketch the design like a storyboard. Sketch three pages of a typical chapter, the title page, and two inside pages (see the sample in figure 9-1). This gives a concrete plan for an identity for titles and running heads.

Contrast is accomplished by making copy lighter rather than darker, starting with secondary leading for all copy and run-in subheads. A second color is used to lighten the subheads, the charts, line art, and rules.

3. Choose two or three quality sheets that blend. Inside pages have a light text, book, or bond sheet that complements the heavier sheet for financial statistics. The cover may be one of the inside sheets in a cover weight, without a texture. Work closely with the paper specification representative.

4. Bindery. Saddle stitch if the report is no more than ⅜″ thick; if it is thicker than ⅜″, it should be perfect bound or wire bound.

5. Cost per copy must be established early. Keep design and schedules within budget of the publication.

6. Keep leadings proportional to each other.

Sections of an annual report

Sections of an annual report will appear similar to other publications, but there are less units within each section. They appear in the order listed and the report has one set of numbering, which begins by counting the outside cover.

Element	Comments
Front and back cover	Sets the theme that is clearly identified with the publication and continues from the front to the back with a wrap
Front inside cover	Use for letter from the CEO, special interest story
Back inside cover	Listing of officers, report committee
Table of contents	Included with reports longer than thirty-two pages, very brief
Letter to shareholders	From the CEO

The inside text should include the following sections:

Section 1: Business activities for the year. A personal approach to accomplishments told with customized art, photographs, and easy-to-read text with extra leading and lighter choices in subheads.

Section 2: Financial statements. This contains every kind of chart and graph available. Number charts are straightforward and designed with tints (figure 9-28a) to help the reader move across the columns. Complex financial statements may be turned sideways or presented as a fold-out. Infographs, pie charts, and bar graphs are typically page elements used to present statistics (figure 9-28b).

Report from an independent auditor. This is presented briefly and adds a professional validation to the report.

Corporate information. This information is important when a large group of new stockholders exists.

Glossary. A glossary is used for high technology or when new terminology has recently become part of the industry.

Annual report samples

Premium level designs focus on storyboard sketches, complex photo manipulation, multiple color samples, and additional conferences with the client. For the cover, use 65-100# cover stock with texture and a coated finish; use white 60-80# offset for inside pages and textured 60-80# text in a neutral color for the second section of the document. Art boards should be used for presentation of all work. The fol-

	1995	1994	1993
Revenues[1]	$493.6	$546.0	$660.4
EBITDA[2]	55.1	90.2	129.3
Capital expenditures	14.6	20.4	27.2
Orders	594.9	520.6	542.3
Backlog (as of year-end)	323.6	219.7	245.9

1 Excludes income from equity investments.
2 Excludes nonrecurring/unusual charges.

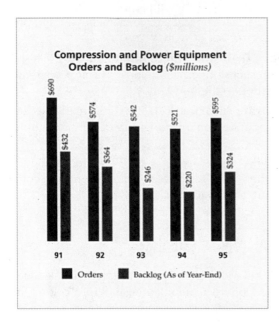

Figure 9-28a (Above) Chart for annual report.
Credit: Manlove Advertising, Pasadena, TX, design and production

Figure 9-28b (Left) Bar graph for annual report.
Credit: Manlove Advertising, Pasadena, TX, design and production

lowing are examples of typical premium level publications:

Range for type specifications

Element	Type Sizes	Comments
Introduction	14/30	Script
Body Text 1	9/12-8/18	Prestige, light face such as Caslon or Garamond
Body Text 2	10/16	Leadings of 140% to 200% of type size
Subhead	Size of body	Script, run-in, a different color, U & lc
Title	12 pt	Small caps (80%), add letterspacing
Subtitle	12 pt	Italics
Sidebars	7/11	Italics
Quote	11-12 pt	Italics, 3-pt hanging indent
Captions	7/9	Medium
Folios	7 pt	Medium
Chart titles	7 pt	Italics, U & lc
Chart body	8/12	Medium, 1-pica hanging indent

Premium level annual reports

Figure 9-29 is an excellent example of quality with two and three colors of ink. The cover (figure 9-29a) is printed on an 80# matte enamel with two-color black duotones. The inside text (figure 9-29b) is printed on 70# text and does not include a separate financial section. Colors: PANTONE 312, a turquoise, and black.

Figure 9-30 is an excellent example of photo manipulation and interesting graphs. The cover (figure 9-30a) is printed on 90# high-gloss enamel with a laminate. The inside text (figure 9-30b) is printed on 80# enamel, and the financial section is printed on 60# fiber in light gray. Color: four-color process.

Figure 9-31 is an excellent example of photo manipulation and illustration and includes an additional die cut. The cover (figure 9-31a) is printed on dark burgundy 90# cover stock with a texture and a metallic silver ink. The inside text (figure 9-31a) is printed on 70# enamel text with one spot color plus varnish. Color: four-color process.

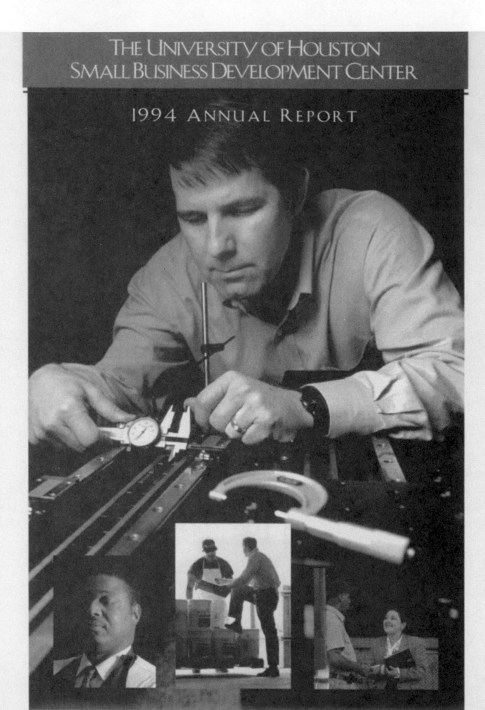

THE UNIVERSITY OF HOUSTON
SMALL BUSINESS DEVELOPMENT CENTER

1994 ANNUAL REPORT

A program of the College of Business Administration

REFLECTING ON THE PAST

1984 1994

Focusing On The Future

Figure 9-29 Premium level annual report, cover and inside pages.
Credit: Creative Art Director: Jennifer Woeste, University of Houston Small Business Development Center
Graphic Designer: David Leiper, Leiper Design, Houston, TX,
Photographer: Fred Carr, Photographer
Printer: Jimmy Seiford, The Beasley Company

PREMIUM

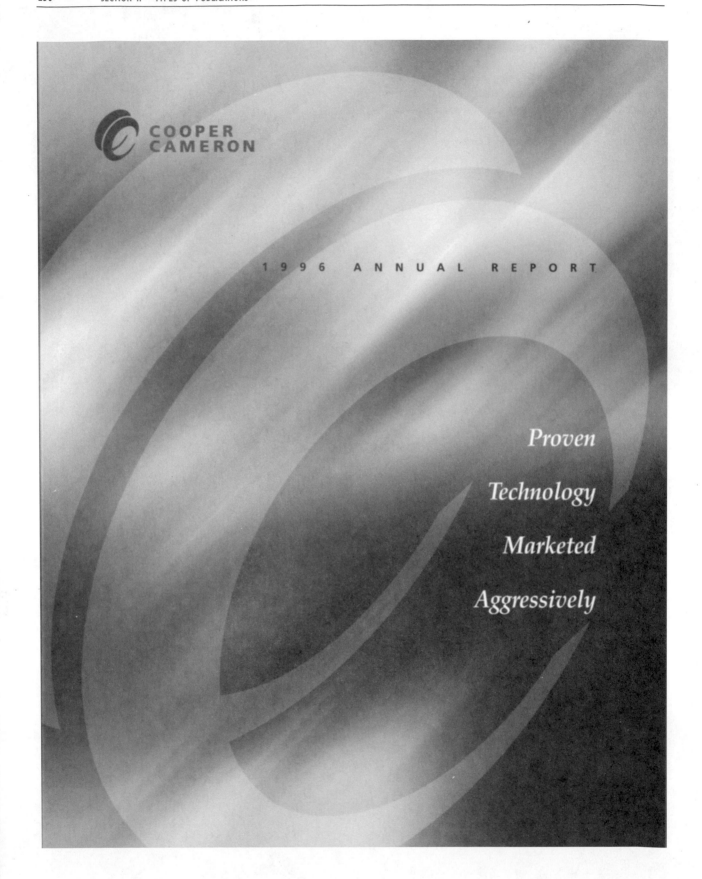

COOPER
CAMERON

1996 ANNUAL REPORT

Proven

Technology

Marketed

Aggressively

Figure 9-30 Premium level annual report, cover and inside pages.
Credit: Manlove Advertising, Pasadena, TX, design and production

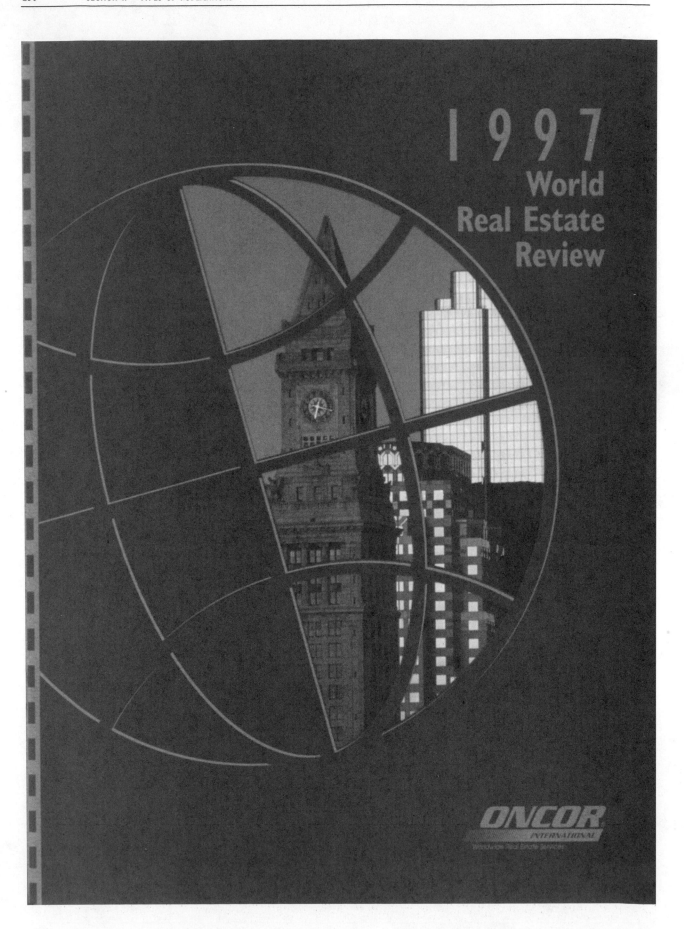

1 9 9 7
World
Real Estate
Review

ONCOR
INTERNATIONAL

Figure 9-31 Premium level annual report, cover and inside pages.
Credit:Vosburg de Seretti, inc., designers

Other text projects

Several other publications are grouped in this section either because the designs are usually similar to each other or the publication has similar specifications to another publication that was presented in great detail.

Poetry

Poems should be set to complement the intent of the poet. Poems are set with the longest line centered on the page but with a flush left alignment, which produces generous margins. Generous secondary leading between verses helps the rhythm. If two lines are to be read without a pause, the second line is given a 1 pica indent and the indent continues until the author breaks (figure 9-32). Except in anthologies, poems usually start at the top of a page. Poetry and readings follow document page formats. Use white 20-24# bond with or without rag (such as writing papers) or textured 50-60# text in neutral colors. Also, use 9-11-point type with leading up to double the type size.

Plays and readings

With plays and readings, there is a second indent of 2 picas on some lines that are like a sub of the 2-pica indent when they are to be read together. The author of the play or reading determines where lines break; this is accomplished with a manual return.

This typing format is also followed for readings with a leader and a group response. The leader's words are typed in medium type with the response in bold or vice-versa. If this is a special occasion, more direction is given on the copy with the words "leader/audience" preceding their readings. This is set up with tabs and hanging indents similar to numbers and bullets (figure 9-33).

Catch of the Day
by J. Kay Toler

"I caught them all — he said
 Paw paw didn't catch any!"
Five year old arms
 Illustrated the big fish.

"I caught all eight — he said
 Nodding in agreement."
I smiled as I caught
 Paw paw's smile and wink.

Figure 9-32 Poem. *Credit: J. Kay Toler, poet*

Robert: Shouldn't she be home by now?

Linda (annoyed): Yes. She is thirty minutes late.

Robert (crosses behind couch): She didn't say she had somewhere to go after school did she?

Linda: No, she is just late.

Robert: She knows she is supposed to tell us when she goes anywhere. Hmph! If I had it my way, I'd attach a monitor to her so I would know where she was every single minute of the day. It is the only safe way to raise kids nowadays.

Linda : I don't think Emily would ever agree to such an idea.

Robert (crossing back to window): Well, she'd certainly have no say in the matter. She's only eighteen; she can't have a mind of her own yet.

by Lee Ann Janik

Figure 9-33 Dialogue. *Credit: Lee Ann Janik, writer*

Recipe books

Recipe books are a popular way for nonprofit organizations to raise money. They usually contain a section on the history of this group and are packed with hundreds of recipes. Since they must lay flat to use, the books are conveniently spiral, plastic binding, or three-hole punched. The unique part of typesetting these recipe books is that the ingredients contain fractions. Purchase a fraction font specifically for a project like this (figure 9-34).

-Yogurt Pineapple Shake-

1 cup milk	1 T. flaked coconut
1 egg	1 ½ t. sugar
¼ cup plain yogurt	½ (8oz.) chunk pineapple in juice
⅛ t. vanilla	

Combine all ingredients in electric blender. Whir until smooth and frothy. Makes about 1⅔ cups.

—The Best of a Good Lay by JoAnn Shoup

Figure 9-34 Recipe book. *Credit: Jo Ann Shoup, cookbook author*

For additional research

Keep a well-balanced design approach by continuing research into some suggested sources:

Review annual reports (great typography).

Check the design on the first page of magazine articles.

Check the hierarchy of type specs from books typeset before 1970.

Read any copy with several levels of subheads and body text combination.

Review demonstration samples from the quality paper houses.

Contact the Association of American Publishers
220 East 23rd Street
New York, NY 10022

Historical information

Berryman, Greg, *Designing Creative Résumés,* Los Altos, CA: Crisp Publication Inc., 1991.

Bringhurst, Robert, *The Elements of Typographic Style,* New York: Hartley and Marks, Inc., 1996.

Nelson, Roy P., *Publication Design,* Dubuque, IO: W.C. Brown, 1990.

Wilson, Andre, *The Design of Books,* Chronicle Books, 1993.

Now that the annual event is over, it's time to plan the design for next year.

10 Advertising Packages

Designing advertising packages
Flyers and posters
Invoice stuffers and mailers
Advertisements
Programs
Pocket folders
Brochures
Other advertising projects
For additional research

After reading this chapter and applying its principles, the designer should have success producing:

- Flyers
- Direct mailers
- Stuffers
- Programs
- Pocket folders
- T-shirts

- Posters
- Brochures
- Ads
- Menus
- Table tents
- Specialty items

An advertising package contains the printing publications required to sell a new company or a new product, or to announce an event. All companies and nonprofit organizations need to reach their clients or potential clients by bringing them relevant information. Therefore, an advertising package becomes the main tool for new sales and publicity. "Loud but attractive" are good adjectives describing advertising publications. In contrast to the quiet look of the business communication package, advertising publications are back and front, folded, have additional type elements, and require a blend of advertising design and text document specifications.

Designing advertising packages

State and nationwide workshops, festivals, and conventions are a large market for custom publications. Business-to-business and large corporate ventures use custom photos, art work, and four-process color in their advertising packages. An additional market, the classified ad, was originally part of the newspaper market. Today's classified ads appear in the advertising market in newspapers, newsletters, magazines, programs, telephone directories, direct mailers, maps, and calendars. Some of these publications exist as classified publications for the purpose of distributing.

The audience

Attracting an audience is the single purpose of advertising. Advertising sets a focus or theme to attract prospective customers. For the ad package to be successful, there must be a theme or identity throughout all the projects. The element of focus can be the headline, price, photo, or art. Establish the identity of the project package with each publication. Reuse some of the designs and type specifications. Four different audiences affect the choice of design level and style of the project (figure 10-1):

1. Intercompany
2. Business-to-general public (figure 10-1, top)
3. Business-to-target customer
4. Business-to-business (figure 10-1, bottom)

Page elements

The page elements are arranged to draw attention and direct the reading pattern. Copy in advertising projects is not always specifically written for its printed publication. Copy is often presented as straightforward information taken from a news release or printed publication and then edited for advertising. It can be planned, such as a sketched sheet of copy, or casual, such as written on a napkin.

A Bright Idea For Brazoria County

BRAZORIA COUNTY
RECYCLING CENTER

WRS
A WASTE REDUCTION SYSTEMS, INC. PROJECT

Figure 10-1
Similar brochures aimed at
different audiences

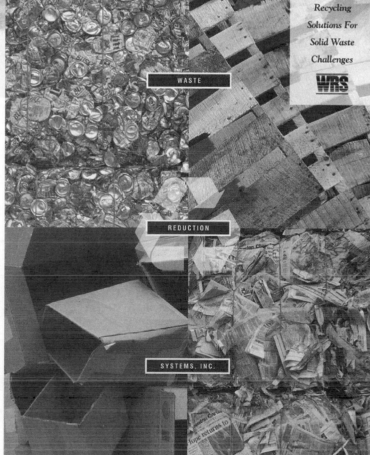

Recycling Solutions For Solid Waste Challenges

WRS

WASTE

REDUCTION

SYSTEMS, INC.

Separate the copy into four major type elements: headlines, subheads, body copy, and signature (figure 10-2). Then, divide each major type element of headline and body text into additional type elements and specifications to cover areas such as cover title, body A, and body bullets. If the copy is not clearly defined into type element groups, the design will reflect this disorder. Ask the client questions to help determine which copy belongs to each element:

Art (photo)

Art includes good illustrations, photos, or a group of images. Avoid an undirected, unprofessional look—do not place several small pieces of cute art randomly on the page!

Body

Body copy is the paragraphs, bullets, or numbered copy. On advertising projects with more than two paragraphs of text, marketing and writing skills play an important part in relaying the message or purpose of the printed publication. The goal is to include the most requested information in the text. *Application: "Now let's talk about what is included in this company/product/event."*

Credit card listing

Credit card listings include written listing or logos for credit cards that are accepted.

Directions

A map or location information placed in a box to separate it from other copy.

Headline

Headlines are used as a title. They set the theme and share the focus with a photo. Headlines appear on flat sheets and on the cover of folded and two-sided publications. *Application: "Give me two or three words that would be used to get someone's attention..."*

Numbers

The specifications for the phone numbers, fax numbers, e-mail address, and so on, can be set up close to the signature.

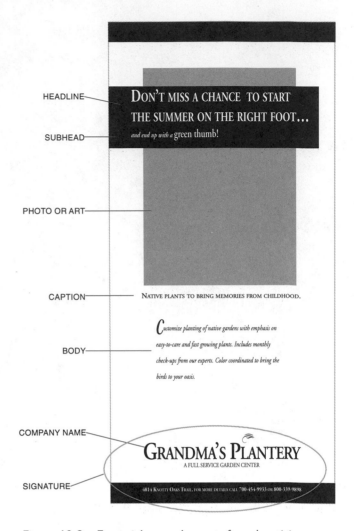

Figure 10-2 Essential page elements for advertising publications

Price information

Price information is frequently set up in a headline size as part of the body text (not included in yellow pages).

Product or service

A written or visual of products or services that appears as listings or as the product logos.

Signature

The signature may be the company logo, which includes name and address, or specially designed for a particular project, such as a festival.

Subhead

A subhead is a phrase that reads as the second half of the headline, bringing interest from the headline into the body copy. Both subheads and kickers on advertising projects give the reader a sentence or complete a claim or topic sentence. *Application: "Give me a sentence or phrase to help the reader decide if they are interested enough to read further…"*

Proportional page sizes

Advertising publications are produced for every conceivable page size from 2″ x 3½″ to 17″ x 22″ or large press formats up to 28″ x 40″. One advertising package may have several different kinds of printed publications in different page sizes using the same copy or a portion of the same copy. Rather than starting each project from scratch, build one on the other.

Ads can be designed in page layout, by drawing, or built by special ad software. Ads are measured in column widths. The length is measured in inches. Not all publications use the same number of columns, sheet size, or gutters. If an ad will be used in several publications, contact each magazine, newspaper, or directory for their ad submission requirements.

If the copy is identical and proportional to 8½″ x 11″, scale the type size up or down to match the sheet size or reduce or enlarge the design when it goes to the output device. The fit may not be exact, but it should be proportional to fit well on the sheet (figure 10-3). The percentage is as follows: 8½″ x 11″ to 5½″ x 8½″ = 64%; 8½″ x 11″ to 11″ x 17″ = 129%.

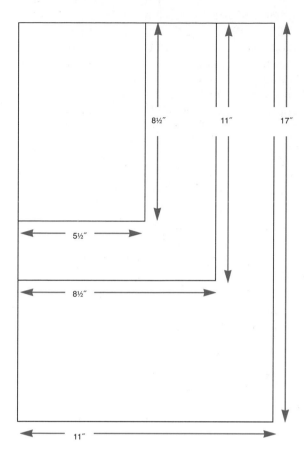

Figure 10-3 Three sheets with similar proportions

Standard proportions are 8½″ x 11″, 5½″ x 8½″, 11″ x 17″ and 17″ x 22″, and 22″ x 28″. A 2:3 proportional sheet size is used both tall and wide. This shape has the greatest potential for design choices, grids, and positioning copy with a large number of elements. Designs may have one of three shapes: tall portrait, wide landscape, and small square.

Tall portrait

The tall portrait shape proportion is 1:2 or at least twice as tall as it is wide. By putting a large box at the bottom or top, the shape can be broken up to appear proportional. Leadings and before paragraph leading help group the type. It may be necessary to use extra returns to add additional white space between elements. If photos or line art are difficult to fit, try overprinting. Try setting off the bottom with a coupon or signature.

Wide landscape

The wide landscape proportion is 2:1 or at least twice as wide as it is tall. A three and five column grid helps when working with this shape. One-third of the design can be boxed or reversed to separate it with the grid pattern.

Small square

The small square is a shape rarely used for anything but classified ads. These sizes are from one column (1½″) square to as many columns as the publication uses. Even in the smallest ads, keep page elements separated for readability. Try half-point type sizes and half-point leadings to create room without tightness.

Since specifications or designs can be moved from one printed publication to another, learn to identify similar shapes in printed publications. For example, find three different size telephone directories. The same classified ad will appear in all three in the same shape but slightly different sizes.

Sections of a folded publication

The sections of a folded advertising publication include the outside cover, the text, and the response section. The focus is on photos, which appear throughout the publication. The publication is viewed in a combination of pages as it unfolds. It is not separated like a text document and it is not usually numbered. The exception is a few advertising publications which are single folds, set up with additional sections and page numbers.

Outside cover

The outside cover should have a strong design using photos, art, or tints. Type may be layered with each other and is sometimes set as a bleed. The cover design sets an identity that continues to the inside pages.

Element	Comments
Title	Place at eye level on the panel; set like a headline
Subtitle	Used when photos are not available
Company signature	Appears at the bottom of the cover
Photos or line art	Overlay with type and use as a bleed

Inside flap

The reader sees the inside flap second. Depending on the way the flat sheet is folded, the placement of the inside flap varies. Use copy that provides information and answers to the most frequently asked questions.

Element	Comments
Questions	Those most often asked
Response	Perforated reply cards for additional information
Introduction	A paragraph set exactly like the inside text, with larger type and leading
Photos	Consistent with the message from the cover

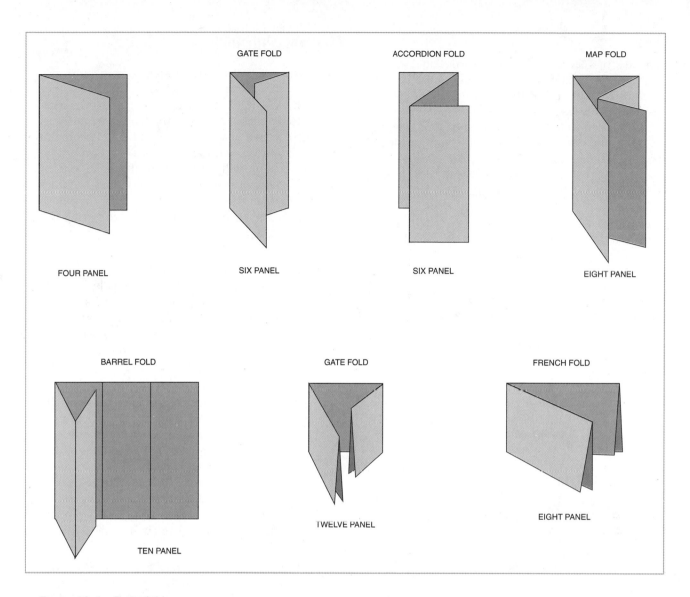

Figure 10-4 Basic folds

Text

The text of a folded publication carries all the information. The design is constructed on a folded sample. Copy is placed in the order of unfolding and requires a sheet size dummy that is folded correctly and unfolded to follow the placement, keeping the design order of the panels. Simplify hard to manage text by running some of the designs across several panels with two panels of photos, the inside title, boxes, photos, charts, and graphs.

Element	Comments
Introduction	Several paragraphs of overview; usually set differently than body text
Subheads	Used throughout for threading related information
Body text	May include several sections of text
Tables	Title, subtitle, and leader dots or text; usually separated with a box
Photos	Special effects photos, scaled to page size and overrunning several panels
Company signature	Repeats inside as a small version
Acknowledgments	For volunteers, new members, special gifts, and so on
Ads	Advertisements are used to pay the cost of the publication and announce upcoming events

Response section

The back side or the panel on the edge of the sheet can be used for direct mailings, permanent information about the company, or reader-response.

Element	Comments
Reply card	Membership, season ticket, or request for more information
Maps	Maps with floor plans for meeting rooms, special interest areas in the community, or location of company
Policies	The company creed or policies related to the audience
Advice or letter	A good will message, possibly from the CEO

Designs with folds

Instructions for design techniques of brochures are given by the number of panels on a flat sheet rather than "double fold" and "single fold." Include additional folding instructions for the kind of fold as well as where to fold and what order to fold. Marking the fold location is important but does not ensure that the publication will be folded in the right order it was designed for reading. Staple a dummy showing to the job ticket showing the folding order (figure 10-4). Panels and their folds fit into the following descriptions:

- Four-panel. The simplest fold design is a four-panel, single fold. After the outside cover is read, the next two panels are seen as a page spread. If possible, increase the paper weight to a light weight cover to give the project some substance and to meet postal requirements if it is a direct mailing publication.

- Six-panel. The most popular brochure is a six-panel parallel fold design consisting of the cover, back side and flap, and inside (left, right and center). These six pages should not look like a report; instead, the copy should flow and link together in the order the reader views it. Use wide page margins and double the outside margins for the space between columns so that the copy will match the folds. To keep the printing on one side, use an accordion fold or gatefold.

- Eight-panel. An eight-panel folded publication is commonly used when the copy will not fit on a six-panel design. Increase the sheet to 8½″ x 14″, which adds two more panels; 8½″ x 14″ can be designed for a parallel or accordion fold.

- Additional multiple panels. Some premium level brochures can unfold endlessly up a press sheet of 28″ x 40″. Since they are run on larger presses, they usually include a four-color process. If a brochure is to be machine folded, be sure to check with the bindery department on their folding machine's order, especially with large sheet sizes that have a crossfold.

Production hints

When designing folded publications, be aware of limitations such as margins and paper size. One-half inch margins are required because of the outside margin trim. When printing to a copier or small press, double the amount between the columns for the folds as "space between columns."

Custom and premium publications may have a bleed of a tint, photo, or art on the cover and will need to be run on larger paper and trimmed to the final sheet size. When possible, design brochures with bleeds to fit on the next standard paper size to save paper cost for presses that print up to 11″ x 17″. For example, 8″ x 10″ can run on 8½″ x 11″ and still fit, but 8½″ x 11″ uses 11″ x 17″, doubling the paper cost.

When the sheet is folded, the three sections will be unequal in sizes. For example, a standard fold will have all edges matching after the fold. The inside flap will be shorter than the first two. State the location and direction of folds on a dummy and on the design. Place a dotted line on the edge of the page to indicate folds.

Flyers and posters

The purpose of flyers and posters is to relay information to a large number of people. Flyers and posters can be found as handouts at large gatherings or attached to doors, walls, and windshields. Sometimes, they are mailed by request. Many flyers and posters are poorly produced and are, therefore, easily ignored or discarded. It is very easy to design flyers and posters that stand out. Flyer and poster designs are often used interchangeably for one advertising package. A large volume of flyers are standard level designs while the greatest number of posters are usually premium level, four-color process.

Standard level flyers are fast and fun. They should be brief and relate who, what, when, where, and why (without using those specific words). When time is critical, try to have a template with grids to help fit the copy. The fastest way to produce a flyer is on a three, five, or seven column horizontal grid with eight vertical guidelines to maintain areas to be used by each element. Be realistic; the quality typography required for other publications on the standard level design are a luxury on flyers because of deadlines. These grids, as well as a few good templates, will help stay within time constraints. Custom or premium level flyers and posters also can be sized to fit several other printed publications such as direct mailers and brochures.

Design

Type choice is the most important decision in the design of flyers and posters. Choose a display face with power or dignity and a narrow letter shape to match the shape of the sheet and fit copy on a line. Use a headline 2 to 4″ tall with leadings to help group the copy. Work with leadings that are multiples of 12 to cut down on revision time because the design will follow 12-point horizontal lines on the grid sheet. As with any design that has a variety of type sizes linked in one text block, setting the leading method on baseline for each element will make it easier to adjust the space between the lines of copy. Grids and templates will help when time limits other design techniques.

The headlines on standard level flyers is usually a narrow width type. If the headline is not powerful enough, try a 40% width and double the size. For all level flyers with a playful look, the type can be any face, even grunge type.

Quick production steps

Flyers and posters usually have a short deadline and require quick production steps. Move through the design steps with the client on an "as-you-wait" basis following these steps:

1. Discuss the deadline and the printing method. If the deadline is very short, begin by being honest about what can be completed. For custom projects, use a checklist listing all the steps and work backwards to establish a realistic deadline.

2. Define the copy into elements. With the client, identify a headline, subhead, body, art, and signature of the design. If needed, add additional elements to a group or rewrite the copy on a new sheet of paper.

3. Decide what to emphasize. Maximize the design by emphasizing the headline or art. Use it on at least one-quarter of the page near optical center (three-eighths the length of the page).

4. Choose the type and specifications. Advertising publications use every possible typeface, especially for headlines and company names. Review the customized type specimen sheets. Analyze any additional faces that are appropriate for the printed publication or for the company. If there is no art or photos, the type must carry the page. Use contrast techniques.

5. Find the line art or photo. If flyers are not part of an advertising package, there will be an additional step to locate art or photos. For tight deadlines, the first choice will be EPS clip art and scanned photos. Buy a good selection of quality clip art to use for standard flyers. Encourage the client not to be too specific about the line art since special requests either require production drawing or time-consuming searching. Let the client choose from stock art or photos.

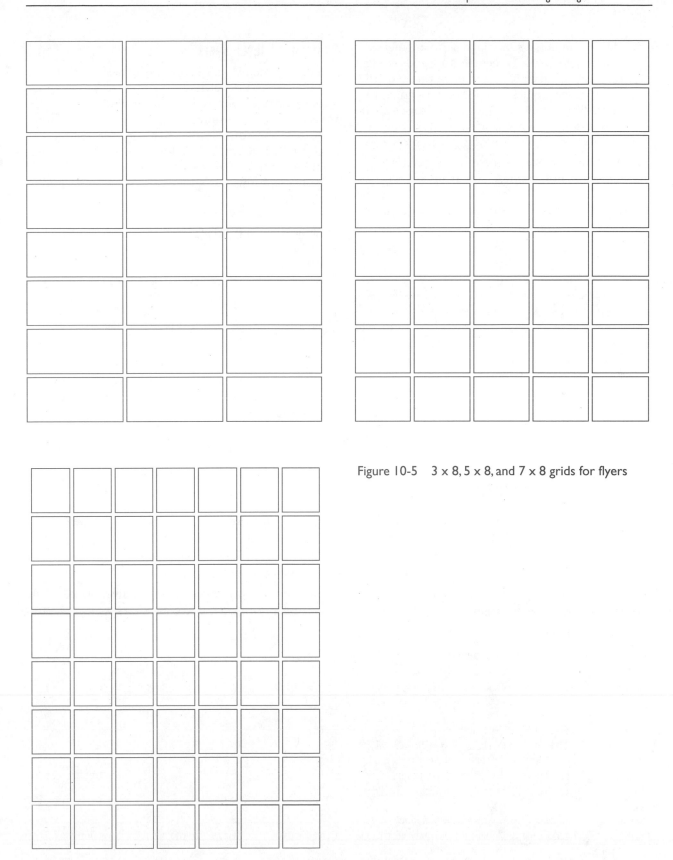

Figure 10-5 3 x 8, 5 x 8, and 7 x 8 grids for flyers

6. Sketch thumbnails or rough on computer-generated grid sheets. Remember that grids of eight on three, eight on five, and eight on seven (figure 10-5) give quick solutions to designing with immediate deadlines. Draw boxes to set up the grid and print for a quick sketch. Change the grid to non-printing for design and production.

7. Add rules, boxes, or reverses to reinforce the focus and add contrast. Just as photos with unequal sizes need to be grouped, give rules and boxes similarity by either fitting them to the grid or matching one dimension.

> ✖ Cross reference: See Chapter 5 for samples of shades and color.

8. Share customized templates with colleagues. Save the best flyer as a template and keep fine-tuning it. A change of typeface or grid will make the template seem unrecognizable. Build a small but quality library of templates, one each for portrait, landscape, centered, formal, and asymmetrical.

> ✖ Cross reference: See figure 2-8 for use of templates.

Flyer and poster samples

Use 8½″ x 11″ or 5½″ x 8½″ (2-up 8½″ x 11″) 20-24# bond in all colors or textured 50-70# book. Up to 10-point cover stock cast coat can serve as a flyer and a poster.

Range for type specifications (8½″ x 11″ flyers)

Element	Type Sizes	Comments
Headline	48-144 pt	Condensed width, bold
Subhead	16-36 pt	Two type sizes smaller than the headline, change in weight and case
Body copy	12-24 pt	Generous leading
Company name	24-48 pt	Can be as large as the subhead if they have a different look
Address	12-24 pt	Serif or sans serif, medium
Kicker	16-36 pt	Helps when no photo or line art is used
Store hours	12-24 pt	Group with the signature
Prices	various	May be the focus of the ad; if so, use headline sizes
Map	6-7 pt	Sans serif, all caps, medium

Standard level flyers

Small quantities and urgent deadlines are well met with standard level flyers. Writing papers without deep textures will print easily in the laser printer. Ask the paper representative for specific paper choices and consider 5½″ x 8½″ for handbills to cut cost in half or stuffer size for displays. Try the specifications from figures 10-6 through 10-8 for style palette information or change fonts and modify slightly:

Element	Type Specifications
Headline A	104/104 Helvetica bold, all caps, tight tracking
Headline B	54/54 Helvetica condensed, tight tracking
Subhead/kicker	24/36 Helvetica condensed bold, all caps
Body	18/18 Helvetica condensed bold, all caps, tight tracking, 12-pt before paragraph leading
Signature	Per company or project signature

PAPER AND INK. Use black or a spot color with 8½″ x 11″ 20# bond in fluorescent colors for activities and up to 80# text with texture in neutral colors for business information.

LINE ART. Use purchased EPS line art, an ornament font, or add textures.

OUTPUT DEVICE.

1st Choice—Laser original (600 dpi or greater) to copier or on-demand printing.

2nd Choice—Laser original (600 dpi or greater) to conventional small press.

3rd Choice—Direct-to-plate at conventional small press for over 5,000 copies.

Custom level flyers

Additional page elements, contrast techniques, and use of additional software packages add production time and increase printing requirements (figures 10-9 through 10-11).

Element	Type Specifications
Headline A	84/84 Caslon bold italics, small caps 90%, baseline spacing
Headline B	24/24 Caslon semi-bold, horizontal scale 120%, increased letterspacing, baseline spacing
Kicker	14/14 Helvetica condensed bold, increased letterspacing
Subhead A	18/18 Caslon semi-bold, horizontal scale of 120%, increased letterspacing, 12-pt before paragraph leading
Subhead A	14/16 Caslon semi-bold
Body A	10/12 Caslon, 3-pt before paragraph leading
Body B	10/12 Caslon italics, 3-pt before paragraph leading, 1-pica indent
Dates/Time	10/12 Caslon semi-bold, 1-pica indent
Price	36/32 Helvetica condensed bold
Quote	14/12 Caslon italics
Signature	Per company or project signature
Coupons	Use separate specifications, place in a location that is easy to cut out

PAPER AND INK. Use one color with tints or two colors of ink with tints and no tight register. Use 8½″ x 11″ 20# bond in bold colors with black ink with tints, 80# text with texture and black ink, or 65# cover.

PHOTO OR LINE ART. A photo CD or scanned photo is usually of products, not people. Use custom designed art for an event, purchased EPS line art, or an ornament font.

OUTPUT DEVICE.

1st Choice—On-demand printing.

2nd Choice—Direct-to-plate at conventional small press.

3rd Choice—Direct-to-film negative (service bureau) for conventional small press.

Premium level poster

Premium level design for posters focus on additional size, heavy stock, and added reply cards. For additional impact, business reply cards can be attached to the poster by hand by the designer or client.

Figure 10-12 is an 8½″ x 14″ color-on-color poster. The cost includes custom-drawn art. The paper is a 80# cover weight mauve that fits postal requirements with a perforated return card at the bottom. Color: PANTONE 209, a red, with a 50% tint.

Figure 10-13 is a four-color process plus two spot colors. The stock is 80# cover, one side coated. Color: four-color process.

Figure 10-14 is a publication that functions as a poster, flyer, and mailer. It is on 80# semi-gloss enamel. Colors: spot color converted to process colors.

LAKESIDE COMMUNITY IS REACHING OUT TO HELP...

RECYCLING DAYS

April 1–3
9:00–9:00
Primary School

- **NEWSPAPER**
 Bring tied or in paper bags

- **GLASS**
 Washed and labels removed

- **ALUMINUM**
 Can be mashed or bagged

- **PLASTIC**
 With recycle symbol on it

SUPPORT OUR KIDS...THE FUTURE

Figure 10-6 (Left) Standard level flyer with a three column grid

Figure 10-7 (Below) Standard level flyer with a five column grid

LAKESIDE COMMUNITY IS REACHING OUT TO HELP...

RECYCLING DAYS

April 1–3
9:00–9:00
Primary School

- **NEWSPAPER** — Bring tied or in paper bags

- **GLASS** — Washed and labels removed

- **ALUMINUM** — Can be mashed or bagged

- **PLASTIC** — With recycle symbol on it

SUPPORT OUR KIDS • SUPPORT THE FUTURE

RECYCLING DAYS

April 1–3
9:00–9:00
Primary School

NEWSPAPER — Bring tied or in paper bags
GLASS — Washed and labels removed
ALUMINUM — Can be mashed or bagged
PLASTIC — With recycle symbol on it

SUPPORT OUR KIDS • SUPPORT THE FUTURE

**LAKESIDE COMMUNITY
IS REACHING OUT TO HELP**

Figure 10-8 (Left) Standard level flyer with a seven column grid

Figure 10-9 (Left) Custom level flyer with a three column grid

Figure 10-10 (Below) Custom level flyer with a five column grid

Figure 10-11 (Left) Custom level flyer with a seven column grid

PREMIUM

Figure 10-12 Flyer and poster with mailer. *Credit: Kathryn Vosburg-Seretti, designer*

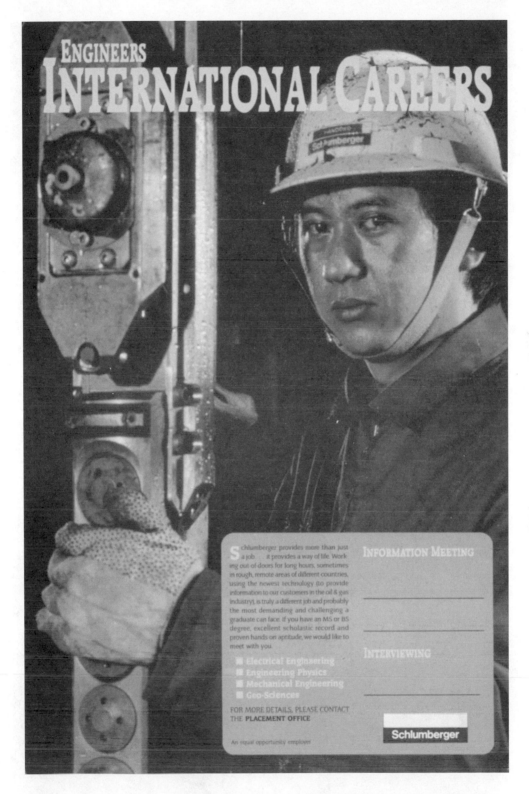

Figure 10-13 Poster for placement interviews. *Credit: Kathryn Vosburg-Seretti, designer*

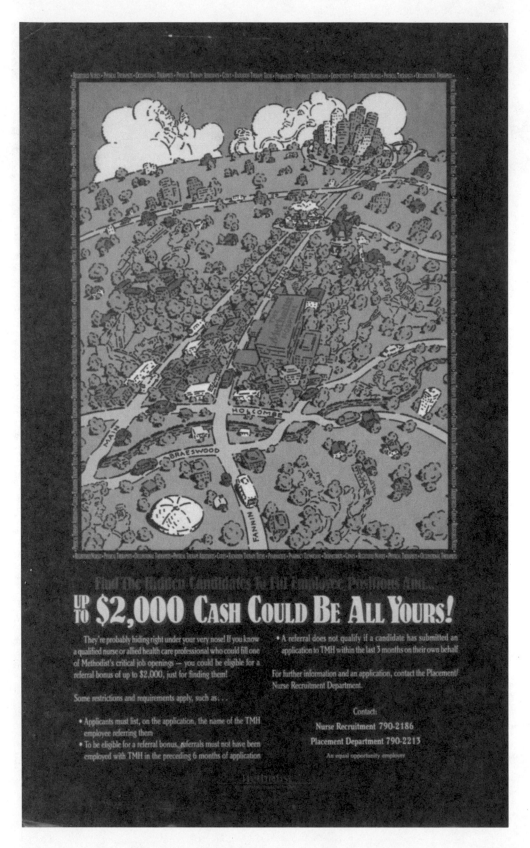

Figure 10-14 Poster for recruitment. *Credit: Kathryn Vosburg-Seretti, designer*

Invoice stuffers and mailers

Stuffers are an economical way to bring information to customers. They can be included in bulk mailings or individual mailings. Banks and utility companies frequently include stuffers for nonprofit organizations with their monthly statements.

Stuffers use several design formats: classified ad, brochure, or text document. If they are part of an advertising package, the design should match other publications. If they are printed together as part of a large press run by **ganging** (printing them all on the same sheet), the cost of the stuffer will be minimal.

Flat sheets for stuffers are quiet and smaller than flyers. Some follow type specifications for ad design or brochures depending on the amount of information to be included. This publication is given a lighter look by using white space, a ½- to 2-point rule or boxes and a serif typeface. In addition, medium and italics should be considered rather than bold.

The landscape shape works best for mailing with 8½″ x 11″ sheets such as invoices. The stuffer will be turned the same direction of the other publications in the envelope. If it is mailed with a brochure or used in a brochure holder, use its portrait shape.

Postcards are similar in type specifications to stuffers. They are used on all design levels. A direct mailer will have postcard design with front and back printing. Flat sheets mailers that fit postal regulation can be from 3½″ x 5½″ (postcard size) up to 9″ x 12″ without an additional mailing cost.

Margins

For invoice stuffers and flat sheets, be aware of the following margin limitations. Set up a ¼″ side margin for small presses and copiers for 3½″ x 8½″ printed 3-up on 8½″ x 11″ (figure 10-15). The single stuffer will not need a gripper margin, but has a ½″ trim at the top. The larger presses print on a 24″ x 36″ sheet 24-up, usually set up by the prepress department from the file.

Postcards and flat mailers will need ¼″ to ⅜″ on one edge for feeding on a small offset press and ¼″ to ½″ for printing on all copiers. Large presses can

Figure 10-15 Set-up for 3-up on 8½″ x 11″

handle a bleed on all sides. Postal regulations, listed with the envelope design, apply for mailings, paper weight, and thickness. Their maximum size is 4½″ x 6″ for minimum postage charges and a calibration of .007 for the sheet weight no less that 67# bristol cover up to 12-point cast coat. Contact the post office for current size and weight mailing information.

Production hints

Invoice stuffers and flat sheets should carry an identity through their production. Because stuffers are usually mailed with other unrelated publications, there should be a contrast between the stuffer and the other publications in the envelope. This identity can be established with paper changes such as uncoated or coated, textured or no texture, and colored paper or colored ink.

Stuffer and mailer samples

Use 50-80# text, either coated or uncoated.

Range for type specifications

Element	Type Sizes	Comments
Headline	24-60 pt	Condensed width, script, italics and some bold
Subhead	14-18 pt	Same as body typeface
Body	8-14 pt	Paragraphs and bullet, extra leading
Signature		Letterhead size or larger
Coupons	8-24 pt	Use design specifications for body, place in a location that is easy to cut out
Kicker	16-36 pt	Used when design has no photo or line art
Store hours/ Phone number		Group with the signature
Prices	various	Use headline sizes if it is the focus or body text sizes
Map	6-7 pt	Sans serif, all caps, medium.

Paper

Cut Size	Fits in Envelope
4″ x 9″	#10, 4⅛″ x 9½″
3″ x 8½″ (3-up 8½″ x 11″)	#10, 4⅛″ x 9½″
3½″ x 6¾″	#6¾, 3⅝″ x 6½″

Standard level stuffer

Small quantities and urgent deadlines are well met with standard level stuffer. Try the specifications from figures 10-16 through 10-18 for style palette information or change fonts and modify slightly:

Element	Type Specifications
Headline	59/60 Caslon semi-bold, decreased letterspacing
Quote	14/14 Caslon semi-bold
Body	10/14 Caslon regular, 7-pt before paragraph leading
Signature	14/14 Caslon semi-bold, small cap/all caps
Address	10/14 Caslon semi-bold, large and small caps
Price	72/72 Caslon semi-bold, horizontal scale of 70%

PAPER AND INK. Black or spot color on 20-24# bond or 50-60# book in neutral grays and beige tones or soft colors for business information or fluorescent colors for activities. For business information, use up to 80# text with texture.

LINE ART. Use purchased EPS line art, an ornament font, or add borders.

OUTPUT DEVICE.

1st Choice—Laser original (1000 dpi or greater) to copier or on-demand printing.

2nd Choice—Laser original (1000 dpi or greater) to conventional small press.

3rd Choice—Direct-to-plate at conventional small press.

Custom level stuffers

Additional page elements, ink color, bleeds, and custom art add production time and increase printing requirements (figures 10-19 through 10-21).

Element	Type Specifications
Headline	59/60, Caslon semi-bold, decreased letterspacing
Quote	14/14 Caslon semi-bold
Body	10/14 Caslon, 7-pt before paragraph leading
Signature	14/14 Caslon semi-bold, small cap/all caps
Address	10/14 Caslon semi-bold, large and small caps
Price	72/72, Caslon semi-bold, horizontal scale of 70%

Figure 10-16, -17, -18 Standard level stuffers

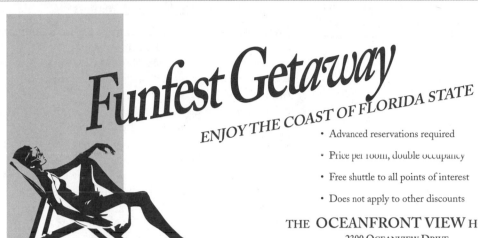

Funfest Getaway

ENJOY THE COAST OF FLORIDA STATE

$70.00
per room • per day
double occupancy

- Advanced reservations required
- Price per room, double occupancy
- Free shuttle to all points of interest
- Does not apply to other discounts

THE OCEANFRONT VIEW HOTEL
2300 OCEANVIEW DRIVE
TAMPA, FL 23101

ENJOY THE COAST OF FLORIDA STATE

Funfest Getaway

$70.00 per room, per day, double occupancy

- Advanced reservations required
- Price per room, double occupancy
- Free shuttle to all points of interest
- Does not apply to other discounts

THE OCEANFRONT VIEW HOTEL
2300 OCEANVIEW DRIVE
TAMPA, FL 23101

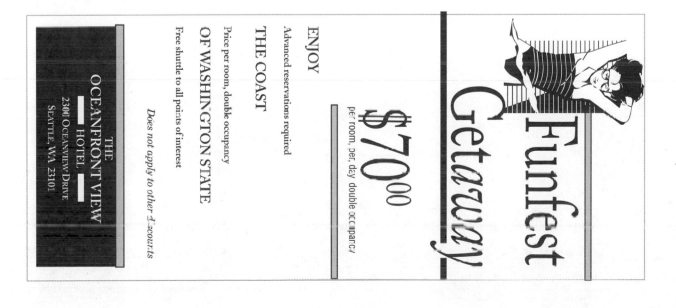

PAPER AND INK. One color with tints or two colors of ink with tints and no tight register on 8½″ x 11″ 20# bond in bold colors, 80# text with texture, or 65# cover.

PHOTO OR LINE ART. A photo CD or scanned photo is usually of products, not people. Use custom designed art for an event, purchased EPS line art, or an ornament font.

OUTPUT DEVICE.

1st Choice—Direct-to-plate at conventional small press.

2nd Choice—Direct-to-film negative (service bureau) for conventional small press.

Premium level stuffers and mailers

Premium level designs for stuffers and mailers focus on multiple ink colors and fine papers.

Figure 10-22 uses PANTONE 311, a turquoise, which contrasts well with the black ink. It is printed on a coated 70# text. The focus is on the art and the bleed; additionally, the large solid requires a medium-size press or larger. The back side is mostly black but uses the other color for the statistical information subheads.

Figure 10-23 used a metallic silver ink matching the other publications in this advertising package. The stuffer is an 80# cover coated on one side. The reverse type on silver is PANTONE 301, a blue, which requires printing on a medium-size press to hold the ink coverage.

Figure 10-24 is an example of a mailer and stuffer combination. The paper is a 65# cover semi-gloss enamel. Color: spot converted to four process colors.

Figure 10-19, -20, -21 Custom level stuffers

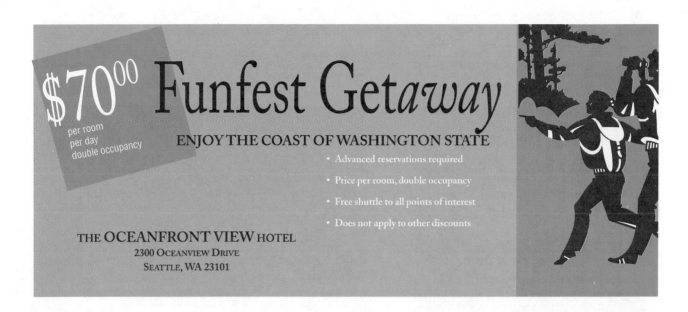

$70⁰⁰
per room
per day
double occupancy

Funfest Get*away*

ENJOY THE COAST OF WASHINGTON STATE

• Advanced reservations required

• Price per room, double occupancy

• Free shuttle to all points of interest

• Does not apply to other discounts

THE OCEANFRONT VIEW HOTEL
2300 OCEANVIEW DRIVE
SEATTLE, WA 23101

$70⁰⁰ per room, per day, double occupancy

ENJOY THE COAST OF WASHINGTON STATE

• Advanced reservations required

• Price per room, double occupancy

• Free shuttle to all points of interest

• Does not apply to other discounts

THE OCEANFRONT VIEW HOTEL
2300 OCEANVIEW DRIVE
SEATTLE, WA 23101

Funfest Get*away*

Funfest Get*away*

ENJOY THE COAST OF WASHINGTON STATE

• Advanced reservations required

• Price per room double occupancy

• Free shuttle to all points of interest

$70
per room
per day
double occupancy

THE OCEANFRONT VIEW HOTEL
2300 OCEANVIEW DRIVE
SEATTLE, WA 23101

PREMIUM

Figure 10-22 and -23 (Left and below left) Premium level stuffer/mailers. *Credit: M H & T Advertising Agency*

Figure 10-24 (Right) Premium level stuffer/mailer. *Credit: Vosberg de Seretti, inc., designers*

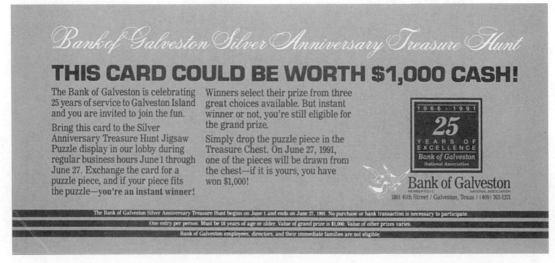

Advertisements

Advertisements must grab the reader's attention and provide information in a limited amount of space. Ads are printed separately or placed in publications and are given the most visible areas of a page. A page composed mostly of ads requires special attention: each separate ad design must look different to help the reader distinguish between them.

Advertisements in local newspapers, telephone directories, and other local publications are considered classified ads. These are usually standard and custom level designs. If a color of ink is available, it will usually be one or two colors used throughout that publication.

Classified ads use stock art and photographs unless special art or photos are furnished by the advertiser. They use laser originals or are placed from a drawing package into a page layout software package.

Nationally distributed ads are designed with custom photograph manipulation and added color. Four-color process has become popular because of electronic production. It is used increasingly in some smaller but nationally distributed publications.

A variety of people may develop the design of an ad depending on the percentage of the budget that is set aside for design and production:

- The sales department for the publication.
- The in-house typesetters for the advertiser.
- A local designer for the advertiser.
- National advertising firms for national products sold locally; some have their company's signature added.

Design

The demand with ad production is "on time and fill the space." Ads, like flyers, have tight deadlines. Standard level ads are sometimes completed in 5 minutes in a condensed sans serif such as Helvetica condensed. Custom designs may have similar deadlines, but there is more to accomplish. The alignment of custom designs will be mixed with centered and flush left. Heavy lines and reverses print well on newsprint.

Ads use common proportional sizes (see figure 10-3). For research, find ads that are proportional to these shapes since the design can be the same. Frequently, one ad design will go into several publications, each having a different column width. Magazines distribute information on specifications for their specific magazine; use these sheets to determine design information for magazines.

Production hints

The production of ads requires designs to focus on readability while grabbing attention. Borders that separate various ads, traditionally, are on the edge of their space. As with all borders, copy should fall 6 to 12 points from the borders, but tints, line art, and photos can bleed into the border without additional cost. Bleeds should not go beyond the border when they are part of other copy on a page.

Ad samples

Ad sizes vary. They are measured by multiplying the number of column inches by inches long or are a fraction of the total page (such as a quarter page ad or a half page ad).

Range for type specifications

Element	Type Sizes	Comments
Tall Portrait		
Headline	27-42 pt	Condensed type, bold, U & lc
Subhead	14-30 pt	
Body	7-12 pt	
Signature		Can be as large as the subhead; photos, line art, and directions should be grouped with the signature
Wide Landscape		
Headline	24-48 pt	Expanded type, bold, U & lc, large and small caps
Subhead A	14-18 pt	All caps or italics
Body A	7-12 pt	Using leadings from set solid to 20 pt
Subhead B	12-16 pt	
Body B	7-10 pt	Italics
Signature	14-72 pt	Can be as large as the subhead but they must have different specifications

Element	Type Sizes	Comments
Small Ads: 1 Square Column		
Headline	12-30 pt	Bold, condensed width
Subhead	9-14 pt	
Body	7-9 pt	
Signature	6-14 pt	Can be as large as the subhead but they must have a different look
Kicker	16-36 pt	Helps when no photo or line art is used
Bullets	7-10 pt	Add 3 to 4-pt above paragraph leading

Standard level ads

Small quantities and urgent deadlines are well met with standard level ads. Writing papers without deep textures will print easily in the laser printer. Ask the paper representative for specific paper choices. Try the specifications from figures 10-25 through 10-27 for a style palette information or change fonts and modify slightly:

Element	Type Specifications
Headline A	30/30 Helvetica condensed bold, all caps, 70% horizontal scale
Headline B	12/12 Helvetica condensed italics, all caps
Subhead/kicker	12/12 Helvetica condensed oblique, 90% horizontal scale
Body	7/8 Helvetica condensed
Body list	7/8 Helvetica condensed, 70% horizontal scale
Signature	18/12 Caslon semi-bold, italics
Address	7/8 Helvetica

PAPER AND INK. Black or a spot color ink on newsprint.

LINE ART. Use purchased EPS line art and picture fonts.

OUTPUT DEVICE.

1st Choice—Laser original (1000 dpi or greater) to copier.

2nd Choice—Direct-to-plate at conventional press.

3rd Choice—Direct-to-film negative (service bureau) for conventional press.

Custom level ads

Additional page elements, contrast techniques and use of customized line art and photography add production time (figures 10-28 through 10-30).

Element	Type Specifications
Headline A	30/30 Caslon semi-bold, italics, all caps
Headline B	12/12 Helvetica condensed bold, all caps
Subhead	10/12 Caslon semi-bold italics, 90% horizontal scale
Body	7/7 Caslon, 2-pt before paragraph leading
Body list	7/9 plus size 12 Caslon semi-bold, 2-pt before paragraph leading, horizontal scale of 70% width
Signature	Business card size

PAPER AND INK. Use one color ink with tints or two colors of ink with tints on newsprint or matte finished enamel.

PHOTO OR LINE ART. Use a photo CD or scanned photo of both products and people. Also, use custom designed art for the company, purchased EPS line art, or a font.

OUTPUT DEVICE.

1st Choice—Desktop file, which is sent to publication to place from file.

2nd Choice—Direct-to-paper (imagesetter), which is sent to publication to photograph.

Premium level ads

Premium level designs for ads focus on copywriting, multiple color samples, and additional conferences with the client. Art boards should be used for presentations. The following are examples of typical premium level publications:

Figure 10-31 is a tall portrait shape. Typical of tall portrait ads, the type is overprinted on the photo, which becomes the signature. Color: four-color process.

Figure 10-32 is a wide landscape ad using a six column grid design. The photo of the thermometer follows three columns of the grid. Color: four-color process.

Figure 10-33 is a proportionally shaped ad, 8½″ x 11″. This ad was so successful that additional copies were printed on 100# enamel, one side coated, for industrial trade shows and business presentations. Color: four-color process.

PHOTOS...
HOLIDAY GIFTS

PRESERVE
YOUR FAMILY PHOTOS

A new process for photo reprinting.
One week service for black and white
reprints from old photographs.
Surprise your loved ones
with photos from the past.
Build a photo family tree
for your children.

1-8 x 10	5.00
additional copies	2.00
2-5 x 8	5.00
additional copies	1.00

*Photo*GENEOLOGY
1400 Center Street
Madisonville, AR 55401
1-800-GET-FOTO

PHOTOS FOR HOLIDAY GIFTS
PRESERVE
YOUR FAMILY PHOTOS

1-8 x 10	5.00
additional copies	2.00
2-5 x 8	5.00
additional copies	1.00

1-800-GET-FOTO

A new process for photo reprinting.
Build a photo family tree for your children.
Surprise your loved ones with photos from the past.
One week service for black and white reprints
from old photographs.

*Photo*GENEOLOGY
1400 Center St • Madisonville, AR 55401

PHOTOS HOLIDAY

preserve your family photos

A new process for photo reprinting.
Build a photo family tree for your children.
Surprise your loved ones with photos.
One week service for black and whites
from old photographs.

1-8 x 10	5.00
additional copies	2.00
2-5 x 8	5.00
additional copies	1.00

Photo
GENEOLOGY
1400 Center Street
Madisonville, AR 55401•1-800-GET-FOTO

Figure 10-25 (Far left) Standard level ad. Body size is 9/12 and body list is 9/12; tall portrait

Figure 10-26 (Above right) Standard level ad; wide landscape

Figure 10-27 (Left) Standard level ad; square

Photos...
Holiday
Gifts

preserve your family photos

A new process for photo
reprinting. One week service on
quality paper black and white
reprints from old photographs.

Surprise your loved ones with
photos from your past. Build a
family tree for your children with
photos from previous generations.

1-8 x 10	$5.00
additional copies	2.00
2-5 x 8	5.00
additional copies	1.00

*Photo*GENEOLOGY
1400 Center Street
Madisonville, AR 55401
1-800-GET-FOTO

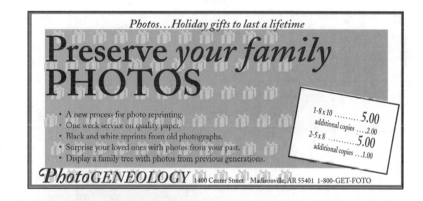

Photos...Holiday gifts to last a lifetime

Preserve *your family*
PHOTOS

• A new process for photo reprinting.
• One week service on quality paper.
• Black and white reprints from old photographs.
• Surprise your loved ones with photos from your past.
• Display a family tree with photos from previous generations.

*Photo*GENEOLOGY 1400 Center Street Madisonville, AR 55401 1-800-GET-FOTO

1-8 x 10	5.00
additional copies	2.00
2-5 x 8	5.00
additional copies	1.00

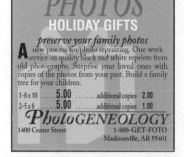

PHOTOS
HOLIDAY GIFTS
preserve your family photos

A new process for photo reprinting. One week
service on quality black and white reprints from
old photographs. Surprise your loved ones with
copies of the photos from your past. Build a family
tree for your children.

1-8 x 10	5.00	additional copies	2.00
2-5 x 8	5.00	additional copies	1.00

*Photo*GENEOLOGY
1400 Center Street
1-800-GET-FOTO
Madisonville, AR 55401

Figure 10-28 (Far left) Custom level ad. Body size is 8/11 with 6-point before paragraph leading; tall portrait

Figure 10-29 (Above right) Custom level ad; wide landscape

Figure 10-30 (Left) Custom level ad; square

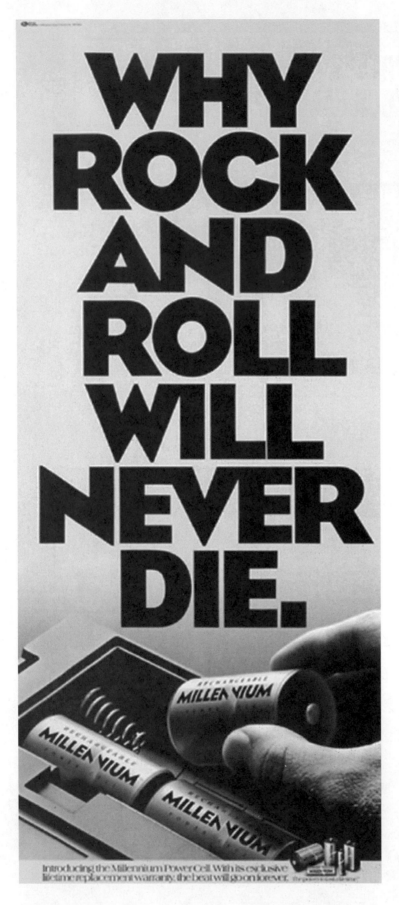

Figure 10-31 (Left) Premium level ad; Millenium Power Cell. *Credit: Agency: Earle Palmer Brown, Atlanta, GA, Art director/writer: Joe Paprocki, Photographer: Jamie Cook, By permission of the EvereadyBattery Company, Inc.*

Figure 10-32 (Opposite, top) Premium level ad; Thermoscan. *Credit: Franklin Stoorza, San Diego, CA, Art director: John Vitro, Writer: Bob Kerstetter, Illustrator: Mark Fredrickson*

Figure 10-33 (Opposite, bottom) Premium level ad; Allwaste Environmental Services, Inc. *Credit: Manlove Advertising, Pasadena, TX, design and production*

IF AN EAR THERMOMETER SOUNDS PECULIAR, IMAGINE THE REACTION TO THE FIRST RECTAL THERMOMETER.

Until now, parents never had much choice. And kids had even less.

If there was a temperature to be taken, a rectal thermometer was the way to take it.

An uncomfortable, messy, risky way. But the only accurate way.

Until, that is, we introduced the Thermoscan Instant Thermometer. It's specially designed to take a temperature at the ear (doctors recognize this as the most accurate way to take a reading).

You just place the probe tip in the ear and press a button—you'll get a reading in under one second. No struggle. No fear of injury. No unhappy kid.

No wonder it's become so popular with doctors and nurses.

Want to know where to get one? Call us, toll-free. 1-800-EAR-TEMP.

THERMOSCAN
INSTANT THERMOMETER

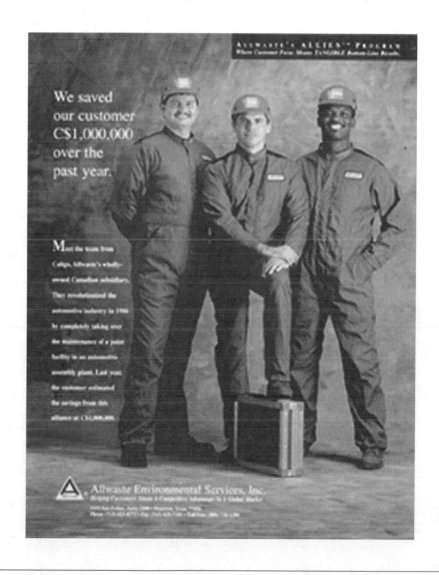

Programs

The final publication completed for an event advertising package is usually the program. Programs have not changed drastically in style and form since hot type. To support the formal look, use one serif face that has a good medium and italics.

Program design and type specifications resemble brochures. Keep type specifications as simple as possible because deadlines are tight and additions and revisions can occur up to the last minute, as "the show must go on."

There are three types of programs:

1. Programs for banquets or celebrations. Use one or two sheets. The single sheet program is printed on cover weight stock or heavy text because they are saved as souvenirs. The program and responsive readings are set with leader dots.

2. Programs for performances. These are usually lengthy and include photos. Color may be on the cover. The body text is leader dots, paragraphs, and tab columns. Ads fill at least half the copy area and are used to defray printing costs. Multiple sheet programs use cover weights for the outside pages and text weights for the inside pages or a 70-80# text weight for all pages. They are saddle stitched or folded and slipped inside each other if there are only two sheets.

3. Programs for multiple day conferences and conventions. These have multiple pages. They are pocket/purse size and include maps, biographies, columns with time, and presentation summaries. The body text is set like tabular charts.

Set leader dots narrow to assist the reader in moving from left to right. If the copy is tight on the page, set some of the leader material as two columns. This also allows room for additional leading.

> ✗ Cross reference: The techniques for page elements requiring leader dots or tabs are shown in figures 4-24 through 4-28.

Use before paragraph leadings instead of double returns for copyfitting flexibility. If copyfitting is difficult, both leadings can be adjusted. Use before paragraph leadings for text, leader dots, and subheads. If most of the body is set as leader dots, build before paragraph leadings for them first. The specifications used for the samples give a typical set of before paragraph leadings. Additional techniques for breaking up sections of type would be ornament or other faces (see figure 10-39), a hairline (see figure 10-35), a hairline box (see figure 10-39), or a tint (see figures 10-37 and 10-39).

Elements of a folded program

Elements of a folded program present straightforward information.

Acknowledgments

Program acknowledgments include the names of all who volunteered their services, donated equipment or props, and any governing boards. This listing appears in columns or in paragraph form, depending on the number of names.

Ads

Ads are for upcoming events or business advertisements. Information on the specific performance can be inserted or changed for each play or presentation.

Biography of main performers

Biographies are popular, even for small performances. Each performer supplies his/her own biography and photo. Give each performer a limit for length or number of words. The leading roles and the producer and director are given more space.

Company signature

Treat the occasion or presentation information from the cover like a logo and carry it to the performance name on the inside. The title can spread across the length of the unfolded sheet or begin in the left column.

Leader dots

When using leader dots with two lines of copy on the left, follow figure 4-26. The additional copy goes on a second line with an em indent (9-point type is equal to a 9-point hanging indent. Use italics for the name of musical presentations.

✗ Cross reference: See Chapter 4 for additional leader dot information.

Maps

Conferences will include the floor plan for meeting rooms and a map noting special interest areas in the community.

Membership

Membership or season ticket information appears on the back page with a ½″ line box or dotted line to separate it.

✗ Cross reference: Follow the guidelines for forms in Chapter 12.

Subheads

Subheads are used for the order of the program, participants, characters, music, and directions for the audience.

Production hints

Production techniques for folded programs vary, depending on the number of folds. Be sure the column margins on the folds are double the measurement of the outside margins. This will allow each panel to center the copy from the fold to the edge of the page. Setting the page with maximum outside margins of 1″ will prevent 22-pica leader dots lines and help the copy match the shape of the page.

For back and front, single sheet programs, set up a two-page file. Treat the outside panels as page one and the inside panels as page two. This will also allow for three panel designs and special folds

(figure 10-36a). Programs give more folding freedom than most projects because they do not need to fit in an envelope or display holder; however, if a folding machine cannot handle the fold, they will need to be hand folded.

Single page programs can be set up with a variety of folding directions. Try the accordion fold for programs with one page of information for easier fit of leader dot information. Economically, copy will print as one-sided.

For multiple pages, treat each panel as a single column. If the software will build a booklet, the pages can be assembled by the computer. Remember to keep the number of pages in multiples of four. Most multiple page programs will be a single fold. If there are only two sheets, they will be inserted without a saddle stitch.

Copyfitting leader dots material

After the thumbnails are completed and the location of the parts of the copy are organized, it is time-saving to do a short approximate copyfitting. Add a line count for each subhead. Follow these steps:

1. Count the lines for one page. This will equal "Y."
2. Convert the length of the type area to points. This will equal "X."
3. X divided by Y = leading.
4. Choose a type size 2 to 4 points smaller than the leading and within the standards for the body text.

Program samples

Range for type specifications

Element	Type Sizes	Comment
Outside cover		
Performance		All faces, any type specifications
Performance date(s)		Same as body text face
Location or sponsor		Same as body text face

Element	Type Sizes	Comment
Inside copy		
Performance	12-24 pt	Can be signature look for cover
Subheads	7-12 pt	Serif medium, large and small caps, centered, increased letterspacing
Body text	7-9 pt	Serif medium, sometimes smaller than rest of copy, justified
Leader dots	7-9 pt	Serif medium mixed with italics, tab columns
Back side		
Acknowledgments	7-9 pt	Serif medium, justified paragraph
Application	7-9 pt	Use forms design standards

Paper

Sheet Size	Fold Size
8½″ x 11″	5½″ x 8½″ or 3¾″ x 8½″
8½″ x 14″	7″ x 8½″ or 4¾″ x 8½″
11″ x 17″	8½″ x 11″ or 5¾″ x 11″

Standard level programs

Small quantities and urgent deadlines are well met with standard level programs. Usually, the outside cover can be printed early and the inside information can be partially designed with parts of the copy finalized close to the event. Try the specifications from figures 10-34 through 10-36 for style palette information or change fonts and modify slightly:

Element	Type Specifications
Inside copy	
Headline	24/28 New Century Schoolbook bold italics, increased letterspacing 125%
Kicker	14/18 New Century Schoolbook italics
Subhead A	8/10 New Century Schoolbook bold, all caps, 120% width, 1-pt before paragraph leading
Subhead B	8/10 New Century Schoolbook bold, 120% width 6-pt before paragraph leading
Subhead C	8/12 New Century Schoolbook bold italics, 6-pt before paragraph leading
Body text	8/10 New Century Schoolbook italics
Body leaders	8/10 New Century Schoolbook, 1-pt indent left and right, 5-pt before paragraph leading
Body tabs	8/10 New Century Schoolbook, right tabs on 2, 7, 13, and 19 picas
Embellishment	48/24 Woodtype Ornament
Page set-up	4-pica margins

PAPER AND INK. Use black or a spot color ink on 8½″ x 11″ 24# bond, in fluorescent colors for activities and gray or beige for business information, or use a 60-80# text with texture.

LINE ART. Use purchased EPS line art, an ornament font, or, if not available, add texture or reverse type.

OUTPUT DEVICE.

1st Choice—Laser original (1000 dpi or greater) to copier or on-demand printing.

2nd Choice—Laser original (1000 dpi or greater) to conventional small press.

3rd Choice—Direct-to-plate at conventional small press.

Custom level programs

Complex folds, additional pages or page elements, and ink colors created for repetitive presentations may be used on these programs. They may also include ads, request forms, and photographs (see figures 10-37 through 10-39).

Element	Type Specifications
Inside copy	
Headline	24/28 New Century Schoolbook bold italics, increased letterspacing
Subhead A	8/10 New Century Schoolbook bold, all caps, 120% width, 1-pt before paragraph leading
Subhead B	8/10 New Century Schoolbook bold, 120% width, 6-pt before paragraph leading
Subhead C	8/12 New Century Schoolbook bold italics, 6-pt before paragraph leading
Body text	8/10 New Century Schoolbook italics
Body leaders	8/10 New Century Schoolbook, 1-pt indent left and right, 5-pt before paragraph leading
Body tabs	8/10 New Century Schoolbook, right tabs on 2, 7, 13, and 19 picas
Embellishment	48/24 Woodtype Ornament
Page set-up	4-pica margins

PAPER AND INK. Use one color ink with tints or two colors of ink with tints and no tight register. Use 8½″ x 11″ 24# bond, in bold colors with black ink with tints, or 80# text with texture and black ink, or 65# cover.

PHOTO OR LINE ART. Use a photo CD or scanned photos of primary characters. Also use custom designed art for the event, or purchased EPS line art.

OUTPUT DEVICE.

1st Choice—Laser original (1000 dpi or greater) to conventional small press.

2nd Choice—Direct-to-plate at conventional small press.

3rd Choice—Direct-to-film negative (service bureau) for conventional small press.

Premium level program

Premium level design for programs focus on folds and a unique cover design.

The program cover for figure 10-40 was created by scanning a piece of rope and creating the background in a photo manipulation program. The background is carried into the inside pages and columns created within the photo. It is set up as a duotone with brown and black. The paper is 80# smooth vellum cover to match the feel of the rope. Colors: PANTONE 4515, a gold, and black.

Figure 10-41 is included because of the unique approach to the fold. The design is a duotone with photo embossing. The paper choice is an 80# high gloss enamel. Colors: PANTONE 390, a green, and PANTONE 101, a yellow.

Figure 10-42 is a two-color project with a real bandanna scanned and repeated on the outside and inside design. The paper is a 100# matte finish text sheet with a linen finish. Colors: Pantone 214, a red, and black.

STANDARD

Figure 10-34 (Left)

The City Parks and Recreation Department
presents
OKLAHOMA

Synopsis of Scenes
The entire action takes place in Indian Teriitory (now Oklahoma)
just after the turn of the century.

ACT 1

Scene I - The front of the Laurey's Famhouse

Oh, What a beautiful Morning	Curly, Laurey, Aunt Elen
Kansas City	Ado Annie
Many a New Day	Laurey, Female Ensem le
People Will Say We're in love	Curly, Laurey

Scene 2 - Smoke House

Pore Jud is Dead	Curly, Jud
Lonely Room	Jud

Scene 3 - A Grove of Laurey's Farm

Out of My Dreams	Laurey
Dream Ballet	Dream Laurey, Dream Curly, Jud, Dancing Ensemble

fifteen minute intermission

ACT II

Scene 1 - The Skidmore Ranch

The Farmer and the Cowman	Entire Company
All Er Nuthin	Ado Annie, Will

Scene 2 - Inside Skidmore's Barn

People Will Say We're in Love (Reprise)	Curly, Laurey

Scene 3 - The Front of Laurey's Farmhouse

Oklahoma	Entire Company
Finale	Entire Company

CAST OF CHARACTERS
in order of appearance

Aunt Ellen	Majorie Turner
Curly	Morris Plumb
Laurey	Pamela White
Ike Skidmore	James Jatzlau
Fred	Ray Booth
Will Parker	Sam Danna
Jud Fry	David Horn
Ad Annie	Coleena Brown
Ali Hakin	James Dement
Gertie Cummings	J.C. Sanders
Andrew Carnes	Jason Chesterfield
Dream Laurey	Chelsea Rogers
Dream Curly	Bill Hudson
Cord Elam	Tony Harrold

Singing Ensemble

Ann Anders	Lisa Cannon	Judy Ireland	Rene Escobar
Vivian Festro	Lou Ann Hiltown	Terry Kwight	Art Panderson
Carol Russ	Bill Schischcik	James Schauer	Art Wells

Dancing Ensemble

Charles Bailey	Kathy Guin	Rene Haven	Gay Glazner
David Justin	James McKibben	Lori Miller	Rocky Williams

Children
(Chil/dren appearing in this production are students from City Dance Studio)

Jessica Denney	Jamie Lee	Kirk Hines	Elizabeth Martin
Melissa Campbell	Mark Lively	Jim Martin	Jeff Palmer

ADMINISTRATION STAFF

General Manager—Carolyn Fisher
Administrative Assistant—Pamela White
Director of Publicity—Amanda Kilgore
Public Relations Coordinator—Susie Wilson
General Accountant—Douglas McInnis
Administrative Sec.—Anne Coppenhaver
Ticket Manager—Skip Kishbaugh
Ushers—City Theatre Auxiliarry

We wish to thank the following for their property and production
Bob's Western Wear
Denise Barnhold
Buttermilk Station Antiques
Burger Barn
KIIB-TV
City Musuem

Figure 10-34 (Left) Standard level program, 8 1/2″ x 11″

Figure 10-35 (Below) Standard level program, 8 1/2″ x 11″

Figure 10-35 (Below)

The City Parks and Recreation Department
presents
OKLAHOMA

Synopsis of Scenes

The entire action takes place in Indian Territory (now Oklahoma)
just after the turn of the century.

ACT 1

Scene I - The front of the Laurey's Famhouse

Oh, What a beautiful Morning	Curly, Laurey, Aunt Elen
Kansas City	Ado Annie
Many a New Day	Laurey, Female Ensem le
People Will Say We're in Love	Curly, Laurey

Scene 2 - Smoke House

Pore Jud is Dead	Curly, Jud
Lonely Room	Jud

Scene 3 - A Grove of Laurey's Farm

Out of My Dreams	Laurey
Dream Ballet	Dream Laurey, Dream Curly, Jud, Dancing Ensemble

fifteen minute intermission

ACT II

Scene 1 - The Skidmore Ranch

The Farmer and the Cowman	Entire Company
All Er Nuthin	Ado Annie, Will

Barn

	Curly, Laurey
e)	

y's Farmhouse

na	Entire Company
le	Entire Company

CAST OF CHARACTERS
in order of appearance

Aunt Ellen	Majorie Turner
Curly	Trent Franks
Laurey	Pamela White
Ike Skidmore	Bill Dunnely
Fred	Ray Baker
Will Parker	Ray Cole
Jud Fry	David Horn
Ad Annie	Coleena Brown
Ali Hakin	Charles Bailey
Gertie Cummings	J.C. Sanders
Andrew Carnes	Jason Chesterfield
Dream Laurey	Chelsea Rogers
Dream Curly	Bill Hudson
Cord Elam	Tony Harrold

Singing Ensemble

Ann Anders	Lisa Cannon	Judy Ireland
Rene Escobar	Vivian Festro	Lou Ann Hiltown
Terry Kwight	Art Panderson	Carol Russ
Bill Schischck	James Schauer	Art Wells

Dancing Ensemble

Charles Bailey	Kathy Garcia	Rene Haven
Gay Glazner	David Justin	J. McKibben
Lori Miller	Rocky Williams	

Children
(Children appearing in this production are students from the City Dance Studio)

Jessica Denney	Jamie Lee	Kirk Hines
Elizabeth Martin	Melissa Campbell	Mark Lively
Jim Martin	Jeff Palmer	

ADMINISTRATION STAFF

General Manager	Carolyn Fisher
Administrative Assistant	Pamela White
Director of Publicity	Amanda Kilgore
Public Relations Coordinator	Susie Wilson
General Accountant	Douglas McInnis
Administrative Secretary	Anne Coppenhaver
Ticket Manager	Skip Kishbaugh
Ushers	City Theatre Auxiliarry
Design Consultant	Harry Preston

We wish to thank the following for their property and production

Denise Barnhold	Buttermilk Station Antiques
KIIB-TV	City Musuem

Figure 10-36 (Below)

Figure 10-36 (Below) Standard level program, 8 1/2″ x 11″

The City Parks and Recreation Department presents...
OKLAHOMA

Synopsis of Scenes
The entire action takes place in Indian Teriitory (now Oklahoma) just after the turn of the century.

ACT 1

Scene I - The front of the Laurey's Famhouse

Oh, What a beautiful Morning	Curly, Laurey Aunt Elen
Kansas City	Ado Annie
Many a New Day	Laurey, Female Ensem le
People Will Say We're in Love	Curly, Laurey

Scene 2 - Smoke House

Pore Jud is Dead	Curly, Jud
Lonely Room	Jud

Scene 3 - A Grove of Laurey's Farm

Out of My Dreams	Laurey
Dream Ballet	Dream Laurey, Dream Curly, Jud, Dancing Ensemble

fifteen minute intermission

ACT II

Scene 1 - The Skidmore Ranch

The Farmer and the Cowman	Entire Company
All Er Nuthin	Ado Annie, Will

Scene 2 - Inside Skidmore's Barn

People Will Say We're In Love (Reprise)	Curly, Laurey

Scene 3 - The Front of Laurey's Farmhouse

Oklahoma	Entire Company
Finale	Entire Company

CAST OF CHARACTERS
in order of appearance

Aunt Ellen	Majorie Turner
Curly	Trent Franks
Laurey	Pamela White
Ike Skidmore	Bill Dunnely
Fred	Ray Baker
Will Parker	Ray Cole
Jud Fry	David Horn
Ad Annie	Coleena Brown
Ali Hakin	Charles Bailey
Gertie Cummings	J.C. Sanders
Andrew Carnes	Jason Chesterfield
Dream Laurey	Chelsea Rogers
Dream Curly	Bill Hudson
Cord Elam	Tony Harrold

Singing Ensemble
Ann Anders, Lisa Cannon, Judy Ireland, Rene Escobar, Vivian Festro, Lou Ann Hiltown, Terry Kwight, Art Panderson, Carol Russ, Bill Schischcik, James Schauer, Art Wells

Dancing Ensemble
Charles Bailey, Kathy Guiltintione, Rene Haven, Gay Glazner, David Justin, J. McKibben, Lori Miller, Rocky Williams

Children
(All children appearing in this production are student from the City Dance Studio)
Jessica Denney, Jamie Lee, Kirk Hines, Elizabeth Martin, Melissa Campbell, Mark Lively, Jim Martin, Jeff Palmer.

ADMINISTRATION STAFF

General Manager	Carolyn Fisher
Administrative Assistant	Pamela White
Director of Publicity	Amanda Kilgore
Public Relations Coordinator	Susie Wilson
Administrative Secretary	Anne Coppenhaver
Ticket Manager	Skip Kishbaugh
Ushers	City Theatre Auxiliarry
Design Consultant	Harry Preston

We wish to thank the following for their property and production
Bob's Western Wear
Denise Barnhold

Buttermilk Station Antiques
Burger Barn

KIIB-TV

City Musuem

CUSTOM

The City Parks and Recreation Department presents

OKLAHOMA

Synopsis of Scenes
The entire action takes place in Indian Territory (now Oklahoma) just after the turn of the century.

ACT 1

Scene 1 - The front of the Laurey's Farmhouse

Oh, What a beautiful Morning Curly, Laurey, Aunt Ellen
Kansas City .. Ado Annie
Many a New Day Laurey, Female Ensem le
People Will Say We're in Love Curly, Laurey

Scene 2 - Smoke House

Pore Jud is Dead Curly, Jud\Lonely Room Jud

Scene 3 - A Grove of Laurey's Farm

Out of My Dreams .. Laurey
Dream Ballet Dream Laurey, Dream Curly, Jud, Dancing Ensemble

fifteen minute intermission

ACT II

Scene 1 - The Skidmore Ranch

The Farmer and the Cowman Entire Company
All Er Nuthin Ado Annie, Will

Scene 2 - Inside Skidmore's Barn

People Will Say We're in Love (Reprise) Curly, Laurey

Scene 3 - The Front of Laurey's Farmhouse

Oklahoma Entire Company
Finale .. Entire Company

CAST OF CHARACTERS
in order of appearance

Aunt Ellen .. Majorie Turner
Curly ... Morris Plumb
Laurey ... Pamela White
Ike Skidmore James Jatzlau
Fred ... Ray Booth
Will Parker .. Sam Danna
Jud Fry .. David Horn
Ad Annie ... Coleena Brown
Ali Hakin ... James Dement
Gertie Cummings J.C. Sanders
Andrew Carnes Jason Chesterfield
Dream Laurey Chelsea Rogers
Dream Curly Bill Hudson
Cord Elam .. Tony Harrold

Singing Ensemble

Ann Anders	Lisa Cannon	Judy Ireland	Rene Escobar
Vivian Festro	Lou Ann Hiltown	Terry Kwight	Art Panderson
Carol Russ	Bill Schischcik	James Schauer	Art Wells

Dancing Ensemble

| Charles Bailey | Kathy Guin | Rene Haven | Gay Glazner |
| David Justin | James McKibben | Lori Miller | Rocky Williams |

Children
(Children appearing in this production are students from the City Dance Studio)

| Jessica Denney | Jamie Lee | Kirk Hines | Elizabeth Martin |
| Melissa Campbell | Mark Lively | Jim Martin | Jeff Palmer |

ADMINISTRATION STAFF

General Manager Carolyn Fisher
Administrative Assistant Pamela White
Director of Publicity Amanda Kilgore
Public Relations Coordinator Susie Wilson
General Accountant Douglas McInnis
Administrative Secretary Anne Coppenhaver
Ticket Manager Skip Kishbaugh
Ushers City Theatre A

We wish to thank the following for their property and prod

Bol's Western Wear Denise Barnhold
Buttermilk Station Antiques Burger Barn
KIIID-TV City Museum

Figure 10-37 (Left) Custom level program, 8 1/2″ x 11″

Figure 10-38 (Below) Custom level program, 8 1/2″ x 11″

The City Parks and Recreation Department presents

O·o·o· kla- ho- ma

Synopsis of Scenes
The entire action takes place in Indian Territory (now Oklahoma) just after the turn of the century.

ACT 1

Scene 1 - The front of the Laurey's Farmhouse

Oh, What a beautiful Morning Curly, Laurey, Aunt Ellen
Kansas City Ado Annie
Many a New Day Laurey, Female Ensem le
People Will Say We're in Love Curly, Laurey

Scene 2 - Smoke House

Pore Jud is Dead Curly, Jud
Lonely Room Jud

Scene 3 - A Grove of Laurey's Farm

Out of My Dreams Laurey
Dream Ballet Dream Laurey, Dream Curly Jud, Dancing Ensemble

fifteen minute intermission

ACT II

Scene 1 - The Skidmore Ranch

The Farmer and the Cowman Entire Company
All Er Nuthin Ado Annie, Will

Scene 2 - Inside Skidmore's Barn

People Will Say We're In Love (Reprise) Curly, Laurey

Scene 3 - The Front of Laurey's Farmhouse

Oklahoma Entire Company
Finale Entire Company

CAST OF CHARACTERS
in order of appearance

Aunt Ellen Majorie Turner
Curly Trent Franks
Laurey Pamela White
Ike Skidmore Bill Dunnely
Fred Ray Baker
Will Parker Ray Cole
Jud Fry David Horn
Ad Annie Coleena Brown
Ali Hakin Charles Bailey
Gertie Cummings J.C. Sanders
Andrew Carnes Jason Chesterfield
Dream Laurey Chelsea Rogers
Dream Curly Bill Hudson
Cord Elam Tony Harrold

Singing Ensemble

Ann Anders	Lisa Cannon	Judy Ireland
Rene Escobar	Vivian Festro	Lou Ann Hiltown
Terry Kwight	Art Panderson	Carol Russ
Bill Schischcik	James Schauer	

Dancing Ensemble

Charles Bailey	Kathy Garcia	Rene Haven
Gay Glazner	David Justin	J. McKibben
Lori Miller	Rocky Williams	

Children
(Children appearing in this production are students from the City Dance Studio)

Jessica Denney	Jamie Lee	Kirk Hines
Elizabeth Martin	Melissa Campbell	Mark Lively
Jim Martin	Jeff Palmer	

ADMINISTRATION STAFF

General Manager Carolyn Fisher
Administrative Assistant Pamela White
Director of Publicity Amanda Kilgore
Public Relations Coordinator Susie Wilson
General Accountant Douglas McInnis
Administrative Secretary Anne Coppenhaver
Ticket Manager Skip Kishbaugh
Ushers City Theatre Auxiliarry
Design Consultant Harry Preston

thank the following property and production

Denise Barnhold
Burger Barn
City Museum

We wish to thank the following for their property and production

Bol's Western Wear
Denise Barnhold
Buttermilk Station Antiques
Burger Barn
KIIID-TV
City Museum

Figure 10-39 (Below) Custom level program, 8 1/2″ x 11″

The City Parks and Recreation Department presents

OKLAHOMA

Synopsis of Scenes
The entire action takes place in Indian Territory (now Oklahoma) just after the turn of the century.

ACT 1

Scene 1 - The front of the Laurey's Farmhouse

Oh, What a beautiful Morning Curly, Laurey, Aunt Ellen
Kansas City Ado Annie
Many a New Day Laurey, Female Ensem le
People Will Say We're in Love Curly, Laurey

Scene 2 - Smoke House

Pore Jud is Dead Curly, Jud\Lonely Room Jud

Scene 3 - A Grove of Laurey's Farm

Out of My Dreams Laurey
Dream Ballet Dream Laurey, Dream Curly, Jud, Dancing Ensemble

fifteen minute intermission

ACT II

Scene 1 The Skidmore Ranch

The Farmer and the Cowman Entire Company
All Er Nuthin Ado Annie, Will

Scene 2 - Inside Skidmore's Barn

People Will Say We're In Love (Reprise) Curly, Laurey

Scene 3 - The Front of Laurey's Farmhouse

Oklahoma Entire Company
Finale Entire Company

CAST OF CHARACTERS
in order of appearance

Aunt Ellen Majorie Turner
Curly Trent Franks
Laurey Pamela White
Ike Skidmore Bill Dunnely
Fred Ray Baker
Will Parker Ray Cole
Jud Fry David Horn
Ad Annie Coleena Brown
Ali Hakin Charles Bailey
Gertie Cummings J.C. Sanders
Andrew Carnes Jason Chesterfield
Dream Laurey Chelsea Rogers
Dream Curly Bill Hudson
Cord Elam Tony Harrold

Singing Ensemble
Ann Anders, Lisa Cannon, Judy Ireland, Rene Escobar, Vivian Festro, Lou Ann Hiltown, Terry Kwight, Art Panderson, Carol Russ, Bill Schischcik, James Schauer, Art Wells

Dancing Ensemble
Charles Bailey, Kathy Guiltintione, Rene Haven, Gay Glazner, David Justin, J. McKibben, Lori Miller, Rocky Williams

Children
(All children appearing in this production are student from the City Dance Studio)
Jessica Denney, Jamie Lee, Kirk Hines, Elizabeth Martin, Melissa Campbell, Mark Lively, Jim Martin, Jeff Palmer

Figure 10-40 Premium level Oklahoma program with scanned rope. *Credit: Azalia Alvarez, designer*

PREMIUM

OKLAHOMA

Based on Lynn Brigg's "Green Grow the Lilacs"

Music ..Richard Rodgers
Book & LyricsOscar Hammerstein II
Producer & Musical DirectorFrank M. Young
Assistant Musical DirectorSharon Birkman
Director & ChoreographerCarolyn Franklin
Assistant ChoreographerKathy Castillion
Scenery ..Robert Howery Studios
Lighting ..Neil P. Jampolis
Costumes ..Bonnie Ambrose

Synopsis of Scenes: The entire action takes place in Indian Territory
(now Oklahoma) just after the turn of the century.

ACT I

Scene I- The front of the Laurey's Farmhouse

Oh, What a Beautiful Morning ..Curly
The Surrey With the Fringe on TopCurly, Laurey, Aunt Elen
Kansas City ..Ado Annie
Many a New DayLaurey, Female Ensemble
People Will Say we're in LoveCurly, Laurey

Scene 2 - The Smoke House

Pore Jud is Dead ..Curly, Jud
Lonely Room ...Jud

Scene 3 - A Grove at Laurey's Farm

Out of My Dreams ..Laurey
Dream Ballet ...Dream Laurey
Dream Curly, Jud
Dancing Ensemble

FIFTEEN MINUTE INTERMISSION

ACT II

Scene 1 - The Skidmore Ranch

The Farmer and the CowmanEntire Company
All Er NuthinAdo Annie, Will

Scene 2 - Inside Skidmore's Barn

People Will Say we're In Love (Reprise)Curly, Laurey

Scene 3 - The Front of Laurey's Farmhouse

Oklahoma ..Entire Company
Finale ..Entire Company

CAST OF CHARACTERS

In order of appearance

Aunt EllenMajorie Carrol
Curly ..Travia Franklin
Laurey ..Pamela Whitten
Ike SkidmoreGreg Dunes
Fred ..Greg Dumas
Will Parker ...Ray Colbert
Jud Fry ..Daniel Hannaim
Ad Annie CrnesColleen O'Kit
Ali Hakin ...Charles Krohn
Gertie CummingsJ.C. Baker
Andrew CarnesAdy Misthos
Dream LaureyChesley Santoro
Dream CurlyBill Hudson
Cord Elam ..Teny Turner
(Bill Hudson appears through the courtesy of Houston Con-
temporary Dance Theatre)

THEATRE UNDER THE STARS

Artistic DirectorFrank M. Young
& Founder

ADMINISTRATION STAFF

General ManagerJerry Lowery
Adm.Asst.Pamela Whitten
Director of PublicityAmanda Tyler
Public RelationsSusie Works
General AccountantDoug Kilgore
Adm.SecretaryAnne goldstone
Ticket ManagerLeo Hamil
UshersTheatre Inc. build
PresidentCorothy Gerfy
Deisgn ConsultantPreston Hatcher

TUTS/HUMPHREYS SCHOOL
OF MUSICAL THEATRE STAFF

Executive DirectorCarolyn Franklin
Adult Prod. DirectorVivan Altfeld
Speech & Film Instr.Gary Chason
Acting InstructorTravic Frankline
Make-up InstructorSkip Milhousen
Musical Instructor,George Morgenstern
Student Prod.DirectorJulie Rozan
Voice InsturctorDiane Tabola
Stage ManagerBonnie Weeks
Acting & Music CoachFrank Young

SINGING ENSEMBLE

Adelaida Anderson, Miles Anderson , Lesa Aratit, Soh-pemple Cannon, Greg Dumas, Judy England Bill Erwin, Rene Escobar , Vivian Flynn, Janet Golasinki , Orielie Gudbser, Bob McCullough
Lou Ann Miles , Terry Turner , Cynthia Anne Wright, Art Yelton

DANCING ENSEMBLE

Charles Brown, Kathy Castillon , Jackie Elridge, Re-nouarri Been , Gaye Glazner, David Greiss
Cathy Gurensey, Morris Hilton , Kerry Kreiger, Kim Lung, Sally McCravey, B. J. Provenzano, Chelsey San-toro, Carol Sloss, Rocky Sude

CHILDREN

(All children appearing in TUT's production are student from
the TUTS Humphreys School of Musical Theatre)

Jess Buaghman, Ja Dorr, Adrienne Heins, Kirk Kimball, Mary Gaye Kimball, Mark Kinkaid , Delse Lively, Jim Tucker

Production Stage Mgr.Bill Roberts
Stage ManagerBonnie Webber
Asstistant Stage Mgr.Doug Kilgore
Dance CaptainMaida Ambrose
Property ManagerMarty Ambrose
Property AssistantsE.Clibourne,
Mike Miller, John Nameth, Rita Robert

OrchestraHouston Pops
Make-up & Hair DesignPhil Hayes
Wardrobe MistressEunice Hayes
Musical CoachChuck Hunnice
Master Sound TechnicianJerry Lowery
Fight Sequence StagingBill Roberts
Master CapentryLarry Gatz
Property MasterHyman Werner
Assistants to Mr. LoweryDennis Keller,
Sandra Grover

Western WearBoot'N Stirrup
Official CarGulf Coast Motor

Give To Keep Us Going…

If you enjoy TUT's Free Summer Musicals and would like to see them continue, then do your share, send your tax deductible contribution today. Our future is dependent upon financial support form people just like you. And you donors receive advance notice of show, indoor seating priorities and other benefits. TUTS is financed entirely through contributions. Help us in whatever way you can, but please help us continue.

Send your tax deductible contributions to TUTS, 2017 West Gray, Houston, TX 77019.

…Give to Keep us Free

Name _____

Address _____

City _____

State _____ Zip_____

Phone _____

We wish to thank the following for their property and production:

Almeda Stables Dennis Barhorst
East End Transfer & Storage Frank Horlock
KQUE-FM Joe Polichuno, Sr.
Phillips Presbyterian Church McDonald's
Woodstock Stripping & Antiques Asbury School of Dance
Burger King Gulf Coast Motor Leasing
Houston Grand Opera KTRK-Channel 13
Mobil Air Conditioning Westerby Arms Museum
Miller Theater Staff:
Manager Bret Weil
Technical Director Jerry R. Lowe
Publicity and Production Jeanne Jones
Secretary Judith Reining
Program Production
Typography & Design Azalia V. Alvarez

The City of Houston
PARKS & RECREATION DEPARTMENT
The Miller Advisory Council
& THEATRE UNDER THE STARS

PRESENTS

OKLAHOMA

Based on Lynn Brigg's "Green Grow the Lilacs"

WE WISH TO THANK THE FOLLOWING
FOR THEIR PROPERTY AND PRODUCTION

Almeda Stables

Dennis Barhorst

East End Transfer & Storage

Frank Horlock

KQUE-FM

Joe Polichuno, Sr.

Phillips Presbyterian Church

Woodstock Stripping and Antiques

Asbury School of Dance

Burger King

Gulf Coast Motor Leasing

Houston Grand Opera

KTRK-Channel 13

Mobile Air Conditioning

Westerby Arms Museum

Miller Theater Staff

Manager Bret Weil

Technical Director Jerry R. Lowe

Publicity and Production Jeanne Jones

Secretary Judith Reining

Program Production

Typography and Design Natalia Karachevtseva

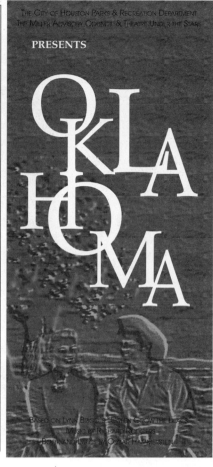

THE CITY OF HOUSTON PARKS & RECREATION DEPARTMENT
THE MILLER ADVISORY COUNCIL & THEATRE UNDER THE STARS

PRESENTS

O K L A H O M A

BASED ON LYNN RIGGS'S "GREEN GROW THE LILACS"
MUSIC BY RICHARD RODGERS
BOOK AND LYRICS BY OSCAR HAMMERSTEIN II

Figure 10-41 Premium level Oklahoma
program with photo embossing.
Credit: Natalia Karachevtseva, designer

CITY OF HOUSTON PARKS & RECREATION DEPARTMENT
MILLER ADVISORY COUNCIL & THEATRE UNDER THE STARS

P R E S E N T S

CAST OF CHARACTERS

In order of appearance

Aunt Ellen	Majora Carol
Curly	Travia Franklin
Laurey	Pamela Whitten
Ike Skidmore	Greg Dunes
Fred	Greg Dumas
Will Parker	Ray Colbert
Jud Fry	Daniel Hannaim
Ad Annie Crones	Colleen O'Kit
Ali Hakin	Charles Krohn
Gertie Cummings	J.C. Baker
Andrew Carnes	Ady Misthos
Dream Laurey	Chesley Santoro
Dream Curly	Bill Hudson
Cord Elam	Teny Turner

Bill Hudson appears through the courtesy of Houston Contemporary Dance Theatre

Singing Ensemble

Adelaida Anderson, Miles Anderson, Lesa Aratit, Sohpemple Cannon, Greg Dumas, Judy England, Bill Erwin, Rene Escobar, Vivian Flynn, Janet Golasinki, Orielie Gudbser, Bob McCullough, Lou Ann Miles, Terry Turner, Cynthia Anne Wright, Art Yelton.

Dancing Ensemble

Charles Broum, Kathy Castillon, Jackie Flridge, Renouarri Reen, Gaye Glazner, David Greiss, Cathy Gurensey, Morris Hilton, Kerry Kreiger, Kim Lung, Sally McCravey, Benjamin J. Provenzano, Chelsey Santoro, Carol Sloss, Rocky Sude.

Children

(All children appearing in TUTS's production are student from the TUTS/Humphreys School of Musical Theatre)
Jess Buaghman, Ja Dorr, Adrienne Heins, Kirk Kimball, Mark Mary Gaye Kimball, Mark Kinkald, Delse Lively, Jim Tucker.

Territory (now Oklahoma)	
century.	
y's Farmhouse	
Laurey, Aunt Elen	
Annie	
Female Ensemble	
urey	
House	
ud	
rey's Farm	
Laurey, Dream Curly,	
ncing Ensemble	
ission	
Ranch	
Company	
nnie, Will	
e's Barn	
Laurey	
y's Farmhouse	
Company	
Company	

Stars

Frank M. Young

AFF

owery

whitten

la Tyler

Works

Kilgore

Administrative Secretary	Anne goldstone
Ticket Manger	Leo Hamil
Ushers	Theatre Inc. build,
	Corothy Gerfy, President
Design Consultant	Preston Hatcher

TUTS/HUMPHREYS SCHOOL OF MUSICAL THEATRE STAFF

Executive Director	Carolyn Franklin
Adult Production Director	Vivan Altfeld
Speech & Film Acting Instructor	Gary Chason
Acting Instructor	Travic Frankline
Make-up Instructor	Skip Milhousen
Musical Instructor	George Morgenstern
Student Production Director	Julie Rozan
Voice Instructor	Diane Tabola
Stage Manager	Bonnie Weeks
Acting & Musical Coach	Frank Young

PRODUCTION STAFF

Production Stage Manager	Bill Roberts
Stage Manager	Bonnie Webber
Assistant Stage Manger	Doug Kilgore
Dance Captain	Maida Ambrose
Property Manager	Marty Ambrose
Property Assistants	Elizabeth Clibourne, Mike Miller, John Nameth, Rita Roberts
Orchestra	Houston Pops
Make-up & Hair Design	Phil Hayes
Wardrobe Mistress	Eunice Hayes
Musical Coach	Chuck Hunnice
Costume Coordinator	Pat Humphries
Master Sound Technician	Jerry Lowery
Fight Sequence Staging	Bill Roberts
Master Capentry	Larry Gatz
Property Master	Hyman Werner
Master Electrician	Mel Weinbreed
Assistants to Mr Lowery	Dennis Keller, Sandra Grover
Western Wear	Boot'N Stirrup
Official Car	Gulf Coast Motor Leasing
Producer and Musical Director	Frank M. Young
Assistant Musical Director	Sharon Birkman
Director and Choreographer	Carolyn Franklin
Assistant Choreographer	Kathy Castillion
Scenery	Robert Howery Studios
Lighting	Neil P. Jampolis
Costumes	Bonnie Ambrose

GIVE TO KEEP US GOING...

If you enjoy TUT's Free Summer Musicals and would like to see them continue, then do your share, send your tax deductible contribution today. Our future is dependent upon financial support form people just like you. And you donors receive advance notice of show, indoor seating priorities and other benefits. TUTS is financed entirely through contributions. Help us in whatever way you can, but please help us continue.

Send your tax deductible contributions to TUTS, 2017 West Gray, Houston, TX 77019

Give to keep us Free

Name _____

Address _____

City _____ Phone _____

State _____ Zip _____

PREMIUM

Figure 10-42 Premium level Oklahoma program with bandana. *Credit: Dana Stuart, designer*

PART FIVE

Theatre Under the Stars
Artistic Director and FounderFrank M. Young

Adminstration Staff
General Manager Jerry Lowery
Administrative Assistant Pamela Whitten
Director of Publicity Amanda Tyler
Public Relations Coordinator Susie Works
General Accountatnt Doug Kilgore
Administrative SecretaryAnne Goldstone
Ticket Manger Leo Hamil
Ushers Theatre Inc. build, Corothy Gerfy, President
Design ConsultantPreston Hatcher

**TUTS/HUMPHREYS SCHOOL OF
 MUSICAL THEATRE STAFF**
Executive Director Carolyn Franklin
Adult Production Director Vivan Altfeld
Speech & Film Acting Instructor Gary Chason
Acting InstructorTravic Frankline
Make-up InstructorSkip Milhousen
Musical InstructorGeorge Morgenstem
Student Produciton Director Julle Rozan
Voice Instructor Diane Tabola
Stage Manager Bonnie Weeks
Acting & Musical Coach Frank Young

PART SIX

Give To Keep Us Going...
If you enjoy TUTS Free Summer Musicals and would like to see them continue, then do your share, send your tax deductible contribution today. Our future is dependent upon financial support from people just like you. And donors receive advance notice of show, indoor seating priorities and other benefits. TUTS is financed entirely through contributions. Help us in whatever way you can, but please help us continue.

Send your tax deductivel contributions to TUTS, 2017 West Gray, Houston, TX 77019.
...Give to keep us Free
Name_____
Adress_____
City_____
State_____Zip_____
Phone_____

PART SEVEN

We wish to thank the following for their property and production
Almeda Stables
Dennis Barhorst
East End Transfer & Storage
Frank Horlock
KQUE-FM
Joe Polichuno, Sr.
Phillips Presbyterian Church
Woodstock Stripping and Antiques
Asbury School of Dance
Burger King
Gulf Coast Motor Leasing
Houston Grand Opera
KTRK-Channel 13
Mobil Air Conditioning
Westerby Arms Museum

Miller Theater Staff
Manager Bret Weil
Technical DirectorJerry R. Lowe
Publicity and Production Jeanne Jones
Secretary Judith Reining

Program Production
Typography and Design Dana Stuart

Presented by
The City of Houston Parks & Recreation Department
The Miller Advisory Council
Theatre Under the Stars

PART ONE

OKLAHOMA
Based onLynn Brigg's "Green Grow the Lilacs"
Music byRichard Rodgers
Book and Lyrics Oscar Hammerstein II
Producer and Musical DirectorFrank M. Young
Assistant Musical DirectorSharon Birkman
Director and ChoreographerCarolyn Franklin
Assistant Choreographer....................Kathy Castillion
SceneryRobert Howery Studios
LightingNeil P. Jampolis
CostumesBonnie Ambrose

PART TWO

Production Stage Manager....................Bill Roberts
Stage Manager....................................Bonnie Webber
Assistant Stage Manager'Doug Kilgore
Dance CaptainMaida Ambrose
Property ManagerMarty Ambrose
Property Assistants ..Elizabeth Cliboume, Mike Miller, John Nameth, Rita Roberts
Orchestra Houston Pops
Make-up & Hair DesignPhil Hayes
Wardrobe MistressKathy Castillon
Musical CoachChuck Hunnice
Costume Co-ordinatorPat Humphries
Master Sound TechnicianJerry Lowery
Fight Sequence StagingBill Roberts
Master CarpentryLarry Gatz
Property MasterHyman Werner
Master ElectricianMel Weinbreed
Assistants to Mr. LoweryDennis Keller, Sandra Grover
Western WearBoot'N Stirrup
Official CarGulf Coast Motor Leasing

PART THREE

Synopsis of Scenes
The entire action takes place in Indian Territory (now Oklahoma) just after the turn of the century.

Act I
Scene 1- The front of the Laurey's Farmhouse
Oh, What a Beautiful Morning Curly
The Surrey With the Fringe on TopCurly, Laurey, Aunt Elen
Kansas City Ado Annie
Many a New Day Laurey, Female Ensemble
People Will Say We're in Love.................... Curly, Laurey

Scene 2 - The Smoke House
Poor Jud is Dead Curly, Jud
Lonely Room Jud

Scene 3 - A Grove of Laurey's Farm
Out of My Dreams Laurey
Dream Ballet Dream Laurey, Dream Curly, Jud, Dancing Ensemble

Fifteen Minute Intermission

Act II
Scene 1 - The Skidmore Ranch
The Farmer and the Cowman Entire Company
All Er Nuthin Ado Annie, Will

Scene 2 - Inside Skidmore's Barn
People Will Say We're in Love (Reprise) Curly, Laurey

Scene 3 - The Front of Laurey's Farmhouse
Oklahoma Entire Company
Finale Entire Company

PART FOUR

CAST OF CHARACTERS
In order of appearance
Aunt Ellen Majorie Carrol
Curly Travia Franklin
Laurey Pamela Whitten
Ike Skidmore Greg Dunes
Fred Greg Dumas
Will Parker Ray Colbert
Jud Fry Daniel Hannaim
Ad Annie Crnes................................ Colleen Q'Kit
Ali Hakin Charles Krohn
Gertie Cummings J.C. Baker
Andrew Carnes Ady Misthos
Dream Laurey................................ Chesley Santoro
Dream Curly Bill Hudson
Cord Elam Teny Turner
Bill Hudson appears through the courtesy of Houston Contemporary Dance Theatre

Singing Ensemble
Adelaida Anderson, Miles Anderson, Lesa Aratit, Sohpemple Cannon, Greg Dumas, Judy England, Bill Erwin, Rene Escobar, Vivian Flynn, Janet Golasinki, Orielie Gudbser, Bob McCullough, Lou Ann Miles, Terry Turner, Cynthia Anne Wright, Art Yelton.

Dancing Ensemble
Charles Brown, Kathy Castillon, Jackie Elridge, Renouarri Been, Gaye Glazner, David Greiss, Cathy Gurensey, Morris Hilton, Kerry Kreiger, Kim Lung, Sally McCravey, Benjamin J. Provenzano, Chelsey Santoro, Carol Sloss, Rocky Sude.

Children
(All children appreaing int TUTS production are student from the TUTS? Humphreys School of Musical Theatre) Jess Buaghman, Ja Dorr, Adrienne Heins, Kirk Kimball, Mary Gaye Kimball, Mark Kinkaid, Delse Lively, Jim Tucker.

Pocket folders

Pocket folders are covers that have pockets on the inside for pull out information pages and brochures. Pocket folders have recently become popular on all levels of design. They are an alternative to using binders or envelopes for handouts. Standard die cut folders include one and two inside flaps (figure 10-43).

A standard die cut is often half the cost of a specially made die cut. Request strike sheets of the available dies from your printing company. One common die cut includes a slit for a business card. When including a die cut as a design element, pick up the scissors instead of a pencil to work on ideas.

Finishing and bindery

Pocket folders usually include finishing techniques. The pocket folder is printed as a flat sheet on a cover weight. Other finishing and bindery work is completed and then it is die cut to the shape of the folder plus pockets, slit for business cards, scored to be able to bend the sheet without cracking at the fold, and then glued and stapled. An economical choice is to purchase the folders cut as a flat publication and do the hand work yourself. Some special considerations include:

Embossing

When there is a problem seeing the backside of the embossing, place the embossing so that it falls behind the flap. Consider specialty houses that can silk screen and foil stamp the company name and logo at less cost than a conventional print shop and bindery.

Folds

Single flaps are good for standard levels. If a heavy text sheet is used, the flap will fold up and not require a die cut. Gatefolds and pocket folds are considered premium level designs because of the added cost of hand work. For samples of folds, see figures 10-50 through 10-52.

If there is paper waste, use the extra to print stuffers, handouts, table tents, name tags, business cards, or any additional projects. Since this is an unusual cut, there is always some room for another project.

Hot stamping

Contact the vendor for hot stamping colors. Keep the area small or within standard sizes of the rolls.

Score

Most cover weights will need a score as well as a fold. Two scores can be used to make a box pocket

ECONOMICAL FOR SHORTER RUNS

FITS WITH SINGLE AND DOUBLE FLAP

Figure 10-43 Popular die cuts for one- and two-pocket folders.

for the back if the folder has several publications to fit inside it.

Use of photos and background textures

The cover can be printed with as much design and color as any large advertising publication. It is better to print a texture on the sheet than to use a textured sheet. The folds should follow the grain of the sheet; if the project folds in both directions, test the sheet.

The paper stock

Use lighter cover weights for folders with limited budgets or for an event with a one time use. Cast coat is an extra hard coating that will increase the durability of the folder. The grain is very critical and must run with the 11½″ side since it is the longer visual fold. Avoid heavier sheets with deep textures that will crack even when they are scored.

The sheet size

The press sheet size must match the design to give the least amount of waste. Use it for all projects in the advertising package that require the same weight and type of paper.

Pocket folder samples

Use 6-12-point cast coat covers, one or two sided, 100# enamel, 70# text, 80# cover, or 24# writing bond for lighter weight.

Range for type specifications

Element	Type Sizes	Comments
Title	14-48 pt	All caps, bold
Address or quote	14-18 pt	Medium, or italics for quote

Paper

Common Sheet Size	Common Fold Size
26″ x 20″	9″ x 12″
14″ x 17″	8½″ x 11″

Standard level pocket folders and covers

Small quantities and urgent deadlines are well met with standard level covers or with standard die cut pocket folders. Choose a paper that will not require scoring or use the design as a cover for spiral bound, perfect bound, or front-sleeved notebooks. Try the specifications from figures 10-44 through 10-46 for style palette information or change fonts and modify slightly:

Element	Type Specifications
Headline A	54/60 Caslon bold
Headline B	30/36 Caslon bold
Body	12/28 Caslon, italics
Signature A	18/20 Caslon bold, italics
Signature B	18/14 Caslon bold, italics
Address	12/24 Caslon, increased letterspacing

PAPER AND INK. Use black or a one spot color ink on textured 80# cover.

LINE ART. Use purchased EPS line art or an ornament font.

OUTPUT DEVICE.

1st Choice—Laser original (1000 dpi or greater) to conventional small press.

2nd Choice—Direct-to-plate at cover specialty printing house.

Custom level pocket folders

Additional layers of custom and stock textures and photos add production time and increase printing requirements (figures 10-47 through 10-49).

Element	Type Specifications
Headline A	54/60 GillsSans ultra bold
Headline B	30/36 GillsSans ultra bold
Body	12/24 Caslon
Signature	18/20 Caslon

PAPER AND INK. Use one color ink with tints or two colors of ink with tints and 80# cover.

PHOTO OR LINE ART. Use a photo CD or scanned photo of both products and people. Also use custom designed art for the company, purchased EPS line art, or an ornament font.

OUTPUT DEVICE.

1st Choice—Direct-to-plate at conventional medium-size press.

2nd Choice—Direct-to-film negative (service bureau) for conventional small press.

Premium level pocket folders

Premium level designs for pocket folders focus on specialized die cuts, folds, multiple color, and finishing techniques. Art boards should be used for presentations.

Figure 10-50 showcases a wrap-around photo taken in the client's production area using the craftsman's tools from this established company. The pocket shows the background photo in register on the inside cover spread. The type on the outside is 24 points and inside it is 18, 11, and 12. The paper is a 80# cover, gloss coated enamel that is laminated. Color: four-color process.

Figure 10-51 is a good example of a gatefold. It is printed on an 80# cover, matte finish enamel, with two slits outside by the logo to lock the gatefold and one inside for a business card. The pocket is built for a ¼″ thickness of inserts. It uses two varnishes, one dull and one high gloss, which accents a checkboard on the front and back. The inside type is 36, 22, and 14. Colors: PANTONE 1545, a brown, and PANTONE 315, a blue.

Figure 10-52 is a corporate folder. The 80# cover, dark blue with a waffle texture, has a Velcro closure and rounded pockets. It matches the series of brochures that it is designed to present. The type sizes are 54, 30, and 30 italics. The folder closes with Velcro as a gatefold and uses a round shape for the pockets. The ink color is opaque white with a gold foil embossing.

STANDARD

The
25th
Anniversary
Portfolio

———

{A pictorial of the corporation
from 1976 when Georgia Sanders open her center
until 2001 as a national franchise.}

LiLblessings
•SCHOOLS•

New York • San Franscisco

Figure 10-44 (Left) Standard level cover

Figure 10-45 (Below) Standard level cover

The
25th
Anniversary
Portfolio

{A pictorial of the corporation
from 1976 when Georgia Sanders open her center
until 2001 as a national franchise.}

LiLblessings
•SCHOOLS•

New York • San Francisco

1976–2001 1976–2001 1976–2001 1976–2001 1976–2001 1976–2001 1976–2001
1976–2001 1976–2001 1976–2001 1976–2001 1976–2001 1976–2001 1976–2001 1976–2001
1976–2001 1976–2001 1976–2001 1976–2001 1976–2001 1976–2001 1976–2001
1976–2001 1976–2001 1976–2001 1976–2001 1976–2001 1976–2001 1976–2001 1976–2001
1976–2001 1976–2001 1976–2001 1976–2001 1976–2001 1976–2001 1976–2001
1976–2001 1976–2001 1976–2001 1976–2001 1976–2001 1976–2001 1976–2001 1976–2001
1976–2001 1976–2001 1976–2001 1976–2001 1976–2001 1976–2001 1976–2001
1976–2001 1976–2001 1976–2001 1976–2001 1976–2001 1976–2001 1976–2001 1976–2001
1976–2001 1976–2001 1976–2001 1976–2001 1976–2001 1976–2001 1976–2001
1976–2001 1976–2001 1976–2001 1976–2001 1976–2001 1976–2001 1976–2001 1976–2001
1976–2001 1976–2001 1976–2001 1976–2001 1976–2001 1976–2001 1976–2001
1976–2001 1976–2001 1976–2001 1976–2001 1976–2001 1976–2001 1976–2001 1976–2001
1976–2001 1976–2001 1976–2001 1976–2001 1976–2001 1976–2001 1976–2001
1976–2001 1976–2001 1976–2001 1976–2001 1976–2001 1976–2001 1976–2001 1976–2001
The
1976–2001 1976–2001 1976–2001 1976–2001 1976–2001 1976–2001 1976–2001
25th 1976–2001 1976–2001 1976–2001 1976–2001 1976–2001 1976–2001 1976–2001
Anniversary Portfolio 1976–2001 1976–2001 1976–2001 1976–2001
1976–2001 1976–2001 1976–2001 1976–2001 1976–2001 1976–2001 1976–2001 1976–2001
1976–2001 1976–2001 1976–2001 1976–2001 1976–2001 1976–2001 1976–2001
1976–2001 1976–2001 1976–2001 1976–2001 1976–2001 1976–2001 1976–2001 1976–2001

LiLblessings
•SCHOOLS•

New York • San Franscisco

1976–2001 1976–2001 1976–2001 1976–2001 1976–2001 1976–2001 1976–2001
1976–2001 1976–2001 1976–2001 1976–2001 1976–2001 1976–2001 1976–2001

Figure 10-46 (Left) Standard level cover. Headline A uses 120-point type.

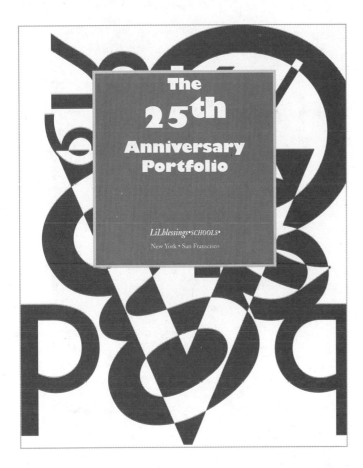

Figure 10-47 (Left) Custom level cover. *Credit: Brian Campbell, background design and production*

Figure 10-48 (Below) Custom level cover. *Credit: Natalia Karachevtseva, designer*

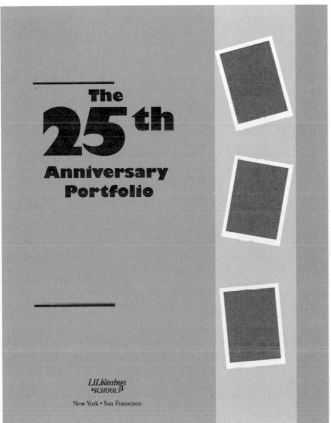

Figure 10-49 (Left) Custom level cover. Headline A uses 120-point type.

Figure 10-50 (Left) Premium level pocket folder, photo embossing. *Credit: Manlove Advertising, Pasadena, TX, design and production*

Figure 10-51 (Below) Premium level pocket folder, special die cuts. *Credit: Kathryn Vosburg-Seretti, designer*

Figure 10-52 (Left) Premium level pocket folder, gold foil embossed. *Credit: Western National Life Insurance Co., Randi Stephens and Jennifer Junemann, designers/production*

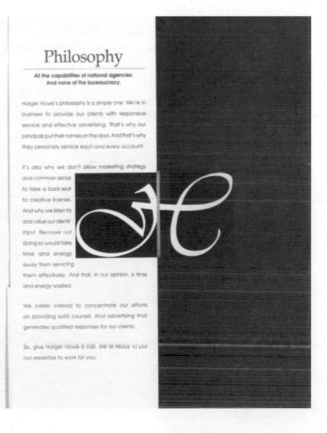

PREMIUM

Brochures

A brochure can be the first link to an interested, potential customer. Brochures are displayed in racks, on coffee tables of waiting rooms, at product shows, and through direct mailings. They are the most frequently used advertising piece for all levels of design and are used to give information on a specific product, event, service, or organization. To extend its life, avoid printing dated information or employees' names.

Type

The type specifications are the same for every sheet size of a brochure because the reading distance is generally the same. The amount of type in a brochure may resemble a long document, but the type is usually set with additional leading and the design and placement of copy is different.

The most popular sizes for body text are 9/14 (9-point type with a 14-point leading) and over half of the brochures use a leading of 12 to 15 points. Subheads are two sizes or more greater than the body copy size. Subheads with two levels have one subhead the same size as the body.

> ✗ Cross reference: See figures 4-8 through 4-10 for interesting techniques for breaking up text.

The sheet size of a brochure is usually controlled by the amount of copy and the budget. When facing copyfitting problems, the sheet size and number of folds are increased. Premium brochures may have a final sheet size and page spread of 17″ x 22″ with folds and a crossfold.

The cover is the showcase, bringing the reader into the brochure; then the information is presented as a continuous story that unfolds as the panels are unfolded. Sketches should be built on folded sheets to keep from losing this thread and to avoid confusion in the production stage. To give unfolded sections their greatest potential, set up the sheet size for each page and use the dummy for location of copy.

Brochure samples

Use 70#-80# text, coated and textured, or 65# cover, coated and textured.

Range for type specifications

Element	Type Sizes	Comments
Outside cover		
Title	24-144 pt	All fonts, large when no art or photo is used
Subhead	12-36 pt	Serif, leading double the type size
Company name	18-24 pt	Bold or wordmarks
Company Address	8-11 pt	Letterhead sizes
Inside copy		
Subheads	9-24 pt	Serif, same size as body if there are two levels of subheads and two or more sizes greater than body if there is only one level of subhead
Body text	8-11 pt	Serif, medium, leading 2-5 pt greater, use advance techniques for breaking up paragraphs
Inside flap		
Copy	8-11 pt	Same specifications as inside copy or larger size/leading
Map/chart	6-7 pt	Serif or sans serif, all caps, medium

Paper

Number of Panels	Sheet Size	Folded Size	Envelope Size and Kind
4	8½″ x 11″	5½″ x 8½″	6″ x 9″, catalog or booklet
4	8½″ x 7″	3½″ x 8½″	4⅛″ x 9½″, business
6	8½″ x 11″	3½″ x 8½″	4⅛″ x 9½″, business
6	8½″ x 14″	4½″ x 8½″	6″ x 9″, catalog or booklet
	11″ x 17″	8½″ x 11″	9″ x 12″, catalog or booklet

Standard level brochures

Small quantities and urgent deadlines are well met with standard level brochures. Standard single and double folds make designs easier to reuse. Try the specifications from figures 10-53 through 10-55 for style palette information or change fonts and modify slightly:

Element	Type Specifications
Outside cover	
Title	48/48 New Century Schoolbook bold, U & lc, 80% width, tight tracking
Subhead A	18/21 New Century Schoolbook bold, U & lc
Signature	8/10 Helvetica black, U & lc, 120% width
Inside	
Title	18/24 Helvetica condensed bold, U & lc
Introduction paragraph	12/16 New Century Schoolbook italics, 2-pt before paragraph leading, 1-pt after paragraph leading
Subhead	10/12 Helvetica bold, 1-pt before paragraph leading
Initial cap	72/24 Helvetica condensed bold
Text	9/12 New Century Schoolbook, U & lc, 6-pt before paragraph leading
Bullet	9/12 Helvetica bold, 2-pt before paragraph leading
Addresses	9/12 New Century Schoolbook
Mailer	Signature from envelope size

PAPER AND INK. Choose a dark color of ink to maintain readability of the type with 24# bond in soft or neutral colors or 60-80# text with texture.

LINE ART. Use purchased EPS line art, an Ornament font, texture, or reverse type.

OUTPUT DEVICE.

1st Choice—Laser original (1000 dpi or greater) to copier or on-demand printing.

2nd Choice—Laser original (1000 dpi or greater) to conventional small press.

3rd Choice—Direct-to-plate at conventional small press.

Custom level brochures

Additional fine papers, ink colors, and custom art or stock textures and photos add production time and increase printing requirements (figures 10-56 through 10-58).

Element	Type Specifications
Outside cover	
Title	30/36 New Century Schoolbook bold, U & lc, 80% width, tight tracking
Subhead A	18/21 New Century Schoolbook bold, U & lc
Signature	8/10 Helvetica black, U & lc, 120% width
Inside	
Title	18/24 Helvetica condensed bold, U & lc
Introduction paragraph	12/16 New Century Schoolbook italics, 2-pt before paragraph leading, 1-pt after paragraph leading
Subhead	10/14 Helvetica black, 1-pt before paragraph leading
Text	9/12 New Century Schoolbook, U & lc, 6-pt before paragraph leading
Bullet	9/12 Helvetica bold, 4-pt before paragraph leading
Addresses	9/12 New Century Schoolbook
Mailer	Signature in envelope size

PAPER AND INK. Add photos and tints to previous choices with one color ink with tints or two colors of ink and loose register. Use 8½″ x 11″ 20# bond in bold colors with black ink with tints or 80# text with texture or 65# cover.

PHOTO OR LINE ART. Use a photo CD or scanned photo of products, not people. Also, use custom designed art for the event, purchased EPS line art, or an Ornament font.

OUTPUT DEVICE.

1st Choice—Laser original (1000 dpi or greater) to copier or on-demand printing.

2nd Choice—Laser original (1000 dpi or greater) to conventional small press.

3rd Choice—Direct-to-plate at conventional small press.

Premium level brochures

Premium level designs for brochures focus on additional sketches, multiple color samples, and additional conferences with the client. Art boards should be used for presentations.

Figure 10-59 is a single fold/four panel design. The paper choice is an 80# cover, matte finish enamel. Inside type specifications are 14-point subheads and 10/12 body text. Colors: four-color process.

Figure 10-60 is an example of a double fold/standard six panel design. It is printed on 65# cover, matte finish enamel. Inside type specifications are 14-point subheads and 10/12 body text. The sheets are scored to keep them from cracking when folded. Colors: PANTONE 305, a blue, and black.

Figure 10-61 is an example of a double fold/eight panel design. The paper choice is an 80# text, high gloss. Colors: PANTONE 301, a blue, and PANTONE 124, a yellow, converted to process color.

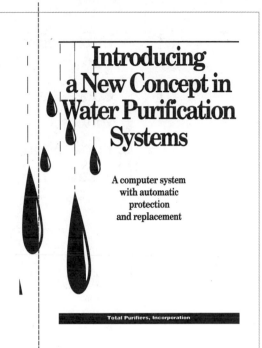

You'll have...

- Affordable dependable clean pool and drinking water.
- Mutually convenient monthly check ups to the system.
- $35.00 installation fee per outlet.
- Less than $1.00 per day estimated summer water worries
- Phone calls are answered by real people with immediate answer — 24 hours a day, seven days a week.
- Satisfaction guaranteed.
- Add as many water outlet to this plan at any time for the original cost per outlet, no increase in charges to your account.

Introducing a New Concept in Water Purification Systems

A computer system with automatic protection and replacement

Total Purifiers, Incorporation

Figure 10-53 Standard level brochure, 8 1/2″ x 11″, single fold

A computer water purification solution

for a wide range of home and business applications. The Total Purifier's computer water system is a fast, high-quality water purification system with multi-user and multi-tasking capabilities, plus state-of-the-art filter cleaning. It gives more than 16 million gallons and 256 filters of quality water at up to 30 feet below sea level.

- Onboard water processor with resident frame filtering and purification
- A four-pass filter system for superior quality
- Highly reliable technology
- Up to 40 station interface filters
- 8 station interface filters
- Water tubing system, overhead or underground
- Full maintenance to water system of appliances and swimming pools
- Fashion designed outdoor pumps
- Compatibility with leading swimming pool filter systems
- Total Purifiers II for upgrading, easily installed

The System

The System is computer-driven. Specifically, the Total Purifier's Option 75 interface for a complete water purification system includes a compatible parallel interface filters, interface cable, and filter driver software conforming to Total Purifier's guidelines for FastFilter based water systems. Plus, the driver is compatible with such water systems as Dualist Water System, Dualist FreedomFoot.

Additions

Grasshopper Grass Grow and existing compatibility to pool filter system's SOME, among others. Option 23 also provides you with high-speed screen systems. You can check an entire water system from our computer in as little as five seconds, freeing you for further productivity and leisure time.

Speed and Quality

For the right balance of speed and quality, Total Purfier's Option 75 offer two choices of systems. For example, a first home with 3,000 square feet usually requires low-to-medium size systems for best output results, whereas home with pools and heavy use are at their greatest advantage with the Total Purifier's full Option 75.

To accommodate your computer requirements, the Water Purifier's driver-software diskettes include selected high-resolution fonts and HD disk or CD for all operating systems. The software searches your computer system, identifies which software is needed and then ask you a series of questions

For more information call, fax or write to:

Total Purifiers, Incorporation
5114 West Montgomery Road
Clear Park, Michigan 51533
Phone: (800) 242-8474
Fax: (602) 242-8475

International Offices
Total Purifiers, Incorporation
Unit 222, Milam Place
West Umbert, Germany GN30 0BR

In the United Kingdom and Europe
Total Purifiers, Incorporation
499 Caplin Avenue
Lyndell Park, Oxford OX 32 2CS

In the Mexico and South America
Total Purifiers, Incorporation
5 West Montgomery Road, 3rd Floor
Xanisa, Columbia CO 51533

STANDARD

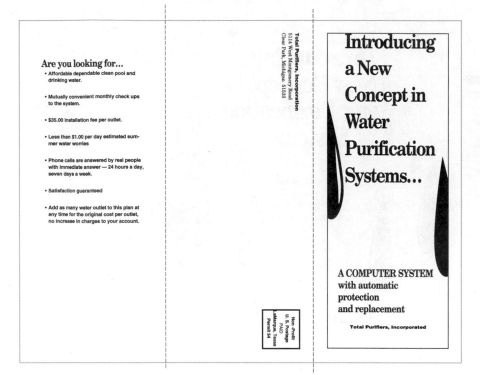

Are you looking for...

- Affordable dependable clean pool and drinking water.

- Mutually convenient monthly check ups to the system.

- $35.00 installation fee per outlet.

- Less than $1.00 per day estimated summer water worries

- Phone calls are answered by real people with immediate answer — 24 hours a day, seven days a week.

- Satisfaction guaranteed

- Add as many water outlet to this plan at any time for the original cost per outlet, no increase in charges to your account.

Total Purifiers, Incorporation
5114 West Montgomery Road
Clear Park, Michigan 51533

Non-Profit
U. S. Postage
PAID
Albuquerque, Texas
Permit 54

Introducing a New Concept in Water Purification Systems...

A COMPUTER SYSTEM
with automatic
protection
and replacement

Total Purifiers, Incorporated

Figure 10-54 Standard level brochure, 8 1/2″ x 11″, double fold

A complete

water purification solution

for a wide range of home and office applications. The Total Purifier's computer water system is a fast, high-quality water purification system with multi-user and multi-tasking capabilities, plus state-of-the-art filter cleaning. It gives more than 16 million gallons and 256 filters of quality water at up to 300 feet below sea level.

—Onboard water processor with resident frame filtering and purification

—A four-pass filter system for superior quality

—Highly reliable technology

—Handles up to 16.7 million gallons and 256 different filters

—Up to 40 station interface filters

—Water tubing system, overhead or underground

—Full maintenance to water systems of appliances and swimming pools

—Fashion designed outdoor pumps

—Compatibility with leading swimming pool filter systems

—Total Purifiers II compatible for upgrading, easily installed

■ THE SYSTEM IS COMPUTER-DRIVEN

Specifically, the Total Purifier's Option 75 interface for a complete water purification system includes a compatible parallel interface filters, interface cable, and filter driver software conforming to Total Purifier's guidelines for Fast-Filter based water systems. Plus, the driver is compatible with such water systems as Dualist Water System, Dualist FreedomFoot and Element Xpect.

■ COMPATABILITY

Grasshopper Grass Grow, BetterMak Color Additions, and existing compatibility to pool filter system's SOME, among others. Option 23 also provides you with high-speed screen systems. You can check an entire water system to our computer in as little as five seconds, freeing you for further productivity and leisure time.

■ SPEED AND QUALITY

For the right balance of speed and quality, Total Purifier's Option 75 offer two choices of systems. For example, a first home with 3,000 square feet usually requires low-to-medium size systems for best output results, whereas home with pools and heavy use are at their greatest advantage with the Total Purifier's full Option 75 system.

To accommodate your computer requirements, the Water Purifier's driver-software diskettes include selected high-resolution fonts and HD disk or CD for all operating systems. The software searches your computer system, identifies which software is needed and then ask you a series of questions that hook your computer to our home system for calibrating and maintenance. The result is quality water filtering, always available and maintenance always up-to-date.

■ LEADING TECHNOLOGY

To rapidly perform the task of create millions of evaluations, the Total Purifier's integral 2500-based image processing controller uses new technology. To speed action, a minimum of 32 MB of memory is required..

FOR MORE INFORMATION CALL, FAX OR WRITE TO:

Total Purifiers, Incorporation
5114 West Montgomery Road
Clear Park, Michigan 51533
Phone: (800) 242-8474
Fax: (602) 242-8475

International Offices
Total Purifiers, International
Unit 222, Milam Place
West University, Germany GN30 0BR

In the United Kingdom and Europe
Total Purifiers, International
499 Caplin Avenue
Lyndell Park, Oxford OX 32 2CS

In the Mexico and South America
Total Purifiers, Incorporation
51 West Montgomery Road, 3rd Floor
Xaniea, Columbia CO 51533

STANDARD

The Important Facts

- Affordable dependable clean pool and drinking water.
- Mutually convenient monthly check ups to the system.
- $35.00 installation fee per outlet.
- Less than $1.00 per day estimated summer water worries.
- Phone calls are answered by real people with immediate answer — 24 hours a day, seven days a week.
- Satisfaction guaranteed
- Add as many water outlet to this plan at any time for the original cost per outlet, no increase in charges to your account.

A computer water purification solution

for a wide range of home and office applications. The Total Purifier's computer water system is a fast, high-quality water purification system with multi-user and multi-tasking capabilities, plus state-of-the-art filter cleaning. It gives more than 16 million gallons and 256 filters of quality water at up to 300 feet below sea level.

Total Purifiers, International
5114 West Montgomery Road
Clear Park, Michigan 51533

Non-Profit
U.S. Postage
PAID
Lafburque, Texas
Permit 54

Introducing a New Concept in Water Purification Systems

Total Purifiers, Incorporation

A COMPUTER SYSTEM
with automatic protection and replacement

A Water Filter System that's computer-driven

- Onboard water processor with resident frame filtering and purification
- A four-pass filter system for superior quality
- Highly reliable technology
- Handles up to 16.7 million gallons and 256 different filters
- Up to 40 station interface filters
- Water tubing system, overhead or underground
- Full maintenance to water systems of appliances and swimming pools
- Fashion designed outdoor pumps
- Compatibility with leading swimming pool filter systems
- Total Purifiers II compatible for upgrading, easily installed. Specifically, the Total Purifier's Option 75 interface for a complete water purification system includes a compatible parallel interface filters, interface cable, and filter driver software conforming to Total Purifier's guidelines for FastFilter based water systems. Plus, the driver is compatible with such water systems as Dualist Water System, Dualist FreedomFoot and Element Xpect.

Computability

Grasshopper Grass Grow, BetterMak Color Additions, and existing compatibility to pool filter system's SOME, among others. Option 23 also provides you with high-speed screen systems. You can check an entire water system to our computer in as little as five seconds, freeing you for further productivity and leisure time.

Speed and Quality

For the right balance of speed and quality, Total Purifier's Option 75 offer two choices of systems. For example, a first home with 3,000 square feet usually requires low-to-medium size systems for best output results, whereas home with pools and heavy use are at their greatest advantage with the Total Purifier's full Option 75 system.

To accommodate your computer requirements, the Water Purifier's driver-software diskettes include selected high-resolution fonts and HD disk or CD for all operating systems. The software searches your computer system, identifies which software is needed and then ask you a series of questions that hook your computer to our home system for calibrating and maintenance. The

result is quality water filtering, always available and maintenance always up-to-date.

Leading Technology

To rapidly perform the task of create millions of evaluations, the Total Purifier's integral 2500-based image processing controller uses new technology. To speed action, a minimum of 32 MB of memory is required..

For more information call, fax or write to:

Total Purifiers, International
5114 West Montgomery Road
Clear Park, Michigan 51533
Phone: (800) 242-8474
Fax: (602) 242-8475

International Offices
Total Purifiers, International
Unit 222, Milam Place
West University, Germany GN30 0BR

In the United Kingdom and Europe
Total Purifiers, International
499 Uapin Avenue
Lyndell Park, Oxford OX 32 2CS

In the Mexico and South America
Total Purifiers, International
51 West Montgomery Road, 3rd Floor
Xaniea, Columbia CO 51533

Figure 10-55 Standard level brochure, 8 1/2″ x 14″, double fold

CUSTOM

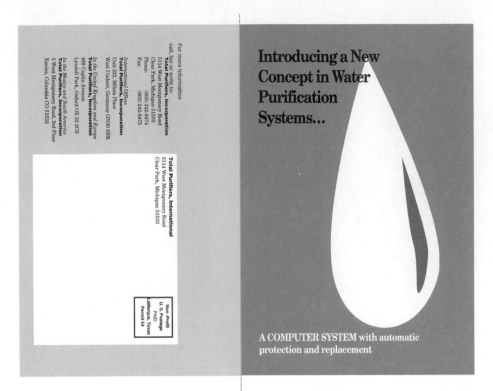

For more information
call, fax or write to:
Total Purifiers, Incorporated
5114 West Montgomery Road
Clear Park, Michigan 51533
Phone: (800) 242-3474
Fax: (602) 242-8475

International Offices
Total Purifiers, Incorporation
Unit 222, Milam Place
West Umbert, Germany GN30 0BR

In the United Kingdom and Europe
Total Purifiers, Incorporation
499 Caplin Avenue
Lyndell Park, Oxford OX 22 2CS

In the Mexico and South America
Total Purifiers, Incorporation
5 West Montgomery Road, 3rd Floor
Xaviea, Columbia CO 51533

Total Purifiers, International
5114 West Montgomery Road
Clear Park, Michigan 51533

Non-Profit
U. S. Postage
PAID
LaMarque, Texas
Permit 54

Introducing a New Concept in Water Purification Systems...

A COMPUTER SYSTEM with automatic protection and replacement

Figure 10-56 Custom level brochure, 8 ½″ x 11″, single fold

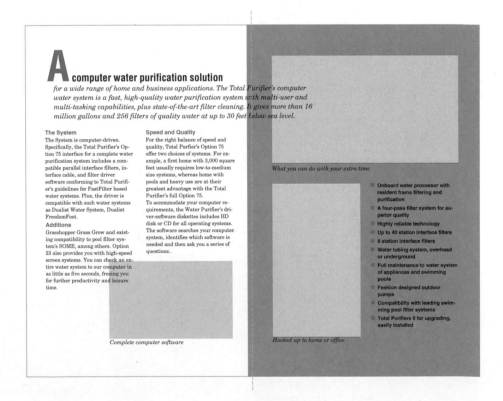

A computer water purification solution

for a wide range of home and business applications. The Total Purifier's computer water system is a fast, high-quality water purification system with multi-user and multi-tasking capabilities, plus state-of-the-art filter cleaning. It gives more than 16 million gallons and 256 filters of quality water at up to 30 feet below sea level.

The System
The System is computer-driven. Specifically, the Total Purifier's Option 75 interface for a complete water purification system includes a compatible parallel interface filters, interface cable, and filter driver software conforming to Total Purifier's guidelines for FastFilter based water systems. Plus, the driver is compatible with such water systems as Dualist Water System, Dualist FreedomFoot.

Additions
Grasshopper Grass Grow and existing compatibility to pool filter system's SOME, among others. Option 23 also provides you with high-speed screen systems. You can check an entire water system to our computer in as little as five seconds, freeing you for further productivity and leisure time.

Speed and Quality
For the right balance of speed and quality, Total Purfier's Option 75 offer two choices of systems. For example, a first home with 3,000 square feet usually requires low-to-medium size systems, whereas home with pools and heavy use are at their greatest advantage with the Total Purifier's full Option 75.

To accommodate your computer requirements, the Water Purifier's driver-software diskettes includes HD disk or CD for all operating systems. The software searches your computer system, identifies which software is needed and then ask you a series of questions..

What you can do with your extra time

Complete computer software

Hooked up to home or office

- Onboard water processor with resident frame filtering and purification
- A four-pass filter system for superior quality
- Highly reliable technology
- Up to 40 station interface filters
- 8 station interface filters
- Water tubing system, overhead or underground
- Full maintenance to water system of appliances and swimming pools
- Fashion designed outdoor pumps
- Compatibility with leading swimming pool filter systems
- Total Purifiers II for upgrading, easily installed

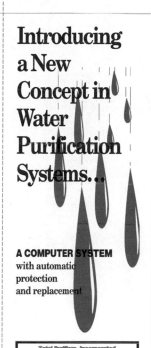

Are you looking for?...

■ Affordable dependable clean pool and drinking water.

■ Mutually convenient monthly check ups to the system.

■ $35.00 installation fee per outlet.

■ Less than $1.00 per day estimated summer water worries

■ Phone calls are answered by real people with immediate answer — 24 hours a day, seven days a week.

■ Satisfaction guaranteed

■ Add as many water outlet to this plan at any time for the original cost per outlet, no increase in charges to your account.

FOR MORE INFORMATION CALL, FAX OR WRITE TO:

Total Purifiers, Incorporation
5114 West Montgomery Road
Clear Park, Michigan 51533
Phone: (800) 242-8474
Fax: (602) 242-8475

International Offices
Total Purifiers, International
Unit 222, Milam Place
West University, Germany GN30 0BR

In the United Kingdom and Europe
Total Purifiers, International
499 Caplin Avenue
Lyndell Park, Oxford OX 32 2CS

In the Mexico and South America
Total Purifiers, Incorporation
51 West Montgomery Road, 3rd Floor
Xaniea, Columbia CO 51533

Introducing a New Concept in Water Purification Systems...

A COMPUTER SYSTEM with automatic protection and replacement

Total Purifiers, Incorporated

Figure 10-57 Custom level brochure, 8 ½" x 11", double fold

A computer water purification solution

for a wide range of home and office applications. The Total Purifier's computer water system is a fast, high-quality water purification system multi-user and multi-tasking capabilities, including new state-of-the-art filter recycled cleaning. It gives more than 16 million gallons and 256 filters of quality water at up to 300 feet below sea level.

THE SYSTEM IS COMPUTER-DRIVEN

Specifically, the *Total Purifier's Option 75* interface for a complete water purification system includes a compatible parallel interface filters, interface cable, and filter driver software conforming to Total Purifier's guidelines for FastFilter based water systems. Plus, the driver is compatible with such water systems as Dualist Water System, Dualist FreedomFoot and Element Xpect.

COMPATABILITY

Grasshopper Grass Grow, BetterMak Color Additions, and existing compatibility to pool filter system's SOME, among others *Option 23* also provides you with high-speed screen systems. You can check an entire water system to our computer in as little as five seconds, freeing you for further productivity and leisure time

SPEED AND QUALITY

For the right balance of speed and quality, Total Purifier's Option 75 offer two choices of systems. For example, a first home with 3,000 square feet usually requires low to medium size systems for best output results, whereas home with pools and heavy use are at their greatest advantage with the *Total Purifier's full Option 75 system.*

To accommodate your computer requirements, the Water Purifier's driver-software diskettes include selected high-resolution fonts and HD disk or CD for all operating systems. The software searches your computer system, identifies which software is needed and then ask you a series of questions that hook your computer to our home system for calibrating and maintenance. The result is quality water filtering, always available and maintenance always up-to-date.

LEADING TECHNOLOGY

To rapidly perform the task of create millions of evaluations, the *Total Purifier's integral 2500-based image processing* controller uses new technology. To speed action, a minimum of 32 MB of memory is required.

TEN REASONS TO ADD A TOTAL PURIFICATION SYSTEM TO YOUR HOME OR OFFICE

1. Onboard water processor with resident rame filtering and purification.
2. A four-pass filter system for superior quality and assurance.
3. Highly reliable technology.
4. Handles up to 16.7 million gallons and 256 different filters.
5. Up to 40 station interface filters.
6. Water tubing system, overhead or underground.
7. Full maintenance to water systems of appliances and swimming pools.
8. Fashion designed outdoor pumps.
9. Compatibility with leading swimming pool filter systems.
10. Total Purifiers II compatible for upgrading, easily installed.

Total Purifiers, Incorporated

CUSTOM

A **computer water purification solution**

for a wide range of home and office applications. The Total Purifier's computer water system is a fast, high-quality water purification system with multi-user and multi-tasking capabilities, plus state-of-the-art filter cleaning. It gives more than 16 million gallons and 256 filters of quality water at up to 30 feet below sea level.

THE SYSTEM IS COMPUTER-DRIVEN

Specifically, the Total Purifier's Option 75 interface for a complete water purification system includes a compatible parallel interface filters, interface cable, and filter driver software conforming to Total Purifier's guidelines for FastFilter based water systems. Plus, the driver is compatible with such water systems as Dualist Water System, Dualist FreedomFoot and Element Xpect.

COMPATIBILITY

Grasshopper Grass Grow, BetterMak Color Additions, and existing compatibility to pool filter system's SOME, among others. Option 23 also provides you with high-speed screen systems. You can check an entire water system to our computer in as little as five seconds, freeing you for further productivity and leisure time.

SPEED AND QUALITY

For the right balance of speed and quality, Total Purfier's Option 75 offer two choices of systems. For example, a first home with 3,000

square feet usually requires low-to-medium size systems for best output results, whereas home with pools and heavy use are at their greatest advantage with the Total Purifier's full Option 75 system.

To accommodate your computer requirements, the Water Purifier's driver-software diskettes include selected high-resolution fonts and HD disk or CD for all operating systems. The software searches your computer system, identifies which software is needed and then ask you a series of questions that hook your computer to our home system for calibrating and maintenance. The result is quality water filtering, always available and maintenance always up-to-date.

LEADING TECHNOLOGY

To rapidly perform the task of create millions of evaluations, the Total Purifier's integral 2500-based image processing controller uses new technology. To speed action, a minimum of 32 MB of memory is required.

F **AX, CALL OR WRITE FOR MORE INFORMATION:**

Total Purifiers, Incorporation	International Offices	In the United Kingdom and Europe	In the Mexico and South America
5114 West Montgomery Road	**Total Purifiers, International**	**Total Purifiers, International**	**Total Purifiers, Incorporation**
Clear Park, Michigan 51533	Unit 222, Milam Place	499 Caplin Avenue	51 West Montgomery Road, 3rd Floor
Phone: (800) 242-8474	West University, Germany	Lyndell Park, Oxford OX 32 2CS	Xanies, Columbia CO 51533
Fax: (702) 242-8475	GN30 0BR		

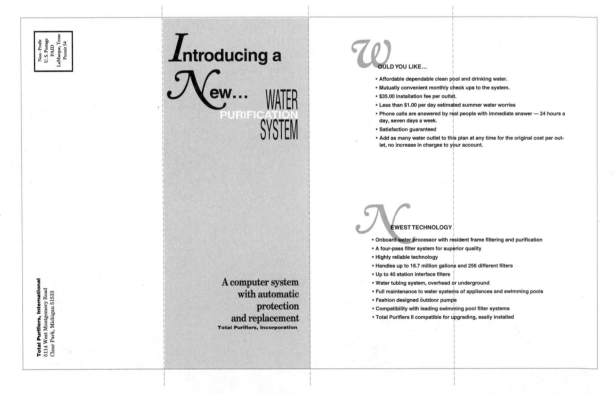

Figure 10-58 Custom level brochure, 8 1/2″ x 14″, double fold

Figure 10-59 Premium level brochure, 7 1/2″ x 9″, single fold.
Credit: Western National Life Insurance Co., Randi Stephens and Jennifer Junemann, designers/production

ASPEN ...

even the word is legendary, for since the 1800s this silver mining town has enjoyed rich culture, entertainment and drama. Today, colorful Victorian buildings are home to exclusive shops and galleries. The village is filled with parks, flowers, fountains and music.

Inspired by the rich history of Aspen, The Ritz-Carlton Hotel embodies the relaxed, open spirit of the frontier. It is casual and truly comfortable.

Open the windows of your room for a breath of fresh air and views of the Rocky Mountains, almost close enough to touch. Enjoy superb dining under blue skies beside cascading waterfalls in the flower-filled Fountain Courtyard or take in the fabulous mountain view from the Lobby Lounge, one of Aspen's most inviting gathering places. Soar to the summit of Aspen Mountain in a gondola. The serenity of the Rockies envelopes you. Hike through the aspens, take in a round of golf or a game of tennis, then relax in or by the pool, a most inviting way to end the day.

As a Western National top producer, such a prized vacation can be yours.

PREMIUM

PREMIUM

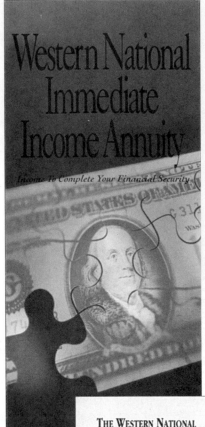

Western National Immediate Income Annuity

Income To Complete Your Financial Security

A Single-Pr

Figure 10-60 Premium level brochure, 9″ x 11″, double fold.
Credit: Western National Life Insurance Co., Randi Stephens and Jennifer Junemann, designers/production

THE WESTERN NATIONAL IMMEDIATE INCOME ANNUITY

The *Immediate Income Annuity* is a contract issued by Western National Life Insurance Company. The annuity is purchased with a single premium payment, which guarantees to provide regular income payments to you or another person. You select the frequency and duration of these income payments from a variety of income plans. Income is usually received monthly; however, quarterly, semi-annual and annual payment plans are also available.

The amount of each income payment is based on both the amount of your original single premium payment and the benefit rate in effect for the income plan you select when the annuity is purchased.

BENEFITS OF AN IMMEDIATE INCOME ANNUITY

CONVENIENCE: The *Immediate Income Annuity* provides guaranteed systematic payments that can be automatically deposited to your checking or savings account. Your income tax liability is evenly spread over many years. This helps keep your tax bill as low as possible.

SELECTION: You may choose from a variety of income payment plans, such as: guaranteed income for the rest of your life or for the lives of yourself and another; income for life with a guarantee to also pay for a minimum number of years; income for a guaranteed payment period you select; or lifetime income payments guaranteed to continue to your beneficiary should you pass away before receiving a full refund of your premium payment.

TAX ADVANTAGES: Only a portion of your annuity payment is taxable, since part of it is considered for tax purposes as a return of your original premium payment. The non-taxable part of your income payment continues for the payment period until it adds up to your original purchase premium.* After that, all future payments are fully taxable.

SECURITY: The *Immediate Income Annuity* is issued and guaranteed by Western National Life Insurance Company. Founded in 1944, Western National is financially strong with more than $8 billion in assets. It is one of the 50 largest life insurance companies in the United States and a leading provider of income annuities.

** With tax-qualified plans (e.g., IRAs), 100% of the income payment is taxable, since all the money paid out (principal and interest earnings) is from pre-tax dollars.*

WESTERN NATIONAL MEANS DEPENDABLE INCOME

If you need a way to guarantee income payments to yourself or another person, Western National's *Immediate Income Annuity* provides a steady stream of income payments on which you can depend.

If you are retired or preparing for retirement and want to turn a lump sum into a dependable income source, an *Immediate Income Annuity* is an excellent way to secure income that you cannot outlive.

For those who have reached age 70-1/2 and own IRAs, or who will be receiving lump-sum distributions from other tax-qualified retirement plans, an *Immediate Income Annuity* is an excellent way to distribute taxable income, spreading your tax liability over the maximum number of years.

MANY WAYS TO GUARANTEE INCOME

• **LIFETIME ONLY ANNUITY.**
A monthly payment for as long as you live.

| Guaranteed income for as long as the annuitant lives | → | Death occurs/ Income ends |

• **JOINT AND SURVIVOR.**
Payments are guaranteed by Western National Life based upon two lives, usually that of a husband and wife. Full income payments continue until the first death with full or partial payments continuing until the survivor's death.

| Guaranteed income for as long as both annuitants live | → | Death occurs | → | Income continues at full or partial level | → | Death occurs/ Income ends |

• **LIFETIME ANNUITY WITH GUARANTEED PERIOD.**
Payments are guaranteed by Western National Life for the life of the annuitant until the date of death. If the guaranteed period has not expired at the time of death, payments will continue to the beneficiary for the remainder of the guaranteed period.

| Guaranteed income for as long as the annuitant lives | → | Death occurs | → | Income continues until the end of the guarantee period |

• **INSTALLMENT REFUND LIFE ANNUITY.**
Payments are made as long as the annuitant lives. If the annuitant dies prior to receiving at least the initial premium, any remaining payments will be payable to the beneficiary.

| Guaranteed income for as long as the annuitant lives | → | Death occurs | → | Income continues to the beneficiary until the entire premium has been refunded |

• **FIXED PERIOD.**
Payments are made for a fixed period of three or more years. The total of all premium and interest will be distributed during the period of time elected.

| Guaranteed income for the fixed period you select (3 or more years) | → | Death occurs | → | Income continues to the beneficiary until the end of the original fixed period |

• **FIXED AMOUNT.**
Payments are made for a minimum of three years and a maximum of 20 years in an amount elected, until the amount applied together with interest is exhausted.

| Guaranteed income in the fixed amount you select (3-20 years) | → | Death occurs | → | Income continues to the beneficiary until the premium with interest is exhausted |

PREMIUM

Figure 10-61 Premium level brochure, 8″ × 15″, parallel fold.
Credit: Western National Life Insurance Co., Randi Stephens and Jennifer Junemann, designers/production

Other advertising projects

Several other publications are grouped in this section either because the designs are similar to each other or the publication has similar specifications to another publication that was presented in great detail.

Menus

Menu specifications are similar to programs (figure 10-62). They usually have tight copyfitting, leader dot body text, and a powerful cover. To prolong the life of a menu, it can be laminated or placed into a purchased plastic holder. If the menu is changed weekly or daily, the cover can be designed to be permanent and the menu itself can be held temporarily with slits or an elastic band. Use 11″ x 17″ or 17″ x 22″ with single or double fold, high quality heavy cover stock, 20# bond, laminated.

Table tents and place cards

Table tents have specifications similar to an ad or stuffer and paper and finishing techniques similar to pocket folders (figure 10-63). They will stand up better if the paper grain runs short (sideways). The fold-under section should be at least 2″ and slit to fit together. For smaller projects such as place cards, use 67# bristol run through the laser and hand slit. Paper sizes will vary; for a proportional shape, cut it out of an 8½″ x 14″ or 11″ x 17″ sheet. The paper should be a minimum of 1-ply index.

Figure 10-62 Menu. Credit: M H & T Advertising Agency

T-shirts

Screen printing has gone electronic and the images that can be produced in photo imaging software will not require trapping or line width problems (figure 10-64). The minimum line width that is readable is 2 points. Bigger traps are needed for silk screening than for offset printing. Work closely with the silk screen company for line widths and register specifics since they are different than offset printing requirements.

Specialty items

Specialty items are unique in purpose and printing surface. The samples from left to right are a door knocker on 12-point cast coat, a carton label on a foil coated stock, back stage passes on fabric and pressure sensitive paper, an acetate label with heat resistant adhesive backing, and a jar label of an enamel stock on pressure-sensitive with removable adhesive backing sheet (figures 10-65a through 10-65e).

Figure 10-63 Table tent. *Credit: HL&P Corporate Graphics, Regina List-Grace, designer*

Figure 10-65 Specialty items (below and continued on next page). *Credit: AirView Graphics and Printing, Cheryl Evans, artist*

Figure 10-64 T-shirt. *Courtesy of Delmar Publishers*

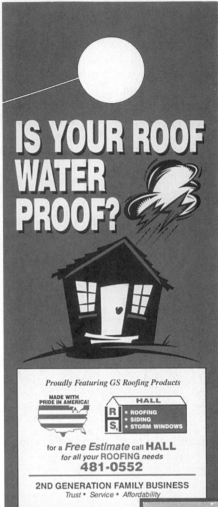

Figure 10-65
Specialty items
(continued).
*Credit: AirView
Graphics and Printing,
Cheryl Evans, artist*

For additional research

Keep a well-balanced design approach by continuing research into some suggested sources:

Read national magazine ads.

Review advertisements from different eras.

Check demonstration samples from the quality paper houses.

Contact the American Advertising Federation
Educational Service
1406 K Street NW, #1000
Washington, DC 20005

Historical information

Stiebner, Erhardt D., *Signs and Emblems,* New York: Von Nostrand-Reinhold Co., 1982.

Swann, Alan, *Graphic Design School,* New York: Von Nostrand-Reinhold, 1992.

Wilde, Judith, *Visual Literacy,* New York: Watson-Guptil Publications, 1991.

Withers, Larry, *How to Fold,* Volume 2, New York: Art Direction Book Company, 1993.

Trends

Landa, Robin, *Graphic Design Solutions,* New York: Delmar Publishers, 1995.

"It looks good, but we still need two more articles included this month."

Chapter

News and Product Publications

The news and product publication group
Nameplates
Newsletters
Catalogs
Other news and product projects
For additional research

After reading this chapter and applying its principles, the designer should have success producing:

- Nameplates
- Newspapers
- Journals
- Directories
- Newsletters
- Magazines
- Catalogs

News publications began in the United States when the country began. They were not mass produced, but nailed to the door or posted in a public place as "broadsides." They helped to create our history. As towns and settlements grew, news publications became the newspapers we know today. This market has expanded and now includes a variety of printed publications and web page designs that form the fastest growing segment, news and product publications.

The news and product publication group

The news and product publication group is designed to include publications that have combined characteristics of both advertising publications and text documents. They are not flat sheets or paneled designs like advertising packages. Instead, they are page formats like text publications but with the glamor and complexity of advertising publications. They are not just one subject or one product but design blocks of articles or advertisements that fit together like a jigsaw puzzle.

News text contrasted with text documents

Since the volume of text in text documents is similar to the volume of text in news and product publications, it may be best to explain news text in contrast to the text of text documents.

Shorter line lengths

Three columns of type or two columns of type on a five column grid are the most popular page designs for these publications because the reader can quickly skim the information. This shorter line length (9–14 picas) does not always allow seven words per line without using the smaller typefaces and smaller type sizes.

Small body text

The news and product publications with minimum line lengths require small typefaces and smaller sizes (8, 9, and 10 points). In contrast to text, documents with maximum line lengths require large faces and type sizes (10 or 11 points). News and advertising publications frequently use half-sizes of type to balance the type/face/line length combinations.

Copy linking

The goal of long publications is to have all text linked and flowing to all pages and proper links to illustrations and photos. News and product publications may have ten articles or products on the page that are linked to each other. If an article appears on more than one page, each section should be linked.

Gutters

The minimum gutter for news publications is 18 points (1.5 picas), which is the same for text documents.

No above paragraph leadings

Before paragraph leading is seldom used in articles for news and product publications. Usually, the goal is to fit many different blocks of copy onto one page, tightly and orderly. Above paragraph leading defeats this purpose. The only exception is one column type with no paragraph indent. Whenever possible, any snap-to leading control should be turned on.

Less text wrap

Short line lengths make it impossible to text wrap without leaving lines of only two or three words. Move pull quotes further into the outside margin or side bar area. Instead of text wrapping, break the text and widen the art or photo. Also, pull quotes, art, and photos can be centered between two columns, creating a narrower run around on each column of text.

Different names for page elements

There are several page elements whose functions and specifications are the same as they would be for long documents but they are called by different names. As desktop publishing continues to merge these industries, one name for each element will probably emerge.

News publication element name	Long document element name
Nameplate (flag)	Signature
Logo	Logo
Legend	Caption
Headline 1, 2, 3, 4,	Subheads
Folio line	Running heads/footer
Jumpline	Continued to/from
Cutline	Credit included with legend
Kicker (eyebrow)	Kicker

Page elements

The page elements of news and product publications are developed for newspaper terms and include the following parts and elements (figure 11-1):

Body

The body copy uses type sizes smaller than most body text. There are three common indents: 1 pica first indent, flush left; 1 pica first indent, justified; and no indent and one-half of text leading as above leading. First paragraphs sometimes begin with a drop cap, especially for boxed articles. It can be justified if the amount of white space between words is not greater than the amount of white space between lines. Most are set on automatic hyphenation.

Boxed headline

Headlines are centered and sometimes include a second level headline within the text, as with a brief. A few of these headlines are all caps. They are usually the smallest size headline in the newsletter. The second level may be the same size as the body text, centered or flush left with or without a hairline.

Boxed text

Consider boxing or tinting a text block for editorials, index, staff, article promotions, news flashes, facts, IDs, weather, scoreboards, want ads, briefs, sidebars

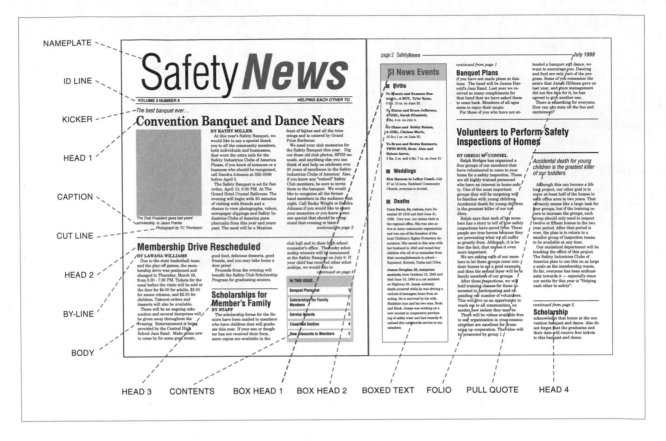

Figure 11-1 Essential page elements for news publications

(scholar's margins), graphs, and charts. All type has a 1 pica indent both left and right. The typeface can be the same as the text or a body weight of the headline face, but the size may be different. Some boxes are 1-point boxes, tinted boxes, or boxes with tints and lines. To help separate this text, include a pi character from the Zapf Dingbats typeface at the beginning of each subject or a drop caps for editorials.

By-line

Although italics is the most popular choice, if there are several other specifications in italics, choose one of the other possibilities. Use of all caps or bold is the second most common weight.

Caption

The caption line, which appears below a photo will not be linked to any other elements on the page. Draw a small rectangular box about one-half pica tall and use the box to space the caption from the bottom of all photos consistently. Set up alignment flush left (FL) or centered. Italics is a popular choice of type weight, but if italics is already used for the by-line or jumpline, typing the caption in the headline face, condensed or regular, is appropriate.

Cutline

The cutline is the credit line for the photographer or the organization supplying the photograph and is set below the caption, aligned flush right (FR).

Folio line

Inside pages require a folio line for identification, similar to a running head. The folio line is usually a header and includes the newsletter logo, date, folio, and, sometimes, the name of the organization or location of the company. Sometimes, the folio will appear as a footer.

Headlines

An article title is called a headline rather than a subhead. It is edited to fit the width of all the columns that the article covers. For publications with only four or five levels of headlines, use the narrowest width face or condensed style, upper and lower case. The size of the headline indicates the importance given the article. Headline 1 is reserved for the lead article and may be set in several different sizes for different issues, depending on its importance. For instance, 72-point type on 8½″x 11″ sheet would only be used for a national crisis. Headline 2 or 3 may be set in italics to give it some contrast. Headlines for boxed sections have their own set of specifications and are centered.

Jump headline

Jump headlines are one or two words from the name of the article that appears to the left side of a "continued from." All jump headlines will be the same size as the smallest and medium weight headline in the news publication (with the exception of subheads within boxed areas).

Jumpline

There are two kinds of jumplines: those appearing either at the end of the first part of the article or at the beginning of the second part of the article. The first jumpline uses the words "continued on page..." or "see page..." and is located on the right. Some newsletters put a hairline above the jumpline to help locate the instructions. Jumplines are always included as part of copy that is aligned across the live area of the page. If italics or bold are used for other page elements, use upper and lower case bold in the type size of the text. The second page jumpline is set flush left and says "continued from page...". It appears with the jump headline. The same style can be used for both of these by setting the paragraph alignment flush left and including a right tab for the first page jumpline.

Kicker/subhead

Kickers or subheads are useful when type must carry the page. They are extremely helpful on standard level pages that lack the contrast that can be accomplished by using photos and tints (because of the printing process). They are similar in purpose and specifications. The kicker goes above the headline and the subhead goes below the headline. Both are usually two standard sizes smaller than the headline. The kicker is usually italics and the subhead is usually medium.

Pull quote

Pull quotes serve two purposes: to add contrast to the page with type only (no photos) and to draw the reader into the copy. Pull quotes and photos give flexibility for copyfitting.

Divided by page design

Within the category of news and product publications are some divisions that reflect additional similarities.

Newsletter and newspaper

Newsletters and newspapers include a mix of text document specifications with pages in blocks as well as grids. Body text, photos, and ads fill the blocks of the grid. Different grid patterns may be used on different pages or sections of the publication. Body text may be in half or whole sizes.

Catalog and directory

These use multicolumn advertising specifications but not rigid panels of copy since the copy is scattered over the page. They also follow a less rigid page de-

sign and include more photos, art, and/or listings. The type is set in short blocks with very short line lengths and in the smallest sizes, the smallest faces, and leadings of half and whole sizes.

Magazine and journals

Magazines and journals are quarterly and monthly publications by professional and nonprofit organizations. They are similar in content to newsletters but have a design format that is easier to lay out. The beginning page of each article is set similar to a short document. Other pages are given the block look of newsletters. These are excellent for informative articles.

Design

Designing news and product publications requires a solid base design that is fine-tuned with each issue. Gradually add techniques that improve on the design and the production time. Results include templates containing style sheets palettes, copyfitting formulas that estimate the space required early in the production, and elimination of problems for output and printing.

As mentioned in Chapter 7, if the designer is stepping into someone else's design or a file that is poorly executed, it is easier to set up a new file. Since turning off a weak design and revising it to fit standards is a major production, try revising one part on each issue, such as the nameplate, the headlines, and body text, and then the page set-up.

If a printed publication has several design blocks on each page, each design block has its own set of type specifications, grids, and eye patterns. Visualize these pages as composed of multiple publications grouped together. Follow the reader through the articles to locate continued sections in a consistent manner.

When leaving a news publication for someone else to produce, include a file that contains a sample page of all specifications and written type style specifications—the next designer or desktop publishing specialist will never be able to sort out a news publication without it.

Word processing instructions

Word processing files for news publications include separate files for each section of the article. It requires simple instructions for those who type the articles.

1. Use separate word processing files for each article, and include the by-line.
2. Use one space bar and one return on all copy.
3. Do not use the tab key to indent the paragraphs.
4. The name of the file should match the name of the article.
5. Get a character or word count for copyfitting and type it at the end of the article.
6. Make copy corrections at this point with spelling checker, proofreading, and author corrections. (Some editing may be done during the design production to copyfit or to remove widows.)
7. Use the size and face of the publication and/or tagging to save time in the page layout software.

 ✘ Cross reference: See Chapter 8 "Typing a text document" for information on tagging.

Templates

Templates provide an outline for design. Templates for news and product publications use several master pages. There are three basic master pages:

1. The nameplate page (the first right hand page). The first page with table of contents, nameplate, and lead articles.
2. The left and right inside pages. Used for all inside pages.
3. The mailer page (a left hand page). The back side of the newsletter, sometimes containing a blank space to place a mailing label.

Copyfitting

Copyfitting is an important step to becoming a professional designer of news and product publications. The page design requires copyfitting since articles, product information, ads, and photos are all set up in separate blocks on the page. Copyfitting is explained in detail specifically for each news and product publication.

There are two difficult steps to producing news publications: learning to copyfit and not learning to copyfit. Not learning to copyfit means that each issue requires hours of revision usually at the monitor and the confusion is multiplied by the amount of times the copy is adjusted. If pieces of an article need moving, the task is like working a jigsaw puzzle in a spider web! Learning how to copyfit is difficult because it requires math skills (designers usually do not consider being a mathematician as their second career choice) and it must be revised with any change to typeface, line length, or leading. Once it is done, the design can be sketched on dummy pages and the copy can be slightly edited if the fit is a little off or a photo size can be changed to fit.

Nameplates

The purpose of a nameplate is to create an identity that is easily recognized. The nameplate or flag is the design block with the logo of the news publication plus other elements that appear in that area such as the ID line, a quote, the company logo, or tag line. An ID line contains information about issue date and volume number. A tag line contains the publisher or company name.

> ✗ Cross reference: Additional logos are shown in figures 8-3 through 8-5.

Design

Except for the nameplate logo, the other elements of the nameplate use the typeface of the text or headlines. The design of the nameplate must complement the typeface of the text and the style of the news publication. Production steps include:

1. Sketch samples of the nameplate with all the elements. Develop many sketches. Make two sets of sketches. The first set has ideas for size, typeface, and layout; take the best idea and continue a second set of sketches with an optional design built from the idea. Use the grid of the news publication to interact with the design.

2. Narrow the sketches to one and sketch from that.

3. Measure the type of the sketch. Be sure to include an imaginary descending letter (y or g) and measure from the top of the tallest letter to the bottom of the hand drawn "y." Carefully study the width of the type, determining if the typeface will lose its shape with the width change. Consider a multimaster typeface for extreme distortion.

4. Type the copy according to the specifications. If it will not fit on one line, do not make it smaller until it is compared to the rough. Tighter tracking, width changes, and expert kerning are better choices than going to smaller type sizes. Consider using drawing or photo software.

5. Add letterspacing and kerning to polish the look. Try a decorative typeface. When using decorative, script, or Old English typefaces, watch for legibility. If a second typeface is needed for the second line of type, use a straightforward serif or sans serif. Avoid type specifications that cause the nameplate to appear as one of the headlines. When using the same typeface for the logo and nameplate as the headlines, consider all caps and small caps at 85% or greater of the type size.

The space allowed for a nameplate is a maximum of 2½″ from the top of the page. The nameplate logo and an ID line usually fill this space. Most nameplates cover the width of the sheet size and some are only the width of several columns of the page grid. For copyfitting, the nameplate requires tall but large type. Try narrowing the width like the headline of a flyer (it should be readable from two feet away). For non-corporate or internal publications with a friendly lighter look, decrease the width type to 40%.

The nameplate logo is used full size on the cover as part of the nameplate (flag), on the inside pages as part of the folio line, and again with the return address on the mailer.

Nameplate samples

Range for type specifications

Element	Type Sizes	Comments
Nameplate logo	72-300 pt	Kerning, width changes, and type design
ID line	8-12 pt	Volume number, date, and cost in a clear serif or sans serif face
Quote	8-12 pt	
Company logo	1½″	Proportional to nameplate
Tag line	8-12 pt	Company or publisher's name

Standard level nameplates

Small quantities and urgent deadlines are well met with standard level nameplates. Picture fonts, automatic letter kerning, and grids to match the letter format build unique characteristics into standard level nameplates. Try the specifications from figures 11-2

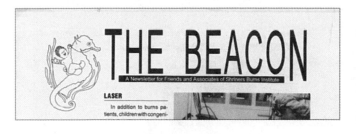

Figure 11-2 Standard level nameplate.
Credit: Alice Russell, Shriners Burns Institute

Figure 11-3 Standard level nameplate.
Credit: Suzanne Melear, graphic designer for Heavenly Visions
Ministries, International

Figure 11-4 Standard level nameplate. Reprinted courtesy
of: University of Texas Medical Branch at Galveston

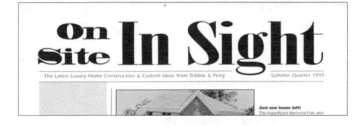

Figure 11-5 Custom level nameplate.
Credit: Kathryn Vosburg-Seretti, designer

Figure 11-6 Custom level nameplate.
Credit: John Helms, LeeAnne Seidensticker, and R.G.
McConnell, designers

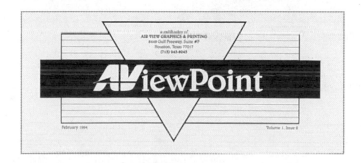

Figure 11-7 Custom level nameplate.
Credit: AirView Graphics and Printing

STANDARD

CUSTOM

PREMIUM

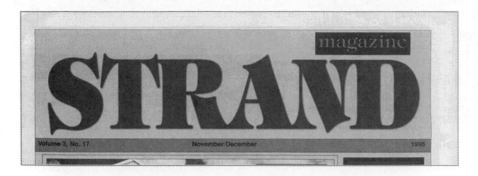

Figure 11-8 Premium level nameplate.
Credit: Manlove Advertising, Pasadena, TX, design and production

Figure 11-9 Premium level nameplate.
Reprinted courtesy of: University of Texas Medical Branch at Galveston

Figure 11-10 Premium level nameplate.
Credit: Manlove Advertising, Pasadena, TX, design and production

through 11-4 for style palette information or change fonts and modify slightly:

Element	Type Specifications
Logo	2″ tall
ID line	7-pt Helvetica, all caps

Custom level nameplates

Individual typeface kerning, letterspacing, and leadings add fine techniques to wordmarks and initialmarks as well as custom line art and additonal ink colors (figures 11-5 through 11-7).

Element	Type Specifications
Nameplate logo	2″ tall
ID line	7-pt Helvetica, all caps
Company Logo	1½″ tall

Premium level nameplates

Premium level designs focus on logos with custom-made type and art. Several different designs brought to the final stage are presented to the client.

Figure 11-8 is an example of an event nameplate. Colors: PANTONE 3288, a green, PANTONE 192, a red, and black.

Figure 11-9 is an example of a corporate nameplate. Colors: PANTONE 159, an orange, and black.

Figure 11-10 is an example of a corporate nameplate. Colors: spot colors converted to process colors.

Newsletters

Newsletters are the fastest growing publication market. They are used for special interest groups, timely material, and general information and serve as a sales or public relations tool for some professionals. If they include ads, the ad may be company-specific or from outside vendor. The more specific the market, the greater the possibility of producing a newsletter that is well read.

Research

News and product publications are designed for two markets: business-to-consumer and business-to-employees. Newsletters can be directed to a general group of consumers. If a newsletter relies on ads to make a profit, they should get the prime location on the page.

Company newsletters also can be directed to a specific group of consumers or employees. An employee newsletter might feature photos of employees in rewarding or satisfying situations and the total design is personal and warm. A consumer newsletter will have less photos but more informative charts and graphs.

Newsletters that inform clients and employees of current events and products are usually produced weekly or monthly. The format should immediately identify the publication as a newsletter of a particular company; therefore it should remain constant for at least a year.

- Determine the market characteristics such as age group and special needs.
- Choose a design level for the newsletter. Match the subject and budget.
- Pick a style. Some choices are modern, traditional, short topics, long topics, personal, technical, or photographic.

Design

Choosing the right typeface for the body text of news publications is essential. We are all familiar with reading 10-point type on a 12-point leading because this was the most popular size of body text of news publications before the advent of laser printers

and computer typefaces. Laser printers cause 10-point type to look thicker and bigger. Some 10-point type has a crowded leading even when it is output to imagesetter resolutions because many computer typefaces have descenders (below the baseline) and ascenders (above the baseline) that fill the space between lines. Times Roman was a face that was created for newspapers and is still dependable. Helvetica condensed is popular for boxed articles, or try a new typeface designed for computers. The type needs to be placed in the chosen column in 9, 9½, and 10 points. Let the eye determine if this face works for the newsletter.

Margins

If the page format is 8½″ x 11″, which most are, it will affect the line lengths (shorter) and the choices of first paragraph indents. Rather than crowding the margins, leave at least ½″ on the outside, inside, and bottom. The top margin is kept at a minimum (¼″ for folded sheets and ½″ flat sheets for gripper margin). The articles begin 2 picas below the ID line.

Columns and grids

Each of these grids creates an acceptable design for a newsletter (figure 11-11). The choice depends on the skill level of the desktop specialist, the amount of time available, and the complexity of the style palette. Rather than draw a text block to override the column guides, use guidelines to mark the permanent columns and set up column guides that will allow the article to flow between the columns or outside margins. Develop a vertical grid system that matches the leading of the text and ask the computer to use "snap to guides." (Samples in the chapter will show copy in as many different grid patterns as possible and include the grid information in the type description.)

Adding contrast

A newsletter with no photos or very few photos must have contrast. Some techniques can be identified in the samples and include the following:

Figure 11-11 (Opposite) Newsletter grids

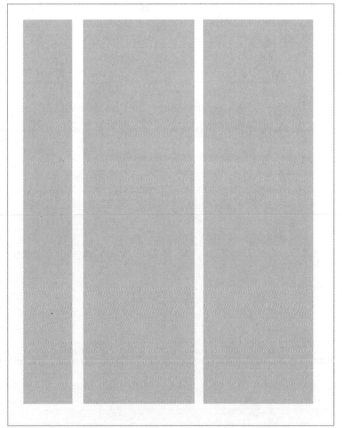

- A drop cap for the lead paragraph
- A kicker line above the headline and/or a sub-head below the headline
- A dingbat to end the article
- Rules, boxes, or tints

Do's and don'ts

DO have a straight margin across the bottom of the page that emphasizes the boxed look.

DO place the beginning of as many articles as possible on the front page of the publication.

DO edit and spread the headlines across all multiple column articles.

DO use one set of specifications for all articles, unless they are in a separate box.

DO include by-lines with every article (use "staff" if everyone contributed).

DO place ads along the outside edges of the right hand pages.

DO NOT hyphenate anything but text.

DO NOT allow the headlines of two articles to read next to each other unless one is boxed.

DO NOT use photos without captions (but photos may be used without a corresponding article).

DO NOT use large and small caps unless it is an ad.

Production hints

Maintain a written style sheet or the choices will become unruly and begin to look the same or not work together smoothly. The nameplate and folio line should already be determined as part of the master page system. The ads are also treated separately and are given type specifications individually or placed from a drawing package. The style sheets included with the standard and premium samples are good examples of what to include on a style sheet. Systematically pick the specifications so they will work together.

Copyfitting

Different newsletters create a need for different copyfitting methods. Answer the question, "How much space will the article take?" with two questions:

1. What is the average number of words or letters that fit on the column width?
2. How many words or letters does this article have?

If copyfitting is used to determine the number of letters per line, some situations will allow the writer a range with the number of words. Also, after newsletter copy first arrives, the editor can immediately tell if the articles submitted need an extra two to four pages or additional copy. The most difficult scenario would be to let everyone write as much as they wish and then edit, hunt for more articles, or redesign to fit available space or add pages.

There are many formulas for copyfitting. Following is a simple one for beginners (it works for body copy using a 12-point leading—the most popular leading for the type sizes in newsletters). This is acceptable because 12-point leading equals 1 pica of line count.

1. For word processing software, type an article in the word processing software and read the character count. This will be "A."

 Example: On Our Way Home = 400 characters. A=400.

2. For page layout software, place the article in one column of the newsletter and add the newsletter type specifications for body text. Measure the length of the article in picas. This will be "B."

 Example: On Our Way Home = 400 characters; article measures 12 picas long. B=12.

3. Total number of characters (A) divided by the length of article measured in picas (B) = C (number of characters for pica line count).

 Example: 400 characters divided by 12 picas line count = 35 characters per pica.

4. Set up a chart to figure the line count of each article with number of characters given. Use this count to divide by the character count per pica line and it will give the pica line count.

 Example: Reunion a Success: 800 characters divided by 35 characters per pica = 24 picas line count.

Art and photos

It is difficult to make a newsletter look professional without art or photos. If they are used, they should be used in a powerful way—large enough to balance with the strength given to that particular article or as a series of thumbnail photos (head shots no larger than 1″ and laid out orderly between several columns).

Except for national organizations, nonprofit organizations rarely have photos available. Smaller organizations rely on clip art to give the newsletter some contrast. Set up clip art to reuse with each issue for categories such as thank yous, birthdays, club events, and so on. If the same size square or round cornered box is added to the art, it will help build an identity.

Familiar clip art will help the reader find the copy that interests them. Add only one special holiday or theme art for each issue.

Newsletter samples

Use 60-80# book or offset, uncoated, or enamel with a matte finish.

Page size	Page spread	Uses
8½″ x 11″	11″ x 17″	Most common and easiest size to work with. Works with all column width formats and can be printed on 11″ x 17″ and folded and cross-folded without stapling, for mailing.
8½″ x 14″	8½″ x 14″	Works best for single sheets, back and front, does not come out of a common size to be printed and folded.
11″ x 17″	17″ x 22″	Tabloid size, closely resembles a full-size newspaper.
7″ x 8½″	8½″ x 14″	Excellent for organization news, meets postal requirements, gives better column width for 2 column design.

Range for type specifications

Element	Type Sizes	Comments
Body text	8-11 pt	A narrow serif face that gives minimum of seven words per line
Heads	16-36 pt	Condensed sans serif face, U & lc, various weights and styles
Kicker	14-24 pt	Two sizes smaller than head
By-line	8-11 pt	Same size or one size smaller than text, italics
Captions	8-11 pt	Italics, same size as text
Jumpline	7-10 pt	One size smaller than text, italics, FR=continued to, FL=continued from
Boxed head	14-18 pt	Smallest head size, centered
Boxed text	7-12 pt	Matches ID line, usually smaller size
Table of Contents text	8-12 pt	One size larger or smaller than text
Folio line	7-10 pt	Uses nameplate logo plus smaller type and matching ID line
Pull quotes	14 pt	Centered or FL, 20-pt leading or a multiple of the text leading

Standard level newsletters

Small quantities and urgent deadlines are well met with standard level newsletters. Try the specifications from figures 11-12 through 11-14 for style palette information or change fonts and modify slightly:

Element	Type Specifications
Caption	9½/10 Helvetica bold, all caps
Nameplate	200/200 New Century Schoolbook, U & lc, 70% width
ID line	9½/12 Helvetica bold, all caps
Body text	9½/12 New Century Schoolbook, 1-pica first line indent
Headline 1	36/36 New Century Schoolbook bold, U & lc
Headline 2	24/24 Helvetica condensed bold, U & lc
Headline 3	18/18 Helvetica condensed italics, U & lc
Kicker	14/15 Helvetica condensed italic, FL
By-line	9½/10 New Century Schoolbook bold, all caps, rule above/below
Jumpline	9/12 New Century Schoolbook italics, all caps, U & lc
Boxed text	9/12 Helvetica condensed light, 1 pica indent left and right
Table of Contents text	9/14 Helvetica, FL
Folio line	8/10 Helvetica bold, all caps, decreased letterspacing

Custom level newsletters

Additional page elements, ink color, and use of additional software packages add production time and increases printing requirements (figures 11-15 through 11-17).

Element	Type Specifications
Caption	9½/10 Helvetica bold, all caps
Nameplate	200/200 New Century Schoolbook, U & lc, 70% width
ID line	9½/12 Helvetica bold, all caps
Body text	9½/12 New Century Schoolbook, 1 pica first line indent
Headline 1	36/36 Helvetica condensed bold, U & lc
Headline 2	24/24 Helvetica condensed bold, U & lc
Headline 3	18/18 Helvetica condensed italics, U & lc
Kicker	14/15 Helvetica condensed italics, FL
By-line	9½/12 New Century Schoolbook bold, all caps, rule above/below
Jumpline	9/12 New Century Schoolbook italics, all caps, U & lc
Boxed text	9/12 Helvetica condensed light, 1 pica indent left and right
Table of Contents text	9/14 Helvetica, FL
Folio line	8/10 Helvetica bold, all caps, decreased letterspacing

Premium level newsletters

Premium level designs for newsletters focus on process color and larger formats.

Figure 11-18 is a sample of a business-to-employee design. This is printed on a 70# gloss enamel stock. The type specifications for the body text is 10/12 in a smaller serif typeface. Colors: PANTONE 300, a blue, and black. This sample shows an excellent use of tints.

Figure 11-19 is a sample of business-to-customer design. This newsletter has recently gone from two colors of ink to four-color process. It is printed on 60# uncoated book sheet, a #1 grade. Each ad has its own unique, but not a cluttered, look. The body text is set in 9/12. Colors: PANTONE 294, a blue, and black.

Figure 11-20 is a sample of a business-to-business design. The paper is 80# high gloss enamel, which gives a better feel to a four-page newsletter. Colors: four-color process plus one PANTONE spot color.

Band Booster

SPRING EDITION BY AND FOR THE PARENTS OF BAND MEMBERS AT CENTRAL HIGH SCHOOL 1999

Don't forget...

Lasagna Supper
March 28
6:30–7:30 pm
R.J. Wollam
Cafetorium

Band Banquet
April 5
6:30 pm
R.J. Wollam
Cafetorium

Candy Sales
Jan.–May.

Garage Sale
March 10
9 am - 5 pm
City Bank

Banquet Set for Celebration

BY KATHY MILLER

At this year's band banquet, we would like to say a special thank you to all the community members, both individuals and businesses, that went the extra mile for the Central High Band program. Please, if you know of someone or a business who should be recognized, call Sandra Johnson at 925-3568 before April 5.

The Band Banquet is set for Saturday, April 13, 6:30 p.m. at R. J. Wollam Cafetorium. The evening will begin with 30 minutes of visiting with friends and a chance to view photographs, videos, newspaper clippings, and Central High Band paraphernalia from this year and years past. The meal will be a Mexican feast of fajitas and all the trimmings and is catered by Grand Prize Barbecue.

Parents - we need your Central High Band memories for the band banquet this year. Dig out those old Band photos, SFHS annuals, and anything else you can think of and help us celebrate over 30 years of excellence in the Central High Band program! Also, if you know any "retired" Central High band members, be sure to invite them to the banquet. We would like to recognize all the former band members in the audience that night. Call Becky Wright or Sandra Johnson if you would like to share your memories or you know someone special that should be recognized that evening.

Lasagna Supper Rescheduled

BY LAWANA WILLIAMS

Due to the basketball team and the play-off games, the Spaghetti Supper was postponed and changed to a Lasagna Supper on Thursday, March 28, from 5:30 - 7:30 p.m. at R. J. Wollam Cafetorium. Tickets will be sold at the door for $4.00 for adults, $3.50 for senior citizens, and $2.00 for children. Takeout orders and desserts will also be available.

There will be an ongoing cake auction and several doorprizes will be given away throughout the evening. Entertainment is being provided by the Central High High School Jazz Band. Make plans now to come by for some good music, good food, delicious desserts, good friends, and you may take home a door prize! Proceeds from the evening will benefit the Band Booster Scholarship Program for graduating seniors and new costumes for the High School Jazz Band.

Attention Senior Parents!

BY STAFF

The scholarship forms for the Seniors have been mailed. If your son or daughter has not received their form, more copies are available in the band hall and in the counselor's office. The lucky scholarship winners will be announced at the Band Banquet on April 13. If your child has received other scholarships, we would like to anounce those at the Band Banquet, please call one the officers with that information. The forms should be filled out and returned to the counselor's office before noon on April 1, 1996.

Questions? Comments? Concerns? Give one of the officers a call.	
President, Nick Krumrei925-8664	Vice President, Larry Griswold . . .925-6754
Secretary, Billie Mahoney925-1830	Treasurer, Alana Bryant925-8633

Band Booster

SPRING EDITION BY AND FOR THE PARENTS OF BAND MEMBERS AT CENTRAL HIGH SCHOOL 1999

Don't forget...

Lasagna Supper
March 28
5:30 – 7:30 pm
R.J. Wollam
Cafetorium

Band Banquet
April 13
6:30 pm
R.J. Wollam
Cafetorium

Candy Sales
Jan. – May

Garage Sale
March 10
9 am – 5 pm
City Bank

Saturday, April 13 at 6:30 pm

Banquet Plans Set

BY KATHY MILLER

At this year's band banquet, we would like to say a special thank you to all the community members, both individuals and businesses, that went the extra mile for the Central High Band program. Please, if you know of someone or a business who should be recognized, call Sandra Johnson at 925-3568 before April 5.

The Band Banquet is set for Saturday, April 13, 6:30 p.m. at R. J. Wollam Cafetorium. The evening will begin with 30 minutes of visiting with friends and a chance to view photographs, videos, newspaper clippings, and Central High Band paraphernalia from this year and years past. The meal will be a Mexican feast of fajitas and all the trimmings and is catered by Grand Prize Barbecue.

Parents...we need your Central High Band memories for the band banquet this year. Dig out those old Band photos, CHS annuals, and anything else you can think of and help us celebrate over 30 years of excellence in the Central High Band program! Also, if you know any "retired" Central High band members, be sure to invite them to the banquet. We would like to recognize all the former band members in the audience that night.

Call Becky Wright or Sandra Johnson if you would like to share your memories or you know someone special that should be recognized that evening.

Lasagna Supper Rescheduled

BY LAWANA WILLIAMS

Due to the basketball team and the play-off games, the Spaghetti Supper was postponed and changed to a Lasagna Supper on Thursday, March 28, from 5:30–7:30 p.m. at R. J. Wollam Cafetorium. Tickets will be sold at the door for $4.00 for adults, $3.50 for senior citizens, and $2.00 for children. Takeout orders and desserts will also be available.

There will be an ongoing cake auction and several doorprizes will be given away throughout the evening. Entertainment is being provided by the Central High High School Jazz Band. Make plans now to come by for some good music, good food, delicious desserts, good friends, and you may take home a door prize! Proceeds from the evening will benefit the Band Booster Scholarship Program for graduating seniors and the High School Jazz Band.

Attention Sr. Parents!

BY STAFF

The scholarship forms for the Seniors have been mailed. The forms should be filled out and returned to the counselor's office before noon on April 1, 1996. The lucky scholarship winners will be announced at the Band Banquet on April 13.

Tickets will be available at the Lasagna dinner and the April 2 Band Booster meeting, or you can drop by Amigo Mart and see Bonita Hyatt between 8:30 a.m. and 4:00 p.m. You may also call Becky Wright at 925-5169. Tickets will be $7.00 per person and must be purchased **by Friday, April 5.**

Questions? Comments? Concerns? Give one of the officers a call.
President, Nick Krumrei925-8664
Vice President, Larry Griswold925-6754
Secretary, Billie Mahoney925-1830
Treasurer, Alana Bryant925-8633

Figure 11-12 (Left) Standard level newsletter

Figure 11-13 (Below) Standard level newsletter

BY AND FOR THE PARENTS OF BAND MEMBERS AT CENTRAL HIGH SCHOOL

Band Booster

Saturday, April 13 at 6:30 pm

Banquet Plans Set

BY KATHY MILLER

At this year's band banquet, we would like to say a special thank you to all the community members, both individuals and businesses, that went the extra mile for the Central High Band program. Please, if you know of someone or a business who should be recognized, call Sandra Johnson at 925-3568 before April 5.

The Band Banquet is set for Saturday, April 13, 6:30 p.m. at R. J. Wollam Cafetorium. The evening will begin with 30 minutes of visiting with friends and a chance to view photographs, videos, newspaper clippings, and Central High Band paraphernalia from this year and years past. The meal will be a Mexican feast of fajitas and all the trimmings and is catered by Grand Prize Barbecue.

Parents...we need your Central High Band memories for the band banquet this year. Dig out those old Band photos, SFHS annuals, and anything else you can think of and help us celebrate over 30 years of excellence in the Central High Band program! Also, if you know any "retired" Central High band members, be sure to invite them to the banquet. We would like to recognize all the former band members in the audience that night. Call Becky Wright or Sandra Johnson if you would like to share your memories or you know someone special that should be recognized that evening.

Lasagna Supper Rescheduled

BY LAWANA WILLIAMS

Due to the basketball team and the play-off games, the Spaghetti Supper was postponed and changed to a Lasagna Supper on Thursday, March 28, from 5:30 - 7:30 p.m. at R. J. Wollam Cafetorium. Tickets will be sold at the door for $4.00 for adults, $3.50 for senior citizens, and $2.00 for children. Takeout orders and desserts will also be available.

There will be an ongoing cake auction and several doorprizes will be given away throughout the evening. Entertainment is being provided by the Central High High School Jazz Band. Make plans now to come by for some good music, good food, delicious desserts, good friends, and you may take home a door prize! Proceeds from the evening will benefit the Band Booster Scholarship Program for graduating seniors and the new stage equipment for the Jazz Band.

Attention Sr. Parents!

BY STAFF

The scholarship forms for the Seniors have been mailed. If your son or daughter has not received their form, more copies are available in the band hall and in the counselor's office. The forms should be filled out and returned to the counselor's office before noon on April 1, 1996. The lucky scholarship winners will be announced at the Band Banquet on April 13.

Tickets will be available at the Lasagna dinner and the April 2 Band Booster meeting, or you can drop by Amigo Mart and see Bonita Hyatt between 8:30 a.m. and 4:00 p.m. You may also call Sandra Johnson at 925-3568 or Becky Wright at 925-5169. Tickets will be $7.00 per person and **must be purchased by Friday, April 5.**

Don't forget...

Lasagna Supper
March 28, 5:30–7:30 pm
R.J. Wollam Cafetorium

Band Banquet
April 13, 6:30 pm
R.J. Wollam Cafetorium

Candy Sales
Jan.–May.

Garage Sale
March 10, 9 am–5 pm
City Bank

Questions? Comments? Concerns?
Give one of the officers a call.

President, Nick Krumrei
925-8664
Vice President, Larry Griswold
925-6754
Secretary, Billie Mahoney
925-1830
Treasurer, Alana Bryant
925-863

Figure 11-14 (Left) Standard level newsletter

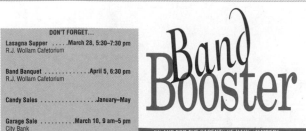

DON'T FORGET...

Lasagna Supper March 28, 5:30–7:30 pm
R.J. Wollam Cafetorium

Band Banquet April 5, 6:30 pm
R.J. Wollam Cafetorium

Candy Sales January–May

Garage Sale March 10, 9 am–5 pm
City Bank

BY AND FOR THE PARENTS OF BAND MEMBERS
SPRING 1999

Banquet Celebration Set

AT this year's band banquet, we would like to say a special thank you to all the community members, both individuals and businesses, that went the extra mile for the Central High Band program. Please, if you know of someone or a business who should be recognized, call Sandra Johnson at 925-3568 before April 5.

The scholarship forms for the Seniors have been mailed. If your son or daughter has not received their form, more copies are available in the band hall and in the counselor's office. The forms should be filled out and returned to the counselor's office before noon on April 1, 1996. The lucky scholarship winners will be announced at the Band Banquet on April 13.

The 1996 Band Banquet is set for Saturday, April 13, 6:30 p.m. at R. J. Wollam Cafetorium. The evening will begin with 30 minutes of visiting with friends and a chance to view photographs, videos, newspaper clippings, and paraphernalia from this year and years past.

LAST YR'S SENIORS SERIOUS AT THE BANQUET

Parents...If you have any photo of your kids or of past band activities, we want to put together a media presentation to show during the meal that will run in a loop and that can be purchased as a complete memory
Continued on page 2

Lasagna Supper Rescheduled
BY LAWANA WILLIAMS

DUE to the basketball team and the play-off games, the Spaghetti Supper was postponed and changed to a Lasagna Supper on Thursday, March 28, from 5:30 - 7:30 p.m. at R. J. Wollam Cafetorium. Tickets will be sold at the door for $4.00 for adults, $3.50 for senior citizens, and $2.00 for children. Take out orders and desserts will also be available.

There will be an ongoing cake auction and several doorprizes will be given away throughout the evening. Entertainment is being provided by the Central High High School Jazz Band. Make plans now to come by for some good music, good food, delicious desserts, good

friends, and you may take home a door prize! Proceeds from the evening will benefit the Band Booster Scholarship Program for graduating seniors and new costumes for the High School Jazz Band.

Attention Senior Parents!
BY STAFF

THE scholarship forms for the Seniors have been mailed. If your son or daughter has not received their form, more copies are available in the band hall and in the counselor's office. The lucky scholarship winners will be announced at the Band Banquet on April 13. If your child has received other scholarships, we would like to anounce those at the Band Banquet, please call one the officers with that information. The forms should be filled out and returned to the counselor's office before **noon on April 1, 1996.**

Figure 11-15 (Left) Custom level newsletter

Figure 11-16 (Below) Custom level newsletter

Central High School BANDBOOSTER

BY AND FOR THE PARENT OF CHS BAND MEMBERS SPRING 1999

Banquet Celebration Set

SENIORS BRAD LEINING AND SHARON WAITE AT LAST YEAR'S BANQUET

BY KATHY MILLER

At this year's band banquet, we would like to say a special thank you to all the community members, both individuals and businesses, that went the extra mile for the Central High Band program. Please, if you know of someone or a business who should be recognized, call Sandra Johnson at 925-3568 before April 5.

The Band Banquet is set for Saturday, April 13, 6:30 p.m. at R. J. Wollam Cafetorium. The evening will begin with 30 minutes of visiting with friends and

a chance to view photographs, videos, newspaper clippings, and Central High Band paraphernalia from this year and years past. The meal will be a Mexican feast of fajitas and all the trimmings and is catered by Grand Prize Barbecue.

Parents...we need your Central High Band memories for the band banquet this year. Dig out those old Band photos, SFHS annuals, and anything else you can think of and help us celebrate over 30 years of excellence in the Central High Band program! Also, if you know any "retired" Central High band members, be sure to
Continued on page 2

Don't forget...

Lasagna Supper
March 28, 5:30 - 7:30 pm
R.J. Wollam Cafetorium

Band Banquet
April 5, 6:30 pm
R.J. Wollam Cafetorium

Candy Sales
Jan. - May.

Garage Sale
March 10, 9 am - 5 pm
City Bank

Lasagna Supper Rescheduled
BY LAWANA WILLIAMS

Due to the basketball team and the play-off games, the Spaghetti Supper was postponed and changed to a Lasagna Supper on Thursday, March 28, from 5:30 - 7:30 p.m. at R. J. Wollam Cafetorium. Tickets will be sold at the door for $4.00 for adults, $3.50 for senior citizens, and $2.00 for children. Takeout orders and desserts will also be available.

There will be an ongoing cake auction and several doorprizes will be given away throughout the evening. Entertainment is being provided by the Central High High School Jazz Band. Make plans now to come by for some good music, good food, delicious desserts, good friends, and you may take home a door prize! Pro-

ceeds from the evening will benefit the Band Booster Scholarship Program for graduating seniors and the new stage equipment for the Jazz Band.

Attention Sr. Parents!
BY STAFF

The scholarship forms for the Seniors have been mailed. If your son or daughter has not received their form, more copies are available in the band hall and in the counselor's office. The forms should be filled out and returned to the counselor's office before noon on April 3. Scholarship winners will be announced at the
Continued on page 2

Central High School BANDbooster

SPRING EDITION BY AND FOR THE PARENTS OF BAND MEMBERS AT CENTRAL HIGH SCHOOL 1999

Featured Seniors...

Brad Williams

Sue Long

Leslie Martin

Bradford Mairs

Lane Laird

Banquet Celebration Set

BY KATHY MILLER

At this year's band banquet, there will be a theme, "Community Extra Miles". We would like to say a special thank you to all the community members, both individuals and businesses, that went the extra mile for the Central High Band program. Please, if you know of someone or a business who should be recognized, call Sandra Johnson at 925-3568 before April 5.

The Band Banquet is set for Saturday, April 13, 6:30 p.m. again at the R.J. Wollam Cafetorium. The evening will begin with 30 minutes of visiting with friends and a chance to view photographs, videos, newspaper clippings, and Central High Band paraphernalia from this year and years past. The meal will be a Mexican feast of fajitas and all the trimmings and is catered by our

SENIORS AT LAST YEAR'S BANQUET

favorite Benito's Mexican Restaurant. We need your Central High Band
CONTINUED ON PAGE 2

Lasagna Supper Rescheduled
BY LAWANA WILLIAMS

Due to the basketball team and the play-off games, the Spaghetti Supper was postponed and changed to a Lasagna Supper on Thursday, March 28, from 5:30 - 7:30 p.m. at R. J. Wollam Cafetorium.

Tickets will be sold at the door for $4.00 for adults, $3.50 for senior citizens, and $2.00 for children. Takeout orders and desserts will also be available.

There will be an ongoing cake auction and several doorprizes will be given away throughout the evening. Entertainment is being provided by the Central High High School Jazz Band.

Make plans now to come by for some good music, good food, delicious desserts, good friends, and you may take home a door prize! Proceeds from the evening will benefit the Band Booster Scholarship Program

for graduating seniors and the High School Jazz Band. And the special treat is that the Jazz Band will provide music for the supper!

Questions? Comments? Concerns?
Give one of the officers a call.

Attention Sr. Parents!
BY STAFF

The scholarship forms for the Seniors have been mailed. The forms should be filled out and returned to the counselor's office before noon on April 1, 1996. The lucky scholarship winners will be announced at the Band Banquet on April 13.

Tickets will be available at the Lasagna dinner and the April 2 Band Booster meeting, or you can drop by Amigo Mart and see Bonita Hyatt between 8:30 a.m. and 4:00 p.m. You may also call Becky Wright at 925-5169. Tickets will be $7.00 per person and must be purchased **by Friday, April 5.**

Figure 11-17 (Left) Custom level newsletter.

Figure 11-18 (Left) Premium level newsletter.
Credit: Air View Graphics and Printing

Figure 11-19 (Below) Premium level newsletter.
Credit: M H & T Advertising Agency

Figure 11-20 (Left) Premium level newsletter. *Credit: Manlove Advertising, Pasadena, TX, design and production*

PREMIUM

Catalogs

Mail order catalogs have gained popularity since the early 1990s as the prices of quality products became competitive with in-store items. Catalogs try to give each product the same exposure it would receive in a store. Catalogs require professional photographers or illustrators since they include quality photographs or drawings of each item.

All style elements appear on every page and the page is full of photos of the products, each competing for the customer's attention. If the products fit the customer's interest, the catalog is saved for reference.

Body text and leadings may be in half sizes (8½) because they consist of a large number of items per page. To eliminate overcrowding and still have easy-to-read type that does not take up valuable space, try smaller sizes with larger leadings (8½/12, 7½/12). Be cautious of catalog pages printed with a background and type that is overprinted. These factors affect the choice in type size and face.

Design

The press, sheet and trim size, bindery, and total cost per copy are finalized before design begins. Although the typography is similar to documents, the design works like news publications. Every page is sketched with type and photos. Unlike other publications, there are no blank pages.

Margins

Use narrow margins on all sides, but keep the outside margin at a minimum of ½″ for trim. Most catalogs are saddle stitched and, therefore, have a very small inside (gutter) margin. Know the trim size so that copy will not be cut off when the publication is given a final trim.

Grids and columns

Use a five column or greater grid system. Most catalogs use several grid patterns because the number of products on a page vary. The variety of grids add interest to the catalog (figure 11-21).

Additional page elements

Catalog page elements include additional elements that are unique to this particular publication.

Photos

The focus of catalogs is product photos. Photo sessions scheduled after the design will narrow the number of shots needed. A grid pattern is the building block for all quality catalogs. Even pages where the text and photos look scattered are built on a very complex grid. Use a grid system to locate rectangular photos in groups.

> ✗ Cross reference: See Chapter 5 for information on handling photos and for additional suggestions.

Product description

The type should not compete with the photos. Most of the elements on the page are in the same sizes of type or one size different with changes to weight, position, or letterspacing. Sans serif typefaces are used in catalogs for the body text. Choose a face with a narrow width to fit as many words as possible on the page. Helvetica condensed, Optima, and Times are examples of typefaces with narrow letters. Body type is small but leadings are generous to give the page a clean look and some space. The copy can form neat blocks with no first line indent and justified text.

Headline

Not all pages have a headline. When they are used, they should not compete with the photos. Headlines have a lighter look with script and serif typefaces. Italics should be no larger than 24 points.

The price

The size and appearance of the price should be decided by the client. In some cases, the price will be set as a separate page element or with a second color of ink.

Figure 11-21 Grids for catalogs

Catalog samples

Typical catalog sizes include 8½″ x 11″ and 5½″ x 8″. Always check the size to make sure it fits postal regulations for mailing. Use coated 40# book for thick catalogs or coated 70# book, textured or smooth, for small catalogs.

Range for type specifications

Element	Type Sizes	Comments
Head A	14-24 pt	Serif and sans serif, bold and italics, increased letterspacing
Head B	36-42 pt	Script
Body	7-9 pt	Leading is 2-4 pt larger than type size
Product title	Same as body	Bold, all caps, letterspaced
Subheads	7-9 pt	Same as body, bold, U & lc
Product ID	7-9 pt	Same as body, bold, U & lc, leader dots
Price	7-9 pt	Same as body or larger than head

Standard level catalogs

Small quantities and urgent deadlines are well met with standard level catalogs. Writing papers without deep textures will print easily in the laser printer. Ask the paper representative for specific paper choices. Try the specifications from figures 11-22 through 11-24 for style palette information or change fonts and modify slightly:

Element	Type Specifications
Running head	18/24 Helvetica condensed italics, bold, tight tracking
Product head	8/12 Helvetica bold, all caps, increased letterspacing
Body	8/12 Helvetica condensed light, justified, 6-pt before paragraph leading
Subheads	8/8 Helvetica black, U & lc, 2-pt before paragraph leading
Product ID	7/8 Helvetica condensed light
Price	Part of product ID

PAPER AND INK. Use 40# book, coated, in white or 50# book, uncoated with vellum finish, in white or ivory; also, use black ink only or black and one PANTONE Color ink.

OUTPUT DEVICE. Quantities over 3,000 and number of photographs will be as economical as any traditional methods.

Custom level catalogs

Additional page elements, photo and art techniques, as well as using additional software packages add production time and increase printing requirements (figures 11-25 through 11-27).

Element	Type Specifications
Head	18/24 Helvetica italics, bold, letterspacing
Body	8/12 Helvetica condensed light, justified, 9-pt before paragraph leading, 9-pt after paragraph leading
Product title	8/14 Helvetica bold, all caps, letterspacing
Subheads	8/8 Helvetica black, U & lc
Product ID	7/8 Helvetica condensed light
Price	Part of product ID

PAPER AND INK. Use coated 40# book in white or uncoated 50# book with vellum finish in white or ivory; also, use black ink or black and one PANTONE Color ink.

OUTPUT DEVICE. Quantities over 3,000 and number of photographs will be as economical as any traditional methods.

Premium level catalogs

Premium level designs focus on multiple photographs and multiple text blocks.

Figure 11-28 is a sample of a catalog for a startup company. The paper choice is a 80# matte finish enamel. Colors: PANTONE 357, a green, and black.

Figure 11-29 is a sample of a business-to-business catalog. The production was completed in a drawing package rather than a page layout package because of the number of charts and illustrations. Paper choice is 80# matte finished enamel. Colors: PANTONE 145, an orange, and black.

Figure 11-30 is a business-to-customer catalog. The paper is a 40# enamel. Color: process color.

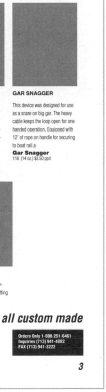

Bow Additions

RETRIEVER DOVETAIL

This new mount allows easy removal of the Retriever for storage and cleaning. Solves mounting problems on bows with offset windows. Hardware & mounting instructions included.
Retriever Dovetail
104 (1 lb.) $3.50 ppd

SCREW ON REEL

5' Screw on Reel. Spun aluminum, plastic mounting brackets, steel flat bar with stud. Stainless steel string clip for minimum line drag. Comes with 50' of 80# line.
Red Trim
107R (12 oz.) $3.50 ppd
Black Trim
107B (12 oz.) $3.50 ppd

TAPE ON REEL

5' Tape on Reel. Spun aluminum. Stainless steel string clip gives minimum line drag. Aluminum mounting bracket for easy installation. Comes with 50' of 80# test line.
Red Trim
108R (12 oz.) $3.50 ppd
Black Trim
108B (12 oz.) $3.50 ppd

REEL ADAPTER

Screws into stabilizer hole. Has an attractive finish of black anodize and bright aluminum. Accepts most popular fishing reels. Threaded adapter allows attachment of rod or fishing light.
Reel Adapter
116 (1 lb. 14 oz.) $3.50 ppd

ARROW REST

One piece anodized aluminum. Comes with jam nut and nylon washer. Allows adjustment for proper center shot. Made to support the weight of fiberglass fishing arrows.
Arrow Rest
117 (1 lb. 12 oz.) $3.50 ppd

GAR SNAGGER

This device was designed for use as a snare on big gar. The heavy cable keeps the loop open for one handed operation. Equipped with 12' of rope on handle for securing to boat rail.
Gar Snagger
118 (14 oz.) $3.50 ppd

SHOOT THRU TAPE ON REEL

For the discriminating fisherman. Offers direct shot design. All aluminum construction with snagproof line holder. Comes with 50' of 80# line.
7" Reel
109 (2 lb. 15 oz.) $18.95 ppd
10" Reel
111 (2 lb. 16 oz.) $22.95 ppd

SHOOT THRU BOLT ON REEL

Direct shot design. All aluminum construction with snag proof line holder. For mounting on compound bows. Comes with 50' of 80# test line.
7" Reel
110 (2 lb. 12 oz.) $3.50 ppd
10" Reel
113 (2 lb. 13 oz.) $3.50 ppd

ROD ASSEMBLY

Bowfishing rod comes with a reel adapter and an attractive finish of black anodize and bright aluminum.
16"
114 (3 lb. 10 oz.) $3.50 ppd
8" Assembly
115 (3 lb. 4 oz.) $3.50 ppd

FAST FLIGHT

Bowfishing line made with the same Spectra fibers found in premier bowstrings. Truly the thinnest, strongest line around with virtually no line cutting on shoot throughs.
200#
401 F (12 oz.) $3.50 ppd
400#
402 (2 lb.) $3.50 ppd

all custom made

Orders Only 1-800-251-6461
Inquiries (713) 941-4882
FAX (713) 941-3222

2 3

Figure 11-22
(Left) Standard level catalog

Figure 11-23
(Below) Standard level catalog

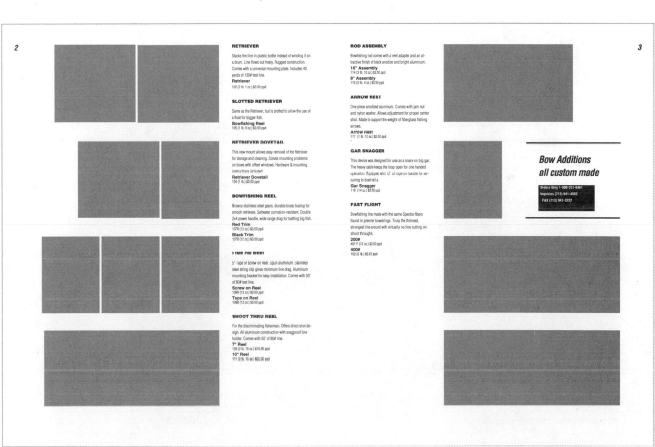

2 3

RETRIEVER

Stacks the line in plastic bottle instead of winding it on a drum. Line flows out freely. Rugged construction. Comes with a universal mounting plate. Includes 40 yards of 130# test line.
Retriever
102 (2 lb. 1 oz.) $3.50 ppd

SLOTTED RETRIEVER

Same as the Retriever, but is slotted to allow the use of a float for bigger fish.
Bowfishing Reel
105 (1 lb. 9 oz.) $3.50 ppd

RETRIEVER DOVETAIL

This new mount allows easy removal of the Retriever for storage and cleaning. Solves mounting problems on bows with offset windows. Hardware & mounting instructions included.
Retriever Dovetail
104 (1 lb.) $3.50 ppd

BOWFISHING REEL

Brawny stainless steel gears, durable brass busing for smooth retrieves. Saltwater corrosion-resistant. Double 2x4 power handle, wide range drag for battling big fish.
Red Trim
107R (12 oz.) $3.50 ppd
Black Trim
107B (12 oz.) $3.50 ppd

LINE ON REEL

5' Tape or screw on Reel. Spun aluminum. Stainless steel string clip gives minimum line drag. Aluminum mounting bracket for easy installation. Comes with 50' of 80# test line.
Screw on Reel
108R (12 oz.) $3.50 ppd
Tape on Reel
108B (12 oz.) $3.50 ppd

SHOOT THRU REEL

For the discriminating fisherman. Offers direct shot design. All aluminum construction with snagproof line holder. Comes with 50' of 80# line.
7" Reel
109 (2 lb. 15 oz.) $18.95 ppd
10" Reel
111 (2 lb. 16 oz.) $60.00 ppd

ROD ASSEMBLY

Bowfishing rod comes with a reel adapter and an attractive finish of black anodize and bright aluminum.
16" Assembly
114 (3 lb. 10 oz.) $3.50 ppd
8" Assembly
115 (3 lb. 4 oz.) $3.50 ppd

ARROW REST

One piece anodized aluminum. Comes with jam nut and nylon washer. Allows adjustment for proper center shot. Made to support the weight of fiberglass fishing arrows.
Arrow Rest
117 (1 lb. 12 oz.) $3.50 ppd

GAR SNAGGER

This device was designed for use as a snare on big gar. The heavy cable keeps the loop open for one handed operation. Equipped with 12' of rope on handle for securing to boat rail.
Gar Snagger
118 (14 oz.) $3.50 ppd

FAST FLIGHT

Bowfishing line made with the same Spectra fibers found in premier bowstrings. Truly the thinnest, strongest line around with virtually no line cutting on shoot throughs.
200#
401 F (12 oz.) $3.50 ppd
400#
402 (2 lb.) $3.50 ppd

Bow Additions
all custom made

Orders Only 1-800-251-6461
Inquiries (713) 941-4882
FAX (713) 941-3222

STANDARD

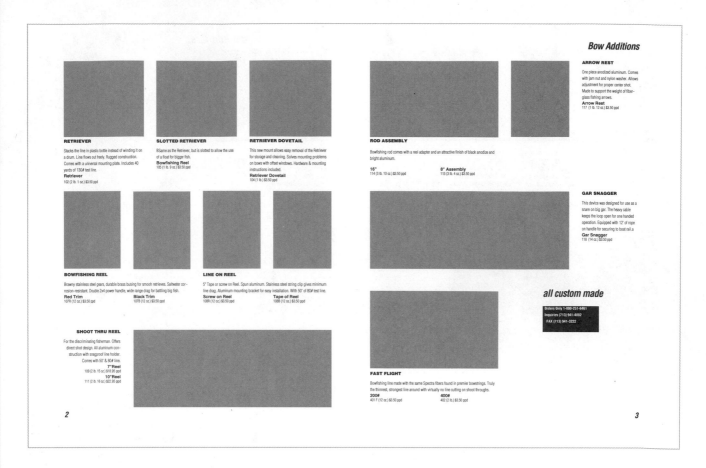

Bow Additions

ARROW REST
One piece anodized aluminum. Comes with jam nut and nylon washer. Allows adjustment for proper center shot. Made to support the weight of fiberglass fishing arrows.
Arrow Rest
117 (1 lb. 12 oz.) $3.50 ppd

RETRIEVER
Stacks the line in plastic bottle instead of winding it on a drum. Line flows out freely. Rugged construction. Comes with a universal mounting plate. Includes 40 yards of 130# test line.
Retriever
102 (2 lb. 1 oz.) $3.50 ppd

SLOTTED RETRIEVER
BSame as the Retriever, but is slotted to allow the use of a float for bigger fish.
Bowfishing Reel
105 (1 lb. 9 oz.) $3.50 ppd

RETRIEVER DOVETAIL
This new mount allows easy removal of the Retriever for storage and cleaning. Solves mounting problems on bows with offset windows. Hardware & mounting instructions included.
Retriever Dovetail
104 (1 lb.) $3.50 ppd

ROD ASSEMBLY
Bowfishing rod comes with a reel adapter and an attractive finish of black anodize and bright aluminum.

16"
114 (3 lb. 10 oz.) $3.50 ppd

8" Assembly
115 (3 lb. 4 oz.) $3.50 ppd

GAR SNAGGER
This device was designed for use as a snare on big gar. The heavy cable keeps the loop open for one handed operation. Equipped with 12' of rope on handle for securing to boat rail.a
Gar Snagger
118 (14 oz.) $3.50 ppd

BOWFISHING REEL
Brawny stainless steel gears, durable brass busing for smooth retrieves. Saltwater corrosion-resistant. Double 2x4 power handle, wide range drag for battling big fish.
Red Trim
107R (12 oz.) $3.50 ppd
Black Trim
107B (12 oz.) $3.50 ppd

LINE ON REEL
5" Tape or screw on Reel. Spun aluminum. Stainless steel string clip gives minimum line drag. Aluminum mounting bracket for easy installation. With 50' of 80# test line.
Screw on Reel
108R (12 oz.) $3.50 ppd
Tape of Reel
108B (12 oz.) $3.50 ppd

all custom made

Orders Only 1-800-251-6461
Inquiries (713) 941-4882
FAX (713) 941-3222

SHOOT THRU REEL
For the discriminating fisherman. Offers direct shot design. All aluminum construction with snagproof line holder. Comes with 50' & 80# line.
7"Reel
109 (2 lb. 15 oz.) $18.95 ppd
10"Reel
111 (2 lb. 16 oz.) $22.95 ppd

FAST FLIGHT
Bowfishing line made with the same Spectra fibers found in premier bowstrings. Truly the thinnest, strongest line around with virtually no line cutting on shoot throughs.
200#
401 F (12 oz.) $3.50 ppd
400#
402 (2 lb.) $3.50 ppd

2 3

CUSTOM

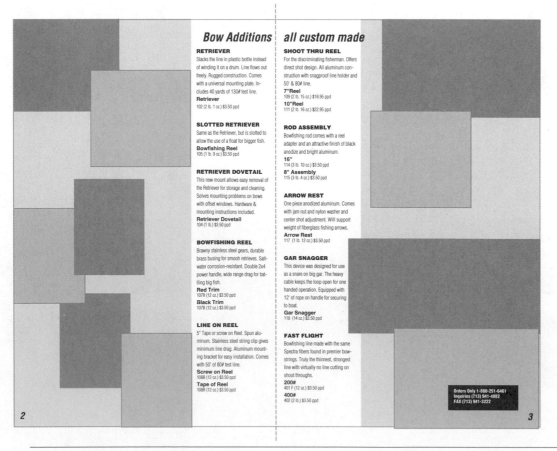

Bow Additions

RETRIEVER
Stacks the line in plastic bottle instead of winding it on a drum. Line flows out freely. Rugged construction. Comes with a universal mounting plate. Includes 40 yards of 130# test line.
Retriever
102 (2 lb. 1 oz.) $3.50 ppd

SLOTTED RETRIEVER
Same as the Retriever, but is slotted to allow the use of a float for bigger fish.
Bowfishing Reel
105 (1 lb. 9 oz.) $3.50 ppd

RETRIEVER DOVETAIL
This new mount allows easy removal of the Retriever for storage and cleaning. Solves mounting problems on bows with offset windows. Hardware & mounting instructions included.
Retriever Dovetail
104 (1 lb.) $3.50 ppd

BOWFISHING REEL
Brawny stainless steel gears, durable brass busing for smooh retrieves. Saltwater corrosion-resistant. Double 2x4 power handle, wide range drag for battling big fish.
Red Trim
107R (12 oz.) $3.50 ppd
Black Trim
107B (12 oz.) $3.50 ppd

LINE ON REEL
5" Tape or screw on Reel. Spun aluminum. Stainless steel string clip gives minimum line drag. Aluminum mounting bracket for easy installation. Comes with 50' of 80# test line.
Screw on Reel
108B (12 oz.) $3.50 ppd
Tape of Reel
108R (12 oz.) $3.50 ppd

all custom made

SHOOT THRU REEL
For the discriminating fisherman. Offers direct shot design. All aluminum construction with snagproof line holder and 50' & 80# line.
7"Reel
109 (2 lb. 15 oz.) $18.95 ppd
10"Reel
111 (2 lb. 16 oz.) $22.95 ppd

ROD ASSEMBLY
Bowfishing rod comes with a reel adapter and an attractive finish of black anodize and bright aluminum.
16"
114 (3 lb. 10 oz.) $3.50 ppd
8" Assembly
115 (3 lb. 4 oz.) $3.50 ppd

ARROW REST
One piece anodized aluminum. Comes with jam nut and nylon washer and center shot adjustment. Will support weight of fiberglass fishing arrows.
Arrow Rest
117 (1 lb. 12 oz.) $3.50 ppd

GAR SNAGGER
This device was designed for use as a snare on big gar. The heavy cable keeps the loop open for one handed operation. Equipped with 12' of rope on handle for securing to boat.
Gar Snagger
118 (14 oz.) $3.50 ppd

FAST FLIGHT
Bowfishing line made with the same Spectra fibers found in premier bowstrings. Truly the thinnest, strongest line with virtually no line cutting on shoot throughs.
200#
401 F (12 oz.) $3.50 ppd
400#
402 (2 lb.) $3.50 ppd

Orders Only 1-800-251-6461
Inquiries (713) 941-4882
FAX (713) 941-3222

2 3

Figure 11-24 (Above) Standard level catalog

Figure 11-25, -26, -27 (Left and opposite) Custom level catalogs

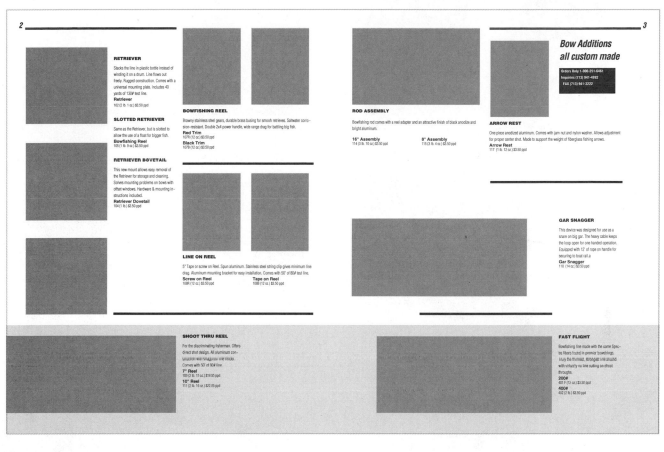

2

RETRIEVER

Stacks the line in plastic bottle instead of winding it on a drum. Line flows out freely. Rugged construction. Comes with a universal mounting plate. Includes 40 yards of 130# test line.
Retriever
102 (2 lb. 1 oz.) $3.50 ppd

SLOTTED RETRIEVER

Same as the Retriever, but is slotted to allow the use of a float for bigger fish.
Bowfishing Reel
105 (1 lb. 9 oz.) $3.50 ppd

RETRIEVER DOVETAIL

This new mount allows easy removal of the Retriever for storage and cleaning. Solves mounting problems on bows with offset windows. Hardware & mounting instructions included.
Retriever Dovetail
104 (1 lb.) $3.50 ppd

BOWFISHING REEL

Brawny stainless steel gears, durable brass busing for smooh retrieves. Saltwater corrosion-resistant. Double 2x4 power handle, wide range drag for battling big fish.
Red Trim
107R (12 oz.) $3.50 ppd
Black Trim
107B (12 oz.) $3.50 ppd

LINE ON REEL

5" Tape or screw on Reel. Spun aluminum. Stainless steel string clip gives minimum line drag. Aluminum mounting bracket for easy installation. Comes with 50' of 80# test line.
Screw on Reel
106R (12 oz.) $3.50 ppd
Tape on Reel
106B (12 oz.) $3.50 ppd

SHOOT THRU REEL

For the discriminating fisherman. Offers direct shot design. All aluminum construction with snagproof line holder. Comes with 50' of 80# line.
7" Reel
109 (2 lb. 15 oz.) $18.95 ppd
10" Reel
111 (2 lb. 16 oz.) $22.95 ppd

ROD ASSEMBLY

Bowfishing rod comes with a reel adapter and an attractive finish of black anodize and bright aluminum.
16" Assembly
114 (3 lb. 10 oz.) $3.50 ppd
8" Assembly
115 (3 lb. 4 oz.) $3.50 ppd

3

Bow Additions
all custom made

Orders Only 1-800-251-6461
Inquiries (713) 941-4882
FAX (713) 941-3222

ARROW REST

One piece anodized aluminum. Comes with jam nut and nylon washer. Allows adjustment for proper center shot. Made to support the weight of fiberglass fishing arrows.
Arrow Rest
117 (1 lb. 12 oz.) $3.50 ppd

GAR SNAGGER

This device was designed for use as a snare on big gar. The heavy cable keeps the loop open for one handed operation. Equipped with 12' of rope on handle for securing to boat rail.a
Gar Snagger
118 (14 oz.) $3.50 ppd

FAST FLIGHT

Bowfishing line made with the same Spectra fibers found in premier bowstrings. Truly the thinnest, strongest line around with virtually no line cutting on shoot throughs.
200#
401 F (12 oz.) $3.50 ppd
400#
402 (2 lb.) $3.50 ppd

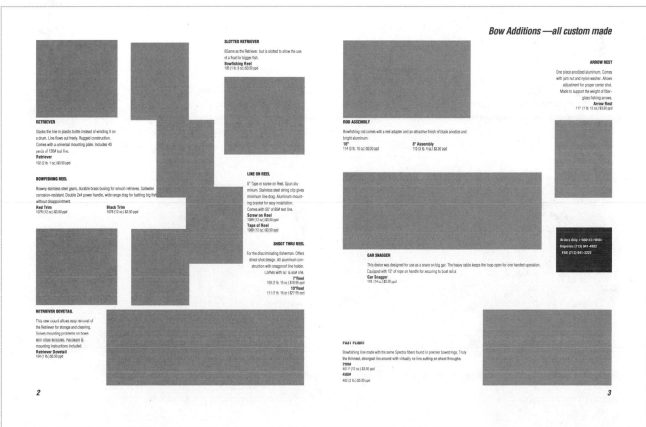

Bow Additions —all custom made

RETRIEVER

Stacks the line in plastic bottle instead of winding it on a drum. Line flows out freely. Rugged construction. Comes with a universal mounting plate. Includes 40 yards of 130# test line.
Retriever
102 (2 lb. 1 oz.) $3.50 ppd

BOWFISHING REEL

Brawny stainless steel gears, durable brass busing for smooh retrieves. Saltwater corrosion-resistant. Double 2x4 power handle, wide range drag for battling big fish without disappointment.
Red Trim
107R (12 oz.) $3.50 ppd
Black Trim
107B (12 oz.) $3.50 ppd

RETRIEVER DOVETAIL

This new mount allows easy removal of the Retriever for storage and cleaning. Solves mounting problems on bows with offset windows. Hardware & mounting instructions included.
Retriever Dovetail
104 (1 lb.) $3.50 ppd

SLOTTED RETRIEVER

BSame as the Retriever, but is slotted to allow the use of a float for bigger fish.
Bowfishing Reel
105 (1 lb. 9 oz.) $3.50 ppd

LINE ON REEL

5" Tape or screw on Reel. Spun aluminum. Stainless steel string clip gives minimum line drag. Aluminum mounting bracket for easy installation. Comes with 50' of 80# test line.
Screw on Reel
106R (12 oz.) $3.50 ppd
Tape of Reel
106B (12 oz.) $3.50 ppd

SHOOT THRU REEL

For the discriminating fisherman. Offers direct shot design. All aluminum construction with snagproof line holder. Comes with 50' & 80# line.
7"Reel
109 (2 lb. 15 oz.) $18.95 ppd
10"Reel
111 (2 lb. 16 oz.) $22.95 ppd

ROD ACCEMDLY

Bowfishing rod comes with a reel adapter and an attractive finish of black anodize and bright aluminum.
16"
114 (3 lb. 10 oz.) $3.50 ppd
8" Assembly
115 (3 lb. 4 oz.) $3.50 ppd

GAR SNAGGER

This device was designed for use as a snare on big gar. The heavy cable keeps the loop open for one handed operation. Equipped with 12' of rope on handle for securing to boat rail.a
Gar Snagger
118 (14 oz.) $3.50 ppd

FAST FLIGHT

Bowfishing line made with the same Spectra fibers found in premier bowstrings. Truly the thinnest, strongest line around with virtually no line cutting on shoot throughs.
200#
401 F (12 oz.) $3.50 ppd
400#
402 (2 lb.) $3.50 ppd

ARROW REST

One piece anodized aluminum. Comes with jam nut and nylon washer. Allows adjustment for proper center shot. Made to support the weight of fiberglass fishing arrows.
Arrow Rest
117 (1 lb. 13 oz.) $3.50 ppd

Orders Only 1-800-251-6461
Inquiries (713) 941-4882
FAX (713) 941-3222

2

3

CUSTOM

PREMIUM

Figure 11-28 Premium level catalog.
Credit: M H & T Advertising Agency

Figure 11-29
Premium level catalog.
*Credit: Air View Graphics
and Printing*

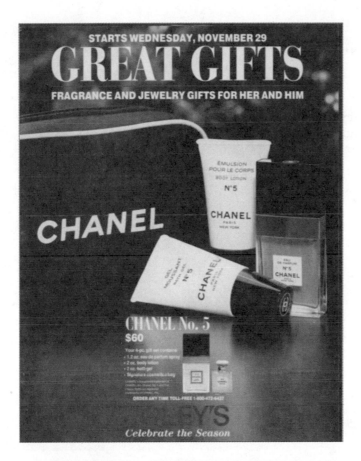

Figure 11-30
Premium level catalog.
*Credit: Foley's, Ellen Hollingsworth,
system manager, John Meyer, art director*

Other news and product projects

Editorial magazines

The margins match long documents with a narrow inside margin. Uses traditional design and type specifications and few photos; some do not use cover stock (figure 11-31).

SIZES. 8½″ x 11″, 5½″ x 8½″, and 6″ x 9″.

PAPER. 40# book, coated for thick catalogs, and 70# book, coated (textured or smooth) for small catalogs.

Client-focus magazines

The reader scans a magazine, holding it at the saddle stitch and flipping in either direction. Headlines and photos are presented boldly to catch the reader's

Figure 11-31 Broadsides Magazine.
Credit: College of the Mainland, Dotti Jones, editor, Jean Burkhardt, cover design and production

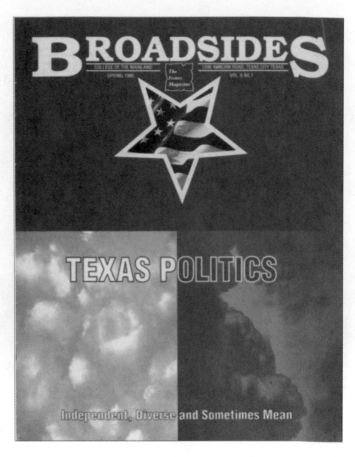

NATURE'S LESSON FOR THE WORLD
by Ali Ravandi

"A potluck dinner... is...far more interesting than a single dish."

Who can resist the beauty of a flower garden? One could only marvel at the variety and magnificent blend of fragrance and form of a field of wild flowers in the spring. It makes you ponder, though, how it is that we are so appreciative of the diversity abounding in all of God's creations except for his greatest creation. Is it not astonishing how skillful and elaborately, yet seemingly easy, nature manifests the lesson of diversity to the world?

Diversity may be defined as all the different elements necessary to bond and create a truly homogeneous unity. A potluck dinner at your favorite picnic is simply an offering of more choices, of which you may not like all, but yet far more interesting than a single dish. American cars are much better now than they were a decade ago simply because of the presence of Japanese competition.

American people coming from different backgrounds, beliefs and a multitude of different cultural/demographical backgrounds have merged and intermixed to create the strongest nation on earth. We can retain a strong nation and survive the murky waters of the years ahead by creating unity and a sense of oneness among all members of our community and the nation. Cultural diversity can spark a nation into greatness if stereotypical myths and unfair prejudicial treatments of people are truly eradicated.

In the words of a famous Persian poet and philosopher (loosely translated): "All human being are organs of the same body, made of the same material." If a member fails it will affect the whole body. "It is time to stop discrimination of anytype and to provide true equal opportunity for all and then all will reap the enormous benefits of a truly great nation, unified and strong and prosperous." Those who choose to use this nation's opportunities will succeed and those who do not can complain.■

Ali Ravandi, Ph. D. is on the Math, Health and Natural Science Faculty of College of the Mainland.

THOUGHTS ON DIVERSITY: CHALLENGES FOR URBAN AMERICA
By Lee A. McGriggs

The future of urban life is inextricably linked to diversity. A fundamental issue is the extent our urban society can coexist in a multicultural environment while sustaining a level of consensus. Americans of diverse racial and ethnic groups do not share equally in the dominant culture. As America becomes more urban and diverse, a major concern is whether the nation's social and political institutions will promote diversity and seek to end racial and ethnic division. The diversity factor is crucial to the future of urban America.

Demographic data indicates that by the twenty-first century, only fifty-seven percent of the people entering the American workforce will be native born in the U.S. More and more the economic future of white Americans will depend on the talents of non–white Americans. Multiculturalism will become paramount in an increasingly diversified society. As a nation, America must find common ground through acceptance of cultural diversity.

Urban America is not divided only by racial lines between black and white. There is a mixture of other races, languages and religions as millions of new immigrants arrive in America in search of economic promise and political freedom. The emerging dynamics of "one world with many cultures" provide a path to progress through acceptance of cultural diversity. Although the quality of life in urban America is dependent on recognition and acceptance of diversity, many white Americans resist relinquishing the entitlement skin color has given them throughout the nation's history. Many Americans perceive people different from

themselves as "the others," thus, locking those of other racial and ethnic groups into their own narrow perspectives; they prefer to be wrong rather than change those views. Therefore, absurd stereotypes continue to exist. Apparently many Americans are more interested in defending their racial territory than recognizing that the nation can be enriched through valuing diversity.

The politics of the last twenty-five years has intensified racial issues in urban America either by silence or distortion. Many politicians either have ignored America's deepening racial division or cynically exploited those crises for political gains. Both Republicans and Democrats have contributed to the problem. Republicans have played the race card in a divisive way to obtain votes while the Democrats have evaded racial issues in a cloak of silence and denial.

For Americans who came a generation ago, affirmation to the principles of liberty, equality and democracy created an optimistic society. This optimism that every person can realize his or her potential in an atmosphere of nurturing liberty was grounded in the conviction that each person has an obligation to the other individual simply because that person is a human being. Urban America is where these ideas and cultures have always clashed – sometimes violently.

Few people of different races encounter real contact or have conversations with each other. Thus, television and newspapers educate many Americans about race. This results in the continued division among races in our cities and the

"The diversity factor is crucial to the future of urban America."

eye. The design is focused to its market. Figure 11-32 is a magazine that is distributed nationally for high school seniors. The copy and the back page ad are personalized for a particular junior college. This client-focus magazine has been developed for dentists and retail merchants and the idea also is used for local markets.

SIZES. 8½″ x 11″.

PAPER. 40# book, coated for thick catalogs, and 70# book, coated (textured or smooth) for small catalogs.

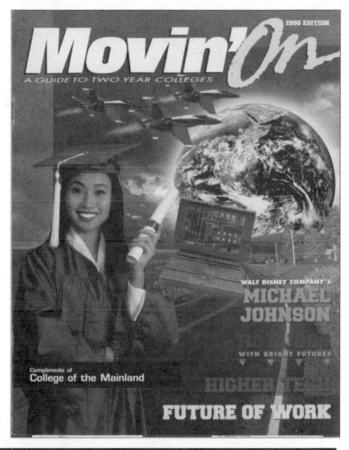

Figure 11-32 Movin' On Magazine.
Credit: 7th edition, Nov. 1995, copyright 1995 by Venture Publications, Inc., 4808 Fairmont Parkway, Suite 194, Pasadena, TX 77505. All rights reserved. Reproduction in whole or in part without written permission of the publisher is prohibited. "Movin' On" is protected through trademark registration in the United States.

Newspapers

Newspapers are larger, more complex news publications than newsletters. They include a large staff that is divided into several groups: advertising sales, advertising production, editorial, printing production, and electronic pages. The page elements listed for newsletters are multiplied by the number of sections that appear in the publication, but they begin with the newsletters elements (figure 11-33).

Because of the complexity of this publication, this book is unable to go into newspapers in depth. Page sizes of newspapers vary and newsprint paper is used.

Journals

Journals are news publications with longer articles of similar importance and length and are ideal for monthly publications. Authors are given information about the maximum and minimum letters, words, and lines of copy required for each article. Have fillers available that can be used at the end of any article. *Reader's Digest* is a good example of journal style.

The advantage of this format is that it gives a more permanent look to the publication; therefore, people are more likely to save journals (figure 11-34). Also, a 40# book can be used in the smaller sheet sizes to cut mailing costs.

SIZES. 5″ x 8½″, 8½″ x 11″.

PAPER. 20-24# bond or 40-60# book, coated and uncoated.

Directories

Directories are publications containing listings. Directories can be found in all companies, profit and nonprofit, as well as commercially produced as part

Figure 11-33 Inside section, front page.
Courtesy of: Delmar Publishers

Figure 11-34 Journal.
Credit: Suzanne Melear, graphic designer for Heavenly Visions Ministries, International

of the classified industry. Hanging indents and 1 pica right indents help separate the copy (figure 11-35). A condensed or narrow typeface is used and the body copy is set with a tight leading and type sizes as small as 7 points. Page sizes vary and directories are printed on newsprint or 20# plain bond.

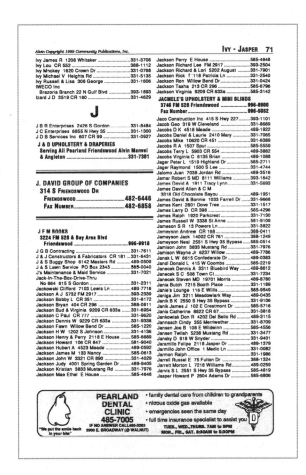

Figure 11-35 Directory.
Credit: Community Publications Incorporated, Roy Dabney and Angi Haxton, production artists

For additional research

Keep a well-balanced design approach by continuing research into some suggested sources:

Contact the Magazine Publishers of America
 575 Lexington Avenue
 New York, NY 10022

Historical information

Joran, Lewis, *The New York Times Manual of Style and Usage,* 1976.

White, Jan V., *Designing for Magazines,* New York: Bowker, 1992.

Trends

Nelson, Ray Paul, *Publication Design,* Dubuque: William Brown Publishing, 1987.

PageWorks, *Designing and Producing Newsletters,* Chicago: PageWorks, 1992.

*All forms multiply;
poorly designed forms
multiply and waste
employees' time.*

12 Forms

Form design and production
For additional research

*After reading this chapter and applying its principles, the
designer should have success:*

- Designing and controlling forms.
- Producing forms in a desktop publishing package
 or other similar packages.

Forms are similar to work orders that must be filled in completely. If forms are clear and orderly, the data can be filled in without questions or confusion. Then, forms can be processed and data retrieved rapidly.

Form design and production

Forms are a unique group of printed publications because they are purely functional. The function is to gather and move data in a way that saves the company money. Designing a form requires following standards that are established in a company or developing standards for collective application. The results are standardized forms with the same design style and type specifications grouped in the same order. Consistency increases efficiency and ease in completion.

Forms filled in at a computer may or may not be printed; instead, they may be stored electronically. Whether a form is printed or produced electronically, the design steps are the same and equal in importance.

The larger the company, the more critical it is for one person to be responsible for consistency. Designers establishing themselves in this market need traditional designing, English, LAN training, programming, system analysis abilities, and people skills.

Research and analysis

The time spent designing a form can rival the time spent on a premium logo but they do not require the same kind of research or analysis. The analysis of forms requires tracking the data being entered, processed, and retrieved and includes typical research such as matching the printing and bindery with the type specifications and grid.

Evaluation of function

Planning begins by establishing personal contact with the client. Ask questions about time, quality, and quantity in addition to questions about the data that the form is to collect. Then consider how the form serves the two types of users:

1. **For people who enter the data,** a form should…

 …take as little time as possible.

 … be easy to understand.

 …have adequate space for entries.

 …follow a logical sequence.

 …follow the standards of other forms.

2. **For people who process the data,** a form should…

 …take as little time as possible.

 …have data arranged in the processing order.

 …look light on the page so that fill-ins are prominent.

 …ask for the same data only one time.

Begin by establishing a standard system and design. Collect all forms from the different departments and then analyze and redesign where needed. If this is not possible, a system can be established with the first new forms and then gradually applied to others. The following sequences may be helpful:

1. Use an existing form. If it requests the same data, it is usable.

2. Consolidate with an existing form. If the data collected on both forms is similar consolidate and customize to suit your needs.

3. Design the new form.

Develop a checklist

This data will determine the level of design as well as how it should be set up on the page. Develop a standardized forms checklist to track how and where the form is used. Then choices of software and printing techniques can be made. Establish questions that fit these categories:

- Methods of entering data. Include questions related to how, when, and where the form is used.

- Processing of data. These questions include how the data is going to be interpreted. Some forms may be given to another employee and some will be returned in the mail or go directly from the screen image into the data storage area.

Design

Designing the form will continue to clarify the choice of software and output. Start by determining standard parts or elements that are common to all forms.

Assign a form name and number

This is the first step to standardize and consolidate forms. A form name gives a reference name. It has two parts: descriptive—what it is, and functional—what it does. The form number gives an orderly way to identify the form.

Choose a functional name

Following is a listing of basic function names, alternate names, and typical form names. A firm may use an alternate function name because of their professional language. If that is the case, switch to the alternate descriptive name for all forms. Transfer design techniques learned from one form to another form. For example, use the function name "request." Add a description to it: "Personnel request." Other forms may be called "Leave request" and "Work request."

Adjustment. To correct, increase, decrease, amend, eliminate, cancel, or reject.
Examples: Inventory adjustment and salary adjustment.

Application. To function, operate, employ, use, or exercise.
Examples: Job application and credit application.

Authorization. To allow, commission, permit, approve, consent, or support.
Examples: Medical authorization and vacation authorization.

Cancellation. To abolish, annul, recall, repeal, retract, dissolve, or invalidate.
Examples: Service cancellation and prescription cancellation.

Claim. To demand, ask, entitle, call, declare, or maintain.
Examples: Insurance claim and luggage claim.

Confirmation. To validate, support, verify, authenticate, or document.
Examples: Reservation confirmation and appointment confirmation.

Contract. To attest, confirm, endorse, guarantee, testify, verify, or agree.
Examples: Service contract and employment contract.

Estimate. To appraise, calculate, compute, or evaluate.
Examples: Service estimate and project estimate.

Inventory. To catalog, list, record, register, account, establish, or describe.
Examples: Software inventory and product inventory.

Invoice. Statement, bill, tab, or check.
Examples: Supply invoice and service invoice.

Log. A diary or listing in chronological order.
Examples: Daily log and phone log.

Memo. To communicate within a company.
Examples: Debit memo and monthly memo.

Notification. To inform, invoice, report, or warn.
Examples: Service notification and past due notification.

Order. To instruct, regulate, rule, purchase, or secure.
Examples: Work order and change order.

Receipt. A ledger, book, record, roster, list, or account.
Examples: Delivery receipt and payment receipt.

Report. An inventory, account, summary, or announcement.
Examples: Expense report and accident report.

Request. To apply, ask, inquire, question, petition, demand, or appeal.
Examples: Personnel request and supply request.

Routing. To transmit, send, transport, transfer, forward, issue, or remit.
Examples: Employee routing and lab routing.

Schedule. A list, classification, catalogue, record, or register.
Examples: Service schedule and work schedule.

Statement. An account, budget, bill, audit, invoice, check, or charge.
Examples: Monthly earnings statement and credit statement.

Summary. A brief, abstract, outline, summary, or data.
Examples: Contract summary and sales summary.

Transfer. To relocate, move, reassign, or shift.
Examples: Equipment transfer and budget transfer.

Assign a form number

When there are more than fifty forms, a small identification number at the top left hand corner or one of the bottom corners helps to file and locate. Begin with an alpha number for each company. Let the first one or two prefixes give information about the department; let any other numbers be sequential; for example SI = Safety Industries, 01 = Personnel Department, and 018 = 18th form for that department. Therefore, a typical form number would read: SI 01-018.

Page segments

Grouping the Upper Left hand Corner (ULC) areas on a form is done in zones and segments. Separating copy into zones and segments helps to place the copy when sketching. Divide the body into segments (figure 12-1).

Permanent information

Some permanent data identifies and informs but does not require a response. It can be positioned wherever it is noticeable to the reader. Once an area on the format is identified for this information, it should be located in that position consistently. Following are permanent information categories in order:

PERMANENT
INFORMATION

FILL-IN
SEGMENTS

QUICK LUBE WORK ORDER Nᵒ.

CM-1001 (12/99) 1 OF 2

TO: MAINTANENCE DEPARTMENT

CUSTOMER NAME	ORDER DATE/TIME
TELEPHONE NUMBER	DUE DATE/TIME
ADDRESS	SERVICE CONTRACT ☐ YES ☐ NO

CITY	STATE	ZIP	ODOMETER READING

CHECK BOXES

QUANTITY	PART NUMBER	WEIGHT OF OIL	COST

COLUMN DESIGN

LABOR

BRIEF
DESCRIPTION

			TOTAL	

PLEASE CHECK:

☐ OIL CHANGE ☐ LUBRICATION

☐ TIRES ROTATED ☐ HOSES AND BELTS CHECKED

☐ AIR FILTER ☐ FLUIDS ADDED

MECHANIC'S SIGNATURE	CUSTOMER'S SIGNATURE	DATE

SIGNATURES
LINE

Figure 12-1 Sample form showing page segments

1. Form name and number. This should be out of the way of the data. It can appear at the top or bottom left or right hand side.

2. Company signature. For business-to-customer forms, it is displayed prominently and includes the logo. For business-to-employee forms, it is for identification and may be with the form name and number within its type specifications.

3. Numbering. All forms software programs can include automatic numbering. Traditionally, the most common location is in the upper right hand corner. Consecutive numbering of a printed form requires exact placement of a blank area of the form for the numbering device (see figures 12-1 and 12-16).

4. General instructions/routing. General instructions for filling in data should be listed at the top of the form, but special instructions should be listed throughout as needed. Distribution information can be listed in the routing or mailing address window at the top or at the bottom.

5. Functionality (intelligence). Plan additional information for electronic forms by adding functionality (intelligence) with customized help fields, calculation within the data fields, down multiple choices, and radio buttons for yes/no.

Fill-in segments

This permanent information explains what kind of information is requested in each blank. Like body copy, the rest of the form should be built around the requirements for these sections.

1. Standard personal data. This includes the request for name, address, city, state, zip, Social Security, and so on. Always set them in the same sequence.

2. ULC boxes have type in the upper left hand corner to fill in short answers.

3. Ballot boxes. Use ballot boxes instead of fill-ins when choices are limited to two or a few common answers.

4. Column material. Column information, like listings on a purchase order, requires lines to follow for each section of the fill-in.

5. Narrative. Narrative or short essay type answers need lines for writing.

6. Approvals. Authorization signatures and dates are easiest to find if they are after the last item of fill-in data.

7. Special instructions/reference material. Instructions are permanent information listed in the section above and repeated because they may be interspersed between fill-in segments.

Identifying segments

Dividing the copy into segments is similar to adding subheads in body text. In the body of the form, divide segments by either heavier lines (2 points) or by a box, which makes the form easier to follow. The "subhead" is used to identify each segment and can be included as a heading placed at the top of each segment between two lines or at a 90° angle on the left margin. Form samples within this chapter use both methods and types of divisions. Three helpful ways to segment are:

1. By type of fill-in, such as write in, column material, check boxes, and signatures.

2. By type of data (the functional use for the information) such as shipping.

3. By areas reserved to each person handling the form. Consider areas for the flow from customer, expediter, processing clerk, technical, and so on.

ULC arrangement

An efficient format for forms is ULC arrangement. All printed captions are located in the upper left hand corner of a box, which allows the person who enters the data to write or type in the entire box, not just after the caption. ULC arrangement design includes all the guidelines of good design: the data is grouped, the reader can move smoothly from one area to another, all forms within a company have a consistency of design, and they are pleasant to handle.

"Captions concise and clear, instructions brief but useful," is an example of how easy it is for an efficient statement to be written in only a few words. The printed data on a form should take as little time and space as possible. In most cases, this requires only one or two words.

For example, start with a simple request for a mailing address and compare the traditional typewriter format and ULC arrangement. Change it from fill-in-the blank to ULC box style (figure 12-2).

Date _____

Social Security Number _____

Name (First, (MI or Maiden), Last)_____

Address _____

City _____State_____

Zip _____

Phone (Include your area code)_____

Fax _____

NAME (First, MI/Maiden, Last)		DATE
ADDRESS		SOCIAL SECURITY NUMBER
CITY		PHONE (Area Code+)
STATE (ABBREVIATION.)	ZIP	FAX

Figure 12-2 ULC arrangement with segments

| NAME (Last, mi, first) | SOCIAL SECURITY |
| BIRTHDAY(use numerical numbers) | PLACE OF BIRTH (Include city and state) |

Lower case

| NAME: Last MI First | SOCIAL SECURITY |
| BIRTHDAY: Use numerical numbers | PLACE OF BIRTH: City State |

Lower case with tabs and markers

| NAME *(Last, mi, first)* | SOCIAL SECURITY |
| BIRTHDAY (use numerical numbers) | PLACE OF BIRTH *(Include city and state)* |

Lower case italics

Figure 12-3 Expanding a blank

BRIEFLY DESCRIBE THE ACCIDENT

BRIEFLY DESCRIBE THE ACCIDENT

Figure 12-4 Paragraph fill-in

ARRIVAL	NAME	BUSINESS	DEPARTURE

ARRIVAL	NAME	BUSINESS	DEPARTURE

ARRIVAL	NAME	BUSINESS	DEPARTURE

ARRIVAL	NAME	BUSINESS	DEPARTURE

Figure 12-5 Column design

- Change wordy explanation sentences to one or two words.
- Establish a line spacing: 24 points (.333 inches) for handwriting or computer fill-ins.
- Place permanent information at the same tab stop whenever possible.

Expanding a blank

This is a technique used when it is important to list the data in a specific order or to make the box clearer. Expansion can be lower case, a serif face, or italics. Some expansions may be clearer alone in a blank (figure 12-3).

Questions requiring a brief description

These are used to keep the orderly look of the form. ULC arrangement continues to be used for areas that require a short essay. No lines are required for electronic forms (figure 12-4).

Column design

For a column section on a form, there is little printed text. Use the same crisp clean sans serif face. The column heads are all caps, centered in each column. The type size is the same size or one size smaller than the rest of the printed data. If the headings are longer than the column area, the text block containing all the headings can be turned 90° or put on multiple lines like on charts (figure 12-5).

Reverse boxes and tints

Reverse boxes or column headings are used to identify the most important or most frequently used areas and to separate an area that will be used later. The first sample is 100% blue and black and the second sample is 60% blue and 60 percent black.

Check boxes

Check boxes, pull down windows (with choices), and radio buttons all assist in processing the data when the same answers occur frequently. There are times when a response requires an answer of which there is no common choice of answers. When there are two or three common answers and many other answers that are less frequently given, the question is placed in the center of the block (figure 12-6).

Questions with ratings

Rather than repeating a rating scale, it can be included across the top of the form (figure 12-7).

Design for filing and mailing

Filing and mailing are important aspects of forms but they present limitations. If a window return envelope is used for mailings, the location of the block marked for the customer's address must match the window. Cut a sheet of paper to fit into that specific envelope and mark the location of the mailing address area. Use a sheet size ¼ to ½" smaller than the envelope size. It should not slip around and hide the address, nor should it fit so tight that the envelope cannot lay flat. If the form is to be used as a shipping slip, the 8½" x 11" sheet will be folded so that the customer's address is in the top right hand side to match the shipping sleeve.

Binders

Allow ¾" at the top for a fold-over binder or ½" on the side for side binders.

Punching

For use in file folders, two-hole punch at the top, 3¾" out of center.

Numbering

When numbering is required, ask the printer where to locate the space needed for the numbering machine. It is usually in the top right hand corner or in the bottom right hand corner.

Window envelopes

The window openings are usually, but not always, ⅞" from the side and ½" from the bottom. The address should not fit to the end of the area since the sheet needs about a ½" movement in the envelope to prevent from buckling.

✗ Cross reference: Refer to figures 11-8 through 11-10 for samples.

Envelope Size	Invoice Size	Sheet Size
#9	3⅞" x 8⅞"	8½" x 11" or 8" x 7"
#10	4 ¼" x 10⅛"	8½" x 11" or 8½" x 7"
#6¾	3⅝" x 6½"	8½" x 11" or 8½" x 7"
#8⅝	3⅝" x 8⅝"	8½" x 11" or 8½" x 7"

Sketches

If the form needs to be sketched full size, use a sheet of grid paper, a pencil, and a big eraser. Most forms filled in by a computer use 24-point spacing and by hand use 24- or 36-point spacing (2 or 3 picas). Forms look ragged when sections are not set at the same tab because the fill-in cannot be made with the same tabs. One sketch is probably all that is necessary for most forms. Use a full size pica grid sheet to clarify the size and shape of the design, put the segments and zones in a logical order, and track the path the data will follow.

Page sizes

If a form is to be printed, there are a variety of sheet sizes used for special needs. Whenever possible, the standard and custom design should fit on 8½" x 11". Electronic forms may need to be printed to laser prints or copiers and require standard size sheets. If a size larger than 8½" x 11" is required, a warning should be included on the form to change sizes in the printer.

IMAGESETTER CHECKLIST

CUSTOMER

INCLUDE WITH JOB...	COMPUTER INFORMATION

DOS

☐ 5 1/2 " DISK ☐ 3 1/2 " DISK

MAC	DISK	SYSTEM VERSION
☐ SUPER DRIVE ☐ 800K DRIVE	☐ 1.2 MEG ☐ 800K ☐ REMOVABLE	

☐

FILE

FILE NAME	PAGE SIZE	NO. OF PAGES

SOFTWARE PROGRAM	☐ PREPRINT ☐ CHECKLIST	VERSION (later versions of the program need to accompany the job)

☐

FONTS

FONT NAMES (i.e., Times Bold Italics, etc.)	KIND OF FONTS

☐ ADOBE, TYPE 1

☐ POSTSCRIPT

☐ TRUE FONTS, must send fonts

☐ NON-POSTSCRIPT, must send fonts

If non-PS fonts give additional information

☐

GRAPHICS

GRAPHICS (List exact names)	FILE FORMAT

☐

LASER PROOF

PMS COLORS

☐ SPOT COLOR

☐ SPOT COLOR WITH PMS

☐ FOUR-COLOR SEPARATION

☐ FOUR-COLOR SEPARATION WITH PMS

☐ BLEEDS

☐ TRAPS

NAME OF LASER PRINTER

FINAL OUTPUT	OUTPUT ☐ NEGATIVE ☐ PAPER PROOF ☐ RREU ☐ RRED	DPI ☐ 1270 ☐ 2540	CROP MARKS ☐ YES ☐ NO	% OF ORIGNIAL SIZE	NO. OF COPIES
	LINE SCREEN ☐ 133 ☐ 150 ☐ 175 ☐ 200	OTHER			

Jobs requiring assembly for press sheet sizes or tints need to include prepress charges. S. Devall

Figure 12-6 Check boxes

INDUSTRY EVALUATION

INSTRUCTIONS:

Please circle the rating that matches your department requirements.
Thanks again for your help.

RATING
0 - NO EXPERIENCE /KNOWLEDGE IN THIS AREA
1 - EXPOSED TO CONCEPT/NO HANDS-ON EXPERIENCE
2 - ENTRY LEVEL SKILLS WITH CLOSE SUPERVISION
3 - TECHNICAL SKILLS WITH LIMITED SUPERVISION
4 - TECHNICAL SKILLS WITH NO SUPERVISION

OVERALL COMPETENCIES OF ALL WORK GROUPS

	0	1	2	3	4
Identify, evaluate, organize, and plan work area.	0	1	2	3	4
Able to work in a multi-task department.	0	1	2	3	4
Work cooperatively with others.	0	1	2	3	4
Manage complex interrelationships, proper work ethic/habits.	0	1	2	3	4
Work with a variety of occupational specific and related areas within a department.	0	1	2	3	4
Improve techniques or conditions in the work environment.	0	1	2	3	4
Exhibit mastery of verbal and written English.	0	1	2	3	4
Exhibit mastery of verbal fluency in a secondary language, such as Spanish.	0	1	2	3	4

	0	1	2	3	4
SAFETY					
Know all general safety rules and techniques.					
Read and comprehend Material Safety Data Sheets.					
Follow specific safety procedures when operating equipment.					
MATH					
Solve math problems involving fractions, decimal & percentages.					
Solve paper cutting calculations.					
Solve inches, picas, & points conversion problems.					
Use points and picas for all measurements other than paper.					
Solve cost estimating problems.					
PREPARATION & RESEARCH					
Design publications on a basic and standard level using industry standards.					
Design publications on a premium and showcase level using industry standards.					
Use type sizes and format for fifteen kinds of publications within professional standards.					
Use the basic principles of design with grids.					
Spec copy as to font, weight, leading, case and line length.					
Complete a rough requiring copyfitting.					
Know the name of at least ten serif and sans serif type styles and their uses.					

Figure 12-7 Questions with ratings

Sheet size **2-up** **4-up**
8½″ x 11″ 5½″ x 8½″ 4¼″ x 5½″

Type specifications

A good, clean sans serif face will help the data (fill-ins) stand out. For electronic forms, the font must be available to every computer workstation.

Try to use the smallest readable size body copy so that the permanent data will allow room for fill-ins across each box. The permanent data can be 40% gray and the fill-in black. Some printed forms use light green or brown ink to let the filled-in data stand out.

If the form is on the computer, fill-in data should be larger than the permanent data, up to 12-point type, to contrast with the form. Some typefaces are not as readable on a computer screen as others. Set up a sample page of all typefaces as screen samples.

Production software

There are a variety of software packages used for forms. Choose one that fits the company size, location of use, and storage data requirements from this group of software.

Electronic forms software

Software is used when the personal computer will gather, transmit, store, and retrieve the data. It can be linked through networks and printed copies. Forms can be generated on-demand or in quantities. The end result of this system is not only a screen-imaged form that works effectively with data, but rather a *system* that does. Since screen images can bring the user to a screen containing only the boxes for one section or one question, the image may only appear "form-like" in a storage or printed phase.

Advantages: Software eliminates the need for printed form storage. Revisions can be placed on a network without the normal headache of destroying old forms. Most are user-friendly: the user only has to know how to type and tab. Because data fields are intelligent, the information is automatically processed and distributed. Data is fed back to the user if the form is incomplete.

There is still the option of printing a single copy at any time.

Disadvantage: Use of software requires security and is, therefore, dependent on a company information systems infrastructure.

Data management software

This software allows designing in the software package, storing the data, and moving it automatically into other forms and network transfer. Text can be imported for a word processing or page layout software package.

Advantages: The software is user-friendly and revises without loss of data. It has security options for revisions and access of data and works in tandem with complex forms produced in a page layout package.

Disadvantage: There is less latitude for data storage and transfer intelligence.

Office integrated software

This software is most effective in a small office environment. Programs may link data, so it is also accessible for word processing and multimedia.

Advantages: Office integrated software is linked to other office software and has storage capacity.

Disadvantages: It is limited to standard level forms and to forms requiring printed copies. Data should not be stored in a separate usable file.

Page layout and drawing software packages

Small and medium-size companies may use their graphics department for forms design. If this is the case, that group will use page layout and drawing software packages.

Advantage: They give a range of design choices and measurement systems.

Disadvantage: These packages will not always link to information processing or electronic forms software.

Forms inventory log

Use a database or a numerical listing with descriptive names, dates assigned, and dates destroyed. A new form should not be assigned a number for two years, since the form might be reactivated.

> ✘ Cross reference: Refer to the "Assign a Form Number" section at the beginning of this chapter.

SI 01-017	Daily log	7-97
SI 01-018	Personnel request	3-99
SI 01-019	Employment contract	10-99

Production hints

Page layout, drawing, and some data and office integrated software allow the type to be set up with text blocks and tabs. Production is simple when a few general rules are followed:

- Set all leading at 12 points.
- Keep each zone in one text block.
- Use tab defaults whenever possible or keep tabs set on a pica measurement.
- Paste ruled lines at exact multiples of 12 points and if master pages are available, place them on a master page.
- After the form is completed, move all text blocks 3 points to the left and add vertical lines at pica measurements.
- If a form has a section that cannot be set at 12-point leadings, build a style with the rules included and adjust the leading until that block fits into the assigned space.

Specialty printing

Forms manufacturers produce printing copies with interleaf carbons to use when a form is sent outside the office or a computer is unavailable. Small and new companies may purchase preprinted forms and add their names with a rubber stamp. Some forms are universal, such as invoices, telephone slips, and employee logs. Forms catalogs are available at office supply companies, local printing companies, and in business magazines.

Forms samples

Range for type specifications

Element	Type Specifications for Printed Forms	Type Specifications for Electronic Forms
All permanent information	Helvetica (Arial) regular or condensed	Helvetica (Arial) regular or condensed
Headings	10–12 pt, all caps	10–12 pt, all caps
Column heads	6–8 pt, all caps	7–8 pt, all caps
Other type	6–8 pt, all caps	7–8 pt, all caps
Paragraphs	6–8 pt, U & lc	9–10 pt, U & lc
Window/address	Follow postal requirements	(not applicable)
Special instructions	6–8 pt, U & lc	7–8 pt, U & lc
Column material	6-8 pt, all caps	
Signatures	Same as column heads	
Fill-ins	8–11 pt	9–10 pt, Times or any narrow serif face, U & lc, bold

Standard level forms

Standard level forms (figures 12-8 through 12-10) require little or no analysis and little designing. With the exception of job applications, most basic forms are standard level. Invoices, purchase orders, inventory sheets, estimating sheets, installation schedules, telephone messages, vacation forms, and daily logs are a few examples. There are also good templates included with some software programs, which can serve initial needs.

Elements	Type Specifications
Form name	10-pt Helvetica bold, all caps, 12-pt leading
Body copy	7-pt Helvetica regular, all caps, 24-pt leading
Line width	½-point lines

PAPER. Use 20# bond/50# book and carbonless paper, 67# bristol, or 1-ply index.

METHODS OF TYPESETTING. Page layout, drawing, data management, and office integrated software.

OUTPUT DEVICE.

1st Choice—Laser original (1000 dpi or greater) to copier or on-demand printing.

2nd Choice—Laser original (1000 dpi or greater) to conventional small press.

3rd Choice—Desktop file to plate at conventional small press.

Custom level forms

Custom level forms require some forms analysis and designing from scratch. The software package of choice should output to film or store data, depending on the needs of the form (figures 12-11 through 12-13). Most are produced in a page layout and/or data management software. A specific work group can have all their forms linked in that software package and can automatically upgrade data and revise forms. Forms that are filled in away from a computer will need a hybrid system.

After the first form has been completed, a customized template can be made. If the software allows multiple master pages, any horizontal line spacing can be saved. There may be two or three templates to accommodate different paper sizes or several software packages for different environments. All methods of typesetting are used.

OUTPUT DEVICE.

1st Choice—Laser original (1000 dpi or greater) to conventional small press.

2nd Choice—Desktop file to plate at conventional small press.

3rd Choice—Desktop file to film negative (service bureau) for conventional small press.

Premium level forms

Premium level forms will look like other forms but the analysis and system design will be more complex. Some outputs can range from on-demand specialty to multi-platforms (figures 12-14 through 12-16). The analysis and tracking of information for this data gathering resembles programming. The information can be gathered by several methods, translated into stored data, and retrieved in many formats from various software. The larger the information base, the more likely that a premium level design will be necessary.

PAPER. Use 11–17# bond with carbon interleafing for forms manufacturing, 20# bond for output to a laser printer from a computer file, and carbonless paper in a variety of paper choices for copiers or presses.

METHODS OF TYPESETTING. Web press, rough sketch on special grid sheet, and electronic storage.

OUTPUT DEVICE.

1st Choice—On-line at computer without a printed (hard) copy.

2nd Choice—On-demand printing.

3rd Choice—File to film negative (service bureau) for printing press.

Figure 12-14 is an excellent example of a form that is filled in by hand; there is adequate space both vertically and horizontally.

Figure 12-15 shows a computer-generated form. The type size of the text is 12 points for easier monitor viewing of the variety of sizes.

Figure 12-16 shows that analysis of the whole path of the data is more important than how complex the form looks.

STANDARD

SAFETY INDUSTRIES
5114 CENTRAL EXPRESSWAY
BUFFALO, WA 50012-0412
(214) 387-6632

QUANTITY	PRODUCT #	DESCRIPTION	UNIT PRICE	AMOUNT

SALES AMOUNT		
SALES TAX		
FREIGHT/SHIPPING		
TOTAL		

Figure 12-8, -9, -10
Standard level forms

SAFETY INDUSTRIES
5114 CENTRAL EXPRESSWAY
BUFFALO, WA 50012-0412

QUANTITY	PRODUCT #	B/O	DESCRIPTION	UNIT PRICE	AMOUNT

Payments received two weeks from the date listed on the invoice will receive a 10% discount. Payments received after the 25th of the month will not be posted until the next month. Products that are not satisfactory can be returned by postal delivery and will be replaced within one week.

TOTAL SALES		
SALES TAX		
FREIGHT/SHIPPING		
TOTAL		

SAFETY INDUSTRIES *Safety Films and Videos • Safety Supplies • Safety*

5114 CENTRAL EXPRESSWAY
BUFFALO, WA 50012-0412

DESCRIPTION OF SERVICE PERFORMED

TOTAL	SIGNATURE	DATE

WAT 1 (4-96)

**RECORDS & REPRODUCTION
PRINT REQUEST**

No. 04 15 96 07 50 06

DATE SUBMITTED	NAME			PROG. ACCOUNT	COST CODE	CHARGE ACCOUNT
DATE REQUIRED	DEPARTMENT		PHONE & EXTENSION	LOCATION (BUILDING & ROOM NO.)		

AVERAGE TURN AROUND TIME TWO (2) WORKING DAYS

PLEASE CHECK: BOND ☐ VELLUM ☐ BLUELINE ☐ PLEASE CHECK: PICK-UP ☐
FILM ☐ OPAQUE ☐ BLACKLINE ☐ OTHER ☐ MAIL ☐

PLEASE CHECK: FOLD ☐ STAPLE ☐ SCALE % ☐ ____ COLLATE ☐ 3-HOLE ☐

NO. OF ORIGINALS	COPIES PER ORIGINAL	SPECIAL INSTRUCTIONS	DRAWING NO. OR TITLE	SHEET NO.	PULL

DRAWING TRANSMITTAL SHEET

ORIGINAL(S) TO: _____ ROOM NO. _____

JOB _____ WORK ORDER NO. _____

____ prints per drawings above, transmitted to: _____
____ prints per drawings above, transmitted to: _____
____ prints per drawings above, transmitted to: _____
____ prints per drawings above, transmitted to: _____
____ prints per drawings above, transmitted to: _____
____ prints per drawings above, transmitted to: _____
____ prints per drawings above, transmitted to: _____
____ prints per drawings above, transmitted to: _____
____ prints per drawings above, transmitted to: _____
____ prints per drawings above, transmitted to: _____

Figure 12-11 Custom level form.
Credit: Tobi Watashe, CNA, forms automation specialist for HA Electronic Forms Specialty Interest Group

INDUSTRY QUESTIONNAIRE

YOUR COMPANY

1. Check the following classification that best describes your company:

☐ In-House Graphic Dept. ☐ Education ☐ Commercial Printing
☐ Advertising Firm ☐ Trade Shop ☐ Service Bureau

JOB CLASSIFICATION

2. Check the following workstations which apply to your business (check as many as necessary:)

☐ Pre-Press ☐ Printing ☐ Photography
☐ Desktop Publishing ☐ MultiMedia ☐ Bindery

If you are not directly involved with some of the above workstations...
- **please reproduce as many copies as necessary for your company or**
- **please call us so we can send additional questionnaires to those responsible for the other areas.**
- **please help us to get this information to multimedia.**

EMPLOYEES	ENTRY LEVEL	TECHNICAL	PROFESSIONAL
3. Number of employees in each trade group category:			
4. Salary range (if known) for each level of positions:			
5. Indicate by checking your preference of education level in each of these:	☐ High Schools ☐ Jr. Colleges ☐ 4 year colleges	☐ High Schools ☐ Jr. Colleges ☐ 4 year colleges	☐ Jr. Colleges ☐ 4 year colleges ☐ Graduate Degree

6. Which are your sources of new skilled employees?

☐ High Schools ☐ Professional Associations
☐ Jr. Colleges ☐ Texas Employment Commission
☐ 4 year colleges ☐ Want Ads
☐ Personal Referral ☐ Walk-ins

7. Your perception of the effectiveness of vocationally trained employees:

☐ Below average performance ☐ Average performance
☐ Above average performance

8. Your source for retraining and upgrading employees:

☐ Educational Facilities ☐ In-house ☐ Private Trainers
☐ Association Training ☐ None done

9. Does your company support reimbursement for training?

☐ yes ☐ no

EQUIPMENT / SOFTWARE

10. Have you added new equipment or computers in the last three years?

☐ Equipment ☐ Computers ☐ Software

11. List them:

_____ _____ _____

_____ _____ _____

12. Check computer platform for desktop publishing:

☐ Mac based ☐ PC based ☐ Unix
☐ Sun

13. Check computer platform for electronic prepress:

☐ Mac based ☐ PC based ☐ Unix
☐ Sun

GRAPHIC INDUSTRY SURVEY

Figure 12-12 Custom level form

WAT 2 (4-96)

OFFICE SUPPLIES
NON-STOCK REQUISITION

N- 4 15 07 50 20

- A computer generated ticket is returned with your order to verify and acknowledge receipt of supplies requested.
- Back orders will automatically be shipped when the product is available. DO NOT REORDER.
- For information on Returns or Credits, see Stationery Catalog.
- Retain a copy for your records and send one copy to Stationery, Headquarters, Room 123.

DEPARTMENT NAME	DEPT. COST CODE	CHARGE CODE	DATE 04-15-96
NAME OF PERSON ORDERING	ROOM NO	PHONE NO.	EXTENSION

DESKTOP DELIVERY? YES ☐ NO ☐

DESKTOP: MAIN ☐ SUB ☐ ATLANTA ☐ L.A. ☐

(WRITE IN LOCATION IF NOT A DESKTOP DELIVERY.)

SHIP TO:

QUANTITY REQUESTED	MANUFACTURER		DESCRIPTION
	STOCK NUMBER	NAME	

SUBMITTED BY	CHARGE CODE MANAGER'S APPROVAL	FILLED BY

This form is for NON-STOCK items only. Stock items should be ordered using WAC 3A (Office Supplies Stock Requisition).
Non-stock orders will be charged directly to the requisitioning department.

Figure 12-13 Custom level form.
Credit: Tobi Watashe, CNA, forms automation specialist for HA Electronic Forms Specialty Interest Group

PREMIUM

E-Z-OUT ®

Uarco Business Forms - P

08048

D-427 (4/73)

EFFECTIVE DATE	CONTROL NO.

MARKETING AUTOMOTIVE CHANGE NOTIFICATION

TYPE OF CHANGE (Check appropriate box and enter required information)

☐ LOCATION CHANGE ▶ FROM LOCATION TO LOCATION

☐ NEW UNIT ▶ A.F.E. NO. ☐ LOST UNIT ▶ D-121 NO. ☐ REVISION OF EXPENSE DISTRIBUTION

☐ ASSIGNMENT CHANGE ▶ EMPLOYEE NAME NOW ASSIGNED TO EMPLOYEE NO. EMPLOYEE LOCATION

TYPE OF VEHICLE

☐ PASSENGER CARS AND LIGHT TRUCKS (CODE 10) ☐ AVIATION REFUELER Complete next line (CODE 20) ☐ TRUCK (CODE 30) ☐ TRAILER (CODE 40)

AVIATION REFUELER ▶ LEASED TO LOCATION

KEYPUNCH DATA — (Shaded area will be completed by Information Center)

CONTROL	VEHICLE NO.	LINE ITEM	SUB ACCOUNT	RECEIVING LOCATION W.I.C. NUMBER	TANK CAPACITY	YEAR ACQ.	VEHICLE STATUS
1 2 3 4	5 6 7 8 9	10 11 12 13 14	15 16 17 18	19 20 21 22 23 24 25 26 27 28 29	30 31 32 33 34	35 36	37 38 39 40 41 42
* 2 V V							

EMPLOYEE NO.	VEHICLE DESCRIPTION	TYPE OF VEH.	APPR. CODE	DEPT.	CLASS OF TRADE	EXPIRATION DATE MO.	DAY	YEAR
43 44 45 46 47 48	49 50 51 52 53 54 55 56 57 58 59 60 61	62 63	64 65	66 67	68 69 70	71 72	73 74	75 76 77 78 79 80

PREPARED BY	APPROVAL ▶	DISTRICT MGR./PLANT SUPER./DEPT. MGR.	LOCATION

INFORMATION CENTER
MARKETING GENERAL ACCOUNTING

SAMPLE

Figure 12-14 Premium level form. *Credit:Lou Ledda, forms analyst*

For additional research

Keep a well-balanced design approach by continuing research into some suggested sources:

Review forms from outside the company, especially job applications.

Check other forms from this company.

Review magazine articles on the newest software.

Attend technical seminars from professional groups and software providers.

Contact the
Association of Information System Production
104 Wilmot Road #201
Deerfield, IL 60015

Historical information

Jacobs, Marvin, *Forms Design II: The Course for Paper and Electronic Forms,* Cleveland: Mueller Printing, 1992.

Knox, Frank M., *The Knox Standard Guide to Design and Control of Business Forms,* New York: Mc-Graw-Hill Book Company, 1965.

PREMIUM

WAT 12 (4-96)

CENTRAL LAN SECURITY FORM

ADD ☐ DELETE ☐ MODIFY ☐

USER INFORMATION

Employee # _____

User Last Name _____

First Name _____ Middle Initial _____

Phone _____ Title _____

Dept/Div _____ Location _____ Room _____

Indicate DEFAULT SERVER with an X Indicate ADDITIONAL access with an A	COMMENTS
CEN1 CENTRAL LAN	
SUB1 SUBSTATION LAN	
DAL1 DALLAS LAN	

CENTRAL SQL SERVER; Indicate system(s) requested. Additional form will be sent to you.

Electronic Mail Access YES ☐ NO ☐

Dial In Access YES ☐ NO ☐

Restrict Dial In Hours YES ☐ NO ☐ If YES, hours of access are: _____ to _____

Restrict Dial In Days YES ☐ NO ☐ If YES, days of access are:

S ☐ M ☐ T ☐ W ☐ T ☐ F ☐ S ☐

Internet Access YES ☐ NO ☐ *If YES, Manager approval is required.*

GROUPS/SHARED DIRECTORIES

SPECIAL INSTRUCTIONS/COMMENTS

USER SIGNATURE _____ DATE _____

SYSTEM ADMINISTRATOR _____ DATE _____

Manager's Signature is Required for Internet Access Only

MANAGER'S SIGNATURE _____ DATE _____

Figure 12-15 Premium level form.
Credit: Tobi Watashe, CNA, forms automation specialist for HA Electronic Forms Specialty Interest Group

PREMIUM

Shell Oil Company
Shell Chemical Company
Shell Pipe Line Corporation
Shell Development Company

CONTROL NO.

SERVICE ANNIVERSARY AWARD ORDER

SR-5776 (REV. 9-81)

SHIP AWARD TO	

COMPANY PAY CENTER ▷	DATE REQUIRED BY "SHIP-TO" LOCATION ▷
YEARS OF SERVICE ▷	ANNIVERSARY DATE ▷

EMPLOYEE NAME AND ADDRESS

WALLACE BUSINESS FORMS, INC.

PLEASE RETURN FORM WITHIN 30 DAYS TO ENSURE DELIVERY PRIOR TO ANNIVERSARY

FOLD

PLEASE MAKE SELECTION FROM ENCLOSED BROCHURE AND CHECK CORRESPONDING BOX BELOW.

☐ A - TIE TACK/LAPEL PIN COMBINATION

☐ B - TIE CHAIN- ADJUSTABLE 2½" TO 4"

☐ C - PULL APART KEY CHAIN AND DISC-FLORENTINE FINISH

☐ D - KNIFE-FLORENTINE FINISH- Scissors, file and knife of fine West German steel

☐ E - BRACELET- FLORENTINE FINISH

☐ F - WATCH BANK- SPEIDEL TWIST-O-FLEX
 ☐ Gold Filled ☐ Stainless Steel

☐ G - BELT BUCKLE- 1¾" WIDTH FLORENTINE FINISH

☐ H - BROOCH/PENDANT COMBINATION

☐ I - 18" ROPE CHAIN AND PENDANT

☐ J - FLORENTINE SERPENTINE CHAIN WITH LOCKET- 15" long chain

☐ K - DOUBLE LINK BRACELET WITH CHARM

☐ L - DOUBLE STRANDED SERPENTINE BRACELET

☐ M - HEAVY CURB LINK NECKCHAIN—18"

EMPLOYEE'S SIGNATURE	DATE SIGNED

After signing, remove envelope from back of form, fold form on "FOLD" marks, insert in envelope and mail.

PERSONNEL INSURANCE AND RECORDS COPY

Figure 12-16 Premium level form. *Credit: Lou Ledda, forms analyst*

"...and before I knew it, I had been on the Web all night!"

Chapter

13 Web Design Packages

Introduction to the World Wide Web
Levels of design
Further research
For additional research

After reading this chapter and applying its principles, the designer should have success producing:

- Catalogs
- Newsletters
- Résumés
- Advertising
- Tutorials
- Technical assistance
- Magazines
- Corporate communications

A Web page is a convergence of book and broadcast media and can take on a number of communication directions, such as advertising, news, educational, research, intercompany communication, or public relations.

Introduction to the World Wide Web

The nature of the Web is that information is constantly in flux. To repeatedly attract a viewer (or "surfer"), the information on a Web page must change frequently. Visits (or "hits") by the surfer can be counted by the receiving computer via a small programmed application, providing an instant tally of readership.

Historically, the Internet was once a communication network for the purpose of sharing research between the education and defense systems. The communication format was in text form designed to move quickly from computer site to computer site via a network. CERN, The European Particle Physics Laboratory in Geneva, Switzerland, envisioned a more media-rich environment. The programmers at CERN created a common architecture for communications across a global network environment, now knows as the World Wide Web (WWW). Using Hypertext Transfer Protocol (HTTP), the WWW can send information regardless of the operating system (Mac, IBM, or UNIX). Through Hypertext Markup Language (HTML), a simple coding language interpreted by a "browser," the Web environment combines text with still graphics, audio, video, animation, and databases structured to link information. As the Internet became more media-oriented an provided an inexpensive method to communicate globally, industry and consumer presence has become more dominant.

Due to the initial communication format of the Internet, Web page design structure is dependent on the speed of transmission. Therefore, the design of a Web page must take into consideration how quickly the page appears on screen to the viewer. Text-based pages are faster to transmit and receive than pages with heavy graphics. So, knowing when to use graphics is very critical in the design of a Web page.

Focus and Reading environment

Understanding the design of a Web page begins with understanding the structure of a network. In a network, a client and a server communicate instructions to each other in the process of displaying a Web page. (The client, or viewer, is considered the receiving end of the Web page.) The display medium is

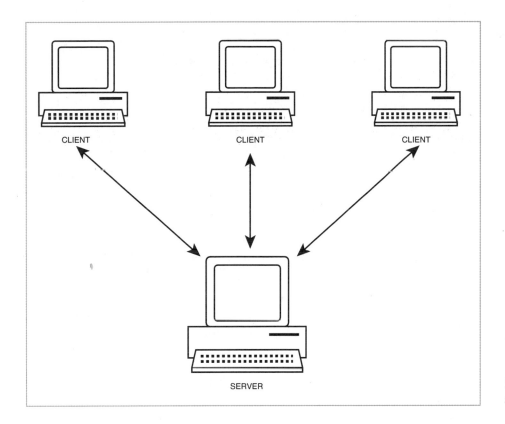

CLIENT

CLIENT

CLIENT

SERVER

Figure 13-1 Diagram of a client-server connection

usually a computer screen and the viewer has the option to print out or download to their own computer any information displayed. The server is the central depository of the Web page elements and all of the graphics, video, audio, and HTML documents are stored here. These two entities are connected, most commonly, through a phone line. The server can service a local client, such as within a company, or a remote client on the other side of the world. When the viewer from the client location calls a specific Web page on the server location via a Universal Resource Location (URL) address, the server responds by sending that page back to the client for viewing via an application called a browser (figure 13-1).

Netscape is a popular browser that displays Web pages in a window format and allows for the viewing of text, graphics, video, animation, and sound. When "browsing," the viewer may read in depth, scan the content very quickly in search of specific information, or just explore until some subject matter catches and holds his/her attention.

Web page design is structured to contain hyperlink jumps. Hyperlinks can be key words or graphics that are HTML coded to display additional

information when clicked on by the viewer. The designer of a Web page must have an understanding of navigation interface issues that organize information differently than a printed piece, since the viewer is interacting with the content to gain supportive information. This information is set up in modular form for ease of content construction and speed of transmission. Graphics are used as focal points or hyperlinks to other information. Video and audio are used sparingly, depending on the audience and the kind of computer connection the viewer has access to.

Audience

Web pages appeal to several audiences:

Business	Nonprofit organizations	Personal
Intercompany	Education	Individuals/private
Business-to-business	Government	Entertainment
Business-to-consumer	Museums	
Business-to-public		

Elements

Type can be HTML coded to display computer screen fonts or inserted as a graphic element. HTML type will display faster than fonts used as bitmap graphic elements. However, HTML type is controlled by the viewer through their browser of choice rather than by the designer of the Web page. HTML type has no tracking, kerning, or line spacing control when displayed by a browser.

In a basic Web page structure, type elements can be classified into two basic levels: headers and paragraphs.

Headers

Headers are divided into six sizes, level 1 the largest and level 6 the smallest. Paragraph text is used for body copy, which usually defaults to a consistent size indicated by the basefont value and controlled by the viewer. Depending on the Web browser, the designer can manipulate the font sizing relative to the default size of the basefont, which is controlled through the browser's "Preferences" or "Styles" dialog box. If a basefont value equals 3, then values less than 3 will result in a smaller size and values greater than 3 will result in a larger size (figure 13-2).

Paragraphs

Body copy in paragraphs can be controlled through basic HTML coding. Styles include bold, italic, strikethrough, pre-formatted, blockquotes, line breaks, and so on.

These styles allow the designer limited control over the typographical look. For example, browsers cannot recognize breaks in a line, extra spaces, or returns. The designer must use style formats such as line breaks, blockquotes, or pre-formatted text to control line breaks and spacing. However, such styles as the pre-formatted text display as a monospaced font such as Courier. This can be used in tables with columns or ASCII art (figure 13-3).

Type elements can also be created in graphic programs such as Adobe Illustrator™ and Adobe PhotoShop™, and embedded as inline graphics for more type design control. This style is considered art because it becomes a bitmap graphic. Be aware that "art type" can slow down the transmission of information if the page becomes too image intensive and it will not appear in browsers that display computer text only (figure 13-4).

Design sizes

Web page design size has two aspects: **memory size** of the HTML document according to upload and download time of information from server to client and the user's **computer monitor size**.

Regarding memory size, the designers often provide for various hook-ups by designing two ways of accessing the information. For the user that has fast connections, such as ISDN or T1 phone lines, the designer can be more generous in the inclusion of graphics, video, and audio. For the graphically challenged user with 9600 to 28.8K modem baud rates or older browsers such as Lynx (which is text only), the designer should provide a viewing alternative that is text based. The designer should always give the user a format choice between look and function unified by a solid navigation structure.

Regarding monitor sizes, the standard monitor is 640 (horizontal dimension) x 480 (vertical dimension) pixels. Pixels are small square dots, or "picture elements," that make up an image on the monitor. Their size corresponds to the "point" measure used in type sizing: 72 points = 6 picas or 1″. The ratio of any monitor size will be 4 units width to 3 units height. The viewing filed will be dependent on the size of the open window of the browser, which is scalable (figure 13-5). For example, the Netscape browser will open to an initial size of 486 (horizontal dimension) x 320 (vertical dimension) pixels and computer system based information such as HTML type will conform to the size of the window. Graphic images may extend beyond the default opening of the browser window, appearing cropped. The images will be offset from the top left edge of the window by 8 pixels. If the user changes the size of the window by scaling it larger or smaller, the text will reflow to fit the new size; however, the graphics will remain the size created by the designer. For example, if the window in Netscape is resized to fit a 14″ color screen, the available space for content will be 604 (horizontal dimension) by 304 (vertical dimension) pixels. This type of control is known as "user centric." It gives the user control of the viewing environment. The design for a user centric environment presents a challenge for the designer who is concerned with controlling the visual look of a page's layout.

This is a sample of Header 1

This is a sample of Header 2

This is a sample of Header 3

This is a sample of Header 4

This is a sample of Header 5

This is a sample of Header 6

Figure 13-2 Header level sizes/paragraph text and font size values

This a sample of a paragraph with a default basefont value of 3.

This a sample of a paragraph with a default font size value of 1.

This a sample of a paragraph with a default font size value of 2.

This a sample of a paragraph with a default font size value of 3.

This a sample of a paragraph with a default font size value of 4.

This a sample of a paragraph with a default font size value of 5.

This a sample of a paragraph with a default font size value of 6.

This a sample of a paragraph with a default font size value of 7.

```
Preformatted text uses a monospaced font such as Courier
and keeps spacing, tabs and returns intact.

HTML tags                               Function

<Hn></Hn>                               Header sizing
<P></P>                                 Paragraph
<B></B>                                 Bold style
<I></I>                                 Italic style
<U></U>                                 Underlining
<CENTER></CENTER>                       Center Alignment
```

Figure 13-3 Computer system type styles/pre-formatted text

bold, *italic*,

blockquotes

and ~~strikethrough~~

Figure 13-4 Art type

Netscape: WebMaster Home

Welcome to WebMaster Communications.

WebMaster's central offices is located in sunny California, with satellite offices in Denver, New York, and Paris. We are a full service web page design studio that specialize in creative solutions for your web site. Work with a staff of trained professional graphic designers, information designers, and programmers. We will work with you to maximize your communication dollars through carefull analysis and evaluation. Take a moment to review our portfolio.

Document: Done.

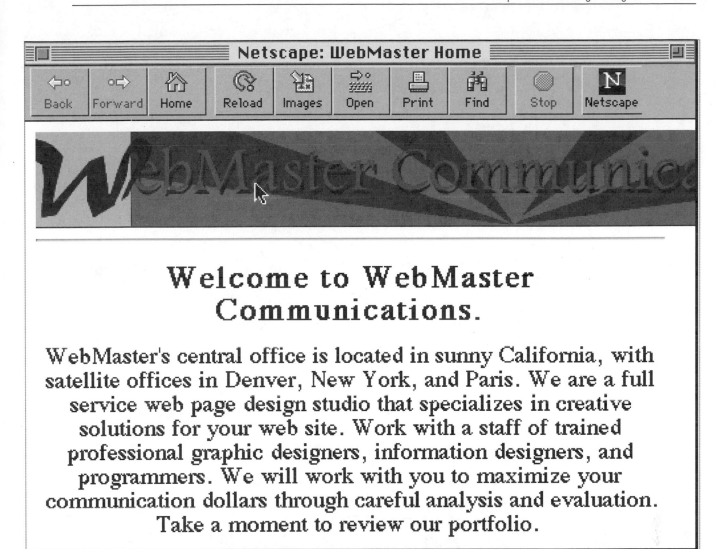

Figure 13-5 (Opposite, bottom and this page, above) Scaleable windows content

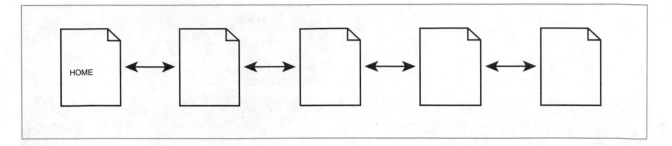

Figure 13-6 Linear navigation structure

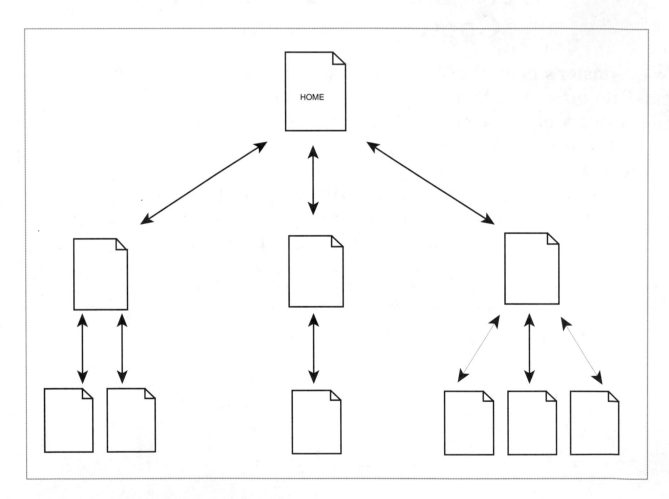

Figure 13-7 Hierarchical navigation structure

Layout

Web page layout consists of navigation layout for hyperlinked information and the individual page layout of each linked page.

Navigation layout

Navigation is based on the principles of "wayfinding" and is set up in linked information units or modules that are internal document links or external document links. Wayfinding structures provide the user with recognizable cues that give an indication of where to go to find information. These structures have various formats. The modular structure provides a way to keep the information in bite-size chunks for presentation, organization, transmission speed, and team collaboration (for complex Web site construction). An organizational chart is the best way to lay out the navigation for a Web page. The chart allows the designer to quickly establish the structure of navigation in various formats. Some common formats are linear, hierarchical, combination linear/hierarchical, and web.

Linear navigation works well with content that is book oriented. The first page leads to the next page and so on. It is easy for the user to follow, but static in its look and feel (figure 13-6).

Hierarchical navigation works well with content that is newspaper oriented. Each section has topics to choose from such as business, sports, or entertainment. It is easy for the user to follow and provides more variety of choice in its look and feel (figure 13-7).

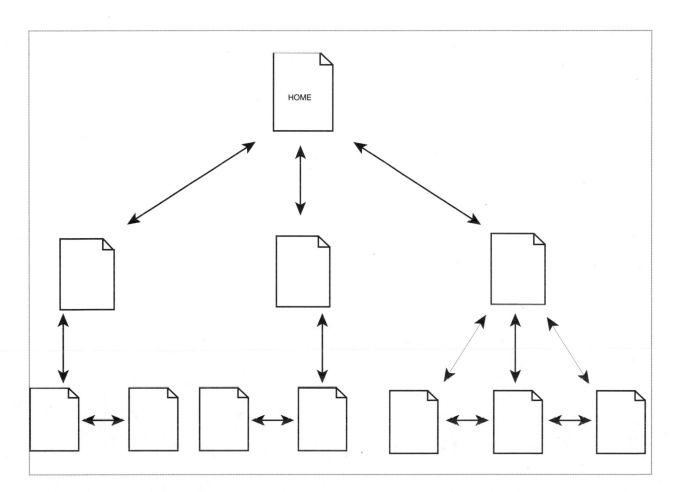

Figure 13-8 Linear/Hierarchical navigation structure

Linear/hierarchical navigation works well with content that is tutorial oriented. Each section has levels to choose from such as beginner, intermediate, or advanced. Sections may branch into a linear format to present procedures for that level of instruction. It is easy for the user to follow and provides more variety of choice in its look and feel (figure 13-8).

Web navigation works well with content that is exploratory oriented. This is a freeform format that borders on chaos. This format has a variety of choices in its look and feel but can be confusing to some users (figure 13-9).

Individual page layout

The individual page layout depends on the audience and their ability to access the content quickly. Up front optimization of colors and compression of audio and video must be done for a Web page to ensure speed in load times. Also, different operating systems will "see" information differently. For example, colors can have radical shifts from one system to another. Not all browsers see images and text the same way. Provide alternate text-based descriptions of images for on-line users who cannot access images through their browsers.

Image formats and optimization

The formats commonly used in Web pages re Graphics Interface Format (GIF) and Joint Photographic Experts Group (JPEG). Both allow the various computer platforms and operating systems to display images.

Images produced for a Web page can be scanned an retouched or created from scratch in a software package such as Adobe PhotoShop™. Since the display medium is a computer or a TV monitor, any image over 72 dpi will be wasted and require long download times. Images should be optimized to give the best color depth possible without using a lot of memory. For scanned photos, the most widely used color depth is 8 bit at 256 colors.

Color

Colors used in hyperlinks, HTML type, and backgrounds are generated by HTML encoding. They are identified by hexadecimal code. When creating custom artwork such as logos or graphics, use browser-save colors that will translate to all the computer platforms. Not all browsers, computer platforms, and operating systems see color the same way. There are only 216 browser-safe colors available in the 256 system palettes of the various computer platforms. It is recommended to use browser-safe colors to ensure that the colors are displayed as intended.

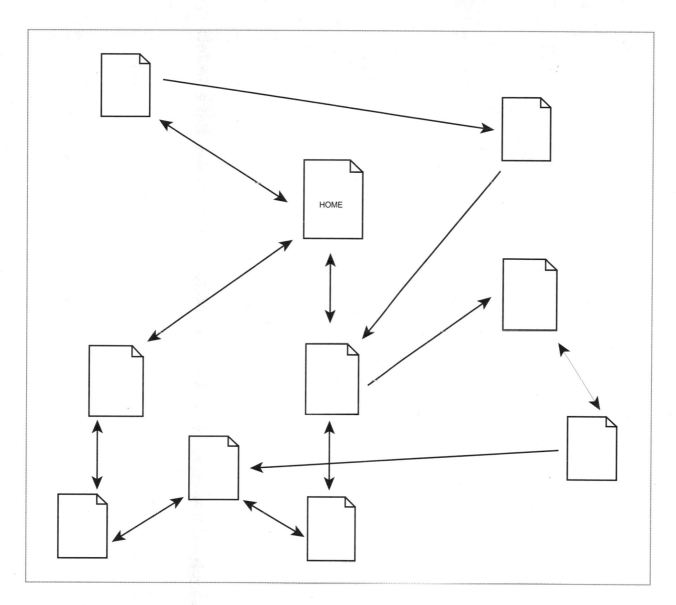

Figure 13-9 Web navigation structure

Levels of design

Levels of design are as important with web projects as they are with printed projects.

Standard level web pages

A standard web page has HTML type in a structured style with color backgrounds and color hypertext. Style guides were set up in early versions of HTML to help in Web information structure. Headers, for instance, divide content. While there are six levels of headers, most people do not use more than three. Think of headers as chapter divisions. Paragraphs flesh out the content. Early HTML browsers could only handle flush left text. With current versions, the designer can center align text. Tables and pre-formatted text are other ways to organize body copy in a column-like format. Hyperlinks can be structured within the body copy or as a table of contents that branches to relevant information in another document. Current browser extensions set up information in "frames" that can be structured within a scrollable window format.

The navigation in figure 13-10 is set so that the user can hyperlink to either the main chapter heading or to the specific sections of the chapter from the table of contents. The table of contents and chapters are separate modules linked by the designed hyperlinks. At the bottom of each section, paging text is available for the user to page either to the previous page or to the next page within the chapter section.

The background color has a hex value of #FFFFFF, the body text has a hex value of #330000, an unvisited link color hex value is #990000, the visited link hex value is #006666, and the active link hex value is #990033.

The main header, "Adobe Illustrator™," is header level 1. Subheads are set to header level 3 and chapter headings are set to header level 4. The basefont value of the body text is set to 3. The overview section is font value of 4 and font style is italic. The font color has a hex value of #AA1177. Each section is divided by a horizontal rule.

The practice steps are set within a table with a border of 1. The step procedure is set in bold, while the text explaining the action is set in plain text.

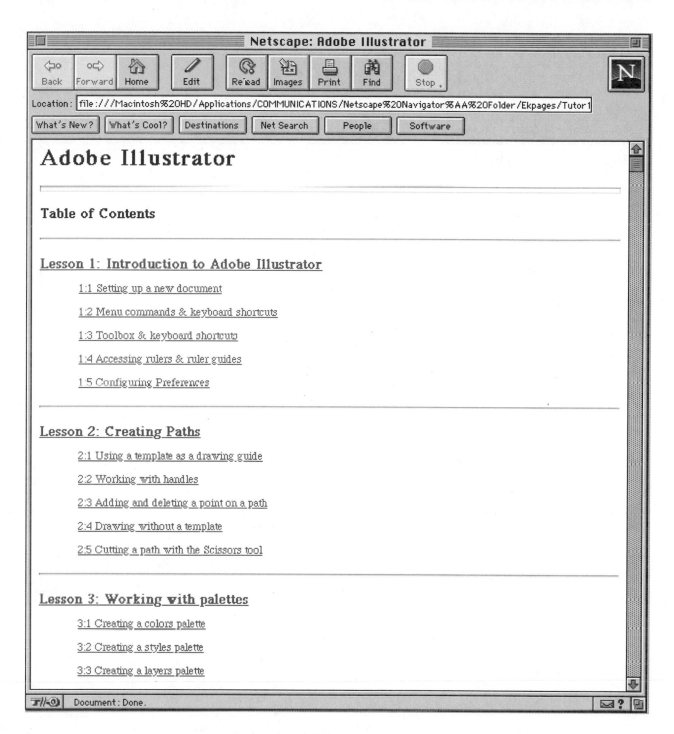

Figure 13-10 Standard level Web page (tutorial). ©1996 Web Design and HTML, created by Esther Kibby

(Continued)

Figure 13-10 Continued. Standard level Web page (tutorial). ©1996 Web Design and HTML, created by Esther Kibby

(Continued)

Figure 13-10 Continued. Standard level Web page (tutorial). ©1996 Web Design and HTML, created by Esther Kibby

(Continued)

Figure 13-10 Continued. Standard level Web page (tutorial). ©1996 Web Design and HTML, created by Esther Kibby

(Continued)

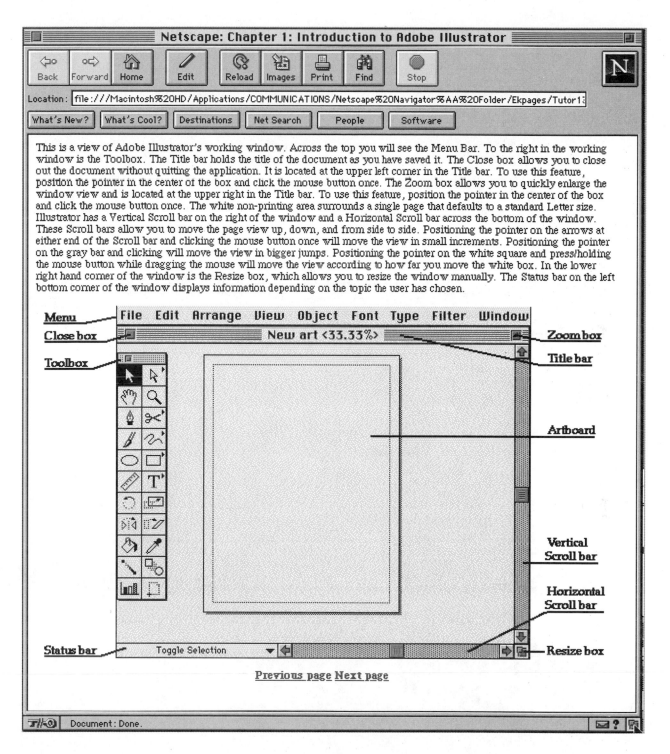

This is a view of Adobe Illustrator's working window. Across the top you will see the Menu Bar. To the right in the working window is the Toolbox. The Title bar holds the title of the document as you have saved it. The Close box allows you to close out the document without quitting the application. It is located at the upper left corner in the Title bar. To use this feature, position the pointer in the center of the box and click the mouse button once. The Zoom box allows you to quickly enlarge the window view and is located at the upper right in the Title bar. To use this feature, position the pointer in the center of the box and click the mouse button once. The white non-printing area surrounds a single page that defaults to a standard Letter size. Illustrator has a Vertical Scroll bar on the right of the window and a Horizontal Scroll bar across the bottom of the window. These Scroll bars allow you to move the page view up, down, and from side to side. Positioning the pointer on the arrows at either end of the Scroll bar and clicking the mouse button once will move the view in small increments. Positioning the pointer on the gray bar and clicking will move the view in bigger jumps. Positioning the pointer on the white square and press/holding the mouse button while dragging the mouse will move the view according to how far you move the white box. In the lower right hand corner of the window is the Resize box, which allows you to resize the window manually. The Status bar on the left bottom corner of the window displays information depending on the topic the user has chosen.

Figure 13-10 End. Standard level Web page (tutorial). ©1996 Web Design and HTML, created by Esther Kibby

The navigation in figure 13-11 is set so that the user can hyperlink to the main chapter heading from the table of contents. Within the chapters, the user can hyperlink to the various sections of that chapter. The table of contents and chapters are separate modules linked by the hyperlinks. At the bottom of each section, paging text is available for the user to page either to the previous page or to the next page within the chapter section.

The background color has a hex value of #CC-CCFF, the body text has a hex value of #330000, an unvisited link color hex value is #993333, the visited link hex value is #996666, and the active link hex value is #990033.

The main header, "Adobe Illustrator," is header level 1. Subheads are set to header level 3 and chapter headings re set to header level 4. The basefont value of the body text is set to 3. The overview section is font value of 4 and font style is bold with a color hex value of #333366. The overview section and the practice sections are inset from the section hyperlinks. Major chapter sections are divided by a horizontal rule. The horizontal rule separating the overview from the concepts has a value of 6.

In the practice section, all the body text is set in bold while the text explaining the action is indented from the step procedure.

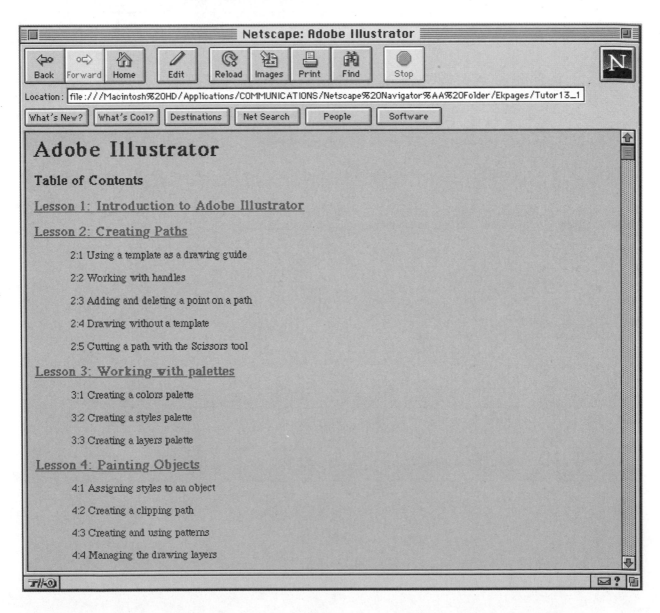

Figure 13-11 Standard level Web page (tutorial). ©1996 Web Design and HTML, created by Esther Kibby

(Continued)

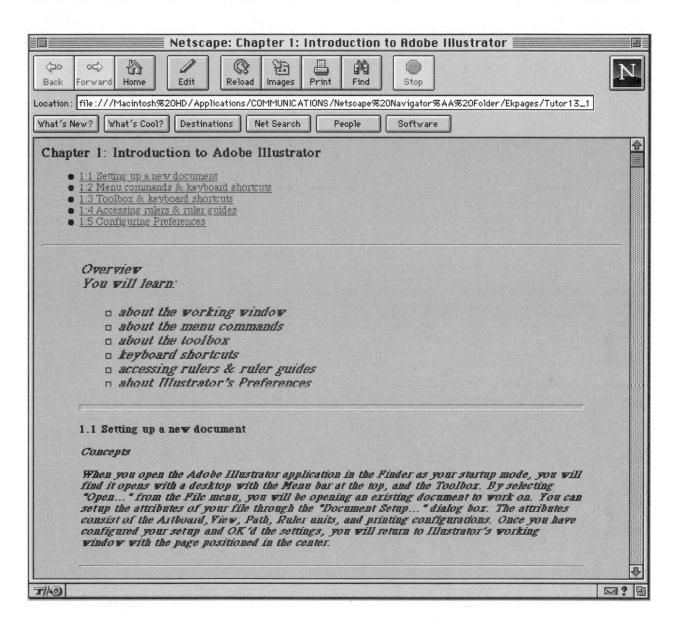

Figure 13-11 Continued. Standard level Web page (tutorial). ©1996 Web Design and HTML, created by Esther Kibby

(Continued)

Figure 13-11 Continued. Standard level Web page (tutorial). ©1996 Web Design and HTML, created by Esther Kibby

(Continued)

Next page

Figure 13-11 Continued. Standard level Web page (tutorial). ©1996 Web Design and HTML, created by Esther Kibby

(Continued)

Figure 13-11 End. Standard level Web page (tutorial). ©1996 Web Design and HTML, created by Esther Kibby

The navigation in figure 13-12 is set so that the user can hyperlink to the main chapter headings and sections from the table of contents. The difference is that the model is set up within frames so that the table of contents is included along the left side of chapter contents. The frame windows that hold the table of contents and the individual chapters are scrollable, allowing access to both sets of information. If the user selects one of the links in the table of contents, the selected information will display on the window to the right. At the bottom of each chapter section, paging text is available for the user to page either to the previous page or the next page.

The background color for the *table of contents frame* is set with a hex value of #FFFFFF, the body text has a hex value of #330033, and unvisited link color hex value is #990033, the visited link hex value is #9999CC, and the active link hex value is #990033. The background color for the *chapter frame* is #CC9966, the body text has a value of #000000, an unvisited link color hex value is #669999, the visited link hex value is #6699FF, and the active link hex value is #990033.

The main header, "Adobe Illustrator," is header level 1. Subheads re set to header level 3 and chapter headings are set to header level 4. The basefont value of the body text is set to 3. The overview section is font value of 4 and font style is italic with a color hex value of #003300. The overview section and the practice sections are inset from the section hyperlinks. Major chapter sections are divided by a horizontal rule. The horizontal rule separating the overview from the concepts has a value of 6.

In the practice section, the body text for the step procedure is set in bold while the text explaining the action is indented from the step procedure and set in plain text.

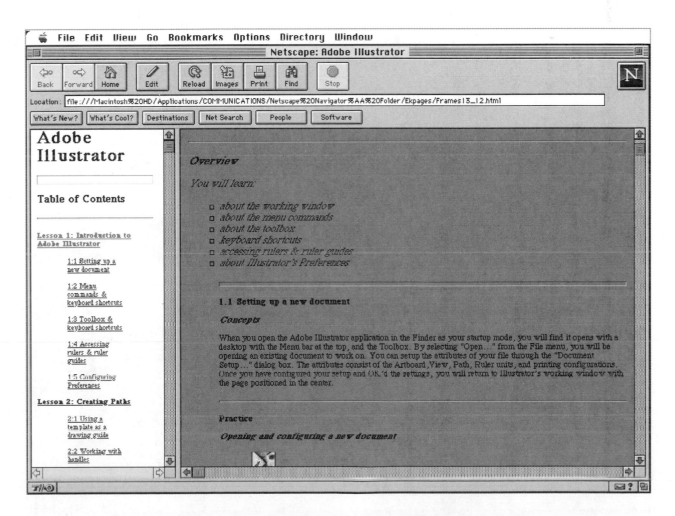

Figure 13-12 Standard level Web page (tutorial). ©1996 Web Design and HTML, created by Esther Kibby

(Continued)

Figure 13-12 Continued. (Opposite page and above) Standard level Web page (tutorial). ©1996 Web Design and HTML, created by Esther Kibby

Custom level web pages

The custom web page contains minimum graphics with limited colors combined with text and background textures. Inline graphics that have been color indexed to 8 bit, 256 colors or less, and 72 dpi are preferred for optimum upload time from server to client. Banners provide effective use of inline graphics. Icon symbols combined with headers or text create a table of contents or menu. Type can be used as art. Hyperlinks can be attached to these inline graphics as well as to body text. As HTML versions matured, table encoding became a way to set up a simple design grid. Client-served image maps can be used to divide a single graphic image into a more sophisticated design that can be structured to branch to external pages, graphics, animation, video, and audio.

The Web site shown in figure 13-13 is used as a marketing tool for a cafe. The navigation is a basic hierarchical structure. The "home page" uses an imagemap to link to the other four modules. An imagemap is a single graphic with the menu of items embedded as a single unit. It is constructed so that specific coordinates of the graphic are hyperlinked to external content. The imagemap method requires additional common gateway interface (cgi) programming to act as a bridge between the server and the client when an active linked area is clicked. In this graphic, Kafé, Bakery, Catering, and Favorites are the hyperlinks to their respective external pages.

On the secondary pages are imagemaps that function as site maps to the other pages. The small stars are indicators of where the user is on the site and can access the other pages by clicking on the titles. Each secondary page has a header bar that is a smaller, edited version of the main homepage graphic. The addressing information is just below the header with an Internet mail address for user comments nd feedback. The basic colors are gold with a hex value of #CC9933, blue with a hex value of #0033CC, and dark brown with a hex value of #003333.

The introductory and body copy is computer system type. The initial cap and section subheads are blue and, the rest of the body copy is dark brown. The icon on each section and the horizontal rules are gold. The basefont for the body copy is a value of 3, the initial cap is a font value of 6, and the rest of the introductory copy is set at a value of 4. Section subheads are set at a value of 4. The secondary pages are designed for the content to be weighted to the right providing white space to give emphasis to the site map on the upper left. The logo graphic is 48-point Matura MT Script Capitals; the type for the site map is 24-point Rotis Semi Sans Bold.

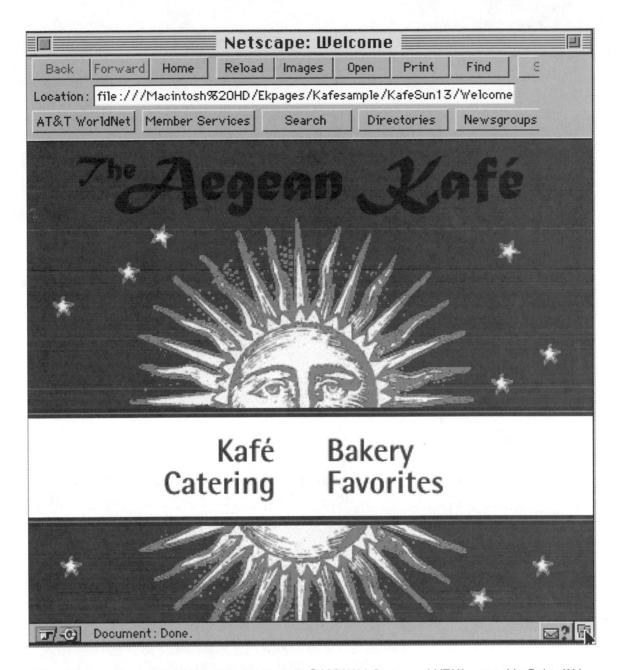

Figure 13-13 Custom level Web page (marketing). ©1996 Web Design and HTML, created by Esther Kibby

(Continued)

Netscape: Menu

Back | Forward | Home | Reload | Images | Open | Print | Find | Stop | Netscape

Location: file:///Macintosh%20HD/Ekpages/Kafesample/KafeSun13/Kafe.html

AT&T WorldNet | Member Services | Search | Directories | Newsgroups

2343 Kronos Street
Athens, Texas
909.555.3920
For comments, you can contact us at aegean@cyperspace.com

Kafé ☆
Bakery
Catering
Favorites
Home

Bring a little Mediterranean sunshine to your day. Experience Greek cooking at its finest at The Aegean Kafé.

MENU

Tzatziki
2.95
A light snack of pita slices with a mixture of fresh cucumbers and yogurt.

Dolmades
3.50
Rolled grape leaves stuffed with rice, pine nuts, onions and raisins with fresh spices.

Avgolemono Soup
1.95
A delicate lemon chicken soup.

Spicy Broiled Quail
10.95
Broiled quail that has a zesty bite.

Shrimp Kabobs
7.95
Grilled shrimp with bacon and tomatoes on a skewer.

Moussaka 2.95	*Beef with eggplant, tomatoes topped with kefalotti cheese, yogurt combination baked to perfection.*
Pourgouri Pilaf 2.50	*Rice with tomatoes, green peppers, onions and vermicilli.*
Honey Cakes 1.95	*Little spiced cakes with a lovely honey syrup topping.*
Baklava 2.25	*Flakey filo pastry stuffed with nuts and sweetened with honey.*
Kadaifi 2.50	*A delightful pastry roll with a sweet honey syrup*
Greek coffee 1.95	*A strong, sweet coffee*
Spiced Tea 1.95	*A tea with hint of cinnamon and orange*

WINE

Chardonnay **Glass 5.50** **Bottle 11.95**	*A light fruity semi-dry white wine.*
Cabarnet Sauvignon **Glass 4.95** **Bottle 10.95**	*A dry red wine with a wonderful bouquet.*
Merlot **Glass 6.95** **Bottle 15.95**	*A robust red dry wine.*
Ouzo **Glass 4.95** **Bottle 10.95**	*A sweet, heavy liquor*

Document : Done.

Figure 13-13 Continued. (Opposite page and above) Custom level Web page (marketing). ©1996 Web Design and HTML, created by Esther Kibby

(Continued)

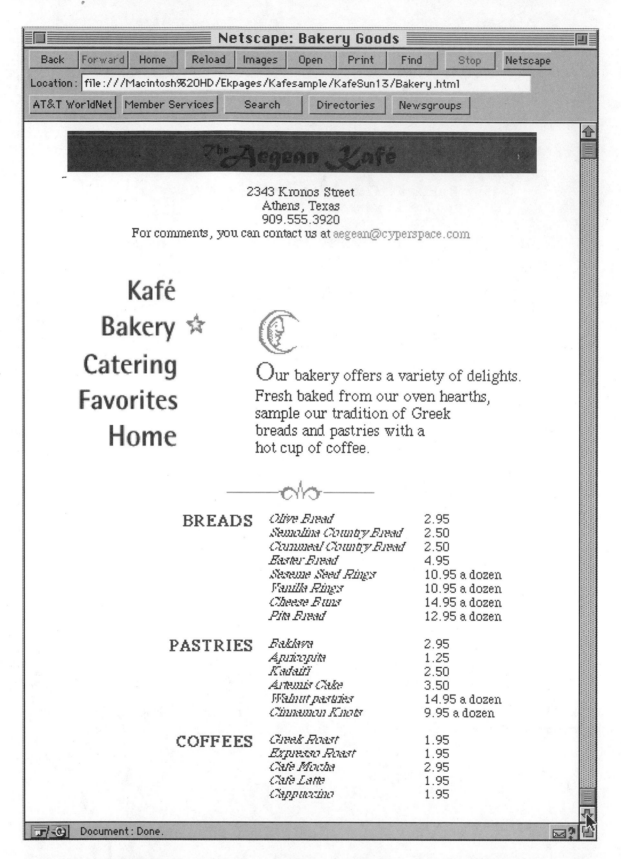

Figure 13-13 Continued. (Above and opposite) Custom level Web page (marketing). ©1996 *Web Design and HTML, created by Esther Kibby*

(Continued)

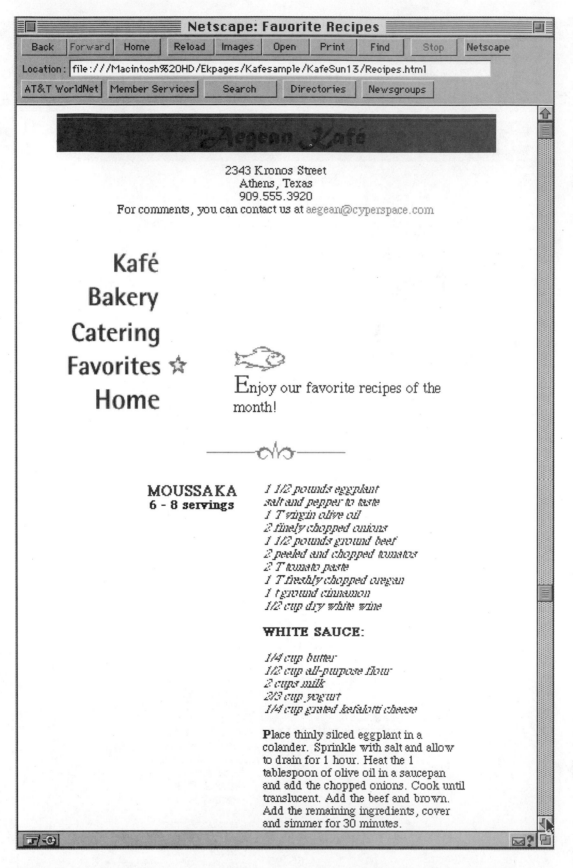

Figure 13-13 Continued. Custom level Web page (marketing). ©1996 Web Design and HTML, created by Esther Kibby

Figure 13-14 uses illustrations with graphic labels as the links. The graphics have a similar feel to the imagemap but are constructed using tables instead. This method does not need the cgi programming. At the bottom of every section is a text version of the links to the other external pages. The addressing information is at the bottom of the "homepage" with an Internet mail address for user comments and feedback. The background is a light beige and white split graphic.

Each secondary page has a header graphic that is a smaller version of the main homepage graphic with the corresponding illustration. The content of each page is aligned to the center. The basic colors are beige with a hex value of #CC9933, dark brown

with a hex value of #003333, red with the hex value of #FF0033, medium gray with a hex value of #666666, and dark charcoal with a hex value of #333333.

The introductory and body copy are computer system type. The introductory copy is a medium gray, section subheads are red, and the rest of the body copy is dark charcoal. The dingbat separating the section content is dark brown.

The basefont for body copy is a value of 3, the introductory copy and section subheads area set at a value of 4. The logo type is 48-point Charlemagne Bold with the accent text and labels in 24-point Dorchester Script MT.

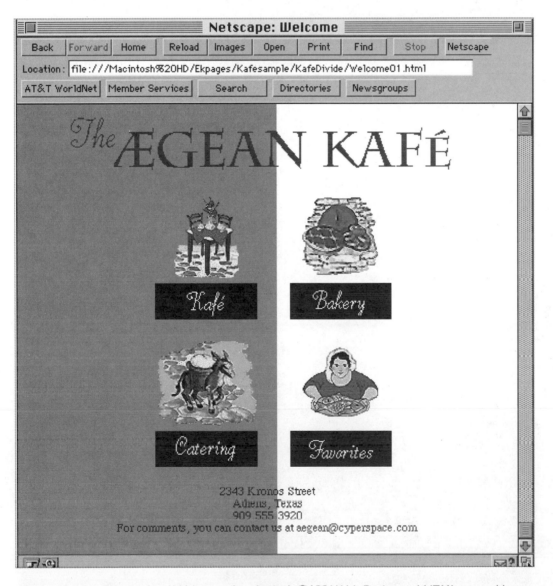

Figure 13-14 Custom level Web page (marketing). ©1996 Web Design and HTML, created by Esther Kibby

(Continued)

| Back | Forward | Home | Reload | Images | Open | Print | Find | Stop | Netscape |

Location : file :///Macintosh%20HD/Ekpages/Kafesample/KafeDivide/Kafe.html

| AT&T WorldNet | Member Services | Search | Directories | Newsgroups |

The ÆGEAN KAFÉ

BRING a little Mediterranean sunshine to your day.
Experience Greek cooking at its finest
at The Aegean Kafé.

MENU

Tzatziki
$2.95
A light snack of pita slices with a mixture
of fresh cucumbers and yogurt.

Dolmades
3.50
Rolled grape leaves stuffed with rice, pine nuts,
onions and raisins with fresh spices.

Avgolemono Soup
2.50
A delicate lemon chicken soup

Spicy Broiled Quail
10.95
Broiled quail that has a zesty bite.

Shrimp Kabobs
12.95
Grilled shrimp with bacon and tomatoes on a skewer.

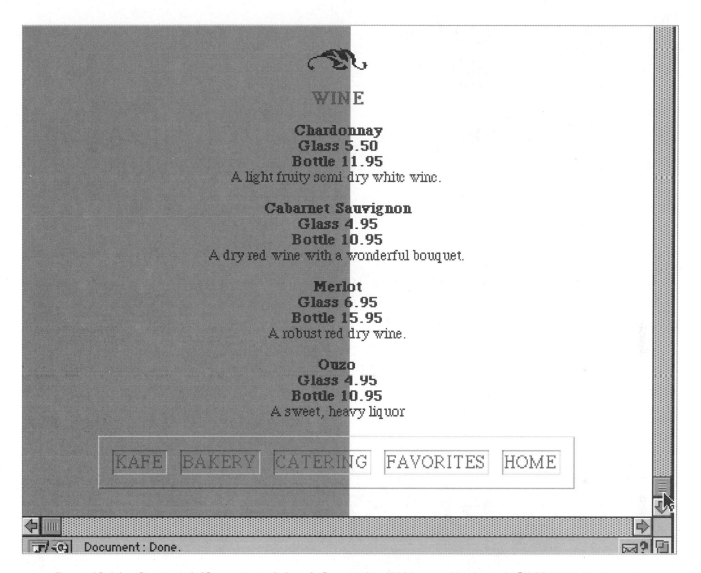

Figure 13-14 Continued. (Opposite and above) Custom level Web page (marketing). ©1996 Web Design and
HTML, created by Esther Kibby

(Continued)

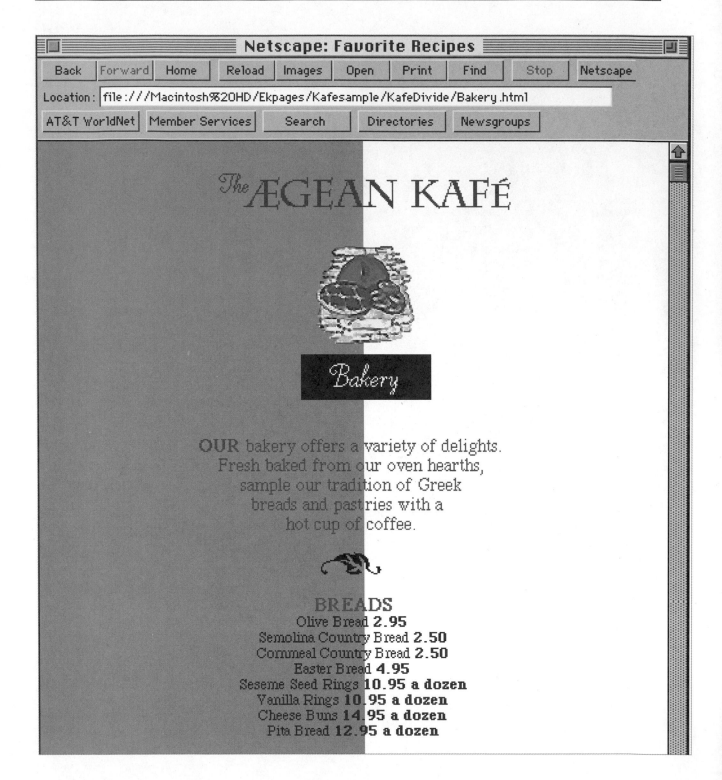

The AEGEAN KAFÉ

Bakery

OUR bakery offers a variety of delights.
Fresh baked from our oven hearths,
sample our tradition of Greek
breads and pastries with a
hot cup of coffee.

BREADS
Olive Bread **2.95**
Semolina Country Bread **2.50**
Cornmeal Country Bread **2.50**
Easter Bread **4.95**
Seseme Seed Rings **10.95 a dozen**
Vanilla Rings **10.95 a dozen**
Cheese Buns **14.95 a dozen**
Pita Bread **12.95 a dozen**

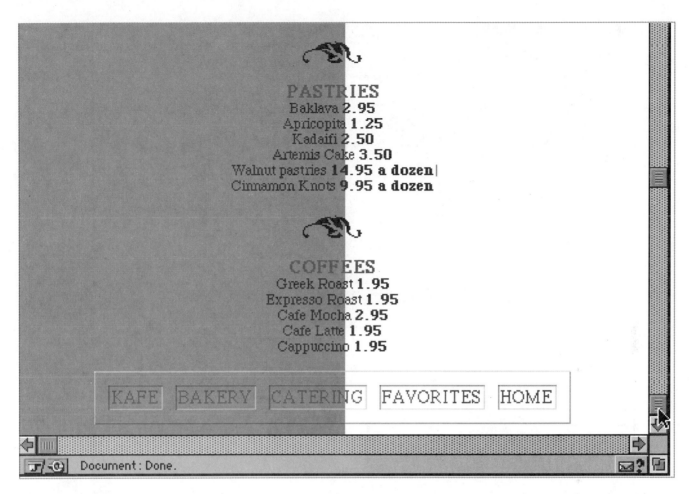

Figure 13-14 Continued. (Opposite and above) Custom level Web page (marketing). ©1996 Web Design and HTML, created by Esther Kibby

(Continued)

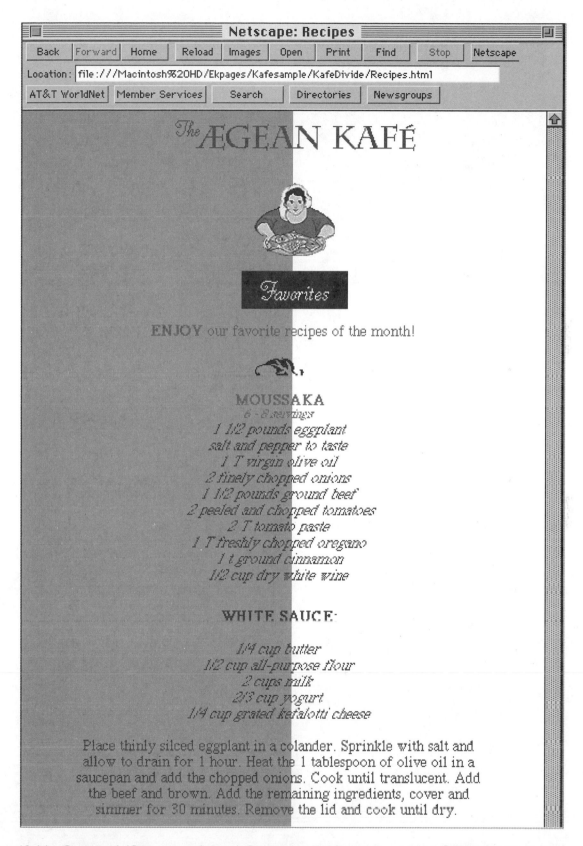

Figure 13-14 Continued. (Opposite and above) Custom level Web page (marketing). ©1996 Web Design and HTML, created by Esther Kibby

(Continued)

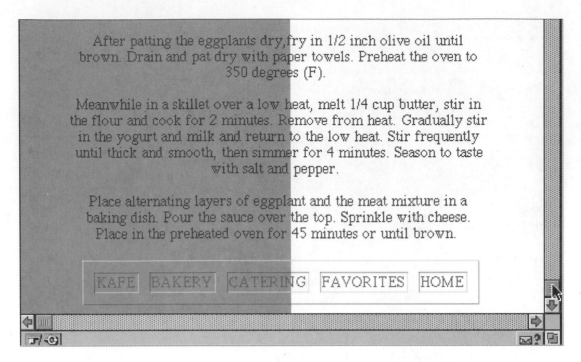

Figure 13-14 Continued. (Opposite and above) Custom level Web page (marketing). ©1996 Web Design and HTML, created by Esther Kibby

Figure 13-15 uses graphic icons with graphic labels as the links.

The logo, logo type, and icons are centered on the page. The addressing information is divided between the top and bottom of the homepage with an Internet mail address for user comments and feedback. The background is a graphic with a lighte purple and white wave pattern.

On each of the secondary pages, the header is the icon graphic represented on the homepage. The contenet of each module is laid out in a central column with generous margins. The basic colors are light purple with a hex value of #9999CC, medium purple with a hex value of #666699, raspberry with the hex value of #000033, and gold with a hex value of #FF9900. At he botom of every secondary section is an icon with text version of the links to the other external pages.

The basefont for the body text is a value of 3, the introductory copy and section subheadsa re set at a value of 4. The icon graphics, a medium purple re set in Davy's Dingbats, LAstrology Pi, and LDecoration Pi. The logo graphic is 48-point and icon labels are 36-point and a raspberry color set in Bauer Bodoni Roman SC. The body font is a medium purple.

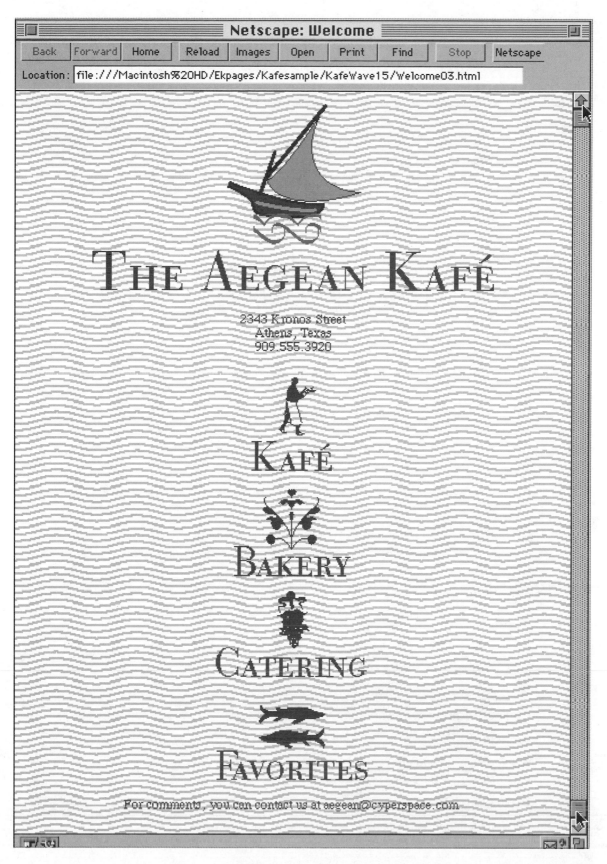

Figure 13-15 Custom level Web page (marketing). ©1996 Web Design and HTML, created by Esther Kibby

(Continued)

```
┌──────────────────────────────────────────────────────────────────────┐
│ ▣▤▤▤▤▤▤▤▤▤▤▤▤▤▤▤▤     Netscape: Menu     ▤▤▤▤▤▤▤▤▤▤▤▤▤▤▤▤▤ ↵ │
├──────────────────────────────────────────────────────────────────────┤
│ ┌──────┐┌────────┐┌──────┐ ┌────────┐┌────────┐┌──────┐┌──────┐┌──────┐ ┌──────┐ │
│ │ Back ││Forward ││ Home │ │ Reload ││ Images ││ Open ││ Print││ Find │ │ Stop │ Netscape │
│ └──────┘└────────┘└──────┘ └────────┘└────────┘└──────┘└──────┘└──────┘ └──────┘ │
├──────────────────────────────────────────────────────────────────────┤
│ Location: │file:///Macintosh%20HD/Ekpages/Kafesample/KafeWave15/Kafe.html│ │
└──────────────────────────────────────────────────────────────────────┘
```

KAFÉ

Bring a little Mediterranean sunshine to your day.
Experience Greek cooking at its finest
at The Aegean Kafé.

ENTREES

Tzatziki 2.95

A light snack of pita slices with a mixture of fresh cucumbers and
yogurt.

Dolmades 3.50

Rolled grape leaves stuffed with rice, pine nuts, onions and raisins
with fresh spices.

Avgolemono Soup 2.50

A delicate lemon chicken soup.

Spicy Broiled Quail 10.95

Broiled quail that has a zesty bite.

Shrimp Kabobs 12.95

Grilled shrimp with bacon and tomatoes on a skewer.

Moussaka 7.95

Beef with eggplant, tomatoes topped with kefalotti cheese, yogurt
combination baked to perfection.

Pourgouri Pilaf 2.50

Rice with tomatoes, green peppers, onions and vermicilli.

Honey Cakes 1.95

Little spiced cakes with a lovely honey syrup topping.

Baklava 2.25

Flakey filo pastry stuffed with nuts and sweetened with honey.

Kadaifi 2.50

A delightful pastry roll with a sweet honey syrup.

WINE

Chardonnay Glass 5.50 Bottle 11.95

A light fruity semi-dry white wine.

Cabarnet Sauvignon Glass 4.95 Bottle 10.95

A dry red wine with a wonderful bouquet.

Merlot Glass 6.95 Bottle 15.95

A robust red dry wine.

Ouzo Glass 4.95 Bottle 10.95

A sweet, heavy liquor.

HOME KAFE BAKERY CATERING FAVORITES

Document: Done.

Figure 13-15 Continued. (Opposite and above) Custom level Web page (marketing). ©1996 Web Design and HTML, *created by Esther Kibby*

(Continued)

Netscape: Bakery Goods

| Back | Forward | Home | Reload | Images | Open | Print | Find | Stop | Netscape |

Location: file:///Macintosh%20HD/Ekpages/Kafesample/KafeWave15/Bakery.html%20

BAKERY

Our bakery offers a variety of delights.
Fresh baked from our oven hearths,
sample our tradition of Greek
breads and pastries with a
hot cup of coffee.

BREADS

Olive Bread	2.95
Semolina Country Bread	2.50
Seseme Seed Rings	10.95 a dozen
Vanilla Rings	10.95 a dozen
Cheese Buns	14.95 a dozen
Pita Bread	12.95 a dozen

PASTRIES

Baklava	2.95
Apricopita	1.25
Kadaifi	2.50

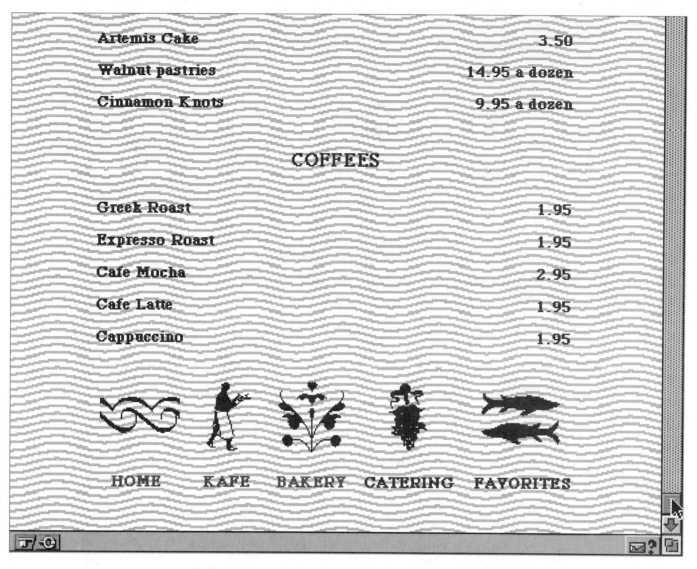

Figure 13-15 Continued. (Opposite and above) Custom level Web page (marketing). ©1996 Web Design and HTML, created by Esther Kibby

(Continued)

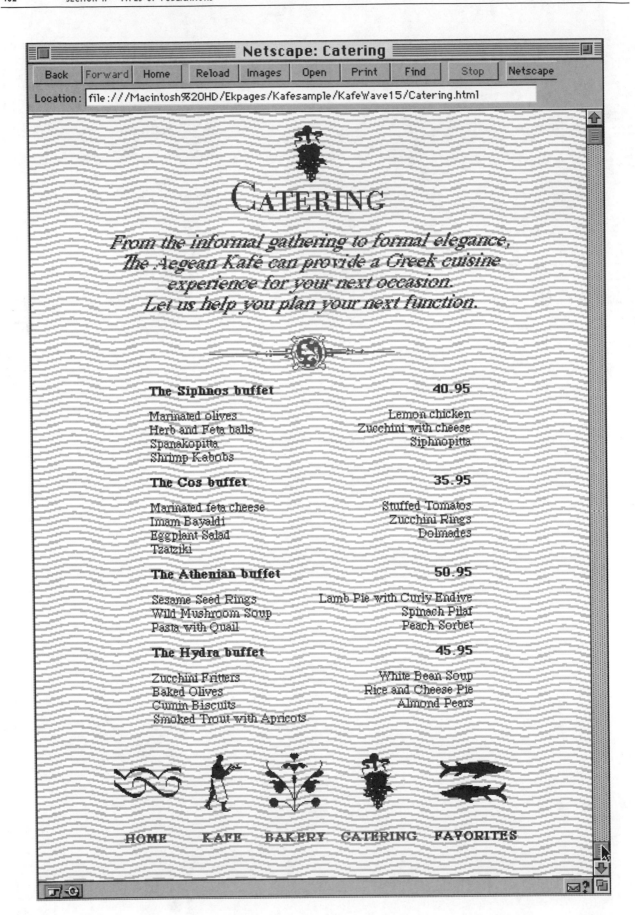

Netscape: Catering

Back | Forward | Home | Reload | Images | Open | Print | Find | Stop | Netscape

Location : file :///Macintosh%20HD/Ekpages/Kafesample/KafeWave15/Catering.html

CATERING

*From the informal gathering to formal elegance,
The Aegean Kafé can provide a Greek cuisine
experience for your next occasion.
Let us help you plan your next function.*

The Siphnos buffet 40.95

Marinated olives Lemon chicken
Herb and Feta balls Zucchini with cheese
Spanakopitta Siphnopitta
Shrimp Kabobs

The Cos buffet 35.95

Marinated feta cheese Stuffed Tomatos
Imam Bayaldi Zucchini Rings
Eggplant Salad Dolmades
Tzatziki

The Athenian buffet 50.95

Sesame Seed Rings Lamb Pie with Curly Endive
Wild Mushroom Soup Spinach Pilaf
Pasta with Quail Peach Sorbet

The Hydra buffet 45.95

Zucchini Fritters White Bean Soup
Baked Olives Rice and Cheese Pie
Cumin Biscuits Almond Pears
Smoked Trout with Apricots

HOME KAFE BAKERY CATERING FAVORITES

Figure 13-15 Continued. (Opposite and above) Custom level Web page (marketing). ©1996 Web Design and HTML, created by Esther Kibby

Premium level Web pages

The premium Web page contains a combination of text, graphics, video, animation, forms, and sound. For example, the user can experience an animated company logo or a video/audio clip of the president describing the company's mission or product.

Forms can be constructed to receive feedback from the user for ordering or marketing purposes. Small programs such as counters can give an account of the number of visits to the Web site.

Figure 13-16 shows a Web site that offers information on graphic and multimedia services in a corporate setting. The Welcome page functions as the homepage and contains information about Creative Media Services. The navigation is a basic hierarchical structure with Web structure within the sections, enabling crossover links to specific content in other sections.

A light-toned blue-embossed graphic composed of media icons is tiled across the background. This provides a athematic visual consistency throughout the pages of the Web site.

The CMS specially created glyph (Creative Media Services) is combined with main header art type, Gill Sans Bold with a 38-point initial cap and 26-point small caps. Subhead art type is Gill Sans Bold with 20-point initial cap and 14-point small caps. The art type are aligned flush right.

Section headers on the Welcome page are HTML coded header level 3. Section headers on the Services and What's New pages are header level 2 with subsection level 3. Section headers on Web Resources re header level 1 with subsection titles level 2. The body text has a basefont value of 4. Links to various sections are enclosed in the embossed bars. Links to specific parts such as video and audio are imbedded into the regular body text. The underlined, active link is a blue color with a hex value of #0000FF and denotes a link that has not been visited. Visited links will become purple with a hex value of #3F007F. Regular body copy is black with a hex value of 000000. The horizontal rules are multicolored graphic bitmaps used as framing and dividing devices throughout the site. Iconic graphics are used as links to the various media samples and are displayed across the bottom of the section. Illustrations, duotone photographs, animation, video, and audio are dispersed throughout the sections.

Figure 13-16 Premium level Web page (corporate). ©1996 Web Design and HTML, created by Scott Campbell of E-Systems' Creative Media Service

(Continued)

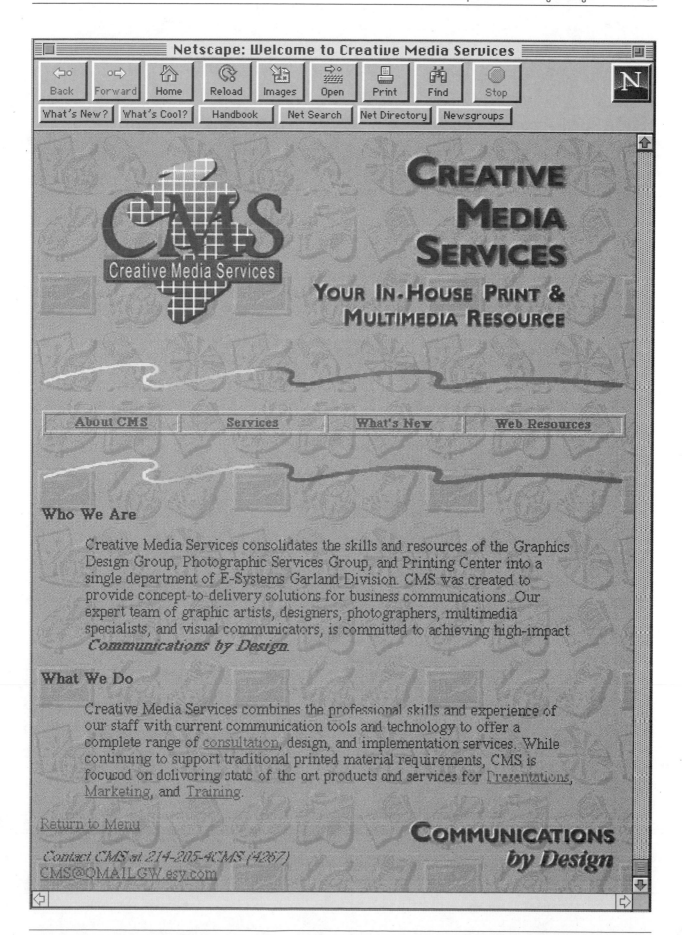

Netscape: Welcome to Creative Media Services

Back | Forward | Home | Reload | Images | Open | Print | Find | Stop

What's New? | What's Cool? | Handbook | Net Search | Net Directory | Newsgroups

CMS
Creative Media Services

CREATIVE MEDIA SERVICES
YOUR IN-HOUSE PRINT & MULTIMEDIA RESOURCE

About CMS | Services | What's New | Web Resources

Who We Are

Creative Media Services consolidates the skills and resources of the Graphics Design Group, Photographic Services Group, and Printing Center into a single department of E-Systems Garland Division. CMS was created to provide concept-to-delivery solutions for business communications. Our expert team of graphic artists, designers, photographers, multimedia specialists, and visual communicators, is committed to achieving high-impact *Communications by Design.*

What We Do

Creative Media Services combines the professional skills and experience of our staff with current communication tools and technology to offer a complete range of consultation, design, and implementation services. While continuing to support traditional printed material requirements, CMS is focused on delivering state-of-the-art products and services for Presentations, Marketing, and Training.

Return to Menu

Contact CMS at 214-205-4CMS (4267)
CMS@QMAILGW.esy.com

COMMUNICATIONS
by Design

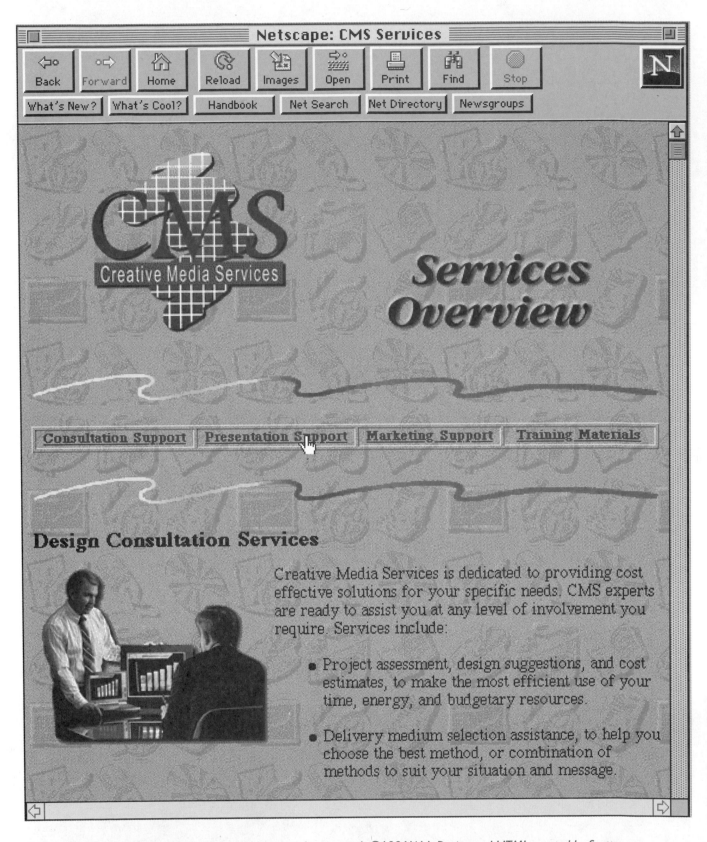

Figure 13-16 Continued. Premium level Web page (corporate). ©1996 *Web Design and HTML, created by Scott Campbell of E-Systems' Creative Media Service*

(Continued)

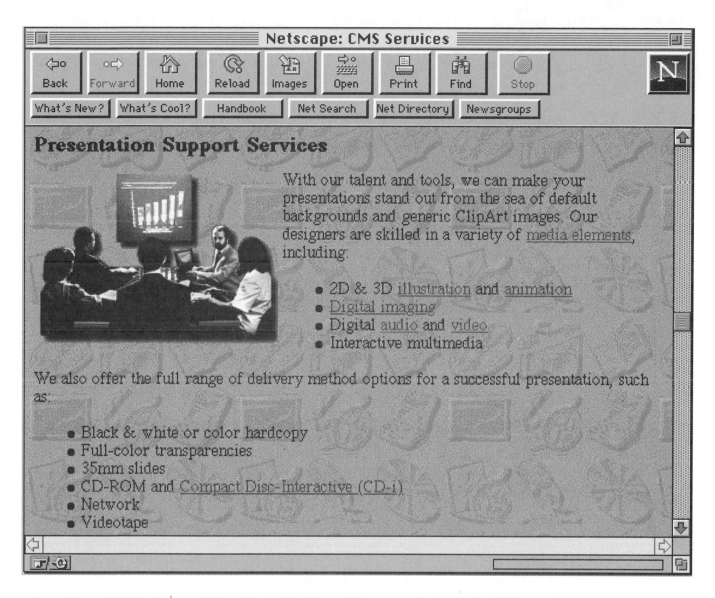

Figure 13-16 Continued. Premium level Web page (corporate). ©1996 Web Design and HTML, created by Scott Campbell of E-Systems' Creative Media Service

(Continued)

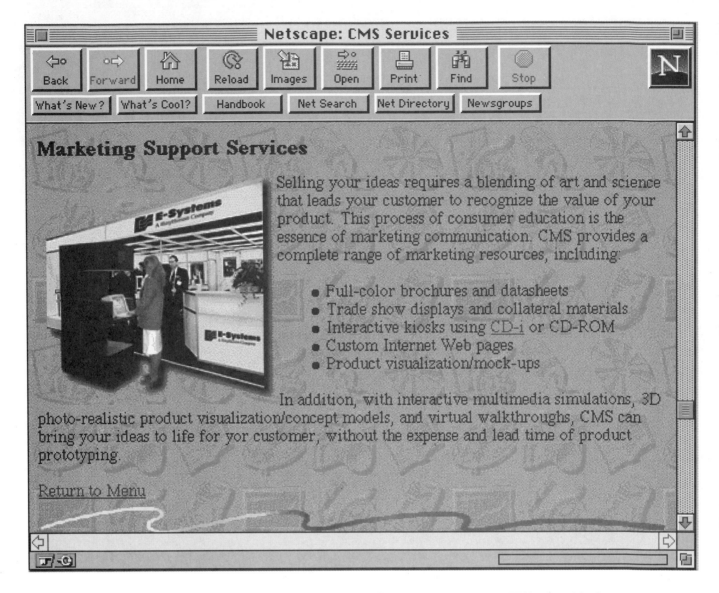

Figure 13-16 Continued. Premium level Web page (corporate). ©1996 Web Design and HTML, created by Scott Campbell of E-Systems' Creative Media Service

(Continued)

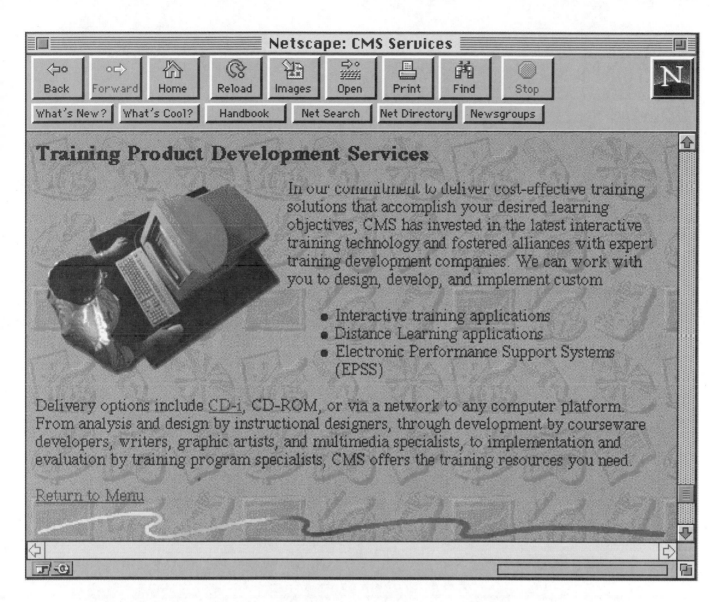

Figure 13-16 Continued. Premium level Web page (corporate). ©1996 Web Design and HTML, created by Scott Campbell of E-Systems' Creative Media Service

(Continued)

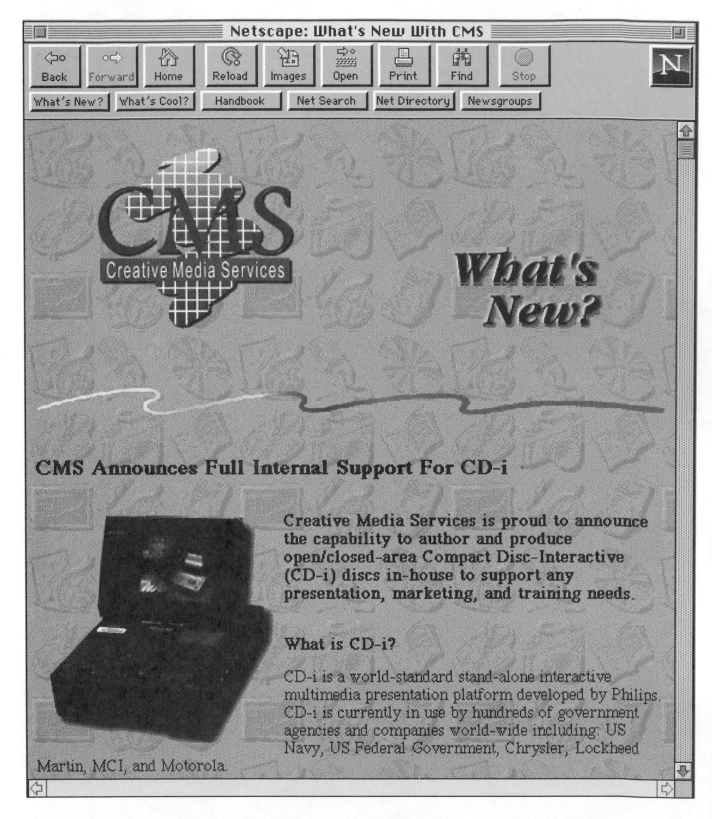

Figure 13-16 Continued. Premium level Web page (corporate). ©1996 Web Design and HTML, created by Scott Campbell of E-Systems' Creative Media Service

(Continued)

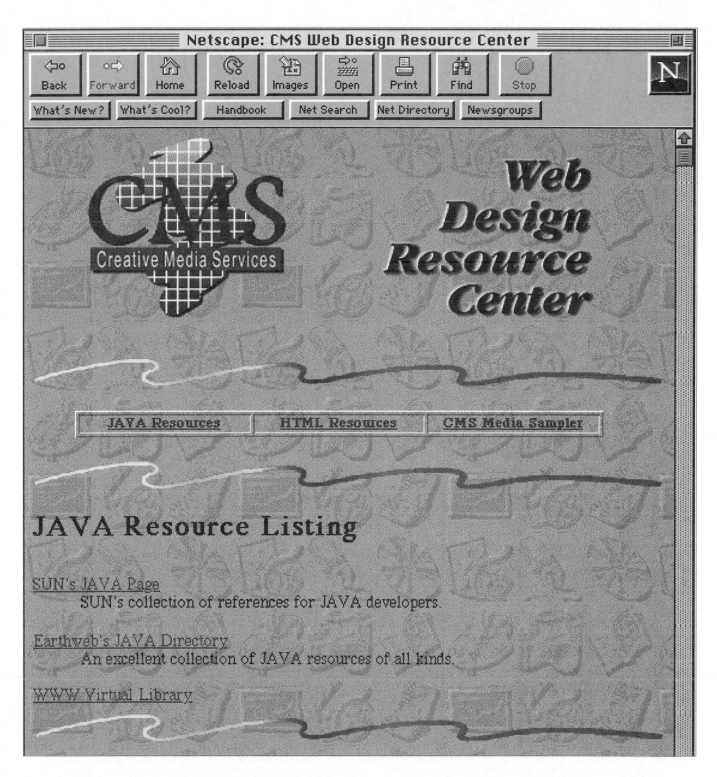

Figure 13-16 Continued. Premium level Web page (corporate). ©1996 Web Design and HTML, created by Scott Campbell of E-Systems' Creative Media Service

(Continued)

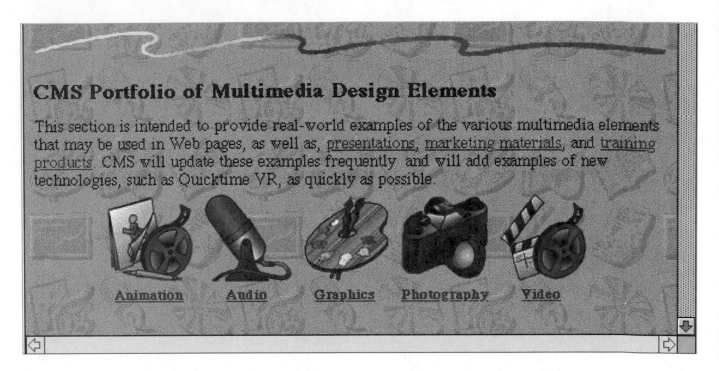

CMS Portfolio of Multimedia Design Elements

This section is intended to provide real-world examples of the various multimedia elements that may be used in Web pages, as well as, presentations, marketing materials, and training products. CMS will update these examples frequently and will add examples of new technologies, such as Quicktime VR, as quickly as possible.

Animation Audio Graphics Photography Video

Figure 13-16 Continued. Premium level Web page (corporate). ©1996 Web Design and HTML, created by Scott Campbell of E-Systems' Creative Media Service

(Continued)

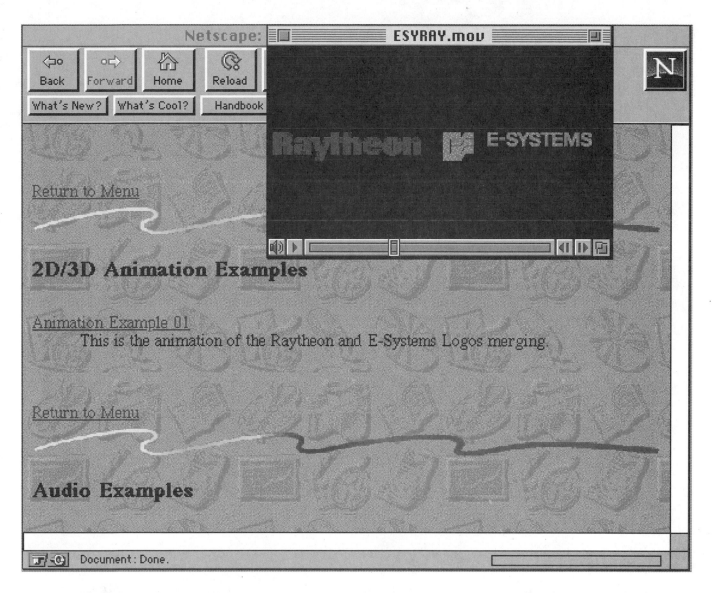

Figure 13-16 Continued. remium level Web page (corporate). ©1996 *Web Design and HTML, created by Scott Campbell of E-Systems' Creative Media Service*

(Continued)

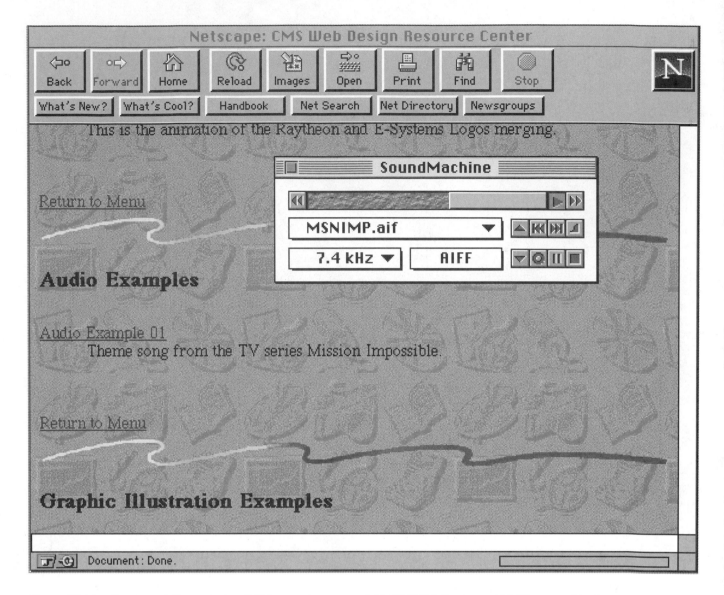

Figure 13-16 Continued. Premium level Web page (corporate). ©1996 Web Design and HTML, created by Scott Campbell of E-Systems' Creative Media Service

(Continued)

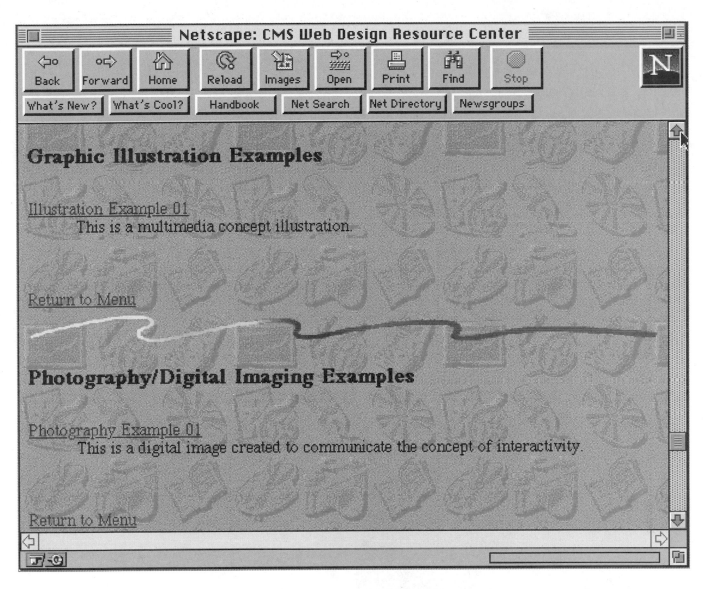

Figure 13-16 Continued. Premium level Web page (corporate). ©1996 Web Design and HTML, created by Scott Campbell of E-Systems' Creative Media Service

(Continued)

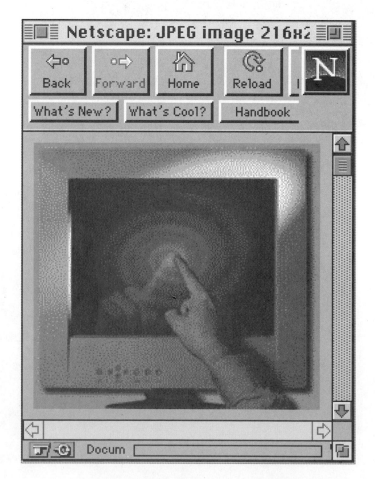

Figure 13-16 Continued. Premium level Web page (corporate). ©1996 Web Design and HTML, created by Scott Campbell of E-Systems' Creative Media Service

(Continued)

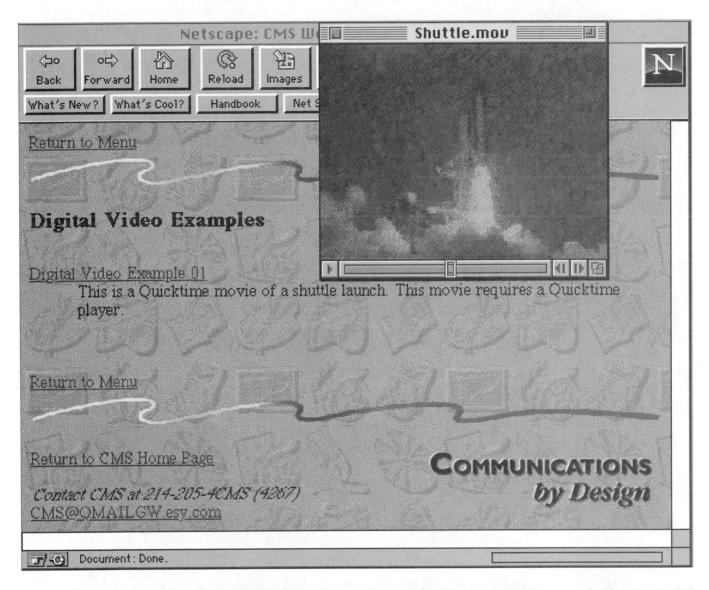

Figure 13-16 End. Premium level Web page (corporate). ©1996 Web Design and HTML, created by Scott Campbell of E-Systems' Creative Media Service

Figure 13-17 offers information on eyewear and eyecare services. The navigation is a basic hierarchical structure. The homepage displays a large custom graphic that leads into the menu of services as the user scrolls down. The user can then choose which section to move to gain more information about the different services. The horizontal rules are thin gray bars separating the content.

The background is white with a subdued corporate blue bar and red sidebar on the left. The white portion of the background is used to hold the text content. Custom photography is displayed, intersecting the blue/red sidebar and the white background, providing aconsistent look and feel throughout the Web site. On the Welcome page the main product identification is a graphic element. The

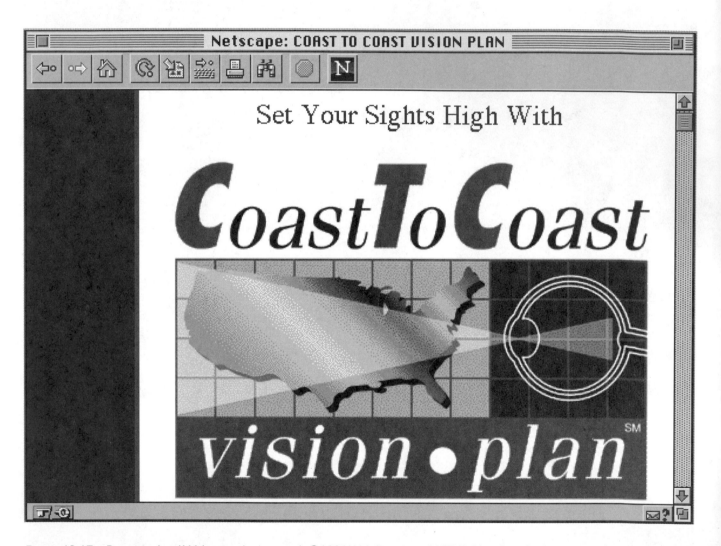

Figure 13-17 Premium level Web page (corporate). ©1996 Web Design and HTML, New Benefits, Incorporated, Marilyn Forest-Dott, designer

(Continued)

menu hyperlinks are arranged in a bulleted list. Regular body copy has a basefont value of +2 and a color of black with a hex value of #000000 or corporate blue with a hex value of #152C74. The underlined, active link is a bright blue color with a hex value of #0000FF and denotes a link that has not been visited. Visited links will become purple with a hex value of #3F007F. Section paragraphs have initial caps and keywords displayed in red with a hex value of #C91F16. Section and subsection headers are a font value of +5 and in the same corporate blue color as the sidebar. The headers on the forms are the corporate blue color with red keywords to identify the target audience or to emphasize the product name. The basefont value is +2 with fields available to enter user information.

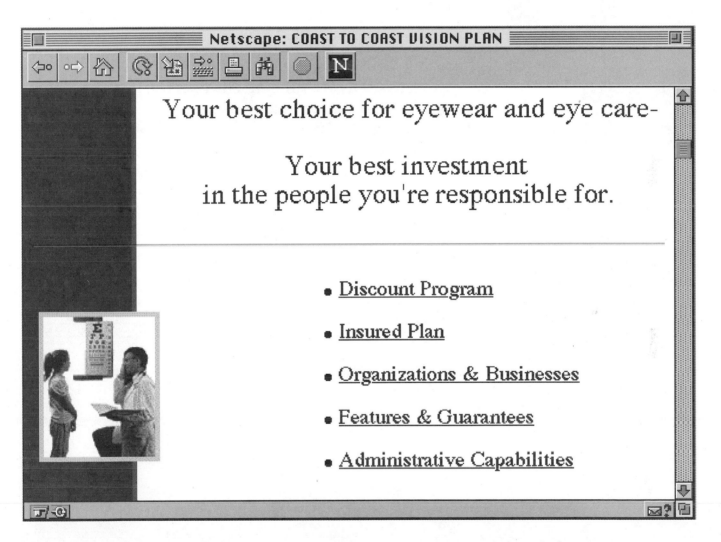

Figure 13-17 Continued. Premium level Web page (corporate). ©1996 Web Design and HTML, New Benefits, Incorporated, Marilyn Forest-Dott, designer

(Continued)

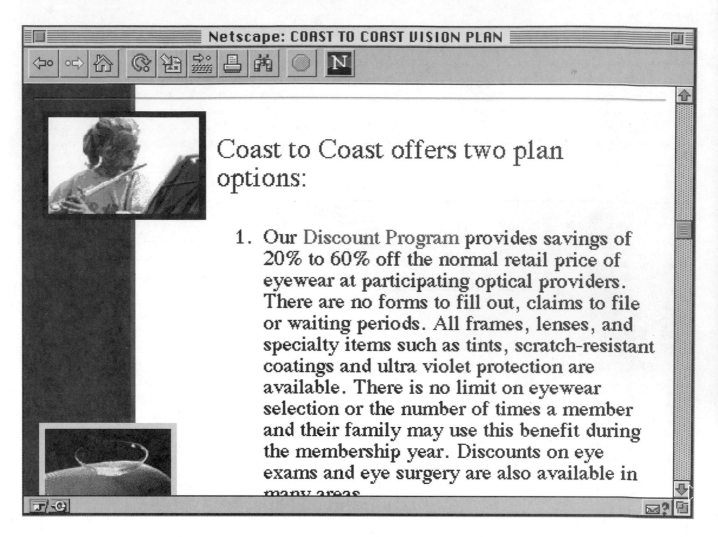

Figure 13-17 Continued. Premium level Web page (corporate). ©1996 Web Design and HTML, New Benefits, *Incorporated, Marilyn Forest-Dott, designer*

(Continued)

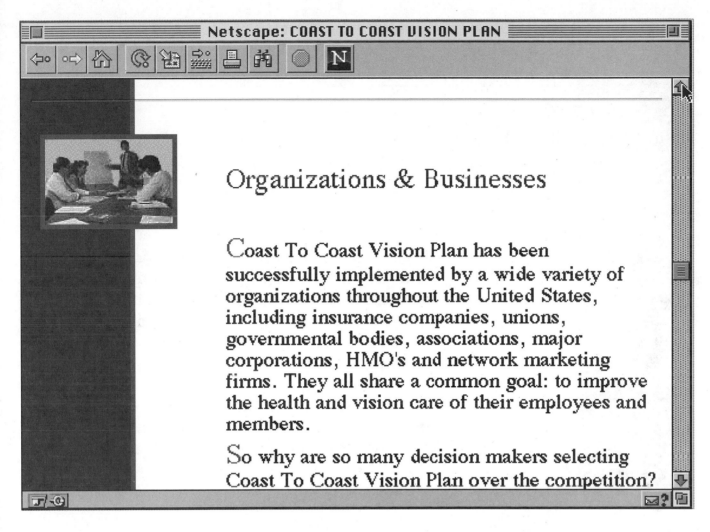

Figure 13-17 Continued. Premium level Web page (corporate). ©1996 *Web Design and HTML, New Benefits, Incorporated, Marilyn Forest-Dott, designer*

(Continued)

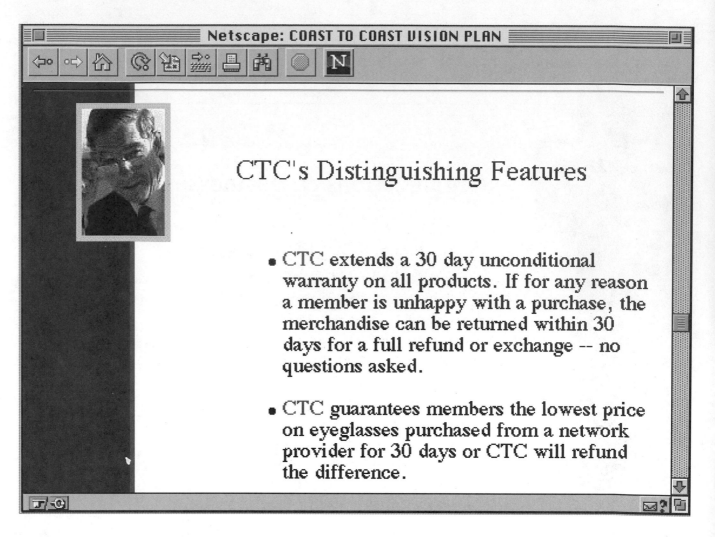

Figure 13-17 Continued. Premium level Web page (corporate). ©1996 Web Design and HTML, New Benefits, Incorporated, Marilyn Forest-Dott, designer

(Continued)

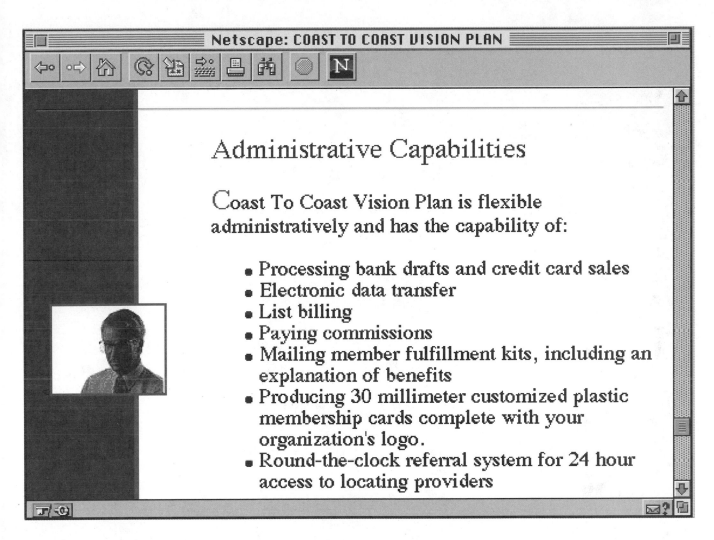

Figure 13-17 Continued. Premium level Web page (corporate). ©1996 Web Design and HTML, New Benefits, Incorporated, Marilyn Forest-Dott, designer

(Continued)

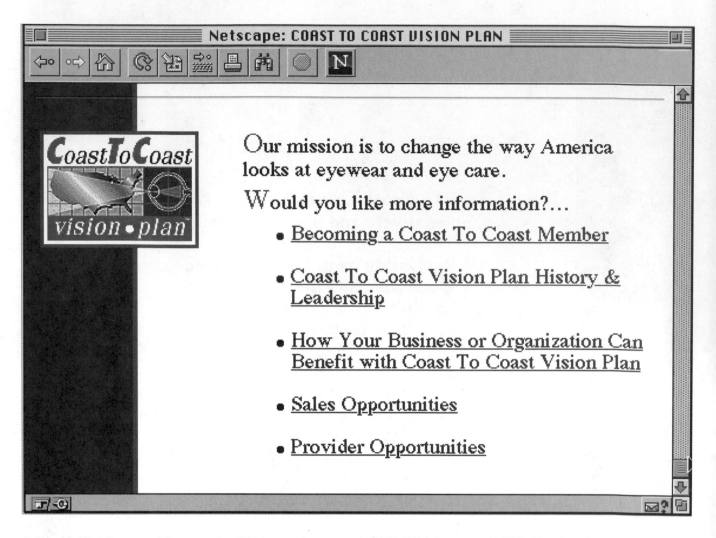

Figure 13-17 Continued. Premium level Web page (corporate). ©1996 Web Design and HTML, New Benefits, Incorporated, Marilyn Forest-Dott, designer

(Continued)

Figure 13-17 Continued. Premium level Web page (corporate). ©1996 Web Design and HTML, New Benefits, Incorporated, Marilyn Forest-Dott, designer

(Continued)

Figure 13-17 Continued. Premium level Web page (corporate). ©1996 Web Design and HTML, New Benefits, Incorporated, Marilyn Forest-Dott, designer

(Continued)

Netscape: COAST TO COAST VISION PLAN–BROKER INQUIRY FORM

To be contacted with more information on
becoming an Independent Broker for
Coast To Coast Vision Plan
fill out the following :

First Name:

Last Name:

Title:

Company or Organization:

Street Address:

Additional Address:

City:

State:

ZIP:

Tel. No. (area code):

Fax No. (area code):

E-Mail Address:

Document : Done.

Figure 13-17 Continued. Premium level Web page (corporate). ©1996 Web Design and HTML, New Benefits, *Incorporated, Marilyn Forest-Dott, designer*

Figure 13-18 is an example of a corporate Intranet solution. The navigation is a basic hierarchical structure. The Welcome page displays a background graphic overlaid with individual images contained within a table grid structure. The graphic menu type is hyperlinked to the other content pages. The user can choose which section to move to gain more information about the different services.

The background is white with a gray bar with logo identification on the left. The white portion of the background is used to hold the text content. The graphic typeface is Letraset Radiant Bold Condensed. "Welcome to the CSC" is 32-point with the "W" and "CSC" in 68-point. "Computing Support Center" is 60-point. Macintosh/Windows/General Information is 40-point. This convention is used throughout the

Figure 13-18 Premium level Web page (corporate). ©1996 Web Design and HTML, created by Darren Dittrich for ARCO Exploration and Production Technology

(Continued)

site, supported by HTML type. The background color is specified as white with a hex value of #FFFFFF. The body text color is black with a hex value of #000000. The hyperlink is #C50E0E, the active link is #FF3300, and the visited link is black with a hex value of #000000.

The sidebar is used for corporate identification on the main pages and as an icon display relating to the body text on the right in secondary information pages. The body text size is a defauld of 3 with a +1 for icon date identifiers. This Web site uses a visible counter that is linked to a small server application to tally the number of visits, as well as reflecting the visitors' domain name and the browser being used.

Figure 13-18 Continued. Premium level Web page (corporate). ©1996 Web Design and HTML, created by Darren Dittrich for ARCO Exploration and Production Technology

(Continued)

Figure 13-18 Continued. Premium level Web page (corporate). ©1996 Web Design and HTML, created by Darren Dittrich for ARCO Exploration and Production Technology

(Continued)

Figure 13-18 Continued. Premium level Web page (corporate). ©1996 Web Design and HTML, created by Darren Dittrich for ARCO Exploration and Production Technology

(Continued)

Figure 13-18 Continued. Premium level Web page (corporate). ©1996 Web Design and HTML, created by Darren Dittrich for ARCO Exploration and Production Technology

(Continued)

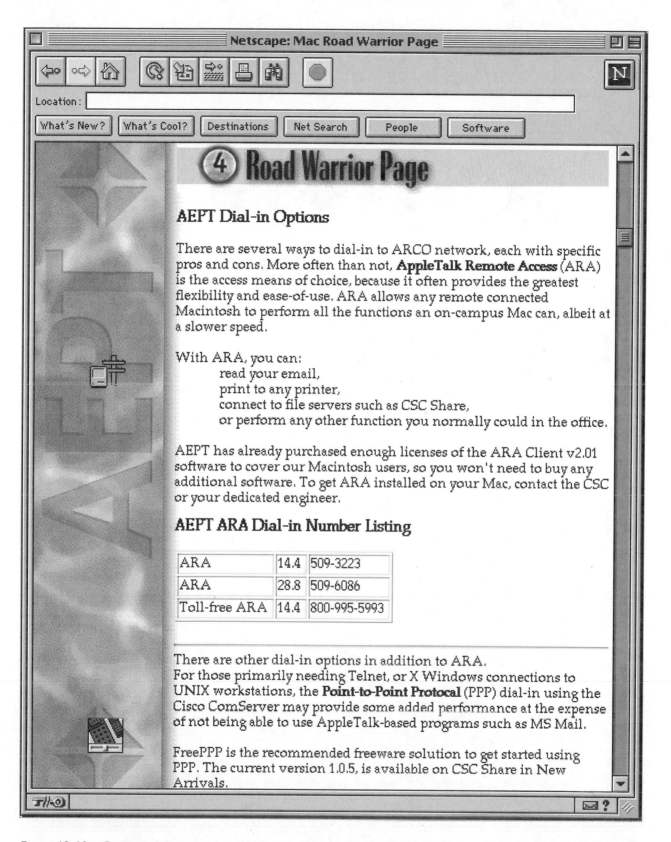

Figure 13-18 Continued. Premium level Web page (corporate). ©1996 Web Design and HTML, created by Darren Dittrich for ARCO Exploration and Production Technology

(Continued)

Figure 13-18 Continued. Premium level Web page (corporate). ©1996 Web Design and HTML, created by Darren Dittrich for ARCO Exploration and Production Technology

(Continued)

CSC Information

How do you contact the CSC?

You can contact the CSC at our main number, **x6700**. An engineer is always on duty to answer calls between **7:30am** and **5:00pm** Monday through Thursday, and **7:45am** and **4:30pm** on Friday. In addition to the centralized help desk, the CSC has support staff located in several locations on the AEPT campus. If you are in RRTS, ERTS, or PRTS, a dedicated engineer is situated in your area and will likely be your best first contact:

Reservoir	**Chuck Mitchell**	6491	PRC-E1251
Exploration	**Rob Gorman**	6828	PRC-D2435
Production	**Kevin Parks**	6565	PRC D1150

If you cannot reach your dedicated engineer, feel free to leave them a phonemail, or call the CSC at x6700 for immediate assistance. The CSC may be able handle your problem, schedule a software/hardware installation, or if necessary, page your dedicated engineer.

Where is the CSC located?

The centralized CSC Help Desk is located on the **5th floor of the C Building**.
Room **C5613** is situated roughly in the middle of the floor.

If you need assistance, or just want to talk face-to-face to a support engineer, feel free to drop by. Depending on the call load at the time you walk in, you may need to wait for someone to get free. As a result, it's often best to call ahead and schedule time with an engineer, especially when you're trying to solve a complex problem.

Who's in the CSC?

Figure 13-18 Continued. Premium level Web page (corporate). ©1996 *Web Design and HTML, created by Darren Dittrich for ARCO Exploration and Production Technology*

(Continued)

Figure 13-18 Continued. Premium level Web page (corporate). ©1996 Web Design and HTML, created by Darren Dittrich for ARCO Exploration and Production Technology

(Continued)

Figure 13-18 Continued. Premium level Web page (corporate). ©1996 *Web Design and HTML, created by Darren Dittrich for ARCO Exploration and Production Technology*

Further research

Created Web pages must be set up on an internal company server or handed off to an Internet Service Provider (ISP). The first requires a knowledge of server administration with some programming background. The second requires organized files, a designated homepage, (these two items should be done up front to cut down on the editing process), and tests to make sure that pages work correctly. When testing, make sure the test is done on more than one operating system. The ISP will provide assistance by giving their parameters to the designer.

Remember that Web designing never stops. The designer msut change the information frequently, in some cases every month, to keep the user coming back to the site. And, the Web site needs supportive advertising in othere media such as brochures, radio, and TV, to let users know the location of the organization's Web site. It is best to incorporate the Web site into the organizations communication.

For additional research

Keep a well-balanced design approach by continuing research into some suggested sources:

Castro, Elizabeth, *HTML for the World Wide Web,* Peachpit Press, 1996.

Fahey, Mary Jo, *Web Publisher's Design Guide,* Coriolis Group Books, 1995.

Niederst, Jenniver, *Designing for the Web,* Cambridge: O'Reilley and Associates, Inc., 1996.

Siegel, David, *Creating Killer Interactive Web Sites,* Indianapolis, IN: Hayden Books, 1996.

Taylor, Dave, *MacWorld Creating Cool Web Pages with HTML,* IDG Books, 1995.

Weinman, Linda, *Deconstructing Web Graphics,* New Riders Publishing, 1996.

Abbreviations

Abbreviations (abr.) are used in both spoken and written language and are common in all publications. They offer practical solutions to tight copyfitting dilemmas.

Abbreviations include shortened words, acronyms, and selected letters and appear in several forms:

- With or without capital letters.
- With or without periods.
- With spacebars (occasionally, when the abbreviation includes periods).
- In small caps.

Some abbreviations are symbols. The key position sheet gives the location of these on the keyboard. For Macintosh computers, all symbols are available in every type font so that the font will not need to be changed. Presently, the personal computer requires a numerical code or switching to another typeface.

Some abbreviations have three or more acceptable variations. The lists that follow show the preferred forms of commonly abbreviated words. They can be used as guidelines for decisions about abbreviations. Once a writer or designer selects a particular form of an abbreviation, it should be used consistently throughout the document.

Common abbreviations

It is absolutely necessary to use correct abbreviations for mail pieces so that the address can be located and the mail delivered in a timely manner.

States and countries

Alabama	AL
Alaska	AK
American Samoa	AS
Arizona	AZ
Arkansas	AR
California	CA
Canada	CAN
Colorado	CO
Connecticut	CT
Delaware	DE
District of Columbia	DC
Federated States of Micronesia	FM
Florida	FL
Georgia	GA
Guam	GU
Hawaii	HI
Idaho	ID
Illinois	IL
Indiana	IN
Iowa	IA
Kansas	KS
Kentucky	KY
Louisiana	LA
Maine	ME
Marshall Islands	MH
Maryland	MD
Massachusetts	MA
Mexico	MX
Michigan	MI
Minnesota	MN
Mississippi	MS
Missouri	MO
Montana	MT
Nebraska	NE
Nevada	NV
New Hampshire	NH
New Jersey	NJ
New Mexico	NM
New York	NY
North Carolina	NC
North Dakota	ND
Northern Mariana Islands	MP
Ohio	OH
Oklahoma	OK
Oregon	OR
Palau	PW
Pennsylvania	PA
Puerto Rico	PR
Rhode Island	RI
South Carolina	SC
South Dakota	SD
Tennessee	TN
Texas	TX
Utah	UT
Vermont	VT
Virgin Islands	VI
Virginia	VA
Washington	WA
West Virginia	WV
Wisconsin	WI
Wyoming	WY

Street addresses

The U.S. postal service prefers that street addresses be written out completely, but for business communications pieces or addresses, the design may require an abbreviation. The names of the streets are never abbreviated, but it is acceptable to abbreviate the common parts of the address.

Avenue	Ave.
Building	Bldg.
Circle	Cir.
Court	Ct.
Drive	Dr.
Lane	Ln.
Road	Rd.
Parkway	Pkwy.
Place	Pl.
Post Office Box	PO Box
Rural Route	RR
Room	Rm.
Square	Sq.
Street	St.
Suite	Ste.

Company names

Company names should be written out, but when too much space or the design gives the copy an awkward look, the following abbreviations are acceptable:

Associates	Assoc.
Company	Co.
Corporation	Corp.
Incorporated	Inc.
Limited	Ltd.

Calendars and clocks

Months

January	Jan.
February	Feb.
March	Mar.
April	Apr.
May	May
June	June
July	July
August	Aug.
September	Sept.
October	Oct.
November	Nov.
December	Dec.

Weekdays

Sunday	Sun.
Monday	Mon.
Tuesday	Tues.
Wednesday	Wed.
Thursday	Thurs.
Friday	Fri.
Saturday	Sat.

Time

Midnight to noon	a.m.
Noon to midnight	p.m.
Noon	m.
Midnight	p.m.
Year	yr.
Month	mo.
Day	d.
Hour	h.
Minute	min.
Second	s.

Measurements

Inch	in.
Pica	P
Point	p
Page number	pg.
Price per 1000	M
Foot	ft.
Yard	yd.
Mile	mi.
Square (inches/feet/miles)	$in^2/ft^2/mi^2$
Cubic (inches/feet/miles)	$in^3/ft^3/mi^3$

Weights

Adding a period to the end of an abbreviation is optional. Recipes usually leave them off unless they are mentioned within text.

Ounce	oz.
Pound	lb.
Pint	pt.
Quart	qt.
Gallon	gal.
Teaspoon	tsp.
Tablespoon	T.
Cup	C.

Currency

Dollar	$ or dol
Cent	¢ or c
Cents	¢ or ct

Directions

Directions use the first letter of each word in all capitals without periods. Examples are N, NW, or NE.

Mathematical conversions

Inches (fractions to decimals)
7/8 = .125
1/4 = .25
3/8 = .375
1/2 = .5
5/8 = .625
3/4 = .75
7/8 = .875
1 = 1

Picas and points (picas to decimal inches)
6 points = .083
1 pica = .17
2 picas = .34
3 picas = .50
4 picas = .67
5 picas = .83
6 picas = 1

For additional research

The Chicago Manual of Style, Chicago: The University of Chicago Press, 1993.

U.S. Government, *Style Manual,* Washington, DC: United States Government Printing Office, 1984.

Glossary

Some glossary terms are adapted from the following books:

Adams, J. Michael, *Printing Technology,* ed., Albany: Delmar Publishers, 1996.

Cost, Frank, *Pocket Guide to Digital Printing,* ed., Albany: Delmar Publishers, 1997.

Landa, Robin, *Graphic Design Solutions,* ed., Albany: Delmar Publishers, 1996

AA (author's alterations): changes or additions to the copy by the client during the design production stages.

addressability: output dpi addressing the lpi needs.

alignment: visual connections made between and among elements, shapes, and objects when their edges or axis line up with one another.

analog: any image or video format that does not use digital units of information. An analog color proof matches the printing press format.

analysis: part of research that includes how, what, when, where, and why the publication is read.

ascenders: the part of lowercase letters, b, d, f, h, k, l, and t, that rises above the x-height.

asymmetry: the arrangement of dissimilar or unequal elements of equal weight on a page.

back: an even-numbered page.

balance: an equal distribution of weight.

ballot boxes (check boxes): a square that allows frequently used predetermined answers to be chosen.

baseline: the horizontal edge of capital letters and lowercase letters (excluding descenders).

binary (1 bit) file: an image consisting of areas of either black or white, with no intermediate values. On film, a binary image consists of areas of low or high density with no intermediate values. Film negatives or positives used in platemaking for lithography are binary images. Digital binary images are made up of pixels represented by single bits.

bindery: the finishing operation that holds a complete set of pages together.

black and white: refers to printing in black ink on any color of paper.

bleed: tint or photographs printing to the edge of the final sheet size requiring the image on the file to extend 1/8″ beyond the page size.

body copy (the text, the narrative): paragraphs providing the information or advertising concept.

book trim: a trim given to three sides of a book after collating and bindery, resulting in smooth edges.

bullets: dots that fall in the center of the cap height of a font; used to lead the eye to a listing of information or choices.

by-line: the author's credit line.

calibrating: adjusting the quality of an image to match standards.

cap height: the height of the capitals, measured in points.

capitals (uppercase): the larger set of letters.

caption (cutline): description for drawing or photograph.

character: a letterform, number, punctuation mark, or any single unit in a font.

clipping: the image or text appears cut off at the edges.

CMYK (four-color process): the set of four colors (cyan, magenta, yellow, black) that all printing presses and copiers use to create the illusion of a broad spectrum of colors.

coated paper: paper with an added layer of pigment bonded to the original paper fiber surface to smooth the surface.

collating: finishing operation in which individual printed sheets are assembled into the correct sequence.

color guides: samples of printed ink that show the true color of each ink; used to control accurate communications of color specified.

columns: one or more grids used for paragraphs of text.

comp or comprehensive: a detailed representation of a design.

continuous shade/tone: hundreds of shades of gray or color.

contrast: noticeable difference between page element specifications in tone and color.

creep: when the edge of the folded sheet does not align flush; instead, each sheet shifts further away from the edge of the outside folded sheets.

critique: an assessment or evaluation of work.

cropping: cutting an element so that the entire element is not seen.

custom image: a four- to eight-hour design with a logo and one ink color.

descender: the part of lowercase letters g, j, p, q, and y, that falls below the baseline.

design: the arrangement of parts into a coherent whole.

designer: anyone handling a printed publication through the prepress stage.

device independent: an output device with multiple resolutions.

device specific: an output device with one resolution.

die cutting: cutting a shape from printed sheets; performed during the press run or as a finishing operation.

digital: images or information that is recorded as either a plus or minus.

direct-to-plate: a file passed directly to the printing plate without an intermediate negative or original.

display faces: type usually used as headings; type over 12 points in size.

dpi (dots per inch): the input resolution native to printing presses and output devices to prepare its output.

draw down: scrapping a thin layer of ink across a sample sheet of paper.

DTP (desktop publishing): refers to all phases of producing a publication from the idea stage until it is handed or electronically sent to the printing company.

dummy: blank sheets of paper folded in the same manner as the final job and marked with page numbers and heads; when unfolded, can be used to show page and copy positions during paste-up or imposition.

duotone: two images of one photo, creating additional shades and detail in the printed photograph not attainable with one.

duplicator: any offset lithographic machine that makes copies and can feed a maximum sheet size of 11″ x 17″.

dye sublimation (thermal dye diffusion printing): an output device creating a copy when heat transfers colored dye (usually four-process colors) from a ribbon-like roll to the paper.

electronic distribution: file transfer on a network.

em: a measurement specific to a type size equaling the size of the letter "m."

embossing: finishing operation that produces a relief image by pressing paper between special dies.

emphasis: the idea that some things are more important than other things and that important things should stand out and be noticed.

en: a measurement specific to a type size equaling the size of the letter "n" (half of an "m").

EPS (Encapsulated PostScript): a file that has been translated from its screen version to a binary image. An EPS file is resolution independent.

eye pattern: the "flow" that the viewer's eyes follow as the copy is read.

fifth-channel color: a high-fidelity color.

file: a grouping of data produced in a software package.

film negative: a plastic-like sheet showing the image for each ink color as transparent and the non-image areas as an opaque black; the highest quality intermediate available for printing.

finishing cut: the paper cutting that is done after the printing is completed.

first line indents: shift text in the first line.

fixed space: a non-variable space that cannot be affected by any spacing change when the computer automatically justifies a line of copy.

flat sheet: a piece of paper that looks like single sheets in a package.

flush left: only the left margin is straight.

fold lines: dotted lines located outside the sheet area that indicate where the finished copies are to be folded.

folio line: newspaper term for header and footer containing the page number and nameplate.

format: the grid system or other design look used throughout a publication.

front: an odd-numbered page.

functional: a term used when a publication imparts data for work flow.

ganging: printing several designs on one sheet of paper.

GIFF (Gathered Information File Format): format for building and designing web pages.

grain: the direction in which the majority of paper fibers follow. Folds and presses work "with the grain."

grid: a layout device used to achieve unity; a subdivision of a format into fixed horizontal and vertical divisions, columns, margins, and spaces, that establishes a framework for the organization of space, type, and visuals in a design.

gripper margin: unprintable area where the paper is held by mechanical fingers that pull the sheet through the printing unit of the press.

halftone: a continuous tone photo after it has been scanned and broken into dots or pixels.

hanging indents: do not move the first line of text but shift over the remaining lines following the first.

header or footer: any repetitive information placed at the top or bottom of a page that helps the reader reference pages. Does not fall inside text block area and has different type specifications.

heading (on charts): the names of the columns.

headline (head, the line): the main verbal message in an advertisement (although it literally refers to lines that appear at the head of a page).

hickey: a small piece of lint or paper dust that transfers back to the ink roller and is then distributed to the imaging blanket.

image resolution: the amount of information that is stored about a specific image that allows the dots to record the details of that image.

imagesetter: a high-end process that translates type and images onto film or paper at higher dpi than is available with laser printers. Imagesetters can produce type and images with dots that are invisible to the naked eye.

imposition: placement of images in position so they will be in desired location after folding and collating.

initialmark: a unique layout of the initials of a company or person.

ink absorption: the amount of ink that will soak into a particular kind of paper.

inside pages: two pages that are visible at the same time when a document is opened.

job ticket (work order): the control sheet to identify the location and progress of a particular publication at the printing company.

jumpline: the information that tells the reader where to find the rest of a particular article.

justify: both margins straight.

kerning: decreasing or increasing letterspacing between two letters to visually change the look of the white space between different letter combinations.

kicker: a line that appears before the headline, set smaller and used to lead the reader into the headline.

laid: a texture; a reproduction of a handmade paper with a classic look.

laminated: adding a plastic sheet over the printed piece.

landscape: a horizontal design.

laser printer: an output device using the same electrostatic process as a copier but with an exact imaging capacity of a laser light source, directly from the file, increasing the quality to a first generation image.

leader dots: a series of dots used to help the reader get from copy on the left to small pieces of copy on the right. Used for tables of contents, programs, menus, and statistical information.

leading: the name is derived from the days of metal typesetting when strips of lead of varying thickness (measured in points) used to increase space between the lines; line spacing or interline spacing.

legibility: type that can be seen well enough to be read.

letterspacing: the space between letters.

letterwidth: the horizontal proportion changes to a letter.

ligatures: keystrokes that give two letters instead of one.

line art: any image formed by lines.

line length: the width of a body of type or its layout space, measured in picas.

live area: the area on a page that is designated for the text of long documents.

logo (trademark): an identifying mark for a product, service, or organization.

lowercase: the smaller set of letters. The name is derived from the days of metal typesetting when these letters were stored in the lower case.

lpi (Lines per inch): the number of dots per inch that will print to a specific printing press for photographs and tints (100 lpi, 120 lpi, and so on).

mailer: a designated area on a printed piece following United States Postal Regulation; a self-mailer on advertising, news, and product publications.

margins: the area on a page designated as a non-image area to match specifications of the printer, data entry, grid design, and bindery operations.

master pages: one or more page templates that contain margins, columns, guidelines, and repetitive words or images used for a particular set of pages.

metallic inks: inks that give the appearance that the color is printed on a metal rather than a paper surface.

nameplate: the wordmark for a news publication.

numbering: a finishing operation adding sequential numbers.

offset press: press design in which an image is transferred from a plate to a rubber blanket that moves the image to the press sheet; offset principle allows plate to be right reading and generally gives a better quality image than do direct transfers.

on-demand printing: standard level design files or copies released directly to a high volume copier or printing press with "as-you-wait."

opacity (show through): a paper term used to identify how much of the ink on one side of a sheet can be seen on the other side.

optical center: on a grid, the third block down from the top, where the audience first looks.

original: a first generation file or image.

orphan: first line of a paragraph sits alone on a page or in a column.

output device: any device used to send a file that produces a positive or negative translation of the file information.

overprinting: layering one image on top of another.

PA (Publisher's alterations): any copy errors noted by the author or proofreader that are not accurate to the original text or author's instructions.

padding: simplest form of adhesive binding and an inexpensive way of gluing individual sheets together to form notepads.

page elements: any block of copy, art, or photographs that assemble together to form a publication.

paper house: a company whose purpose is to offer a variety of paper from a variety of paper manufacturers.

paper manufacturers: a company whose purpose is manufacturing a particular brand and type of paper.

paragraph: any set of copy that is completed with a return.

parent size (basic size): the original manufactured size of each type of paper (bond, book, text, index, and so on), which matched its original common use.

PDF/PDX (Portable Document Format): drivers to read files independent of their software .

perforating: finishing operation in which slits are cut into a printed sheet so a portion can be torn away.

photos: usually refers to any photograph, intones and dots, or pixels.

Pi fonts: symbol fonts without an alphabet, but keystrokes an image or symbols.

pica: a measurement equal to approximately 1/6 of an inch.

PICT: a standard Apple file format.

point: a measurement equal to approximately 1/72 of an inch.

POP (point of purchase): a term for advertising publication that are positioned at the presentation of a product.

portfolio: a body of work used by the graphic design profession as the measure of one's professional ability.

portrait: a vertical design shape.

posterization: high-contrast photographs creating an effect rather than showing details using two, three, or four layers in different ink colors.

PostScript: graphics language marketed by Adobe Corporation that is now a de facto industry standard for page description.

preflighting: preparing a finished file and its parts for a specific output device and printing process.

prepress cut: a paper cut that is made before the sheet is run through the printing press, either by the paper house or printing company.

premium image: design time controlled only by budget; logo produces in multiple colors or with embossing.

printing process: the process used to produce multiple copies of an original image.

proofing: testing the quality of the image by a process that closely matches the colors of ink and images.

pull quote: a sentence or part of a sentence that is reset in large type and leading and placed in the copy for interest and contrast.

punch (drill): a finishing operation adding holes for binding; can be drilled or punched depending on the shape of the hole.

rag: a paper term used when cotton fibers are added to paper manufacturing.

raster file: a scanned image.

readability: type that can be comprehended by the reader because it is typographically easy to follow.

register: the exact positioning of two or more colors on a sheet aligned within the size of a printable dot. Spoken as "in register."

register marks: targets located outside the final sheet size identifying the exact alignment of each color.

resolution: used to describe the size of dots creating smoothness of the edges of computer image output.

reverse: layering white type or line art over a photo, tint, or solid color.

RGB (red, green, blue): the set of colors that any monitor (TV or computer) uses to create the illusion of a broad spectrum of colors.

roughs: exact size sketches that are larger and more refined than thumbnail sketches and show the basic elements in a design.

saddle stitch: a bindery operation that adds wire staples to the center of a magazine or booklet.

sans serif: letterform design without serifs.

scanning: converting a flat sheet of type or image to digital information.

scholar's column: a column without body text.

scoring: finishing operation that creases paper so it can be folded easily.

screen image: type or images created by lines.

secondary leading: additional white space before a subhead or paragraph to separate it from the other copy.

serif: ending strokes of characters.

service bureau: a graphic arts industry that converts files to imagesetter negatives or paper proofs.

sheet size: the size of paper as it runs through the printing press.

shells: files set up to insert specific information.

signature imposition: process of passing a single sheet through the press and then folding and trimming it to form a portion of a book or magazine.

small caps: capital letters that appear in the size of lowercase letters but proportionally in the shape of true capitals.

spiral binding: a bindery operation using a wire or plastic binder that wraps into a line of small holes creating a booklet of several pieces of paper.

spot color: printed color other than black, but not one of the three process colors (cyan, magenta, or yellow). In traditional printing, this may be a PANTONE color. In digital printing, it often refers to the second color in a two-color system.

standard design: a fifteen-minute to one-hour design printed in black or a standard color ink.

style palette: a listing of tag names linked to type specifications reused in another area of the publication or another publication.

subhead: any level of head that falls below the headline or title, usually within the text.

swipe file: an inventory of printed samples that the collector determines contains at least one outstanding or trendy design or printing and bindery techniques.

symbol: a sign or a simple, elemental visual, that stands for or represents another thing.

symmetry: the balanced arrangement of similar or identical elements so that they are evenly distributed on either side of an imagery vertical axis, like a mirror image.

table of contents: a text document or publication page element necessary when the publication is complex and the reader needs a listing and page numbers of the information covered in the publication.

template: a file saved with reusable file information for future similar publications.

text type: type used for paragraphs of copy in sizes commonly 11 or less, but no smaller than 6.

thermography: a finishing technique using raised letters on the paper.

thumbnail sketches: preliminary, small, quick, rough designs or drawings of ideas.

TIFF: (Tagged Image File Format). A de facto standard format for raster images. TIFF supports binary, gray scale, RCA, and CMYK images. A TIFF file is resolution independent and any tints remain at that resolution setting.

title: a text document page element used for the name of an article or chapter title.

trapping: overlapping the edges where one color of ink fits against another avoiding areas that show breaks between the two colors. Necessary to compensate for slight variations in paper and printing.

trim lines: l-shaped marks that appear at the corners of a layout marking the location of the final size of the publication to the printing and finishing department.

type family: several font designs contributing a range of style variations based upon a single typeface design. Most type families include at least a light, medium, and bold weight, each with its italics.

type font: a complete set of letterforms, numbers, and signs, in a particular face and style, that is required for written communication. In metal type, every available size of this set of characters is a separate font of type.

type specification: information that appears in formatting windows of the software that changes the appearance of type.

type specimen sheet: a sample set of a typeface; used by designers to accurately choose an appropriate face for a particular publication.

type style: the modifications in a typeface that create design variety while retaining the essential visual character of the face. These include variations in weight (light, medium, bold), width (condensed, regular, extended), and angle (Roman or upright, and italic, and oblique), as well as elaboration on the basic form (outline, shaded, decorated).

typeface: the design of a single set of letterforms, numerals, and signs unified by consistent visual properties. These properties create the essential character, which remains recognizable even if the face is modified by design.

typographic marks: proofreading marks that include marks for correction of type specifications and spelling.

U & lc (upper and lowercase letters): a written and verbal term used to indicate standard capitalization in the specifications for a page element.

uppercase: the larger set of letters or capitals. The name is derived from the days of metal typesetting when these letters were stored in the upper case.

varnish: a finishing operation added during the printing process placing varnish in one of the ink fountains; changing the finish on the sheet or specific sections of the sheet to a glossy or matte finish.

vector-images: images that the computer produces from information that tells it the location of two points and any bezier curve between them.

vignette: an adjustment to the edges of a photograph that eliminates the hard edges.

visual hierarchy: arranging elements according to emphasis.

watermark: an impression made into paper during manufacturing that is visible when the sheet is held up to light. The term is sometimes used when a 5% tint is applied to an image and it is placed on the lowest layer.

web press: a printing press that uses a roll of paper at the loader end, prints the sheet, and then cuts it into flat sheets.

widow: the last line of a paragraph sits alone on the next page or column; a single word on a line by itself at the end of a paragraph.

wordmark: a logo design that uses the company name in type in a unique way that is readable, but distinguishes it visually.

x-height: the height of a lowercase letter excluding ascenders and descenders.

4-up: refers to the number of times the same image needs to appear on a sheet for a savings in printing cost and applies to 2-up, 3-up, 8-up and so on.

Index

Colophon

The *StyleGuide* was designed with a two-column grid. The body typeface is ITC Garamond, 10 on 12. The display face is Gill Sans Condensed. The *StyleGuide* text was printed in two colors of ink: PANTONE 301, a blue, and black. The PANTONE®-identified color reproduction information has been provided for the guidance of the reader. The colors have not been checked by Pantone, Inc. Refer to current PANTONE publications for the color standard.

The *StyleGuide* references several graphic arts professional products whose corporations assisted in the correct handling of their products and names. C-Thru ruler provided a copy of their C-Thru ruler, #GA-96, Dynamic Graphics provided graphics which are used throughout the book, Pantone, Inc., granted permission to reference their PANTONE MATCHING SYSTEM®, and Adobe granted permission to reference their fonts and software.

Many of the samples and charts were created by the author in Adobe PageMaker and Adobe Illustrator.

The *StyleGuide* design and production were done by Susan Mathews at Stillwater Studio in Stillwater NY, on a PowerMac 8100. Adobe Illustrator, Adobe Photoshop, and QuarkXPress were used to create art, and to compose pages, cover and insert. Pagemaker files were converted to QuarkXPress with PM2Q.

Electronic files for the 2-color text were ripped and printed at Courier Westford, Inc., Westford MA.

The color insert prepress and printing was done by The Color Shop in Mechanicville NY. It was printed sheet-fed, in four colors on 80# Sterling Litho Gloss.

The cover films were ripped at the Color Shop and the cover was printed in four colors with spot film lamination at Phoenix Color in Hagerstown, MD on 10 point Carolina.